A JOURNEY OF TWO PSALMS

A Journey of Two Psalms

*The Reception of Psalms 1 and 2 in Jewish
and Christian Tradition*

SUSAN GILLINGHAM

OXFORD
UNIVERSITY PRESS

OXFORD

UNIVERSITY PRESS

Great Clarendon Street, Oxford OX2 6DP,
United Kingdom

Oxford University Press is a department of the University of Oxford.
It furthers the University's objective of excellence in research, scholarship,
and education by publishing worldwide. Oxford is a registered trade mark of
Oxford University Press in the UK and in certain other countries.

First published 2013

Impression: 1

British Library Cataloguing in Publication Data

Data available

Library of Congress Control Number: 2013938317

ISBN 978–0–19–965241–9

As printed and bound by
CPI Group (UK) Ltd, Croydon, CR0 4YY

*In memory of my father, Lance Mull (Mühle) 1908–1967,
who, in my formative years, gave me a love of languages,
music, literature and art*

Preface

I am principally indebted to the Board of the Faculty of Theology for encouraging me to apply for a further term's sabbatical leave in Trinity Term 2012 and to the Governing Body of Worcester College for supporting my decision to do so. I was only able to take this leave through the generosity of the John Fell Research Fund of Oxford University Press: it is appropriate that this work is being published by that Press. The staff there have been characteristically supportive—a second book in one year—and I am especially grateful again to Tom Perridge who commissioned this and to Elizabeth Robottom who has been involved throughout its production.

The research for much of this book had been done before the sabbatical leave, and during that research period and throughout the process of writing I have been very much aware of John Sawyer's support, for his advice in the earlier stages and, later, for his suggestions for improvement: he believes in reception history as an academic discipline as much as I do, and his wisdom and encouragement have been indispensable. I am also grateful to the many colleagues in and beyond my Faculty and College who have responded to my many questions about these two psalms and who have helped me, through their expertise, to get some partial answers. These include Afifi Al-Akiti, Jonathan Arnold, Margaret Barker, John Barton, Adele Berlin, Eberhard Bons, Alma Brodersen, George Brooke, Laurent Clémenceau, Mark Chapman, Robert Cole, Barbara Crostini, Brian Daley, Mark Edwards, Peter Flint, Sarah Foot, Howard Goodall, Martin Goodman, Peter Groves, Frank-Lothar Hossfeld, Dirk Human, Bernd Janoswki, Michael Jessing, Simon Jones, Gunnlaugur Jónsson, Christine Stephan-Kassis, Nicholas King, Reinhard Kratz, Michael Kuczynski, Diarmaid MacCulloch, Jonathan Magonet, David Mitchell, Deborah Rooke, Aaron Rosen, Christopher Rowland, Robert Saxton, Jeremy Schofield, Elizabeth Smith, Elizabeth Solopova, Hermann Spieckermann, Till Steiner, David Taylor, Eva de Visscher, Roger Wagner, Robin Ward, Hugh Williamson, Jonathan Wittenberg, Michael Wolter, and until his death in 2010, Erich Zenger. I am equally grateful to the many institutions which have allowed me to use their resources in the presentation of the images, music and poetry of these two psalms: they are acknowledged within the permissions.

Most of the book was written over the period of my research leave, and I thus was dependent on someone close at hand to read and comment on my first draft and someone else who could present the work in a consistent house style. So I thank my husband, Richard Smethurst, for so patiently enduring the former role in the first year of his retirement and indeed for

reading through the draft twice, without complaint, and Holly Morse, my research assistant, for coping so graciously with very tight deadlines in her performance of the other task.

As is always the case, whatever infelicities remain are mine alone. Reception history is a discipline which requires a good deal of collaborative support, and this book has certainly proved it.

List of Acknowledgements for Literary Excerpts

1. Psalm 1: 'Happy is the One' © David Rosenberg, *Blues of the Sky interpreted from the Original Hebrew Book of Psalms* (New York, San Francisco, and London: Harper and Row, 1976): 1–2

2. Psalm 1.1–2 by Richard Rolle © A. Hudson (ed.) *Two Revisions of Rolle's English Psalter Commentary and the Related Canticles Volume I,* Early English Text Society Original Series (Oxford: Oxford University Press, 2012): 2

3. Passus V 415–19; Passus X 322–3, 326; and Passus XV 60–4 © M. P. Kuczynski, *Prophetic Song. The Psalms as Moral Discourse in Late Medieval England* (Philadelphia, PA: University of Pennsylvania Press, 1995): 189–215

4. George Sandys and Henry King's versions of Psalm 1 © H. Hamlin, *Psalm Culture and Early Modern English Literature* (Cambridge: Cambridge University Press, 2004): 78 and 66–7

5. Psalms 1.1–3 and 2.10–12 taken from *The New Jerusalem Bible,* ed. H. Wansbrough (London: Darton, Longman and Todd, 1990), with permission of the publishers

6. Psalms 1.1–4 and 2.1–6 © Marchiene Vroon Rienstra in M. V. Rienstra, *Swallow's Nest. A Feminine Reading of the Psalms* (Grand Rapids, MI: W. B. Eerdmans, 1992): 18–19, 13–14

7. 'Blessed is the Man', from *The Poems of Marianne Moore,* ed. Grace Schulman, © 2003 by Marianne Craig Moore, Executor of the Estate of Marianne Moore. Used by permission of Viking Penguin, a division of Penguin Group (USA) Inc.

8. 'O how well off he will be' © Gordon Jackson in G. Jackson, *The Lincoln Psalter* (Manchester: Carcanet, 1997): 13

9. 'Why are the nations up in arms' © Gordon Jackson in G. Jackson, *The Lincoln Psalter* (Manchester: Carcanet, 1997): 13–14

Contents

List of Figures

List of Plates

Abbreviations

ABull	*The Art Bulletin*
ATD	Das Alte Testament Deutsch (Göttingen)
ANET	Ancient Near Eastern Texts
ASB	*Alternative Service Book*
BOr	*Bibliotheca Orientalis*
Bib	*Biblica*
BibThBul	*Biblical Theology Bulletin*
BibWor	*The Biblical World*
BKAT	Biblischer Kommentar Altes Testament (Neukirchen)
BN	*Biblische Notizen*
CahArch	*Cahiers Archéologiques*
CBQ	*Catholic Biblical Quarterly*
CCSL	*Corpus Christianorum Series Latina*
ChHist	*Church History*
CRBS	*Currents in Research: Biblical Studies*
CSEL	Christian Classics Ethereal Library
CV	*Communio viatorum*
EJJS	*European Journal of Jewish Studies*
ESV	*English Standard Version*
EvT	*Evangelische Theologie*
FC	*Fathers of the Church*
HeBAI	*Hebrew Bible and Ancient Israel*
HBTh	*Horizons in Biblical Theology*
HUCA	*Hebrew Union College Annual*
IEJ	*Israel Exploration Journal*
IJST	*International Journal of Systematic Theology*
Int	*Interpretation*
JBL	*Journal of Biblical Literature*
JEH	*Journal of Ecclesiastical History*
JH	*Jewish History*
JHS	*Journal of Hebrew Scriptures*
JJS	*Journal of Jewish Studies*
JSAH	*Journal for the Society of Architectural Historians*

JECS	*Journal of Early Christian Studies*
JSOT	*Journal for the Study of the Old Testament*
JSR	*Journal of Scriptural Reasoning*
JTS	*Journal of Theological Studies*
JWCI	*Journal of the Warburg and Courtauld Insititutes*
KHC	Kurzer Hand-commentar zum alten Testament (Tübingen)
LD	*Lectio divina*
LXX	Septuagint
MiltonStud	*Milton Studies*
MLR	*The Modern Language Review*
MPG	*Migne Patrologia Graeca*
MT	Masoretic Text
MusicLett	*Music and Letters*
NKJV	*New King James Version*
NRSV	*New Revised Standard Version*
OTE	*Old Testament Essays*
PIBA	*Proceedings of the Irish Biblical Association*
Presb	*Presbyterian*
RB	*Revue Biblique*
Rev Theol Louvain	*Revue théologique de Louvain*
SBL	Society of Biblical Literature
SCM	Student Christian Movement
Sem	*Semitics*
SJOT	*Scandinavian Journal of the Old Testament*
SJT	*Scottish Journal of Theology*
SP	*Studia Patristica*
SPCK	Society for Promoting Christian Knowledge
Spec	*Speculum*
StLi	*Studia Liturgica*
StPhA	*The Studio Philonica Annual*
SVT	Supplements to Vetus Testamentum
The Harp	*The Harp: A Review of Oriental and Syriac Studies*
VT	*Vetus Testamentum*
ZAW	*Zeitschrift für die alttestamentliche Wissenschaft*
ZThK	*Zeitschrift für Theologie und Kirche*

1

Preparing for the Journey

It is somewhat of a challenge to work on the 'genealogy' of a biblical text, particularly one which has been received so prolifically and so differently in two of the three great monotheistic world faiths. This is made even more demanding because within as well as between each of these two faith traditions there has been so much diversity and dissent. This means that interpretations of the text are in a state of constant flux as different stages of cultural history impact upon our understanding of it.

THE AIMS OF THIS RECEPTION HISTORY

It is important that a work such as this establishes its purpose at the outset. I have three aims. The first is to contribute to the debates which have become prominent over the last twenty years or so about the significance of the first two psalms of the Psalter. Most of these studies look at the language, theology, and stylistic associations between these two psalms and how they each relate to the Psalter as a whole; occasionally references are made to the earlier Jewish or Christian interpretation of the two psalms as one unit. My concern is to use these two psalms as a way of demonstrating that a focus on *reception history* can provide a wider perspective in testing, correcting, and adding to these debates. A reception history perspective has the advantage of interacting with a full and often complex interpretative tradition, which literary critics and biblical theologians often fail to take into account.

My second aim is to use reception history to examine how and why Jews and Christians view these psalms so differently. At first sight the differences are obvious, because of the way that Christians read so many of the psalms through the lens of Christ while Jews read them through the lens of the experiences of their own people. However, reception history can also help to establish what the two traditions have in common—one of the emphases will therefore be on the periods in the history of interpretation where there has

been more dialogue and collaboration, not least more recently, starting in the middle of the twentieth century. So a reception history approach can view these hermeneutical controversies in a wider perspective.

My third aim is to test the theory that the theme of the Temple is an important motif which explains how these psalms can be read together. The Temple is still of vital importance in Jewish tradition, for, despite its physical absence for some two thousand years, it still represents the need for a 'sacred space' in prayer and worship. The Temple has a different relevance to Christians: its destruction resulted in a more spiritualized interpretation of what it previously represented, but it still provides a vital metaphor about God's dwelling with his people when they come to pray and worship. So this study will highlight this Temple theme: this is not only in Psalm 2, where it is embedded in the heart of the psalm, with its specific reference to God's protection of Zion, but it is also in Psalm 1, where the references to the life-giving waters and the fruitful tree have allusions to the inner courts of the Temple.

TEXTUAL ANALYSIS OF PSALMS 1 AND 2

We now turn to the texts of these two psalms, which are presented below. The layout is intended to suggest a threefold structure within both psalms.[1]

Psalm 1	Psalm 2
1. Happy are those who do not walk after the advice of the wicked, or stand in the way of sinners, or sit in the seat of scoffers; 2. but their delight is in the law of the Lord, and on his law they meditate day and night.	1. Why do the nations agitate, and the peoples growl in vain? 2. Why do the kings of the earth set themselves and the rulers conspire together against the Lord and his Anointed? saying 3. 'Let us burst their bonds, and throw away their chains!'
	4. He who sits in the heavens laughs; the Lord holds them in derision. 5. Then he will speak to them in his wrath, and will terrify them in his fury,
3. They are like trees planted by streams of water, which yield their fruit in its season, and their leaves do not wither. In all that they do, they prosper. 4. Not so, the wicked! they are like chaff that the wind drives clean away.	saying 6. 'I have set my king on Zion, my holy hill.' 7. Let me proclaim the decree of the Lord. He said to me 'You are my son! Today I have begotten you.

[1] For seminal discussions of the structure and related text-critical issues, see the commentaries on Psalms 1 and 2 by Kraus 1992: 112–35; Craigie and Tait 2004 (2nd edn.): 57–69; Terrien 2003: 69–87; and Goldingay 2006: 79–106. See also Cole (forthcoming) (Psalm 1) and 80–143 (Psalm 2).

Psalm 1	Psalm 2
	8. Ask of me,
	and I will give the nations as your heritage
	and the ends of the earth as your possession.
	9. You shall break them with a rod of iron
	You shall dash them in pieces like a potter's
	vessel'.
	10. Now therefore, O kings, be wise;
	O rulers of the earth, be warned!
5. Therefore the wicked will not stand in the	11. Serve the Lord with fear;
judgement	Rejoice with trembling;
nor sinners in the congregation of the righteous;	kiss the son,
6. for the Lord watches over the way of the	12. Lest he be angry and you perish in the way
righteous	for his wrath is quickly kindled.
but the way of the wicked will perish.	
	Happy are all who take refuge in him!

Should Psalms 1 and 2, neither having a superscription, be read together as one composite psalm? It is impossible to be certain how many composite psalms exist in the Psalter, but there are several very clear examples. Psalm 108 is a compilation of Pss. 57.8–12 (EV 7–11) and 60.7–14 (EV 5–12); while Ps. 40.2–13 (EV 1–12) and vv. 14–18 (EV 13–17) are almost certainly from two separate sources, given that Psalm 70 comprises only 40: 14–18 (EV 13–17). In addition, several psalms suggest a deliberate pairing (Psalms 9–10; 20–1; 32–3; 42–3; 50–1; 65–6; 73–4; 105–6; 111–12; 135–6; and 145–6); although some pairs are more obviously 'twinned psalms' than others, this does suggest some sort of deliberate editorial process, with doublets and catchwords creating the impression that (whenever they were composed) each is a commentary on the other.[2]

COMPARISONS WITH PSALMS 19A AND 19B

A most interesting example of 'two psalms in one' is Psalm 19: the first part is a hymn of praise to El for his gift of the sun (vv. 2–7; EV vv. 1–6) and the second, a psalm of thanksgiving to Yahweh for his gift of the Torah (vv. 8–15; EV vv. 7–14). The rabbis argued that there were only eighteen psalms between 1 and 19, corresponding with the Eighteen Benedictions, and they held therefore that this whole collection began with one Torah Psalm and ended

[2] See for example Zimmerli 1972: 105–13.

with another.[3] The twin themes of Psalms 19A and 19B are 'Creation' and 'Torah': they mirror the two themes of 'Torah' and 'Messiah' in Psalms 1–2.[4]

Seeing Psalm 19 as a model of 'two psalms in one' is helpful, for it suggests that Psalms 1 and 2 could also be different yet interdependent. Just as the Hymn to the Sun in Psalm 19A probably existed before the Torah Psalm 19B, so Psalm 2, a royal psalm, almost certainly existed before Psalm 1, a Torah Psalm, was composed. The placing of Psalms 1 and 2 at the head of the book of Psalms thus provides not one but two distinctive themes to introduce the Psalter. Psalm 2 (actually the older psalm) is of human and divine kingship, a common motif in the ancient Near East; it provides an introduction which looks back to the Davidic dynasty and God's promises about the protection of Zion and forward to the hope of the renewal of these promises. Psalm 1 (the younger psalm) changes from a focus on David and Zion to the Law, and, implicitly, to Moses.[5]

Each psalm is clearly a discrete unit, evident not least in its self-contained structure.[6] Furthermore, in terms of their *Wirkungsgeschichten* (or the history of their influence), each makes a very different impact on the listener or reader. Psalm 1 implicitly raises the question—who *is* the one who is 'blessed'? The singular verbs and the solo voice suggest this is any individual who is devoted to the study of the Law and who avoids discourse with those who have no regard for it. Originally this would have been the pious Jew; later reception history has applied its teaching about faith and practice to anyone, so that the psalm has a more universal, albeit still personal, appeal. Unbelievers are described in the most general terms, such as the 'wicked' (רשעים), the 'sinners' (חטאים), and the 'scoffers' (לצים). Psalm 2, by contrast, has more specific, political concerns: whereas in Psalm 1 we are addressed by just one speaker, in Psalm 2 we hear at least three different voices, addressing at least three audiences—the Gentile nations, the nation of Israel, and the king. Instead of naming unbelievers in general terms, Psalm 2

[3] The tradition of the number eighteen is a common motif: for example, it is found in the proclamation of the name of God, eighteen times, in Psalm 29; there are eighteen references to God in the *Shema*; and eighteen thanksgivings are found in Sir. 51.12. The most quoted rabbinic source in the Babylonian Talmud speaking of the use of Ps. 19.5 reads: '"*Let the words of my mouth which concludes the Shemoneh Esreh*": "*R Judah the son of R Simeon ben. Pazzi said: Since David said it [i.e. Ps. 19.5] only after eighteen chapters [of the Psalms], the Rabbis too enacted that it should be said after eighteen blessings. But are those eighteen Psalms really nineteen?—"Happy is the man" and "Why are the nations in an uproar" form one chapter.*' See Simon and Epstein(eds.) 1960: *Berakoth* 9b–10a; also Willis 1979: 386–7; Høgenhaven 2001: 169–70; and Botha 2005a: 189–203. See also the discussion in Chapter 4 'The Babylonian Talmud': 68–9.

[4] See Botha 2005a: 189–91; Millard 1994: 10; Høgenhaven 2001: 170.

[5] For a similar view albeit with different conclusions, see Cole 2002: 75; 2013: forthcoming.

[6] Psalm 1 is particularly self-contained: 'Aleph, the first letter of the Hebrew alphabet, is the first letter of the first word and Taw, the last letter of the alphabet, is the first letter of the last word.

is more specific: those who oppose God are 'the nations' (גוים) 'the peoples' (לאמים) 'the kings of the earth' (מלכי־ארץ), and 'the princes' (רוזנים). The key subject in Psalm 2 is not simply 'anyone'; it is a specific individual, namely the king. So whilst Psalm 1 is concerned with the accountability of the individual and what they should do for God, Psalm 2 focuses on what God will do through his king for the entire people to bring about the restoration of Zion. Consequently we receive the first psalm as potential participants in a call for righteous living, and we view the second psalm as observers of an unfolding drama directed by God Himself.

Yet there are also connections between the two psalms. The most obvious is the motif of the two ways and two destinies. Each psalm indicates that there is a choice—for God, or against God. In Psalm 1, the model individual who meditates by day and night on the Torah of the Lord (בתורת יהוה) is contrasted with the wicked people around him; in Psalm 2, the ideal king who trusts in the decree of God (חק יהוה) is contrasted with the *hubris* of the Gentile nations surrounding them. Psalm 1 ends with the judgement on all the wicked, and Psalm 2 ends with the judgement on the hostile nations. A further connection is that the deeds of the godless at the end of Psalm 1 are taken up in the words of the godless at the beginning of Psalm 2. In each psalm, their fate is described in eschatological terms: in Psalm 1 this is in the image of the chaff, with its associations with harvesting at the day of judgement, and in Psalm 2 it is in the depiction of God, seated on his heavenly throne, pouring out his anger on the nations. Finally, the importance of trust in God is developed in both psalms. In the later Psalm 1 this has been influenced by the moral teaching found, for example, in Deuteronomy and especially in Proverbs, with the emphasis on personal responsibility; in the older Psalm 2 we find echoes of the teaching of the eighth-century prophets, with the emphasis on divine judgement on foreign nations.

Furthermore, each psalm has a number of linguistic correspondences. Several scholars have noted this, although some examples are more convincing than others.[7] There is the use of אשרי ('Blessed') at the beginning of Psalm 1 and at the very end of Psalm 2; the use of √ישב to depict the seat of the scoffers in Ps. 1.2 (twice), echoed in Ps. 2.4 which describes God sitting 'enthroned' (√ישב); the use of √הגה to describe the reflective murmuring on God's Law in Ps. 1.2 and to depict the sinister growlings of the nations in Ps. 2.1; the use of יומם ('by day') in Ps. 1.2 and היום ('this day') in 2.7; the reference to the righteous individual being like a tree which yields (√נתן) its fruit at the right time in Ps. 1.3, and to God who gives (√נתן) other nations into the hands of righteous Israel in Ps. 2.8. The reference to במשפט

[7] See Brownlee 1971: 325–6; Sheppard 1980: 140; and Barbiero 1999: 35. Cole (forthcoming) is the most comprehensive summary to date.

to describe the judgement on the wicked in Ps.1.5 may be compared with Ps. 2.10 where it refers, more sarcastically, to the wicked 'judges' or rulers of the earth (שפטי ארץ); and the reference to the way (דרך) of the wicked which will perish (√אבד) at the very end of Psalm 1, which echoes the reference to the rulers who will perish (√אבד) in the way (דרך) at the very end of Psalm 2.

The two psalms share two other distinctive features. First, each psalm is classified according to its contents rather than, as is more usual, by any distinct form, such as a lament or hymn. So Psalm 1 is often termed a 'wisdom psalm' (even though the word for wisdom, חכמה , does not occur) because of its didactic appeal; Psalm 2 is usually seen as a 'royal psalm' because of the reference to God being enthroned in heaven, to the king being enthroned on Zion, and to the kings of the earth being warned that their *hubris* will come to nothing. But this classification has nothing to do with form or genre: it is because of the contents of the psalms. Neither follows any typical form-critical genre: each is *sui generis*.

Furthermore, despite the title of the Psalter in Hebrew as ספר תהלים (or 'Book of Praises') neither psalm is actually addressed to God at all. Individuals within the community of faith are addressed in Psalm 1, while the king, the people, the hostile nations, and, finally, the people are the addressees in Psalm 2. The 'prayers of David' (as stated in Ps. 72.20) actually start at Psalm 3: the first superscription (to David) is over Psalm 3 rather than Psalms 1 and 2.[8] Taken together, this leads to the conclusion that, different as these psalms were, in structure, intention, and impact, they were nevertheless intentionally placed next to each other as a twofold Prologue to the entire Psalter, both being very different from the laments and hymns which follow from Psalm 3 onwards.

So what can be said about how each psalm became an introduction to the Psalter? The clear correspondences between Psalm 2 and Psalm 89, at the end of Book Three,[9] as well as the several linguistic links between Psalm 2 and Psalm 41 at the end of Book One,[10] suggest that Psalm 2 was chosen to introduce Books One to Three *before* the addition of Psalm 1. The result is, therefore, that Psalms 2–89 could be read in the light of the rise and fall of the Davidic dynasty, and Psalm 2 in a sense anticipates the absence of the king so clearly lamented in Psalm 89. Thus a 'royal' Davidic focus in

[8] See for example Weber 2010: 834–45.

[9] See Rösel 1999: 89–91: these include the only references in the Psalter to the father/son relationship between God and the king (Pss. 2.7 and 89.26ff. [EV 27ff.]), and the title משיח to describe the Davidic king (Pss. 2.2 and 89.40, 53 [EV 39, 52]) threatened by enemies outside the community.

[10] See Barbiero 1999: 50–5: these include the אשרי formula (Pss. 2.12 and 41.2 [EV 1]) and the protection of the righteous individual.

Books One to Three came first; the 'Torah' Mosaic emphasis, although apparent in Psalm 19, was brought to the fore with the addition of Psalm 1 and the creation of the Psalter not as three books but as five, like the five Books of the Law.[11]

We saw earlier how Psalm 19 is a useful model for understanding how two separate psalms could be read as one. We might now ask: what was the overall *theme* which might have brought together such different psalms as 19A and 19B—one, a hymn of praise to El, creator of the sun (vv. 2–7, EV vv. 1–6) and the other, a psalm of thanksgiving to Yahweh, the giver of the Law (vv. 8–15, EV vv. 7–14)? The fact that, like Psalms 1 and 2, each part shares similar but distinctive vocabulary (for example, words derived from the roots סתר ['to hide'] in verses 6 and 12, and אמר ['to speak'] in verses 2, 3, and 14) shows some interconnectedness. One obvious theme is their shared concern about *order*: just as El brought order into the cosmos through the creation of the sun, so the individual Israelite must bring order into his community through the keeping of Torah.[12]

THE TEMPLE AS A SHARED THEME?

So might there have been a shared theme which could explain why Psalms 1 and 2 were brought together—one which accounts for a mutual concern rather than the first psalm being concerned primarily with law and the second psalm primarily with kingship? Attempts to make Psalm 1 'royal' to fit with Psalm 2[13] or to make Psalm 2 have a 'wisdom' influence to fit with Psalm 1[14] are partly convincing, and there is some evidence in the reception history of these psalms that this way of reading was often used. However, we have still to take into account the differences; and even the similarities cannot be explained by using 'royal' or 'wisdom' categories. So is there another concern which might originally have drawn the two psalms together? In my view, this theme is that of the *Temple*. In Psalm 2 it is quite clear that the central concern at the core of the psalm (v. 6) is the belief in the continuing presence of God

[11] See for example Wilson 1985: 209–28. See also Flint 1997: 168–70, who notes that 4QPs[a], 4QPs[c] and 111QPs[c] testify best to Psalms 2–89 as an earlier edition of the Psalter.

[12] The same concerns are of course evident in narrative from the story of creation in Genesis 1 to the giving of the law in Exodus 20—the God who saw that everything 'was good' offers the laws to his people that they might emulate his image in the created order. The later development of this theme, evident for example in the book of Jubilees, is that the Torah was actually present at the start of creation.

[13] For example, Brownlee 1971: 321–36 and Cole 2002: 75–88.

[14] For example, Sheppard 1980: 136–44, on account of what might be termed didactic elements in Ps. 2.5 and 10–12.

on Mount Zion, through the Davidic king. In Psalm 1 the Temple theme is less explicit. However, at the heart of this psalm, we read that the one who adheres to the Torah is like a tree by streams of water, giving its fruit in due season: it is not coincidental that comparisons with a tree are used elsewhere to refer explicitly to the trees in the Temple precinct (Pss. 52.9 [EV 8] and 92.13–14 [EV 12–13], and also Ezek. 47.12).[15] It is as if the psalmist is reflecting on the stability, security and protection for the individual which is found in the Torah and the compilers of the Psalter saw how this corresponded with the stability, security, and protection for the people which is provided by the Temple.[16] This would mean that the dominant Torah (and individual) theme in the first psalm and the dominant kingship (and communal) theme in the second psalm were connected by a third shared concern: each psalm is also concerned with the protective presence of God in the Temple. In Psalm 1 this presence is for the model individual Israelite who keeps the Law and in Psalm 2 it is for the ideal king who represents the entire Jewish people by trusting in God's promises.[17]

This proposal is borne out in the reception history of these two psalms, not only in early Jewish tradition, but also in later Christian reception. The Temple theme does not occur at every stage, of course, but it is surprising how many times it does occur. It is certainly evident in many of the exegetical commentaries on these two psalms, both Jewish and Christian, at least up to the beginning of the fifth century CE; it is also present, from time to time, when looking at the way these psalms are used in liturgy, art, music, and literature; and it is undoubtedly a theme which has been frequently proposed more recently by commentators on these psalms. So a multifaceted Temple theme is one way of enabling us to view Psalms 1 and 2 as interconnected psalms, even though they also serve as distinct and separate units. That two psalms in different ways once served in the liturgy in the Jerusalem Temple, along with the collections of hymns, prayers and instructions which followed them, is, in my view, quite clear.[18] But even when they and the rest of the psalms became detached from Temple worship, especially after the Temple's destruction in 70 CE, both psalms still provided an important interpretative key as to how the Psalter could still be a resource for a 'democratized'

[15] We shall examine the use of Ezekiel 47 in Psalm 1 in Chapter 2 'The Start of the Journey: The Hebrew Bible': 15–16.

[16] Given the associations of the Ark of the Covenant and the Temple in cultic legislation, the link between Torah and Temple, even in the post-exilic period, would not be impossible. See Barker 2007: 57–8.

[17] It is interesting that all three psalms which focus on the importance of the law (Pss. 1, 19, and 119) have been placed next to other psalms which have an explicit interest in the Temple and the worship there (Pss. 2, 18, and 20; 118, and 120).

[18] I have developed this idea in more historically orientated papers: see, for example, Gillingham 2005: 308–41, on the influence of the Zion tradition within the Psalter as a whole; and Gillingham 2010: 91–123, on the Levitical Singers and the compilation of the Psalter.

Temple community, both Jewish and Christian.[19] Some of the following chapters will demonstrate this theme more than others, but it will become clear that even when this interest recedes it emerges again in a new way, thus making it an important overall motif in the reception history of these psalms and indeed of the Psalter as a whole.

The following nine chapters will examine the different journeys of these two psalms, both individually and interpreted as one unit. A significant feature will be a focus not only on the words of the text (as the medium for Jewish and Christian commentary and liturgy, as in Chapters 2–6 and Chapter 10) but also on their representation beyond the medium of words alone (in artistic imagery, music, and poetic imitation, as in Chapters 7, 8, and 9). This journey will be lengthy in terms of chronology (covering some two and a half thousand years of Jewish and Christian reception history) and diverse because of the very different modes of reception in different periods of cultural history. But the focus will always be on just these two psalms: this therefore allows for some depth of analysis as well. And because Psalms 1 and 2 have been placed together as the opening to the entire Psalter, what we conclude from this more detailed study will have an impact on how we are to understand Jewish and Christian reception of the Psalter as a whole.

[19] Several psalms scholars are beginning to acknowledge the metaphor of the Psalter as a Temple, noting that Psalms 1 and 2 might play an important role in introducing this theme. See for example the discussion by W. P. Brown of the tree as a transforming metaphor and the waters as symbolizing the sanctuary in Psalm 1, 2002: 67–79; similarly the conclusion to Brown's commentary 2010: 157–60 develops this point in relation also to Psalm 2, as does the seminal paper by Janowski 2010: 279–306.

2

Ancient Judaism

THE START OF THE JOURNEY: THE HEBREW BIBLE

Most scholars would agree that Psalm 1, with its focus on the Torah, was a late entry into the Psalter.[1] Psalm 2, by contrast, is likely to be a composition from the time of monarchy because of its focus on the promises made to the Davidic dynasty; it would have been added to Psalms 3–89 (Books One to Three) during the later restoration period. On this account it is more likely that Psalm 2, the earlier (pre-exilic) psalm, was occasionally used in other biblical books, while Psalm 1, the later (post-exilic) psalm, would have been an independent composition which, although using different traditions in the Hebrew Bible, was not itself used by other biblical writers.

An assessment of the biblical reception of each psalm confirms this observation. Let us start with Psalm 2, for here the most obvious examples actually come from the Psalter. For example, Ps. 59.8 (EV v. 9) ('But you laugh [√שחק] at them, o LORD; you hold all the nations in derision [√לעג]') suggests a deliberate play on Ps. 2.4. However, here the specific enemies are the 'workers of evil' (59.3; EV v. 2) which suggests that Psalm 59 is later, being more concerned with factions within the community rather than enemy nations outside it. Ps. 2.4, with its more international focus, reads 'He who sits in the heavens laughs (√שחק); the LORD has them in derision (√לעג)'.[2]

Psalm 33, which celebrates the cosmic power of God in creation, is usually held to be a late addition into Book One (Psalms 3–41) of the Psalter; it is unusual in that it has no Davidic heading. Yet it does have several allusions to Psalm 2. The parallelism of the 'counsel of the nations' (עצת־גוים) and the 'plans of the peoples' (מחשבות עמים) in Ps. 33.10 (EV v. 8) echoes the conspiracies of the nations and the plotting of the peoples in Ps. 2.1, which speaks of the tumult of the nations (רגשו גוים), and the plotting of the peoples (ולאמים יהגו). The picture of the Lord, sitting in the heavens and watching the nations' futile plans (Pss. 2.4; 33.15 [EV v. 13]), is another

[1] We shall discuss the dating for this psalm in Chapter 2 'The Start of the Journey: The Hebrew Bible': 12–13.

[2] See Briggs 1906: 13.

striking similarity. A third shared motif is the appeal to the congregation to 'fear the Lord' (ייראו מיהוה) in Ps. 33.9 (EV v. 8) which compares with 'serve the Lord with fear' (עבדו את־יהוה ביראה) in Ps. 2.11. Taken together, this suggests that Psalm 2 may well have had some influence on the composer of Psalm 33.

The most explicit reception of Psalm 2 is in Psalm 149. Its placing in the Psalter—the second to last psalm—suggests that here there might be some more deliberate links with the second psalm heading up the Psalter.[3] Psalm 149 is another later psalm, like Psalm 59 more concerned with the community of faith (the 'assembly of the faithful' [v. 1], also called 'the faithful ones' in v. 9) than with royal politics. Nevertheless, several themes found in Psalm 2 are also present in Psalm 149, which ends with the judgement on the nations (described as both גוים and אמים) in vv. 7–9; this is an echo of Psalm 2 which both begins and ends with the same theme, using the same Hebrew words אמים and גוים. Although Ps. 149.2 speaks in a more democratized way of the children of Zion rejoicing in their king, and Ps. 2.6 speaks more literally of the king dwelling securely on Mount Zion, the centrality of Zion in each psalm is hardly coincidental. A more particular linguistic association is in Ps. 149.8, which speaks of God binding his enemies with chains of iron (בכבלי ברזל) while Ps. 2.9 speaks of God breaking the nations with a rod of iron (בשבט ברזל). In Ps. 149.8, 'their kings' (מלכיהם) and 'those of high rank' (נכבדיהם) are warned of their subordinate status under God in a manner which recalls Ps. 2.10, where their 'kings' (מלכים) and the 'judges of the earth' (שפטי ארץ) are to be humbled before God. The two themes of the kingship of God and the central place of Zion in his purposes connect both psalms, assigning them as 'bookends' to the Psalter overall.

One text outside the Psalter which has some correspondences with Psalm 2 is Isa. 49.1–7.[4] Again, the rhetoric concerning the nations at the beginning of Psalm 2 ('Why do the nations [גוים] conspire, and the peoples [ולאמים] plot in vain?') may well have been in the mind of the author of Isa. 49.1 ('Listen to me, O coastlands [איים], pay attention, you peoples [לאמים] from far away!').[5] Certainly Yahweh's address to his chosen one in Isa. 49.3 ('You are my servant' [עבדי־אתה]) has clear echoes of Ps. 2.7 ('You are my son' [בני אתה]). The promise in Isa. 49.6 ('I will give you as a light to the nations [גוים] that my salvation may reach to the end of the earth' [עד־קצה הארץ]) has similarities with Ps. 2.8 ('Ask of me, and I will make the nations [גוים] your heritage, and the ends of the earth [אפסי ארץ]

[3] See Brennan 1980: 25–9 and Cole 2002: 80.

[4] See Janse 2009: 15–17, who argues less convincingly to further correspondences between Psalm 2 and Isaiah 11.

[5] The differences in vocabulary (גוים in the psalm, איים in Isaiah) may be explained because of the liturgical and prophetic genres of each text. Isaiah 49 is not a copy of Psalm 2: it does, however, seem to have used some of the motifs in this psalm.

your possession').[6] The admonition at the end of Psalm 2 ('Now therefore, O kings [מלכים] be wise; be warned, O rulers [שפטי] of the earth ...') has links with Isa. 49.7 with its vision of the kings (מלכים) and princes (here, שרים) also prostrating themselves in obeisance to the LORD.

It is of course possible that Isaiah 49 adapted more general Israelite and ancient Near Eastern royal motifs without any reference to Psalm 2. The ultimate vision in Isaiah 49—of peace and the incoming of the nations—is very different from the more military and warlike imagery of Psalm 2, but this could be a deliberate reversal of royal hopes typical of second Isaiah. If Psalm 2 has been an influence here, it has interesting implications for the theology of the servant in second Isaiah; it shows an adaptation and reversal of the theme of victorious kingship in this royal psalm.[7]

Each of these examples offers an important and surprising observation: later biblical reception of Psalm 2 had little to do with anything royal, let alone anything messianic, despite this theme being so dominant in later Jewish and Christian reception history of this psalm. For example, in Psalm 59, the issue is that of unrest within the Second Temple community; in Psalm 33, the psalm is used to express the cosmic power of God not only over the nations, but within the whole created order; in Psalm 149, the link is the kingship of God, not any reigning king, and with this the central place of the Zion community in God's designs; and in Isaiah 49, the royal military figure is replaced by one who will be God's servant suffering on behalf of the whole community.

Psalm 1, as we noted earlier, has a somewhat different reception history within the Hebrew Bible. Its later date seems fairly clear. First, it reflects a developed view of 'the Torah' (v. 2, twice) as a unified whole; there are none of the qualifying references to the 'commandments', 'statutes', and 'ordinances' which we find in the earlier Deuteronomic literature. Secondly, it has correspondences with a more developed wisdom tradition: it outlines, somewhat starkly, the concept of the 'two ways'—the 'way of the wicked' (רשעים) in vv. 1, 4, 5, and 6 and the 'way of the righteous' (צדיקים) in vv. 5 and 6. This stark idea of retribution is found, for example, in Proverbs 1–9 (e.g. 1.26–33; 8.1–21) and also in Ben Sira (e.g. 1.14–30). Thirdly, the references to the 'wicked' no longer denote the enemy nations threatening the nation of Israel or Judah; as we saw for Psalm 59, these are now opposing factions within the community itself, typical of Judaism in the late Persian and early Greek periods. Finally, the offences of the wicked are not so much specific crimes, which could be dealt with in a court of justice, but rather

[6] אפס ('extremity') in Psalm 2 is replaced by a more typically Isaianic expression, namely קצה ('outer region').

[7] Other later examples adapting the royal ideology expressed in Psalm 2 include Hag. 2.21–3 and Dan. 7.13–14, but these are examples of there being so few similarities in style and genre that it is unlikely that this psalm has been of any specific influence in either case.

theological offences against the Torah, which cannot be dealt with simply by human judges but by divine judgement.

So it is more likely that, rather than being used by other biblical writers, Psalm 1 is reception history 'in reverse': it has itself been influenced by a number of biblical texts from the Law, the Prophets and other psalms, and in this sense it receives other texts rather than being received by them, as was the case with Psalm 2.

Jeremiah 17, a complex prophetic composition of unrelated units, is the most discussed text in relation to Psalm 1: the unit which is relevant is Jer. 17.5–8, because of its extended simile about the tree by the waters. These verses serve as an indictment of those who trust in human power: they will become like a dried-up shrub (17.6), while those who instead trust in God's purposes will be like a well-watered tree. However, while the key focus in Psalm 1 is the importance of the Torah, in Jeremiah 17 there is no explicit interest in the Torah at all. Setting the two passages alongside each other in the NRSV translations, the differences in style and structure should be clear:

Jer. 17.5–8	Ps. 1.1–4
[5] Thus says the LORD: Cursed are those who trust in mere mortals and make mere flesh their strength, whose hearts turn away from the LORD. [6] They shall be <u>like a shrub in the desert</u>, and shall not see when relief comes. They shall live in the parched places of the wilderness, in an uninhabited salt land. [7] <u>Blessed are those</u> who trust in the LORD, whose trust is the LORD. [8] <u>They shall be like a tree planted by water,</u> sending out its roots by the stream. It shall not fear when heat comes, and its leaves shall stay green; in the year of drought it is not anxious, and <u>it does not cease to bear fruit.</u>	[1] <u>Happy are those</u> who do not follow the advice of the wicked, or take the path that sinners tread, or sit in the seat of scoffers; [2] but their delight is in the law of the LORD, and on his law they meditate day and night. [3] <u>They are like trees planted by streams of water</u>, which <u>yield their fruit in its season</u>, and <u>their leaves do not wither.</u> In all that they do, they prosper. [4] The wicked are not so, but are <u>like chaff that the wind drives away</u>.

The Hebrew shows just how clear these differences are. Jer. 17.7 reads 'Blessed are those' (ברוך הגבר) while Ps. 1.1 reads 'Happy are those' (אשרי האיש). Jeremiah's use of ברוך ('blessed' and, later, ארור, 'cursed') places more emphasis on what God will do and give; Psalm 1, using the

intensive plural construct of אשר (אשרי, meaning literally, 'the great happinesses of . . .') places more emphasis on what humans can achieve (in keeping the Torah). Furthermore, the similes of the obedient one being like a tree planted 'by the water' in Jer. 17.8 and Ps. 1.3 are not identical: although the verb שתל and noun עץ are the same, the word פלגים ('streams of water') is used in Psalm 1, and this often describes the waters within the Temple precincts (e.g. Pss. 46.5; 65.10; Isa. 30.23–5). Creach suggests that the image is of a believer located amongst the fruitful trees and living waters within the (idealized) Temple.[8]

Another difference between the two texts is the metaphor about 'bearing fruit'. Jer. 17.8 reads 'and it does not cease to bear fruit' while Psalm 1 states 'which yield their fruit in its season': the only common theme here is the 'fruitfulness' of the 'tree'. In Jer. 17.8 the metaphor continues: 'and its leave[s] shall stay green', while Psalm 1 states 'and their leave[s] do not wither': again, the only common motif is the 'leaf' of the 'tree'. R. P. Carroll rightly remarks: '. . . the image of the green tree as a mark of the person blessed by the deity is too common for literary dependence to be involved'.[9] So although a general stock of images has been used—and the image of the fertile tree by the waters is well known in the ancient Near East as well as in the Hebrew Bible[10]—it is unlikely that Psalm 1 has explicitly used this text from Jeremiah 17. As Creach observes, '. . . the figure of speech in Psalm 1 is altered by the addition of fresh vocabulary and images'.[11]

Other texts which also suggest possible correspondences with Psalm 1 also reveal that it is a distinctive composition. For example, commentators have suggested some borrowing in Ps. 1.1–2 from the *Shema* in Deut. 6.4–7, particularly where the sequence of 'sitting' (in one's house) 'walking' (in the way) and of 'lying'/'rising up' might be seen to have some association with the sequence of 'walk'/'stand'/'sit' in Psalm 1.[12] However, not only is this sequence very different (for example, in Deuteronomy 6 four verbs of action are given, while in Psalm 1 only three occur), but also in Deuteronomy 6 the purpose is teaching (√שׁנן and √דבר) within a family context, while in Psalm 1, it suggests a more personal 'murmuring' in meditation (√הגה). Furthermore, the object of teaching is, in Deuteronomy, the 'words/statutes/

[8] See Creach 1999: 41–3. [9] Carroll 1986: 351.
[10] See Creach 1999: 38–9. The most quoted example is of Amen-em-Opet 4.6.1–12, as translated by Wilson in ANET, 422. The negative subject is 'the heated man in the temple': 'He is like a tree growing in the open. In the completion of a moment comes its loss of foliage. . . .' The positive subject is 'the truly silent man': 'He is like a tree growing in a garden. It flourishes and doubles its yield. . . .' See also Engnell (1953) and Widengren (1951). Other biblical examples include Ezek. 47.12, Pss. 52.10 and 92.13–15.
[11] Creach 1999: 39. Bonnard 1960: 29 sees Psalm 1 as '. . . l'oeuvre d'un sage qui s'est inspiré de Jérémie, mais sans réussir à garder la spontanéité et la force de la sentence prophétique' (p. 29). See also Mays 1987: 4.
[12] See for example André 1982: 327.

judgements' (Deut. 6.4–5) and in Psalm 1 it is, more collectively, the 'Torah' (Ps. 1.2).

Two other texts which some would argue have been copied by the author of Psalm 1 are Deut. 31.9–11 and its parallels in Josh. 1.7–8. The most obvious connection is between Ps. 1.2 and Josh. 1.8, especially in the references to meditating (הגה√) on the law both 'day and night'. Although this short phrase might suggest some direct correspondence, the distinction between the wicked and the righteous, so central to Psalm 1, is completely absent in Joshua 1. The context there is the reward of being given the land of Canaan; Psalm 1 is about being spared the judgement of God. So again Psalm 1 seems to suggest little direct borrowing.

One significant text, however, is Ezek. 47.12, where the associations are more precise. The obvious verbal correspondence here is the expression לא־יבול עלהו ('its leaves shall not wither') in the heart of the verse, which is to be compared with the same expression ועלהו לא־יבול in Ps. 1.3, where the only difference is the order of the subject and verb. Creach points out that the use of נבל√ to describe the withering of a plant is rare; and the further references to the fruit not giving out in Ezek. 47.12 have clear associations with Ps. 1.3 where only the word order is different.[13] The context, in Ezekiel, is the life-giving stream which flows from the Temple: given the possible cultic imagery of the life-giving waters (פלגים) earlier in Ps. 1.3, the psalmist may well be referring intentionally to Ezekiel with its references to the trees of the Temple precincts, planted close to the waters. There are two possible reasons for this. Either Psalm 1 is a deliberate refutation of the Temple, and a clear statement that, in a time of political and social insecurity where the role of the Temple was concerned, the Torah was instead the hallmark of faith;[14] or Psalm 1 is an implicit allusion to the close connection between the Torah and Temple.[15] To quote Botha in this latter respect:

> This road (of the righteous) ends in the temple, in the presence of Yahweh ... the Torah has power to sustain because it is linked to Yahweh as its ultimate source. It therefore does not replace the temple, but plays a role parallel to that of the temple ... it leads the worshipper on a road which ultimately ends in the temple as the manifestation of the presence of Yahweh.[16]

So although Psalm 1 does seem to have had some associations with other biblical traditions, especially with Ezekiel 47, it is an individual and freer composition whose actual reception history only starts *outside* the Hebrew Bible.[17] Its individuality is borne out in many ways. For example, the

[13] Creach 1999: 40–1. [14] This is the position taken by Creach 1999: 46.
[15] This is the position taken by Botha 2005: 515, who uses 1 Chron. 22.12–13 as a (fairly late biblical) text which links together the obedience to the Torah and the importance of the Temple. Botha also refers to the similar view of Levenson. See, for example, Levenson 1985: 99–101.
[16] See Botha 2005b: 518. [17] See Durlesser 1984: 30–48.

expression 'stand (√עמד) in the way' is very different from the usual phrase 'walk (√הלך) in the way' found so often in the Deuteronomic literature; or again, the familiar reference to the wicked being 'like chaff' is unique here because of the image of the 'wind' (רוח) driving (√נדף) the chaff away. Even the expression 'delight in the law' (בתורת יהוה חפצו) is only found once elsewhere: a similar idea is found, not surprisingly, in Ps. 119.70, 77 and 174, but in each case there the root is שעע and not חפץ.[18]

So why did the compilers of the Psalter place Psalm 1, an original and creative psalm, interlaced with a tapestry of other biblical traditions, next to Psalm 2? It is puzzling that a later psalm with such a different history and such different ideals should be set alongside an earlier psalm with such royal aspirations. Here our observations about the biblical reception history of Psalm 2 can provide a partial answer. We noted earlier that neither Isaiah 49 nor Psalms 59, 33, and 149 actually adapted any of the *royal* emphasis in this psalm: rather, they each focused on God's vindication of the righteous community of Zion, so this therefore seems to have been its more common reading in its earliest post-exilic reception. Hence it would not be surprising if the Psalter's compilers understood Psalm 2 (which was not even given a Davidic superscription) in a similar way. Psalm 1 was about how God would protect the individual whose obedience to the Torah of Moses was as steadfast as a tree in the royal Temple precincts; Psalm 2 was about how God would protect his people who had a steadfast faith in his promises (made long ago, to the Davidic king) that he would keep them safe on Mount Zion.

This explanation for the initial juxtaposition of Psalm 1 with Psalm 2 can be illustrated further by two other biblical texts (Mic. 4.1–2 and Isa. 2.1–5) which combine the themes of Zion and the Torah. These two (almost identical) texts are also completely silent about the restoration of the Davidic monarchy. Their future hope is on the Law and Mount Zion: 'For out of Zion shall go forth the law, and the word of the Lord from Jerusalem' (Isa. 2.3; Mic. 4.2). And this association of Torah and the Temple is not unique to just these two texts: it is also found in later post-biblical literature.[19] So against this background—of the surprising lack of royal emphasis in the reception of Psalm 2 in the biblical tradition, and the connection between Temple and Torah in the late biblical and post-biblical period—we might be able to understand perhaps why two such different psalms were brought together. In Psalm 1, we read about God's protection of the individual through the Torah,

[18] The only place where the verb חפץ ('delight') is used with reference to the law is in Ps. 112.1, a psalm which also starts with 'Blessed is the man . . .' [אשרי האיש] but in this psalm the delight is in the 'commandments', more generally, rather than the Torah.

[19] The same themes of Zion and Torah are found in the later post-biblical period: for example, in 4QFlor (4Q174) 10–14 which reads '. . . the shoot of David will appear with the teacher of the law . . . in Zion in the end of days'. We shall examine this passage and other ones similar to it in the Apocrypha and Pseudepigrapha shortly.

implicitly in the light of Temple theology; in Psalm 2, we read about God's protection of his people through the king, explicitly in the light of Mount Zion. In Psalm 1, we encounter the righteous individual, the Torah, and the Temple; in Psalm 2, we encounter the promises made once to the king, the righteous community, and the Temple. Although the more specific royal emphasis in Psalm 2 did of course re-emerge, following the emphasis on David as a paradigm of piety in much of the rest of the Psalter, this was in fact some time later: the Torah (inaugurated by Moses) and the Temple (inaugurated by David) seem to have been the initial considerations.[20] If this explanation for the juxtaposition of these two psalms seems somewhat implausible, their reception at Qumran nevertheless illustrates the same interpretation, as we shall see below.

THE QUMRAN SCROLLS

Just as there is no evidence of the reception of Psalm 1 in the Hebrew Bible, so too there is minimal evidence of this psalm at Qumran: twenty-four psalms are absent from the thirty-nine Psalms scrolls and related manuscripts in the Dead Sea Scrolls, and Psalm 1 is one of them. However, as Peter Flint argues, most of these 'missing psalms' would probably have been included, the problem being the fragmentary nature of most of the Scrolls.[21] It is clear that Psalm 1 was in fact known to the community at Qumran: 4QFlorilegium (4Q174) is testimony to it.

4QFlorilegium is a complicated anthology. Below is a translation, taken from G Vermes' *The Complete Dead Sea Scrolls in English.*[22]

Florilegium I or Midrash on the Last Days (4Q Flor or 4Q174)

(1) *[I will appoint a place for my people Israel and will plant them that they may dwell there and be troubled no more by their] enemies. No son of iniquity [shall afflict them again] as formerly, from the day that [I set judges] over my people Israel* (2 Sam. vii.10). This is the House which [He will build for them in the] last days, as it is written in the book of Moses, *In the sanctuary which Thy hands have established, O Lord, the Lord shall reign for ever and ever* (Exod. xv, 17–18). This is the House into which [the unclean shall] never [enter, nor the uncircumcised], nor

[20] We noted this Moses/David typology earlier in Chapter 1 'Comparison with Psalms 19a and 19b': 4. Reading Psalm 2 alongside Psalm 1 but with a more specifically royal ('Messianic') focus is the practice of 'Temple-less' communities, for example at Qumran. And after the destruction of the Temple in 70 CE Psalm 2 was frequently read, in both Jewish and Christian traditions, in a more specifically messianic way, and the role of Zion became more subdued, having a secondary, more spiritualized concern.

[21] See Flint 1997: 48. [22] See Vermes 1999: 493–4.

the Ammonite, nor the Moabite, nor the half-breed, nor the foreigner, nor the stranger, ever; for there shall my Holy Ones be. [Its glory shall endure] for ever; it shall appear above it perpetually. And strangers shall lay it waste no more, as they formerly laid waste the Sanctuary of Israel because of its sin. He has commanded that a Sanctuary of men be built for Himself, that there they may send up, like the smoke of incense, the works of the Law.

(2) And concerning His words to David, *And I [will give] you [rest] from all your enemies* (2 Sam. vii,11) this means that He will give them rest from all the children of Belial who cause them to stumble so that they may be destroyed [by their errors,] just as they came with a [devilish] plan to cause the [sons] of light to stumble and to devise against them a wicked plot, that [they might become subject] to Belial in their [wicked] straying. *The Lord declares to you that He will build you a House* (2 Sam. vii, 11c). *I will raise up your seed after you* (2 Sam vii,12). *I will establish the throne of his kingdom [for ever]* (2 Sam vii,13). *[I will be] his father and he shall be my son* (2 Sam vii, 14). He is the Branch of David who shall arise with the Interpreter of the Law [to rule] in Zion [at the end] of time. As it is written, *I will raise up the tent of David that is fallen* (Amos ix,11). That is to say, the fallen *tent of David* is he who shall arise to save Israel.

(3) Explanation of *How blessed is the man who does not walk in the counsel of the wicked* (Ps. i,1). Interpreted, this saying [concerns] those who turn aside from the way [of the people] as it is written in the book of Isaiah the Prophet concerning the last days, *It came to pass that [the Lord turned me aside, as with a mighty hand, from walking in the way of] this people* (Isa. viii,11). They are those of whom it is written in the book of Ezekiel the Prophet, *The Levites [strayed far from me, following] their idols* (Ezek. xliv,10). They are the sons of Zadok who [seek their own] counsel and follow [their own inclination] apart from the Council of the Community. *[Why] do the nations [rage] and the peoples meditate [vanity? Why do the kings of the earth] rise up, [and the] princes take counsel together against the Lord and against [His Messiah]?* (Ps. ii,1). Interpreted, this saying concerns [the kings of the nations] who shall [rage against] the elect of Israel in the last days . . .

This anthology, one of the twenty-six fragments from Cave 4, is usually dated somewhere between the latter part of the first century BCE and the beginning of the first century CE, mainly because of its Herodian script. It has been termed an 'eschatological Midrash' because of its emphasis on the elect community now at Qumran who are living in 'the last days'.[23] The anthology can be divided into three parts indicated above: the first two start with a quotation from 2 Samuel 7, and the third starts with a citation of Ps. 1.1. The key focus is the locus of the true Temple: we have here an excellent illustration of the way in which Psalm 1 contributed to the discussion about where the true Temple is to be found, with its implicit interest in the link between Torah and Temple.

[23] See Brooke 1999: 297–8, quoting Allegro, 1958: 350–1, and Steudel 1994; also Dimant 1986: 165–89.

The first section begins with 2 Sam. 7.10–11a, concerning God's appointing 'a place' for his people, which, with a *pesher*-like interpretation, quotes Exod. 15.17–18, citing a similar word, 'place' (מקון: i.e. 'sanctuary'). 2 Samuel 7 speaks of the old Davidic–Solomonic Temple which has become a symbol of God's protection of his people from their enemies. The reference from Exodus 15 refers to a Temple in the future, to be built by God Himself. The section ends with a different allusion: the 'sanctuary' (מקום) of men, is a place where, instead of sacrifice, works of the Torah (מעשי תורה) or, as other translations prefer, works of thanksgiving (מעשי תודה) are offered.[24] The first section thus speaks of three Temples: the Jerusalem Temple of 2 Samuel 7 (which, at the time of writing, after the Seleucids and the Hasmoneans, has been defiled); the future idealized Temple of Exodus 15, to which the present community, living in the 'last days', will soon belong; and a different, democratized Temple known as the 'Sanctuary of Israel'. This last Temple community, by implication, comprises those at Qumran who are marked out from their Jewish contemporaries by their 'works of the Torah'.

The second section starts with citations from 2 Sam. 7.11b–14. Here the emphasis moves from an interest in the Temple to David: God has promised to build (for David) 'a house' (בית here denotes lineage rather than a sanctuary) so that David's line might continue forever. The 'Seed' of David in 2 Sam. 7.12 then transmutes into the 'Branch' of David, which, interpreted through Amos 9.11, becomes the 'Tent' (or 'Booth') of David (סכה דויד) which God will *again* raise up. This unit ends by speaking of how this promised Davidic figure will arise, in the last days, in Zion; a distinctive addition to these texts is that the restoration will be undertaken along with another figure who is to be 'the Interpreter of the Law'.

The themes of the Temple and Torah (in the first section) and those of David and Torah (in the second) are developed in a third section, demarcated by מדרש מאשרי (a midrash from the psalm 'Blessed [is the man] . . .'). After this (line 14) the rest of Ps. 1.1 is cited: 'how blessed is the man who does not walk in the way of the wicked'. This verse is then given a *pesher*-like interpretation through the catchword 'walk' and Isa. 8.11 is quoted; it is used to show the context is now the 'last days'. A further reference, probably from Ezek. 44.10 (also 37.23) defines the 'wicked' as the Levites; this is further expanded—appropriate for the community at Qumran—to be the sons of Zadok (a probable reference to the priesthood in the Jerusalem Temple) from

[24] מעשי תורה is an unusual expression, occurring only elsewhere in 4QMMT C 27; many scholars would prefer מעשי תודה. The Torah however is a motif throughout all three sections: in the second section (lines 10ff.) the one who is the 'shoot of David' (צמח דויד: 2 Sam. 7.12, 14) arises along with the one who is the 'Interpreter of the Law' (דורש התורה). In the third section, the use of Ps. 1.1, with the Torah theme which follows it, points again to the Law as a defining characteristic for the Qumran community. So מעשי תורה would not be as unusual as might first appear. Geza Vermes (1999: 493) prefers מעשי תורה; Brooke, 1985: 92, 185–7, prefers מעשי תודה.

whom the community must disassociate themselves. So, in this setting, Ps. 1.1 is not only given a more corporate and eschatological orientation, but the 'wicked' are now a contemporary party within Judaism. Not surprisingly, the community is urged to keep themselves pure and undefiled from the faithless: this refers not only to those outside (the Romans) but those within it as well. These are 'the last days' when what is needed is obedience to Torah.

Ps. 1.1 is placed at an important point in this anthology, after reassurances that the community at Qumran is the true embodiment of the 'sanctuary' of God and the rightful inheritors of the 'house' of David. Psalm 1 fits well with the whole theme throughout the previous two parts: not only the exhortations in the first part, about upholding the Law, but also the teaching in the second part about a coming figure who will be the Interpreter of the Law. Ps. 1.1 is thus used to show how its teaching is in the process of being fulfilled in the 'last days'—within the community at Qumran. Just as the community have become the embodiment of the Temple, and just as they are also the 'Seed of David', so too are they the undefiled keepers of the Torah about whom Psalm 1 testifies. The original impact of this psalm has thus been modified in at least three ways. It now has a more obviously communal emphasis, and not just a personal one; it is now about the future as well as about the present; and as well as being didactic, its purpose is now also prophetic in that it speaks of coming vindication for the present community as a result of God's judgement on peoples and nations.[25]

Ps. 1.1 has also a polemical intention, which is to separate the righteous of the community from the faithless. In this verse, as in the whole psalm, there is a marked dualism—the two ways, and the two fates (those of the righteous and the wicked). This dualism is a common feature in some of the other community works, for example expressed most clearly in the *Community Rule* (1QS) and the *Hodayot* (1QH). In these two works we see the correspondences with Psalm 1 in a more general way.[26] This is not only in the many references to the righteous and the wicked, but, more explicitly, in its concerns with the rites of entrance to the 'council' (often expressed as בעצת חבור ישראל), which may be contrasted with Ps. 1.1, where the concern is not to become part of the 'council' of the wicked (בעצת רשעים). Similarly, 1QS III speaks of the importance of 'walking' in the 'way' of the righteous; Ps. 1.1 again expresses this negatively—*not* 'walking' in the council of the wicked and *not* standing in the 'way' of sinners. 1QS V reflects on the importance of 'reading the law'; and 1QS VI: 6–8, of doing so day and night, as in Ps. 1.2. 1QS IX is clear about the final judgement of the wicked and

[25] Maier, 2004: 364, writes about the typical rather than personal nature of Psalm 1 as follows: 'Dieser eschatologische und polemische Text setzt keine individuelle, meditative Psalmenfrömmigkeit voraus, er enthält vielmehr eine aktualisierende Interpretation biblischer Passagen unter Voraussetzung der repräsentativ-typologischen Bedeutung der Figur Davids.'

[26] Holladay 1993: 109.

righteous; this echoes Ps. 1.5 ('Therefore the wicked will not stand in the judgement, nor sinners in the congregation of the righteous').

So, we might ask, why was Psalm 1, with its central theme of the righteous man being guided and saved by the Torah, and the wicked being condemned, not more widely represented at Qumran? Psalm 119, another Torah Psalm, is not only cited far more, but it is also evidenced, on its own, in two other scrolls (4QPs^i and 5QPs). All we can surmise is that the general influence of Psalm 1 is pervasive, even though its specific use is minimal. Moreover, its brief appearance is, significantly, in an anthology about the place of the Temple in the community at Qumran.

Psalm 2, following the same pattern we saw in the Hebrew Bible, makes a more explicit appearance at Qumran. Ps. 2.6–7 is found as a fragment on its own in scroll 3QPs. Whether it was used as a messianic text about a coming individual from the Davidic line cannot be known: it is a later text, dating from about the first half of the first century CE. Ps. 2.1–8, also from this time, is used as the first psalm of an anthology, written in prose, 11QPs^c.[27] So these instances tell us little more than that the psalm was used and known by the Qumran community.

The most significant use of Psalm 2 at Qumran is in 4QFlor I (lines 18–19). It occurs after the quotation from Ps. 1.1 in line 14. Here Ps. 2.1 illustrates how the whole community are now the recipients of the promises made to David about his house (noting that here 'house' implies the Temple). The citation of this verse indicates that the community identified themselves with the 'Messiah'; like the figure in Psalm 2 they too were suffering because of the raging of the 'nations' (in this first century setting BCE, this was surely an allusion to Rome).[28] The link between Psalm 2 and 2 Samuel 7 would originally have implied one 'anointed', messianic figure. Here however this is reused. Although the text is corrupt, it seems that the plural form משיחיו is used, rather than the singular משיחו as in Ps. 2.2: the use of בחירי ישראל ('the chosen ones') in the line which follows would certainly imply this more corporate appropriation. So the community at Qumran clearly saw themselves as the recipients of the promises in this psalm. This is a prophetic pronouncement in the process of being fulfilled—by the anointed ones, the elect ones, at Qumran.

This is the only example of this use of Psalm 2 at Qumran. At the end of section two of 4QFlor, as noted earlier, there is a more specific Davidic emphasis, but there the text being reinterpreted is 2 Samuel 7, not Psalm 2.

[27] See Abegg Jr, Flint, and Ulrich 1996: 512. Other psalms in the prose version include 9.3–7; 12.5–9; 13.[1]2–3[4], 5–6; 14.1–2, 5–6; 17.9–15; 18.1–12, 15–17; 19.4–8 and 25.2–7. Interestingly here Psalms 12, 13, 14, 17, and 18 are joined together: Psalm 1 is not used, and this might suggest that at this stage Psalm 2 headed up this collection of psalms: see Flint 1997: 157.
[28] This is made explicit in for example 1QM I.5, 13, 15.

This text is important as it speaks of a promised Davidic figure arising, in the last days, in Zion, accompanied by another figure (certainly not referred to in 2 Samuel 7) who is to be the 'Interpreter of the Law'. Although this may be a post-exilic reflection on the allusions to the priestly and royal diarchy described in Zech. 3.6–10; 4.1–14; 6.9–16, it nevertheless provides an interesting insight into why Psalm 2 was *not* consistently used in any clear Davidic messianic way in this early period of Jewish exegesis.[29]

We now turn to some final observations about how Psalms 1 and 2 are used together in this scroll. These two psalms, beginning and ending this third section of 4QFlor, undoubtedly dominate the interpretation of this anthology. Several scholars see the whole of 4QFlor as a midrash not only on 2 Samuel 7 and but also on Psalms 1–2 taken together as one unit.[30]

Ps. 1.1 is quoted first, to be followed (albeit not directly: references from Isa. 8.11 and Ezek. 44.10 come in between) by Ps. 2.1–2. The choice of these two psalms may be to justify the idea of the 'two Messiahs' at the end of the second section: Psalm 1 is used to stand for the 'Interpreter of the Law', and Psalm 2, 'the Branch of David'. Each, significantly, will 'rule *in Zion* at the end of time'. The ideal law-abiding Israelite depicted in Psalm 1 and the idealized ruling Davidic king in Psalm 2 are thus read together creating a twofold messianic hope: the quotation of the first verse of each psalm certainly indicates this.[31] Furthermore, the place for the fulfilment of this hope will be Zion: as we noted earlier concerning the placing of both psalms at the beginning of the Psalter, this is thus the third theme which conjoins both psalms.[32]

4QFlor is an important text for it shows us, first, that both Psalms 1 and 2 were known and used together by the end of the first century BCE; secondly, that reading them together justifies Qumran as both a 'Torah-community' and a 'royal-community'; thirdly, that because much of 4QFlor is also about Qumran as an alternative 'Temple-community', not only Psalm 2, with its explicit reference to Zion, but also Psalm 1 is used to this effect. 4QFlor thus offers a distinctive insight as to how these early ideals of Torah, king/Messiah and Temple are held together through the use of these first two psalms of the Psalter.

[29] See Janse, 2009: 53–4, who makes the same point: 'A clear Messianic exegesis of Ps. 2 cannot be found here. We should rather speak of de-messianizing' (p. 54).

[30] See for example Yadin 1959: 95–8; Brooke 1985: 82, quoted in Flint 1997: 221.

[31] This point was made in a somewhat different way by Willis 1979: 383–4.

[32] This future vision is made more complicated because in each case the community as a whole takes up these messianic ideals—they embody the perfect keeping of the Torah, and they are the true anointed ones of the Davidic line. A good deal of anti-Hasmonean propaganda seems to be at work here, both in that the words of both psalmists are being realized in the present, thus marking off Qumran as the true community of faith, and that the words are still to be finally fulfilled in the future, thus providing the Qumran community with a vision of their central place in the plan of God in the last days.

THE SEPTUAGINT

It is impossible to assess the Greek translations of Psalms 1 and 2 without a brief reference to Septuagint studies within the Psalter as a whole. The recent proliferation of websites, both personal and from university departments,[33] testifies to an increasing interest in Septuagint studies, not least in relation to psalmody: so a discussion of any part of the Greek Psalter can only be undertaken after a reasoned consideration of various assumptions. My own position is, first, that the Hebrew *Vorlage* suggests that the LXX used a different recension from the MT, albeit one close to it, probably in Hebrew rather than Aramaic; econdly, that although outside the psalms the LXX translation reveals a number of different contributions from various dates and provenances, the translation of the psalms suggests, overall, one author, who in what follows will be called G; thirdly, that the Septuagint tradition is only one of several Greek translations, as later Jewish and Christian traditions bear witness, albeit one of the most significant; fourthly, that as far as the Psalms are concerned, the provenance for the translation is likely to be outside Palestine, and the date is probably the second or first century BCE, and a Hellenistic–Jewish setting might explain some of the differences from the Hebrew.[34] Fifthly—and particularly relevant for Psalm 1—I understand G to be concerned not only with as literal and accurate reading of the text as was possible, but also with some overlay of theological interpretation. We shall see that in Psalm 1 there are at least two significant instances of this—an emphasis on a *future eschatological hope* and a concern for the role of *the synagogue* and liturgical practices there.[35] Both of these may have been accentuated by later interpreters of the Greek, both Jews and Christians, but they do seem to have been part of the agenda which G brought to the text.[36]

[33] Significant websites which have studies of the psalms include <http://www.theo.kuleuven.ac.be./lxxtc/en>; <http://ccat.sas.upenn.edu/ioscs/commentary/prospectus.html>; <http://www.twu.ca/sites/septuagint/>; a more personal website <http://www.kalvesmaki.com/LXX/index.htm> lists a useful work by Pietersma whose draft commentary on Psalm 1 has been used in the following discussion.

[34] The following works have shaped my thinking on these issues and the structure of the following assessment: Schaper 1995; Aejmelaus and Quast 2000; Cox 2001; Pietersma 2000b: 12–32, and 2005: 443–75; Rösel 2001: 125–48; Zenger 2001; and Austermann 2003.

[35] On eschatology in the Greek Psalter, see Schaper 1995: 26–30, and for Psalm 1 in particular, (pp. 46–8 and 155). On synagogue concerns, see Gerstenberger 1987: 5–22, and for Psalm 1 (pp. 43–4). Other issues, such as messianic expectations (as developed by Schaper 1995: 138–59), an emphasis on the transcendence of God, an antipathy to anthropomorphisms (as developed and criticized by Soffer 1957: 85–107), and the application of the psalms more universally beyond the community of faith (as argued by Flashar [1912: 241–68]) do not concern our reading of the Greek in Psalm 1, although some of these do concern Psalm 2.

[36] Here I attempt a working compromise between those who give more priority to G as a faithful translator, such as Pietersma 1997: cols. 185–90 and 2000a, and Cox 2001: 289–311, alongside those who believe the Greek Psalter to be a more theological work, such as Schaper

The reception history of any particular psalm has therefore to seek out key 'unequivalencies' and ask how and why these have come about. In most instances the differences may be simply the difficulty of rendering accurately from one language to another, but in other places some theological agenda working on the translation might also be one explanation.

The first unequivalence occurs in the first two words of Ps. 1.1, which is rendered μακάριος ἀνήρ, offering a more gender-specific term in ἀνήρ rather than ὁ ἄνθρωπος, and without the definite article which occurs in the Hebrew. Even Pietersma observes that this is unusual—although he notes that the existence of it in the Hebrew is also unusual (see for example Ps. 112.1, an identical phrase except that the article is absent) and so it has been deliberately omitted by G. So this may be no more than an attempt at accurate rendering.

Another unequivalence is also in v. 1: this is the choice of ἀσεβῶν and ἁμαρτωλῶν to describe the sinners and the ungodly, for, given the attitude to lawlessness in the psalm, one might have expected ἀνομία, (as for example in Ps. 5.5, where רשע is translated in this way). The resultant sense in the Greek is more that of general impiety than any explicit disobedience to the Law which is more evident in the Hebrew.

Verse 2 begins, by contrast, with the neat equivalent use of ἀλλ' ἤ for כי אם but two further unequivalencies are later found in this verse: first, in the use of θέλημα for חפץ, which places more emphasis on the act of will than on, as the Hebrew implies, the sheer delight in meditating on the Law; and, secondly, the verb μελετάω ('to take care over', 'to take pains with') which also heightens the idea of careful disciplined study of the Law rather than quiet prayerful reflection, as indicated in the Hebrew.[37]

Another unequivalence is found in v. 3, concerning the simile of a tree. The Hebrew reads והיה כעץ with no definite article, suggesting this is any tree (as argued earlier, probably in the Temple) nourished by the waters. On this occasion, the Greek adds a definite article: καὶ ἔσται ὡς τὸ ξύλον which implies, as Pietersma points out, that this tree is 'not just any well-planted tree', and he asks whether this is to remind the reader that it might allude to *the* tree in Gen. 2.17 which was in a well-watered garden (Gen. 2.10). If so, given the correspondences between the paradise garden and the Temple, this is more than a stylistic difference and reinforces the way this psalm was read, even in the Greek, in relation to Temple piety.

1995 and Rösel 2001: 125–48. Pietersma 2005: 443–75, especially pp. 444 and 462, argues that where theological interpretation might be a possibility, this is more because of the ambiguity in the Greek and due to later tradition rather than due to G's own translation.

[37] Nevertheless, to illustrate G's interest in equivalence, the same verb μελετάω is used to translate the somewhat different occurrence of הגה in the Hebrew in Ps. 2.1.

A sixth unequivalence is in v. 4: here, more emphatically than in the Hebrew, the Greek reads οὐχ οὕτως οἱ ἀσεβεῖς οὐχ οὕτως, twice repeating the לֹא־כֵן of the Hebrew: stylistically, this creates a clearer break between vv. 1–3 and vv. 4–6 and so stresses the inevitable fate of the wicked. It also fits with the more threatening term for the wicked (λοιμῶν, with its associations with plague and pestilence, for לֵצִים) in v. 1.

Another unequivalence, also in v. 4, is in the selection of χνοῦς for מֹץ. The Hebrew uses a harvesting image of 'chaff' being blown away in the wind; the Greek, by using the slightly different image of 'light dust', changes the harvesting image to one of fine dirt being picked up by the wind and 'flung away' (ἐκρίπτει) in the open land (ἀπὸ προσώπου τῆς γῆς is an addition in the Greek). Although the harvesting metaphor is less apparent, this still has a strong image of annihilation, and fits with the expanded references to judgement in the following verse.

The two final examples of unequivalence are more obviously theological. The first is in v. 5, where the Hebrew לֹא־יָקֻמוּ רְשָׁעִים בַּמִּשְׁפָּט is translated by G as οὐκ ἀναστήσονται ἀσεβεῖς ἐν κρίσει. The Hebrew קוּם suggests the idea of the wicked not 'standing up'—in the sense of 'not enduring'—at the time when justice is meted out; but, as Schaper argues, the use of ἀνίστημι, an intransitive verb in the future indicative, does seem to use the idea of 'rising' (from the dead) when judgement comes.[38]

Schaper's reading has been much criticized.[39] When taken alongside the second unequivalence in v. 5, however, his point is more sustainable. This is the translation of וְחַטָּאִים בַּעֲדַת צַדִּיקִים (here the verb לֹא יָקֻמוּ in the first half of the verse is also assumed) as οὐδὲ ἁμαρτωλοὶ ἐν βουλῇ δικαίων. Even Pietersma acknowledges that βουλή here for √עדה 'comes as a surprise'. G has previously used βουλή to translate עצה ('counsel', although the Hebrew can also mean 'council') in v. 1 of this psalm: it could be that in v. 5 עצה rather than עדה was in G's received text or that G simply chose to read עדה as עצה; if the latter is the case, this could only be because he saw in this verse some parallelism between ἐν κρίσει and ἐν βουλῇ: just as the wicked will not rise when the 'court of judgement' takes place, nor will sinners rise when the 'council of the righteous' (i.e. the heavenly court of

[38] The difference is perhaps easier to understand in German: the sense of the Hebrew is more akin to 'aufstehen', and the Greek, to 'auferstehen'. Schaper is quite right to argue that this is how the term would have been understood by a Greek literate audience: see Schaper 1995, referring to the same use in for example the *Iliad* Book 24, 551. Schaper does however go too far in presuming this is the mark of a proto-Pharisaic origin of the text, because of the implied belief that *only* the righteous will rise from the dead, comparing this with Ps. 72.4 (Hebrew 73.4) which speaks of the ungodly eternally confined in a nether-world. On the understanding of the 'resurrection of the dead' in Second Temple-period Pharisaic Judaism, see Sawyer 1973: 218–34.

[39] See, for example, Pietersma 1997: col. 189 and Cox 2001: 291, who both argue that ἀνίστημι is a common equivalent for קוּם.

judgement, or the heavenly council) takes place.[40] Verse 6 makes it clear that
God alone knows those who are his, and this then implies that God is the one
bringing about the judgement.

There is however another way of reading this latter example, which
suggests not only a future orientation but a present one as well. Craigie has
made the point that a *place* of judgement is intended in the case of both ἐν
κρίσει and ἐν βουλῇ.[41] The interpretation would then suggest that the court
of judgement and the council of righteous were some sort of synagogue
assembly. As Austermann has pointed out, βουλή when translated from עדה
can mean 'synagogue'.[42] We have already noted how the Greek translation of
Ps. 1.3 suggests more a disciplined study of the Law, and this could imply
some synagogue community in which this took place. So those who do not
attend or give time to such study of the Law will in the end be judged by it;
and those responsible for maintaining the Law in the community (the court
of judgement, or the κρίσις) and the counsel [or council] of righteous ones,
or the βουλή will execute judgement by excluding those who fail to meet its
standards. The lack of superscription to this psalm prevents us being as clear
about its use as we might be for other psalms where G has changed the
Hebrew and suggested more liturgical, parochial concerns which would suit a
diaspora synagogue community, but that this is achieved elsewhere makes the
reading here quite likely.[43]

In conclusion, the Greek rendering of this psalm reveals distinctive
theological concerns which were not evident in the Hebrew text. We have
noted a greater emphasis on the disciplined study of the Law, and the image
that the righteous man who studies the Law enjoys intimacy with God as
did Adam in Eden, just as the righteous individual might have done in the
Temple. Two more controversial differences (both in v. 5) may show
the influence of the synagogue community in determining the fate of the
righteous and the wicked, and alongside this we have noted a heightened
sense of eschatological judgement whereby only the righteous will 'arise'
when the heavenly council is called. In this way the psalm has been applied to
the entire community, both present and future. This corporate and exclusivist
stance fits with what we know about how the community at Qumran inter-

[40] This might also mean that in v. 1 G intended the use of βουλή for עדה to be understood
as 'council' (of the wicked) not 'counsel'.

[41] Craigie 2004: 58, n. 5a, observes this is rather like Deut. 25.1, where the wicked have no
place in the courts of law where justice and righteousness are the order of the day.

[42] See Austermann 2001: 487–8.

[43] Although Rösel 2001: 125–48 reads G's rendering of the superscriptions in a more
eschatological way, Schaper's earlier work, 1995: 131–3, actually argued that the Greek psalm
headings, which have several parallels to the Mishnah (for example, daily worship as seen in
Pss. 24, 48, 82, 94, 81, 93, and 92) were a way of enabling the psalms to serve the needs of the
Hellenized Jewish community.

preted this psalm as well: the difference with the Greek translation here is that the 'Temple community' is now seen more as the 'synagogue community'.

If the Greek translation of Psalm 1 exhibits, first, the same didactic concerns as the Hebrew original, albeit emphasizing the role of the synagogue in teaching Torah, and a heightened eschatological awareness in the coming 'Judgement Day', the Greek translation of Psalm 2 not only demonstrates these two concerns but at least three others as well. One is the transcendence of God (and with this, a resistance to what might be seen as crude anthropomorphisms); another (which was hinted at in Ps. 1.1 in the choice of ἀσεβῶν and ἁμαρτωλῶν to describe the sinners and the ungodly) concerns a more universal relevance of the psalm's didactic message; the third is, perhaps not surprisingly given the ambivalent royal emphasis we have already noted in the reception of this psalm, a more subdued messianic expectation.[44]

The didactic emphasis is found in the first verse. In the Hebrew, רגש√ ('be in tumult') is the only instance of the word in a verbal form.[45] The Greek translates this as ἐφρύαξαν (√ φρνάσσω 'to be haughty') and the verb (הגה√) in the same poetic unit as ἐμελέτησαν (√ μελετάω 'to plot'). These two verbs no longer refer to military connotations of tumult and confusion of the nations suggested by the Hebrew; instead, they reveal more attitudes of vain pride and insolence—and not of specific nations, but of all pagan peoples.[46]

This emphasis is continued in v. 2. Here the addition of διάψαλμα at the end of the verse is curious, given that the MT has no corresponding סלה. Yet this one additional word illustrates the way in which the psalm in Hebrew has been dramatically reshaped in the Greek. The effect of this 'rubric' is to separate the focus on the scheming of the peoples in the first two verses from the focus on the community in the rest of the psalm. It thus changes radically the dramatic impact of the psalm.[47] We have seen how the Hebrew can be read as a liturgical drama in four parts, with four different addressees;[48]

[44] This is a controversial issue: Schaper 1995: 72–6 sees the psalm as a 'messianic hymn' by the time of the Greek translation (p. 75), arguing that Psalms of Solomon 17 and 18 borrowed from the Greek translation of Psalm 2 assuming it throughout to be messianic. Against this view, see Cox 2001: 289–311. Janse, 2010: 40–4, argues from the translations in Ps. 109.3 (Hebrew 110.3) which points to a pre-existent messianic figure, and from the reference to the 'unicorn' (καὶ ὁ ἠγαπημένος ὡς υἱὸς μονοκερώτων) in Ps. 28.6 (Hebrew 29.6), that some messianic awareness may be evident in other psalms, but sees little evidence of it in Psalm 2, either in v. 6 or vv. 10–12.

[45] The following observations have been helped by the summary of the Greek translation of the Hebrew by Pietersma (<http://homes.chass.utoronto.ca/~pietersm/Psalm%202.pdf>) and the brief discussion in Janse 2010: 37–44.

[46] The translation of the first verse of this psalm has a good deal in common with the last verse of the psalm, as we shall shortly see.

[47] This will be made more clear in vv. 6–12.

[48] See Chapter 1 'Textual analysis of Psalms 1 and 2': 2–5.

διάψαλμά here prepares us to read the psalm more didactically, as an oration addressing just one audience in which the voice of the leader of the community (in vv. 6–12) is a sapiential figure and the one and only speaker.

An example of the importance of the transcendence of God and a resistance to anthropomorphizing is found in v. 4, where the reference to God 'sitting' (√ישב) on a throne is replaced by the more general image of God as the one who 'resides' in heaven (ὁ κατοικῶν ἐν οὐρανοῖς).[49] A greater eschatological emphasis is also found in this verse: the Qal imperfects of שחק and לעג are given a more clear future emphasis (√ἐκγελάω in the future middle and √ἐκμυκτηρίζω in the future active) indicating what God *will* do at Judgement Day, a theme continued in v. 5. The vision is not so much about a present drama, as presented in the Hebrew, as teaching about what will take place at a future point in time.

Whereas in the Hebrew vv. 6–9 comprise a speech by God to the king (v. 6), followed by a quotation by the king (or a cultic official on behalf of the king) concerning the promises of God (vv. 7–9), in the Greek this has become one long speech by the king himself. So in v. 6 the address by God to the king is omitted: ואני מלכי על־ציון הר־קדשי ('I have set my king on Zion, my holy hill') becomes ἐγὼ δὲ κατεστάθην βασιλεὺς ὑπ' αὐτοῦ ἐπὶ Σιων ὄρος τὸ ἅγιον αὐτοῦ ('I was established as king by him | on Zion, his holy mountain). In the Greek this is followed by διαγγέλλων τὸ πρόσταγμα κυρίου ('declaring the decree of the Lord'): the promise in v. 7 concerning the king as God's adopted son is now no longer addressed *to* the king *by* God but *by* the king *to* the rebel rulers. The use of δὲ at the very beginning of this section admittedly serves to create a contrast with what has gone before, but any suggestion of a liturgical exchange between God, the speaker on behalf of the king, and the king himself on behalf of God has been erased.[50] The effect is that the king is reporting already-known promises. This suggests, by way of historical retrospect, a less immediate appropriation of what could be seen as messianic terminology, taking away the direct divine authority of the promises which are more clear in the Hebrew.

The rest of the psalm, from v. 6 onwards, now can be read as one lengthy speech by the king to the rebel nations, which, placed in the mouth of a synagogue elder at the time of translation, becomes a long didactic passage about God's protection of his people. In this interpretation, the part played by the king is thus minimized rather than expanded, and the messianic

[49] It could be argued that the following reference to God 'laughing' (√ἐκγελάω) at the nations' plotting provides clear evidence of anthropomorphism, but the image is one of righteous scorn at the vanity of the nations rather than anything hysterical in the mind of God.

[50] The so-called genre of 'reported speech' is continued in v. 7 with κύριος εἶπεν πρός με instead of the announcement חק יהוה in the Hebrew.

expressions are lessened. This reading is certainly borne out by the translation of the difficult phrase נשקו בר in v. 12 (often translated as 'kiss the son!'), which the Greek translates as δράξασθε παιδείας ('seize upon instruction!'), thus eradicating any mediating royal role whatsoever.[51] This is not to undermine the role of God in the psalm; conversely, his role alone is strengthened by additions such as κύριος εἶπεν in v. 7b ('*the Lord* said . . .' rather than the simple אמר in the Hebrew) and μήποτε ὀργισθῇ κύριος in v. 12 ('lest *the Lord* will become angry' rather than just פן יאנף in the Hebrew). God is clearly the main director of events in this psalm; but the Greek translation does not always make it clear that the 'anointed one' in v. 3 is the only one who will execute the judgement.

We have already noted the instructional elements in v. 1, and, by implication, throughout vv. 6–9. This is even more evident in vv. 10–11. σύνετε παιδεύθητε ('understand, be instructed') is a fair translation of the Hebrew, although παιδεύω has perhaps more of an element of discipline and correction than the Hebrew √יסר. But this lays the groundwork for the clear didactic emphasis at the beginning of v. 12 δράξασθε παιδείας ('seize upon instruction!'), which expands the motif of παιδεύω from v. 10. Further, in v. 12 we read καὶ ἀπολεῖσθε ἐξ ὁδοῦ δικαίας ('and you will perish from the righteous way') which is a further development of the Hebrew ותאבדו דרך ('and you will perish in the way') reminding one of the same phrase concerning the righteous in the didactic ending in the Hebrew of Psalm 1 ('for the LORD watches over *the way of the righteous*'). This, in addition to the Greek expansion of the expression כי־יבער כמעט אפו ('*for* his wrath is quickly kindled', reflecting a more causal element) which is now ὅταν ἐκκαυθῇ ἐν τάχει ὁ θυμὸς αὐτοῦ ('*when* his wrath quickly blazes'), connects present didactic elements with a future day of judgement. The final blessing with its plural form (μακάριοι πάντες οἱ πεποιθότες ἐπ' αὐτῷ), different from the individual μακάριος ἀνήρ ὅς in Psalm 1, shows that the instructions in this psalm are to be heeded by πάντες—a word also added to the Hebrew address to the nations and rulers in v. 10—everyone, illustrating a more universal application of the message of the psalm.

How does the Septuagint translation affect our understanding of Psalms 1 and 2 as a unity? While Schaper sees that a very close connection has been made between Psalms 1 and 2 in the Greek translation, Pietersma recognizes that the inconsistencies might be due mainly to the parent text and so treats

[51] Pietersma makes the point that G translates √נשק as √καταφιλέω in Ps. 84.11 (Hebrew 85.10) so the meaning 'kiss' was known, and בר in Ps. 17.21 (Hebrew 18.25) is translated as καθαριότης ('purity'): 'Kiss [embrace] purity!' (referring to the king or even to the Torah?) could have been a more wooden translation, therefore, but an interest in instruction and teaching which runs throughout vv. 10–12 was more important than developing any further a messianic emphasis here.

them as separate units.[52] It is difficult to know which scholar is right: against Schaper, if the Greek translators did read Psalms 1 and 2 as a unit, it is odd that when the same Hebrew word occurs in both psalms, the Greek does not always create a similar equivalence. For example, where the Hebrew uses √ישב in Ps. 1.1 and Ps. 2.4, the LXX uses καθίζω in Ps. 1.1 (καὶ ἐπὶ καθέδραν λοιμῶν οὐκ ἐκάθισεν) whereas, perhaps to avoid anthropomorphism, κατοικέω (ὁ κατοικῶν ἐν οὐρανοῖς ἐκγελάσεται) in Ps. 2.4

However, in support of Schaper, it is clear that on other occasions the equivalence does seem to be recognized in the Greek. For example, when the Hebrew √שפט is used in Ps. 1.5 and Ps. 2.10, the LXX uses κρίνω on both occasions (ἐν κρίσει in Ps. 1.5 and οἱ κρίνοντες τὴν γῆν in Ps. 2.10). Or again, where the verb הגה is used to create an onomatopoeic effect in Ps. 1.2 to describe the murmuring on God's Law and in Ps. 2.1 to depict the growling of the nations, the LXX uses μελετάω: in Ps. 1.2 it describes the individual's considered reflections on the Law (καὶ ἐν τῷ νόμῳ αὐτοῦ μελετήσει) while in Ps. 2.1 it denotes the threatening scheming and plotting of the nations (καὶ λαοὶ ἐμελέτησαν κενά). Furthermore, the phrase μακάριος ἀνήρ ὃς . . . at the beginning of Psalm 1 ('happy the individual who. . .) is clearly repeated, albeit in a plural form, at the end of Psalm 2 (μακάριοι πάντες οἱ 'happy are all those who') with the deliberate contrast (which is also in the Hebrew) that the recipient is the individual in Psalm 1, but all the people are involved in Psalm 2.[53] Another example is in Ps. 2.10 where the LXX translates the address to the kings which in Hebrew reads השכילו הוסרו ('Be wise! Be warned!') as σύνετε παιδεύθητε ('Understand! Be taught [receive teaching]!') bringing the Greek more in tune with the didactic and instructional theme of Psalm 1. A final example is an actual addition in the Greek of Ps. 2.12 which creates a deliberate echo of Ps. 1.6. The Hebrew in Psalm 1.6 refers to the wicked perishing in the way (ודרך רשעים תאבד) and the Greek renders this as καὶ ὁδὸς ἀσεβῶν ἀπολεῖται. The Hebrew of Ps. 2.12 speaks of the wicked nations perishing in the way (ותאבדו דרך); the LXX brings the last two vv. of each psalm closer by adding in 2.12 καὶ ἀπολεῖσθε ἐξ ὁδοῦ δικαίας ('and you will perish from the righteous way'). The word δικαίος is used twice in Ps 1.5, 6 but nowhere in Psalm 2 other than in this verse.[54]

To conclude: the Greek translation does seem to bring these psalms together in two particular ways: first, by giving Psalm 2 more of an instructional element, in the choice of particular words in vv. 2, 10 and 12; and, secondly,

[52] See Schaper 1995: 165; Pietersma 1997: cols. 185–90.

[53] It is this term, preserved in both the Hebrew and the Greek, which has caused some scholars to see these two phrases as 'inclusios' deliberately designed to link the two psalms : see for example Craigie 1983: 59–60.

[54] See Brownlee 1971: 324.

by giving Psalm 1 more of an emphasis on coming judgement by the choice of particular words in vv. 5 and 6.[55] Furthermore, by giving neither psalm a superscription—a most unusual trait in the Greek, which usually adds super-scriptions to other psalms without them—the continuity between the two psalms is further preserved. Another curious addition is the addition of διάψαλμα after Ps. 2.2: this may be simply to indicate a break in content and structure of the psalm (English versions often add 'saying' at this point) and to emphasize more dramatically the announcement from God in the verses that follow; alternatively it might be a means of signifying that Ps. 2.1–2 really belong as much to what precede them (i.e. Ps. 1.1–6) as to what follow them (vv. 3–12); Psalm 2 thus continues the theme with which Psalm 1 ends.

Nevertheless, given the way that the Greek translators united some psalms (Pss. 9 and 10, 114–15) and divided others (Pss. 116 and 147) it is curious that they never actually united Psalms 1 and 2: it seems overall they still saw these as two distinct psalms with complementary theological themes.

THE APOCRYPHA AND PSEUDEPIGRAPHA

We have already seen how Psalm 1 seems not to have been used elsewhere in the Hebrew Bible, nor used very much at Qumran; in the post-biblical tradition, similarly, it has an impoverished reception history. Of the four possible texts where a corresponding phrase from Psalm 1 is to be found, only two are really convincing. Not surprisingly, all four have clear wisdom corre-spondences, and all four claim, to different degrees, some pseudonymous relationship with Solomon.[56] This might be due to the wisdom associations, but it might also be that, just as the Hebrew Psalter claimed Davidic authorship, those writing later in a Greek medium claimed Solomon as their source, given that his wisdom and literary activity (and 'authorship' of two

[55] In Ps. 1.5, the use of ἀνίστημι, an intransitive verb in the future indicative, does seem to imply more the idea of 'rising' (from the dead) when judgement comes. It contrasts with the idea of 'not standing' when judged as is implied by the Hebrew קוּם. This is interesting because ἵστημι (which is found, for example, in Pss. 17.39 [Heb. 18.39] and 35.13 [Heb. 36.13]) could have been used in Ps. 1.5 instead.

[56] The Solomonic links are by no means identical in all four texts. In Psalms of Solomon, Solomon never occurs and the title is a later addition. In Wisdom of Solomon, the link is more explicit: 7.1–14 and 18.17–9.18 recall Solomon's prayer for wisdom in 1 Kings 3 and Solomon is 'impersonated' in most of the poems. In Odes of Solomon, the title above the last Ode (42) claims Solomonic authorship and the language in the Ode is reminiscent of Song of Songs, but the link with Solomon is somewhat vague. In Ben Sira, which according to the Prologue is a Greek translation of a Hebrew original, the figure of Solomon is dealt with more negatively, for the author stresses more the covenant with Moses than that with David and his dynasty. For example, Sir. 47.18–21 measures all kings, especially Solomon, against the Deuteronomic laws of obedience in Deut. 17.14–20.

psalms) were legendary. We shall return to the implications of this Solomonic connection later.

The first and most obvious text is Psalms of Solomon 14. Within the work as a whole, several correspondences with the concerns expressed in Psalm 1 are clear. The clearest example, found in several psalms (e.g. 3, 6, 9, 10, 13, 14, 15), is the dualism concerning the 'two ways'—the fate of the wicked and righteous. It is commonly held that the historical setting is some time after Pompey's invasion of Jerusalem (noting the reference to his death in 2.30, 31), and the poet, probably writing in Hebrew (the Greek bears the marks of being a translation, although its date is uncertain), was probably a Pharisee, descended from the Hasidim from the time of the Maccabees, with a marked hostility to the Sadducees and the Hasmonean dynasty (4, 8), and so concerned about keeping the moral and ceremonial law as a way of preserving the community's identity. In addition, he was looking for a final judgement when the wicked would be judged and the righteous rewarded (7, 11, 12, 16). In Psalms of Solomon 14, the number of allusions to specific parts of Psalm 1—each one in consecutive order, corresponding with the psalm— suggests that the author drew consciously from it, identifying with its world view. For example, the reference to 'those who live in the righteousness of his commandments, in the law' (τοῖς πορευομένοις ἐν δικαιοσύνῃ προσταγ- μάτων αὐτοῦ ἐν νόμῳ) in 14.2 has allusions to the (more personal) delight in the law expressed in Ps. 1.2. The reference to the Lord's saints being 'the Lord's paradise, the trees of life' (ὁ παράδεισος τοῦ κυρίου τὰ ξύλα τῆς ζωῆς ὅσιοι αὐτοῦ) in 14.3 has allusions to the righteous being like trees in a well-watered place in Ps. 1.3. The defiant stance against the wicked in 14.6 ('καὶ <u>οὐχ οὕτως</u> οἱ ἁμαρτωλοὶ καὶ παράνομοι: but not so are sinners and unlawful ones) recalls the same interjection in Ps. 1.4: לֹא־כֵן הָרְשָׁעִים / <u>οὐχ οὕτως</u> οἱ ἀσεβεῖς. The reference to the desire of the wicked being 'small and decaying' (ἐν μικρότητι σαπρίας ἡ ἐπιθυμία αὐτῶν) in the next verse is reminiscent of the wicked being 'like chaff', also in v. 4 of Ps. 1. And the reference to the final day of reckoning when the wicked will inherit Hades, 'and they will not be found on the day of mercy for the righteous' (καὶ ἀπώλεια καὶ οὐχ εὑρεθήσονται ἐν ἡμέρᾳ ἐλέους δικαίων) has clear correspondences with Ps. 1.6 which describes how God knows the way of the righteous, while the way of the wicked will perish. Clearly here we are concerned with allusions, rather than citations; but the ordering of these specific texts within the context of the shared, more general outlook makes the link with Psalm 1 quite likely.[57]

A second example is found in the Wisdom of Solomon, a text most commentators would argue is also from the first century BCE, but whereas

[57] See Wright 1985: 639–70 on the Psalms of Solomon in general and the link of ch. 14 with Psalm 1.

the world view of Psalms of Solomon, with its Pharisaical influences and its more obvious Palestinian setting, coincided more with that of Psalm 1, here the probable Alexandrian setting and the more obvious Jewish and Hellenistic wisdom concerns create a different world view from that expressed in the first psalm. The Torah is constantly compared and contrasted with Wisdom, who (unlike Torah) is personified and speaks (e.g. 6.9–25). Solomonic wisdom (rather than the Law of Moses) is therefore the focus in Chapters 7–11.[58] The most obvious allusion to Psalm 1 is in Wisdom of Solomon 5, which describes the dual fate of the righteous and wicked, and in v. 14a describes the fate of the wicked as 'chaff carried by the wind' (ὅτι ἐλπὶς ἀσεβοῦς ὡς φερόμενος χνοῦς ὑπὸ ἀνέμου)'. The dualism and the imagery recall Ps. 1.4: in the Hebrew, this reads כי אם כמץ אשר־תדפנו רוח; the Greek is ἀλλ' ἢ ὡς ὁ χνοῦς ὃν ἐκρίπτει ὁ ἄνεμος ἀπὸ προσώπου τῆς γῆς. The verbs are different: Wisdom of Solomon uses the present passive participle of φέρω whilst Psalm 1 uses the present active indicative of ἐκρίπτω; but the coincidence of χνοῦς and ἄνεμος is notable.[59]

There are two other oblique allusions in two other texts which also need to be noted. Both compare the righteous with a tree gaining its life from the waters. The first is in a second-century BCE work, *The Wisdom of Jesus the Son of Sirach*, which actually has more to do with Moses and Torah than with David, Solomon, and the Psalms, although the wisdom concerns are the connecting motif. Sir. 14.20, for example, uses the same expressions as does the Greek at the beginning of Ps. 1.1 and end of Ps.1.2 (μακάριος ἀνήρ ὃς ἐν σοφίᾳ μελετήσει); but the 'happiness' is not on account of 'a man' 'meditating' on the law, but rather, on wisdom.[60] And Sir. 24.14 describes the growth of the wise man towards God using similes of four trees, of which the first and last read: 'I was exalted like a palm tree in En-gedi. . . .' and 'I grew up as a plane tree by the water'. Given what has been said about the general image of the tree planted by the waters, this correspondence may be merely coincidental; on the other hand, in the same chapter Sir. 24. 25–7 develops other links between the Torah and an Eden-like paradise ('He fills all things with his wisdom, as Phison and as Tigris in the time of the new fruits; He makes the understanding to abound like Euphrates, and as Jordan in the

[58] 11.18–19.22 with its interest in the history of the Exodus and its assocations with the Passover Haggadah is different again and has no connection at all with Psalm 1.

[59] As was noted earlier, the expression does occur elsewhere in the Hebrew Bible (e.g. Job 21.18, with the parallelism of straw (ἄχυρον) before the wind and chaff (κονιορτός) before the storm; see also Pss. 35.5, 83.11, and Jer. 13.24) but the correspondence with Psalm 1 is the most striking.

[60] Marböck 1986: 211–17, makes more of this, arguing that Sir. 14.20–15.10 is in fact a detailed Midrash on Psalm 1 from a wisdom perspective, with its themes of blessedness (Ps. 1.1/Sir. 14.20), its use of הגה (Ps. 1.2/Sir. 14.20), its preoccupation with the Torah (Ps. 1.2/Sir. 15.1), its negative outlook (Ps. 1.1/Sir. 15.7–8) and their final resolutions (Ps. 1.6/Sir. 15.9ff.) as well as the similar images of 'the way' and 'the tree'.

time of the harvest; He makes the doctrine of knowledge appear as the light, and as Geon in the time of vintage') in a way which might suggest that these ideas hinted at in Psalm 1, about the Law restoring the righteous in a well-watered (paradisal) garden, have been taken further.[61]

The second example is in the much later and more Gnostic Odes of Solomon (probably Christian, dating from about the mid-second century CE, albeit with many Jewish apocalyptic features).[62] The hymnic quality of these pieces suggests they are deliberate copies of psalms, in style, if not always in content. Ode of Solomon 11 develops the same image of Ps. 1.3 along the lines of Ben Sira:

> And He took me to His Paradise, wherein is the wealth of the Lord's pleasure.
> I beheld blooming and fruit-bearing trees,
> And self-grown was their crown.
> Their branches were sprouting and their fruits were shining.
> From an immortal land were their roots.
> And a river of gladness was irrigating them,
> And round about them in the land of eternal life.

However, it is more likely that both Ben Sira and Odes of Solomon are developing a common tradition rather than using the psalm itself, and that it is only in Psalms of Solomon and Wisdom of Solomon that the specific allusions to Psalm 1 are clear.

The fact that all four texts have wisdom themes and from this a connection with Solomon as the founder of wisdom illustrates an important later reading of Psalm 1: what might have been implicitly understood as wisdom influence, on account of the didactic concerns in the psalm (although the word חכמה is never used) in later times it is now explicitly interpreted as such. This is of course due to the way in which later wisdom literature—not least, in Ben Sira—identifies Wisdom as Torah and Torah as Wisdom.[63] The later identification of Psalm 1 with the wisdom of Solomon in addition to the law of Moses has an interesting implication: this also includes Solomon as the founder of the Temple as well as of wisdom. Hence the Torah of Moses finds its resting place in the heart of the Temple as well, as texts such as Sir. 24.10–11 made clear.[64] Thus, through the prism of the later wisdom literature, the connection in Psalm 1 between Temple and Torah is seen again.

[61] Another important reference later in the same chapter, which speaks of Wisdom as Torah, reads: 'In the holy tent I ministered before him, and so I was established in Zion. Thus in the beloved city he gave me a resting place, and in Jerusalem was my domain' (Sir. 24.10–11). This corresponds with the earlier discussion of the possible Zion/Temple references in Psalm 1.

[62] See Charlesworth 1985: 725–71.

[63] See for example Sir. 19.20: 'The whole of wisdom is fear of the Lord, and in all wisdom there is the fulfilment of the law'. 'Wisdom' and 'Law' are several times dealt with synonymously in the Prologue to Sirach, and also in 1.26 and 15.1.

[64] See also 4QFlor 10–14 on 2 Sam. 7.14: '. . . the shoot of David will appear with the teacher of the law . . . in Zion in the end of days'.

The use of Psalm 1 was seen to be particularly evident in Psalms of Solomon 14, where the allusions occur in the same consecutive order. The author's interest in moral and ceremonial law at a time when Jerusalem was under threat after Pompey's invasion made Psalm 1 an ideal psalm to use. But the author was also looking for a time when a future king would defeat the people's enemies, purge Jerusalem, gather in the people of Israel, and reduce the foreigners to obeisance and servitude. Hence Psalm 2 provided equally important material, and just as the vocabulary of Psalm 1 is scattered throughout this work, so too the style and language of Psalm 2 can be found in many of the chapters. Nevertheless, as with Psalm 1, caution is necessary, because just as didactic vocabulary is taken from sources beyond Psalm 1, so too the language of Psalm 2 could equally suggest another shared tradition— expressed for example in texts such as Psalm 89, 2 Sam. 7.10–17, Isa. 11.1–10, and Isa. 49.1–7.[65]

Nevertheless, just as Psalms of Solomon 14 drew especially from Psalm 1, Psalms of Solomon 17 draws especially from Psalm 2. The rulers (ἄρχοντες) are waging war (Ps. 2.2; Ps. Sol. 17.12, 20, 22, 36) and Jerusalem is threatened (Ps. 2.6; Ps. Sol. 17.14, 22, 30). The one designated to help is Χριστὸς κυρίου (Ps. 2.2; Ps. Sol. 17.32) who is promised the nations (ἔθνη) as an inheritance (κληρονομία) (Ps. 2.8 and Ps. Sol. 17.22). The enemy nations will be smashed like an iron rod or potter's vessel (Ps. 2.9; Ps. Sol. 17.23ff.). The nations will pay homage (both Ps. 2.11 and Ps. Sol. 17.30 use δουλεύω). The theme of the nations submitting in fear (ἐν φόβῳ in Ps. 2.11) is also taken up in Ps. Sol. 17.34, 40. Furthermore, the military motifs of Psalm 2 are not the only ones used: we have seen how the Greek translation of Psalm 2 emphasizes also a sapiential king, and this is also brought out for example in Ps. Sol. 17.32, 37 in the king's call to the wicked rulers to 'understand' (using σύνεσις in Ps. Sol. 17.37 whereas Ps. 2.10 uses σύνετε).

One interesting omission is the reference to the king as υἱός θεου (Ps. 2.7). It seems that the people themselves now inherit the promises once made to the king: they are the υἱοὶ Θεου (Ps. Sol. 17.27).[66] (The biblical evidence for a similar democratization of the Davidic hope would be Isa. 55.3.) Thus in these examples, which are perhaps the best witness to the use of Psalm 2 in Second Temple Judaism, one of the key themes in later Christian

[65] Janse (2009: 57–60) offers a detailed chart comparing the Greek idioms shared between just one chapter (Ps. Sol. 17) and Psalms 2 and 89, 2 Samuel 7, and Isaiah 11 and 49. Some examples occur in all six texts—variants of βασιλεύς, γῆ, κρίνω being the most obvious, and the greatest sharing of vocabulary being between Psalms of Solomon 17, Psalms 2 and 89.

[66] This is also apparent in the so-called 'messianic hymn' in Psalms of Solomon 18 which also has some correspondences with Psalm 2: vv. 5 and 7 also use Χριστός κυρίου of the coming one as in Ps. 2.7, and there is some evidence of the influence of Ps. 2.10–12 at the end of the hymn. However, the sonship metaphor is again not about God and the king, but God and his people in Ps. Sol. 18.4: the promise in Ps. 2.7 has again been 'democratized'. See Janse 2009: 66.

interpretation—namely the anointed one as the son of God—has been radically transformed.

Just as Psalm 1 also had some correspondences with the Wisdom of Solomon, the more sapiential verses of Psalm 2 are found there as well. The repeated addresses to the rulers of the earth to 'be wise' before the God of Zion take up the same wording as Ps. 2.10. This is found in the very first verse of Wisdom of Solomon where the phrase οἱ κρίνοντες τὴν γῆν is identical to Ps. 2.10. It is also found in Wis. 6.11 where we read: ἐπιθυμήσατε οὖν τῶν λόγων μου ποθήσατε καὶ παιδευθήσεσθε, which has correspondences both with Ps. 2.10 (καὶ νῦν βασιλεῖς σύνετε παιδεύθητε πάντες) and 2.12 (δράξασθε παιδείας), in each case using παιδεύω ('to instruct, teach').[67] We noted how in the Greek translation to Psalm 2 the concern for universal morality was more developed than in Psalm 1, with the stress, twice, on πάντες (vv. 10, 12), and suggested that this indicates the beginning of a theme democratizing the monarchy, whereby not only the king David but all good Israelites are to behave like kings—a theme we have already noted in Psalms of Solomon as well.

Although Psalms 1 and 2 are each found in the same works, nowhere in the apocrypha and pseudepigrapha are they used as a single unit. However, on at least two occasions they are found close together and each serves the same end. Each example is very different—the first concerns a more exclusivist appeal to Jewish identity, focusing on Torah (Ps. 1) and Jerusalem (Ps. 2) and the second, the more universal appeal of Judaism for the diaspora communities, focusing on Torah as Wisdom (Ps. 1) and the universal relevance of God's judgement over all peoples (Ps. 2).

In Psalms of Solomon 14 and 17 the two psalms are used to recall the promises made by God to his people concerning his judgement on the wicked and specific protection of Jerusalem. These promises are to be fulfilled in those who keep the Law (Pss. Sol. 14, using Ps. 1), and the figure of the 'sapiential king' calling to the nations is fulfilled in the present community who become heirs to the promises once made to the king (Pss. Sol. 17, using Ps. 2).

In Wisdom of Solomon 6 the two psalms are recalled within the same chapter.[68] The audience here is no longer Jerusalem but diaspora communities now conquered by Rome: the concerns are not so much with God's particular protection of Jerusalem as with the applicability of God's promises to Diaspora Jews everywhere. Psalm 2, with its address to the wicked rulers (the beginning and end of the psalm are particularly relevant here), is used

[67] Skehan, 1948: 384–6, also notes that Wis. 6.1–2, 21, with its Hellenistic setting, reveals the influence of the Greek translation of Ps. 2.10–12.
[68] Psalm 1 is also used in Psalms of Solomon 5, Psalm 2, and in Psalms of Solomon 1.

to announce God's coming judgement over all peoples, and Psalm 1, with its focus on morality inspired by Torah, is used, first, to identify Torah with wisdom and then to show the universal relevance of its teaching about God's judgement over the wicked and preservation of the righteous.

It is interesting to see how the key explicit identity markers in each psalm—Torah and Messiah—are less apparent here. Torah becomes a handmaid of wisdom, and the particular Davidic king becomes a more universal sapiential king, while God's promises of protection become democratized so that they apply to the entire community. Consequently, the Temple theme, which as we saw drew Psalms 1 and 2 closely together in 4QFlor at Qumran, has also been reshaped: in Psalm 1 the metaphor of the tree is universalized, so that it now compares any individual to any life-giving tree, and in Psalm 2, the focus on Zion at the heart of the psalm is universalized, so that it applies (along with the figure of the king) to all people, whether in Jerusalem or not, who become the righteous community of Zion even though they are living under the wicked rulers.

CONCLUSION

There are a few isolated references to each of these psalms other than the examples given here.[69] This investigation has however covered the key texts, particularly those which acknowledge the complementary nature of each psalm. We now turn to early Christian exegesis: a similar multivalent use of these two psalms will be seen. Sometimes they are kept separate from each other; but on many occasions, for interesting theological reasons, they are combined together as one. During this next period the Temple was of course destroyed: this had a remarkable effect on the interpretation of both these psalms, as the next chapter will demonstrate.

[69] See for example Janse 2009: 68–73.

3

Early Christianity

An assessment of the early Christian reception of these two psalms reveals that, by New Testament times, Psalm 2 is now an important psalm in demonstrating how the 'words of David' have been fulfilled in the life of Christ; there is now less evidence of the earlier more communal reading of the psalm. Psalm 1, however, has still not come into full focus: it is, by contrast, still a marginal psalm where reception history is concerned.[1] Only after the New Testament period, when much more of the Psalter was read and used as prophecy, was this first psalm gradually read in the light of the life of Christ. Commentaries on Psalm 1 then increase in significance, with a curious phenomenon that by the end of this period they are actually more prolific than commentaries on Psalm 2. Another feature is that the earlier Jewish practice of reading Psalms 1 and 2 closely together also continues throughout this early Christian period. The purpose in uniting them is of course very different: the Temple is no longer their shared theme, but rather these two psalms, taken together, serve as double windows looking out on the person and work of Christ.

THE NEW TESTAMENT

Of the one hundred and twenty or so quotations of psalms in the New Testament, not one is from Psalm 1. For example, neither S. Subramanian, in *The Synoptic Gospels and the Psalms as Prophecy* nor S. Moyise and M. Menken (eds.), in *The Psalms in the New Testament*, have any reference to Psalm 1 at all; similarly B. H. McLean, referring to both citations of and allusions to psalms within the New Testament, makes no mention of Psalm 1, although he cites some thirty-six other psalms, including several references to Psalm 2.[2] Citations about a final judgement or about the two ways need not

[1] We noted these contrasting features of Psalms 1 and 2 in Chapter 2 'The Start of the Journey: The Hebrew Bible': 12–13.

[2] See Subramanian 2007; Moyise and Menken 2004; and McLean 1992: 67–81.

imply any use of Psalm 1, because they allude to common ideas rather than this specific psalm.[3] Similarly, references to 'blessed are those' (Μακάριοι οἱ) in Mt. 5.3–11 (also in Lk. 6.21–3), even though they use the same adjective μακάριος as in the Greek of Psalm 1, cannot be citations of the psalm: the subject matter in what follows in Matthew 5 and Luke 6 is entirely different from the emphasis on the Law in Psalm 1. μακάριος has a very common use as a general acclamation and is found not only in the psalms but, in its various permutations, over a hundred times in the Hebrew Bible as a whole.[4]

While Psalm 1 is never explicitly referred to, Psalm 2 is referred to many times, being frequently cited or alluded to in the Synoptic Gospels and in Acts, Hebrews, and Revelation as a prophecy in the process of fulfilment.[5] There are four clear citations of Psalm 2: one is of vv. 1–2 and three are of v. 7.

In Peter's prayer in Acts 4.24–30, recalling the hostility against Christ within the city of Jerusalem, Ps. 2.1–2 is cited in vv. 25–6. Peter prays:

> [25] it is you who said by the Holy Spirit through our ancestor David, your servant: 'Why did the Gentiles rage, and the peoples imagine vain things? [26] The kings of the earth took their stand, and the rulers have gathered together against the Lord and against his Messiah.' [27] For in this city, in fact, both Herod and Pontius Pilate, with the Gentiles and the peoples of Israel, gathered together against your holy servant Jesus, whom you anointed, [28] to do whatever your hand and your plan had predestined to take place. . . .

The parallels are clear. The geographical setting in each case is Jerusalem; in Psalm 2, it is the Gentiles and peoples, kings of the earth and rulers who 'gather together' against God's anointed one (termed χριστός in both the psalm and Acts). In Peter's day it is the Gentiles and peoples of *Israel,* embodied in Pilate and Herod, who conspired against Christ, the anointed one.[6]

A second citation, also in Acts, is of Ps. 2.7. Acts 4 was more concerned with the passion of Christ in Jerusalem; in Acts 13.17–41, Paul's speech at Antioch, the focus is now on the resurrection which also took place in Jerusalem. Here Ps. 2.7 is used as part of a *catena* of psalms to demonstrate that Christ has fulfilled the 'prophecies' of David and Isaiah:

> [32] And we bring you the good news that what God promised to our ancestors [33] he has fulfilled for us, their children, by raising Jesus; as also it is written in the second psalm, 'You are my Son; today I have begotten you.' [34] As to his raising him from the dead, no more to return to corruption, he has spoken in this way, 'I will give you the holy promises made to David.' [35] Therefore he has also said in

[3] For example as in Mt. 12.41 or Mt. 7.13–14.

[4] This is to be distinguished from variations of the verb εὐλογέω which also occur almost twice as many times throughout the Hebrew Bible. To suggest any direct correspondence for either word, therefore, is impossible.

[5] See for example the chart of references in Janse 2009: 80.

[6] See Weren 1989: 197.

another psalm, 'You will not let your Holy One experience corruption.'[36] For David, after he had served the purpose of God in his own generation, died, was laid beside his ancestors, and experienced corruption;[37] but he whom God raised up experienced no corruption.

Ps. 2.7 is found alongside Ps. 16.10; the reference to the 'holy promises' is from Isa. 55.3. Clearly what is assumed here is that the one addressed as God's Son is not in fact David (who 'experienced corruption' and only received the promise) but Christ, hidden in the words of the psalm. It is an unusual use of the verse of this psalm: perhaps what is intended is an image of the 'enthronement' of Christ, through his resurrection, as one who is greater even than the once 'enthroned' king, David.

Two other *catenae* which cite Ps. 2.7 are found in Hebrews. Heb. 1.5–13 is within a longer passage (1.5–2.18) demonstrating Christ's superiority over the angels. Ps. 2.7 (along with 2 Sam. 7.14, or perhaps Ps. 89.26) is used in v. 5:

[5] For to which of the angels did God ever say, 'You are my Son; today I have begotten you'? Or again, 'I will be his Father, and he will be my Son'?

Several other texts are used here in Hebrews, including Deut. 32.43; Pss. 97.7; 104.4; 45.6–7; 102.25–7; and 110.1. The interweaving of so many passages into a *catena* reminds the reader of 4Q174 in the Dead Sea Scrolls.[7] Psalms 2 and 110 are particularly important in this respect: each psalm speaks of a Davidic king and, in the eyes of the writer of Hebrews, its language of the intimate relationship between God and the king signifies the relationship between human kingship and divine kingship and so points to the two natures of Christ. The same two psalms are cited again together in Heb. 4.14–5.14, where the writer seeks to demonstrate Christ's superior role not only as king but also as the great High Priest; Heb. 5.5–6 cites Ps. 2.7 alongside 110.4:

[5] So also Christ did not glorify himself in becoming a high priest, but was appointed by the one who said to him, 'You are my Son, today I have begotten you';[6] as he says also in another place, 'You are a priest forever, according to the order of Melchizedek.'

Just as it might seem unusual to use Ps. 2.7 to demonstrate the resurrection of Jesus, its use in illustrating Jesus' high priesthood might seem somewhat inappropriate. But its use here has been influenced by the tradition of two coming Messiahs, one from the house of David and the other from the house of Levi. So here Jesus Christ is invested as both king (Psalm 2) and priest (Psalm 110), with a royal rule and sacral role which is now located in a Heavenly Court and a Heavenly Temple.[8]

[7] See Brooke 1985: 209–10.
[8] See the discussion of this passage in Janse 2009: 119–224.

There are also several allusions to Psalm 2. Verse 7 is implied six times in the Synoptic Gospels, in the accounts of the Baptism and Transfiguration. Here this verse provides an echo for the celestial voice, which ratifies the authority of the Son and his intimate relationship with God. In Mk 1.11 ('and a voice came from heaven, "Thou art my Son, the beloved: with you I am well pleased"'), it could be argued that its place at the beginning of Jesus' ministry inverts the ideas of sonship and kingship as understood by Imperial Rome; the fact that the verse is alluded to again in the Transfiguration, near the end of Jesus' earthly ministry, makes the same point: the way of this king will lead to the cross. The allusions in Lk. 3.22 (the Baptism) and 9.35 (Transfiguration) have a similar echo: at the beginning of Jesus' ministry and in the heart of his teaching about his coming suffering their purpose seems to be to indicate again a regal Son of God who must suffer and die.[9] Matthew also alludes to Ps. 2.7 in his Baptism and Transfiguration accounts in 3.17 and 17.5: again the twin themes of 'son of David' and 'Son of God' which can be extracted from Ps. 2.7 fit well with the themes expressed in the first two chapters of his Gospel.

Other allusions to Psalm 2 are found in the book of Revelation; these take up the theme of the hostility of the nations expressed in vv. 1–2 and 8–9 of Psalm 2. Rev. 2.26–7 uses the imagery in Ps. 2.8–9 in its references to the 'rod of iron' and the shattered pots: this is in the context of God's vindication of those who remain faithful in the church of Thyatira, alongside a promise that they will rule over the Gentiles:

> [26] To everyone who conquers and continues to do my works to the end, I will give authority over the nations; [27] to rule them *with an iron rod*, as when clay pots are shattered. . . .

This victory promised to the faithful believers has a resonance with the victory promised to the king in Ps. 2.9: 'You shall break them with *a rod of iron*, and dash them in pieces like a potter's vessel.' The Greek (ἐν ῥάβδῳ σιδηρᾷ) is identical in both cases. This particular phrase is used again in Rev. 12.5, this time in relation to the portentous birth of the Christ-child: 'And she gave birth to a son, a male child, who is to rule all the nations with *a rod of iron*' (ἐν ῥάβδῳ σιδηρᾷ). The same phrase occurs in Rev. 19.15, with reference to the victory of Christ over the nations: 'From his mouth comes a sharp sword with which to strike down the nations, and he will rule them with *a rod of iron* (ἐν ῥάβδῳ σιδηρᾷ); he will tread the wine press of the fury

[9] It is interesting to compare the use of this psalm here with its use in Acts 4.25–6, where the first two verses, as we have seen, are used to speak of the conspiring against the royal son by Pilate and Herod. Janse sees the psalm alluded to again in the passion narrative in Lk. 22.63–23.43, with the plays on 'Christos' (Lk. 22.67/Ps. 2.2), on the hostility of the 'people' (Lk. 23.35 and Ps. 2.2), and on the nature of the kingdom (Lk. 23.37 and Ps. 2.6). See Janse 2009: 87–9.

of the wrath of God the Almighty.' The theme of the consummation of the
kingdom of God over the nations is also found in Rev. 11.15, 18.

Although it is possible that these allusions need not refer directly to
Psalm 2, but indirectly to the psalm through a received tradition, it is difficult
to deny the influence of Psalm 2 altogether in the texts discussed here. The
psalm—or at least, individual verses in the psalm—has been covered with
completely new layers of meaning. In the Synoptic Gospels it serves as a
commentary on Jesus' earthly ministry; in Acts, it serves to interpret the cross
and resurrection; in Hebrews, it illustrates further Christ's eternal sonship;
and in Revelation, it is used to reflect further on God's coming kingdom
through Christ his Royal Son.[10]

This more prolific use of Psalm 2 in Christian tradition at this stage is
similar to the way it was readapted in earlier Jewish tradition, although the
extent to which it is now used as a lens to see only the ministry, death,
resurrection, and coming kingdom of Christ is of course very different. The
comparative silence of Psalm 1 might be explained in the light of its more
pragmatic appeal about the rewards for obedience to the Torah, which
initially makes it more difficult to use it in a prophetic way. Psalm 2 is about
a particular individual—God's anointed—and the New Testament writers
mine it for Christological allusions. Psalm 1 is about 'anyone' and 'everyone'
who aspires to the title 'Blessed': in very early Christian reception this makes
it seem to have less potential for any specific Christology.

However, Psalm 1 does make a small appearance in the New Testament—
by way of its implicit connection with Psalm 2. Much has been made of
the fact that both psalms seem to be referred to together in Acts 13.33, which,
as noted above, cites Ps. 2.7 in justifying the resurrection of Jesus. Here
many textual traditions—the fourth-century Sinaiticus uncial manuscripts,
the fourth-century Vaticanus, the fifth-century Alexandrinus, the seventh-
century Papyrus Bodmer XVII, and the ninth-century Leningrad—refer to
Psalm 2 as 'the second psalm' ($\kappa\alpha\grave{\iota}$ $\dot{\epsilon}\nu$ $\tau\hat{\omega}$ $\psi\alpha\lambda\mu\hat{\omega}$ $\gamma\acute{\epsilon}\gamma\rho\alpha\pi\tau\alpha\iota$ $\tau\hat{\omega}$ $\delta\epsilon\upsilon\tau\acute{\epsilon}\rho\omega$).
However, a few others, including fifth-century Old Latin manuscripts, the
sixth-century D Codex, a few eighth-century Latin manuscripts associated
with Bede, and the thirteenth-century Codex Gigas call Psalm 2 'the first
psalm' ($\dot{\epsilon}\nu$ $\tau\hat{\omega}$ $\pi\rho\omega\tau\omega$ $\psi\alpha\lambda\mu\omega$).[11] It might be that in some traditions Psalm 1
was seen as a Prologue to the Psalter as a whole, making Psalm 2, therefore,
appear to be 'the first psalm'. But another view is to see that in some
traditions Psalms 1 and 2 did form just one unit, so that to quote from the
second psalm was also to presume the existence of the first. Thus the frequent

[10] See Watts, 1990: 82, for a similar summary to this; also Bons 1995: 168–71.

[11] See Willis, 1979: 385. for a fuller discussion of these codices. It is noteworthy that Psalm 2
has always been read as the 'second psalm' in *Novum Testamentum Graece* (see for example
Nestle–Aland, 2012).

references to Psalm 2 could also include Psalm 1 in this schema of prophecy and its fulfilment; after all, only particular verses of Psalm 2 (1–2, 7, 8–9) are explicitly used, which leaves the rest of the psalm as 'assumed', and it could be argued that Psalm 1 might also be included in this assumption. This manuscript evidence of course reflects the later views which were developed in subsequent Christian interpreters: but the overall picture does seem to confirm that, in later Christian tradition, Psalms 1 and 2 were in fact closely connected together, albeit for different reasons from those assumed in the earlier Jewish reception history of the two psalms.

THE CHURCH FATHERS

One new feature in this period is the development of a more explicit Christian reading of the first psalm, often on its own and without any obvious reference to Psalm 2. Furthermore, Psalm 1 is not only used to teach the community of faith, but it is also read in order to establish Christian doctrine. Psalm 2, by contrast, is initially used primarily in defence of Christian 'orthodoxy': it is one of just four psalms which were consistently understood to be about the Messiah, for example.[12] Only near the end of this period, in the fourth century, is Psalm 2 used, like Psalm 1, as a didactic psalm. As a result there are actually fewer works on Psalm 2 than on Psalm 1.[13]

Just as Psalm 2 was often used in New Testament exegesis by taking individual verses and asking questions of them and giving (Christian) answers to the various phrases, so now the Church Fathers use Psalm 1 in this way as well. For example, in answer to the question 'Who is the man who is blessed?' there were usually two answers (and often the same commentator could give both in different works). One was that the man was Christ; the other was that the man was the believer made righteous by Christ. With regard to the latter answer, sometimes 'the man' signified not just the individual, but a particular church community; very occasionally the term even included not only Christians but faithful Jews as well. Another question might be 'what is Torah?' and this had at least three different answers: it could mean the New Testament alone; or the Bible as a whole; or Christ as the living Logos. Another recurrent question was about the significance of the tree in v. 3: depending on how the question of the identity of 'the man' was addressed, the answer was that it referred either to the Christian, made right with God

[12] The other psalms are 8, 45, and 110.
[13] For example, the references to Psalm 2 in both volumes of Rondeau, 1982, 1985, are minimal. Other than Hippolytus' sermons on Psalms 1 and 2, the main references to it are by the Antiochene writers who used Psalm 2 alongside Psalms 8, 45, and 110; the only long commentary on Psalm 2 is by Augustine.

through Christ, or that it represented Christ's obedience to God on the cross which reverses Adam's disobedience to God in taking the fruit of the tree in the garden of Eden. There are so many different answers to these questions, as we shall see in the following analysis.

The first known example of an early Church Father using these psalms in this way is actually a work on Psalm 2. *The First Epistle to the Corinthians 36* by **Clement of Rome** (*c.* 96 CE) uses this psalm to demonstrate, somewhat unusually, the *continuity* between the old Jewish covenant and the new Christian one. *1 Clem. 6.1* starts with a reference to Jesus Christ as 'the High Priest of all our offerings' and what follows is a series of hymnic praises, describing what Christ has achieved for the Church: the formula is 'through him . . . we receive . . .'. The psalms used include Pss. 104.4, 2.7–8, and 110.1–2: this is very like the way in which Heb. 1.3–4 used these psalms in *catena* form. The reference to Psalm 2 reads as follows:

> Through Him the Master willed that we should taste of the immortal knowledge, *Who, being the brightness of His majesty, is much greater than angels, as He hath inherited a more excellent name.* For so it is written, *Who maketh his angels spirits and His ministers a flame of fire.* But of His Son the Master said thus: *Thou art my Son, I this day have begotten Thee. Ask of Me, and I will give Thee the Gentiles for Thine inheritance, and the ends of the earth for Thy possession.* And again He saith unto Him, *Sit Thou on My right hand, until I make Thine enemies a footstool for thy feet.* Who then are these enemies? They that are wicked and resist His will.[14]

Two of the earliest examples of the similar use of Psalm 1 are in two apologetic works, namely the **Epistle to Barnabas** (about 130 CE) and **Justin Martyr**'s **Dialogue with Trypho** (*c.* 160 CE).[15] *Barnabas* 10 is a chapter on dietary stipulations in a longer section on the Christian attitudes to the Jewish Law, including sacrifices (ch. 2) fasting (ch. 3), circumcision (ch. 9) and Sabbath keeping (ch. 15). In ch. 10 a curious association is made between the three types of meat forbidden by Moses (seafood, pork, and birds) with the three types of ungodly in Ps. 1.1—the wicked, the sinners, and the scoffers respectively.[16] This illustrates the ongoing pragmatic use of the psalm;

[14] 1 Clem. 36.2–6: taken from <http://www.earlychristianwritings.com/text/1clement-lightfoot.html>. Reventlow (2009: 134) suggests that even by this time these psalms were often used together as a cantata and were thus 'common to early Christian usage in their interpretation of Christ'; see also Watts 1990: 83.

[15] Psalm 1 is not the only psalm used in these writings. *Barnabas* also cites Psalms 51, 22, and 110 in the same spirit; *Dialogue* uses some twenty-four psalms; and the relevant section in *Apology* quotes extensively from Psalms 19, 2, and 96 as well. See Holladay 1993: 162–4; Vesco 1986: 14–15; and Koch 1994: 223–42.

[16] This actually became a typical form of appeal to Ps. 1.1. For example, Clement of Alexandria (*c.* 150–215) in *Stromata XV* also refers to these three 'precepts' of Moses and compares them with the three forms of wickedness; the point is then expanded to include three other types of wickedness—the heathen, the Jews, and heretics within the Christian Church. See <http://www.ccel.org/ccel/schaff/anf02.vi.iv.ii.xv.html>.

however, a more doctrinal use is in the use of Ps. 1.3–6 in *Barnabas* 11, on the ways in which the doctrines of the cross and baptism have been prefigured in the Old Testament. By using Jer. 2.12–13, for example, to demonstrate the Jews' rejection of the practice of baptism, Ps. 1.3–6 is quoted at length, with the conclusion: 'Mark how He has described at once both the water and the cross. For these words imply, Blessed are they who, placing their trust in the cross, have gone down into the water; for, says He, they shall receive their reward in due time: then He declares, I will recompense them.'[17] Vesco comments on the baptismal language in *Barnabas* as follows: 'Ceux, qui ayant mis leur espérance dans la croix sont descendus dans l'eau au baptême, peuvent être déclarés heureux car la retribution divine leur sera accordée en son temps'.[18] These verses from Psalm 1 are now applied to the Christian Church about the work of Christ (on the cross, which is 'the tree') effecting new life for the Christian (by the waters of baptism, referred to as 'running waters' in verse 3). This is an early example, rather like the *catena* at Qumran and also like the Epistle to the Hebrews, of the use of Jewish midrashic exegesis taken through a Christian lens and applied to Psalm 1.

A similar identification of the tree with the cross (through another *catena* of references to the tree of life in Paradise, Moses' rod which sweetened the bitter waters at Marah, Elijah's stick which parted the waters of the Jordan, and Judah's rod) is found in Justin's *Dialogue with Trypho* 86. First refuting the false position of the Jews regarding their understanding of their own scriptures, Justin then argues that the true (hidden) Christian meaning is found, for example, in Ps. 1.3 (alongside Pss. 92.12 and 23.4). The 'tree of life' is again the cross, which is the means of making the 'man' (in Ps. 1.1) blessed; the 'waters' are waters of baptism which are the means of making that same man righteous; so the psalm as a whole is about the status of the Christian, saved by the work of Christ on the cross, a work made effective through the rite of baptism.

A few commentators started to read Psalms 1 and 2 in their entirety as one continuous drama. One of the earliest examples is again Justin Martyr. In chapter 40 of his first Apology (*c.* 150 CE), on the ways in which Christ's advent into the world had been foretold, Justin cites (*1 Apol.* 40.8–10) Psalms 1 and 2 as one continuous narrative of salvation. He argues that the first psalm is about how the Spirit of prophecy exhorts us to live with Christ crucified 'on the tree', while the second psalm is about how the Spirit of prophecy foretells the conspiracy which was formed against Christ by Herod, Pilate, and the Jews, and about how God calls Him His Son, and how He will subdue all enemies under Him; the psalm ends with a call to

[17] Taken from <http://www.ccel.org/ccel/schaff/anf01.vi.ii.xi.html>.
[18] See Vesco 1986: 15.

repentance before the Day of Judgement comes.[19] The chapter ends with citing the last verse of Psalm 2 ('Blessed are all they that put their trust in Him') and notes how this echoes the first verse of Psalm 1 ('Blessed is the man who hath not walked in the counsel of the ungodly . . .'). Thus for Justin Martyr the exhortation at the beginning and the end of this so-called 'drama of salvation' is what roots this as Christian doctrine in the present tense.[20]

A more common use of these two psalms is by way of individual verses to establish a particular point of doctrine. A typical example, using Psalm 2, is by another apologist, **Irenaeus** (130–200 CE), who, like other Latin Fathers and the New Testament writers before them, uses vv. 7–8 alongside Ps. 110.1–2 to demonstrate Christ as the Son of God. This occurs, for example, in Irenaeus' *Proof of Apostolic Preaching* 49 (*c.* 180) where (rather like what was seen in the Epistle to the Hebrews) these verses in these two psalms together demonstrate Christ as 'Son of God and King of all':

> And that He not only is called but is Son of God and King of all, David declares thus: *The Lord said unto me: Thou art my Son, this day have I begotten thee. Ask of me and I will give thee the Gentiles for thy inheritance, and for a possession the utmost parts of the earth.* These things were not said of David; for neither over the Gentiles nor over the utmost parts did he rule, but only over the Jews. So then it is plain that the promise to the Anointed to reign over the utmost parts of the earth is to the Son of God, whom David himself acknowledges as his Lord, saying thus: *The Lord said unto my Lord, Sit on my right hand.* . . . For he means that the Father speaks with the Son; it is not David who speaks . . . but the Spirit of God [who] . . . utters the words sometimes from Christ and sometimes from the Father.[21]

Psalms 1 and 2 were not only used to illustrate Christian doctrine; not only Psalm 1, but also Psalm 2, were gradually used for practical purposes. For example, the North African (Latin) Apologist, **Tertullian of Carthage** (*c.* 160–220), uses both psalms as an appeal to right Christian living. Partly on account of his juridical training before his conversion, he is at pains to use the reference to 'the law' in Ps. 1.2 pragmatically and positively. For example, in *Against Marcion XIX* he writes: 'For what could better tend to make a man

[19] See Willis 1979: 387; Koch 1994: 227; Barbiero 1999: 32, n. 4; Høgenhaven 2001: 171, n. 10; and Reventlow 2009: 135–47. The same method of appealing to Christ as 'hidden' in a psalm is also used for Psalm 2, where again short phrases or individual verses are used to make the point. The most frequently cited reference is Ps. 2.7, because of its witness to the Father/Son relationship. Ps. 2.6 is also often used to illustrate the cross of Christ in its reference to the king on 'Zion, God's holy hill', and is thus developed rather like the 'tree by the waters' in Ps. 1.3. Verses 8–9 are read as references to the resurrection and exaltation of Christ, while vv. 1–2 and 10–12 are seen as referring to the judgement on the Gentiles (and even the Jews) on account of their refusal to respond to Jesus Christ.

[20] 'Christ's Advent Foretold' is taken from <http://www.ccel.org/ccel/schaff/anf01.viii.ii.xl.html>.

[21] Taken from <http://www.ccel.org/ccel/irenaeus/demonstr.toc.html>.

happy, than having "his delight in the law of the Lord"? "In that law would he meditate day and night." It was not in severity that its Author promulgated this law, but in the interest of the highest benevolence, which rather aimed at subduing the nation's hardness of heart . . . it simply bound a man to God, so that no one ought to find fault with it.'[22] In this reading, therefore, offered in the context of arguing against Marcionism on the importance of the Old Testament for understanding the New, Tertullian read the law (and by inference 'the man') in Psalm 1 as about Jewish believers as well as Christians. This more positive attitude to the law in Psalm 1 is also brought out in *De Spectaculis III*. Here the context is a homily instructing Christians to avoid contamination with the heathens by entering 'the circus or theatre', or by gazing on 'combat or show'. Psalm 1.1 is quoted immediately after Exod. 20.14. Tertullian assumes its earliest audience must have been law-abiding Jews who were being instructed not to participate in impious meetings and deliberations of their fellow-Jews: 'If he called those few Jews an assembly of the wicked, how much more will he so designate so vast a gathering of heathens! . . . When God admonishes the Israelites of their duty, or sharply reproves them, He has surely a reference to all men.'[23] So here we see an ethical, practical application of the psalm to all Christians of the Church in Carthage, living in continuity with the faithful Jews of David's day.

Tertullian also uses Psalm 2 in a similarly pragmatic way. In his *Against the Jews* (*c.* 198), chapter XII, Ps. 2.7–8 are cited to show that the Church's mission had always been intended to include the Gentiles:

> Look at the universal nations emerging from the vortex of human error to the Lord God the Creator and His Christ; and if you dare to deny that this was prophesied, forthwith occurs to you the promise of the Father in the Psalms, which says, 'My Son art Thou; today have I begotten Thee. Ask of Me, and I will give Thee Gentiles as Thine heritage, and as Thy possession the bounds of the earth.' For you will not be able to affirm that 'son' to be David, who reigned within the single country of Judea, than to be Christ, who has already taken captive the whole orb with the faith of his gospel. . . .[24]

By the beginning of the third century Psalms 1 and 2 were beginning to be read increasingly as connected together, both as witnesses to appropriate Christian behaviour and also to correct Christian doctrine. Their use in

[22] Taken from <http://www.ccel/org/ccel/schaff/anf03.v.iv.iii.xix.html>.

[23] Taken from <http://www.ccel.org/ccel/schaff/anf03.iv.v.iii.html>. Tertullian compares the wicked of Psalm 1 with 'theatres and circuses' again in *Stromata II*. The same comparison is used by Clement of Alexandria in *Paedagogus III.* 76.3, and even more interestingly, in a reference attributed to R. Shimon ben Pazzi in Tg.Ps. 1.1: see Edwards 2007: 44, n. 157.

[24] Taken from <http://www.ccel.org/ccel/schaff/anf03.iv.ix.xii.html>. A similar appeal to this psalm is found in Tertullian's *Against Marcion* (*c.* 207), chapter XX, which uses the same two verses to show the prediction of Christ's death and triumph over the Gentiles, and chapter XXI, to show how Christ reveals the God of the Old Testament: see <http://www.ccel.org/ccel/schaff/anf03.v.iv.ii.xx.html>.

correcting Christian doctrine usually took on two forms. Some commentators, now regularly interpreting the first psalm in a much more specifically Christ-centred way, and still assuming a Christ-centred reading of Psalm 2, read the two psalms side by side simply because of the hidden Christian emphases in each.[25] Other commentators saw the two psalms as two parts of the same drama, and read the first Psalm as about the two extremes of Christ Incarnate and Christ our judge, and the second Psalm as about the passion, death and resurrection of Christ, ending again with the theme of Christ as judge. In each case the specifically Christian 'take' on the two psalms brings them more closely together.

Hippolytus of Rome (*c.* 170–235) wrote his *Homily on the Psalms* near the beginning of the third century; his Prologue is the oldest known systematic treatment of both psalms read as one drama of salvation. His commentary also shows very clearly how Psalms 1 and 2 are being read together with the same Christian bias.[26] Hippolytus' main concern was the denunciation of the heretics who were undermining the Church in Rome—possibly Gnostics, or possibly Montanists; the emphasis on the humanity and divinity of Christ found in each psalm would suggest the latter.[27] The first psalm is seen as a prophecy about the birth of Christ, 'the blessed man'; the second psalm, as a prophecy about Christ's passion and death. The Prologue to these psalms reads as follows:

> The first (two) psalms are without title, for they indicate (in) the first the birth of Christ, and (in) the second, his passion. And it was not necessary to give them titles from the moment that it was proclaimed by all the prophets that the Word was himself the beginning . . . it is clear that at the beginning (of the Psalter) it is he who had been announced as Servant of God, that is, the Word, the Wisdom, the Only-begotten Son of the Father; he has been indicated by these (first two psalms). There it is said, indeed: 'Blessed is the Man who has not walked in the council of the wicked, etc,' and 'Why have the nations plotted?'[28]

If Hippolytus read Psalm 1 in this Christian way, he used Psalm 2 even more to this effect. The actual words of the psalm disappear from view and what we see and hear instead is the suffering and death of Christ:

[25] The main 'echoes' would be allusions to the incarnation of Christ, the passion and cross of Christ, and the judgement of Jews and Gentiles by Christ in Psalm 1, all of which are expanded in Psalm 2.

[26] See Rondeau 1985: 33–43; also Braulik 2004: 31–4. The whole treatise is concerned with the spiritual value of the superscriptions in the Psalter. *Hom. Ps.* 18 and *Hom. Ps.* 19 refer to Psalms 1 and 2 as two separate psalms, despite the lack of any superscription, even in the Greek.

[27] Against the Montantists, Hippolytus needed to show that the Old Testament had inherent value, that prophecy had ancient foundations, and that the psalms could be used as prophecies.

[28] The citation is taken from Waddell 1995: 512, which is a translation of the French version of Hippolytus by Pierre Nautin, *Le dossier d'Hippolyte et de Méliton* (Paris, 1955): 182–3. See also Gillingham 2008a: 26–7.

When he came into the world, he was manifested as God and man. And it is easy to perceive the man in Him, when He hungers and shows exhaustion, and is weary and athirst, and withdraws in fear, and is in prayer and in grief, and sleeps on a boat's pillow, and entreats the removal of the cup of suffering, and sweats in agony, and is strengthened by an angel, and betrayed by Judas, and mocked by Caiaphas, and set at nought by Herod, and scourged by Pilate, and derided by the soldiers, and nailed to the tree by the Jews, and with a cry commits His spirit to His Father, and drops His head and gives up the ghost, and has His side pierced with a spear, and is wrapped in linen and laid in a tomb, and is raised by the Father on the third day. And the divine in Him, on the other hand, is equally manifest, when He is worshipped by angels, and seen by shepherds, and waited for by Simeon, and testified of by Anna, and inquired after by wise men, and pointed out by a star, and at a marriage makes wine of water, and chides the sea when tossed by the violence of winds, and walks upon the deep, and makes one see who was blind from birth, and raises Lazarus when dead for four days, and works many wonders, and forgives sins, and grants power to His disciples.[29]

Here we see how—probably to challenge the Montanists—Hippolytus used both psalms as prophecies. The first psalm is thus really a prophecy about the birth of Christ 'the blessed man'; the second psalm, continuing the New Testament tradition, is a prophecy about Christ's passion and death.[30]

Also in the first half of the third century, **Origen of Alexandria** (*c.* 185–254) develops the same theme of 'the man' in Psalm 1 as referring to Jesus Christ. His remarks on Psalm 1—that it is a psalm inspired by the Holy Spirit, but that it is a 'locked door which the key of David can open, but only the Lamb who was slain can break'—mean that it is hardly surprising that Origen found the hidden Christ throughout the psalm.[31] In *Tomi in Psalmos,* for example, a work which exists only in fragments, the identification of the 'blessed man' in Ps. 1.1 is as the one 'who was man in the Saviour'.[32] Origen was able to read the psalms in what became known as a 'prosopological' way, whereby a psalm had two voices; in Psalm 1 these voices were of Christ identifying with our humanity and of Christ vindicating his Church.

Origen is also one of the earliest Alexandrian commentators to refer explicitly to two Hebrew manuscripts, one which combined Psalms 1 and 2 and the other which separated them. In his commentaries it is clear that his own Greek manuscripts separate the two psalms: for example, he cites Ps. 2.5

[29] Taken from <http://www.ccel.org/ccel/schaff/anf05.iii.iv.i.v.ii.html>.
[30] Hippolytus needed to show that the Old Testament had inherent value, that prophecy had ancient foundations, and that the psalms could be used as prophecies. See Braulik 2004: 31–4.
[31] See Daley 2004: 193, n. 11, referring to *Philoc.* frag. 2.4.19–24; also p. 194, referring to *Philoc.* frag 2.1.1–10.
[32] Rondeau attributes the *Tomi* not to Origen but possibly to Evagrius. And it has to be admitted that if *Tractatus* as well is not from Origen, but from Jerome, the Christological emphasis is more guarded. On the problem of assigning psalms commentaries to Origen, see Waddell 1995: 508.

as being in 'the second psalm'.[33] This tradition of citing a variant manuscript tradition starts to be a common motif in commentators after Origen.[34]

One Antiochene commentator, perhaps surprisingly, also used both Psalms 1 and 2 to highlight their *hidden* Christian meaning. The commentary on Psalm 1 by **Eusebius of Caesarea** (*c.* 260–340), for example, engages with the more literal and textual tradition, while nevertheless being influenced by Origen's exegesis. (Much earlier, during the Diocletian persecution, Origen had fled to and stayed in Caesarea.) Eusebius takes Origen's prosopological approach, and moves between a David-centred reading and a Christ-centred one.[35] 'Now he (the Saviour) may rightly be said to be the first of those who are blessed. This is why Psalm 1 is to be referred to him, as to the One who would be the man [= husband] of his bride the Church.'[36]

If the Psalms Commentary often ascribed to **Diodore of Tarsus** (d. *c.* 390) is indeed from his own hand, then what we have here is something more typical of the Antiochene literal and historical tradition, a reading which is quite different from Eusebius.[37] What is important in this commentary is that, like the works of his fellow Antiochenes, Theodore of Mopsuestia and Theodoret of Cyrrhus, this primarily historical approach is very close to a *Jewish* reading, with less emphasis on the fulfilment of the Old Testament in the New and a more reasoned appeal for their separateness, based upon (somewhat radically, and not what the Jewish reading would uphold) the universal validity of the former.[38] Diodore read the psalms almost consistently through the history of Israel, from the time of David to Hezekiah; in this respect, there were several echoes of the historical appropriation in the later Jewish traditions in *Targum* Psalms (henceforth TgPss) and *Midrash Tehillim.*[39] Diodore refused any Christological interpretation for all but four psalms (2, 8, 45, and 110). His approach to the entire Psalter was that it was primarily a *moral* text, and only secondarily of *doctrinal* importance for the

[33] For example, in *De Principiis II. iv. 4*: see Jean-Nesmy 1973: 26–7; Koch 1994: 228, n. 19.

[34] Eusebius of Caesarea (*c.* 260–340) in his *Commentaria in Psalmos*, as well as Diodore of Tarsus and the Alexandrian Athanasius (*c.* 295–373) in his *Argumentum in Psalmos* all cite a tradition where Psalms 1–2 are united and Psalms 9–10 are divided. See Willis 1979: 388–91 and Hill 2005: 10.

[35] Ps. 2.7 is a case in point, where Eusebius argues that here Christ, not David, is the one addressed. See Gillingham 2008a: 31.

[36] Taken from Waddell 1995: 510, here referring to *MPG* 23.76.

[37] One of the reasons for doubt about the authenticity of this commentary, despite some eight manuscripts of it, is the title 'father of Nestorianism' given to both Diodore and Theodore of Mopsuestia by Cyril of Alexandria. In the context of Diodore's courageous opposition to Julian the Apostate's attempts to restore pagan worship and declare Christ an impostor, there is some irony here. See Hill 2005: xi–xii.

[38] We shall see shortly how this works out in Psalm 2. In later centuries this was hounded as being heretical: Hesychius of Jerusalem in the fifth century and later Leontinus of Byzantium led this charge. See Waddell 1995: 511; and O'Keefe 2000: 83–6.

[39] These will be discussed in Chapter 4 'Rabbinic and Medieval Judaism': 70–6 and 76–81.

Church: so his commentary on Psalm 1 is more concerned with the moral interpretation, although, exceptionally, the work on Psalm 2 was in part concerned with doctrine.[40]

Psalm 1 nevertheless provided problems, for it was one of the few psalms for which Diodore was unable to provide a historical context; so, with his overriding interest in the moral value of psalmody, he read this psalm as for 'everyman'. Despite its emphasis on Torah in the second verse, the universal and typical interpretation of the law (the 'natural law' in everyman) is clearly evident; it is even emphasized in the very first words of his commentary which introduce the psalm: Ἔστιν οὖν ὁ πρῶτος ψαλμός ἠθικός τε καὶ καθολικός.[41] Diodore was diametrically opposed to Origen's allegorical readings and his use of Platonic philosophy; the result was a Psalms Commentary which was remarkably Jewish (and also Nestorian) in its overall emphases, and for this reason, in his own day, it was deemed heretical as well.[42]

However, even Diodore, the typical Antiochene, had to accept Psalm 2 as one of four 'messianic' psalms in the entire Psalter. Like **Theodore of Mopsuestia** (350–429) he took his authority for reading the psalm in this way from its use in Acts 4 and Hebrews 1, seeing it, alongside Psalm 110, as a drama relating to the ways in which the incarnate Christ suffered at the hands of the Jews, and Herod and Pilate.[43] So, in contrast to his comments on Psalm 1, Diodore reads the second psalm in the light of the *doctrinal* nature of the Psalter as a whole: in its entirety it is 'a prophecy to do with the Lord'.[44]

If Diodore writes untypically from his own tradition about the Christian focus of the second psalm, one of the Cappodocian Fathers, **Basil of Caesarea** (*c.* 330–79), writes somewhat unpredictably (from his own more allegorical tradition of interpretation) about Psalm 1. His *Prefix to Psalm 1* has a more pragmatic than allegorical emphasis, referring to the importance of the psalm for Christian living rather than Christian theology:

[40] See Hill 2005: xix. See also p. 2: 'The overall theme of the psalms then, is divided into these two parts, the moral and the doctrinal.'

[41] See Olivier 1980: 8.

[42] Nevertheless, Diodore's affirmation of the law in Psalm 1 not only as the particular *Torah* of the Jews but also as the natural law which applies to all peoples shows that his reading illustrates how this requires some modification: see Hill 2005: 5–6.

[43] See Rondeau 1985: 281–7, showing how these commentators, as well as Theodoret, recognized various exegetical problems caused by the different speakers in the psalm, not least in the address with its use of 'today' in v. 7 and adapted the prosopological approach (whereby the speaker could be David, or the Eternal Word, or Christ Himself) to attain a unified Christology: 'le Fils ... est identifié par une naissance temporelle, qu'évoque le mot "aujourd'hui", par opposition à le generation de Dieu le Verbe, laquelle est hors du temps' (285). 'C'est comme homme qu'il reçoit cette parole' (287). See also Blaising and Hardin (2008: 14–16) for Theodoret's use of Ps. 2.7 (citing *FC* 101.56) and his comments against unbelieving Jews in Ps. 2.8–9 (citing *FC* 101.57–8).

[44] See Hill 2005: 7–10.

The prophets, the historians, the law, each give a special kind of teaching, and the exhortation of the proverbs furnishes yet another. But the use and profit of all are included in the book of Psalms. . . . A psalm is soul's calm, herald of peace, hushing the swell and agitation of thoughts. It soothes the passions of the soul; it brings her licence under law. . . . It is the voice of the church. . . . Oh, the thoughtful wisdom of the Instructor who designed that we should at one and the same time sing and learn to our profit!

However, not entirely dismissing the possibility of allegorical interpretation, Basil ends this eulogy with the following:

What good thing can you not learn? There is a complete theology; a fore-telling of the advent of Christ in the flesh; threatening of judgement; hope of resurrection; fear of chastisement; promise of glory; revelation of mysteries.[45]

So although the 'blessed man' in Psalm 1 is the Christian and not Christ Himself,[46] the possibility is nevertheless left open for a more explicit Christo-logical reading. This is made particularly clear in his comments on Psalm 1 itself, where Basil begins: 'Blessed indeed is the man who hath not walked in the counsel of the ungodly: What is truly good, therefore, is principally and primarily the most blessed. And that is God. Whence Paul also, when about to make mention of Christ, said, "According to the manifestation of our blessed God and Saviour Jesus Christ." For truly blessed is Goodness itself . . .'[47]

Another Cappodocian, **Gregory of Nyssa** (335–95) is unique in his approach to the Psalter, and this has consequences for our understanding of the relationship between Psalms 1 and 2. His *In Inscriptiones Psalmorum*, with its more spiritual and mystical emphasis, is about the teaching of the Psalter on the origin and goal of the human soul (and the pursuit of virtue): this is very different from the prophetic proof-texting about the person and work of Christ used in earlier Christian tradition. By working through the five books of the Psalter, and focusing on the separate titles to each psalm, Gregory offers a progressive account, in five stages (which, following Greek philosophical terminology, he calls '*akolouthia*', or sequence of changes), of the ascent of man's soul towards God. But in the Greek Psalm 1 is never credited with a title: yet this psalm, marking the very start of the ascent, nevertheless plays an important part in this schema, for it now serves as a title to the Psalter as a whole. Gregory explains that here the *skopos* of the entire

[45] Taken from <www.ccel.org/ccel/schaff/npnf208.vi.ii.iii.html>.

[46] That Basil intended this reading is clear from his commentary on v. 1: 'Why, you say, does the prophet single out only man and proclaim him happy? Does he not exclude women from happiness? By no means. For the virtue of man and woman is the same, since creation is equally honoured in both; therefore, there is the same reward for both.' (See Blaising and Hardin 2008: 3.)

[47] Taken from Waddell 1995: 510, quoting a translation by Agnes Way (n. 38). Waddell observes that Basil is really arguing that the 'man who is blessed' in Psalm 1 is most true of Christ Himself, who is both supremely blessed and also the source of our blessedness (p. 510). Much of this anticipates what Gregory of Nyssa writes about this first psalm.

Psalter is contained in the very first word: 'blessed'; this means, 'becoming like God', the reasons and means of achieving which are summed up in Psalm 1 as a whole.[48] For Gregory, the Blessed Man in Psalm 1 is thus the Christian soul and not Christ Himself, for Christ is the one who is already fully blessed in that He is One with God.

This approach to the Psalter means that Psalms 1 and 2 are read in close proximity. If Psalm 1 concerns the quest for blessedness, with its sapiential teaching about the avoidance of evil, Psalm 2 is the consequence of this: it is about what the one who seeks to be blessed can expect, namely victory over evil as promised by God.[49] Psalm 3 continues this idea, in personal terms, and so on. Gregory's commentary on the Inscription for the Second Psalm reads as follows:

> The first psalm lacks an inscription. . . . The second psalm, which predicts the mystery of the gospel, is then appended that we might be without impiety. Consequently, in a sense, the first psalm is an inscription of the second, for the latter speaks of the one who through flesh was begotten today because of us.[50]

Other commentators in the Greek-speaking churches continued to use these psalms, especially Psalm 2, in a typically allegorical way. The address of the 'Father to the Son' in Ps. 2.7 was a crucial part of their interpretation. Indeed, this was a common theme in Alexandrian commentators as far apart as Clement (150–215 CE), Origen (184–254 CE), Athanasius (296–373 CE) and even Cyril (376–444 CE).[51] The Syrian Bishop, **Theodoret of Cyrrhus**, for

[48] 'Blessedness' is also, according to Gregory, found at the end of the Psalter, in Psalm 150, which Gregory interprets as a hymn on blessedness, and about the soul's eschatological state. See Rondeau 1974: 269–71; also Heine 1995; and Ludlow 2002: 58–9.

[49] Psalm 2 is less significant than Psalm 1 in this respect. The influences upon Gregory were particularly Origen and Basil, and to some extent Athanasius, in their mutual search for the skopos of psalmody (although for the other three this was expressed in relation to the person and work of Christ rather than the ascent of the soul to God). See Heine 1995: 83ff.; Jean-Nesmy 1973: 26–7; and Gillingham 2008a: 30–2.

[50] See Blaising and Hardin (2008: 12), citing Gregory's *On the Inscriptions of the Psalms* 2.8.74–7 (in *GNTIP* 143–4). Gregory actually sees Psalm 1 as the *title* for Psalm 2: Brian Daley, writing on 'Psalm 2' as part of an as yet unpublished commentary for *The Church's Bible*, makes this point. I am most grateful to Professor Daley for letting me see his commentaries on Psalms 1 and 2 before publication.

[51] See Blaising and Hardin 2008: 11–17. Origen, for example, makes much of the ways in which the opposition of the Gentiles (and Jews) to the Messiah in vv. 1–3 has an echo of the same opposition to Christ Himself; repentance is required of all: see Blaising and Hardin 2008: 13 (citing *MPG* 12: 1104–5). Not surprisingly this psalm (often used alongside Ps. 110) is one of the most frequently used by Athananius, as a search of Ps. 2.7 on <http://www.ccel.org/ccel/schaff/npnf204.xxvi.i.html> will reveal. Athanasius also frequently uses Psalm 2 to demonstrate the 'wickedness' of the Jews, who are identified as the 'heathen peoples' in v. 1, failing to recognize their Messiah: see for example <http://www.athanasius.com/psalms/aletterm.htm>. For references by Cyril to Ps. 2.7, see Blaising and Hardin, 2008: 14, citing *MPG* 69.721: recognizing a problem in the use of the word 'today', which might suggest Adoptionism, Cyril sees this referring to the moment of the incarnation: '. . . being made the Son in his humanity even if then he was the Son in his own nature . . .'

example, used this verse in defence of Christian doctrine; he understood the incarnation of Christ to be prophesied in verse 7, whereby 'God the Word' conjoined with 'God the Son'.[52] Often this allowed even for an allegorical reading of Psalm 1, given that Psalm 2 carried over the themes of Psalm 1: Theodoret, for example, argued that just as Psalm 1 ended with the references to the ungodly, Psalm 2 opened with the same theme, showing that the fate which awaits individual sinners also awaits all kings and rulers, Gentiles and Jews alike, who rage against the Saviour.[53]

Before we return to the western Church, two other eastern commentators reveal even more the diverse ways in which these two psalms can be read. One is from a monastic community in the deserts of northern Egypt; the other, some two hundred years later, was probably from a Syrian Orthodox monastery near ancient Dura Europa.

Evagrius Ponticus (*c.* 345–99) produced his *Scholia* on the psalms from the monastic (and later hermetic) tradition of prayer and worship, resulting in a reflective style quite different from many of the polemic concerns of earlier commentators;[54] perhaps the greatest correspondence (whether direct is unclear) is with Gregory, in the mystical use of the psalms as the 'ascent' of the soul to God, although the language of prayerful meditation is even more dominant here. David is the mouthpiece of the psalms, taught by the Holy Spirit;[55] he is also, more unusually, a model for the monastic life, offering 'spiritual weapons' and a 'contemplative vision' (to which Evagrius adds a Christological reading) against evil. So as for Psalm 1, David is the first 'blessed man', and the monks of the Egyptian desert, the present (potential) recipients. A particularly interesting example of Evagrius' reading of Psalm 1 in this more mystical, pastoral, and therapeutic way is in his commentary on v. 5 ('the ungodly shall not rise in judgement') where 'judgement' is read not in a more eschatological sense, but rather more mystically, in terms of transformation from one kind of body ('. . . for the just, the passage from a body for asceticism to angelic things') to another ('. . . for the ungodly, it is the change . . . to darkened and gloomy bodies'). Judgement is thus not in the first instance punishment, but a divine offer of the possibility of a therapeutic transformation. There is much in this pragmatic, David-centred, theocentric approach which is close to Jewish

[52] See Hill 2000; also Blaising and Hardin 2008: 14.

[53] See Blaising and Hardin (2008: 12), citing Theodoret's Commentary on Psalm 2.1, in *FC* 101.52.

[54] Although he served for some time in Basil's church in Caesarea, and later with Gregory the Nazianzene in Constantinople, where he also encountered the writings of Gregory of Nyssa and Jerome.

[55] See Dsyinger 2005: 197–9.

readings; the only thing which makes it distinctly Christian is the additional appeal to Christ as mediator.[56]

The much later East Syrian Orthodox *Great Psalm Commentary* of **Daniel of Salah** would, from a reference in Ps. 83 (Hebrew, Ps. 84), appear to have been written around 542 CE.[57] Daniel of Salah attributed all the psalms to David, inspired by the Spirit. In Psalm 1 he speaks of the various interpretations he has received about the psalm.[58] A title is given to the psalm placing it in a specific historical context (a reading which is reminiscent of *TgPss*): this is about David's reflection on Saul's raising of Samuel through necromancy. Saul is the wicked king, who leaves the paths of righteousness and walks in the path of demonic forces, stands in the counsel of sinners and sits upon the seat of the Witch of Endor.[59] So the wicked man is Saul: the blessed men are all those from David onwards who follow the path of the Torah. A reading not dissimilar to a Jewish one continues by interpreting the 'wicked man' also as Adam, who turned away from the paths of righteousness in Paradise and became a disciple of the serpent. However, by v. 3, in its discussion of 'the tree' we encounter, not surprisingly, a Christological reading: this is the 'Tree of Life': the fruit produced in season is the work Christ achieved on the cross in remitting our sins, and the leaves (which do not 'drop off') are his gift to us of immortality and healing. So what of the waters? This is a reference to our cleansing through baptism. 'And he was *the tree that is planted by a stream of water*, that is, by the torrent of holy baptism, so that he might purify and cleanse those who are defiled with evil things'.[60] Whether or not Daniel knew specifically the traditions of early commentators such as *Barnabas* and *Apology,* or whether these images of trees of life and waters were more generally known and used, is unclear; but it is significant that this sixth-century commentator should have so much in common with the Jewish Targum as well as with early Palestinian traditions.

Daniel's commentary was a deliberate attempt to combine an Alexandrian reading with an Antiochene one. Hence Psalms 1 and 2 can be taken together to show how each approach combines an understanding of these psalms in relation to each other. Psalm 1 is read allegorically about the economy of the

[56] This might be illustrated by an apocryphal story, taken from Palladius' *Lausiac History of Early Monasticism* 22, which recounts an encounter between Paul the Simple, an Egyptian saint, and Anthony the Great, who read to him the first verse of Psalm 1. After some thirty years, when Anthony met him again, St Paul said to him with great humility: 'I have spent all this time trying to become the man that does not walk in the counsel of the ungodly; I am now ready to start to learn now not to stand in the way of sinners.'

[57] See Taylor 1998–9: 33–42; also 2009: 65–92.

[58] I am particularly indebted to David Taylor for allowing me access to his translation of Daniel on Psalm 1 where this reference is found.

[59] Here Daniel is following the *Peshitta* translation, which—perhaps more sensibly—inverts the Hebrew and speaks of 'walking in the way of the wicked' and 'standing in the counsel of sinners'.

[60] See Taylor 1998–9: 40.

Word of God, although it also illustrates the more literal approach reading it as a reflection by David on the foolishness of Saul. Psalm 2, by comparison, is read allegorically for its insights on Christ the Messiah, while in a literal sense it is seen to have been written by David after he was anointed king.

We now turn back to the western churches. They were mainly preoccupied, up to the first part of the fifth century, with the Arian heresy. So here it is not surprising to find that the reading of both Psalms 1 and 2 is as much pastoral as doctrinal, defending and explaining the established doctrine of the Church. Yet within all we still find a good deal of diversity. **Hilary of Poitiers** (*c.* 315–67), for example, follows Origen in at least two, seemingly contradictory, ways: first, Hilary develops further a prosopological reading of the psalms, distinguishing between the voice of the suppliant and the voice of God; secondly, he assumes that because each psalm has been inspired by the Holy Spirit, the 'hidden Christ' can be found in every psalm.

On the first point, Hilary, like Gregory of Nyssa, understood that the Psalter offered 'a detailed map for growth in Christian holiness'.[61] But whereas Gregory placed great emphasis on the fivefold division of the Psalter, Hilary was probably the first to divide the Psalter into three stages of ascent, evoking a type of 'Christian Sabbath' in an imitation of the Jewish Jubilee (three times [$7 \times 7 + 1$]), so that the Psalter comprised 'three fifties' of David for the nurturing of the Christian soul. On this account Psalm 1, with its teaching of blessedness, was not only the first but also the most formative psalm.[62] Because Hilary placed such emphasis on the appropriation of the Psalter in the devotional life of the Christian, he refused to read the 'blessed man' in Psalm 1 as speaking about Christ: 'The contents of the first Psalm forbid us to understand it either of the Person of the Father or of the Son'.[63] This is not to deny that much earlier tradition has understood this psalm in this way, but this, he says, is neither right nor correct.[64] Using the prosopological approach, Hilary argues that the suppliant is speaking *about* God rather than *from* God; Christ is Lord of the Law, and his happiness can

[61] The phrase is from Daley 2004: 199.

[62] See Daley 2004: 199–200, citing Hilary, *Instr. Ps.* 9, 11 (*CCSL* 61. 911) on the influence of Gregory in the reading of the psalms as stages of the ascent of the Christian soul. See Hilary, *Instr. Ps.* 10–11 (*CCSL* 61.10) on the threefold division of the Psalter following the Sabbath-Jubilee pattern. It is probable that Hilary influenced in turn Theodore of Mopsuestia's similar threefold reading of psalmody, which in turn, through the popularity of his Preface to the Psalter in the Celtic tradition, influenced the reading of the psalms as 'three fifties' in Ireland.

[63] Quoted in Waddell 1995: 504, and taken from *Tractatus in Psalmum* 1 (*CCSL* 22.19; similar passages occur in CSEL 22.20 and 21.1–22).

[64] 'I have discovered, either from personal conversation or from their letters and writings, that the opinion of many men about this Psalm is, that we ought to understand it to be a description of our Lord Jesus Christ, and that it is His happiness which is extolled in the verses following. But this interpretation is wrong both in method and reasoning . . .' (translation taken from <http://www.ccel.org/print/schaff/npnf209/ii.vi.ii.i>).

hardly depend on him keeping it Himself: how could happiness be achieved by him becoming like the object he had created?

However, on the second point, Hilary nevertheless does see Christ 'hidden' in this psalm: the key place is in the reference to '*the* tree of life'. Identifying the Tree of Life with wisdom, through Prov. 3.18, Hilary argues that Christ, who is wisdom, is also compared to a tree; consequently the fruits and leaves of the tree compare with the gift of immortality Christ offers to, for example, the penitent thief. Through further reflections which move deeper into the Gospels and further from the psalm, Hilary finds the mysteries of the incarnation, baptism, and passion all hidden in this verse, where the wisdom of Christ who is the Tree of Life 'undoes' the work of Adam who took from the Tree of Life.[65] It is ironic that Hilary, who refuses to accede to the 'voice of Christ' in the first verse of this psalm, spends so much time arguing how much the psalmist, inspired by the Spirit, referred to the 'work of Christ' in v. 3.

Although we lack the same full-length commentary for Psalm 2, we know from Hilary's other works that this psalm is read in the same way, with Acts 13 being a point of reference.[66]

Jerome (*c.* 342–420) takes another slightly different view of these two psalms. *Tractatus suie Homiliae in Psalmos* is a more philological commentary, comparing the Latin with the Hebrew and Greek, and, like Hilary, Jerome is critical of other commentators who have assumed the 'blessed man' is Christ in his manhood.[67] Rather, comparing the first verse with 1 John 1.8, Jerome sees within this verse the continual possibility for the Christian to renew God's blessing through turning their backs on sin: 'Ego heri peccavi, non sum beatus. Si non stetero in peccato, sed retraxero me, iam beatus sum'.[68] Jerome's *Commentarioli* is a work with a more spiritual emphasis, and here Psalm 1 is seen as a great door to the whole building of psalmody ('Psalterium ita est quasi magna domus, quae unam quidem habet exteriorem clavem in porta, in diversis vero intrinsecus cubiculis proprias claves habet ... grandis itaque porta istius domus primus psalmus est').[69] Here Jerome's interpretation of v. 3 is subtly different from Hilary's: the law (in Latin, unlike

[65] All this is developed in Hilary's *Tractatus*, which focuses as much on v. 3 (with respect to Christ) as it does on v. 1 (with respect to the Christian).
[66] See, for example, Rondeau 1985: 87–92; also Sigier 2001: 20–6.
[67] See Gillingham 2008a: 37, and Waddell 1995: 505, n. 12, who is personally more dubious about the authenticity of this work.
[68] See Schwienhorst-Schönberger 2006: 220, n. 27; also p. 222. Here and in the following verse Jerome makes critical comments of Jewish interpretations: first, the Christian, unlike the Jew, is constantly aware of a failure to keep God's commands (v. 1); secondly, the Blessed Man is *not* King Josiah, as sometimes presented in the Jewish (and Antiochene) tradition, but rather the Christian forgiven by Christ; and thirdly, Christians 'meditate' by action while Jews do so just by word ('Judaei igitur ore meditantur: nostra meditation opus est').
[69] See Blaising and Hardin: 2008 13–14, referring to *CCSL* 78.3. This idea develops the same image of Psalm 1 as the 'Door' into psalmody as cited by Origen in *Philoc.* 2.2.

Hebrew, a masculine noun) is what is compared with the tree (rather than the righteous man); the tree is an image of wisdom (this is like Hilary, and uses earlier Jewish tradition, for example Prov. 3.18); Christ is the wisdom of God (using 1 Cor. 1.24); thus Christ as wisdom is hidden in the psalm, and compares with the Tree of Life. Christ the incarnate Word is the only man ever to keep the law and continually to prosper, as v. 3 indicates; so hidden in this psalm is the human Christ, the wisdom of God, the Tree of Life, whose presence here encourages us to become like him.[70] How do we do this? Here Jerome changes the simile: we become like Christ through meditating in thought and word on Scripture, which is also the Tree of Life, whose leaves are the words, and whose fruit is the meaning.[71]

In his commentary on Psalm 2 Jerome continues this prosopological approach, reading vv. 1–4 as if spoken by some prophetic figure (or an angel) concerning the future of all Jews and Gentiles who rage against the Messiah, and vv. 5–12 as God Himself, addressing Jesus as the Messiah and exhorting all peoples to believe in him.[72]

Both Hilary and Jerome offer us further insights into the ways in which these two psalms are now increasingly read as one. In *Tractatus in Psalmos* Hilary of Poitiers offers a long discussion of the different traditions that have split and united these two psalms: in the end he opts for their separateness.[73] In *Breviarum in Psalmos,* Jerome speaks of the tradition in both Hebrew and Greek manuscripts that the two psalms are one, and cites the blessings in Pss. 1.1 and 2.12 as a further explanation of this unity; however, like Hilary, in practice his commentaries treat the psalms as two separate units.[74] These are typical examples of the way in which the Church Fathers, knowing variant traditions, nevertheless commented on the psalms as one piece or two separate ones according to their own theological preferences.[75]

Ambrose of Milan (339–97) offers us yet another contrasting example of how Psalm 1 can be read allegorically, but in a pastoral rather than doctrinal sense.[76] Focusing only on verses 3–4, he writes:

[70] 'When Solomon says, 'She is a tree of life to those who grasp her' [Prov. 3.18], he is speaking of Wisdom. Now, if wisdom is the tree of life, Wisdom itself, indeed, is Christ. You understand now that the one who is blessed and holy is compared with this tree, that is, with wisdom. He is in other words, like Christ' (Blaising and Hardin 2008: 3, quoting from *FC* 48.7). Despite what is said about the Blessed Man in v. 1, we may note here in v. 3 that it is the human Christ who is hidden in the psalm. References to the tree as the cross indicating the divine activity of Christ are absent in this work.

[71] See Blaising and Hardin 2008: 3, quoting from *FC* 48.8.

[72] See Blaising and Hardin 2008: 13–14 (citing *CCSL* 72.181).

[73] See Rondeau 1985: 146; Høgenhaven 2001: 171, n. 10.

[74] See Høgenhaven 2001: 171, n. 10.

[75] See Koch 1994: 228, n. 19; Willis 1999: 388, n. 26.

[76] This is taken from Ambrose, *Explanation of Psalm 1.41–2* (CSEL 64, 35). I am again grateful to Brian Daley for this reference. We shall use more of Ambrose's appropriation of these psalms in Chapter 6 'From the Second Temple up to the fifteenth century': 137 and Chapter 8 'Christian interpretations': 201–2.

The fruit is interior; the leaf, that by which the fruit is protected from the burning sun or from the cold. The fruit seems to be faith, peace, excellence in doctrine, a focus of the mind on true knowledge, an ability to explain the mysteries. . . . The fruit is on the level of mystery, the leaf on that of moral action. For the virtues without faith are leaves: they seem to flourish, but they cannot profit us; they are stirred by the wind, since they have no foundation. How many pagans have mercy, have sobriety—but they have no fruit, because they have no faith! Their leaves fall quickly, whenever the wind blows. Some of the Jews, too, have chastity, and show great care and diligence in their study of the text; but they are without fruit, they are turned upside-down like leaves. Perhaps these are the leaves which the Savior found on that fig-tree, but he found no fruit. Mystical actions save us and free us from death; moral actions are ornaments of propriety, but give us no help towards our redemption . . .'

So according to Ambrose Psalm 1 contains specifically Christian moral teaching: it judges the pagans, but also the Jews (whence this teaching once came) for their lack of fruitfulness.

We finish this survey with **Augustine**, who is arguably the most important Christian commentator on the psalms in the early Church. Not only is his *Enarrationes in Psalmos* the only entire collection of the Psalter from the Fathers of the western Church to survive, but it is also the most thorough-going and detailed Christian reading of the psalms, becoming a major contribution to the Glosses in medieval Psalters.

There are at least three reasons why Augustine adapted a thoroughgoing Christian reading of Psalm 1, in contrast with earlier commentators who focused on the possibility of a Christological reading (mainly of vv. 1, 3, and 6). First, to identify Christ as the 'blessed man' accorded with his theology of the incarnation (in part a response to the Donatist crisis in the north African churches); secondly, an engagement with a theology of works in the light of the grace of God meant this was an ideal psalm to use (in part this was due to his refutation of Pelagianism, which also accounts for his detailed expositions of Psalm 119); and, thirdly, a moral and Christological reading of this psalm allowed Augustine the opportunity to develop his prosopological approach, which was first to hear the voice of the human Christ ('Christ the Body', speaking the psalm for us and with us) and then to hear the voice of the risen and ascended Christ ('Christ the Head') working out salvation for his Church.

So v. 1 starts:

Blessed is the man who hath not walked in the counsel of the ungodly. The blessing applies to our Lord Jesus Christ, *homo dominicus,* the Man of the Lord. *Blessed is the man who hath not walked in the counsel of the ungodly,* as did the man of earth whose wife the serpent beguiled; her husband agreed to her proposal and ignored God's command. *Nor stood in the way of sinners.* It is true that our Lord

came by the way of sinners: He was born as sinners are; but He did not stand still, for He was never captivated by the world's allurements.[77]

The comments on vv. 2 and 3 remind us of Jerome. Speaking of the relationship between Christ and the Law, Augustine comments: '. . . It is one thing to be in the law, another to be under the law. Whoso is in the law, acteth according to the law; whoso is under the law, is acted upon according to the law; the one therefore is free, the other a slave. Again, the law, which is written and imposed upon the servant, is one thing; the law, which is mentally discerned by him who needeth not its "letter" is another thing.'[78] So Christ is the law, and as the law is compared to the tree, and the tree to wisdom, so Christ is also the Wisdom of God through the image of the tree: the waters are on the one hand the turbulent waters of sinners which the tree protects them from, but, on the other, these are living waters offered to those who seek the wisdom and will of God through the risen Christ. 'That tree, therefore, is our Lord, who draws those who are in the way from the running waters, that is, from the peoples who sin. By drawing them into the roots of his discipline, he will bring forth fruit; that is, he will establish churches, but in due time, that is, after he has been glorified by his resurrection and ascension into heaven.'[79]

The reference to the judgement of God on the ungodly and sinners in vv. 4–6 is a development of both Hilary and Jerome (and has correspondences with rabbinical commentators who similarly take apart the parallelism and deal with each part separately). The ungodly will be judged and not rise in judgement, for God will not know them; but the sinners, being beyond judgement, will simply perish, for God does not know them. Thus the righteous are the only ones to be known by God and to rise when judgement comes.[80]

Unusually Augustine has also left us with a detailed account of Psalm 2; here he applies a thoroughgoing Christological approach throughout.[81] Verses 1–3 are about 'the Lord's persecutors' raging against Christ the Messiah; v. 4

[77] The translation is from Hegbin and Corrigan 1960: 21.

[78] This rather more forceful translation is taken from <http://ccel.org/ccel/scaff/npnf108.ii.I_1.html>.

[79] This translation is taken from Blaising and Hardin (2008: 8). This may well have been influenced by Ambrose of Milan, whose commentary on this verse emphasizes the 'drinking' of the living waters of Christ. See CSEL 64.28–30, cited in Sigier 2001: 18–19. It is remarkable in this Christological reading of the psalm that no reference is made to the tree as the cross, or the waters as baptism: this is about Christ the Body and Christ the Ascended Head. Like Jerome, Augustine prefers not to associate this particular psalm with the passion and death of Christ and in this way reads it quite differently from Psalm 2.

[80] This threefold way of seeing the righteous, the ungodly (presumably here heretics) and the sinners all held within different types of the 'knowledge' of God is a clear development of Jerome.

[81] The following summary and citations are taken from Quasten and Burghardt 1960: 25–30.

concerns God's laughter—in pleasure of those saints who will partake in the future victory achieved by Christ, and (v. 5) in derision of those who refuse to know him. Verse 6 'is obviously spoken in the very person of our Lord Jesus Christ': Zion is the Church, and Christ announces Himself as king over His Church. Verse 7 recognizes the problem in speaking of the divinity of Christ in a temporal way: 'It is possible to see in the word *today* a prophecy of the day on which Jesus Christ was born in His human nature'.[82] Verse 8 is also to be seen in the 'temporal economy' ordained by God. Verses 9–11 concern the kings of the earth who have to fear (or perhaps understand) the ways of the Lord. Verse 12 is addressed to all believers: they are to 'embrace discipline' and not risk the anger of God; they are the ones who will be blessed.

Augustine provides us with an excellent example of the ways in which the reception of these two psalms has progressed since New Testament times, whereby both Psalms 1 and 2 are read not only didactically but also seen through the lens of the person of Christ. Now, even Psalm 2, with its instructional elements at the beginning and end, is used to instruct the Church, while Psalm 1 is constantly seen in the same Christ-centred way as Psalm 2. In this way, both psalms are closely related, both for the purpose of Christian instruction and Christian doctrine.

THE VULGATE

These two psalms have also been brought together in translation as well as in the commentary tradition. We saw this in the previous chapter, in the way the Septuagint translation understood the associations between the two psalms in early Jewish tradition; it is also visible in the Latin translation (using here Jerome's *Psalterium Gallicanum* as part of the Vulgate), for Jerome, conscious of the Christian reading of the psalms, assumed their connectedness as part of the translation process.

Psalterium Gallicanum, translated into Latin in Caesarea between 386 and 387, was the second of Jerome's three versions of the Psalms. It was more dependent upon the Greek than his earlier revision of the older Latin Psalter, made in Rome between 382 and 385: the latter most probably had antecedents in both a North African Psalter (the *Vetus Itola* used as early as Tertullian and also by Cyprian [210–58]) and a 'European' Psalter apparently used by Hilary of Poitiers.[83] But *Psalterium Gallicanum* was less dependent

[82] Watts, 1990: 83, notes that Augustine also read this verse as about 'the eternal generation of the Power and Wisdom of God, Who is the Only-begotten Son'.

[83] Admittedly Jerome made a revision of his translation of the Latin Psalters by using Greek versions, resulting in the *Psalterium Romanum,* but this did not incorporate Origen's *Hexapla* in the same way as the *Psalterium Gallicanum.*

upon the Hebrew than his third version, the *Psalterium Hebraicum*, probably completed in Bethlehem in about 393. The fact that *Psalterium Gallicanum* was accepted as the liturgical psalter of the Roman Church tells us something about its aesthetic and practical value, as well as its theological and philological concerns. *Psalterium Gallicanum* used a *Christian* Latin version and *Christian* Greek versions for translation (what he termed as 'sense for sense, not word for word').[84] Given what we have seen of the anti-Jewish nature of some of Jerome's comments on Psalm 1 (for example, his criticisms of the Jews' inability to keep the Law in deed as well as in word, and his identification of the 'blessed man' as the Christian forgiven by Christ) and indeed his anti-Jewish comments also in Psalm 2 (for example, his identification of the hostile peoples in vv. 1–4 as not only Gentiles but also those Jews who rage against the Messiah), it is difficult to assume this was merely a wooden translation into Latin dependent solely upon the Greek. Much of it does use the Greek in a referential way; but there are signs that it was more than this, as we shall see below.

The first example is in the first two words of the psalm: '*Beatus vir*', like the Greek, omits the article which is present in the Hebrew. As Jerome made clear in his *Tractatus,* there is no indication that the loss of the article really suggests '*the* man' (i.e. Christ); rather, it is about '*a* man' (i.e. the Christian). There are other signs of this Christian frame of reference in the Vulgate. These include, first, the suggestion of doctrinal controversies in the phrase '*et in cathedra pestilentiae non sedit*' for καὶ ἐπὶ καθέδραν λοιμῶν οὐκ ἐκάθισεν (in the Hebrew, לצים לא ישב) at the end of v. 1, where the Latin phrase, in its cultural context, evokes an image of teachers in session imparting harmful doctrines to their students).[85] Secondly, in v. 2, the obvious translation of ἐν τῷ νομῷ κυρίου (twice) as '*in lege Domini voluntas eius et in lege eius meditabitur*' uses '*lex*' with its broad range of meaning to suggest not only the Old Testament Law, but, in this context, the revelation of God in a more inclusive (Christian) sense. Furthermore, as with the Greek, its masculine gender allowed for the 'law' (as well as the 'righteous man') to be compared with the tree in v. 3, an observation of which again Jerome made full use in his commentaries. Similarly, '*meditabitur*' (a future tense taken from the Greek translation of the Hebrew imperfect) has a wide frame of reference, suggesting not only the verbal murmuring in the 'meditation' of the Law as in the Hebrew use of √הגה, and not just the disciplined study of it which is implied in the Greek use of μελετάω, but, in the Latin, the *active* practice of what is uttered.[86]

[84] Jerome's preference for the Christian versions is made clear in his Prologue to his (later) Hebrew version of the Psalms addressed to Sophronius.

[85] So Ladouceur 2005: 52.

[86] Hence Jerome's comments in *Tractatus* that the Christian response to the Law is not only in word but in deed.

Turning to v. 3, the use of '*lignum*' for tree and '*aquarum*' for waters, each again offering a broad range of meaning (*lignum* meaning, simply, 'wood' and *aquae*, used in the plural, meaning more generally 'waters'), allowed these also to be referents, which would undoubtedly suggest to Christians the 'wood' of the cross of Christ and the 'waters' of Christian baptism: and of course this symbolism would have been part of the Christian discourse on this psalm which Jerome would have inherited and indeed also commented on.[87]

Verse 4 offers further examples of the dominance of the Greek over the Hebrew: '*Non sic impii non sic*' uses the more emphatic Greek addition compared with the Hebrew[88] and the use of '*pulvis*' ('dust') follows the Greek χνοῦς rather than the Hebrew מץ ('chaff'). Similarly the use of '*a facie terrae*' at the end of the verse follows the Greek addition to the Hebrew in ἀπὸ προσώπου τῆς γῆς.

Verse 5 is another example of how following the Greek rather than the Hebrew allows the broad range of reference in the Latin to suggest more Christian connotations. Here the controversial Hebrew expression לא־יקמו רשעים במשפט becomes '*non resurgent impii in iudicio*', which allows for at last two different meanings—both a sense of not 'standing' (i.e. not winning a case) in a secular suit of law, but also implying, as does the Greek οὐκ ἀναστήσονται ἀσεβεῖς ἐν κρίσει, an image of resurrection at the final judgement.[89]

A final example of how the Latin facilitated a Christian reading is in the use of '*novit*' in v. 6 ('*quoniam novit Dominus viam iustorum*') which, even though it follows the Greek (ὅτι γινώσκει κύριος ὁδὸν δικαίων), still has a wider semantic range than the Hebrew ידע. In the Latin this implies not only relational knowledge (in its context, between God and the believer) but intellectual understanding as well (in its context, a rational faith within a Gentile world).[90] So even though this translation was not overtly theological, in that its purpose was to follow more closely the Greek and to find corresponding Latin terms, the words representing the most controversial meanings enabled a range of theological interpretation.[91]

The same observations apply to the Latin translation of Psalm 2. We noted earlier how in his *Commentariolus in psalmos (CCSL 72)* Jerome used

[87] Although these inferences can be drawn, Jerome himself does not draw them out of this particular psalm.

[88] See Chapter 2 'The Septuagint': 25 on the Greek translation of this verse from the Hebrew.

[89] Certainly this is how Jerome read it in his *Commentariolus*, when he speaks of moving from talk about the present world to meditating on future life and eternity.

[90] This therefore allowed Jerome and later commentators to discuss the extent to which God's 'knowledge' about the state of the wicked has anything to do with their ultimate destiny. Jerome, like Hilary and Augustine, discusses the use of this verb in some detail.

[91] The Gallican Psalter usually formed the basis for later Glosses and manuscript illuminations, where again the capacity for a rich diversity of interpretation of Psalm 1 is clear, as will be seen shortly.

a prosopological approach for this psalm, dividing it into two speakers (an angel or prophet in vv. 1–4, and God Himself speaking to the people about Jesus the Messiah in vv. 6–12) rather than reading it, as in the Hebrew, as a liturgical drama of perhaps four parts.[92] This Christological framework of reference is less obvious in Jerome's actual Latin translation, but this is not surprising, given the more muted Messianic emphasis in the Septuagint, and Jerome has to make a theological compromise in some parts of the translation of this psalm.[93]

The two verbs in v. 1 offer an interesting comparison with Psalm 1. The Greek reading focuses less on the more physical and military connotations of tumult and confusion, which are in the Hebrew original, and more on the less tangible and more general traits of vain pride and insolence exhibited by the Gentiles:[94] this is evident in the Latin as well. In the phrase '*quare fremuerunt gentes et populi meditati sunt inania*' the verb '*fremo*' indicates 'murmur with discontent' and follows the Greek ἐφρύαξαν; whilst '*medito*' ('devise, plot') corresponds with the Greek ἐμελέτησαν.[95]

Other evidence of the preference for the Greek over the Hebrew is found at the end of v. 2, in the use of '*diapsalma*', a literal translation of the Greek διάψαλμα. The corresponding Hebrew term סלה does not occur in this psalm and this intrusion creates a new dynamic in the structure of the psalm. Another literal use of the Greek in this verse is in the translation of χριστός as '*christum*'. This has obvious Christian connotations, and thus the Latin, as the Greek, creates a dramatic effect for what follows concerning *Christus*, the Messiah, and the use of '*diapsalma*' adds weight to this. [96]

In v. 4, '*habitat in caelis*' is another example of the preference for the Greek over the Hebrew. The Hebrew speaks of God 'sitting' in the heavens (using the typically ancient Near Eastern anthropomorphic idea of God seated on a throne) in its use of √ישׁב, but again the Latin follows the Greek ὁ κατοικῶν ἐν οὐρανοῖς ('he *resides* in the heavens') to erase this anthropomorphic image of God actually 'being seated'.

Verses 6–9, in the Hebrew, comprise a dialogue where in v. 6 God speaks directly to the king ('I have set my king on Zion, my holy hill') and in vv. 7–9 the king (or a prophet or priest) reports back on what they have heard God promise—that the king is now ('today') God's Son and will conquer all the

[92] See n. 72 earlier, citing Blaising and Hardin 2008: 13–14. We shall see below how the translation actually follows the Greek more strictly than this, where in vv. 6–12 any dialogue suggesting God as the speaker is taken out.
[93] On the Septuagint translation of Psalm 2, and the evidence of a 'more subdued messianic expectation' there, see Chapter 2 'The Septuagint': 27–31, especially 28.
[94] See Chapter 2 'The Septuagint': 27.
[95] Interestingly the first verb '*fremo*' is the one which captures the more sonorous meaning of the second verb (√הגה: 'murmur') in the Hebrew.
[96] This sits rather oddly with the use of '*eorum*' ('of them') in v. 3, which clearly refers to the Israelites rather than the Messiah.

nations who threaten his kingdom. The Greek rather flattens this liturgical drama: in v. 6 it is clearly no longer God but the king who is speaking, and this speech continues in vv. 7–9. The Latin follows this reading, and in v. 6, the king speaks on his own authority: '*ego autem constitutussum rex ab eo super Sion montem sanctum eius*'. The verse ends, like the Greek, but not being as explicit about the voice of God, with '*praedicans praeceptum eius*' (διαγγέλλων τὸ πρόσταγμα κυρίου) 'declaring his decree'. Thus in the Latin as in the Greek the king is now reporting on already known promises. This is an interesting example of Jerome's loyalty, in translation, to the Greek, because v. 7 was of course a critical one for Christian readings about the Father and the Son, and Jerome himself in his prosopological reading in his commentary interprets the speaker, more dramatically, as God speaking, not the king.

The adherence to the Greek follows throughout the rest of the psalm. In v. 9, the difficult Hebrew expression תרעם בשבט ברזל (where √רעע may in this context mean 'to shatter [smash] with rod of iron') is replaced in the Greek with ποιμανεῖς αὐτοὺς ἐν ῥάβδῳ σιδηρᾷ (where ποιμαίνω means, less violently, 'to rule [shepherd]'). The Latin takes up this phrase in '*reges eos in virga ferrea*'. The result is that the Latin, like the Greek, loses the parallelism which is in the Hebrew poetry, with its double force of 'shatter/. . . break'.

Similarly in v. 12 the odd expression נשקר בר (literally, from the Aramaic, 'kiss the son') is translated with a more universal didactic intention as δράξασθε παιδείας (literally, 'seize instruction'). The Latin follows suit: it reads '*adprehendite disciplinam*' or 'accept instruction [discipline]'.

Another change from the Hebrew gives the end of the psalm, in the Latin, the same eschatological emphasis as in the Greek. The Hebrew reads כי־יבער כמעט אפו ('for his wrath is quickly kindled') but the Greek translates this with a future connotation: ὅταν ἐκκαυθῇ ἐν τάχει ὁ θυμὸς αὐτοῦ really means 'when his wrath will quickly blaze'—referring not to a more general characteristic of God but to a specific time in history when this might be seen. The Latin makes this reading even sharper and draws into it the last phrase of this psalm: '*cum exarserit in brevi ira eius beati omnes qui confidunt in eo*' or, 'when, in a short while, his anger will blaze, blessed are those who trust in Him'.

It is clear, therefore, that the Greek translation of the Hebrew has dominated the choice of translation in this psalm, both in the way in which the ancient liturgical elements in the middle of the psalm have been restructured, and in the attention given to the Greek over the Hebrew in more detailed examples: a previously Jewish text has been used to serve the theology of the Christian Church.

What of the ways in which this translation might have drawn Psalms 1 and 2 more closely together? We have already noted that Jerome knew of the tradition that the two psalms were united, and although he preferred in his

Commentariolus in psalmos to read them as two units he nevertheless frequently referred to their connectedness. Theologically Jerome read them in complementary ways: he understood the subject of Psalm 1 to be the Christian believer, and the subject of Psalm 2 to be Christ the Messiah.

Therefore, even in the Latin, the continuities between the two psalms are preserved in many ways. The use of 'meditato' in Pss. 1.2 and 2.1 remains; 'in iudicio' in Ps. 1.5 is picked up again 'in iudicatis terram' in Ps. 2.10; 'peribit' at the end of Psalm 1 (v. 6) is repeated at the end of Psalm 2 (v. 12); also in 2.12 the use of 'de via iusta' (taken from the Greek addition to the Hebrew, ἐξ ὁδοῦ δικαίας) links this psalm again back to 1.6 and the 'viam iustorum' (ὁδὸν δικαίων in the Greek); and, perhaps most obviously, 'beatus vir qui . . .' at the beginning of Psalm 1 is found, in a plural form, at the end of Psalm 2, as 'beati omnes qui . . .'

These equivalencies are all of course due to the dependence of the Latin upon the Greek, but the overall effect remains the same. The two psalms are related, whether read in Hebrew, Greek, or Latin. Although the first psalm still has a more didactic emphasis, concerned with how the individual believer should live, the Latin, following the Greek, has heightened the eschatological elements concerning the final judgement of God on the righteous and wicked; this gives Psalm 1 clear correspondences with the eschatological elements about God's coming in anger to judge the wicked and bless the righteous, already evident in the Hebrew, at the end of Psalm 2. Conversely, while the second psalm has a more soteriological concern, emphasizing what the '*Christus*' figure will achieve for all believers, the Latin translation, like the Greek, has 'flattened' some of the liturgical drama and given the whole psalm a more instructional element, so that it seems the whole congregation is now being addressed and exhorted not only at the beginning and end but also within the heart of the psalm. This also brings the tenor of Psalm 2 in the Latin closer to the instructional bias in Psalm 1, which also addresses and exhorts the congregation, through the figure of the archetypical 'blessed man', at the beginning, middle, and end of the psalm.[97]

CONCLUSION

One of the most obvious developments at the beginning of this period is the way that, initially (for example, in the New Testament), parts of Psalm 2 were used as prophecies to show the fulfilment of the old Jewish covenant in the new Christian one. Gradually, even as early as the second century, parts of

[97] See Chapter 2 'The Septuagint': 24–7 and 30–1.

Psalm 1 were also used in the same prophetic way, although initially there was a greater tendency to use this first psalm for instructing the Church in the ways of obedient faith (itself a change from New Testament times, when Psalm 1 was never explicitly used at all). A further development, clearly evident by the end of the second century, was the tendency to use both psalms in their entirety (rather than selecting individual verses from each of them) and view them together as witnesses to the whole Christian drama of salvation, testifying in various ways to the incarnation, passion, death, resurrection and coming judgement of Christ. Another development which we noted was the use of Psalm 2, as well as Psalm 1, for pastoral and instructional purposes (about the place of the Gentiles in the economy of salvation, and about the appropriate fear of God, for example); so by the time of Augustine each psalm was used, independently and together, both for Christian instruction and for Christian doctrine.

Despite all this, however, there is one clear difference in the reception of both psalms read together as one, compared with what we saw in their early Jewish reception: instead of the Temple (as a hallmark of the Jewish faith) being a uniting theme, it is now the birth and death of Christ and the life of the Christian Church which unites these psalms. The older Jewish concern with a particular place where God meets his people has been substituted by the Christian emphasis on God coming to his people in Christ wherever they are, and these two psalms are mined comprehensively to demonstrate it; this takes place both in the more literal and textual approaches of the Latin churches in western Christendom, and in the more allegorical and mystical approaches of the Greek churches in eastern Christendom. An obvious consequence of this diverse Christian reception history is that Psalms 1 and 2, taken together, now serve as a double gateway into the Psalter as a whole, providing a theological method for Christian commentators to show how and why other psalms might be read in this way as well.

4

Rabbinic and Medieval Judaism

A repeated theme in the previous chapter was that Psalms 1 and 2 were increasingly read together through the lens of Jesus Christ. One recurrent example was that in the first psalm he was seen as the Blessed Man, and the psalm was a witness to his humanity; and in the second psalm he was seen as the Anointed King and Son of God, and the psalm was a witness to his divinity. Obviously Jewish interpretation used no such lens. In the first psalm, the Blessed Man was, literally, the pious Jew (or, increasingly, the entire Jewish community) who kept the Torah; and in the second psalm, the Anointed King and Son of God represented the Davidic king and indeed the whole community of Israel who were oppressed by Gentile nations. The different ways in which this 'plain sense' approach developed and changed will be seen throughout this chapter.

One other pertinent point is that the Temple theme, one of the connections between the two psalms, which was so prominent in Jewish exegesis in the Second Temple period, is not particularly evident here. This is in part because the emphasis here is on countering Christian exegesis, in which the Temple featured little and the Messiah featured a good deal. It does however feature in the later Jewish mystical tradition, and this will be made clear at the end of this chapter.

THE BABYLONIAN TALMUD

Several times in the previous chapter we saw that Psalms 1 and 2 were read together, albeit with a Christian focus. It is interesting to see here that, throughout the same period, the close relationship between these two psalms is also borne out in the rabbinic tradition. The Babylonian Talmud, comprising some twenty-six volumes, containing both the Mishnah and additional collections known as the *Gemara*, was compiled gradually over the first five centuries of the Common Era. The Talmud frequently cites psalms in its legal, liturgical, and homiletic discussions: verses from many different

psalms were used to illustrate or answer or raise questions which had been raised in other texts, with the Torah presumed as the base text.

The most pertinent citation is the Babylonian Talmud Tractate *Berakoth* 9b–10a, which is a statement of R. Samuel (b. Nahmani in the name of R. Judah the Prince), that 'every chapter' which David held especially dear *began and ended* with אשרי: Psalms 1 and 2 are used as examples of one such 'chapter'.[1] However, the context of this statement reveals that the main concern is to create a parallel between the Eighteen Benedictions and the first eighteen psalms, because of the traditional use in these Benedictions of Ps. 19.5, ('let the words of my mouth . . .'):

> R Judah the son of R Simeon ben. Pazzi said: Since David said it [i.e. Ps. 19.5] only after eighteen chapters [of the psalms], the Rabbis too enacted that it [again, Ps. 19.5] should be said after eighteen blessings. But are those eighteen Psalms really nineteen? [*Here the answer 'no' is expected.*] – 'Happy is the man' and 'Why are the nations in an uproar' form one chapter.

By uniting Psalms 1 and 2 the collection of 18 Psalms not only mirrors the Eighteen Benedictions but also, somewhat appropriately, creates a collection which begins and ends with a psalm in praise of the Torah. The reading in *Berakoth 9.b* continues:

> For R. Judah the son of R. Simeon b. Pazzi said: David composed a hundred and three chapters [of psalms], and he did not say 'Hallelujah' until he saw the downfall of the wicked, as it says, Let sinners cease out of the earth, and let the wicked be no more. Bless the Lord, O my soul. Hallelujah. Now are these a hundred and three? Are they not a hundred and four? You must assume therefore that 'Happy is the man' and 'Why are the nations in an uproar' form one chapter.[2]

Jewish manuscript tradition has several other illustrations of the (literal) uniting and dividing of Psalms 1 and 2. The psalms are in fact united in several Kennicott manuscripts (Mss nos. 17, 37, 216, 409, and 505) and in some of the de Rossi versions (Mss nos. 17, 37, 216, 505 [again], 554, 596, and 782), but they are separated in, for example, the Codex Leningradensis, a seminal version for BHS.[3] So the more detailed evidence provided by *Berakoth* 9b–10a is a significant example of the former tradition.

[1] See Simon and Epstein 1960. This text is taken as evidence for Psalms 1 and 2 as a unit in Jewish tradition in, for example, Willis 1979: 386–7; Høgenhaven 2001: 169–70; and Botha 2005a: 2. A similar reference is to be found in the Jerusalem Talmud (*Berakoth* 4.3, 8a; *Ta'an* 2.2, 65c). See Mitchell 1997: 73. See Chapter 1 'Comparisons with Psalms 19a and 19b': 4, n. 3, which also uses some of these citations and this quotation in a slightly different context.

[2] Uniting Psalms 1 and 2 neatly circumvented the problem of the numbering of Psalm 104, which in rabbinical tradition was quoted as David speaking the first Hallelujah after he had seen the downfall of the wicked. So uniting the two psalms allows the Hallelujuah to be Ps. 103.1, which is in fact the first place in this sequence that 'Bless the Lord' is used.

[3] See Willis 1979: 381, citing Bardtke 1973: 1–18, especially 2–3.

TARGUM PSALMS

In the final part of the previous chapter we assessed Jerome's translation of
the psalms into Latin; it is interesting to see that at about the same time,
Targum Psalms (henceforth, *TgPss*) was also being translated into Aramaic.
This version, bringing for the Jews the sacred Hebrew text into the vernacular,
might also be compared with the production of the Septuagint for the Jews
in Alexandria up to eight hundred years earlier: the key difference is that
TgPss is not only a translation but it also offers many explanatory expansions
which serve as a running commentary. The work is extant in some twenty
manuscripts, the earliest being from the late thirteenth century. However,
older Aramaic versions of particular psalms, especially those used regularly in
liturgy, would have been in circulation many centuries earlier, even before the
production of the Psalter as a whole before the Common Era, and this would
account in part for the textual diversity. Most scholars would date the earliest
recension of *TgPss* to between the fourth and sixth centuries.[4]

Of the two most recently published translations into English of *TgPss*,
one is only available online; the commentary on each is almost entirely
philological.[5] Most of the psalms, including Psalms 1 and 2, belong to what
is termed 'Type A'—a non-literal translation into (probably Palestinian)
Aramaic, the expansions occurring where there were difficulties in under-
standing more precisely the Hebrew.[6] For this reason, the following analysis
will focus on these 'unequivalencies' because these offer the best insights into
whether the differences can be understood as mainly *semantic* or primarily
theological.

Stec outlines the several themes of the various expansions in *TgPss* overall.
These include an interest in prayer, the law, the assembly of Israel, reward and
punishment, Temple and priesthood, prophecy, the Messiah, miracles, angels
and demons, and an interest in historical figures and events.[7] From this list,
the first four are most relevant in Psalm 1.

The translation offered by Stec is as follows:[8]

> [1]Blessed is the man who does not walk in the counsel of the wicked, nor stand in
> the way of sinners, *nor sit at table in the company* of scoffers; [2]but his delight is in

[4] See Gillingham 2008a: 71–2.

[5] See Stec 2004 and Cook 2001 at <http://targum.info/pss/ps1.htm>. White (1997) is an
unpublished thesis and was unavailable except through Edwards 2007.

[6] It is not always clear, however, whether such differences are due to the reception of a
different Hebrew *Vorlage* or the particular concerns of the translator.

[7] See Stec 2004: 4–10. Other characteristic features, such as double translations, treatment of
anthropomorphisms, relationship with Job, different vocalizations, and loan words are also not
as evident in Psalm 1 as in other psalms.

[8] See Stec 2004: 29. Italics mark the passages in the text where there are important
unequivalencies.

the law of the LORD, and in his Law he meditates day and night. [3]He is like the tree *of life* which is planted by streams of water, which *ripens* its fruit in its season, and its leaves do not drop off, *and all its blossom which blooms ripens successfully into berries.* [4]The wicked are not so, but they are like chaff that the *stormwind drives about.* [5]Therefore the wicked will not stand (will not be acquitted) in the *great day of* judgement, nor sinners in the company of the righteous. [6]For *revealed before the LORD is* the way of the righteous, but the way of the wicked will perish.

Turning to some of the unequivalencies the first notable difference is in v. 1, where סחר has been used for ישב, which, as Stec observes, implies more 'motion' than simply 'sitting'.[9] 'Sit around to dine' or 'recline and eat at a table' is more what is implied, and Stec represents this by the translation '*nor sit at the table in the company of sinners*'. Cook reads it as '*nor taken a seat in the band of mockers*'. Edwards also offers some interesting observations on this translation. He notes that Symmachus, who also uses the same image in the Greek translation (i.e. κοινωνέω—the only occasion when this verb is used to translate ישב in the Greek) does so with a negative emphasis on intimacy in the acquaintance with those *outside* the community of faith, an intimacy which is not apparent in the use of ישב.[10] So what is intended in *Targum* is to show the dangers of an increasing sense of familiarity with those who have no regard for the law (in that one first 'walks' then 'stands' and then 'sits to dine' with them). This corresponds with the increasingly specific references to the hardness of heart of those whose company should be shunned (the wicked ... the sinners ... the scoffers). This translation can be, simply, a more poetic and figurative rendering of the Hebrew; but, given the implication of shunning 'table fellowship' with those who 'scoff' at the Torah, the reading could also be a more implicit reference to Jewish/Gentile relationships at the time the traditions were compiled together.[11] This reading moves beyond what we have seen from this verse in earlier readings, where the references to the wicked and unrighteous have often suggested factions within Judaism itself: a good example of this previously was in the way these psalms were used to legitimize the Jewish community at Qumran over and against the Jewish priesthood in the Temple. But in *TgPss* Psalm 1 could be seen as advice to the entire 'Assembly of the Righteous': they must shun those Gentiles who have no regard at all for the Jewish Law.[12]

[9] Setting aside the use of גבר, another gender-specific term rather like the Septuagint: 'Happy is the *man* ...'

[10] See Edwards 2007: 43.

[11] Stec, 2004: 2–3, is typical of many commentators who date this as somewhere between the fourth and sixth centuries CE.

[12] Edwards, 2007: 44–5, observes that the reference to this psalm in *Midrash Tehillim* 1.7 suggests a Jewish/Gentile context is also possible. It is interesting to see how early Church Fathers such as Tertullian and Clement urge Christians similarly to shun 'table fellowship' with those outside their faith.

A more difficult unequivalence is in v. 2, which twice applies the twofold use of the Hebrew תורה. The first reading of תורה uses a loan word from the Greek νόμος (a word often used to translate the Jewish Law but also used more generally to mean a rule, or even principle) and the Aramaic here is בנמוסא; the second time the word occurs, however, it takes the Aramaic equivalent of the Hebrew, and uses ובאורייתיה, which throughout *TgPss* refers exclusively to the scroll containing the Pentateuch. In this paraphrase, therefore, the more general and specific terms for Torah are used, a point which neither the Greek nor Latin translation makes clear, for in each case they use the same term twice. So in *TgPss* this illustrates the somewhat complex interest in the Torah: as can be seen in the translation, Stec signifies the difference by the use of a small letter for the loan word, and the use of the capital letter where the Hebrew is intended. So we read 'his delight is in the *law* (בנמוסא) of the Lord, and in his *Law* (ובאורייתיה) he meditates day and night'.[13] The pleasurable delight in the law of the Lord creates an interesting comparison with the LXX rendering of the 'disciplined study' of Torah: this, and the interest in private prayer, show clear distinctions between the reception of this psalm in *TgPss* and the Greek.[14]

A third unequivalence is in v. 3. The simile of the tree and the water is seen in the use of the definite article (actually implied in the Hebrew by the use of the possessive) so in most manuscripts *TgPss* reads ויהי כאילן חיי for the Hebrew והיה כעץ, reading 'he is like the tree of life'.[15] Then follows a translation of the Hebrew, concerning the fertility of the tree (its fruit and its leaves) and its source of fertility (the streams of water); but added to this is an interesting expansion.[16] The addition applies the entire verse to the tree alone; in the Septuagint, by contrast, the last line is more obviously applied to the righteous man, who 'in all he does, he flourishes'. Hence this verse might be read as a comparison of the tree with the Torah, rather than with the righteous man.[17]

Another unequivalence is in v. 4, where *TgPss* translates the wind (Hebrew, רוח) which drives away the chaff (a simile for the wicked, which creates a vivid comparison with the simile of the tree being like the righteous in the

[13] See a similar use in Pss. 37.31 and 89.32. See Stec 2004: 4–5 and Bernstein 1997: 39–67.

[14] See Stec 2004: 4.

[15] This also has links with Prov. 3.18 and may explain why this is a common motif in synagogue decoration from the Middle Ages onwards.

[16] Cook's translation is '*all its branches that grow ripen and flourish*'.

[17] Edwards, 2007: 88–91, makes an interesting observation which connects with this: the Aramaic does not render שתל for the tree 'transplanted' by the streams of water but rather chooses to use a more distinct term, נצב. From this Edwards, using the debate in *Midrash Tehillim* 1.19 concerning the need for disciples of Torah to stay with one master, deduces that the 'streams of water' now signify the rabbinical teachers of Torah, and the injunction is for the student of the Law not to be 'transplanted' from one school to another, but rather to remain 'planted' and so 'rooted' with just the one in order to produce growth which will last.

previous verse) as עלעולא, which is rendered by both Cook and Stec as 'stormwind': the contrast between the flourishing of the righteous man and the devastation of the wicked is thus starkly portrayed. This reading opens the way for the development of these two outcomes in the last two verses of the psalm.

Two other unequivalencies occur in v. 5, where that which was ambiguous in the Septuagint is made more explicit. First, the translation of לא־יקמו (literally, in the Hebrew, 'they will not stand/be established') is expanded into לא יזכון יקומון (which might now read as 'they will not be *judged as innocent* nor will they stand [be established]').[18] Cook translates this more succinctly as 'they will not be acquitted'. The eschatological connotations which are in the Greek οὐκ ἀναστήσονται ('they will not rise') are not obvious; here the language is more juridical. Nevertheless, a future interpretation is intended in the second half of the verse: לא יזכון יקומון רשיעי ביומא דינא רבא can be translated as 'the wicked will not be acquitted <u>in the great day of judgement</u>'.[19] This reading is also implied in the Hebrew by the use of the definite article for במשפט (literally, 'in the judgement'), which thus implies not only an earthly court but a heavenly one as well. But *TgPss* makes this twofold reading of the fate of the wicked much more clear: they will not only fail to be acquitted in any human (Jewish) court of justice, but they also will not be acquitted in the divine judgement, in the last days.

A final unequivalence is to be found in v. 6. Instead of the Hebrew כי־יודעיהוה ('the Lord knows [the way of the righteous]') the subject is changed so that we read, literally, מטול דגלי קדם יהוה אורח צדיקיא 'Because uncovered [i.e. revealed] before the presence of the Lord is the way of the righteous'. This actually allows a more obvious parallelism: 'the way of the righteous'/'the way of the wicked' corresponds with 'are revealed'/'will perish'. In addition, the translation also highlights the contrast between the fate of the wicked and (by implication) the redemption of the righteous in the previous verse.[20] The translation also makes clear the more intimate fellowship of the righteous with God: it thus forms a fitting 'inclusio', for the first two verses also promise 'great happiness' to the righteous who shun the fellowship of the wicked.

What then are we to make of these expansions as far as the Aramaic reception of Psalm 1 is concerned? Clearly they show the use of this psalm to be

[18] Most manuscripts with the exception of Breslau retain both verbs.

[19] Stec, 2004: 29, notes that the Bomberg Venice edition (1525) and later printed editions omit the words 'of judgement'.

[20] Botha, 2005: 509, observes astutely that this might be an attempt to avoid anthropomorphism, another feature of the *Targum*. In this case, rather than Yahweh 'knowing' the way of the righteous, the 'way of the righteous' is 'made manifest' before Him.

primarily didactic and instructional. The key issue seems to be the purity of the assembly of the righteous and the shunning of fellowship with those outside it (probably at this point in time not unrighteous Jews, but Gentiles). The importance of prayerful reflection on the Torah as a means of avoiding the temptation to mix with the wicked (Gentiles) is also a mark of later reflections on the identity of the Jewish community in the face of external threat. So too is the stress on clear rewards and punishments for both righteous and wicked, both in this life (in the court of judgement) and in the life to come (on the Day of Judgement). The reception of Psalm 1 in *TgPss* thus places greater emphasis overall on the adherence to the Law in order to protect whole diaspora communities from the corrosive influence of the Gentiles living in close proximity to them.

Of Stec's themes evident in the various expansions in *TgPss*, Psalm 2 exhibits four of these most clearly: these include a particular interest in prayer, reward and punishment, prophecy, and the Messiah.[21] Stec's translation is as follows:[22]

> [1]Why do the nations rage, and the peoples utter vanity? [2]The kings of the earth take their stand, and the rulers join together *to rebel before* the LORD *and to strive with* his anointed, [3](saying) 'Let us break their bonds, and cast their *chains* from us.' [4]He who sits in the heavens laughs; *the Memra of* the LORD derides them. [5]Then he will speak to them in his wrath and terrify them in his anger, [6](saying), 'But I have *anointed my king and installed him* on Zion, the mountain of my sanctuary.' [7]I will tell of the decree of the LORD; he said to me, 'You are *as dear to me as a son to a father, pure as though I had created you this day.*[8] Ask of me, and I will give you *the wealth of the* nations as your heritage, and the *rulers of* the ends of the earth as your possession. [9]You will break them *as* with a rod of iron, (and) shatter them like a potter's vessel.' [10]And now, O kings, be wise; accept discipline, O rulers of the earth. [11]Worship *before* the LORD with fear, *pray* with trembling. [12]*Accept instruction,* lest he be angry, and you perish in the way; for his anger is soon kindled. Blessed are all who trust in *his Memra.*

From the italicization it will be seen that the significant unequivalencies are in vv. 2, 6, 7, 11, and 12.

In v. 2, the additional words למרדא and ולמינצי both emphasize further the intensity of Gentile oppression. The unusual use of √חבר ('gather together') for the Hebrew √יסד ('sit together, take counsel') gives the setting of this psalm more threatening, even quasi-apocalyptic, connotations.[23] Undoubtedly the Gentile opposition was strongly felt: as was seen in Psalm 1, this was a familiar experience for diaspora communities at the time of the translation and compilation of *TgPss*.

[21] See Stec 2004: 4–10. The first two themes overlap with Psalm 1.
[22] Stec 2004: 29–30. Italics again denote unequivalencies.
[23] See Edwards 2007: 35–6, who even refers to the 'Gog/Magog' imagery implied here.

A second significant unequivalence is found in v. 6. 'I have *anointed my king and installed him*' is an example of what Stec terms the enjoyment in *TgPss* of 'double translation' of the Hebrew, which reads more simply נסכתי מלכי ('I have installed my king'). The additional use of the unusual word √רבי ('anoint') rather than just using √נסך (literally, 'install') as in the Hebrew, implies the full dependence of the figure on God's commission, and hence his submission and inferiority to God. This becomes clearer by the unequivalencies in v. 7, which is the most interesting verse in the *TgPss* rendering of this psalm. The first is the translation of the Hebrew √ילד, which is usually translated as God 'begetting' His Son: in *TgPss* the word is בריתך (from √ברי, 'create') which is to be read as 'I have created you', not 'I have begotten you'. This would remind the Jewish reader of the way in which wisdom is similarly 'created' in Prov. 8.22, and would again suggest that the figure is not equal to God but is rather subservient to Him. Given that Christians had been using this verse since New Testament times to claim that here was a prophecy about the Father/Son relationship fulfilled in Jesus, the choice of בריתך for the Aramaic translation is significant. The figure referred to in both vv. 6 and 7 is not, literally, God's Son: he is certainly beloved, like a son, and, like wisdom, he is pure, because he is God's creation, but he has not been 'begotten' by God.[24]

The final two verses also offer interesting expansions. In v. 11 the difficult Hebrew, often translated in order to preserve the parallelism as 'Serve the Lord with fear, and rejoice with trembling . . .' has become פלחו קדם יהוה ('serve [or worship] *before* the Lord') and וצלו (pray). The more specific interest in *TgPss* in prayer and devotion is apparent here. Finally, in v. 12, where the Hebrew is again opaque, the expression נשקו בר, sometimes translated as 'kiss the son!' is now more pragmatically קבילו אולפנא ('accept instruction!'), again illustrating the importance of Torah teaching in *TgPss* as a whole. The emphasis on prayer and instruction within both these verses in *TgPss* is made even more clear by the use of √סבר for the Aramaic at the very end of the verse: this changes the meaning of the Hebrew √חסה ('take refuge in') and adds an element of hope as well as trust.[25] But what is extraordinary is that here this is about the response of Gentile kings and rulers: given the way the introductory verses to this psalm emphasized the violence and oppression of the Gentiles, the concluding verses thus offer a vivid contrast with their non-violent view of the Gentiles' submission to Israel's God. These last verses also show a somewhat different attitude to the Gentiles from that of *TgPss* of Psalm 1.

[24] Behind this also lie the debates about Israel, not Jesus, as God's Son and Servant, developed, as we shall see shortly, in the *Midrash Tehillim* and other Jewish commentators. See Edwards 2007: 151–5, who comments on this verse and compares it with the *Midrash*. See also Stec 2004: 30, n. 7.

[25] See Stec 2004: 30, nn. 8–10.

Despite this very different attitude to the Gentiles, *TgPss* 1 and 2 both have several common interests, the most obvious two being instruction and prayer; these are both emphasized at the beginning of the first psalm and the end of the second. It is also clear that the identity and protection of the Jewish people stands at the heart of both psalms: in Ps. 1.2 Israel is the archetypal Jew who holds fast to the Torah; in Ps. 2.6–7 Israel is the one anointed and created by God.[26] In both cases, Israel's reward is great happiness (טובידה טובוהי in Ps. 1.1, and טובידה טב in Ps. 2.12). So again, both in terms of language and shared themes, the two psalms stand closely together and form a fitting Prologue to the Psalter as a whole.

MIDRASH TEHILLIM

The actual sources for *Midrash Tehillim*, the most important Jewish commentary on the psalms, probably go back to the third century, when reference is made to a midrashic work on the psalms in which a certain Rabbi Hiyya was so absorbed that he failed to greet Rabbi Simeon, son of the great Rabbi Judah I (Gen. Rabbah 33.3).[27] Like *TgPss*, the rabbinical sources quoted are almost all Palestinian, and because no rabbi after the Talmudic period is quoted by name, the first recension is likely to have been by the ninth century, although additions were made up to the thirteenth century. There is a consistent interest in the early (usually Davidic) setting of each psalm, and David's moral and theological authority dominates, surpassed only by the greater authority of Moses and the Law.

Midrash Tehillim is a didactic commentary based upon a series of homilies. In the case of Psalm 1 much of it is based on almost every word of the first verse of the psalm; in the case of Psalm 2, which is far shorter, more verses receive comment but in a less expansive way.

The emphasis in Psalm 1 is more explicitly on individual piety (although there are references to corporate piety, like that in *TgPss*, which was as much concerned with the well-being of the whole assembly of the righteous as with the single individual). For example, the interpretation of Psalm 1 in *Midrash Tehillim* focuses almost exclusively on particular heroes of faith: this is probably the result of a greater awareness of the individual at this later period in history.[28] Over half of the commentary is based on many different answers

[26] This is developed more explicitly in the *Midrash Tehillim*, as we shall see below.

[27] See Gillingham 2008a: 117–19.

[28] As Maier, 2004: 374, observes: 'Erst im Mittelalter, unter dem Einfluß philosophierender Tendenzen, verstärkte sich die individuelle Note, entsprechend der Auffassung von der Zweckbestimmung des einzelnen Menschen im Sinne erkenntnismäßiger und moralischer Vervollkommung.'

to the initial question: '*Who* is the blessed man?' (Ps. 1.1). Six models of 'blessedness' are given: all but one look back to examples from the books of Genesis and Exodus.

One answer is that the entire psalm speaks of Adam, before he sinned: 'Adam said: "If I had not walked in the counsel of the serpent, how blessed I would have been! ... If I had not stood in the way of the serpent, how blessed I would have been.... If I had not sat in the seat of the serpent, how blessed I would have been." '[29] Adam had been lifted up, and 'planted' amongst the trees in the Garden of Eden; his 'fruit' was Cain, his 'leaf' was Abel, and in all he did he prospered—through Seth.[30] So God knows the way of righteous Adam and Eve; but the way of the wicked (serpent) will perish.[31] Perceiving a problem in this reading, R. Berechiah adds:

> When the Holy one, blessed be He, was about to create Adam, He foresaw that righteous as well as wicked men would descend from him, and He said '. . . If I do not create him, how will righteous men ever descend from Him?' What did the Holy One, blessed be He, do? Putting the way of the wicked out of His sight, He summoned up the measure of mercy and created Adam. Hence it is said *The Lord knoweth the way of the righteous; but the way of the wicked shall perish. . . .*[32]

Another answer is that the blessed man is Noah, '. . . of whom it is said "Noah was a righteous man" (Gen. 6:9) *that walketh not in the counsel of the wicked*—that is, the wicked of three generations'[33] (i.e. the generation of Enosh, the generation of the flood, and the generation after Babel, and these in turn signify the counsel of the wicked, the way of the sinners, and the seat of the scornful). Noah meditates on the (seven) laws he was commanded to keep,[34] day and night, bringing in more clean than unclean animals into the ark so he had sufficient for burnt offerings after the flood. Noah, safe in the ark, was like a tree planted securely in the rivers of water. Noah's fruit, leaf, and prosperity were Shem, Ham, and Japheth. The way of the wicked perished in the Flood; but God knew the way of righteous Noah.

[29] See Braude 1959: 12.

[30] The inference here is that because Abel was murdered, Cain was cursed; so the real progenitor of the world was in fact Seth.

[31] See Braude 1959: 13–14.

[32] See Braude 1959: 33. Feuer comments on this tradition in a rather different way: 'The sin of Adam introduced decay and deterioration into the world. The man of אושׁ (i.e. the man who is "*praised*") will reverse this trend.' There is an interesting allusion to the Temple in this reference to Adam introducing decay into the world: there is also a rabbinic tradition about the rebuilding of the Temple in the messianic era, after the time of Gog and Magog, which will be on the place where Adam was created and where a stream shall flow from it. At that time the world will return to its state of Paradise, and 'its fruit will be for fruit and its leaf for healing': see Feuer 1995: 62.

[33] See Braude 1959: 15. The paraphrase which follows is from pp. 15–16.

[34] This seems to be a reference to Gen. Rabbah 16.6, which states six laws: idolatry; blasphemy; abusing authority; bloodshed; incest; theft with the seventh concerning not eating flesh torn from a living animal.

Another answer was that the man is Abraham, 'of whom God said, "He is a prophet" (Gen. 20.7). . . .'[35] Abraham did not walk in the counsel of the wicked generation after Babel (Gen. 11.4) nor did he stand in the way of the sinners at Sodom (Gen. 13.13), nor did he sit in the seat of the scornful like Abimelech (Gen. 20.15). He too meditated on the law of the Lord (Gen. 18.19 and 25.5).[36] 'The Holy One, blessed be He, lifted Abraham up, and planted him in the Garden of Eden' (which is) 'the land of Israel'. His fruit is Ishmael, his leaf is Isaac, and his prosperity, the children of Keturah.[37]

Despite the high esteem given elsewhere to Moses, and the references to Torah in this particular psalm, Moses is actually nowhere identified as 'the blessed man' who is to be praised. In fact, most unusually, in this case *Midrash Tehillim* seems to indicate that David supplants Moses in this respect: 'Moses blessed Israel with the words *Blessed art thou, O Israel* (Deut. 33.29), so David blessed Israel with the words *Blessed is the man*.'[38] David's kingdom thus brings in new blessings, and completes the blessing of Moses at the end of his book: 'As Moses gave five Books of Laws to Israel, so David gave five Books of Psalms to Israel, the Book of Psalms entitled *Blessed is the man* (Ps. 1:1).'[39] So just as Moses led the people out of Egypt, David led the people out of servitude to the Philistines; as Moses fought the battles of the Lord against Sihon and Og, so David fought the Lord's battles too; and just as Moses became king in Israel and Judah (Deut. 33.5) so too David became king in Israel and Judah. Moreover David modelled himself on his Creator, not offering curses (as did Moses) but only blessings on the people. So David is the righteous man *par excellence*. (Interestingly, the psalm is not then expounded as a commentary on David's life as it was in the cases of Adam, Noah, and Abraham.)

Two other examples are also singled out as the 'blessed man': one is the tribe of Levi (as a corporate entity), who also neither walked, nor stood, nor sat with the wicked, for they delighted in the Law of the Lord; Levi, like a tree planted by the waters, was planted in the land of Israel.[40] The most surprising commendation is for the sons of Korah; perhaps they were recalled because of the later psalms which were dedicated to them, for here the tradition of their disobedience is not referred to. Instead they are commended for their

[35] See Braude 1959: 17. The paraphrase following is from pp. 17–18.

[36] The commentary continues to explain that Abraham was given wisdom and understanding 'like two pitchers overflowing'—with the inference that Abraham knew of the Torah with God's gift of conscience and reason.

[37] Rashi, too, according to several manuscripts, comments also on Abraham as the 'man to be praised' particularly in Ps. 1.2, where he too refers to Abraham's not 'walking' nor 'standing' nor 'sitting' with the faithless generations. See Gruber 2004: 174–6.

[38] See Braude 1959: 5. Deut. 33.29 also uses the same formula for God: אשריך, a point taken up also by Rashi, as noted by Gruber 2004: 174.

[39] See Braude 1959: 5. Here the use of the title of the psalms from the first two words is to pair it with the title of Deuteronomy, 'These are the words', from the first two words of that book.

[40] See Braude 1959: 19–20.

separation from the wicked, their delight in the Law and their being planted in the land: they too are compared with the 'blessed man' in this psalm.[41]

So through these six models of piety, the predominant emphasis of this psalm is its personal, historicized, moralizing application. The 'blessed one' need not refer only to figures of the past, however: he can also be understood more universally, to apply to every individual (admittedly, male) Jew. Given that six figures of the past have been commended (from Adam to Noah to Abraham to Levi to Korah to David), and given the enjoyment of the number seven in *Midrash Tehillim*, the implication is that the seventh (unnamed) figure is any righteous, law-abiding Jew. In one of the passages concerning Abraham, another אשרי saying is quoted, namely Ps. 84.13 ('Blessed is the man that trusteth in Thee') and the conclusion here is 'The verse speaks not of Abraham here, but of *man*—that is, of every such man'.[42] And because *Midrash Tehillim* compares the Torah with the Tree of Life, the conclusion is that the Torah is the means by which all those who study the Law have access to the presence of God.[43]

The individual emphasis in Psalm 1 is quite different from the more corporate emphasis in Psalm 2, even though David is the constant figure whose authority lies behind each psalm: in Psalm 1, this is as a model for personal devotion, whereas in Psalm 2, he is the one who represents the faith and fate of the entire people.[44]

The first question which is asked is in relation to v. 1: 'Why do the nations rage?' Again, various figures of the past are recalled, but in this case all ten are enemies of the whole people: they include Pharaoh at the time of the exodus, Sisera at the time of the judges, and Nebuchadnezzar at the time of the exile to Babylon. Gog and Magog are recalled: 'Yet, even in the time-to-come, Gog and Magog will set themselves against the Lord and his anointed, only to fall down'.[45] After this, other enemies of the people who 'fell down' before the children of Israel are recalled—Nimrod against Abraham, Abimelech before Isaac, Esau and Laban before Jacob, and again Pharaoh and all the Egyptians,

[41] See Braude 1959: 20–2. The brief reference to Korah's 'wickedness' comes at the end of this exposition on v. 6, where oddly it is said they will not stand but will perish.

[42] See Braude 1959: 8. This is not radical universalism, however. As Briggs 1906: 5, points out, the 'happy man' here is not all humankind, for it concerns men only; it is not all men, for it concerns Jews only; it is not all Jews, for it concerns only pious men; and it is not all pious men, for its emphasis is on the kind of man who is later described: the one who devotes all his time and effort to study of the Law.

[43] See Braude 1959: 26–7.

[44] Maier 2004: 374, makes an interesting observation about the link between Torah piety, relevant to post-exilic Judaism, and the piety of David which is an additional layer to this psalm: 'Die speziellen Anliegen einer individuellen Torahfrömmigket gehören nicht zum ältesten Stratum der Zeugnisse. Dort dominiert die 'davidische' Deutung des Psalms, der einzelne ist jedoch als Teil jener Gemeinschaft miteinbezogen, die durch die Davidsfigur repräsentiert wird'.

[45] See Braude 1959: 35.

before the children of Israel. And then again we then read of Gog and Magog: 'And in the time-to-come Gog and Magog will fall before the children of Israel. Foreseeing their fall David cried out: *Why do the nations rage? . . .*'[46] Yet again, still commenting on this first verse, and speaking of those who oppose Israel as 'fools', we read 'And Gog and Magog will likewise say, "Fools were all the former who involved themselves in taking counsel against Israel." Did they not know that Israel have their Guardian in heaven? . . . the Holy One, blessed is He, will say to Gog and Magog: "O ye wicked, do you set yourselves to make war against Me? . . . How many angels of flame, lightning and fire have I by me!" '[47] What seems to be the case here is that, as we saw in *TgPss*, the expansions seem to imply a quasi-apocalyptic hostility to the people of Israel.[48] Here this state of affairs is even more explicit. Clearly this implies a national, political reading of this psalm which fits with the state of diaspora Jews in the Middle Ages.

In this light, the commentary on v. 7 is interesting. After the briefest of references to God's promise in v. 6 to 'install the king on Mount Zion', the next question which needs an answer from the following verse is '*Who is the "son"?*' One answer is 'the children of Israel are declared to be sons in the decree of the Law, in the decree of the Prophets, and in the decree of the Writings'.[49] References are made to Exod. 4.22, where Israel is called God's Son and first-born; to Isa. 52.13 and 42.1, where in each case 'my servant' is read as 'my son' and seen to refer to Israel; and to Ps. 110.1, where 'my Lord' is also read as Israel, and Dan. 7.13 and 14, where 'like unto a son of man' is similarly read as Israel. The inference is clear: '*Thou art My son . . . Ask of Me, and I will give the nations for thine inheritance*' applies to the children of Israel.

This corporate and semi-apocalyptic reading of 'the Son' again reminds us of the similar inference in *TgPss*. And in *Midrash Tehillim*, as in *TgPss*, a discussion follows about whether the meaning of 'bear' as 'give birth to' is really correct. The conclusion is the same: this cannot be read literally. The Christian reading of this text as Jesus 'begotten' of the Father is thus, by implication, refuted.[50]

Finally, from v. 8 onwards, the commentary begins to refer to a figure termed 'the Messiah'. '*Ask of Me*' is read as God speaking to the Messiah; a discussion follows on three figures to whom God said, '*Ask of Me*': Solomon at Gibeon in 1 Kgs 3.5, Ahaz with the prophet Isaiah in Isa. 7.11, and here in Psalm 2—where the figure is 'the lord Messiah', who in this verse is promised the nations for his inheritance, and the rest of the earth for his possession. Little else is said on the identity of this figure: the discussion reverts to a

[46] See Braude 1959: 36. [47] See Braude 1959: 38.
[48] See Chapter 4 'Targum Psalms': 72, n. 17. [49] See Braude 1959: 40.
[50] See the discussion on *TgPss*, Chapter 4 'Targum Psalms': 75.

discussion of Israel. However, the commentary on v. 12 (translated here as 'Do homage to the son') makes it clear, again, that the one who is called the son has royal pedigree, but he who is called the son is Israel: 'Go and sing (a song of homage) to Israel'. So the final phrase of the final verse: '*Blessed are all they that take refuge in Him*, is spoken of the children of Israel, for they are the ones who take refuge in the Holy One, blessed be He'.[51] One cannot help but surmise, therefore, that 'the lord Messiah' in v. 8 is hardly some future figure, but the personification of Israel herself.

There are some notable comparisons between Psalms 1 and 2 in *Midrash Tehillim*. Psalm 1 offers examples of 'blessedness' by looking backwards to individual heroes of faith, including Adam, Noah, Abraham, and David, inviting the reader to imitate their examples; Psalm 2 offers examples of figures from enemy nations who have attempted to eradicate Israel in the past, including Pharaoh, Sisera, and Nebuchadnezzar. Noting how God has vindicated Israel over her enemies in the past, the reader is invited to believe that the people of Israel will one day be restored again. The idealized figure ('the Blessed Man') in Psalm 1 is the law-abiding Jew; the idealized figure ('My Son') in Psalm 2 is the people as a whole; each is seen through the prism of King David. In using both psalms to address the present Jewish community, the *Midrash* on Psalm 1 focuses on what pious individuals have done in the past and what others now can do in the present through their trust in God; the *Midrash* on Psalm 2 focuses on what God has done for his people throughout their history and what he will do in times to come. The perspective in each psalm is thus very different; one is what the law-abiding Jew can do, the other is about what God will do. But the end result is the same: the ill fate of those who oppose God, and the blessing on those who trust him. So even in *Midrash Tehillim*, these are two sides of the same coin.

JEWISH COMMENTARIES

Each of the commentators here reflects some of the influence of the *Midrash Tehillim* in their exegesis. Mostly they emphasize that the 'blessed man' in Psalm 1 is every law-abiding Jew, with a more corporate emphasis attributed to Psalm 2. This is of course in large measure due to Christian anti-Jewish exegesis.

Rashi (1045–1105), partly because of his provenance from Troyes, and hence his proximity to the Christian schools of exegesis in northern France, used a good deal of anti-Christian polemic in his commentary on the psalms. Although this is more evident in his reading of Psalm 2 than Psalm 1 (mainly

[51] Braude 1959: 48.

because of the more prominent use of Psalm 2 in Christian discourse by the Middle Ages) Rashi's approach to the first psalm was, appropriately, to read it in the light of the entire Psalter. Hence his initial comments on אשרי־האיש is that they anticipate what follows in the Psalter as a whole.[52] Then, following *Midrash Tehillim*, Rashi writes about the ten poetic genres of the Psalter, which include songs, prayers, praises, blessings, thanksgivings, Hallelujahs— and these also include psalms beginning with laudations such as Psalm 1.[53] Rashi also uses an older tradition that there were also ten 'composers' within the Book of Psalms: here he uses not only the psalm titles but internal details in a given psalm, and so includes not only David, Solomon, Asaph, three sons of Korah, and Moses (to whom Rashi attributes not only Psalm 90, with its title, but Psalms 91–100 following it), but also, somewhat surprisingly, Adam,[54] Melchizedek, and Abraham.[55] Then follows the commentary on Psalm 1 itself. Here Rashi reads it plainly, as an inspiration for every pious Jew.[56] Much of this follows what has already been seen in *Midrash Tehillim*: in v. 1 Rashi focuses especially on Abraham (and the book of Genesis) as an insight into obedience, even though Abraham lived before the age of the Torah of Moses. But it is Abraham in particular who is the 'blessed man' who does not walk or stand or sit with the faithless. Much of the rest of the commentary focuses on what it means to be a disciple of Torah; a significant comment on v. 6 of the psalm, concerning the judgement of God on the wicked, is that Rashi reads this as referring not only to the judgements in the synagogues ('the Assembly of the Righteous') but also, ultimately, to God's coming 'Day of Judgement'.[57] So in many respects this is a commentary which echoes what we have noted in *TgPss* and *Midrash Tehillim*.[58]

[52] See Gruber 2004: 174–5.

[53] אשרי is in fact the first word in Psalm 119 as well, and in psalms introduced by a superscription (32, 41, 112, 128). See also Gruber 2004: 174–5. It is interesting to see how form-critical categories such as these were proposed long before the work of Gunkel.

[54] Here Rashi refers to Psalm 139: the 'unformed limbs' in v. 16 he assumes to be a reference to Adam.

[55] This list of ten psalmists is not original to Rashi: it is also found in the commentary to Psalm 1 in *Midrash Tehillim*. The number ten is important because it offers at least two other seminal comparisons of the Book of Psalms with Creation, in the ten divine words, which were uttered in Genesis to bring out the creation of the world, and with Torah, in that the Ten Commandments summarize the teaching of the Law.

[56] See Gillingham 2008a: 84.

[57] See Gruber 2004: 1754–6. Abraham ibn Ezra also understood the Law in Psalm 1 as the Torah, and hence those who can read this psalm can only be the righteous Jews and only they will be able to withstand the Day of Judgement. 'The import of this verse resembles what Moses said about the Torah, and the first fundamental of the Torah is the declaration of the unity of God "when you sit in your house and walk on the road and lie down and rise up" (Deut 6.7).' See Reif 1984: 234; and Simon 1991: 322–4.

[58] Ps. 1.5–6 is also discussed in a similar way in Mishnah Sanhedrin 10.3b where the teaching is about those who will have no share in the world to come: these include those who deny the resurrection, those who reject the heavenly origins of the Torah, the generation of the Flood, and the people of Sodom: *'Therefore the ungodly shall not stand in the judgment'*—this is the

Jewish exegesis of Psalm 2, exemplified by Rashi but also to be found in other Jewish commentators (such as Kimḥi), has several correspondences with the debates in the cathedral schools at, for example, Notre Dame, Chartres, St Victor, and Laon, which centred on how much one should read the psalms in a historical or theological sense. Whether Jewish commentators knew of the *Glossa Ordinaria* (compiled at Laon in the twelfth century) or Peter Lombard's *Magna Glossatura* (from Paris dated at about 1142) is unclear; but the French provenance of these full Christian commentaries on the Old Testament, and the French provenance of Jewish commentators such as Rashi (and also Kimḥi, as will be seen later) make some interchange highly likely.[59] Jewish and Christian readings of the psalms reflect very different approaches at this time. The 'sensus Judaicus' was a historically orientated, David-centred, Israel-centred *peshat,* and although it occasionally led to an exploration of a hidden meaning (*derash*) or even allegory (*remez*) or secret mystery (*sod*), it mainly concerned itself with *peshat.* This contrasted with the Christian readings, which as far as the psalms were concerned, placed much more emphasis on allegory and typology, so that the psalm might more easily be turned 'Christwards'. Even when Christians used a more historically orientated approach they usually reserved it for more grammatical and philological issues arising out of the text which highlighted further a Christian meaning.[60]

At the very beginning of Rashi's commentary in Psalm 2, he makes it clear that any philologically correct interpretation should serve to refute the claims of Christians.[61] His main argument is that Psalm 2 is to be read as *peshat,* about the historical David and historical Israel, and that the text only makes sense when read in this light. Its context is 1 Sam. 5.17–25, when the Philistines heard that David had been made king over all Israel, and they came up to attack him.

> . . . According to its context in the narrative of Scripture . . . and as an answer to Christians it would seem correct to explain it about David himself in accordance with the subject stated in Scripture (2 Sam 5: 17): the Philistines heard that the Israelites had anointed David as a king over them, and the Philistines gathered their legions and they fell into his hand. It is with respect to them that he (David) said, 'Why do the nations assemble. . . .'[62]

generation of the Flood; 'nor the evil in the congregation of the righteous'—these are the men of Sodom. To this it was answered, 'They shall not stand in the congregation of the righteous, but they shall stand in the congregation of the ungodly'.

[59] See Signer 1983: 283–4.
[60] For a fuller discussion of these issues, see Gillingham 2008a: 77–94.
[61] See Gruber 1998: 127–35.
[62] See Signer 1983: 274–5, and Gruber 1998: 177–82, which is a translation of Rashi's preface to this psalm. The fact that nowhere in the psalm is this setting explicitly indicated, and nowhere in 2 Samuel 5 is there any evidence of the Philistines doing battle with David does not seem to create a problem for Rashi here.

The anointing of David as king (v. 6) was ratified by the prophetic ministry of Nathan, and this is why the psalm is full of prophetic speech which is taken from 2 Samuel 7 (the Christian interest in the psalm as a prophecy about Christ is countered here). And because David is king he is now able to be called God's Son.

So Rashi uses mainly *peshat,* taking 2 Samuel as the basis for the plain and historical reading about the life of David and the history of Israel. Although this is never stated in his commentary, there is however another level of meaning (*derash*) which concerns the Messiah and the future of Israel. Although Rashi never develops the theme of Gog and Magog which was often read into vv. 1–4 by the rabbis in the *Midrash Tehillim,* he never denies it either, and his comments on v. 7 which speak of the Messiah being chosen *by* Israel and *for* Israel leave open this possibility. This allows the psalm to have a 'double context'—the literal and the hidden meaning in the text—thus showing that Rashi's Jewish exegesis is in fact as capable of finding hidden meanings as are Christian interpretations.

We turn to a very different and prolific Jewish scholar who frequently cites the psalms, although he never wrote a specific commentary on them. **Maimonides** (also known as **Rambam**: 1135–1204) was born in Spain, but to escape persecution from the Muslim Almohades rulers he fled and travelled eastwards—first to Morocco, then to Israel, at the end of his life finally settling in Egypt. Of his many works, the most pertinent because it uses several psalms, is *Mishneh Torah* ('Repetition of Torah') which was compiled in 1170–80, in Egypt. This was a work which was subsequently questioned because of its radical nature: it was an individual expansion of the Torah in fourteen books, written so that Jews 'in exile' could access the teaching of Torah without becoming lost in the additions provided by the Talmud. Its Egyptian provenance dictated a need to be separate from the Gentiles, and this is a common theme in *Mishneh Torah,* allowing Maimonides to adapt the psalms to illustrate this teaching. Appropriately Psalm 1 is used several times.

One example is in Book 4 of *Mishneh Torah,* on *Nashim* (Women); in section 1, *Ishut* (laws of marriage and holiness), Maimonides comments on the teaching in the Torah about intimate sexual relations on the Sabbath: he uses various references from the Talmud about its negative effect on the draining of physical energy. He then observes that abstinence makes the Jew 'like a tree bringing forth its fruit in due season'; the theme of blessing in this psalm is developed as Maimonides observes that whoever obeys this command will be a tree 'whose leaves will not wither' (Ps. 1.3).

In Book 6, entitled *Hafla'ah* (Separation), which is concerned about living positively in a foreign environment, in Section 1 (*Shevuot*: Laws of Vows) Maimonides discusses how it is possible to live as a Jew in a Gentile milieu—withdrawing from it if necessary:

Therefore, a person is obligated to befriend the righteous and to constantly be in the presence of the wise in order that he learn from their acts. He should [likewise] distance himself from the wicked who go in darkness in order that he not learn from their ways. This is as Solomon stated, '[One who] walks with the wise will become wise, and one who befriends fools will suffer harm' (Proverbs 13:20). It also states, 'Fortunate is the man who did not walk in the counsel of the wicked, [and in the way of sins he did not stand, and in the sessions of the scorners he did not sit]'. (Psalms 1:1)

Jacob ben Reuben was another twelfth-century Jew who, also having been expelled from Spain during the Almohades persecutions in about 1136, probably wrote in Gascony. His concerns were also about Jewish and Gentile relations, and, like Maimonides, his arguments centred on the teaching of the Torah, although his works have far more vitriol than we usually find in Maimonides. His *Milḥamot he-Shem* (*The Wars of God*) was written in about 1170. The third chapter concerns the psalms, and the first psalm to be considered is Psalm 2. This is an explicit refutation of the Christian interpretation of this psalm, especially of vv. 7 and 11–12, the main verses used by Christians to argue that Jesus, as the Son of God, is 'hidden' in the text. Jacob first attacks the Christians for not having a sufficiently metaphorical view of the text: if David is God's firstborn, as suggested here and in Ps. 89.26–7, and if indeed the theme of God electing sons pervades the Hebrew Bible, Jesus is hardly God's unique and only son. He is but one of many sons of God, and so a more nuanced approach to divine paternity is required: Christians have been too literalist in their reading of Jesus as Son of God in Ps. 2.7. Why should this even be a reference to Jesus, who would be the latest of the sons of God? Why should it not refer to one of the prior sons of God—to David, Solomon, or indeed the children of Israel? Why interpret the Hebrew ילד ('to bear') so literally, when, with David, Solomon, and the children of Israel it can also mean to fashion, form, or create? Reuben thus turns the Christian method on its head: it pretends to use allegory and typology, but it is in fact over-literal.[63] This is one of the most innovative readings of Psalm 2 in the face of Jewish and Christian controversy.

A more expansive example of disputation with Christian readings (in this case, of both Psalms 1 and 2) is found in the commentary of **David Kimḥi** (1160–1235). Although originally from Andalusia, Kimḥi was forced to settle in Narbonne and, later, in northern France, where, a century or so after Rashi, he came within close proximity of the Christian cathedral schools of Notre Dame, Chartres, St Victor, and Laon. Kimḥi's key objections to Christian exegesis, more generally, were the two doctrines of Law and Messiah: hence both Psalm 1 and Psalm 2 were particularly pertinent. Although, like ben Reuben, a more specific anti-Christian polemic is reserved

[63] An important account of Jacob ben Reuben's approach is found in Chazan 2004: 236–8.

for Psalm 2, Psalm 1 is also commented on with its Christian exegesis in mind.[64] Kimḥi's reading of Psalm 1 is primarily philological, adhering to the literal and plain meaning (*Peshat*). Following Abraham ibn Ezra (*c.* 1089–1164)—whose exegesis of the psalms and whose use of Deuteronomy 6 Kimḥi expanded upon[65]—the Law in Psalm 1 is, literally and plainly, the Torah, transmitted from Moses to David. It has eternal validity for all Jews at all times (and especially whenever they have been in exile). Hence a psalm which extols the worth of the Torah by implication speaks of the identity and survival of the Jewish people.[66] Kimḥi reads the entire psalm as a homily from David about the importance of keeping the Law 'in deed and in word and in thought'. The audience presupposed is of course Jewish; conversely, the 'wicked' who do not keep the Law and who, according to Kimḥi, clearly 'will not rise in the Day of Judgement' are those who do neither respect nor keep the Torah: these include, primarily, Christians.[67]

Kimḥi, like Jacob ben Reuben, reads Psalm 2 in a more literal way, seeing it as only about the historical David and the historical Israel. The additions to his commentary note that some Jewish commentators also accept the '*derash*'—that there is also a hidden meaning about the Messiah who will defeat all nations on the Day of Judgement—but Kimḥi—perhaps even more so than Rashi who as we saw hints at this *derash*—stands apart from this view, making a distinction between *peshat* and *derash* and clearly preferring the more historical approach.

> And there are some who interpret this Psalm of Gog and Magog, and the anointed one as King Messiah: and so our teachers of blessed memory have interpreted (Babli, *Berakoth 7b*). And the Psalm can be explained in this way, but the better is that David uttered it concerning himself, as we have interpreted.[68]

Certainly as far as Psalm 2 is concerned, Kimḥi's preference is for the literal reading. Like Rashi, his commentary on the first verse of Psalm 2 affirms that 'David composed and recited this Psalm in the opening of his reign, when the nations were gathered against him, as it is said [in] 2 Sam v. 17 . . .'. On that account he refutes the Christian reading of this psalm. First, like Reuben, he sees the Christian reading of v. 7 as referring to Jesus as Son of God as a

[64] See Gillingham 2008a: 86–7. The adherence to Davidic authorship of this psalm is clear: 'And the Psalms which have no superscription "*of David*" David composed; and also those for which no author is mentioned David composed': see Box and Finch 1919: 3. The reading of the psalm as a Davidic homily is seen on pp. 5–7, and the interpretation of the Day of Judgement, on pp. 10–11.

[65] We shall examine ibn Ezra's work on these psalms in Chapter 4 'Jewish commentaries': 88–90.

[66] Kimḥi especially makes this clear by discussing verse 2 and asking how a Jew with business occupations can study the Law 'by night and by day': the answer is 'every time he shall be free from the occupation of his livelihood': see Box and Finch 1919: 8.

[67] See Box and Finch 1919: 10–11. [68] Box and Finch 1919: 18.

mistaken literalism: a dyad of a human and divine figure is, for Kimḥi, philosophically impossible:

> And the Nazarenes interpret it of Jesus; and the verse they adduce by way of proof and make it a support of their error is really their stumbling block: it is *The Lord said unto me, Thou art my son.* For if they should say to you that he was the Son of God, answer that it is not proper to say 'Son of God' in the manner of flesh and blood; for a son is of the species of his father.[69]

God is in every sense a unity. One can speak of sonship figuratively, as a way of talking about God in a similar way to talking about 'the mouth of God' or 'the eyes of God', as we shall see below, but one cannot speak of this literally:

> It is not right to say 'son of God' of flesh and blood, for the son is of a kind with the father. He to whom God says *you are my son* must be of His kind and God must be like him. Further, if anybody were to say: *I have today born you* and the born one is of the same kind as the begetter, then answer them: 'in divinity it is not possible [to assume] father and son, for the Deity cannot be divided. His unity is absolute without addition, distraction or divisiblity' . . . Answer him who says it is not possible to call anyone son of God who is not of the [same] kind of divinity that we can speak of God metaphorically only, as e.g. when we say *the mouth of God, the eyes, the ears of God.* We call him who fulfils His mission and His commandments 'son of God', just as a son fulfils the commandments of his father . . . Again, you say of God that the father said to the son *ask of me and I will give you nations as your inheritance.* If the son is God why should he ask his father? Has he no power over nations and the ends of the earth like Him?' They might point out that this happened after he had become flesh. God has referred to his humanity, . . . But this is not so, because he had no kingdom while in the flesh nor any dominion over any nation . . .[70]

In this way Kimḥi rebukes Christian commentators for not following through their non-literal approach with enough rigour, and for being hypocritical in their criticism of the Jewish plain-sense approach when this is precisely what they do themselves in their reading of Ps 2.7.[71]

So despite all their diversity there is some 'family likeness' in the way each of these commentators reads these psalms. We are now left with the question: does any writer refer to the relationship between them? Each scholar has been at pains to show how, in different ways, Psalms 1 and 2 are 'identity-markers' for Jewish diaspora communities, with the first psalm being an inspiration for Jewish piety, and the second, a commentary on Jewish identity. Hence apart and together, these two psalms illustrate not only what was distinctive in

[69] Box and Finch 1919: 18.

[70] Taken from Rosenthal 1960: 128, referring to the translation by Schiller-Szinessy 1883: 11–12.

[71] See Chazon 2004: 238–41; also Baker and Nicholson 1973: xi–xiii and xvii–xviii.

Jewish tradition but how Christians had sought to wrest this distinction from them: the Torah in Psalm 1 had been abrogated by Christians and the Cross of Christ had been emphasized instead; the Davidic covenant in Psalm 2 had been nullified and replaced by new ideas of a Messiah who was the 'Son of God'. Given many other social and political issues in the Middle Ages, it was small wonder that the 'unrighteous' and the 'heathen nations' in Psalms 1 and 2 respectively were seen as those Gentile Christians (and, indeed, Muslims) who had also persecuted them and prolonged their exile from their land of birth and who had taken their scriptures and reused them as their own. So the shared theme in these two psalms, of God's vindication of the Jews and his consequent opposition to the Gentiles, is what all four commentators agree unites them.

It is no exaggeration to claim that in this period these two psalms together lie at the heart of what divided Jews and Christians in Medieval exegesis. However, of the four Jewish scholars, only Kimhi has anything specific to say about the actual relationship between them. At the very beginning of his commentary on Psalm 2, referring to *Berakoth* 9b, that every section which was especially dear to David he opened and closed with 'Happy', Kimhi goes on to say (somewhat surprisingly, given what we have seen in his commentaries on the psalm):

> The reason why this Psalm follows immediately the other is not known to us; nor why he arranged them in the order in which they are connected, for they are not arranged in historical order. For instance, the third Psalm is concerned with the affair of Absalom, and after it occur many Psalms whose subject-matter is earlier by a considerable period than the incident with Absalom . . .[72]

Surely, of all Jewish exegetes, Kimhi, having acknowledged the chronological anomaly, could have answered his question more precisely than this.

A more satisfying and very different answer is provided by an earlier commentator, **Abraham ibn Ezra**.[73] In his writings we see his emphasis is not only on the relationship between Psalms 1 and 2 but also between Psalms 2 and 3; ibn Ezra understood this relationship by using a more literary and theological approach than a rigorously historical one.[74] This opens up a fresh understanding of the relationship between Psalms 1 and 2: as untitled psalms, by

[72] See Box and Finch 1919: 12. Another allusion to the close relationship between these psalms is made by the tenth-century Karaite commentator Yefet ben 'Ali. Noting that Ps. 142.1 (when David fled from Saul) was chronologically earlier than Ps. 3.1 (when David fled from Absalom) ben 'Ali argues at length that the relationship between Psalms 2 and 3 is more thematic than historical (David's protection in national danger [Psalm 2] and his protection in personal danger [Psalm 3]). See Simon 1991: 96.

[73] See Chapter 4 'Jewish commentaries': 86 for the use of ibn Ezra's commentary by Kimhi.

[74] This was in his fourth inquiry into the nature of the psalms, part of the Preface in the first recension to his commentary on Psalms 1 and 2: see Simon 1991: 316, lines 98–106.

different authors, their relationship is seen to be even closer than that between Psalms 2 and 3.[75]

Ibn Ezra's work on Psalms 1 and 2 is unique because it is extant in two quite different editions, each with a preface, which explain in some detail his approach through these psalms to the entire Psalter; the first (lengthier) recension also has a partial commentary on Pss. 1.1–2.5 (where it abruptly ends).[76] It is here that we see examples of his literary and theological approach. Like Maimonides and Jacob ben Reuben later, ibn Ezra was forced out of Muslim Spain; like Rashi and Kimḥi he also spent time writing in south-western France, but just as ben Reuben, for example, used his skill in Latin for disputing with Christians, ibn Ezra used his skills in Arabic, which in part allowed him to dispute, in theory at least, with a Muslim audience. His Arabic also gave him a different appreciation of Hebrew poetry. Rashi, Maimonides, ben Reuben, and Kimḥi all have little to say about how they view these psalms as Hebrew poetry; by contrast, for ibn Ezra the first question is to ask how these psalms function as Hebrew *poems*.[77] In *The First Recension to Psalms 1–2*, lines 30–2, ibn Ezra speaks of the poetry of the Ishmaelites (i.e. the Arabs) being about love and passion; the poetry of the Edomites (here he is probably referring to the Christians of the western churches) being about war and vengeance; the poetry of the Greeks being about wisdom and discretion; and that of the Indians, about all sorts of parables. Only the ancient poetry of the Hebrews can reveal that God is the one and only God.[78] This thus addressed, somewhat obliquely, the Christian interpretation of these two psalms, with their 'dyadic' belief in Jesus as God's Son, expressed in his humanity in Psalm 1 and in his divinity in Psalm 2. By referring to the religious and poetic quality of the psalms—not least, the way the monotheistic beliefs constantly expressed within them clearly predated any of those which were so important in Islamic literature, ibn Ezra assumed that both literary and theological superiority belonged to the Jews.[79]

So it is the poetic value of these psalms which emerges in ibn Ezra's Preface and individual commentary. Occasionally there are implicit references to the worsening situation for Jews both in Spain and southern France, showing how Psalm 2, for example, might speak to a people under oppression and

[75] See Simon 1991: 218–19. Although ibn Ezra saw that 'every psalm stands by itself' (218) his comments on Psalms 103, 104, and 105 reveal the same literary and theological interest in psalms with close thematic relationships to each other (219).

[76] See Simon 1991: 145–56.

[77] In part this was because ibn Ezra was not only writing in defence of the psalms against Christian exegetes, but also against the Karaites, an eighth-century Jewish prophetic movement which opposed the belief in the unique authority of the Torah.

[78] See Simon 1991: 310.

[79] See Gillingham 2008a: 82–3. *The Second Recension to Psalms 1–2*, for example in lines 7–13 and 35–43, briefly develops this idea of the distinctive nature of the poetic and prophetic value of the psalms. Their value as prophecies is not as texts about to be fulfilled, but as poetry from many different poets who have been inspired by the Spirit of God: see Simon 1991: 330–2.

longing for redemption.[80] But this is rare, and what dominates in these two Prefaces on Psalms 1 and 2 is, quite simply, a literary account of the psalms together being ancient religious poems—composed long before the emergence of either Christianity or Islam, which in different ways had usurped them.

JEWISH MYSTICISM

Thus far the Jewish approach to these psalms has been seen to be primarily philological and textual, centring on the Jewish 'grammarian' tradition, of which Rashi, ben Reuben, Abraham ibn Ezra, and Kimḥi are singular examples because of their specific works on Psalms 1 and 2. But it would be a one-sided account of the Jewish use of psalmody during this period if we were to neglect reference to the Jewish mystical use of the psalms. The most obvious examples include the Karaite movement in Jerusalem, Babylon, and Egypt from the eighth century onwards, and the *Kabbalah* teachings which emerged in southern France and Spain from the twelfth century, exemplified in the book of *Zohar*. The main problem is finding specific references to the use of these two psalms in particular.

This is unfortunate, because in these works the interest in psalmody and Temple symbolism is most apparent, and as we saw in earlier Jewish interpretation this was one conjoining theme which brought together the first two psalms. The interest in psalmody and Temple is found in some of the more mystical commentaries on the psalms from Karaite writers. Yefet ben 'Ali, for example, sees the Psalter as a sanctuary into which there are twelve gates of entrance, echoing the twelve gates for the twelve tribes leading into the Temple in Ezekiel 40–8. Three gates concern creation and history; three, the sin, repentance, and redemption of Israel; three, various forms of supplication for our own redemption; and three, the end of days, when all nations will live peacefully under one God, having submitted to Israel and her Messiah, and universal reign of peace (gates 10–12). Psalms 1 and 2 are found in the second group of three gates.[81]

Partly as a result of the popularity of the *Zohar* and *Kabbalah* mysticism, an increasing interest developed in the *Shekinah*, or the presence of God in the psalms. Alongside this was a fascination about the secret revelation of this

[80] This is found in Abraham ibn Ezra's introduction to his commentary to Psalm 2 in *The First Recension*, lines 33–8. See Simon 1991: 324.

[81] See Simon 1991: 72–3. There seem to be no specific references to the psalms in the ten *sephirot*, or self-manifestations of God, contained in the *Book of Zohar*. Certainly the emphasis on *Shekinah* in the tenth *sephirah* (on the Kingdom of God) has many links with the presence of God and the kingship of God expressed in Psalm 2, and the concern with Torah piety throughout the work has similar links with Psalm 1.

Shekinah in the (inspired) words of the psalms, as well as a way of discovering it. So numbers and combinations of letters in the psalms were viewed as an aid to both mystical and magical uses of the psalms—what might be called 'psalmomancy'. For example, the fact that the first word of Psalm 1 (אשרי) began with the first letter of the Hebrew alphabet and the last word of the Psalm (תאבד) began with the last letter in Hebrew was seen to have quasi-magical significance. *Shimmush Tehillim*, a collection of psalms for use as spells and incantations, whose origins may be traced back also to as early as the eighth century, belongs to this tradition and uses Psalm 1 in this way.[82] Interestingly the Temple theme emerges in Rabbi Isaac Ben Solomon Luria's sixteenth-century commentary on the very first psalm:

> 'Each human being,' says the celebrated Kabbalist, Rabbi Isaac Luria, 'except only the ignorant idolator, *can by a pious and virtuous life enter into the consecrated temple of the true Kabbalah*, and can avail himself of its benefits without being able to speak or understand the Hebrew language. He can pray, read and write everything in his mother tongue; only the holy name of God and the angels that may occur in the experiment, must, under all circumstances, be written and retained in the mind in the Hebrew tongue . . .' (emphasis added)[83]

So engaging with a mystical experience of God was like entering the Temple and being in the presence of God. From this premiss the psalms could be used as incantations to all upon particular facets of the presence of that God. This is very clear in the way that Psalms 1 and 2 were understood in this tradition.

The instructions about the use of the psalm as an incantation start with the recognition of the threefold occurrence of the Hebrew letters *aleph* and *shin* in Psalm 1. From this is created a magical incantation, which is to be inscribed as a prophylactic against miscarriage on the parchment of a gazelle. The first three verses of the psalm are to be written down (here, the reference to the fruitful tree in v. 3 is obviously relevant) and, together with the hidden holy name and appropriate prayer found within the psalm, placed in a small bag and hung around the woman's neck, so it rests against her naked body. As for the holy name, this is 'El Chad', meaning great, strong and only God: this is taken from the 'Aleph' of *Ashre* in v. 1, the 'Lamed' of *Lo ken* in v. 4, the 'Chet' of *yasliah* in v. 3, and the 'Dalet' of *vederek* in v. 6. The prayer, to El Chad, is as follows:

> May it please thee, Oh El Chad, to grant unto this woman, N., daughter of R., that she may not at this time, or at any other time, have a premature confinement; much more grant her a truly fortunate delivery, and keep her and the fruit of her body in good health. Selah!

[82] This edition of psalms was popularized in the sixteenth century onwards and translated into numerous European languages.
[83] Taken from Lanza 2007, on Psalm 1.

As for Psalm 2, the whole of the psalm is to be written on a potsherd and thrown into the raging sea for deliverance from a storm: v. 9 ('you shall dash them in pieces like a potter's vessel') is the pertinent verse here. Here the holy name Shaddai ('mighty God') is found in the psalm. This is the name of the Omnipotent, 'who fixes the boundaries of the seas and restrains its power . . . the waves will cease their roaring and the storm will be lulled.' The holy name is extracted from the psalm as follows: 'Shin' comes from *ragesu* in v. 1; 'Dalet' from *nossedu* in v. 2; and the 'Yod' is read as the 'Waw' in *jozer* in v. 9. The prayer reads:

> Let it be, Oh Shaddai (Almighty God!) Thy holy will, that the raging of the storm and the roaring of the waves may cease, and that the proud billows may be stilled. Lead us, all-merciful Father, to the place of our destination in safety and in good health, for only with Thee is power and might. Thou alone canst help, and Thou wilt surely help to the honour and glory of Thy name. Amen! Selah!

The psalm is also deemed to be a remedy against headache. The first eight verses (aptly finishing with God's calming of the raging of the nations) along with the holy name and the appropriate prayer, are to be written on pure parchment and hung around the patient's neck.[84]

Although nowhere in the mystical tradition are Psalms 1 and 2 assumed to be taken as one psalm, this way of reading each psalm shows that, within Jewish tradition, *peshat* was not in fact the only characteristically Jewish approach. *PARDES,* that acronym which includes not only *peshat,* but also *remez* and *daresh* and *sod,* was well established in Jewish mystical tradition. These psalms were seen to be full of hidden meanings; so the Christian search for allegories, typologies, and analogies in the same psalms is not entirely without Jewish parallel, despite the attempts of some grammarians to avoid it.[85]

CONCLUSION

The first obvious observation is that the tradition of viewing the two psalms together is evident even here in later Jewish tradition. This is made explicit in the Babylonian Talmud; but it is also implicit in *TgPss* and *Midrash Tehillim,* as well as in Kimhi's commentary and especially in ibn Ezra's work. However, the theme uniting them is no longer the theme of the Temple: the only place this is referred to is in Jewish mysticism. The common theme which holds the

[84] All these examples are to be found in Foder 1978: 67–71. The texts have also been expanded from Lanza 2007.

[85] The extent to which later Christian exegesis continued to grapple with literal and/or allegorical ways of reading these psalms will be seen in the following chapter.

two psalms together is rather that of opposition to the Jewish community by the Gentiles (both Muslim and Christian). Psalm 1 is used to inspire Jewish piety in its message of adherence to the Torah and eschewing the company of Gentiles, and Psalm 2 is used to create a sense of Jewish identity in its message about God's protection of his own people and his defeat of all Gentile powers.

A second observation concerns the very different way in which these psalms are used by Jewish commentators, compared with their interpretation by those earlier Christian writers we highlighted in the previous chapter. Jewish commentators, concerned more with the literal reading, mine their own traditions to the very depths, and draw from the rich tapestry of their ancient sacred stories (mainly from Genesis and Exodus) and teachings (mainly from the Torah) so that, verse by verse and phrase by phrase, the whole psalm in question connects with these older works, and in legitimizing them retells their story. This is very clear in *Midrash Tehillim*; but the same method is used by most of the Jewish commentators we have noted here, especially Kimḥi and Rashi. (Christian commentators, by contrast, more concerned with *derash* than *peshat,* tend to take single verses from the relevant psalm and find their meaning illuminated mainly in the light of the Christian Gospel: a similar legitimizing and retelling process is evident, but it starts with the person and work of Christ rather than with the ancient stories and laws of the Torah.) Thus the Jewish approach usually takes an interest in the psalm as a whole rather than a single verse.

A third observation is that in Jewish reception both Psalms 1 and 2 frequently retain a corporate appropriation: although in the first instance there is an admission that each psalm belongs, historically, in the life of David, the psalm is appropriated, in the present tense, to the Jewish community as a whole, which embodies together the 'blessed man' in Psalm 1 and receives together the promises made to David in Psalm 2.[86] In most Jewish readings, even Psalm 1, which is read initially as about the pious Jew, takes on corporate ownership. By contrast, the Christian approach has a greater tendency to personalize and individualize, mainly because of its consistent focus on the life and death of the person of Christ deemed to be hidden in each psalm.

A final observation concerns the very different use of these psalms made by Jewish mystics, in that the words are no longer to be understood rationally, grammatically, and logically, as is clearly evident in the rabbinic frame of mind, but are now to be experienced and used pragmatically. The tendency to find within the words hidden meanings for prayer and worship is actually quite close to the concerns of the early Church Fathers, a feature which continues in Christian reception up to the end of the Reformation period, as we shall see shortly.

[86] It is interesting to note how infrequently reference is made to any 'messianic' figure who will come at some point in the future.

Other than in Jewish mysticism, however, the interpretation of the contents of these two psalms—with their focus on Torah and Messiah—increasingly divided Jews and Christians over the first twelve hundred years of the Common Era.[87] But what has become particularly evident here is that it is not only the *contents* of these psalms but the very different Jewish and Christian exegetical *methods* of reception which divide these two faith traditions at this period.[88] It is therefore not surprising that the period from the Middle Ages up to the end of the Reformation is marked by antagonistic comments, by Jews and Christians alike, against the other tradition: and this is particularly vitriolic in Christian exegesis, from the early Middle Ages to the Reformation, as the following chapter will demonstrate.

[87] We noted this earlier in our discussion of Kimḥi. See Chapter 4 'Jewish commentaries': 85–6.

[88] We shall see the extent of the differences in exegetical methods in the following chapter.

5

From the Early Middle Ages to the Reformation

From the fifth century onwards there emerged a significant development in biblical exegesis—one which particularly affected Christian commentaries on the psalms and the Gospels, but a phenomenon which we have already seen emerging in Jewish tradition: the compilation, covering several centuries, of the authoritative wisdom of commentators into an accepted corpus. As far as the psalms are concerned, in rabbinical tradition this is most evident in the *Midrash Tehillim*; in Christian tradition, this is signalled by the start of the *Gloss.* Thus for Psalm 1, for example, Tertullian, Basil, and Hilary would be cited as a defence for reading the 'blessed man' as the individual Christian, and Jerome and Augustine would be used to refer to the incarnate Christ as the 'blessed man'. And for Psalm 2, Alexandrian exegetes such as Clement, Origen, and Athanasius would be cited in defence of reading the psalm more Christologically, while Jerome and Augustine would be frequently quoted as authorities in the western Church who offered the same Christian insights.

TWO EARLY COMMENTATORS

Cassiodorus (485–580) and **Bede** (*c.* 673–735) are two great western commentators, the one in Italy, the other in the north of England, divided in time by over a century and a half. Cassiodorus was particularly concerned about Christian orthodoxy in the wider Church, and his psalms commentary was in part used to serve this cause; Bede, it seems, never actually wrote an actual commentary on the psalms, although many of his works reveal just how important the psalms were in his pastoral concerns for his particular monastic community. Both writers led and served monastic communities: so, given the central place of the psalms in the monastic rule by this time, both

their works, different in scope and concern, were popularized in different ways through the monastic tradition.[1]

We noted earlier that Augustine was the most radical Christological commentator of Psalm 1.[2] His was the reading assumed and developed by **Cassiodorus** in his *Expositio Psalmorum*, written sometime in the 540s, probably initially in Constantinople and later revised in the newly founded monastery at Souillac in southern Italy. In his citations of earlier commentators, Cassiodorus began to create his own 'Gloss', with Augustine as the primary source. Cassiodorus was particularly drawn to Augustine's prosopological approach and the discernment of the divine 'Christ the Head' and the human 'Christ the Body' speaking throughout all the psalms. In addition, Cassiodorus frequently cites Jerome and Hilary for their own Christ-centred approaches to this psalm, and seminal writers in the eastern churches were also often used, such as Athanasius, Eusebius, and Theodore, not least for the ways in which they read the Psalter as an entire work rather than a composition of individual psalms. Cassiodorus wrote his *Expositio Psalmorum* at the height of Justinian's rule: so it not surprising to see how much of the commentary is a defence of Chalcedon orthodoxy and a polemic against Nestorian heresy.

As well as his reliance on received tradition, Cassiodorus introduces three distinctive features, and these are particularly evident in both Psalms 1 and 2. The first is the organization of the Psalter as a whole into twelve theological and literary categories.[3] Psalm 1 fits into the eighth of the twelve—those psalms where 'the bodily life of the Lord is described'—although within his actual commentary, Cassiodorus, following Augustine, moves between this and the second category, where 'the nature of the Godhead Himself is subtly indicated'.[4] The introduction to Psalm 1 makes this clear: these are words spoken by the prophet, concerning his incarnation: 'though other psalms also say much about Him, none of them speaks in this way about his behaviour on earth'.[5] In his commentary on the very first verse of the psalm, Cassiodorus writes, 'So now we have introduced that blessed man, that is, Christ the Lord . . .'.[6] Christ's 'blessedness' is proclaimed so that the human race might be given an example of how *the heavenly Man* (*sic*) came and bestowed salvation on us, just as the earthly man (i.e. Adam) proclaimed death.[7]

A second new way of reading the psalms was to focus on the titles to the psalms. Psalm 1 of course has no title. However, for Cassiodorus, the fact

[1] This will become evident in the following chapter on the psalms in liturgy.
[2] See Chapter 3 'The Church Fathers': 59–60.
[3] See an account of these in Gillingham 2008a: 56–7.
[4] See Walsh 1990: 43; also O'Donnell 1995.
[5] Walsh 1990: 45.
[6] See Waddell 1995: 513, citing *CCSL* 97.30, 125.
[7] Walsh 1990: 46.

that there is no heading is in itself significant: 'The reason why this psalm has no heading is because nothing is to be put before the Head of our Lord Saviour . . . for undoubtedly He is the Beginning of all things'.[8] Everything in the psalms refers in different ways to the teaching ('Torah') offered by the Blessed Man; thus it is fitting this psalm should come at the head of the Psalter and be a summation of it.

Cassiodorus' third original approach in reading the psalms was to see, in many cases, the significance of their numeration. And so we read for Psalm 1: '. . . the placing of the Lord Jesus Christ at the beginning of the collection is no idle arrangement. He is the unique Oneness, simple and perfect, having need of nothing . . . from this Fount comes the multitude of numbers which however multiplied return always to it, and without it such calculation cannot begin or emerge.'[9] This first psalm offers Cassiodorus the opportunity to teach against Nestorian heresy on the Oneness of the Two Natures of Christ: it not only offers instructions as to how the Church can emulate the Head, but in a mysterious way its teaching about the Blessed Man provides us with a key to the person of Christ found in the entire Psalter.[10]

The actual commentary on Psalm 1—for example, seeing Christ as 'in' the law not 'under' the law in v. 2, speaking of the tree as the cross of Christ and the waters as waters of baptism in v. 3, referring to the judgement on sinners in v. 5, and the omniscience of God in v. 6—is a development of earlier commentators, especially Augustine. Throughout his commentary on Psalm 1 a particular concern shows through: its relevance for a monastic community, both at and beyond Souillac. The monastic culture gave Cassiodorus a central place later in the *Common Gloss*—so much so that he is sometimes presented in the marginal illustrations of later medieval Psalters with a scroll and pointing to passages, which are purportedly his, stating 'Non approbo'—'I do not agree with that!' (see Figure 5.1).

Cassiodorus starts his commentary on Psalm 2 in a similar manner to Psalm 1. His first concern is the classification of the psalm, and this fits well with the second of his twelve categories—namely, along with Psalms 45 and 110, a psalm which offered insights into the nature of God the Father. Cassiodorus explains this further by referring to the number of the psalm: hence just as Psalm 1 offers theological teaching against heresy in its treatment of the *Oneness* of the Two Natures of Christ, so Psalm 2 is used in

[8] Walsh 1990: 45.
[9] Walsh 1990: 56–7.
[10] The idea of the 'key' which unlocks the Psalter takes one back to the different developments of it made by Origen, Jerome, and Augustine.

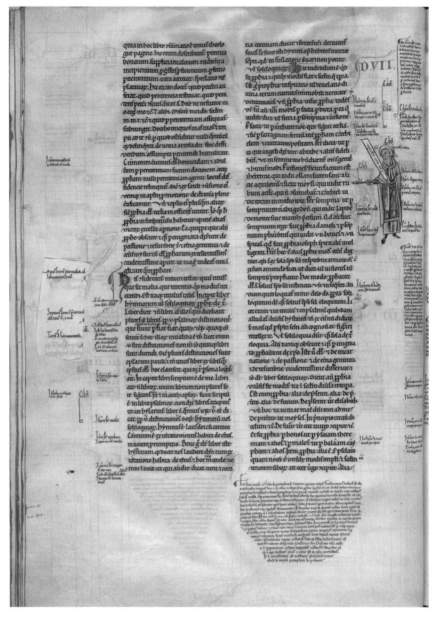

Fig. 5.1. Cassiodorus in Peter Lombard's *Commentary on the Psalms*[11]

[11] This image is taken from the marginal illustrations of Herbert of Bosham's edition of Peter Lombard's *Commentary on the Psalms*, held by Trinity College, Cambridge MS B. 5.4. fol 10v (reproduced with permission from the Master and Fellows of Trinity College, Cambridge).

a complementary way.[12] Psalm 'One' speaks of 'Oneness': *one* 'monad'.[13] Psalm 'Two' speaks of *two* monads:

> It is in the number two, so finely composed of two monads, that the two unmingled and perfect natures are most fittingly set in the single Person of the Lord Christ. By one of these He reigns, and the other He serves. The first is Creator, the second the created ... Let us distinguish the natures with understanding, and avoid harmful errors . . .[14]

This is a good example of how Cassiodorus used these psalms to instruct the faithful about Chalcedonian orthodoxy. Athanasius of Alexandria, Hilary of Poitiers, Ambrose of Milan, Augustine, Jerome, Cyril, and Pope Leo himself are all cited as witnesses to this end. The commentary on the psalm concludes:

> Pope Leo and his holy synod at Chalcedon decreed and decided that whoever wishes to be a Catholic should proclaim the one Christ as being of and in two united and perfect natures. If with the Lord's favour we store these facts in our memory, we always abide by the norms of the Church.[15]

So for Cassiodorus, because the number of the psalm is important, the fact that it is the *second* psalm means that it is vital it is *not* united to the first. For this reason he assumes a manuscript tradition whereby in the Latin the psalm does have a title, 'Psalm of David', thus separating it from the first. Cassiodorus makes much of this title: it anticipates the hymnic quality of the psalm and the Davidic inspiration within it. However, 'David' is both a prophet from ancient times and a speaker on behalf of Christ Himself: 'So David is to be understood here as the Lord Christ, and the prophet speaks of His passion.'[16] This interplay between the human and divine is further seen in the way the four divisions of the psalm are fashioned, according to Cassiodorus. So in the first two verses we read how David the prophet speaks of the Jews in relation to Christ's passion;[17] while in the second section, i.e. in vv. 3–5, we hear 'the words of the deranged Jews', speaking now of their bonds they seek to lose having once thought they were the ones 'binding' Christ; the third section (vv. 6–9) is where David takes upon himself the words of Jesus Christ, speaking about the way Zion (here interpreted as the Church) will inherit with him his 'all-powerful kingdom', and speaking too about 'his own indescribable begetting'. Finally, in the fourth section

[12] Walsh 1990: 56.

[13] See Walsh, 1990: 56, referring to the Greek use of the term, especially in mathematics.

[14] Walsh 1990: 67.

[15] Walsh 1990: 68.

[16] Walsh 1990: 57, noting the influence of Augustine's prosopological approach.

[17] The commentary itself refers to the New Testament tradition of Herod and Pilate and the Jews taking their stance with the nations and against Christ during his passion.

(vv. 10–12) David as prophet speaks again, warning the nations to recognize Christ's majesty, or they will perish.

We now turn to **Bede's** appreciation of the first two psalms. Here we note a very different concern and emphasis. By the time Bede was writing on and preaching from the psalms in the monastery at St Paul's, Jarrow, Cassiodorus' commentary was already known to him.[18] A piece on the psalm headings attributed to Bede[19] is full of allusions to Cassiodorus' work, and several other works, liturgical, academic, and devotional, cite or allude to *Expositio Psalmorum*.[20] The main text used by Bede seems to have been Jerome's *Psalterium Hebraicum*, which was also the text used by Cassiodorus: at least, this was the text of the *Codex Amiatinus* which was preserved at Jarrow, where the importance of Cassiodorus is further evident with its initial illustration of him depicted as Ezra the scribe (see Figure 5.2).

One particular work usually attributed to Bede is an abbreviated psalter, called *Collectio Psalterii Bedae Venerabili adscripta*. This is a collection of one to three verses, taken from Jerome's *Psalterium Hebraicum*, which epitomize the meaning of an entire psalm. Its purpose was for the use in private devotion of the less learned monks who needed a more brief, more easily memorable book of instruction and prayer.[21] For Psalm 1, a comparatively short psalm of six verses, Bede actually selects the first three—and so, unusually, uses half the psalm. But for Bede this was a critical psalm. He saw the 'blessed man' not only, following Cassiodorus, as Christ, but as everyman—or rather, every monk in the monastery at Jarrow. The central part of his selection is in v. 2, where the emphasis on meditating on the Law of the Lord 'by day and night' could also include the *Opus Dei*; the first verse signifies the demands on the righteous man (the threefold walking/standing/sitting is preserved in most manuscripts); while v. 3 is on the consequent rewards of sustenance and prosperity.[22] In this summary of Psalm 1 we thus also find a summary of the monastic ideal: it neatly includes that threefold cord of prayer, teaching, and work so prominent, for example, in the Benedictine Rule.

[18] See Bailey (1983: 189–93), who argues that the eighth-century Durham Cathedral MS B. II.30, an incomplete epitomized text of *Expositio Psalmorum*, was not used by Bede when citing the psalms, for his citations are from a more complete text; this suggests that at least two texts were in circulation in and around Jarrow at this time. On the issue as to whether Bede or Pseudo-Bede was responsible for *In Psalmorum Librum exegesis*, see Sandler 1972: 128, n. 19; also Weisweiler 1937: 197–204. Because of its contentious nature, this commentary has not been used here: it really belongs to scholastic commentators to be discussed in the following section. See Colish 1992: 533–4.

[19] See Fischer 1971: 90–110, who argues convincingly that this text could be attributed to Bede.

[20] See Ward 2002: 5–6.

[21] See Browne 2001: (trans) 2002. See also Ward 2002: 12–14.

[22] This is not to deny that in other works Bede assumes the 'blessed man' to be the Incarnate Christ: see Neale and Littledale 1874: 89. It is simply that these three verses together offer a particularly pragmatic emphasis: for the translation, see Browne 2002: 19.

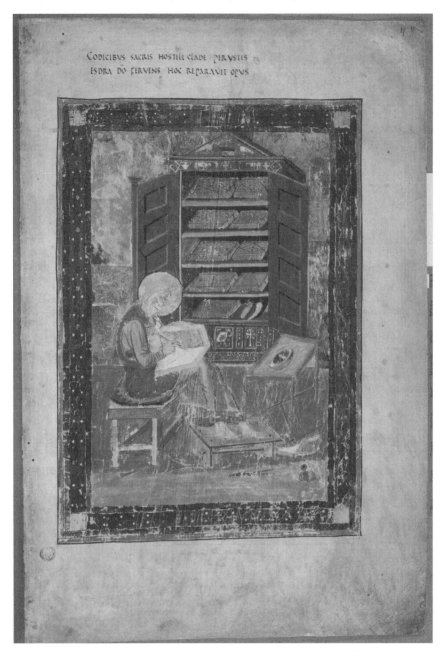

Fig. 5.2. Cassiodorus depicted as Ezra the Scribe in *Codex Amiatinus*[23]

[23] This image of Cassiodorus depicted as Ezra the Scribe is in *Codex Amiatinus* (Ms Amiatino 1, Fol Vr) from the Biblioteca Nazionale Centrale di Firenze (reproduced with permission from Biblioteca Nazionale Centrale, Florence).

Bede used not only Cassiodorus when he referred to the psalms, but Augustine and Jerome as well. That he uses Cassiodorus is clear when in another work he comments on Psalm 2, because he cites the same four divisions apportioned to it by Cassiodorus. He notes how, in the first psalm, the prophet addresses the Jews on their hostility to the passion of Christ; and in the second psalm, the 'judges' themselves speak; in the third, the Saviour speaks of 'his Almighty Kingdom and ineffable generation'; and in the fourth, the prophet addresses the nations, that they should embrace the Christian faith or perish.[24] However, Bede obviously does not have the same Chalcedonian and Nestorian Church controversies in mind, and so he does not develop as persistently as Cassiodorus the two natures of Christ found in this psalm.

Bede's distinctive reading of Psalm 2 is very clear in his selection of verses for the abbreviated psalter. We saw earlier how, in *Collectio Psalterii Bedae Venerabili adscripta*, half the psalm was used to represent Psalm 1; but for Psalm 2, a psalm twice the length of Psalm 1, only one quarter of it is selected, by way of the last three verses—thus omitting all the controversial elements about Christ's two natures earlier in the psalm. What is selected therefore is the instruction to the Gentile nations to learn wisdom and to serve the Lord in fear and rejoice in Him in reverence (note the use of the Vulgate translation here). The key themes within the selection of verses from each psalm are 'compunction, repentance, and thanksgiving': thus from Psalm 2, again with the instruction of the monastic community at Jarrow in mind, only those verses which express this theme have been chosen.[25]

What of the relationship between these psalms? Did either Cassiodorus or Bede suggest anywhere that we might view them as one unit? Although Cassiodorus never refers to the two psalms as one, he nevertheless did write about their intricate interrelationship—the first showing the 'one monad', the second, the 'two monads': so even though they were not one psalm, he could read them as 'indivisible', in that they together pointed to the indivisible nature of Jesus Christ. Bede, however, is more explicit. The instructional elements in each psalm suggested to him a shared theme (Ps. 1.1–3 and Ps. 2.10–12 were Bede's selected verses from each psalm, as we noted earlier). Furthermore, in his comments on Psalm 2, there is also a reference to the tradition of the psalm having no title 'in the Hebrew', being joined to that which preceded it to create one psalm, beginning and ending with 'blessedness'.[26] Bede does not have the same need to emphasize so much how these psalms point independently to the two natures of Christ, so it seems he was more prepared to accept the manuscript tradition which read them as one.

[24] Cited in Neale and Littledale 1884: 97.
[25] See Ward 2002: 12. [26] See Neale and Littledale 1884: 96.

So in both Cassiodorus and Bede, whose works were rooted in the commentaries of the earlier Church Fathers, it is possible to see how Psalms 1 and 2 together introduced key themes of the Psalter. For Cassiodorus, these psalms stood at the heart of Christian controversies about faith and orthodoxy in speaking about the human and divine nature of Jesus Christ. For Bede, his selection of particular verses (Ps. 1.1–3 and Ps. 2.10–12), the one beginning with the theme of 'blessedness' and the other ending with the same theme, shows how he too saw these psalms linked together and introduced a key theme in the Psalter: but this was not so much about Christian orthodoxy, as about Christian obedience.[27] We now turn to see whether later medieval commentators, including those who were known as 'Christian Hebraists', understood these two psalms together to have the same central place in the Psalter.

MEDIEVAL COMMENTATORS

By the thirteenth century, both Jews and Christians had each consolidated further their authoritative traditions of received wisdom on various psalms, and commentators who served either in *yeshiva* communities or in monastic schools would have access to much of it, through copies of the *Midrash Tehillim* or different expansions of the Christian Gloss.[28] In many ways the existence of these accumulated literary works from the different traditions fuelled Jewish–Christian controversies, as each disputed with the other's interpretation.[29]

An early example is found in the glossed Psalms commentary of **Gilbert of Poitiers** (1080–1154), which he completed somewhere around 1117 while studying with Anselm of Laon.[30] His work has sometimes been called the first real transition from the reading of the psalms as *lectio divina* and *sacra pagina* (in liturgy and monastic instruction) to reading them with the rhetorical and analytical interests appropriate for the lecture room. Gilbert was, through the influence of Anselm, associated with the Victorine school of exegesis in Laon and especially in Paris. His primary concern was to serve the cathedral

[27] This has correspondences with our observations in the preceding chapter about how Jewish readings of Psalms 1 and 2, later, in the Middle Ages, illustrate their central place in the Psalter: there they stood at the heart of Jewish controversies with the Christians, in that there they speak of both the Law and the Messiah. See, for example, Kimḥi's exegesis in Chapter 4 'Jewish commentaries': 85–6.

[28] An important resource was Peter Lombard's *Glossae Psalterii* in the mid-twelfth century, which gave rise to the *Glossa Ordinaria* and the *Magna Glosatura.*

[29] See Gillingham 2008a: 77–94; Timmer 1989: 310–12.

[30] See Colish 1992: 536–8. A second version appeared between the 1130s and 1140s.

schools at Laon, Chartes, and Paris and so he dealt with these texts in a scholarly and didactic way.[31]

Gilbert sees the entire subject matter of the Psalter as Christ as Head and Christ as Body: the influence of Cassiodorus, and behind this, Augustine, is clearly to be seen. Perhaps even more important, however, is the influence of **Remigius of Auxerre** (*c.* 841–908) who is frequently cited in his marginal references. A clear example of this is in his 'supercessionist' approach to the Law in Ps. 1.1–2, where Gilbert both follows earlier tradition and expands upon it, using Remigius. He compares the 'wicked man' with Adam (note here the negative use of Adam compared with the positive references in *Midrash Tehillim* and in Rashi) who lived 'under the Law' and failed to obey it, and he identifies the righteous man with Christ (who, by implication, through his Incarnation lived 'in the Law' and in his Death freed humanity from subservience to it).[32] The influence of Remigius is evident again when Gilbert discusses the significance of 'the waters' in v. 3: first they are identified with the Wisdom of Christ (there is some use of Augustine here) but then— somewhat unpredictably—the waters also become all those individuals (on the basis of Rev. 17.15) who choose to be redeemed by Christ through the Spirit (this is by implication, as Gilbert quotes Rom. 8.3–4, which speaks of the way we live not by the Law but by the Spirit). Gilbert then proceeds to identify 'the tree' with the Tree of Life once planted in the midst of the Garden of Eden, but now planted by Christ Incarnate in the midst of the Church on earth. The additional layers of commentary are all too apparent. Furthermore, this reading of Psalm 1 through a Christian lens, with its negative emphasis on the Jewish law and its positive emphasis on the moral life of the Christian, as well as the negative emphasis on Jewish interpretation and the positive Christian reading, represents another stage in the anti-Jewish exegetical approach, which intensified in the twelfth and thirteenth centuries. But it is also a reading which is more analytical: the verses in the psalm constantly prompt Gilbert to ask deeper questions about the relationship between the nature of virtue and vice, and whether sin is located in the voluntary consent of the individual.[33] In both its anti-Jewish rhetoric and its more philosophical emphasis, this reading of Psalm 1 represents a very different world from the Chalcedonian controversies in Cassiodorus.

Gilbert's commentary on Psalm 2 applies the scholastic and rhetorical method very differently from his reading of Psalm 1. We see in his comments on the second psalm a more expansive Christological reading, with less emphasis on any moral teaching, and Gilbert sees Psalm 2, rather than

[31] See Gross-Diaz 1996: xiv. Gilbert's close association with Anselm at Laon was a major influence in this respect.

[32] See Gross-Diaz 1996: 107–9.

[33] See Colish 1992: 538.

Psalm 1, as serving as a Prologue to the Psalter as a whole.[34] Hence his *accessus* to Psalm 2 speaks about its human and divine authorship through the mediation of a prophetic voice. Gilbert reads the first five verses as the prophet speaking, and the last seven verses as Christ Himself speaking. Readapting Cassiodorus' division of the psalms into twelve categories, Gilbert, also using in his Gloss comments on this psalm by Hilary and Augustine, reads Psalm 2 as one of eight psalms giving information about the divine and human natures of Christ.[35]

Peter Lombard (1100–1160) is another example of this 'scholastic' reading of the psalms in the setting of the newly established cathedral schools. His work has much in common with Gilbert in the way it offers a thematic analysis of the psalms: like Gilbert, he uses typically scholastic (Aristotelian) rhetoric in asking questions about the psalm's title, subject matter, intention, and mode of arrangement. Peter may also be compared with Gilbert in his emphasis on the moral life throughout the entire Psalter: understandably, Psalm 1 played a critical part in this discourse. His *In Psalmos Davidicos Commentarii (Glossae Psalterii)* (*c.* 1138) is a vital resource for seeing how a number of new Glosses were added to various psalms: these included 'Pseudo-Bede' from the twelfth century, and Anselm's *Glossa Interlineas* as well as Gilbert of Poitier's own commentary.[36]

Peter's Preface to and Commentary on Psalm 1 illustrate both his concern with the moral life and his use of additional 'Glosses'. Even in the Preface the identity of the Blessed Man (who is Christ) is discussed, as is the fate of the wicked man who is like Adam: this reminds us again of Gilbert.[37] However, Peter expands this theme (still in the Preface) by way of Glosses, to speak of the three sins of Adam, 'in thought, intention, and deed', which resemble the walking, standing, and sitting of the wicked man in v. 1; this then leads to a discussion of the various types of sinful acts. Using a similar technique to Gilbert, in applying New Testament passages to these texts, Peter compares these three sins with three miracles where Christ raised the dead ('in the house': Jairus' daughter; 'at the gate': the widow of Nain's son; and 'in the tomb': Lazarus). Just as Adam was wretched and cursed in all he did, the second man is blessed and gives blessing in all he did.[38] All this is achieved

[34] See for example the earlier discussion, in Chapter 5 'Two early commentators': 97–9, of Cassiodorus' understanding of the two natures of Christ in Psalm 2, where Psalm 1 is about the *oneness* of Christ and Psalm 2 is about his two natures.

[35] Other themes, a little different from Cassiodorus, included the First and Second Coming of Christ, the Passion and Resurrection, Prayer, Penitence, Divine Love, and the Church Triumphant and the Church Militant: see Gross-Diaz 1999: 100.

[36] See Colish 1992: 532–8, on the way these different resources produce a rich and varied anthology for Lombard.

[37] Colish 1992: 540–2.

[38] See Minnis and Scott 2003: 111–12.

by a rhetorical style which is expanded by New Testament references: this is very much like Gilbert, and it is not surprising that we also find in Peter some anti-Jewish rhetoric.

The commentary then discusses the psalm, verse by verse, clarifying the various historical, moral, and mystical levels of meaning. Agreeing with Gilbert, as well as with Cassiodorus and Augustine, that this psalm encapsulates and anticipates the themes in the rest of the Psalter, Peter Lombard divides it into two parts: vv. 1–3 show the importance of living a life of virtue, and vv. 4–6, the consequences of a life of vice. So again in v. 1 *Beatus vir* is seen through the lens of Adam, the Christian, and Christ Himself, and to illustrate each point Peter draws from other Glosses as well as other passages from Scripture.

Another feature in this commentary is the way it seeks to illustrate a particular article of Christian faith through specific verses of the psalm. For Ps. 1.6, for example, Peter uses the idea of the wicked not 'standing' on the day of judgement to develop his teaching on the resurrection in the last days: this of course picks up the earlier references to the resurrection in his Preface, although here Peter also draws from Jerome, Augustine, and Gregory. He notes that the saints and apostles will judge but will not be judged themselves, and the faithless and sinful will not judge and will not be judged either, for their fate is sealed.[39] Thus in this one psalm we can see the rich adaption of older tradition applied to several new ways of reading, creating what Colish terms a 'systematic theology', psalm by psalm.[40] Small wonder, as she observes, this was the psalms commentary most cited, copied, and used in the twelfth century.

Peter Lombard's commentary on *Psalmus Secundus* is missing in *Patrologia Latina* 191, so we have to surmise how his systematic treatment of this psalm would follow Psalm 1. From his other works it is clear that the *materia* (subject matter) is quite simply, like Gilbert, 'Christ in his two natures', to be read (just as we saw with the early Fathers) in the same way as Psalms 45, 72, 89, and 110. But if his treatment of these other psalms is to yield any further clues on this missing commentary, it would have been not only about dogmatic theology—the Christological agenda—but also about the moral discourse which arises out of the psalms, not least about how the Church lives out in practice its response to Christ.

[39] Peter continues to compare those whose fate is sealed before they die with the fate of those whose ultimate destinations are not clear upon their death: this leads on into a further discussion of purgatory. See Colish 1992: 543–4.

[40] Colish 1992: 548. One of the English commentators from the fourteenth century who was profoundly influenced by Peter Lombard's work is Richard Rolle: translating from and commenting on the Vulgate in a somewhat stolid north-English dialect, his work in turn influenced Wycliffe and the Lollards. His commentary on Psalm 1 and 2 follows the Christian interpretation above. See Hudson 2012: 8–26.

The Dominican **Thomas Aquinas** (1225–1274) illustrates the development of this tradition, although his scholastic enquiry is primarily addressed to a monastic community rather than to a cathedral school: Aquinas' *studium* was probably in Naples. The fact that his commentary suddenly breaks off at Ps. 55.11 suggests that *Postilla super Psalmos* was one of the last things Aquinas wrote. Although in many psalms Aquinas draws from Augustine, Cassiodorus, and Bede to enforce a Christological reading, the commentary on Psalm 1, because of its context, is, even more than Bede, more pastoral than doctrinal.[41] He only loosely follows the typical Aristotelian prologue for this psalm.[42] So for the '*matter*' of this psalm, the literal interpretation concerns the blessed one, 'a man who is lifting his eyes to the entire state of the world and considering how some do well, and others fail', while the Christological reading, along the lines of Gilbert, is that 'Christ is the first among the blessed ones; Adam is the first among the evil ones'—where each seeks different ways to happiness, the one reaching it, the other not.[43] Christ is in this way primarily our Exemplar for faith, not our means of attaining it.

From this Aquinas develops the '*form*' of the psalm, and this is also two-fold: first, the description of the way to happiness (vv. 1–2) and, secondly, the outcome of that pursuit (vv. 3–6). Much of the commentary on the '*origin*' of the psalm then focuses on practical aspects. Christ is seen as the inspiration for our obedience (here Jn 6.38 is cited). The discussion of the metaphor of the tree, far from following Gilbert, is again more pastoral, and neither the incarnation nor crucifixion receives any mention; the only obvious Christian inference is the comparison of the fruits of the tree with the fruits of the Spirit in Gal. 5.22. The description of the judgement on the wicked in vv. 5 and 6 has no obvious eschatological reference, and certainly no reference to the resurrection, as in Peter Lombard, but is rather about the accountability of evil men before God, with verses from Jn 3.18 (concerning the wicked) and 2 Tim. 2.19 (concerning the faithful) serving as illustrations. So although the *goal* of the psalm is indeed the Gospel, in its several references to Christ's example as the Blessed Man, it is the Gospel in a moral and pastoral sense and not an explicitly redemptive one.

[41] Compare for example Aquinas' commentary on Psalm 8, where he readily identifies 'the man . . . son of man' with Christ Incarnate and sees this psalm as much about Christ as Redeemer as about God as Creator: see Gillingham 2008b: 183–4, and n. 35.

[42] Aquinas uses this tradition quite differently from Gilbert of Poitiers and Peter Lombard: see Gross-Diaz 1999: 99–101. In an *accessus*, four rhetorical questions are posed, each relating to the causes of a particular psalm: the *matter* (which is Christ), the *form* (which is prayer and teaching [interestingly, not prophecies in the process of fulfilment]), the *origin* (which is the divinely inspired words), and the *goal* (which is the Gospel). See Gillingham 2008a: 92–4.

[43] 'Expostio ejusdem primi psalmi secundum allegoricum intellectum, videlicet de Christo': see Waddell 1995: 509, n. 36. The English translation used above is taken from <http://www4.desales.edu/~philtheo/loughlin/ATP/Psalm_1.html>.

Aquinas' commentary on Psalm 2 has emphases which are typical of other Christian commentators at this time. He too introduces the Christological interpretation in his *accessus*, and it is clear that he understands that here the psalmist is in fact speaking about Christ:

> In the prior psalm, wherein the psalmist generally described, as it were, the state and progression of the human species, in this one, he proceeds to a definite matter, namely his tribulations, signifying the tribulations of Christ.[44]

Accepting the (lesser known) tradition that Psalm 2 has the title 'Psalm of David', Aquinas first comments on how the psalm speaks of David's kingdom as a prefigurement of the kingdom of Christ. So the tribulations described in the psalm can be read on two levels—literally, against David, and typologically, against Christ. Although the commentary does pause briefly on v. 7 to assess the meaning of '*Today* I have begotten you', this is very different in style and intent both from Gilbert of Poitiers and Peter Lombard and from the later Christian Hebraists, Herbert of Bosham and Nicholas of Lyra.

On both the historical level (David) and the theological level (Christ) the commentary repeatedly emphasizes that the cause and effects of the tribulations include both Jews and Gentiles. Yet in all these references Aquinas exhibits some sort of acceptance of the Jews, whom he sees as having been 'already once converted' and so deserving a lesser fate than the 'idolatrous Gentiles': in the context of the more blatantly anti-Jewish exegesis in other commentaries at this time, this is a different approach.[45] His particular pastoral concerns are developed in a lengthy exposition of v. 12; this is concerned with the importance of 'embracing and serving truth' (this is in preference for the more controversial translation, 'kiss the son!') in the discipline and fear of the Lord. The commentary ends with a short passage on 'Blessed are those . . .' although this takes the reader back to Jeremiah 17 rather than to Psalm 1.

Thus far we have found little in these Christian commentaries which engages directly with Jewish concerns. However, other commentaries in the twelfth and thirteenth centuries, mainly from the schools of northern France and monastic communities in England, attempt to deal with some of these issues. As well as being familiar with the Glosses, these commentators exhibit, to different degrees, a good knowledge of Hebrew (for example, of Jerome's

[44] Taken from <http://www4.desales.edu/~philtheo/loughlin/ATP/Psalm_2.html>.

[45] On v. 1: 'subjugated gentiles and faithless Jews . . . both struggled against him [= David]'. On v. 2: 'the gentiles, namely the soldiers, have assembled against Christ: And the people, namely the Jews, have devised useless things . . .'; on v. 4: 'The people, gentiles and princes, rose up against Christ'; on v. 8: 'the giving of the Gentiles (to Christ) is clearly a gift. For the Jews had returned, as it were, because they had been given before . . .'; also for v. 9 (on Christ's rule over Jew and Gentile). Taken from <http://www4.desales.edu/~philtheol/loughlin/ATP/Psalm_2.html>.

Psalterium Hebraicum) and they often cite the Jewish sources they might be opposing. In part the learning of Hebrew sprang from a desire to reform the Latin texts of Jerome's Psalter, which in its many manuscript versions was recognized as being in a corrupt state: it was hoped that by returning to the Hebrew original, a refined version of Jerome could be produced. Important evidence of this approach is seen in a number of thirteenth-century manuscripts, which copy out the Hebrew and Latin texts in corresponding columns. One example of Psalm 1 is in a manuscript which in fact has three columns, using both Jerome's Gallicana and the Hebraica versions alongside the Hebrew (see Figure 5.3).

One notable commentator in this respect is **Herbert of Bosham** (1120–1194). One seminal influence on his formation was Andrew St Victor, with whom he studied, both at Paris and the Victorine Abbey in Wigmore, Wales. Hence his approach, like that of Gilbert, was to view the psalms as texts for analysis as well as prayers in liturgy. One of his earlier works was a revision of Peter Lombard's *Gloss* on the psalms: his concern for the Hebrew 'original' thus runs alongside his concern for the inherited traditions of the Church.[46] Herbert's *Psalterium cum commento* was written later in his life, probably in Paris.[47] The text has over a hundred interlinear and glossed corrections of Jerome's Gallicana and Hebraica Psalters, and is set in two columns; the corrections are from Herbert's own reading of the Masoretic text.[48] The commentary also has a number of marginal annotations, some of which are no longer legible. But what is clear is that, on Herbert's own admission in his dedicatory letter to Peter, Bishop of Arras, this is a commentary with a particular Hebrew emphasis: '*psalterii editionem novam a patre Ieronimo sermone latino ab hebraica veritate translatam, et usque ad hos dies a doctoribus intactam*'.[49] It is possible that Herbert used one or more of the bilingual Hebrew-Latin psalters which appeared in northern France and southern England in the late twelfth and early thirteenth centuries: several of the variant readings have correspondences, for example, with a twelfth-century bilingual psalter from St Augustine's, Canterbury (Ms Leiden Or. 4725).[50] He may also have consulted the Hebrew-Latin-French-dictionary tradition also used in his day; and have learnt some Hebrew through his associations with the Victorene school at Paris.[51]

[46] See de Visscher 2009: 251–2, who observes that Herbert's interest in Hebrew is already evident in the additional details brought to his edition of Peter Lombard's Gloss.

[47] A copy of Herbert of Bosham's work, dating from about 1220–40, was discovered in the 1930s and is now preserved at St Paul's Cathedral (MS 63).

[48] See Loewe 1953: 44–77; Goodwin 2006: 51–72; de Visscher and Olzsowy-Schlanger and de Visscher 2009.

[49] See Loewe 1953: 48–9.

[50] See de Visscher 2009: 261.

[51] See de Visscher and Olzsowy-Schlanger 2009: 249–77.

Fig. 5.3. A Thirteenth-Century Psalter in Latin and Hebrew Columns[52]

[52] This image is of Ms CCC 10 and is held at Corpus Christi College, Oxford, reproduced here by permission from the President and Fellows of Corpus Christi College, Oxford. Another example is MS Longleat House 21, which has sometimes been attributed to Robert Grosseteste, Bishop of Lincoln. This and MS CCC 10 might be compared with Origen's *Hexapla* and triplex medieval psalters in the shared concerns to understand and compare early versions of the text. On this topic see de Visscher and Olzsowy-Schlanger 2009.

It is no surprise, therefore, to find in Herbert's commentary on Psalm 1 an interest not only in the blessedness of the 'man' in v. 1 but also in the meditation on the 'Torah' in v. 2, and Herbert refers explicitly to the Hebrew discourse on this verse found in *Midrash Tehillim* and in Rashi.[53] Another illustration of his Jewish interests is in v. 5, where he states a preference for *synagoga* rather than, according to both of Jerome's translations, *congregatione*.[54] Overall, because Herbert is concerned essentially with the literal and grammatical sense of Scripture, his approach is closer to the use of *peshat* in Jewish commentaries than to the rhetorical, moral, and mystical readings of, for example, Gilbert of Poitiers and Peter Lombard and even Aquinas. It is difficult to be sure who were the intended readers here. Were they, as is the case for contemporary writers such as Odo, whose commentary uses Hebrew in a more consistently polemical way, the Jews, whom it was hoped might be converted by reference to their own language and methods of reading the text?[55] Or was Herbert's intention to educate Christians? Both audiences may well have been intended, as Herbert drew from both sources and appears to engage with the views of each tradition. But what can certainly be known is that Herbert's main concern was to bring the best of the Hebrew tradition to serve the Church and to produce a more accurate version of Jerome for his own time.

Just as Herbert's commentary on Psalm 1 is full of Jewish sympathies, so too his work on Psalm 2, which shows that this is because of his ability to engage more explicitly with the Hebrew text and so directly with Jewish commentators. A clear contrast with Aquinas can be seen in his translation and commentary on Ps. 2.12: here Herbert prefers the translation which, following Jerome's *Hebrew* Psalter, assumes the use of the Aramaic '*bar*' for son and thus reads the phrase as 'kiss the son' rather than 'embrace/accept discipline'. Paradoxically, by using the Hebrew and by aligning himself with rabbinic tradition ('kiss the son' is also Kimḥi's translation, for example), Herbert then shows how the verse is open, particularly in the light of v. 7, to a

[53] See Loewe 1953: 55. It is noteworthy that although Kimḥi was a near contemporary, Herbert does not seem to use either Kimḥi or Abraham ibn Ezra whom Kimḥi used. Herbert's frequent use of 'litterator'—teacher, grammarian—when referring to Rashi, but his use of the plural 'litteratores' when referring to the Jewish school of exegesis in general, is a clear illustration of fundamental dependence on, probably, a written commentary from Rashi. See de Visscher 2009: 264–5.

[54] We noted in the comments about the Greek and Latin versions of this verse how בעדת צדיקים created difficulties for translation. Some Latin versions offer 'in consilio iustorum', others, 'in congregatione iustorum'. Herbert is distinctive in his preference for 'in *synagoga* iustorum'. See de Visscher 2009.

[55] Herbert's knowledge of Hebrew and use of Rashi and other Jewish sources did not always result in a positive appraisal of their reading of the psalms: although not as apparent in Psalm 1, Herbert often takes issue with Rashi's typically Jewish interpretation of the Law and Messiah, as is seen, for example, in Psalm 21: see de Visscher 2009: 266–9.

more Christological reading.[56] de Visscher explains Herbert's interpretation so well: '. . . Herbert clearly considers the notion of *hebraica veritas* as the programme of literal exegesis . . . he seeks to demonstrate, first, that the Psalms *ad litteram* can already contain a Christological interpretation and, secondly, that establishing and clarifying the correct *littera* is a condition for the understanding of the Psalm's *spiritus*'.[57]

Theresa Gross-Diaz describes the attitude to the Jews shown by the Franciscan, **Nicholas of Lyra** (1270–?1349) as 'not one of open hostility, but rather of wariness and respect'.[58] There are many similarities between Herbert and Nicholas—their concern with improving the accuracy of Jerome's text by emendation from the Hebrew, their use of the historical and literal meaning of the text, which echoes Jewish *peshat*, their willingness to combine Jewish readings with the Christian Gloss—but there are also key differences. Nicholas' *Postilla litteralis* on the psalms was written in about 1326, probably also in Paris, but well over a century after Herbert's work. The Jews had been expelled from France, the legislation of the Third and Fourth Lateran Councils (1179 and 1215) had resulted in increased ostracizing of Jewish communities, and at least twenty-four copies of the Talmud had been burnt in Paris in 1242 after they had been condemned as 'heretical'. So, using the more rhetorical and scholastic approach of Aquinas, and thus maintaining a more irenic approach with less Christology and more moral application, Nicholas, like Herbert, applied his skills in the Hebrew language and his good knowledge of the Hebrew tradition—Rashi he termed his 'Hebrew doctor', and *midrashim* and even the Talmud are also quoted—to engage with the Jews on their own terms.

So, as far as the actual commentary on Psalm 1 is concerned, Nicholas offers a very different interpretation from the line of Christian commentators before him: his suggests yet another Christian commentary which has a Jewish as well as Christian readership in mind. Nicholas first raises questions about the psalm having no title and then cites Rashi's views on the ten authors of the psalms, followed by Jerome who offers a corresponding view. Then, again citing Rashi, Nicholas makes it clear that the 'blessed man' of v. 1 is every pious believer who seeks to study Scripture. He even takes Aristotle's *Ethica Priora*, instead of the Christian Glosses, to develop the virtue of blessedness in the most universal sense. He never refers to the Blessed Man as Christ, and he never assumes the Law to be anything other than the words of Scripture—shared by Jews and Christians. The

[56] Herbert translates this as '*Diligite filium*' following Jerome's Hebrew Psalter rather than '*Apprehendite discipliniam*' of the Gallican Psalter. For a fuller discussion of this translation, see Loewe 1953: 54–6.

[57] See de Visscher 2009: 270.

[58] Gross-Diaz 2000: 118.

tree by the waters, bearing fruit, represents the *doctores*—again, Jewish and Christian teachers alike. The *impii* are not the perverse Jews—a point implied by many of the earlier commentators such as Augustine and Cassiodorus and consolidated in the Glosses: they are not identified at all. Psalm 1 thus offers Nicholas an ideal opportunity for a thoroughgoing literal meaning, which he follows through to the end of the psalm.[59]

Like Herbert, Nicholas of Lyra applied literal exegesis to the psalms from a good knowledge of Hebrew. Given the fate of the Jews at the time of his writing, it is likely that Nicholas used this approach so he could engage better with the Jews.[60] If this is the case, it shows a slightly different approach from Herbert, whose reading (as seen in de Visscher's observation above) could compel him, with integrity, to follow a more specifically Christian interpretation. What Nicholas seems to be concerned to do may be even more paradoxical than this. By seeking to hold together a dialogue between rabbinical and New Testament readings, or between 'Catholic . . . and Jewish teachers' of the psalms, he prefers to accept the Jewish readings 'insofar as they are in accord with reason and the true literal meaning'.[61] So the difference between Herbert and Nicholas might be that the former looked more explicitly for a Christian emphasis, and the latter came to it after a dialogue with the Jewish tradition had failed.

Nicholas' approach is also illustrated in his reading of Psalm 2, which is in effect a dialogue between his understanding of Rashi and of the New Testament, but with the Christological emphasis being more muted. So, first, he notes (without much comment) how Rashi reads this psalm as about David and the wars with the Philistines. When he reads v. 7, Nicholas affirms the reading of Rashi (and his student Joseph Kara) that because David was the first ruler of Israel he could rightly have been understood as 'the firstborn'. But then, ingeniously using the fact that in Hebrew tradition this psalm does not have a title, Nicholas then suggests that the psalm was never seen in Jewish tradition as referring to David, but to one greater than David. This then leads to a citation of Acts 4.25–8, where the first two verses of this psalm are seen to concern not David, but Christ. From this point on there is a more standard Christological reading of the psalm, on the grounds

[59] See Gross-Diaz 2000: 120–4. This rather more anodyne and irenic reading continues into the first part of Psalm 2; only when Nicholas reaches the reference to 'the anointed one' in v. 7— on the basis of its interpretation in the New Testament—is he compelled to accept a more Christian reading. It is as if Nicholas presumes that in using the Old Testament alone a Christian reading is not necessarily apparent: Psalm 1, which is not used in the New Testament, thus has no need to be read in a specifically Christological way.

[60] See Gross-Diaz 2000: 113.

[61] See Minnis and Scott 2003: 268, translating extracts from *The Second Prologue to the Literal Postill on the Psalms.*

of what might be termed a 'double-literal sense': one as given in the Old Testament and interpreted through the rabbinic tradition, and one as given in the New Testament and interpreted through the Christian tradition. And if there is any conflict between the two, the New Testament reading has to be decisive.[62]

So, throughout this period, encompassing the twelfth to fourteenth centuries, is there any evidence that Psalms 1 and 2 were read together? Starting with Gilbert, all these commentators understood Psalm 1 to play an important part as a *Prologue* to the Psalter, but here little is said about the way Psalm 2 might function similarly. Thomas Aquinas is one of the few exegetes to have anything explicit to say about the relationship between these two psalms, but he perhaps encapsulates a view which would have been shared by others noted here as well. Pointing out, at the beginning of his commentary on Psalm 2, a view that Psalm 2 could be part of the first psalm ('and this was the opinion of Gamaliel'), and noting that the chief reason was the double use of 'Blessed' at the beginning of Psalm 1 and the end of Psalm 2, Aquinas then refutes this view: '. . . because there would not be one hundred and fifty psalms'.[63] He adds another numerical point apparently taken from Augustine: Psalm 1 starts with *Aleph* in Hebrew, so must be first; Psalm 2 has *Beth*, the second letter in Hebrew, 'positioned at the beginning of the psalm so must be the second psalm (just as *Gimmel* is in the third psalm, and so on). But there is no *Beth* to be found in Psalm 2 until the middle of the first word of the second verse; it is hardly the same as the *Aleph* in Psalm 1. In fact, the very first word of the first verse in Psalm 3 (after the title) starts with a *Beth*: so this is a point rather oddly made.

Perhaps one other factor uniting these psalms in scholastic tradition is their complementary contribution to matters of doctrine and morality (noting the latter to be of specific scholastic interest). Psalm 1 teaches more about morality but requires the more explicitly Christological basis of Psalm 2 to give it a Christian focus, and Psalm 2 offers a more Christological reading but needs the moral world of Psalm 1 to root it in reality: this is clearly illustrated by the last three verses of Psalm 2 which echo the ethical world of Psalm 1.[64]

[62] One could argue that Nicholas' understanding of David the prophet is the figure who actually bridges this gap. See Gross-Diaz 2000: 123–34.

[63] Although Aquinas does note the existence of the additional Psalm 151, the psalm about David and Goliath, which would counterbalance this view.

[64] This is implied in the comment in Minnis and Scott 2003: 276, that faithful doctrine needs to be grounded 'in the law'; or to put it more broadly, that Christian doctrine is not faithful unless it has an ethical basis.

REFORMATION COMMENTATORS

Compared with Herbert of Bosham and Nicholas of Lyra, **Desiderius Erasmus Roterdamus** (1469–1536) was far from sympathetic to a Jewish exegesis of the psalms. It is clear he occasionally used Nicholas, along with Jerome's *Psalterium Hebraicum*, to compensate for what was lacking in his knowledge of Hebrew, but Erasmus disagreed with Nicholas' more literal approach.[65] Hilary, Jerome, Augustine, and Cassiodorus are frequently cited (and sometimes criticized) and Jerome's Gallican text was used primarily for explaining the psalms. Although not a Religious, Erasmus recited the psalms daily as part of the *Opus Dei* and his commentary on the first four psalms (Psalm 1 in 1515; Psalms 2–4 between 1522 and 1525) arose out of a concern that those who recited them should do so with a considered understanding of their spiritual meaning.[66]

Erasmus' lengthy commentary on Psalm 1 is part essay, part sermon. Its subtitle '*Iuxta tropologiam potissimum*' announces his main emphasis, which was—in its essay form—a consideration sent to his friend 'Beatus Rhenanus' of the way the moral teachings of the ancient philosophers gave too little attention to the seriousness of sin, and—in its sermon form—a plea that temptation can be overcome with due meditation upon Christ who gives us the supreme example of the practice of virtue.[67] Much of the commentary is a criticism of those in authority in Church and State who substitute an empty religiosity for true blessedness and true virtue: bishops and princes are considered no better than pagan philosophers nor any better than the scribes, Pharisees, and rabbis in this respect.[68] The commentary also reveals some

[65] See Heath 1991: 367, referring to Erasmus' use of Nicholas on Psalm 2. Heath 1991: 364 also illustrates how Erasmus described Hebrew as a 'barbaric tongue' and was unsympathetic to using a literal interpretation as this was akin to the rabbinical interpretations which were 'much stuffed with vapourings and old wives' tales'.

[66] See Rummel 2008: 219–30.

[67] This is because, Erasmus argues, 'that reform of morality [which] is my principal aim' (Heath 1997: 11). The application is for every Christian, not only the 'blessed man', but women too. Although Erasmus is one of the first to bring out the universality of p. 1 in this respect, it is followed by an extraordinary section on the place of women in Christian history, a 'new creature in Christ' but subservient to man in every way. Erasmus concludes: '. . . clearly you are a true [blessed] man—even if you are a woman' (Heath 1997: 14–15).

[68] For example: . . . 'everyone must listen . . . the princes rouse themselves, and the bishops be attentive, to what the Spirit . . . tells us concerning true bliss through the mouth of the holy prophet' (Heath 1997: 13). And, when commenting on v. 2, on those who 'sit in the plague-seat': 'Yet everywhere today we see bishops, not content with ecclesiastical position, taking on the roles of kings and satraps . . . in their tyrannical pursuit of power, revenue and plunder . . . on such a [plague-]seat sat Pilate . . . Here sat the Scribes and Pharisees, who observed the precepts of the law, but, in their greed and ambition, exercised power for themselves, not for the people' (Heath 1997: 20). Citing Augustine, 'sitting on the plague-seat refers to those who, abusing the authority of their position, corrupt the minds of simple people with pernicious teaching' (Heath 1997: 22, citing *Enarratio in Psalmum 1*).

typical anti-Semitic tendencies. For example, Erasmus compares from the beginning the Jewish (false) delight in the 'Law of the Lord' and the Christian (true) delight in it: in many ways this expands upon Jerome and Augustine in their distinction between 'living under the law' and 'living in the law': 'The Jews were under the law; they were confined, fenced in, as it were, by the dictates of the law, and they obeyed it, out of fear not choice, as if it were a slavemaster. Christians live their lives "in the law", and choose to live according to the law because they are invited to do so by charity, not compelled by threats of punishment.'[69] Erasmus then explains this: the failure to meditate properly on the law is equally evident in the Church which is full of 'those who, day after day, mumble their way through psalms they don't understand . . . those who approach the mystic writing seeking ammunition for their frivolous debates . . .'[70] His tropological approach is again seen in the comments on v. 3, where much attention is given to the metaphor of the leaves of the tree: these are compared with the false teachings of the Jews and Church leaders alike, and little is made of the comparison between the tree and the cross of Christ.[71] Similarly in vv. 5–6, Erasmus prefers to read the references to the councils and judgements primarily in a moral rather than eschatological way: these are the councils of princes and bishops ('and God forbid, the popes as well') which are executed without concern for justice, by those who are worldly and lack 'virtue' which is the result of 'blessedness'.[72] Small wonder, Erasmus continues, that God will not recognize them—and indeed all sorts of Christians living out a faith without virtue—when the Day of Judgement comes.[73] *Enarratio in Primum Psalmum* was a critical psalms commentary to be written just before Luther's; it undoubtedly signalled the signs of the times.

Thus Erasmus mainly used a tropological approach for Psalm 1, with an eye to the changing authority of the Catholic Church in Europe. When Christology was used in this psalm, it served this greater goal. His commentary on Psalm 2 could not be more different: here the allegorical and Christological interpretation is primary, and it is really only the final three verses which have anything to say explicitly to a sixteenth-century audience.[74] In Erasmus' words, the allegorical and analogical approaches '. . . beneath the cloak of historical events, conceal, or rather reveal the gospel story. . . .'[75] This strikes the reader as somewhat strange: Psalm 1 was produced in 1515, before the real start of Luther's Reformation; but Psalms 2–4 appeared between 1522

[69] See Heath 1997: 28. This is followed by a sharp attack on the Jewish sacrifice system and the dependence upon the letter not the spirit of the law.

[70] See Heath 1997: 30.

[71] See Heath 1997: 48, 52, 55, with a specific reference to Christ's cursing of the fig tree for its lack of fruit 'in due season'.

[72] See Heath 1997: 58–9. [73] See Heath 1997: 61–2.

[74] Heath 1991: 369; Heath 1997: 66–7. [75] Cited in Heath 1991: 363.

and 1525, when the cataclysmic events of the interim years might have elicited some more explicit commentary, and Psalm 2, far more than Psalm 1, is open to a more immediate and political appropriation. Nevertheless, Erasmus' focus throughout reads Psalm 2 almost exclusively through the life and death and resurrection of Christ, as presented in the New Testament and foretold in the Old. He sees the psalm *in toto* as a prophecy about Christ. So despite the ways in which the context of the psalm might call for some contemporary comment, the chaotic world of sixteenth-century Europe receives as little mention as the ancient world of King David.[76]

As with Psalm 1, Erasmus uses the Septuagint translation alongside Jerome's Gallican and Hebrew Psalters. Just occasionally the Hebrew is preferred to the Septuagint. For example, in v. 6, Erasmus prefers to see the speaker as God, as in the Hebrew, rather than the king, as in the Septuagint.[77] Similarly his translation of the Hebrew at the beginning of v. 12 discusses at length whether this should read 'kiss the son' (on the basis of the Aramaic) or 'kiss/worship purity' (using the Hebrew word בר meaning 'purity'). Erasmus decides on a compromise: 'worship the Son in purity'.[78] The issue of 'sonship' is important within the psalm, not only in v. 7 but in this difficult Hebrew of v. 12. Erasmus published an edition of Hilary of Poitier's commentary on the Psalms in 1523, so it is not surprising that he uses Hilary and other commentators, especially Augustine and Cassiodorus, to show how these verses apply 'to our David, that is, to Jesus Christ'.

So Erasmus takes issue with Rashi's interpretation that the psalm refers to the context of David's defeat of the Philistines and considers this an insipid waste of time, a product of the letter that kills: 'What interest do we have in David, who rules a precarious kingdom soon to be destroyed in Palestine, a mere dot on the map? ... We prefer to drink from the new wine of our king.'[79] His translation of the Hebrew as 'worship the Son in purity' actually serves a double purpose: it encapsulates not only anti-Jewish comment, in so far as the 'Son' is not David but Christ, but here it also has a more contemporary comment, in so far as those Christians in his day who also rely on 'works' for salvation are hardly worshipping the Son of God 'in purity'.[80]

[76] See Heath 1997: 79–80. On the ancient world of David: 'So I shall not waste any time in considering how individual parts of the psalm may be applied to history; let us investigate instead the extent to which it applies to our David, that is, Jesus Christ, about whom it is unquestionably written' (p. 80). Just occasionally within the references to the hostility of the scribes and Pharisees to Jesus there is an implicit allusion to similar hostility experienced in Erasmus' day (for example, Heath 1997: 99, 137, and especially 139) but compared with the explicit outrage in Psalm 1, and given the greater relevance of Psalm 2 to this sort of application, Erasmus' focus only on the work of Christ in this psalm is astonishing.
[77] See Heath 1997: 118–20.
[78] See Jenkins 2001: 3–6.
[79] See Heath 1997: 119.
[80] See Jenkins 2001: 4–5.

This is an interesting example of what has been termed as 'philology at the service of Christian exegesis': and at some seventy-six pages, it is probably one of the longest allegorical commentaries on Psalm 2 that has been made.[81]

Martin Luther (1483–1546) gave his first lectures at Wittenberg on the psalms (lectures on Galatians and Romans were to follow two years later). This was in 1512–13—after some eight years as an Augustinian friar and priest, illustrating how praying the psalms had been a fundamental part of his religious formation. Luther used Lefèvre's *Quincuplex Psalter* (1509) with its Glosses on Augustine and Lyra and its versions dependent upon the Hebrew, Latin, and Greek; the lectures, including that on Psalm 1, have a specifically doctrinal emphasis, seeing the eternal but hidden voice of Christ in the psalms, and correcting or addressing the imperfect and temporal voices of David and of the people. A second series of lectures was published in 1519—four years after Erasmus', and two years after the conflict with Church and State leaders at Worms—and these are more full of social and political comment, some of them echoing Erasmus' reading of Psalm 1.

Both versions of Psalm 1 reveal the tension in Luther's theology between his love for psalmody because all of the psalms teach Christian doctrine, correcting the wayward teaching of the Roman Church, and his more cautious, sometimes anti-Semitic, approach to the Old Testament in general as a vehicle for faith. Put quite simply, Psalm 1 proved a challenge for how Luther worked out his antithetical theology of 'Law' and 'Gospel'. The key problem was how a Christian could 'delight in the Law': for this Law brought about the self-righteousness of the Jews which led to their rejection of Christ, and similarly encouraged the works-righteousness of the Roman Church, which resulted in both the suppression of the laity and indeed of the true voice of Scripture itself.

The commentary on Psalm 1, one of five psalms published in *Operationes in Psalmos* in 1519, is a striking example of how Luther works through this tension. First he identifies the wicked and the sinners in v. 1 as the Jews.

[81] See Heath 1997: 67. It is interesting to see how commentaries from Catholic writers, writing at the same time, worked in a very similar way. In 1508 Jacques Lefèvre d'Etaples also wrote a philological commentary on the Psalter (*Fivefold Psalter*) based upon the Old Latin Psalter and Jerome's Gallican and Hebrew Psalters in three columns and followed by a *titulus* and verse-by-verse paraphrase. Yet he too starts the *titulus* of Psalm 2 as 'A Psalm of the Lord Christ. The prophet speaks in the Spirit. The heathen: the Roman soldiers. The people: the scribes, Pharisees and the crowd of followers. The kings of the earth: Herod and Pilate . . . The princes: the chief priests Annas and Caiaphas. Against the Lord: God the Father and his Christ . . . All the blessed who trust in him: apostles, disciples and those coming to faith through them.' In all this David is not a historian but a prophet. See Reventlow, 2010: 37–41, citing Lefèvre's *Quincuplex Psalterium* fol. 2v. See also Pak 2010: 19–20 and Venderjagt 2008: 177–9. The only difference from Erasmus is the lack of more contemporary (tropological) application concerning Church and State leaders.

Stressing, as did Erasmus, the 'seat of pestilence' as an example of wrong teaching, Luther's reading places the full blame on the Jews:

> This is what the Jews do, who have abandoned Christ. Under their lips is the deadly venom of vipers (Ps. 140:3), and their wine is the poison of serpents (Deut. 32:33). Therefore they must teach contrary to Christ, for they do not teach Christ.[82]

Their errors have been passed on to the Church today:

> . . . and, to come now to our own times, those occupy the 'seat of the scornful' who fill the church of Christ with the opinions of the philosophers, the traditions of men, and the counsel of their own minds, and oppress poor souls. They neglect the Word of God, through which alone the soul is fed, lives and is sustained.[83]

So the 'Law' which both the Jews and the leaders of the Catholic Church follow is not the will of God at all: being blown hither and thither by false doctrines, their teaching is like the chaff that the wind takes clean away (v. 4); and on the Judgement Day they will meet the fearful storms of God's wrath (vv. 5–6). Thus 'the Law'—here echoing Erasmus and the Augustinian tradition before him—has become for them an enslavement: it has been 'lived under' rather than 'lived in'. The true Christian response—the path to virtue and true blessedness—is to meditate on Scripture as a free response to the voice of Christ.

> See that you always separate most widely and distantly the Law of the Lord from the laws of any men, and watch with all diligence that the two, confused in one chaos (as is done by the doctors of destruction), do not miserably destroy you. They either turn the Law of God into human tradition or human tradition into the Law of God.[84]

To 'delight' in the Law is not possible through human endeavour, but is rather a gift from God which comes through faith in Jesus Christ. In this way the Christian, imitating Christ and being given grace from Christ, is like the tree in the midst of the garden (v. 3) and that Christian will be exempt from God's wrath on Judgement Day (vv. 5–6). True blessedness, therefore, is in the Christian love of the Word of God, following the example of Christ who in his human life is the 'blessed man' above all men.[85] Like Erasmus, but in this case with a more doctrinal than tropological emphasis, Luther uses this psalm to voice the concerns which were leading to the break with Rome.

Because Luther's commentaries on the psalms spanned several decades, it is possible to see some development in the interpretation—from a more

[82] See Oswald 1974: 293. [83] See Oswald 1974: 293. [84] See Oswald 1974: 294.
[85] See Bauer in <http://ejournals.library.ualberta.ca/index.php/jhs/articles/view/5999> (pp. 1–6) and also, for the full commentary, see <http://www.ccel.org/l/luther>.

Christological reading to a more tropological approach, which becomes increasingly specific as the Lutheran churches bore some of the cost of the Reformation.[86] Psalm 2 offers us a good example of this progression in Luther's thinking: the first commentary appeared between 1513 and 1516, at the same time as Psalm 1, and here it applies to Christ alone, as Luther worked out systematically his theology of redemption by reflecting on the psalms.[87] The second commentary appeared between 1518 and 1519: it is fairly similar to the first commentary, with the typical commentary on vv. 1–2 accepting the references, based upon Acts 4, to Herod, Pilate, the Jews, and the Gentiles as 'enemies' of Christ. Nevertheless, at times his experiences with the Church's leaders at Worms only two years previously occasionally show through. Commenting on v. 4, for example, Luther states 'Anyone who wishes to be a sincere Christian ... will suffer his Herods, Pilates, rulers, kings, Gentiles, and other people who rage against him, meditate vain things, set themselves against him, and take counsel together. ... But he who sits in heaven laughs at them, and the Lord has them in derision ...'[88] Much of the comments on vv. 6, 7, and 12 follow Erasmus as Luther makes a clear distinction between the empty power of a monarchy and the spiritual power of the kingdom of Christ.[89]

By March 1532, when Luther turned again to Psalm 2, the tone is notably more harsh and direct. In the short preface the enemies are now named as the priests who make impious sacrifices, including the 'reprobate pope along with his doctors'. These are 'miserable times'. The introduction to the commentary again begins with Acts 4. However, on this occasion Luther notes how Psalm 2 was included in the very first words of prayer and thanksgiving sung to God by the New Testament Church, as the disciples 'prayed that in the face of such great perils and the great madness of the adversaries their spirits might remain steadfast and that they might preach the Word with confidence'. Through this psalm David ... 'console[s] and teach[es] the church about the spreading of Christ's kingdom in spite of the powers of the world ...'.[90] The ancient historical Jewish context is thus of no concern: it is David the prophet, speaking as Christ and in the Christian Church, which is of primary importance, and a clear bridge between the New Testament Church and the Protestant Christians in sixteenth-century Germany is thus created. Verses 1–2 of this commentary focus especially on the adversaries of the Church; and v. 7, on the kingdom of Christ and the kingdom of the world, with a fierce attack on Zwingli and Carlstadt along the way.[91] A bold

[86] The tropological reading in Luther is very different from that used by scholastic interpreters such as Gilbert and Peter. There the focus is more philosophical, analytical, and somewhat detached. Here, as also with Erasmus, this is more theological, pragmatic, and immediate.

[87] See Goldingay 1982: 47–8; Holladay 1993: 192–3.

[88] See Oswald 1974: 321. [89] See Oswald 1974: 328. [90] See Pelican 1955: 4–6.

[91] See Pelican 1955: 41–2.

definition of the 'decree of the Lord' is also given, by way of reference to the Hebrew word חֹק: this indicates the superiority of the decree of David (and hence ultimately of Christ) over the laws of Moses: God's eternal gift of his Son is superior to his temporary gift of the Law.[92] Much that follows uses the traditional arguments from Athanasius and Augustine about the meaning of 'today' referring to the incarnation of Christ, and the threat of the nations referring to the passion of Christ. Luther's overall view of this psalm is that if what the psalm says is true, then the allegations and aims of the papists are stark lies and folly.

Hence it is possible to see in Luther's treatment of Psalm 2 a development of his mode of exegesis overall: starting with a more idealized Christological reading, he increasingly appropriates a more pragmatic approach, which, by the 1530s, becomes even more urgent and impassioned: this is so different from the more theoretical, rhetorical, and measured approach of the scholastic exegetes, and is even more direct and particularized than Erasmus.[93]

Alexander Ales (Alesius) (1500–65) offers us a good example of the developing use of the psalms during the period of the *English* Reformation. Graduating from St Andrews in 1515, Alesius was 'converted' to the Reformation cause through the execution of Patrick Hamilton, Abbot of Fern, in 1528.[94] Imprisoned for his own views expressed at the Synod of St Andrews, Alesius escaped to Germany and from 1532 onwards spent time in Wittenberg with Luther and Melanchthon, at the time when Luther was writing a vast amount, from sermons, lectures, and commentaries, on the psalms. The so-called *Coburg Psalms* by Alesius—which was a commentary on the first twenty-five psalms—had been written (or rather, dictated, during his confinement in Coburg Castle) in 1530; his revision of the Psalter appeared in 1531. In 1532, just a week after his arrival in Wittenberg University, Luther began his lectures on the Psalms of Ascent (which lasted the entire academic year) at which it seems fairly clear that Alesius was present. The influence of Luther is evident in Alesius' classification of individual psalms as well as in Alesius' own commentary, which is more of a

[92] See Pelican 1955: 43–6.

[93] Luther has been described as 'a contextual rather than a systematic theologian, a biblical scholar who felt constrained to relate his findings to concrete situations relating to the issues of his age'. See Pak (2010: 37), citing Gritsch 1983: 266–7. Interestingly, in later commentaries Luther became more historically interested in the moral lives of psalmists *per se* and, like Martin Bucer, in a more typological reading where the life and kingdom of David foreshadows the life and kingdom of Christ. See Gillingham 2008a: 133–41, and related literature cited there. On Bucer's 1529 commentary on his reading of this psalm, see Pak 2010: 59, 61, 65, and 71; she terms him as another 'Christian Hebraist'.

[94] 'Conversion' is an appropriate term as the more scholastic Alesius had been commissioned to bring about Hamilton's recantation, but it was the latter's heroic convictions even at the stake which impressed Alesius beyond any academic argument.

tractate than anything verse-by-verse, and his Latin text is almost identical to what is found in Luther's works.[95]

So Psalm 1, following Luther's classification, is not a 'psalm of instruction', as might be expected, but a 'psalm of consolation', to strengthen the godly in times of oppression, and to chastise their persecutors: '*Primus Psalmus est παραινεσις quodam ex genere suasoris*'.[96] The psalm speaks about how the Law brings about judgement to those who are proud in their own achievements and blessedness to those who trust only in God's goodness, knowing they can never attain the Law's demands but only accept the mercy and forgiveness offered by the Gospel of Christ. The 'delight in the Law' is thus the result of being blessed, not the condition for it. Like Luther, Alesius identifies the 'wicked' in the psalm as the Jews; he also explicitly includes Catholics, Anabaptists, and any who trust the rites of religion to bring about salvation.[97] The psalm teaches us, therefore, about the nature of the True Church which is distinguished by its submission to the Word of God and by its submission to suffering on account of holding fast to that Word. The False Church includes those who apparently prosper but, because they do not submit to the Word of God but trust in their own religiosity, will eventually be brought down by the judgement of God. The whole psalm is thus a vehicle for reformed doctrine and a consolation for those who, suffering on account of it, will eventually receive the vindication for their trust and faith. They will be those truly 'blessed'. Alesius provides an intriguing example of the transmission of reformed doctrine from Scotland to Germany and so back to England.

If Luther's exegetical works on the psalms mark the beginning of his concern to reform the church, **John Calvin** (1509–64) produced his best-known commentaries near the end of his life. Much of his attention to psalmody had earlier been in encouraging metrical psalmody, first for the church in Strasbourg (1538–41), and then, until his death, for the church in Geneva.[98] Although the effects of this had been to enable the laity to memorize the psalms for themselves, so they were sung and prayed not only in worship but also at home and work (very different from the ways in which Latin plainchant, sung by cantors and skilled experts, prevented the laity knowing and using the psalms for themselves), what they were in fact singing were *paraphrases*—often with specifically Christian additions—rather than the text itself. Calvin, once a trained lawyer, with an orderly and systematic mind, and competent not only in Greek and Latin but also, through the aid of Hebraists

[95] Much of the information here has been taken from Wiedermann 1986: 15–41, who in turn has used the manuscript of Alesius' commentary on the psalms from the Cecil Papers at Hatfield House: see here Wiedermann 1986: 20, n. 37.

[96] See Wiedermann 1986: 25.

[97] See Wiedermann 1986: 38.

[98] For further discussions of this issue, see Chapter 6 'The Liturgy': 142. See also Chapter 8 'Christian interpretations': 207–8.

such as Louis Budé, adept at reading the original Hebrew, was ideally suited to fill that gap between paraphrase and textual exegesis. Much of his psalms commentary emerged from a weekly discussion group, *Congrégations*, near the end of his life, between 1555 and 1559: unlike Luther's, the comments on Psalm 1 are more pastoral than doctrinal.

Psalm 1 is in many ways the fruit of Calvin's many sermons on Psalm 119 in 1554—a period when Calvin, like Luther, had reflected upon the relationship between the Old Testament Law and the New Testament Gospel. Noting its place, without title, as a Preface to the entire Psalter, Calvin immediately applies the attainment of 'Blessedness' not to David, nor to Christ, but to his own congregation: 'The sum and substance of the whole [psalm] is, that they are blessed who apply their hearts to the pursuit of heavenly wisdom'.[99] What follows could not be more different from Erasmus' or Luther's reading of this psalm. There is nothing explicit on the doctrinal debates about the relationship between the Law and the Gospel. There is no indictment of misguided Jewish interpretation, nor any specific references to the abuse of 'the law' (i.e. Scripture) by Church leaders. The antithesis implied by 'the righteous' and 'the wicked' is not between Jews and Christians, nor between corrupt and genuine leaders of the Church in teaching and in practice; the antithesis here is that of the Church and world—between the godly, who know true happiness by pursuing heavenly wisdom, and the ungodly, who think they possess happiness but who are to discover that what they possess is a mere shadow of the real thing.

Occasionally Calvin refers to the psalmist as 'David', sometimes as 'the prophet': but other than brief observations about the meaning of the Hebrew for the three different stages of wickedness in v. 1 (the רשעים, the חטאים and the לצים), the emphasis and focus is entirely on the meaning of the verses for the congregation in Geneva. By learning a joyful and constant meditation on the Law (i.e. Scripture), they will receive the blessing from God (i.e. it is this which will make them blessed, rather than the result of any effort of their own) and it is this which will make them flourish like a tree: although the ungodly may also seem to be like trees by the water, they will be consumed by the tempest, deprived of their pleasures. By contrast, the godly, for whom 'happiness is the inward blessing of a good conscience', will remain secure. Even the discussion of the judgement of the unrighteous (or in Calvin's terms, the 'ungodly') in vv. 5–6 has no eschatological application, but is rather focused on this present life: 'According to all outward appearance, the servants of God may derive no advantage from their uprightness; but as it is the peculiar office of God to defend them and take care of their safety,

[99] Calvin's systematic approach to reading the psalms would usually be to look first at the meaning of the psalms in the life of David, then in the life of Christ, then in the life of the Church. This will be seen more clearly in his reading of Psalm 2.

they must be happy under his protection'.[100] The practical, contemporary application of this psalm could not be more clear.

Calvin's reading of Psalm 2 has some similarities with the way in which his near contemporary Martin Bucer read this psalm, although Calvin's historical reading, starting with understanding the psalm within the context of the life of David, is even more emphatic. Certainly a comparison between the ways in which Luther, Bucer, and Calvin read Psalm 2 highlights the emerging differences in the sixteenth century between 'Protestant confessional identities'—with Calvin making the greatest break with earlier Christian exegetical tradition.[101] The most obvious way this is seen is in their very different responses to Jewish tradition: we have seen how Luther occasionally uses Hebrew, but refutes the usefulness of rabbinical tradition because of his Christological reading of this psalm. Bucer, by contrast, uses both Hebrew and the rabbinical tradition, but does so in order to refute an exclusively historical David-centred reading of Psalm 2 in order to promote a Christ-centred reading instead. Calvin, by contrast, uses both Hebrew and Midrashic exegesis only to highlight the importance of a historical David-centred reading—without being dependent upon either rabbinical tradition or any Christological exegesis. Furthermore, Luther—at least in his earlier years—sees the Jews as enemies to the Church; Bucer, as a good Christian Hebraist, contends with them in order to persuade them of the error of their ways; but Calvin actually promotes Jewish exegesis and sees its emphasis on David as vital in feeding the faith of the Christian church. All this is evident in their individual exegeses of Psalm 2.

Turning to Calvin's approach to Psalm 2, we may note that, at the beginning of his commentary, his *titulus* starts with explaining that this is about David, whose kingdom is assailed by powerful enemies, who exhorts kings and rulers to lay aside their pride. He ends with this brief comment: 'All this was typical and contains a prophecy concerning the future kingdom of Christ.'[102] It is strange that the commentary on Psalm 1 had so little of this David-centred approach: there, the focus was mostly on encouraging the faith of the church in Geneva. But what is clear here in Psalm 2 is that Calvin himself *identifies* with the figure of David:

> . . . in considering the whole course of the life of David, it seemed to me that by his own footsteps he showed me the way. . . . As that holy king was harassed by the Philistines and other foreign enemies, while he was much more grievously afflicted by the malice and wickedness of some perfidious men amongst his own people, so I can say as to myself, that I have been assailed on all sides . . . but have

[100] The commentary has been taken from <http://www.ccel.org/ccel/calvin/calcom08.vii.html>.
[101] See Pak 2010: 125–8.
[102] See 'Psalm 2: Introduction', at <http://www.ccel.org/ccel/calvin/calcom08.i.html>.

always had to sustain some conflict either from enemies without or within the Church. . . . For although I follow David at a great distance, and come far short of equalling him . . . yet if I have any things in common with him, I have no hesitation in comparing myself with him.[103]

Whereas Erasmus and Luther preferred to start from the use of this psalm in the life of Christ and the New Testament Church, Calvin started and continued with the psalm in the context of 'David's kingdom' and only later applies it to 'Christ's kingdom'. So his commentary on vv. 1–2 starts with the conspiracies against David. A brief reference is made to Christ's conflicts with his enemies, but only halfway through this section does Calvin start to write about David's temporal kingdom as a shadow of Christ's eternal kingdom: here we may note the use of typology, but certainly not of allegory, for which Calvin had little taste. The commentary on vv. 4–6 has the same format: first David's suffering and then, close to the end, a comment on Zion and the Temple connecting this psalm with the kingdom of Christ. In vv. 7–8, Calvin's dislike of allegory is clear: the sonship declared in v. 7 first belongs to David 'who could with propriety be called the son of God on account of his royal dignity', and only later, through David the prophet, pertains to Christ, because he has been given a kingdom (as in v. 8) far greater than that of David. In v. 7 Calvin also disputes with the ways in which fathers and medieval exegetes used analogy and allegory to explain that the word 'begotten' means bringing into time what was once eternal. 'This expression, to be begotten, does not therefore imply that he then began to be the Son of God, but that his being so was then made manifest to the world.'[104] The commentary on v. 9 continues in the same way: first David's reign, then more particularly, Christ's reign are considered. So too vv. 10–11: first the submission of all rulers to David, and then the submission of all human pride to the authority of Christ. Verse 12 is interesting, for it assumes the translation 'Kiss the Son' and here only briefly considers the homage due to David, focusing mainly on the homage to Christ as the Son ultimately referred to in v. 7. The 'blessed are those' at the end of the psalm is simply a way of David tempering the severity of God's judgement expressed earlier in the psalm with a theme of comfort at the end of it: the commentary ends by explaining that the 'him' referred to ('Blessed are they that put their trust in him') may be a reference both to God and to Christ.

So throughout all this psalm, by implication, Calvin is constantly aligning himself with the figure of David.[105] In stark contrast to his reading of Psalm 1, and certainly in contrast to the ways in which Erasmus and Luther applied this psalm so much more directly to their own church communities, Calvin

[103] See 'The Author's Preface' at <http://www.ccel.org/ccel/calvin/calcom08.i.html>.
[104] See 'Psalms 2:7–8 at <http://www.ccel.org/ccel/calvin/calcom08.i.html>.
[105] The same point is made by Pak 2010: 87–91.

makes little reference to the sufferings of the Church in sixteenth-century Geneva. Because of this he never uses the same anti-Jewish rhetoric as Erasmus and Luther do in comparing the 'enmity' of the Catholics (and Anabaptists) with the hostility of the Jews. This, as well as his enjoyment of using Hebrew to make a David-centred point, gave him the title 'Calvinus Iudaizani'.[106] A more judicious term to use would be a later 'Christian Hebraist', with an empathy for the historical (Jewish) sense of the psalms as well as their typological significance within the Christian faith.

So again we are left with the question: did any of these reformers connect together these two psalms? In fact, only Erasmus (in his Preface to Psalm 2) discusses the relationship between Psalms 1 and 2. He starts with a discussion of the (more authoritative) New Testament passage, Acts 13.33, which as we have seen refers to Psalm 2 as the 'first psalm'. This clearly provides a problem: after some discussion Erasmus concludes that it is likely that Psalm 2 is continuous with Psalm 1.[107] The linguistic links between the two psalms, as well as the probable references by Augustine and Jerome (here, Erasmus is more suspicious of his sources) suggest, at the very least, that Psalm 1 forms the Prologue to the entire Psalter and that Psalm 2 is thus 'the first psalm' within the actual collection.[108]

In their actual commentaries on these two psalms Luther and Calvin add little more to Erasmus' judgement. However, a new slant is now evident in their exegeses, and this has a bearing on the relationship between Psalms 1 and 2. All three emphasize, to different degrees, the importance of an obedient faith in enabling the believer to survive the attacks of the impious inside and outside the Church. And they all agree—and indeed explicitly note—that what is taught in these first two psalms has much in common with what is found in Psalm 3, where, first, 'David' faces the taunts and threats of those who wish him ill, and, secondly, Christ Himself speaks as the innocent sufferer.[109] So, when taking the theme of God's protection of the righteous against the threats of the wicked (Pss. 1.6; 2.8–9; 3.8) the continuity is not only between the first two psalms, but between the first three.[110] This has some further implications as to how we understand not only Psalm 1, Psalm 2, and Psalms 1–2, but also Psalms 1–3 in relation to the rest of the Psalter: we

[106] See Pak, 2010: 103–24, on the debate between Aegidius Hunnius and David Pareus between 1593 and 1595 who made particular reference in their attack and defence of Calvin to his use of Psalm 2.

[107] See Heath 1997: 73.

[108] See Heath 1997: 73–5.

[109] See for example Heath 1997: 144–6 and 148–9: it seems that by the use of the 'I' form throughout Psalm 3 Erasmus interpreted the whole psalm as an allegory of the crucifixion, mirroring much of Psalm 2.

[110] The continuity between these three psalms was briefly recognized in earlier exegesis, for example in Gregory of Nyssa: see Chapter 3 'The Church Fathers': 52–3.

will return to these observations in Chapter 10 when we discuss the observations of psalms commentators over the last thirty or so years.[111]

CONCLUSION

This wide-ranging chapter, covering some thousand years, demonstrates just how much the context of the interpreter determines how these psalms are received. For Cassiodorus and Bede (and, later, Aquinas) the context was a monastic community: hence the positive and practical reading of Psalm 1, with its emphasis on personal and reflective prayer which was so appropriate for the *Opus Dei*; and hence the similarly positive use of Psalm 2, as a guide to doctrine and as a means of defending Chalcedonian orthodoxy in the Catholic churches in the West. Both psalms were understood to be mutually complementary, although they were rarely read together as one: nevertheless, the teaching on morality in Psalm 1 also required the more explicitly Christological teaching of Psalm 2 to give it a Christian emphasis, and the Christological concerns of Psalm 2 needed the moral world of Psalm 1 to give it roots in Christian discipleship.

Another context evident in the twelfth to fourteenth centuries might be called the 'lecture theatre'. Here these two psalms were read using rhetorical and scholastic approaches: obviously this still implied Christian assumptions, but its difference was that it was more open to questioning earlier tradition. One of the most important changes was a more systematic approach to each psalm: the *entire* psalm was read (as we noted was Jewish practice in the previous chapter) instead of selecting relevant verses from it. Gilbert, Peter Lombard, and Aquinas are all skilful in this respect. So the *accessus* informs us what to expect in this more holistic reading, and the form of the commentary focuses on textual and historical issues as well as theological ones. Here especially the Gloss was used, sometimes questioning earlier works: Ambrose, Augustine, Jerome, and Cassiodorus were especially used, although commentators from the eastern churches were frequently cited as well, and sometimes rabbinical works too.[112] Alongside this was an interest in tropological readings of Scripture as a whole: hence a greater emphasis was given to Psalm 1, not only because of its moral teaching but also because of its place in being a gateway to the Psalter.

A third context we noted in this chapter is the engagement between Jewish *yeshiva* communities and monastic schools of learning, particularly in

[111] See Chapter 10 'Literary-critical works': 273–88.
[112] This has some parallels with Jewish commentaries on psalms by way of citing ancient rabbinical tradition.

northern France and southern England. This encouraged a number of Christian commentators to learn Hebrew and to read these psalms in a way which started with an appreciation of Judaism rather than a denunciation of it. Herbert of Bosham and Nicholas of Lyra were leading figures in this respect. Here we find a detailed engagement with rabbinical tradition as well as with the Christian Gloss. Again, Psalm 1 (because of its emphasis on the Torah) and Psalm 2 (because of the way it had been read in the light of the Messiah) were crucial psalms in establishing such a dialogue.

Finally, another context was created by writers disenchanted with the Catholic Church: although they still initially wrote within their own (safe) setting, we noted a growing critique of the Church's abuse of power alongside an active support for the piety of the laity. This is a critical change from the position of commentators such as Cassiodorus and Bede, who were keen to preserve all forms of Catholic orthodoxy, and even used Psalms 1 and 2 to this effect. Fifteenth- and sixteenth-century commentators such as Erasmus and Luther were determined to expose the hypocrisy and undermine the overbearing teaching of the same Church, and ironically they too used Psalms 1 and 2 for this purpose. Another change is the way these reformers equated the Church's outdated and corrupt faith with the legalism assumed to be at the heart of the Jewish faith: so 'the wicked' in both Psalms 1 and 2, according to both Erasmus and Luther, were both Jewish and Catholic teachers who led astray those of obedient and simple trust in Jesus Christ. This could not be more of a contrast with the pro-Jewish works on these two psalms by, for example, Herbert of Bosham and Nicholas of Lyra.

There is some continuity with earlier medieval commentators: this is in the tropological reading of these two psalms, which emphasizes their more moral requirements. The commentator who uses this most is John Calvin, whose works always emerged from the pastoral care of congregations in Strasbourg or Geneva. In Calvin's writings, however, we find a rather different approach to Psalms 1 and 2; Calvin was most critical of the allegorical method, which as we have seen was widely used by commentators in both the western and eastern churches (and especially used by both Erasmus and Luther) in their search for hidden (Christian) meanings in these psalms. Instead Calvin preferred a typological reading, applying, first, a 'historical' David-centred way of reading each psalm and then, secondly, a 'theological' Christ-centred way of reading it. This of course allowed a greater appreciation of the Jewish roots of the psalms and distanced Calvin from reformers such as Erasmus and Luther. Calvin could still write about the temporal (Davidic) kingdom and the eternal (Christian) kingdom expressed within each psalm: but even so, this approach provided some dialogue between Jewish and Christian approaches to these two psalms.

So in the one and a half millennia of commentaries on these two psalms we may note a movement from very little reference to Jewish modes of reading

(in Cassiodorus and Bede) to greater engagement with them (in Herbert and Nicholas) to a harsh criticism (in Erasmus and Luther) to the possibility of some dialogue (in Calvin).

Thus far, we have only used the commentary tradition to highlight these different approaches: the next three chapters look beyond this to the 'performance' of psalmody in liturgy, music, and art. The following chapter on liturgy will yield some surprising results: these two psalms, so central in these last four chapters which have focused on the commentary tradition in both faiths, actually play only a small part in Jewish and Christian worship.

6

The Liturgy

INTRODUCTION AND OVERVIEW

'The liturgy of the church was often a powerful context within which . . . exegesis was carried out, with passages interpreted in relation to other passages used in the worship service for the same day. . . . Psalms were often sung or read during the liturgy and were interpreted within the context of the history of salvation (e.g. Psalms 2, 22, 110).'[1] So write Alan Hauser and Duane Watson in 'Introduction and Overview' to their second volume of *A History of Biblical Interpretation*. The same observation could apply to Jewish liturgy. Hence all that has been written in the previous chapters about Jewish and Christian exegesis should come to fruition in a chapter which looks at Psalms 1 and 2 in the context of private prayer and public worship: because these two psalms were so rich exegetically, one would expect to find the same resonance liturgically. Thus it is most surprising to realize that it is very difficult to find much evidence about how these two psalms were *actually* used in public worship and private prayer. There are some brief references in the early Christian period within the Ambrosian and Gregorian offices, and an illustration or two suggesting their more popular appeal; for Judaism, at least in the Talmudic and Gaonic periods, the evidence is even more scarce. In part this is due to the nature of the sources, which even when they inform us *that* these psalms were used rarely explain *how* or *why*; in part it is due to the fact that, perhaps surprisingly, Psalms 1 and 2 were just not as significant in liturgy as the quotation above implies. So this chapter will examine the extent of this near silence and seek to account for it.

This introduction is an overview of the problem, and this takes us back to the biblical period itself, for even there the actual use of these two psalms in worship and prayer is not at all obvious. Indeed, a good deal of scholarly discourse has taken place over recent years as to the part which Psalm 2, for example, might or might not have played in cultic worship by or for the king

[1] Hauser and Watson 2009: 6. A similar view is expressed in Barthélemy 1996: 206–18.

in pre-exilic times.[2] A similar veil of uncertainty shrouds our understanding of the role played by Psalm 1—it is now almost universally dated as post-exilic but there is a good deal of disagreement as to whether it was composed for use in the Temple, synagogue, or home.[3] Hence just as the liturgical development of both these psalms is unclear, so too is their liturgical origin.

A paradox is that both within the biblical period and beyond it is clear that there exists an obviously close relationship between psalmody and liturgy, first in Jewish tradition and in Christian reception history: it takes several centuries, however, before we can be certain which psalms were used when, and this applies to most of the psalms, not just Psalms 1 and 2. For example, in Judaism, and as early as Philo (20 BCE–40 CE), we find only general references to singing and hymnody in the synagogues in Alexandria.[4] Later Talmudic sources (despite the greater preoccupation with the Law than with liturgy) provide a little more specific evidence: for example, the *Tracate Soferim*, from the sixth century, lists some thirty psalms used in daily prayers and annual festivals.[5] A similar state of affairs exists in early Christian traditions: initially we have only the most general references to the regular use of the psalms in worship, starting with the New Testament which refers to the singing of psalms as hymns and prayers.[6] By the fourth century, the evidence is only a little more specific: in the Latin West, Church orders such as *Didascalia Apostolorum* and *The Apostolic Tradition of Hippolytus* point to the increasing use of the psalms, both in regular services and as 'Proper' psalms for particular festivals, and several references in the Church Fathers confirm this to be a growing practice; but the number of psalms cited is no more than

[2] Despite the traditional association of this psalm with David, its use in worship has always been a subject of debate. It is found, for example, in commentaries throughout the whole of the last century, including Briggs and Briggs 1906; Mowinckel 1982; and Eaton 2003. For a discussion of the issues and a compelling account of the place of Psalm 2 in pre-exilic worship, see Day 2004: 225–50.

[3] Here again the issue of Davidic authorship is set aside. The most prevalent scholarly view over the last century is that Psalm 1, with its emphasis on the personal meditation of the Torah, may well have been composed late and was not originally intended for use in Temple worship. For an overview of the diverse views of scholars on this issue, see Gillingham 2008c: 209–16.

[4] See Lamb 1962: 10, citing Philo *In Flacc* 14. This however records no psalms: it is difficult to ascertain how many psalms were used in synagogues in Talmudic times. Maher (1994: 22–3) argues that in this period synagogue liturgy was almost completely 'psalmless', the only clear group being Psalms 113–18, used in the Hallel at Passover time: Maher 1994: 14. This is found in *M. Pesach* 5.7 and 10.6, 17.

[5] The reference to the rabbinic preference for Law over Liturgy is taken from Hoffman (2002: 739) who makes the point that rabbinic tradition has nothing in it which corresponds with early Christian accounts such as the *Didascalia* or *Apostolic Consitutions*. On the *Tractate Soferim*, see Willems 1990: 411–13; Maier 1983: 74–5. One clear example is the use of Psalms 120–34 as a collection at the Feast of Tabernacles: see also *M.Sukkah* 5.4 and *M.Middot* 2.5.

[6] See for example Lk. 24.44; Eph. 5.19, and Col. 3.16. On the general liturgical use of the psalm in this early period see Box (1996: 4–5).

a tenth of the Psalter.[7] The same is true of the eastern churches, where *The Apostolic Constitutions* gives evidence of regular and specific morning and evening psalms, but these are few in number.[8] One exception is the growing practice of reading the whole Psalter during the course of a week, dividing it into twenty *kathisma* with some eight psalms in each—a practice from Byzantine liturgy, as early as Basil of Caesarea.[9]

By the sixth century, in both the western and eastern churches, two great liturgical traditions were clearly beginning to emerge, each testifying to the more central use of psalmody in Christendom in both public and private prayer. In one tradition Psalms such as 1 and 2 play a minor role: this is in the cathedral offices where specific psalms were recited (or sung, by *schola cantorum*) according to local liturgical prescription. The other tradition, illustrated in the Byzantine liturgy, is where Psalms 1 and 2 would at least have been used once a week: this is in the monastic offices where the whole Psalter was prayed through, *recitatio continua*, usually week by week.[10] A discernible pattern also begins to emerge in Jewish liturgy, albeit somewhat later, by the beginning of the Gaonic period, around the start of the eighth century. The *siddurim* (prayer books) reveal just how much the psalms are now being used at home and in the synagogue in daily and Sabbath prayers; the *maḥzorim* contain an annual cycle of 'holiday festivals', and here larger collections of psalms play a part. However, specific references to Psalms 1 and 2 are not to be found.[11]

This contrasts with the ways in which other psalms are now beginning to be used more specifically in each tradition: sometimes this is by choosing particular ('Proper') psalms for festival days, sometimes it is by using a group of psalms, and sometimes it is by selecting specific verses from a single psalm. Taking Jewish examples first, the most obvious are the so-called *Tamid* Psalms, apportioned in the Mishnah for daily use, a practice which may well go back to Second Temple times.[12] The fact that some of the Septuagint headings also refer to the same psalms being used on the same days—for

[7] See Lamb 1962: 31–2. The texts cited are from Justin, Irenaeus, Clement, Origen, and Tertullian. Tertullian's *Adv. Marc.* iii, 22 is particularly interesting in its reference to specific hours of prayer and Psalm 63 within them. See also Bradshaw 1992: 399–403.

[8] Psalm verses were more prominent in the Eucharistic Services while specific psalms were used in the Daily Offices, with Psalm 63 being used as the morning psalm and Psalm 141 as the evening psalm. See Lamb 1962: 47–54 (Eucharistic Services) and 54–63 (Daily Offices).

[9] See Gillingham 2008a: 50–1.

[10] See Box 1996: 5–6.

[11] See Hoffman 2002: 733–9.

[12] See Trudinger 2004: 1, 14–51, citing several later Mishnaic tractates which support this tradition (for example, p. 18, n. 19). The psalms are 24 for Sunday, 48 for Monday, 82 for Tuesday, 94 on Wednesday, 81 on Thursday, 93 on Friday and 92 for the Sabbath. The criteria for their selection may well be the Jerusalem/Zion themes implicit within them: see Trudinger 2004: 211–15. After the destruction of the Temple, they were used in the synagogue as 'daily Levitical psalms' as recorded in *M. Tamid* 7.4. See also Maher 1994: 10–13.

example Psalms 24, 48, 94, 93 and the Sabbath Psalm 92—suggests this was an early practice.[13] Examples of the use of collections of psalms would include Psalms 113–18 for the Passover, with Psalm 136, the Great Hallel, serving as an important addition.[14] Similarly Psalms 120–34, which were used at the Feast of Tabernacles, a practice which the Mishnah traces back to the Second Temple, became an important part of synagogue liturgy.[15] Psalms 145–50 were also often used in Gaonic times, especially in the daily round of hymns and prayers in the *Pesukei d'Zimra*, with Psalm 145 often used on its own in the afternoon service.[16] Examples of psalm verses gaining increasing popularity are those cited during the New Year Festival and the Day of Atonement: these are Psalms 29.1, 50.6, 94.16, 94.8, 81.7, and 82.5.[17] But there is nothing here to suggest the specific, regular use of either Psalm 1 or 2.

This pattern of the growing popularity of the selection of specific psalms, of collections of psalms, and of psalm verses is mirrored in Christian practice. For example, by the end of the fourth century a few individual psalms emerge as the most frequently used in both the cathedral and monastic offices, as seen by references in John Cassian's *Institutes*. In the monastic offices, Psalm 63 is the regular Matins psalm, while Psalm 93 is used for Vespers, and Psalms 148–50 for Lauds. In the cathedral offices, Psalms 51 and 90 are also evident as morning psalms, and Psalm 141, again, as an evening psalm.[18] One clear collection, as in Jewish worship, comprises Psalms 120–34, used continuously as Gradual psalms before Matins; a more scattered group of individual psalms (like the *Tamid* Psalms), evident by the early Middle Ages, is the 'psalms of penance' (6, 31, 37, 51, 101, 130, 143).[19] Specific verses include two from Psalms 63 and 141, used as Matins and Vespers psalms: for example, from Ps. 63.6: '. . . when I think of you on my bed, and meditate on you in the watches of the night', and from Ps. 141.2: 'Let my prayer be counted as incense before you, and the lifting up of my hands as an evening sacrifice'.

The two lists reveal an interesting correspondence between Jewish and Christian custom, with Psalms 148–50, for example, featuring in each

[13] See Maier 1983: 65–6.
[14] See Maher 1994: 14–15 (referring to several Mishnaic and Talmudic sources). See also Willems 1990: 406–10. On Psalm 136 see Willems 1990: 410.
[15] See Maher 1994: 15–16 (again referring to the relevant Mishnaic and Talmudic sources). See also Willems 1990: 410–11.
[16] See Maher 1994: 21, noting however the lack of clear evidence for this in Talmudic times. See also Maier 1983: 75–6.
[17] See Thoma 1983: 99–100, citing *bSuk55a*. Other psalms most frequently used are 30, a morning psalm; 6 and 130, in Tahanum; 104, at Rosh Hodesh, the beginning of a new month; 27, for times of repentance; 95, 96, 97, 98, 99, and 29, for Kabbalat Shabbat; and 19, 34, 90, 91, 135, 136, and 33, as Shabbat morning psalms. See Glazer 2008: 104–11, 118–45, and 146–85; see also Gillingham 2008a: 43–4, referring to Holladay 1993: 134–60.
[18] See Grisbrooke 1992: 410–14.
[19] See Lamb 1962: 105 and Gillingham 2008a: 113–14.

tradition.[20] But this brief survey also demonstrates two extraordinary omissions. Neither Psalm 1 nor 2 features in these accounts. Yet in both Jewish and Christian prayer, Psalm 1 would make an ideal psalm for morning or evening use ('on his law they meditate by day and by night'): but neither tradition makes any reference to it. In Jewish public liturgy, Psalms 1 and 2 together would be obvious choices for New Year and Memorial Days, and for the Day of Atonement, partly because of their emphasis on the Torah and the coming messianic kingdom, and partly because of their corresponding views on God's judgement of the wicked; but there is no evidence of such a practice. No specific reference is made to the liturgical use of either psalm throughout the Talmudic and Gaonic periods, neither in the *Tractate Sofarim*, nor in the *siddurim*, nor in the *machzorim*: given the amount of attention afforded to both psalms in the *Midrash Tehillim* and in the rabbinic commentators on the psalms by the Middle Ages, this is again most surprising.[21]

Similarly in Christian liturgy, from all that was written about Psalms 1 and 2 as a testimony to the two natures of Christ, one would expect to find them being used frequently in early liturgical offices, at Christmas, or the Feasts of Epiphany and Transfiguration, or Easter; yet the only clear reference in this earlier period is to the use of Psalm 2 at Eastertide by the late fifth century. Given the rich exegetical use of these two psalms by Christian commentators throughout this time, this minimal usage is extraordinary.[22] Neither psalm is cited as being used in liturgy by the early Church Fathers; nor do they occur as regular psalms in the early Church orders, and they do not feature as prominent psalms in the cathedral offices.[23]

In sum, the most that can be found in the first four centuries is in Christian worship, in the regular recital of these psalms as part of the recital of the Psalter as a whole at the eight daily offices. The *Psalterium Feriale*, dating perhaps as early as the end of the fifth century, and used mainly in the monastic (and occasional cathedral) offices, gives us the best evidence of this. Psalm 1 comes first in the eight different liturgical divisions of this Latin Psalter (Psalms 26 [*NRSV* 27], 38 [*NRSV* 39], 52 [*NRSV* 53], 68 [*NRSV* 69],

[20] See Werner 1959: 156–8, for a table of all the corresponding psalms used in the synagogue and western church: of the some forty psalms listed, neither Psalm 1 nor 2 is cited.

[21] Willems, 1990: 416–17, draws up a list of the psalms used in the Sabbath cycle, the weekly cycle and the festival cycle. Neither Psalm 1 nor 2 is found in any of them.

[22] This omission was also noted in Gillingham 2008a: 40–6, 47–55, 68–71, in an account of the liturgy of the psalms over the first fifteen centuries. The surprising absence of Psalm 2 in both Jewish and Christian liturgical practices was also noted (pp. 44–5).

[23] One exception might be Hipploytus' sermon on Psalms 1–2: see Chapter 3 'The Church Fathers': 48–9. Obviously the psalms are used in the rotation of the entire Psalter in the Divine Office: the two tables in Wallwork 1977: 49–52 and 53–64 show how Psalm 1 and 2.1–8 are used once at Christmas, Easter, and Pentecost, but this is taken from a nineteenth-century source and cannot tell us much about these psalms in this earlier period.

80 [*NRSV* 81], 97 [*NRSV* 98], and 109 [*NRSV* 110] begin the other divisions) and so it would be the first psalm to be used at Prime on Mondays (just as Psalm 26 [27] was regularly used for morning prayer on Tuesdays, Psalm 38 [39] for Wednesdays, and so on). Because Psalm 1 always began the collections, it is hard to know whether Psalm 2, without a superscription in most Latin versions, was read as if united with it or not: as we shall see in the following chapter, illuminations of these psalms in liturgical psalters from the ninth century onwards often only illustrate Psalm 1, or David as psalmist, rather than taking up the themes of Psalm 2 as well.[24] In Judaism, which in the early period did not normally follow this practice of praying right through the Psalter, the evidence is even less substantial than this.

FROM THE SECOND TEMPLE UP TO THE FIFTEENTH CENTURY

We now turn from this overview to a more detailed examination of Psalms 1 and 2, beginning with what evidence we can find of their use in **Jewish liturgy**. In the *Amidah* services, usually in the morning, afternoon, and evening, there is great emphasis on benedictions offered to God (with the repeated themes of the rewards for the righteous and punishment for the wicked, and the importance of keeping the Law). In the morning service this is made even more specific by the reading of the Torah, and, in the evening service, by the reading of the *Shema*. Yet Psalm 1 is neither cited nor alluded to: maybe this is because the focus is on God who is blessed, not the 'man' who is blessed by God; maybe it is because the example upheld in the psalm was not easy to emulate. Nevertheless, it is odd that this psalm is not used in the Torah liturgies, nor in the reading of the Torah on Sabbaths and festivals, even though several verses from other psalms (e.g. Pss. 34.4; 99.5–9; 148.13) are frequently used.[25] This is all the more notable because verses from the other two Torah Psalms—from Psalm 119 (for example vv. 153–4) and from Psalm 19 (for example, v. 14) are in fact regularly cited.[26]

The Mishnah is not an easy place to discover the psalms: in its six lengthy sections there are some forty references, usually indicating how certain psalms are to be used. There are perhaps two brief references to Psalm 1. One is to v. 1 in *Aboth* 3.2 (concerning those who speak without reference to the words of the law being likened to those who 'sit in the seat of scoffers') and the other to v. 5 in *Sanhedrin* 10.3 (which, referring to the judgement on

[24] See Chapter 7 'Introduction and overview': 158–60.
[25] See Donin 1980: 231–55; also Thoma 1983: 102.
[26] See Gillingham 2008a: 70–1.

Sodom as a foreshadowing of the ultimate judgement on the wicked, refers to 'the wicked and sinners not standing in the congregation of the righteous'). But neither reference testifies to their use in any specific liturgy.

The only clear liturgical adaptation of Psalm 1 is found in a very specific liturgy known as *Tu B'Shevat*, one of the four New Year festivals. Designated as a type of Arbour Day, or a ceremony of tree-planting, taking place on 15 Shevat (during January and February) the festival itself is found in the Mishnah, and is listed as a thanksgiving for trees.[27] It is difficult to know when the practice of reciting Psalm 1 at this feast began, but it is clear that in Jewish Kabbalism, *Tu B'Shevat* was expanded into a prolonged feast with the offering of seven types of crops, the partaking of four cups of wine, and the reading of the Torah. The citation of Psalm 1, due to v. 3, with its motif of the Tree of Life, which was applied not only literally but also metaphorically to the obedient Jew and to the Law, became part of this ritual. The feast recounts a story, which is itself an expansion of the blessings on trees taken from *Talmud Taanit* 5b. A weary, hungry, and thirsty traveller traverses the desert and comes upon a tree with luscious fruit and the offer of shade, under which runs a spring of water. The man eats the fruit, drinks the water, and rests under the shade. Before he leaves he blesses the tree in the words of *Taanit* 5: 'Tree, Oh Tree, with what should I bless you? Should I bless you that your fruit be sweet? Your fruit is already sweet. Should I bless you that your shade be plentiful? Your shade is plentiful. That a spring of water should run beneath you? A spring of water runs beneath you. There is one thing with which I can bless you. May it be G-d's will that all the trees planted from your seed should be like you . . .' After this Psalm 1 is read, evoking a picture of Eden restored through the giving of the Law, whereby the pious Jew reverses the curse of Adam by his meditation on the Torah by day and by night.[28]

As for Psalm 2, although we might expect to find citations of this psalm in the *Amidah*, the lack of evidence is surprising. Repeated themes in the *Amidah* are the kingship of God, the subduing of the wicked, the prayers for the restoration of Jerusalem and the establishing there of the throne of David, and God's continuing protection of his people—themes which are all found throughout Psalm 2. Yet nowhere does this psalm appear. Psalms 30, 100, 145, and 150, for example, are used in the morning prayer, with Psalm 145 also used for the afternoon service and Psalm 134 for the evening services.

[27] The quasi-liturgical use of Psalm 1 was discussed in the context of the *Kabbalah* tradition: see Chapter 4 'Jewish mysticism': 90–2. This was in the *Shimmush Tehillim*, dating back to the Middle Ages. In the previous reference the psalm was seen to have a magical quality in guarding against miscarriage (possibly because of the imagery of waters and fertility in v. 3). Another magical use, also on account of v. 3, is against trees shedding their fruit—see Magonet (1994: 6)—and this has associations with the practice noted here.

[28] Psalm 92.12–15 is also read because this associates the tree with the pious Jew, along with passages from various Midrashim which identify the tree as the Torah.

Psalm 2 is referred to perhaps twice in the Mishnah. It is alluded to in *Berakoth* 30b in the context of appropriate behaviour and posture in synagogue worship, remembering that one is 'standing before the King': Ps. 2.11 ('Serve the Lord with fear, and rejoice with trembling') is one of the references used. It is also found in *Sukkah* 5, again on the appropriate attitude in worship, in the context of waiting for the Messiah to come. Ps. 2.7 is noted: 'Ask of me and I will give . . .'. But as with Psalm 1, neither example offers any further insights into the use of this psalm in actual liturgy.

Psalm 2 is not even used in the minor liturgies at annual festivals. Its quasi-magical use in *Shimmush Tehillim*, which as was noted earlier may go back to the eighth century, shows a personal and private use: the psalm is used for the calming of a storm at sea or for a raging headache, but there is no evidence of any use of it in festivals such as *Tu B'Shevat*.[29]

So in Jewish tradition what little we know of these psalms pertains more to their use in popular piety rather than to any part of public liturgy. We turn now to the reception of these two psalms in **Christian liturgy** in the same period.

By the fifth century, a search for some Christian liturgical use of Psalm 1 yields a few results although there are some curiosities. For example, Ambrose of Milan (*c.* 339–97), for whom the psalms played a central place within daily cathedral worship in the fourth century, wrote as much about Psalm 1 as any other psalm: yet in the Ambrosian Offices there is one brief reference to it, in the way it starts the continual reading of the Psalter, at Matins on Mondays.[30] And in the eastern churches, John Chrysostom, whose famous dictum 'David, first, last and midst' illustrates the widespread use of psalmody in the monastic and cathedral offices, gives no explicit reference to Psalm 1 in his account of liturgy in the East. Psalm 141 is cited as an evening psalm, Psalm 63 is prescribed for morning prayer: but Psalm 1 is not referred to.[31] Similarly the *Master's Rule*, accredited to Basil of Caesarea, and the *Rule of Benedict* never allude to Psalm 1 in any of the discourses about prayer and liturgy. For example, Psalm 1 is absent in the Prologue to the *Rule of Benedict*, as well as in chapters 8–20, suggesting that, other than its commencing the continuous prayer of the Psalter, it was not a prominent liturgical psalm singled out for special use in the monastic offices.[32]

It is not until the Gregorian Offices were finally established that Psalm 1 receives minor attention in the cathedral offices, and here not just as the first

[29] See Chapter 4 'Jewish mysticism': 90–1.
[30] See Neale and Littledale 1874: 89. On the lack of any further reference, see Riain 2000: 7–35.
[31] As in *Apostolic Constitutions c.* 380 CE, Ambrose of Milan (*c.* 339–97) similarly testifies to Psalm 141 at evening prayer; Psalm 119 is used at morning prayer. But Psalm 1 is absent. See Woolfenden 1993: 88–94.
[32] See Gillingham 2008a: 52–4, on which psalms are actually cited in the Rule of Benedict.

of the psalms to be used in the continual prayer of the church. It is prescribed as a Proper psalm at Nocturn for a few feast days, such as Corpus Christi, and at the Feast of Agnes and Agatha, where various antiphons adapt the first two verses of this psalm.[33] In each of these cases the 'blessed man' is clearly the obedient Christian. The psalm is also prescribed, along with Psalm 2, at Matins on Easter Day, at the Feast of the Invention and Exaltation of the Cross, and again at the Feasts of the Crown of Thorns and of Spear and Nails: each of these cases shows the Blessed Man is now the obedient Christ: 'I am that I am, and My counsel is not with the wicked, and in the law is my delight'.[34] This is the very first clear example of the use of Psalm 1 anywhere in the formalized liturgy of the western churches.

Psalm 1 might be seen to have some popular lay appeal, for it played a part in enabling the laity to 'recite' the Psalter. The psalms were 'memorized' by keeping count through filling a pouch with 150 pebbles or tying a rope with 150 knots, and offering the Lord's Prayer, or a Hail Mary, after each psalm or every ten psalms. Psalm 1 belonged to a division known as the 'First Fifty': these were the veiled prophecies believed to be about the incarnate life of Jesus (the other two fifties being about his death and resurrection). Psalm 1 seems to have been particularly important here not only because of its primary place in the Psalter but also because of its supposed identification of the incarnate Jesus as the 'blessed man'.

By the fifteenth century this memorization of the psalms evolved into praying them through the *Mysteries of Mary*: the 'Three Fifties' were now the 'Joyful Mysteries' (Psalms 1–50), reflecting on the incarnation; the 'Sorrowful Mysteries' (Psalms 51–100), reflecting on the death of Christ; and the 'Glorious Mysteries' (Psalms 101–50), considering Christ's resurrection and ascension. For meditation on each of these liturgical subdivisions, a part of the psalm was recited: the 'Joyful Mysteries' were further divided into themes, the first being the Annunciation, using Psalms 1–10. For this Ps. 1.1–2 were the verses used.[35] The knotted rope became a string, first with wooden blocks, and then with beads added to it; from there came the rosary, with Ps. 1.1–2, by implication, originally heading up this entire prayer.[36]

When we focus on the liturgical use of Psalm 2, yet again the evidence is sparce. There are two specific references to it in the Ambrosian rites. The first is as a psalm to be used at Matins on Christmas Day, and the Antiphon is also from v. 7 of this psalm ('The Lord said unto me Thou art my Son, this

[33] See Neale and Littledale 1874: 89–90. [34] Quoted in Neale and Littledale 1874: 89.
[35] Ps. 2.8 was the verse from Psalm 2, and 3.4, 4.7, 5.3, 6.3, 7.8, 8.3, 9.6, and 10.12 the verses for the other psalms. So in this way Psalms 1 and 2 were read together, albeit in continuity with the other eight psalms.
[36] Psalm 1, however, never features in the *Office of the Dead*: given its position in the Psalter and its contents, not least its last verse, this is surprising. The most cited psalms in this Office are 16, 23, 31, 83, 88, 116, and 139. See Gillingham 2008a: 55.

day have I begotten Thee . . .'). The second is at Matins on the Feast of the Epiphany, in celebration of the Baptism of Christ, where the Antiphon is adapted from v. 7 in the Gospels' account of the Baptism: 'The Holy Ghost came in the form of a dove; the voice of the Father was heard, This is my beloved Son, in whom I am well pleased'.

The Gregorian Offices associate this psalm not so much with Christmas as with Easter: it is prescribed for Nocturn on Good Friday and on Easter Day. The Easter antiphons reflect the way some of the Church Fathers read this psalm: on Good Friday Ps. 2.2 is used ('the kings of the earth stood up, and the rulers took counsel together, against the Lord and against his anointed . . .'),[37] while on Easter Day v. 7 is used: 'I desired of my Father, Alleluia. . . . He gave me the Gentiles, Alleluia . . . for an inheritance, Alleluia.'[38] Psalm 2 is also prescribed for Nocturn at the Feast of the Invention and Exaltation of the Cross, the Feast of Spear and Nails, and the Feasts of Agnes and Agatha: in these lesser feasts, therefore, Psalm 2 was always used alongside Psalm 1, and always at Nocturn.

We are now left with the question of whether these two psalms were ever used together in Jewish and Christian worship throughout this period. In the Christian tradition of the continuous reading of the psalms we have already seen that Psalms 1 and 2 were used consecutively. In eastern practice this is especially evident in the twenty *kathisma* in eastern liturgies and in the traditions of reading the psalms as three fifties, again especially in the eastern churches. In the West, the psalms are used alongside each other in the continuous reading of the Psalter in the monastic tradition, and in the cathedral tradition, particularly in the Gregorian Offices, they are used together at Nocturn in some of the minor festivals. This reminds us of Hippolytus' admonition, in his *Homily on the Psalms*, that Psalm 1, concerning the incarnation of Christ, and Psalm 2, about the Passion of Christ, should be prayed together as a Prologue to what follows in the Psalter as a whole.[39]

One other distinctive example when Psalms 1 and 2 were used sequentially is at the Nocturn of the Feast of Confessors. Even the Antiphon used brings together both psalms: 'Blessed is this saint, who trusted in the Lord, preached the law of the Lord, and was set upon His holy hill . . .'[40]

Jewish tradition, because it uses this custom of sequential reading far less, offers very little evidence of these two psalms being used together in liturgy.

[37] An interesting antiphon for Psalm 1 at Easter is the citation of the first verse in the light of Exod. 3.14: 'I am that I am: My counsel is not with the wicked, and in the laws of the Lord is my delight.' For an explanation of the use of this term, identifying the 'blessed man' with God Himself and so with the incarnate Christ, see Waddell 1994: 515–16.

[38] See Neale and Littledale 1874: 97.

[39] See Chapter 3 'The Church Fathers': 48–9. See also Rondeau 1982: 27–34. On the way this affects the Christian liturgical use of the Psalter as a whole, see also Braulik 2004: 31–4.

[40] See Neale and Littledale 1874: 97.

But there is one interesting allusion, which corresponds with the way in which Psalms 1 and 2 have been brought together in an Antiphon at the Feast of Confessors. In Jewish worship the allusion concerns the regular liturgical use of אשרי, which is found at the beginning of Psalm 1 and the end of Psalm 2. Ismar Elbogen's *Jewish Liturgy: A Comprehensive Survey* refers to this word not as 'Blessed' but as 'Happy': it is a liturgical formula frequently referred to in the index at the back of his book, because it is used as part of several liturgies, including the morning benedictions, the afternoon service, the holiday festivals, and the 'days of awe'.[41] Initially, it is clear that what is being referred to in this אשרי ('Happy') formula has nothing to do with either Ps. 1.1 or Ps. 2.12, but instead is from Ps. 84.5 ('Blessed is the man whose strength is in Thee . . .'), an ideal psalm to use for entering a place of worship. This verse is then linked to the same formula in the last verse of Psalm 144, which in turn serves as an introduction the collection of liturgical psalms (145–150) which are read as part of the above services. Nevertheless, the use of אשרי in Ps. 84.5 should at least remind the worshipper of the same word in Ps. 1.1; and such a reminder is intensified when we observe that what follows this formulaic prayer in the *Amidah* is a brief liturgical interlude entitled 'A Redeemer will come to Zion'. This in turn is part of the order of the *Kedushah* which serves as a prayer in praise of the study of the Torah.[42] So what we have in this brief liturgical collection is a 'Blessed . . .' saying, a reference to the study of the Law, and a prayer for the restoration of Zion. These themes are closely related to those which link together Psalms 1 and 2, each with an אשרי saying. So although the psalms are not referred to explicitly, the theological motifs would undoubtedly remind the informed worshipper of the same themes in the two psalms which head up the Psalter.

FROM THE SIXTEENTH CENTURY TO THE PRESENT DAY

We turn, first, to the use of these two psalms in **Christian worship** in this later period. However, although the evidence here is somewhat greater than Jewish worship, it is still remarkably minimal when compared with all we have observed in the previous chapters about their importance throughout the entire medieval period, in both Jewish and Christian exegesis. Given the great commentaries on these psalms in the works of early reformers such as Erasmus, Luther, and Calvin, one would expect that, at least by the sixteenth century, their liturgical use might be more obvious. Yet, despite the fact that

[41] See Elbogen 1993: 71, 75, 99, 114, 127, 181, 214.
[42] See Elbogen 1993: 70, 99, 100, 114, 127, 214.

in the sixteenth century the status of psalmody in Christian worship became more significant than ever, and indeed evolved in a number of different ways which made it more accessible to the laity in the vernacular, specific references to Psalms 1 and 2 are again hard to trace.

In fact, the only evidence of the use of these psalms in Christian liturgy in England, particularly before the 1530s, is, as before, at Christmas (mainly Psalm 1), and at Easter (especially Psalm 2) as well as on a few saints' days. They were of course still used, in Latin, in continual recitation in monastic prayer: they would be used in various cycles of one day, one week, or one month, but even this ceased officially when monasteries and chantries were abolished under Henry VIII.[43] Throughout Henry's reign, in parish and cathedral worship, these two psalms featured as before: the changes to the actual liturgy, other than the prayers and Bible readings (and psalmody) being in English, were actually minimal at this time. Even after the Act of Uniformity in 1549 Cranmer's liturgical reforms gave little extra prominence to Psalms 1 and 2, because Cranmer chose to follow an English revision of the Roman Breviary and the Sarum Rite. There was however one significant difference: with Cranmer's reduction of the daily offices to only morning and evening prayer, all the psalms were now more frequently sung responsorially, in English, throughout the course of one month. The practice of 'lining out' became popular in parish churches, with the people repeating lines of psalms after the priest or cantor; court musicians, meanwhile, composed for royal patrons more complicated versions for use by *schola cantorum*.[44] Psalms 1 and 2 would occasionally have been used to this end. One such example from the sixteenth century is Thomas Tallis, who wrote compositions for eight psalms, taking the English words from Archbishop Parker's *The Whole Psalter translated into English Metre* (1567). Two of Tallis' compositions were on Psalms 1 and 2, although it is not clear that these were for specific liturgical

[43] It might be worth noting here that Henry used a *Latin* Psalter for his own private prayer, and 'glossed' it, in Latin, in many places. For example, in the margins of Psalm 1, which has an image of Henry in his bedchamber, dressed as a scholar king and meditating on the words of the psalm, is written, by v. 1, 'nota quis est' (note who is the Blessed Man); and by v. 4, 'nota quid de impiis' (note what happens to the ungodly). And next to Ps. 2.1 is written (in Latin) 'note the reward of those who rage'; and by vv. 10–11, where kings are charged to trust and fear the Lord, is a typical 'tadpole' sign to signify the importance of these verses for Henry as king. (For further information about this manuscript preserved in the British Library see <http://www.bl.uk/onlinegallery/onlineex/henryviii/musspowor/henryspsalter/>.)

[44] In many ways this is little different in its effect from the new experimentation with Gregorian plainchant some eight centuries earlier, where elaborations and embellishments also demanded highly skilled singers, thus suppressing congregational participation. By the sixteenth century, however, this resulted in a certain amount of dexterity by court composers such as William Byrd and Thomas Tallis, who were required under Mary to produce motets in Latin and, under Henry, Edward, and Elizabeth, to compose music for the more Lutheran-influenced prose–rhythmic version by Coverdale for Matins and Evensong. See Chapter 8 'Christian interpretations': 207 n. 53 (on Byrd) and 217–20 (on Tallis).

occasions; rather they were experimentations with the different musical modes of the psalms.[45]

Undoubtedly the liturgical use of psalmody throughout the sixteenth century was more prolific than it had ever been, and certainly more varied. As well as the 'lining out' of the psalms by whole congregations, psalm antiphons, in English or Latin (depending on the political climate) would have been sung by skilled singers. Under Edward, Coverdale's translation of the psalms in English was used and the emphasis was more on monthly recitation. Under Mary, Cardinal Pole reintroduced traditional Roman Catholic emphases which included the continuous weekly use of the entire Psalter (in Latin), later affirmed by the Council of Trent in 1562–3 and further encouraged by the publication of the 1568 *Roman Breviary*. Then there was the growth of the Reformed Churches in England and Scotland, promoted under Edward, demoted under Mary, and allowed again under Elizabeth, where congregations sang easily memorable English paraphrases of the psalms in metre and rhyme to popular tunes. 'Metrical psalmody' flourished in this period, and one version which stood out from the others was 'The Geneva Psalter' (so called because of its origins) or, more popularly, 'Sternhold and Hopkins' (because these two figures contributed several metrical psalms as early as the 1530s). This was published by John Daye in 1567, three years after the first *Scottish Psalter* was popularized in the Reformed Churches of Scotland (in part the work of John Knox, who had returned to Scotland from Geneva in 1559).[46] However, in all these three variant traditions—Catholic, Protestant, and Reformed—the popularity of Psalms 1 and 2 is difficult to determine. Other than both psalms occurring in those Metrical Psalters which produced versions of every single psalm, there are no singular versions of each individual psalm to suggest they had any exceptional use.[47]

By the end of the seventeenth century, the liturgical convention of praying through the entire Psalter, whether by the day, week, month, or year, was a

[45] We will look in more detail at these examples, and others referred to in later paragraphs, in Chapter 8.

[46] This had many psalms in common with the *Geneva Psalter*, and included different compositions by Sternhold, Hopkins, Whitingham, and Kethe, with some forty-six psalms of Scottish authorship. Several other metrical versions appeared: one was Coverdale's own *Goostly Psalmes and Spirituall Songs*, dating from 1535, but rejected (and indeed symbolically burnt) during the reign of Henry VIII in favour of his prose–rhythm version. Later, it was Henry Ainsworth's *Book of Psalms* (1612) which was taken by the Pilgrim Fathers to Plymouth, Massachusetts in 1620; George Wither's *Psalms of David* (1632); George Sandys' *Paraphrase upon the Psalms of David* (1636); and *The Scottish Psalter* in 1650. The best-known version is by Tate and Brady (1696) which eventually replaced Sternhold and Hopkins: see Gillingham 2008a: 151–3.

[47] We will examine significant metrical versions of these two psalms, starting with Luther's German and Calvin's French and better-known English metrical versions, in Chapter 8 'Christian interpretations': 207–20.

common practice, both publicly at Communion or morning and evening prayer, and privately as well. A well-known publication, intended to aid such recitation, was an edition of 'psalm collects' designed to be read after each psalm. Although mainly intended for continuous recitation of the psalms, they could also be used when the psalm was used for a specific liturgical purpose. These collects were intended to supplement the more general and traditional collects to be said at Matins, Evensong, and feast days: as the, Preface indicates, this was an ecumenical and irenic attempt to support the devotional reading of the psalms throughout the Universal Church.[48] The Collect after Psalm 1 reads:

> O Holy Jesu, fountain of all blessing, the Word of the eternal Father, be pleased to sow the good seed of thy Word in our hearts, and water it with the dew of thy divinest Spirit; that while we exercise our selves in it day and night, we may be like trees planted by the water side, bringing forth in all times and seasons the fruits of a holy conversation; that we may never walk in the way of sinners, nor have fellowship with the unfruitful works of darkness, but that when this life is ended, we may have our portion in the Congregation of the righteous, and may be able to stand upright in Judgment, through the supporting arm of thy mercy, O blessed Saviour and Redeemer Jesu.

The collect, beginning and ending with the name Jesu, takes the key themes of the psalm—the tree, the sinners, the judgement—and weaves these with other specifically Christian themes taken from the writings of the Fathers. Instead of the Law we pray for the Word and the Spirit; and instead of asking any blessing for ourselves, Jesus is the 'fountain of all blessing'. The collect for Psalm 2 echoes more the turbulent international affairs of the sixteenth and seventeenth centuries:

> O Blessed Jesu, into whose hands is committed all dominion and power in the Kingdoms and Empires of the World, out of whose mouth goeth a sharp sword, that with it thou mightest smite the Nations, and rule them with a rod of Iron, on whose vesture and on whose thigh a name is written, King of kings and Lord of lords; we adore thee in thy infinite excellency and most glorious exaltation, beseeching thee to reveal thy Name and the glory of thy Kingdom to the Heathen which know thee not, and to the uppermost parts of the earth, which are given thee for thy possession and inheritance. And to us give thy grace to serve thee in fear, and plant the reverence of thy law and of thy name in our hearts; lest thy wrath be kindled against us, and thou break us in pieces like vessels of dishonour. Have mercy on us, O King of kings, for we have put our trust in thee: thou art our Saviour and Redeemer Jesu.

[48] The reproduction by Gale ECCO Print Editions (2010) is taken from the twelfth edition in 1702; there were multiple contributors, and the author of the Preface is unknown: see *The Psalter of David; with Titles and Collects according to the Matter of each Psalm: Twelfth edition* 2010 (reproduced from the 1702 edition): 1–4 (on Psalms 1 and 2).

Although again this begins and ends with 'Jesu', there is no reference to Jesus as the 'Beloved Son' nor to the messianic connotations of this psalm. The key theme—using motifs borrowed as much from Revelation as from Psalm 2—is the might of Christ's kingdom over the rule of men. Some connection is also made between this psalm and Psalm 1, in the reference to the 'reverence of thy law', although the ultimate concern is about the affairs of this world, whereas the collect for Psalm 1 is more concerned about the world to come.

Another liturgical genre through which we encounter these two psalms in a later period still is the sermon. There is a close relationship here between sermons and exegetical works, for many homilies delivered for a particular occasion eventually were produced in a more universally available written form. For example, Augustine's and Calvin's exegeses of these psalms were often delivered through the medium of preaching and teaching in the churches under their care. One of the first appearances of Psalms 1 and 2 is in a collection of extensive homiletical notes by John Wesley (who also wrote at least one metrical version of Psalm 1). Wesley usually took two or three key words from each verse ('Blessed' . . . 'Standeth' . . . 'Day and Night' . . . 'Wither' . . . 'Chaff' . . . 'Judgement' . . . 'Knoweth') and developed each of these further.[49]

In the latter half of the nineteenth century, a particularly well-known liturgical example of the 'sermon medium' which focused entirely on the psalms is the non-conformist preacher Charles Spurgeon's *Treasury of David*, which comprised weekly sermons published over a twenty-year period. The exposition of Psalms 1 and 2 is shrewd and practical, giving close attention to the details of the English text. For Psalm 1, for example, Spurgeon speaks of the Christian's delight as being 'in' the law but not being 'under' it; he refers to the tree which is 'planted'—chosen, cultivated, secure, not wild; and to the 'ungodly' who, although the least offensive of the sinners in the first verse, are those blown away like chaff in the third verse. Spurgeon's explanatory notes, 'quaint sayings', and 'hints to the village preacher' show his skill as a teacher as well as preacher. His exposition of Psalm 2 is particularly forceful: the psalm is about the Messiah the Prince, and sets forth in a vision 'the tumult of the people against the Lord's anointed and God's determinate purpose to exalt his own Son, and the ultimate reign of that Son over all his enemies'. The exposition takes up phrases such as 'God laughing' at the ravings of the wicked, and the phrase 'Thou art my Son'. Both educated laity and preachers serving an illiterate audience would have gained from the clarity and simplicity of these sermons, first preached at New Park Street Chapel in Southwark and then published as weekly

[49] John Wesley's sermon notes are found on <http://www.christnotes.org/commentary.php?com=wes&b=19&c=1>.

instalments in London Metropolitan Tabernacle's periodical, *The Sword and the Trowel*.[50]

Spurgeon's congregation and readership were conservative and evangelical, with a clear concern to apply these first two psalms from liturgy to life. Other nineteenth-century preachers, writing with a different emphasis, were the Tractarians: John Keble, for example, used the poetic medium of the psalms as means of teaching the laity,[51] while John Neale was more interested in emulating and recording the piety of the early Fathers in their use of the psalms.[52] A most interesting contrast with Spurgeon is a sermon on 'Christian Reverence' by Cardinal John Henry Newman, also using Psalm 2 (starting with v. 11, 'Serve the Lord with fear and rejoice with trembling'), preached somewhat earlier than Spurgeon's sermons, on 8 May 1831. The central theme is similar, although the touch is more subtle and refined: Newman's emphasis is on worldly opposition to Christ and the need for Christians to submit themselves in quiet reverence to Christ's Kingly Rule.[53]

We now turn to the more recent use of these two psalms in Christian worship in the twentieth century. Just as was the case some four hundred years earlier, this century saw a plethora of liturgical reforms and vernacular translations which promoted the use of psalmody in worship. In the sixteenth century, the singing of the psalms helped to advance a sense of the Universal Church throughout a divisive period in Church history; in the twentieth century, they played a similarly formative role in promoting a more modern form of ecumenism.[54] However, with hindsight, these reforms sometimes had a detrimental effect on psalmody. This was in part because of a tendency to be increasingly selective as to which psalms (or parts of psalms) were appropriate for public worship, and this undoubtedly reduced the significance and impact of the Psalter as a whole. It was also due to the lengthening of the period for the recitation of the Psalter as a whole. The fates of Psalms 1 and 2 mirror some of this liturgical change.

[50] Taken from *The Spurgeon Archive* at <http://www.spurgeon.org/treasury/treasury.htm.>.

[51] We shall refer to this in Chapter 9 'Christian translation, paraphrase, imitation, and allusion': 251–2.

[52] Neale and Littledale's research on the Gregorian Offices was referenced in the earlier part of this chapter: see Chapter 6 'From the Second Temple up to the fifteenth century': 137–8, nn. 33, 34, 38, and 39.

[53] Newman's sermon, inspired by Psalm 2, is found at <http://www.newmanreader.org/>. Another feature of churchmen such as Keble, Neale, and Newman was their composition of psalm-like hymns, mirroring the eighteenth-century Methodist tradition associated with the Wesleys. The Tractarian *Hymns Ancient and Modern* was first published in 1861; the second edition was in 1875. Although several psalms feature in this version, Psalms 1 and 2 are again absent.

[54] The later century has also been associated with a second concern as far as the psalms are concerned, namely, the mission of the Church. This resulted in many 'contemporary' translations and paraphrases of the entire Bible, including the psalms. Because the context is less explicitly liturgical, but still includes many literary imitations of the psalms, some of these will be discussed in Chapter 9 'Christian translation, paraphrase, imitation, and allusion': 252–60.

Ecumenical concerns were at the heart of the conference on Faith and Order at Lausanne (1927) and the establishment of the World Council of Churches (1948). Such interdenominational liturgical initiatives between the Protestant, Reformed, and Orthodox churches (and, after 1968, the Catholic Church as well) involved debates about the place of psalmody in worship: it was amid these discussions that the increasingly selective use of Psalms 1 and 2 came about. For example, the 1928 Prayer Book of the Anglican Church was the first to recommend a more selective and reduced use of the continual reading of the psalms. In time, seven weekly cycles (1948) and then ten weekly cycles (1980) were proposed, and the number of verses to be used from any one psalm was also reduced; similarly the number of psalms to be used in one liturgical reading was made less; and verses from a psalm which were deemed inappropriate on account of any nationalistic and vindictive references were bracketed out. So less liturgically advantaged psalms, such as 1 and 2, undoubtedly suffered;[55] one clear consequence for Psalm 2 was the 'bracketing off' of the more military and violent vv. 9–11.[56]

The ebb and flow of psalmody is equally evident in twentieth-century liturgy. For example, the Joint Liturgical Group (1963), which involved both Protestant and Reformed Churches and which published *The Daily Office* in 1968, built upon some of the recommendations made in the 1928 Prayer Book and advocated a new lectionary for the use of the psalms at morning and evening prayer, Communion, and the Daily Offices: in this case the Psalter was now to be read through just four times a year. *The Revised Psalter*, produced in 1963 (under Archbishop Fisher with T. S. Eliot and C. S. Lewis as often dissenting literary consultants) was to accompany *The Daily Office*; but this version lacked any sense of inclusive language (a matter which affected Psalm 1, starting with 'Blessed is the *Man* . . .'), which was becoming a pressing issue. Hence the use of the psalms, now read over a longer period of time, was still felt to be in need of further reform.

The Liturgical Commission of the Church of England (1972) thus commissioned another Psalter: this time the team of experts first translated directly from the Hebrew and gave agreed versions to David Frost, who chaired the commission; he then produced a psalm in a style which was to emulate Coverdale for the twentieth century. *The Psalms: a New Translation for Liturgy* appeared in 1977: it was to accompany the new *Alternative Service Book* (1980). Frost writes about the problems and possibilities created by a project such as this: the difficulties of word order, of stress, and word endings, and of generally creating a liturgical rhythm; the avoidance of a

[55] This is illustrated in the increasingly reduced role they have in lectionary prescriptions, as we shall see below.

[56] Some twenty-seven psalms suffered this fate, as well as the total omission of seven others.

literal 'metaphrase' and a liberal 'imitation' while trying to create a 'high poetic style'.[57] Furthermore, there was the challenge of knowing whom this version was really for: psalmody in cathedral liturgy sung by skilled choirs was obviously different from psalmody in the parish church sung by the entire congregation, and a version for singing the psalms is different from one designed for chanting them or reading them in private. Frost avoided what he sardonically called 'pious fibs' in the Christianizing of the psalms, translating them without recourse to this secondary meaning; he also advocated avoiding some of the cursing and jingoistic psalms in contemporary liturgy.[58] Unlike Coverdale's version, this 'new version' was only intended to be used for ten years, and it actually survived for twenty. For Psalm 2, verses 9–11 were still 'bracketed off', but with more flexibility about its possible use in worship; as for Psalm 1, the issue of inclusive language was still not resolved: Frost's version still starts 'Blessed is the man . . .'.

A 'gender sensitive' as well as 'politically correct' version of the psalms was felt to be required, and Psalms 1 and 2 were undoubtedly relevant in both these debates: the 'gender' issues were problems for the beginning of Psalm 1, and the 'political' issues were difficulties for Psalm 2, with its imagery of the nations being broken with a rod of iron. The version of the psalms chosen to accompany the new Prayer Book of the Church of England (*Common Worship* [2000]) was an adaptation of the *ECUSA Psalter* from America (1979, revised in 1992 and 1997). This project was chaired by David Stancliffe in consultation with another team of Hebraists. Known simply as *The Common Worship Psalter*, its main concern was again to modernize the cadences of Coverdale while removing many of the archaisms and introducing more inclusive language.[59]

So over the last century, within the Church of England alone, there have been four editions of liturgical psalters—that of Coverdale in *The Book of Common Prayer*, *The Revised Psalter*, *The Liturgical Psalter*, and *The Common Worship Psalter*, of which the most radical is the last, which allows for a whole psalm or part of a psalm to be used on its own, or with a refrain, or as part of a liturgy with an additional collect. The *Common Worship* version of both psalms shows the extent to which the more difficult verses have been revised:

[57] We shall deal with some of these issues in Chapter 9, on literary imitations of the psalms.

[58] See Frost 1981: 10–25, 26–39.

[59] This version has had its critics. See, for example, Toon (2003: 126–8), who argues that by omitting the word 'man', 'Jesus Christ has been excluded from the very Psalter which was his basic prayer book and from which he used prayers at critical moments in his life and ministry'. The 'Man' is Jesus: '. . . and the Psalm has been taken as introducing the whole Psalter, with the result that Jesus is here established as the One to whom the whole Psalter witnesses' (p. 126).

Psalm 1 in *The Common Worship Psalter*
Refrain: The Lord knows the way of the righteous.

1 Blessed are they who have not walked
in the counsel of the wicked, •
nor lingered in the way of sinners,
nor sat in the assembly of the scornful.

2 Their delight is in the law of the Lord •
and they meditate on his law day and night.

3 Like a tree planted by streams of water
bearing fruit in due season, with leaves that do not wither, •
whatever they do, it shall prosper. *R*

4 As for the wicked, it is not so with them; •
they are like chaff which the wind blows away.

5 Therefore the wicked shall not be able to stand in the judgement, •
nor the sinner in the congregation of the righteous.

6 For the Lord knows the way of the righteous, •
but the way of the wicked shall perish.
Refrain: The Lord knows the way of the righteous.

Christ our wisdom,
give us delight in your law,
that we may bear fruits of patience and peace
in the kingdom of the righteous;
for your mercy's sake.[60]

Psalm 2 in *The Common Worship Psalter*
Refrain: The Lord is the strength of his people,
a safe refuge for his anointed.

1 Why are the nations in tumult, •
and why do the peoples devise a vain plot?

2 The kings of the earth rise up,
and the rulers take counsel together, •
against the Lord and against his anointed:

[60] We may note how v. 3 is now just one verse, as in the Hebrew, rather than two verses, as in Coverdale. There is also an additional 'psalm collect' for this psalm: *Christ, our fountain of living water, welling up to eternal life: as by your obedience many were made righteous, so may we delight in your commandments and flourish in your way; who live and reign, now and for ever. Amen.* This whole version is found online at <http://www.churchofengland.org/prayer-worship/worship/texts/daily2/psalter/psalms1to25.aspx#1>.

3 'Let us break their bonds asunder •
and cast away their cords from us.' *R*

4 He who dwells in heaven shall laugh them to scorn; •
the Lord shall have them in derision.

5 Then shall he speak to them in his wrath •
and terrify them in his fury:

6 'Yet have I set my king •
upon my holy hill of Zion.' *R*

7 I will proclaim the decree of the Lord; •
he said to me: 'You are my Son; this day have I begotten you.

8 'Ask of me and I will give you the nations for your inheritance •
and the ends of the earth for your possession.

9 'You shall break them with a rod of iron •
and dash them in pieces like a potter's vessel.' *R*

10 Now therefore be wise, O kings; •
be prudent, you judges of the earth.

11 Serve the Lord with fear, and with trembling kiss his feet, •
lest he be angry and you perish from the way,
for his wrath is quickly kindled.

12 Happy are all they •
who take refuge in him.
Refrain: The Lord is the strength of his people,
a safe refuge for his anointed.

Most high and holy God,
lift our eyes to your Son
enthroned on Calvary;
and as we behold his meekness,
shatter our earthly pride;
for he is Lord for ever and ever.[61]

[61] This version is found online at <http://www.churchofengland.org/prayer-worship/worship/texts/daily2/psalter/psalms1to25.aspx#2>. Again the psalm has been preserved in its twelve verses as in the Hebrew; Coverdale had thirteen.

The Church of England is of course only one of several denominations to have produced editions of psalters throughout the last century. The Roman Catholic Church, for example, has also produced its own versions. First, the Pontifical Bible Commission was commissioned by Pope Pius XII to produce a more refined Latin edition of the Vulgate (1941). This appeared in 1945, and was used mainly in the Daily Offices. Secondly, an English version of the Psalter, for private reading, appeared in 1947: the work of Ronald Knox, this supplanted the *Douai-Rheims* version of 1609. Thirdly, an enormous influence on the popular use of psalmody in liturgy—beyond the Catholic Church—has been *The Gelineau Psalter*, translated from the French into English in 1969.[62] Joseph Gelineau developed a format known as 'sung speech' (here again one traces the influence of Gregorian plainchant), with a stress of two, three or four beats each line, into which the syllables of each psalm verse could fit. It also made great use of psalm antiphons: these were usually set in 2.4 time, and allowed a certain predictability so that congregations could participate and respond to the lead by more experienced cantors. Gelineau's skill was to achieve congregational participation and yet avoid the pitfalls of metrical psalmody, which often resulted in a poetic and aesthetic compromise: here the performance is both traditional and easily memorable.[63] *The Grail Psalter* (an inclusive language psalter published in 1963, taken from *The New Jerusalem Bible*, revised in 1984 and 1993) adapted some of Gelineau's plainsong psalms, thus boosting its popular appeal. A fourth Catholic version of the Psalter has been the most controversial: called *The ICEL Psalter* (1995), it went further than most in its radical gender-inclusiveness. A comparison of Ps. 1.1–2, using *The Gelineau Psalter* (set out in three-beat rhythm) and *The ICEL Psalter* (which is succinct to the point of seeming terse and abrupt) shows these differences very clearly, and hints at the attendant theological issues which arise out of them:

> Psalm 1: *Gelineau* (noting the three-beat rhythm)
>
> Háppy indéed is the mán
> who fóllows not the cóunsel of the wícked;
> nor língers in the wáy of sínners
> nor síts in the cómpany of scórners
> but whose delíght is the láw of the Lórd
> and who pónders his láw day and níght.

Psalm 1: *ICEL*

If you would be happy: never walk with the wicked, never stand with sinners, never sit with cynics, but delight in the Lord's teaching and study it day and night.

[62] We shall assess in more detail the actual musical rendering of Gelineau psalmody in Chapter 8 'Christian interpretations': 225–8.

[63] A comparable contribution to the place of psalms in worship is Roger Schutz and the Taizé Community established in the 1940s.

It is interesting to compare not only the translations but also the liturgical potential in each of these psalters. Some—for example, *The Liturgical Psalter* (1977)—were a modest but, in terms of the poetic value, successful, updating of Coverdale; others—for example, *The Revised Psalter* (1963)—were more concerned with political correctness and the negative effect of using, for example, cursing psalms in public worship; others—for example, the *Ecusa Psalter* (1979)—were concerned as well with gender-inclusiveness, which in turn raised theological issues when the words of the psalm which previously were deemed to apply to Jesus (as the Blessed Man in Psalm 1; as the human and divine king in Psalm 2) were now applied to everyone.

The versions noted here, focused on Anglican and Roman Catholic innovations, are just eight of many. There are at least twenty more editions of liturgical Psalters—some further translations of psalms, but mostly adaptations along the lines of metrical psalms. Another feature in the latter part of the last century was a number of more ecumenical and contemporary 'hymns' from the psalms: the most influential include *Psalms Praise* (1973), *Psalms for Today* (1990), and the *Selah Psalter* (2001). Overall, it is clear that reading and praying the psalms in public liturgy, in a variety of church traditions, is still very much a going concern.[64]

So what of the regular use of Psalms 1 and 2 within these many liturgical performances? We have seen in the above examples that they have been repeatedly translated and adapted, but this has mainly been because they are part of versions of the entire Psalter. At this point, by way of concluding over four hundred years of liturgical tradition and innovation, we end by echoing where we began, in the very earliest formative years of the Christian churches. A survey of most of the recent English-language lectionaries stating the practice of psalmody in the most prominent denominations (Protestant, Catholic, Free Church and Orthodox) furnishes the same results: whatever we may make of the rich exegetical life of these two psalms, their liturgical value has always been limited. They occur infrequently in the lectionary traditions of all these four Christian denominations.[65]

If we compare the traditional lectionary in *The Book of Common Prayer* with the more recent lectionaries in *The Alternative Service Book* and in *Common Worship* we can observe this trend more clearly. In the former, Psalm 2 (along with Psalms 57 and 111, somewhat curious choices) is to be

[64] It is impossible to give examples of Psalms 1 and 2 from all these versions, many of which are also used in the Free churches. But Psalms 1 and 2 feature alongside each other as nos. 62 and 63 in *Psalm Praise*, for example. A most helpful website is <http://hymnal.oremus.org/>: searching for 'blessed is the man' or 'why do the nations' produces several results. For a further survey on these issues, including further discussions of innovations by the Methodist churches and of the continuous use of the psalms in Orthodox Liturgy, see Gillingham 2008a: 154–64.

[65] This survey was undertaken by using the websites of these four denominations.

used at Matins on Easter Day.[66] This is its only use as a 'Proper' psalm. Psalm 1, by contrast, is never used as a Proper psalm. However, each is used of course in the monthly reading of the Psalter as a whole. In the lectionary for *The Alternative Service Book*, they are prescribed together (Years 1 and 2 are the same) at either morning or evening prayer three times a year—before Christmas and after Easter and Pentecost. Psalms 1, 2, and 3 are used together three other times in the liturgical year at these services. Psalm 1 is now used as a 'Proper' psalm, at the Feast of Joseph of Nazareth (19 March); and Psalm 2, at Epiphany, with Psalm 8. The prescriptions for their use at Holy Communion result in each psalm being used once before Christmas, and Psalm 1 also for the Feast of Commemorating the Death of a Bishop (*sic*) and Psalm 2 at Holy Cross Day (14 September) and whenever prayers are offered for the missionary work of the Church. Once Ps. 2.1–8 is given; another time the whole psalm is set.[67] In the lectionary for *Common Worship*, these two psalms fare even less well than before. Psalm 1 is used as a Proper psalm for the Feast of St Barnabas (11 June); Psalm 2, for the Feast of the Holy Cross (14 September), as one of three psalms. It is no longer used as an Easter psalm, although the first part of it can be used for the mission of the Church. Otherwise each psalm features no more than four times at the Principal, Second or Third Service for Years A, B or C—i.e. no more than once a year.[68]

In the Orthodox churches, the situation is only a little different: Psalm 2 is used on Christmas Eve, as the Gradual psalm before the Epistle, and it also is prescribed as the psalm at Vespers on Maundy Thursday and for the First Hour of Prayer in the Good Friday Liturgy.[69] Psalm 1, however, does not feature as a Proper psalm. It is used as a Gradual psalm on the first Monday in Lent and part of it is used as an antiphon on September 1st and on Christmas Eve. The main appearance of these two psalms is leading the first of the monthly readings of the twenty *Kathismata* (Psalms 1–3, followed by Psalms 4–6 and 7–8).

There is also little difference in the Roman Catholic lectionaries which prescribe the specific use of these psalms. The Roman lectionary prescribes Psalm 1 on the second Friday of Advent and the Thursday after Ash Wednesday, because of its teaching on the two ways (Deut. 30.15–20 being the Old Testament lesson); also for the Thursday of the second week in

[66] See <http://www.churchofengland.org/prayer-worship/worship/texts/the-calendar/lect/altpsalms1.aspx>.

[67] Taken from *The Alternative Service Book 1980* (Oxford: Oxford University Press, 1980): 983–1091.

[68] Taken from <http://www.churchofengland.org/media/41133/mvlectionary524–591.pdf>. For a similarly minimalist situation in the Episcopalian churches in America and Canada, where the only notable difference is the use of Psalm 2 at the Feast of Transfiguration, see Van Harn and Strawn 2009: 50–5 and 55–8.

[69] We shall look at Rachmaninoff's setting of Psalm 1 for the liturgy of the Russian Orthodox Church in Chapter 8 'Christian interpretations': 226–30.

Lent, with Jer. 17.5–8, 10 as the set lesson; and for the Thursday of the 29th Week in Ordinary Time, when its teaching on 'bearing fruit' is used with Rom. 6.19–23 as the New Testament lesson.[70] But neither psalm is used regularly at morning or evening prayer, nor prominently at the Mass, nor at marriages or funerals (even though these are rich in other antiphons). Nor is either psalm deemed as one of those 'suitable for singing throughout Catholic Liturgy'.[71]

Finally, although the Free Church tradition adopts a less prescriptive lectionary, *The Methodist Worship Book* (1999) confirms a by now familiar picture. Neither psalm is found in morning or evening prayer, nor for baptisms, marriages, funerals, nor at the seasons of Christmas and Easter.[72]

So as far as Christian liturgy is concerned, these two psalms play a minimal explicit role, and of what little is prescribed not all would necessarily be applied. The reasons for this are not entirely clear: the personal elements of the first psalm, with its emphasis on the Law, and the more nationalistic and aggressive elements of the second psalm may have something to do with it.

We now turn to the use of these psalms in the last four and a half centuries of **Jewish worship:** here there is even less evidence for the specific use of Psalms 1 and 2 than there was in the earlier period. This may be in part because liturgical reform took place a good deal later in Judaism than in Christianity, and in part it may be the result of a longer period of assimilation into English culture. *The Translation of the Hebrew Prayers and Services into English*, by David Levi, was published as late as 1789–93; Levi's translation of the *Seder* was in 1794. This English version included several psalms: but neither Psalm 1 nor 2 was among them. Daily psalms used from Sunday to Sabbath, i.e. Psalms 24, 48, 82, 81, 94, 93, and 92, are evident, as also those prescribed for the *Amidah* (for example, Psalms 30, 145–150, and 100 in the morning, and 134 in the evening). Psalms 29 and 95–9, for example, are found in the *Seder*, as well as Psalms 112–18 for Passover, Psalm 7 for Purim, Psalm 30 for Hanukkah, and Psalms 103 and 150 for the Day of Atonement. This list could expand to some thirty other psalms; but Psalms 1 and 2 are absent from it.

The first publication of all the psalms in English was part of a Reform Judaism initiative to translate the whole of the Hebrew Bible, undertaken by Isaac Leeser in 1852; but its aims were not specifically liturgical, and added

[70] Taken from 'The Psalter' in *The Bible and its Traditions*, the reception history project of the École Biblique, at <http://www.bibest.org/demonstrationvolume>.

[71] In fact, neither psalm is referred to at all on the website <http://www.catholic-resources.org/Lectionary/1998USL-Psalms-Alleluias.html.>, although the Gelineau version of Psalm 2 adds the note that it is used at Christmas, Palm Sunday, Holy Week, Christ the King, Corpus Christi, and morning prayers.

[72] See Westerfield Tucker 2001: 4–12 and 33–6; also *Methodist Worship Book* 1999: 2–25, 129, 240, 367, 448, 501, 567.

little more to the use outlined in the earlier public and private prayer books associated with David Levi.[73] Even the almost eleven hundred pages of the most recent edition of the publication from Orthodox Judaism, *The Complete Artscroll Siddur* (1984; revised 1989, eleventh impression 2011), a work in Hebrew with an English translation, commentary, and rubrics, has no specific reference to either psalm. It does however include the entire Psalter in Hebrew at the end: Psalms 1–9 are prescribed as readings on the first Sunday of the month.[74] Similarly *Gates of Prayer: A Gender Sensitive Prayer Book* (1996), an updated adaptation of the *Union Prayer Book* (1975) from Reform Judaism assigns no specific role of Psalms 1 and 2 in public and private prayer.

The situation is no different when we turn to academic studies of Jewish liturgy. Eric Werner's *Sacred Bridge*, which records the individual psalms that are each used in both synagogue and church, begins his list with Psalm 6.[75] Ismar Elbogen, whose *Jewish Liturgy* was referred to earlier in this chapter[76] has eight references to the Hebrew word אשרי ('Happy') in the long list of incipits, but each reference is to other psalms beginning with or including this term.[77] Hayim Halevy Donin's *To Pray as a Jew* makes no explicit reference to these two psalms, and nor do they occur in his index accounting for the several ways in which the psalms serve the liturgy.[78]

Similarly more popular and devotional works are silent about Psalms 1 and 2: Miriyam Glazer's *Psalms of the Jewish Liturgy* has its focus on psalms used every day of the week, on psalms of penitence and praise, on psalms of salvation, on the late evening and early morning psalms, on psalms used for blessing after meals and on psalms of confidence and for peace. Some forty psalms are used for private reflection; Psalms 1 and 2 are not among them.[79] And starting in the opposite direction, with the psalms themselves, recent

[73] For examples of other psalms used in Jewish liturgy see Gillingham 2008a: 236–7 and 264–5.

[74] See R. N. Scherman, *The Complete Artscroll Siddur* 2011: 1025–6.

[75] See Werner 1959: 156–8.

[76] See Chapter 6 'From the sixteenth century to the present day': 140, nn. 41 and 42.

[77] See Elbogen 1993: 485. The psalms are 84, 144, and 145, referred to earlier. See Chapter 6 'From the sixteenth century to the present day': 140. There is absolutely no reference to למה, the incipit for Psalm 2.

[78] See Donin 1980: 379. There is no mention of the use of Psalm 1 in the account of the 'Torah Reading Service' (231–55) nor of Psalm 2 as part of the fourteenth and fifteenth petitions in the eighteen blessings (the 'Shemoneh Esrei': these petitions are the 'Birkat Yerushalayim' and the 'Birkat David'), which is again puzzling, as the restoration of Jerusalem and the coming of the Messiah are such prominent themes in this second psalm.

[79] See Glazer 2008: v–vii. Private communications with more expert colleagues such as Jonathan Magonet, Jeremy Schofield, and Jonathan Wittenberg have yielded few results. Indeed, Jeremy Schofield writes of Psalm 1: 'Ps. 1 almost never appears in traditional synagogue liturgies in use now. It is read, together with Ps 2 and 3 at the end of the evening service for the eve of Atonement in the Oriental Sephardi as well as the Western Spanish and Portuguese rites, probably as a way of signalling the reading of the whole book during the night. The last six psalms are read every morning of the year as a symbolic "completion" of the book. As far as I can tell it never appears in the Ashkenazi rite' (e-mail correspondence, June 2009).

Jewish commentaries—which are full of references to their use in earlier exegesis—make no reference to their use in liturgy.[80] Perhaps the only explicit reference to the liturgical use of either psalm, which is for Psalm 1, to be read at the unveiling of a tombstone, is oddly appropriate.[81]

A final question, given such paucity of consistent and clear evidence, is whether during these last four and a half centuries Psalms 1 and 2 were ever used liturgically together. The only evidence—and it is meagre—is actually found in the Christian tradition. Here, the only clear references we can glean are from sermons, of which the one by Charles Spurgeon, concluding Psalm 2, is a very good example:

> The first Psalm was a contrast between the righteous man and the sinner; the second Psalm is a contrast between the tumultuous disobedience of the ungodly world and the sure exaltation of the righteous Son of God. In the first Psalm, we saw the wicked driven away like chaff; in the second Psalm we see them broken in pieces like a potter's vessel. In the first Psalm, we beheld the righteous like a tree planted by the rivers of water; and here, we contemplate Christ the Covenant Head of the righteous . . . while he himself gives a blessing to all those who put their trust in him. The two Psalms . . . are in fact, the preface to the entire Book of Psalms . . .[82]

As a complete contrast, one contemporary liturgical use of Psalms 1, 2, and 3 being prayed or sung together is at the Additional Liturgy of *Tenebrae*, on Maundy Thursday, Good Friday, and Easter Saturday of Easter Week. This is a tradition of both Catholic and Anglican worship, and in each case these three psalms are prescribed.[83] Together they witness to the battle between light and darkness, goodness and evil, and the final judgement of God over darkness. For the same reason, these three psalms are also read together at the Nocturn of the Exaltation of the Cross in Orthodox and Catholic liturgy.[84]

[80] See for example Cohen 1992: 1–3 (Psalm 1) and 3–5 (Psalm 2); Feuer 1995: 56–63 (Psalm 1) and 65–72 (Psalm 2); Hakham 2003: 1–5 (Psalm 1) and 6–11 (Psalm 2).

[81] This is cited, for example, in *The Jewish Study Bible* 2003: 1947. The service is found at the online version of Simeon Singer's Daily Prayer Book, at <http://www.sacred-texts.com/jud/spb/spb56.htm>.

[82] This has been taken from *The Spurgeon Archive* at <http://www.spurgeon.org/treasury/treasury.htm>.

[83] The use of these psalms is recorded in Neale and Littledale 1894: 14–15.

[84] There is no comparable usage in Jewish tradition: if they hardly occur on their own, we would not expect them to occur together. All that is clear is that where Jewish practice does occasionally follow the recitation of the psalms on a weekly basis, the first group is from Psalms 1–29, and if this is prescribed as on a monthly basis, this is from Psalms 1–9.

CONCLUSION

We noted earlier that just as Psalms 145–50 were used from Gaonic times in morning and afternoon services of Jewish prayer, so too Psalms 148–50 were used from at least the fifth century as part of Lauds, or morning prayer.[85] So the last three psalms, as the epilogue to the Psalter, have been used prominently in both Jewish and Christian daily worship. It is extraordinary, therefore, that there is so little evidence in either tradition of the comparable liturgical use of the first two (or perhaps even three) psalms, given that in every other way they form such an important Prologue to the Psalter. This is even more extraordinary, given the way these psalms are so prominent in illuminated psalters (many of these serving a liturgical purpose), as we shall see in the following chapter.

[85] See Chapter 6 'From the Second Temple up to the fifteenth century': 133–4. See Werner 1959: 156–8 on the Jewish use of Psalms 145–50; and Box 1996: 5–6 on the Christian use of Psalms 148–50.

7

Visual Exegesis

INTRODUCTION AND OVERVIEW

This chapter involves a somewhat different way of assessing the reception history of these two psalms, where the meaning of a psalm is not constrained by the specificity of language, and where intellectual enquiry now has to work alongside the imagination, given that the reception is no longer of a text but of an image. Two particular features will emerge. First, that, compared with the dearth of liturgical material on Psalms 1 and 2, this mode of reception has abundant resources, and what follows is a small selection of a very rich field. Secondly, that especially in Christian art these two psalms are frequently depicted together, showing that visually they can reflect similar, complementary themes.

The two main sections of this chapter will focus on two distinct periods, chosen because the depictions of the psalms in art thrived most during these times. Some introductory observations are important at this stage. The first period is between the ninth and fifteenth centuries (before the invention of the printing press), when Christian Psalters—and later, by the thirteenth century, some Jewish books of psalms as well—were meticulously and often lavishly illuminated. They were usually produced as self-contained works, independent of the rest of the Hebrew Bible, being designed to serve a particular patron or religious community. The second period is from the twentieth century up to the present day, when artistic representations are intended for a more general audience. In Jewish tradition especially, the images often stand totally independently of the biblical text, usually focused on one lead metaphor in the text: even when a brief citation is given, which then links the image and psalm together, this still encourages a more open-ended interpretation on the part of the observer.

Each of these periods offers a very different case study for Psalms 1 and 2. Before we look at specific examples, some of these differences need to be appreciated in more detail. Taking, first, illuminated psalters from the earlier period, there were several reasons why this art form evolved. In Christian tradition, one obvious explanation was that it served as a teaching device,

enhancing the meaning of a psalm—sometimes with a literal, practical, and tropological emphasis, but often also with Christological intentions, particularly evident by the inclusion of *catena* of different commentaries alongside the illustrations of individual psalms.[1] Another related reason was that illumination was an *aide memoire*, so that those less literate (usually members of a particular monastery) could engage with the continuous reading via 'pictures'.[2] Another reason was that it was simply an aesthetic exercise, designed for pious reasons to honour a wealthy patron, such as an abbot of a monastery, or for political reasons, such as honouring an emperor or king.[3] Fourthly, some psalters were designed simply to mark out the weekly or monthly cycles of reading the psalms in public and private prayer: these books usually had a liturgical calendar at the beginning and canticles and prayers at the end. In liturgical psalters illustrations were most common in the historiated initials of the first letter of the first word of every psalm which began each new liturgical division in the overall recitation of the psalms.[4]

Unlike the previous chapter where the evidence for Psalms 1 and 2 in liturgy was scarce, Psalm 1, because it serves as a gateway into the Psalter, has a particularly rich history of illumination, often being one of the very few psalms to be illustrated. For example, in illuminated Psalters compiled for liturgical purposes, Psalm 1 (despite its limited appearance in the lectionaries) was always illustrated. So if the Latin Psalter was divided liturgically into threes (1, 51 [52], 101 [102]), Psalm 1 was always one of three psalms to have an historiated initial; if the Psalter was divided into fives, following the Hebrew divisions (1–41, 42–72, 73–89, 90–106, 107–50), again, Psalm 1 was one of five to be used; and if the Psalter was divided into eights (where the first seven portions were psalms to be used at Matins, and the last portion, psalms to be used at Vespers), Psalms 1, 26 [27], 38 [39], 52 [53], 68 [69], 80 [81], 97 [98] were used for Matins and 109 [110] to 147 for

[1] Many of the psalters, to be discussed in Chapter 6 'Introduction and overview': 162–79 fall into this category. Examples from the West include the closely related Utrecht, Harley, Paris, and Eadwine Psalters, as well as the Stuttgart and Windmill Psalters. Examples from the East include the Khludov Psalter and *Vaticanus graecus* 752; the latter is particularly interesting in its additional use of *catena*.

[2] Some of the examples in note 1 also fulfilled this purpose as well: the best examples include the Utrecht, Harley, and Stuttgart Psalters.

[3] This is often evident in the illustration before Psalm 101 (102). From the West, the Vespasian, Eadwine, St Albans, and Lutterell Psalters are good examples, and from the East, the Theodore Psalter represents this best. The Psalter of Charles the Bald is a typical example of a psalter honouring the power of a Byzantine ruler. This is also evident in Jewish illustrated psalters: the Kennicott Bible and the Parma Psalter are obvious examples of this.

[4] These are complete psalters, not psalters of selected psalms ('Ferial Psalters') which arranged the psalms according to their liturgical use. The Tiberius and Eadwine Psalters offer striking examples of this, as well as the St Albans, Tickhill, and Gorleston Psalters.

Vespers. Psalm 1 was always illuminated.[5] Similarly, in psalters where every psalm was illustrated—whether for teaching purposes or as an aesthetic exercise for a patron—the very first illumination, for Psalm 1, was often undertaken in great detail. A typical way of illustrating this psalm was through the initial letter 'B' (standing for *Beatus* in the Latin) which was enlarged so that the illustrations appeared in the double circles of the letter, as well as under it, above it, and even in the margins.[6]

The very first extant Christian work using the form of what is called an 'historiated initial' is the **Vespasian Psalter**; dating sometime between 720 and 760, its earliest associations are probably with St Augustine's Abbey, Canterbury and its text is in Latin and Old English.[7] The illustrations suggest an Italian and early Byzantine influence on account of the thick lines, the drapery, and the depiction of birds and beasts. This is clearly a liturgical psalter, as seen from the illuminated initials of Psalms 26 (27) and 52 (53). The folio for Psalm 1 is missing: it almost certainly would have had an historiated initial, possibly of Samuel anointing David as the 'blessed man'.[8] The miniature before Psalm 26 (27) shows how it might have looked: here we see David playing the lyre, between two scribes, flanked by four men playing pipes and two men underneath dancing (see Figure 7.1).

In the medieval period Jewish Psalters were not usually illustrated, mainly the result of the ban on 'graven images': the emphasis at that time was more on what was heard (in synagogue reading) than what could be seen, because of the belief that God was beyond representation by the eye. Indeed, at this time, to make an image of a psalm using human forms would have been seen as imitating pagan practice. This was modified by the time of the *Haskalah* in the eighteenth century; but even in this earlier period a distinction was sometimes made between the absolute rejection of imagery and the restricted use of it. Hence in the *Mishnah* the ban is on symbols which encourage idolatrous worship, such as the sun and moon, rather than all images *per se*.[9] So in the synagogues coloured tapestries for the Torah, for example, were permitted; and, by the thirteenth century, manuscripts of biblical books are sometimes found with coloured geometric designs as well as fauna and flora, while

[5] Psalm 1 is not the only one of the eight psalms to have stylized historiated initials: for example, Psalm 26 (27) is often produced with a figure of David pointing to his eyes ('The LORD is my light and salvation' being the first verse of this psalm) with God, or a bright light, shining through the sky. But of all the psalms, Psalm 1, with its own stylized forms, is always the most ornate.

[6] See Helsinger 1971: 161–76.

[7] The image below is from the British Library, Ms Cotton Vespasian A I, fol 30v (reproduced with permission from the British Library Board). Interestingly the lyre depicted in this miniature of David the musician is very like one found in the Sutton Hoo burial (625 CE).

[8] A frequent feature in early psalters, particularly when not prefaced by Liturgical Calendars or other Canticles or extracts from Commentaries, is that the folios to Psalm 1 were the first to disintegrate and disappear.

[9] See Bland 2001; also Mann 2000.

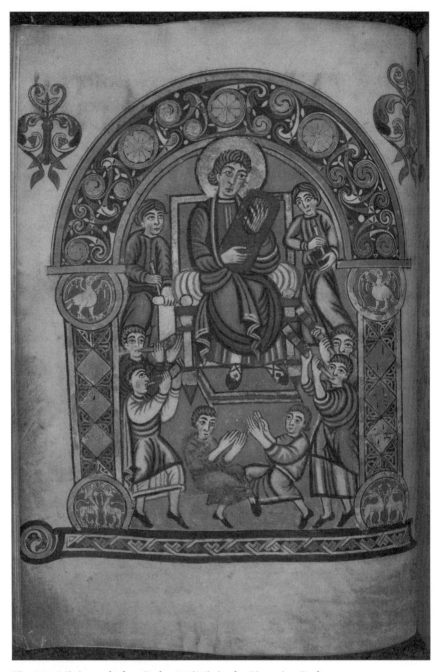

Fig. 7.1. Miniature before Psalm 26 (27), in the *Vespasian Psalter*

prayer books for great festivals, for example the *haggadoth* for use at Passover, often produced lavish depictions of the stories of Exodus, using bright colours, gold gilt, and, of course, human forms.[10] Some Jewish prayer books reflected the influence of miniatures found in Christian Psalters—for example, of David playing a 'psaltery', just before the first psalm. The image of David, sitting on a chair and wearing an ermine-laced red cloak, with harp and crown, is placed between two collections of psalms, written out by a scribe called Benjamin. It could be taken from a Christian Psalter, were it not for the Hebrew writing at the bottom of it (see Figure 7.2).[11]

Between this early period and the twentieth and twenty-first centuries, artistic representations of particular themes of the Psalter proliferated. The most recurrent is the classic portrayal of David the psalmist, usually playing a harp. Because this iconic image was no longer tied to the text of the Psalter (although the manuscript tradition must have been a seminal influence) Jewish as well as Christian artists could sketch, etch, and paint in this way. However, these only encapsulate the more general themes from the Psalter as a whole, with very few works of art which explicitly relate to the texts of Psalms 1 or 2, so it is not appropriate to record them all here: there are many websites which offer examples.[12]

There are, however, some striking exceptions: one is *The Flagellation* (about 1455–1460), by Piero della Francesca, because the original frame of the painting had the words 'convenerunt in unum' ('they assembled together') taken from Ps. 2.2, echoing the debates in Christian exegesis of this verse, that those who put Christ to death were Herod, Pilate, and the Jews. The figures at the back, around the cross, certainly suggest this interpretation: Herod is wearing a turban and Pilate is seated, with some sort of staff. The conspiracy against Christ is mirrored in the three figures in the foreground: one is the Count of Urbino, also conspired against and later murdered, and those with him are two of his betrayers. This is one of the few 'narrative' accounts of Psalm 2 in art, and it is an unusual one.[13]

[10] One lavish example is the *Golden Hagadah* in the British Library, found in the 'turning pages' of the British Library website. See <http://www.bl.uk/onlinegallery/ttp/confirmation.html?book=hagadah>.

[11] This has been dated in the late thirteenth century, and is part of *A North French Miscellany* from the British Library, Ms Add. 11639, fol 117v (reproduced here with permission from the British Library Board). It can be viewed at <http://www.bl.uk/learning/cult/sacredbooks/religiousbooks/jewish/kingdavid1/kingdavid.html>. It may be that the actual illustration is by Christian artists, but its occurrence in a manuscript written by a Jew and amid texts of psalms is most unusual. See Gutmann 1978: 78–9.

[12] By entering 'David' or 'Psalms' into the following websites the full scale of these artistic representations should be evident. See, for example, <http://www.biblical-art.com>; <http://www.wga.hu/index.html>; <http://www.tate.org.uk/>; and <http://www.jesuswalk.com/psalms/psalms-artwork.html>.

[13] This is now in the Galleria Nazionale delle Marche in Urbino, Italy. See <http://www.italian-renaissance-art.com/Piero-della-Francesca.html> for a copy of this painting.

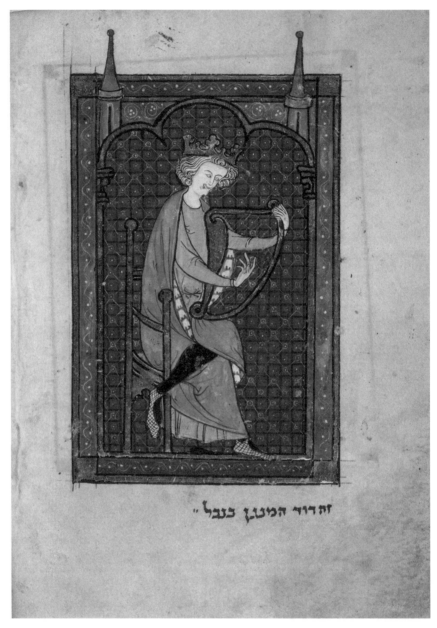

זה דוד המנגן בנבל "

Fig. 7.2. Miniature between two groups of psalms from *A North French Miscellany*

So, eschewing these intervening centuries, the second part of this chapter will focus instead on specific Jewish and Christian illustrations of Psalms 1 and 2 in the twentieth and twenty-first centuries. This is a deliberate choice, because these drawings and sketches and paintings encapsulate a psalm in just one image, and the connection with the entire psalm text is much looser. Furthermore, whereas illuminated manuscripts were constrained by the community or individual which commissioned them, here the artists usually work independently and so are less constrained by particular stylized forms than the illuminators in that earlier period. This allows for a multitude of interpretations, and the fact that the community they address is no longer monastic, or even, sometimes, of any one particular faith, means that they now rarely engage in the previously familiar dialogue with the exegetical traditions of figures of the past. Because they presume a more general cultural memory, they address the common human condition rather than the needs of a particular community of faith; these images are often designed to make a more general social, political, or religious comment.[14]

This is not only the case with Christian representations of this psalm. Jewish depictions tend to work in the same way, and in this case the image is rarely embedded in the actual psalms texts; because of the distance between the image and the text there are several examples of the painting or sketching of the human form, and even, occasionally, representations of God.[15]

We now turn to examine in more detail the visual exegesis of Psalms 1 and 2 in each of these two periods.

THE NINTH TO THE FIFTEENTH CENTURY

We start first with the visual reception of Psalms 1 and 2 in **Christian art**, given that this developed earlier than Jewish artistic representation and was more prolific being closely related to the commentary tradition. However, given the plethora of images of Psalms 1 and 2 in psalters, from both western and eastern Christendom, some selectivity is essential. In what follows the images illustrate, in different ways, just how much Psalms 1 and 2 were read and apparently illustrated *together* as closely related psalms. We shall start in the West, with the Utrecht Psalter and three other psalters from England

[14] Examples of this artwork include those by Arthur Wragg, Roger Wagner, and Michael Jessing, to be discussed in Chapter 7 'The twentieth and twenty-first centuries': 182–5.

[15] This is the case with Marc Chagall's etchings of Psalms 1 and 2. However, when the image is still embedded in the text of the psalms, the tendency in Jewish works is to decorate rather than use human figures: a typical example is Debra Band's illustrations of the English and Hebrew texts of the psalms. Both examples will be discussed in Chapter 7 'The twentieth and twenty-first centuries': 186–8 and 189–90.

which are closely related to it; we shall then focus on three psalters from Byzantium, all of which seem to show some knowledge of the Utrecht Psalter or its counterparts. We then return to the West, looking at psalters which, although only illuminating Psalm 1, show how the less illustrated Psalm 2 might have been read. Thus this selection (out of a vast number of possible examples) has been for the purpose of illustrating the close theological (and sometimes political) relationship between Psalms 1 and 2.

Of the western manuscripts, a group of four related psalters, the first from Carolingian times and all offering some Anglo-Norman influence, is particularly interesting.

The most influential manuscript is also one of the earliest fully illustrated Psalters known. This is the **Utrecht Psalter** (see plates 1 and 2), from the Benedictine monastery of Hautvillers, near Eperny, using artists from the school of Rheims, dating from between 820 and 835.[16] One hundred and sixty-six dynamic dark brown pen-and-ink drawings accompany the psalms (Psalm 151 is included) as well as each of the Canticles at the end. The text is Jerome's Gallican Psalter. Unusually the script is Rustic capitals, except for the first word of each line which is in uncial style. Headings were later added in red. The draughtsmen worked in what space was left, illustrating the psalm verse by verse, applying a literal, often practical, reading of each psalm. Despite the presence of the Canticles, this does not seem to be a liturgical psalter: if anything, it falls into two divisions, Psalms 1–76 and 77–150, with an almost blank page on folio 44 verso halfway through.[17] It was also probably too large for liturgical use (measuring 370 cm by 310 cm). This factor, and the clear evidence that mistakes were made and it has not been finished, makes it unlikely that it was commissioned by or for a royal patron, such as Emperor Louis the Pious or Empress Judith. It is more likely that the Utrecht Psalter was used for teaching and memorizing the psalms.

Psalms 1 and 2 seem to be by different artists: the former suggests a similar style to Psalms 36–50 and the Canticles, and the latter suggests the same hand as in Psalms 3–10.[18] It is also clear that the artists originally placed Psalm 1 in the space intended for Psalm 2, and placed Psalm 2 where the illustrations for Psalms 3 and 4 were meant to be. The erasures can just be seen beneath Psalm 2. This meant that, after corrections, the only space for Psalm 1 was on a full leaf on its own; this explains why it is the only one of the illustrations to have a full folio. The interesting result is that now the text of Psalm 1 is on the same folio as the illustration and text of Psalm 2, so some connection between the two psalms is immediately visible.

[16] The Psalter is now in Utrecht University Library (MS Bibl. Rhenotraiectinae 1 Nr 32). A seminal work on this Psalter is by Van der Horst, Noel, and Wüstefeld 1996.
[17] There is however a suggestion of a threefold division in that Psalms 1, 51 (52), and 101 (102) have larger historiated capitals.
[18] See Van der Horst, Noel, and Wüstefeld 1996: 50–1.

The artist for Psalm 1 used the psalm as a 'narrative' in order to create a series of literal illustrations.[19] The 'blessed man', seated at the top left just outside a circular tempietto, is clearly not Christ, as there is no typical cross-nimbus, although the figure could be reading about him (with the sun and moon above indicating that this is 'by day and by night', as in vv. 1–2). The figure is also not David, for he apparently 'wrote' the psalm. So here the 'blessed man' (given the monastic context of the scribes and artists) suggests a typical Christian, and the angel standing behind marks him out as blessed. Opposite him is the ungodly man, seated on a 'chair of pestilence', surrounded by soldiers and demons. Below the tempietto is the tree planted by the waters, and the wind is personified so that it blows about the soldiers as if they were chaff (vv. 3–4); as they are propelled downstream, their eventual destiny is the pit in the bottom right (vv. 5–6).[20]

The focus in Psalm 2 is not in the top left corner but rather the middle of the drawing, where there is a figure, not cross-nimbed but certainly with a halo, standing on Mount Zion (v. 6), ruling over a group of people who stand to his right, as armed men, ready for war.[21] This kingly figure is in fact marked out as Jesus Christ, and the hand of God raised in blessing in the top right corner refers to the words addressed to this figure: he is God's 'son' (v. 7). On the left of the king, the Gentiles (also dressed as soldiers) conspire and rage (vv. 1–3) and the demons in the top left of the illustration (they are unlikely to be angels, given that they are naked) are laughing at their audacity (vv. 4–5), shooting arrows into the sky and throwing down spears, routing the Gentiles and forcing them into some sort of pit (in the bottom left). The Christ figure is holding a rod, which is about to break open an already cracked cooking pot, symbolizing what will happen to the peoples on the left (vv. 8–9). In the bottom right corner is a tree (not referred to in the psalm) and this denotes the words of blessing for the king found at the end of the psalm (vv. 10–11, especially 11b).

So each psalm tells a story. In Psalm 1 the narrative moves from the top left to the bottom right, as the viewer follows the different destinies of the righteous and the wicked; in Psalm 2, the story starts from the centre of the illustration and works outwards to all four corners, highlighting again the different destinies of the righteous and the wicked. At least two features connect these psalms together. The most obvious is the fate of the wicked, who in each case are being driven by demons into some abyss (the image of a pit symbolizing Hell is more clear in Psalm 1). The other feature is the tree: in both psalms this appears as a symbol of blessing—in Psalm 1, for the Christian, and in Psalm 2, for Christ as King who defends his kingdom under

[19] See plate 1.
[20] See Van der Horst, Noel, and Wüstefeld 1996: 56–7 and 85.
[21] See plate 2.

God. We view Psalm 1 as about the fate of individuals (the blessed man on the left in his tempietto, the wicked man on the right on his chair of pestilence), while we view Psalm 2 as about the fate of nations or peoples, noting the different fates of those who accept Christ as King (the soldiers of the king on his right seem safe) and those who do not bow to his Kingdom (his enemies on the left falling down in disarray). So despite the hands of different artists there are some clear thematic correspondences between these two psalms.

The Utrecht Psalter influenced many later psalters, both East and West, although three western psalters demonstrate this more than any others. The first derivative is the **Harley Psalter** dated between 1010 and 1020.[22] It is even less finished than the Utrecht Psalter, ending at Psalm 143 (144) and there are no illustrations for Psalms 66–100 (67–101). Its provenance is likely to be St Augustine's Canterbury, suggested by the historiated initial 'B' at the beginning of Psalm 1 in which an Archbishop of Canterbury is lying prostrate before Christ, where he is perhaps depicted as another type of the penitent 'blessed man'. (The historiated 'Beatus' is an additional feature which Utrecht lacks, showing by contrast here the importance of the figure in the letter 'B'.) The illustrations for Psalms 1 and 2 are now in colour, and unlike Utrecht have been inserted before the scribes wrote the text. Like Utrecht, Psalms 1 and 2 are found on the same page, with the illustration for Psalm 2 coming between them. The text itself is in Caroline minuscules, not Rustic capitals, and is from the Roman rather than the Gallican Psalter.

The layout of both psalms shows how close a copy it is of Utrecht. In Psalm 1 the 'blessed man' is in his tempietto watched by an angel: the key difference from Utrecht is that in the Harley Psalter the first words of the psalm are actually being written, in Latin, in the book: the rest of the page is empty. (In Utrecht both pages are full, and the man is reading, not writing.) So this implies that here we have David, the assumed composer of the psalm, achieving his blessedness by the act of composition. Like Utrecht, the wicked man is seated opposite him: the tree, the waters and the wind, and demons driving the wicked falling into a pit follow the pattern of Utrecht.

Psalm 2 is also very similar to Utrecht. The kingly haloed figure is now on a rather grassy hill (illustrating v. 6) and in the top right corner the hand of God is again raised in blessing (illustrating vv. 7–9). The two groups are on each side of the king, and the demons are attacking the group on the left from above (here they are more clearly demons, for they are even more visibly naked and have no wings), and the pot and rod are just below the king (although here it is neither cracked nor broken, suggesting that the strike against those opposing God's kingdom has not yet happened but is imminent).[23] The

[22] This is now kept in the British Library: Harley MS 603. For an account of this Psalter, see Noel 2009.

[23] It may be that the reason is simply that v. 9, which this illustration is referring to, is actually on the next page.

tree has moved to the bottom centre. The only other difference is a number of buildings have been drawn behind each side of the hill, but the links between the two psalms are the same as in the Utrecht Psalter.

The Utrecht Psalter influenced the **Eadwine Psalter** (*c.* 1150–60—see plates 3 and 4), also from Christ Church, Canterbury.[24] It is a most ambitious glossed psalter, undertaken by at least twelve scribes and artists, with five textual versions, three in Latin (using all of Jerome's Latin versions, the Gallican, Roman, and Hebrew), one in Old English, and one in Anglo-Norman. Each psalm has a prologue, a commentary, and concluding prayers, with the first letter of the first word of every psalm (and of every canticle following the psalms) set in large historiated initials. It is prefaced by a large cycle of biblical miniatures and a liturgical calendar. Like the Utrecht and Harley Psalters, it was probably too large for liturgical use. It is most likely that it was made to the order of either Wilbert, Prior of the Abbey between 1153 and 1167, or Thomas à Beckett (archdeacon of the Cathedral from 1154, before he became Archbishop from 1162 to 1170).

Psalms 1–4 are all by different hands. Psalm 1, like Utrecht, takes up a whole page of the Psalter and precedes the illustrations of the psalm, the Gallican text itself being heavily glossed between the lines with the works of, for example, Augustine and Cassiodorus. The additional marginal illustrations, and the collect at the end, show that this is a much more explicitly Christian work than Utrecht.[25] The whole illustration is nevertheless very like Utrecht, except more graphic and in vivid colours. The 'blessed man' is in the top left, again in his tempietto, meditating on (this time not writing in) a book on a lectern, with an angel standing behind him indicating that he is 'blessed'. The sun and moon again represent the 'day and night'. This time, however, the ungodly man is explicitly a medieval king, surrounded by servants, and he bears a sword. He is being taunted by a demon with serpents coming from his limbs and head. Two figures take up the centre of the image, who seem to be discussing the two paths of the godly and ungodly. The Tree of Life is in full leaf and laden with fruit, and the waters alongside it emerge from an urn as if from a river god; a similar personification is of the wind which blows the waters and the wicked (who are dressed as soldiers with spears) towards a pit, where there are two demons, bearing hooks and tridents, and a monster personifying Hades, his jaws ready to crush and

[24] The manuscript is now kept in Trinity College Cambridge as MS R.17.1. By 1321 it was already listed in the inventory for Christ Church Library. The portrait of Eadwine the chief scribe, the depiction of a comet (known to have appeared in 1145 or 1147) and sketched plans for waterworks in Canterbury Cathedral Priory, installed in about 1160, suggest a date around 1160. The calendars recording the feasts of the death of Lanfranc and Anselm and the dedication of Christ Church in 1130 also confirm this. For a critical account of this Psalter, see Gibson, Heslop, and Pfaff (1992). See also Van der Horst, Noel, and Wüstefeld 1996: 236–7.

[25] See plate 3.

consume them. Many of the sketches have writing above them indicating which verse of the psalm is being illustrated.

Psalm 2 is more overtly Christological.[26] The hill upon which the haloed figure stands is painted green and looks more like a grass mound than Mount Zion. (For this reason, possibly, a later scribe wrote to the side of it 'Mons Syon' to avoid confusion.) The two groups of soldiers are clearly labelled 'Gentes' (on the left) and 'Populi' (on the right). The hand of God emerges from a coloured scroll with the words, in Latin, from v. 7 ('Today I have begotten you . . .') emerging from it. The 'pot of anger' now looks more like a familiar twelfth-century cooking pot: it has not yet been broken. Those who pour down God's wrath, from the top left, are no longer demons, but angels, doing the work of God, under the clear command of another haloed figure (who is either God or Christ). There are more buildings than in the Harley Psalter's illustration. The one to the right of the hill is labelled 'sancta ecclesia', indicating that Mount Zion is no longer Jerusalem but the Church of Christ. The one to the left is labelled 'sinagoga', suggesting that the 'populi' assembled here and waging war against the Christ-figure on the top of the hill are now in fact the Jews: thus they are the recipients of the angelic scorn and the coming wrath of God. Finally, the image has no fewer than five different trees: the one in the right corner is in the same place as in the Utrecht Psalter, and this is probably the one symbolizing blessing. When taken alongside the Glosses to this psalm, the Christian overlay and the anti-Jewish reading are clear.

The connection between Psalms 1 and 2 is the same as in Utrecht, although Psalm 1, with its dramatic portrayals of demons, focuses more on the fate of the wicked, while Psalm 2, with its portrayal of angelic beings and Mount Zion as the Church, has a more Christian appeal and even suggests the possible conversion of the Gentiles: these are the 'gentes' and they are not attacked by the angels as are the 'populi'.

The **Paris Psalter** (see plates 5 and 6), also from Canterbury, and also dating from the late twelfth century, is more a copy of the Eadwine Psalter than Utrecht and it is more complicated still.[27] It contains many of the same prologues and collects as Eadwine, and uses the same three Latin Psalters, as well as interlinear translations in Old English and Anglo-Norman. It is also unfinished, ending at Psalm 98, and is probably the work of one scribe and two artists. The illustrations are fully painted miniatures, often using gold leaf, rather than outlined drawings. Other influences have come into play here as the faces and bodies emulate more the Byzantine tradition. It

[26] See plate 4.

[27] This is now kept at the Bibliothèque Nationale, Paris (Ms Lat. 8846). For an inventory and commentary on this and some 472 other Latin psalters kept in public libraries in France, from the eighth to the sixteenth centuries, with accompanying black and white plates, see Leroquais 1940–1.

is so sumptuous that it is likely it was originally designed for a royal patron.[28]

The group of five connected miniatures for Psalm 1 shows the Blessed Man is now Christ Himself, cross-nimbed, accompanied by two angels; a Byzantine-type church replaces the tempietto and this is above and behind.[29] Christ is no longer meditating on the Law: he is writing, as if the 'story' of the psalm comes directly from him. The second miniature is of the two figures discussing the two ways: the one on the left could be David himself. In the third miniature the 'chair of pestilence' is again a throne, on which sits a king, with a sceptre and sword, who is being tempted by a devil on the right, as in the Eadwine Psalter. The tree (the bottom left miniature) is now highly stylized, but the waters and the wind and the sea monster are personified in a way which again replicates the Eadwine illustration: so, too, the last image, which is of the wicked being dragged by various demons into the pit. On the opposite folio is the text of the psalm, with a historiated 'B': the three figures above the initial are meditating, and they hold out speech scrolls, as if bidding the reader to reflect on the scene and emulate the example of Christ, the Blessed Man.

Psalm 2 is even more stylized.[30] It comprises one whole miniature set against a gold background and as with Psalm 1 it avoids using the 'word-labels' which the Eadwine Psalter had. Christ, now cross-nimbed, both stands on the hill, which is now covered with trees and shrubs, and, in a second image, above the hill, directs the angels. There are now just three buildings: although not named, the building on the right is clearly a church and the one on the left is possibly still a synagogue, with a chimney, although it could be a church. In this case, the crowds to the right of the hill seem to be peasants, with knee-length tunics, carrying spears; those to the left are clearly kings, wearing crowns, suggesting a more political interpretation. The pot this time seems more like a pitcher for wine, and is already smashed in two. In the upper right corner is the hand of God, offering a scroll to Christ the Son, who in turn seems to be offering it to both groups below the hill. There are several stylized trees: the one to the right of the picture may again symbolize the blessing associated with Psalm 1, but this is far less clear.

Thus in all these four examples of psalters from the western churches, an explicit link between Psalms 1 and 2 can be seen: each psalm tells a story, the first of a righteous individual (who in the Paris Psalter is Christ Himself) and the second of Christ as the righteous king. Although the feature of the

[28] See Van der Horst, Noel, and Wüstefeld 1996: 240–1. Perhaps it was on this account the manuscript found its way to Spain where it was finished by Catalan artists in the fourteenth century, probably in Barcelona. (In 2005 a facsimile, from the Spanish publishing house Moleiro, was given to Christ Church University College, Kent, in memory of its origins.)

[29] See plate 5.

[30] See plate 6.

tree combining the two psalms is more clear in the two earlier psalters, the constant theme is the punishment of the wicked and the vindication of the righteous. There are many other theological and political undercurrents, of course, not only about the Jews but also about kings and nations and Holy War (the Second Crusade from 1144 to 1155 and the Third Crusade from 1187 to 1192 must surely have had an effect on these draughtsmen), but there are enough shared themes to suggest the draughtsmen of all four Psalters viewed Psalms 1 and 2 in relation to one another.

One other very early western Psalter which is pertinent here is the **Stuttgart Psalter** (see plates 7 and 8), dating from about 830 CE and originally from St Germain-des-Près near Paris, so it is close to Utrecht in time and place: as another Carolingian work, some correspondences between the two Psalters are inevitable.[31] Usually, as in Utrecht, the illustrations are more literal; but in Psalms 1 and 2, they are more overtly Christian and this is what makes it such an interesting and distinctive Psalter.

As with the Utrecht Psalter, the images occur as miniatures but these are integrated more with the text of the psalm and often take up one of the margins as well. They are found before every single psalm. Unlike Utrecht, these images are multicoloured and although one image encapsulates the whole of the psalm, they do not attempt to tell the 'story' of the psalm, but rather select the most important verses which provide a Christian reading. So in Psalm 1, the image of 'blessedness' is no longer the typical Christian but the crucified Christ, who hangs on the tree of life (v. 3), which is the cross; this is 'guarded' by a Roman centurion, above it; and the 'ungodly men' turning from the cross are depicted as the 'wicked Jews'.[32]

Psalm 2 is also explicitly Christian and has an even more obvious anti-Jewish reading.[33] Here there are two images. The first, illustrating vv. 1–2, and reinterpreting traditional Christian commentaries with the enemies as Herod and Pilate during the trial of Jesus, takes us not to the trial of Jesus but to the passion in the Garden of Gethsemane, where the betrayers nevertheless are still both Romans and Jews. The second image depicts Christ after his resurrection (illustrating vv. 6–7 and 8–12), ruling over all those who had betrayed and opposed him.

Again it is possible to see shared themes within these two psalms. Both are explicitly Christian, giving not so much an exegesis of each psalm but

[31] The Psalter is now kept in Württembergische Landesbibliothek Stuttgart, Cod. Bibl Fol 23. See also <http://www.medieval.library.nd.edu/facsimiles/>. One common theme between this and the Utrecht Psalter is in the military imagery, with Christ often presented as a 'holy warrior' (not only in Psalm 2, but here, unusually, in Psalm 91 as well).

[32] See plate 7. The image of the crucifixion for Psalm 1, first referred to by Justin Martyr (see Chapter 3 'The Church Fathers': 45–6), became increasingly used in the early Middle Ages: see, for example, the tenth-century Ramsey Psalter, probably from Winchester (British Library Harley MS 2094 fol 3v–4r).

[33] See plate 8.

interpreting each through the passion and resurrection of Christ; and both place some emphasis on the enemies of Christ as military forces (and hence all such forces in ninth-century Carolingian France) as well as the Jews.

We now turn to three psalters from eastern Christendom; these date between the ninth and eleventh centuries. One of the features here is the prevalence of Davidic motifs at key points throughout the illustrations; because psalters from the East typically divided the book into three parts, Psalm 1 (as well as 50 [51], 77 [78], and 151) is an important psalm, and often illustrated. Furthermore, because glossed psalters were more common in the East than in the West, illuminations often become a visual commentary not only on the psalm text but on the Gloss as well.

The **Khludov Psalter** (see plates 9 and 10), dating from the ninth century, has some parallels with Utrecht, but its provenance in Byzantine Constantinople makes it very different in style and emphasis.[34] In terms of style, the illustrations are marginal and comment on just a few verses rather than the entire psalm, being placed as close as possible to the text they are illustrating; the iconoclastic schisms in Constantinople, and the part played by the Jews in these, have created a particular anti-Jewish stance in some of these vignettes.

Psalm 1, although damaged, clearly makes this point.[35] The Blessed Man is most likely to be David, and he is in the right-hand margin but set to the left, studying the Law; two wicked men, also apparently studying the Law, are set to his right; a haloed Christ, close to the words of the psalm, observes their fates. The rest of the illustrated margin depicts the effects of the wind as it blows figures across the surface of the page (and the earth). And those who suffer most, driven into the pit, are no longer armed soldiers, or even peasants: they are three Jews, evidenced by their (tenth-century) attire, which matches that of the figures studying the Law in the image at the top of the page.

Psalm 2 is more explicitly Christological.[36] The marginal images this time illustrate the commentary tradition transmitted through the Gloss as much as the text itself. The image next to v. 7 is of the Nativity, and this is followed down the page to the bottom, where a stable, with an ox and ass, illustrate that the one pronounced Son of God is the incarnate Christ.[37] But the image goes one stage further: the inscription across the top of the folio reads 'woe to the sinful nation', taken from Isa. 1.4, and is clearly an allusion from this verse to

[34] The Psalter is now kept in the Moscow History Museum (MS D.129). For details on this psalter see Van der Horst, Noel, and Wüstefeld 1996: 85–6; also Corrigan 1992.

[35] See plate 9.

[36] See plate 10.

[37] Images of the nativity for Psalm 2 are found in other psalters as well: the Bristol Psalter (eleventh to twelfth centuries: BL Add MS 40731), which also has a Byzantine provenance, has a similar image.

the ox and ass 'who know the master's crib', whereas the disobedient people of Israel do not. So the three figures in conversation at the top of the page may well be the prophet Isaiah (with raised hand) speaking to a Jew, who has his hand on his chest as if to indicate disbelief that this prophecy could be applied to him. The two figures at the very bottom also may well suggest another two Jews who (like the rebellious nations in the psalm) do not know Christ, as Isaiah prophesied.

So for this psalter, at least, one association between these two psalms is the Jewish opposition to the Christian Gospel and their subsequent punishment. It is a theme developed in a few other psalms in the Khludov Psalter, but it is unusual to have two psalms together reflecting this ethos.

This anti-Jewish polemic is not particularly evident in **Ms Vaticanus Graecus 752** (see plates 11 and 13), probably from the Studios monastery at Constantinople; its liturgical calendar, which starts at 1059, is likely to originate from that date.[38] Although it is in two volumes, this is a psalter whose contents indicate liturgical use, and the five hundred folios usually have one or even two illuminations. At the beginning are paschal tables, presented in linked medallions; at the end are the odes and canticles, also often illustrated. Just before the Psalter itself are illustrated prefaces taken from commentaries of the early (mainly eastern) Fathers (such as pseudo-Chrysostom, the Letter of Athanasius to Marcellinus, and 'Joseph and Theodoret'). Throughout all the images we see a particular interest in music, singing, and church architecture; another feature is the theme of piety and penitence, found throughout the commentaries and *catena* accompanying the text of the psalms. (Each psalm is set in two columns, one being the text and the other, the *catena*.) Most psalms begin with a heading from the Septuagint and an explanatory preface often taken from the fifth-century commentator, Hesychius of Jerusalem. The images not only illustrate the psalm texts but also the many glossed commentaries used in a *catena* form around the margins.

Psalms 1 and 2 together form a Prologue to the Psalter and so introduce several of the themes which are to follow. The first is the emphasis on David as the composer of all the psalms: 'David the Singer and Christ the Song' might be an appropriate summary of this.[39] So in the three-sided headpiece to Psalm 1 David is the 'blessed man' who keeps the Law, accompanied (as in Utrecht) by a protecting angel (with some sort of lyre): here this is the archangel Michael, prince of the people of Israel.[40] And in the miniature heading the cantata to Psalm 2 David and Michael are together again: here

[38] This psalter has been in the Vatican Library, Rome since the middle of the sixteenth century. For information on this psalter see de Wald (1942).

[39] See Gillingham 2013a (forthcoming).

[40] See plate 11.

Plate 1. Psalm 1, *Utrecht Psalter*, from the University Library Utrecht, MS Bibl. Rhenotraiectinae 1 Nr 32, fol 1v (with permission from the University Library Utrecht).

Plate 2. Psalm 2, *Utrecht Psalter*, from the University Library Utrecht, MS Bibl. Rhenotraiectinae 1 Nr 32, fol 2r (with permission from the University Library Utrecht).

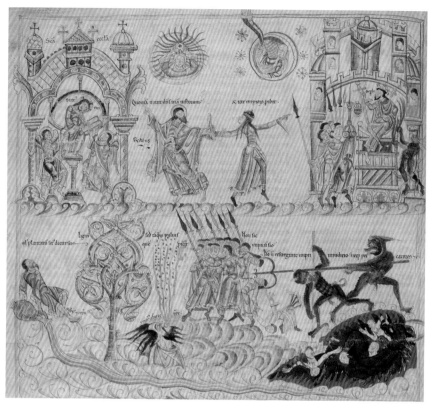

Plate 3. Psalm 1, *Eadwine Psalter*, from Trinity College Library, Cambridge, Ms R.17.1, fol 1v (with permission from the Master and Fellows of Trinity College, Cambridge).

Plate 4. Psalm 2, *Eadwine Psalter*, from Trinity College Library, Cambridge, Ms R.17.1, fol 6v (with permission from the Master and Fellows of Trinity College, Cambridge).

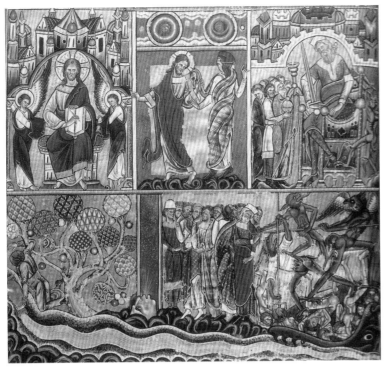

Plate 5. Psalm 1, *Paris Psalter,* from Bibliothèque Nationale de France, Ms Lat8846, fol 5v (with permission from Bibliothèque Nationale de France).

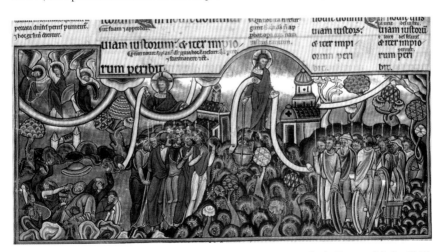

Plate 6. Psalm 2, *Paris Psalter,* from the Bibliothèque Nationale de France, Ms Lat8846, fol 6v (with permission from Bibliothèque Nationale de France).

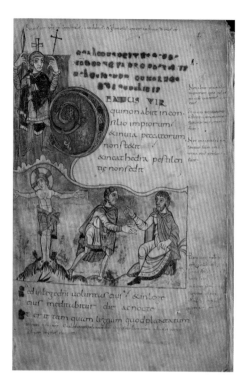

Plate 7. Psalm 1, *Stuttgart Psalter*, from Württembergische Landesbibliothek Stuttgart, Cod. Bibl Fol 23 2r (with permission from Württembergische Landesbibliothek Stuttgart).

Plate 8. Psalm 2, *Stuttgart Psalter*, from Württembergische Landesbibliothek Stuttgart, Cod. Bibl Fol 23 2v–3r (with permission from Württembergische Landesbibliothek Stuttgart).

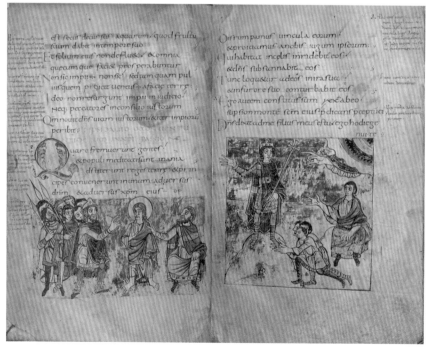

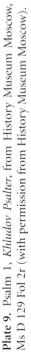

Plate 9. Psalm 1, *Khludov Psalter*, from History Museum Moscow, Ms D 129 Fol 2r (with permission from History Museum Moscow).

Plate 10. Psalm 2, *Khludov Psalter*, from History Museum Moscow, Ms D 129 Fol 3v (with permission from History Museum Moscow).

Plate 12. Psalm 2 from *Vaticanus Graecus 752*, from Biblioteca Apostolica Vaticana, Fol 20r (with permission from the Biblioteca Apostolica Vaticana Rome).

Plate 11. Psalm 1 from *Vaticanus Graecus 752*, from Biblioteca Apostolica Vaticana, Fol 19r (with permission from the Biblioteca Apostolica Vaticana Rome).

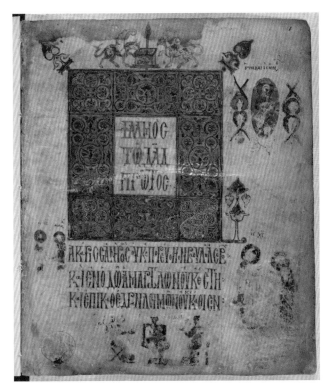

Plate 13. *Makarios* page, *Theodore Psalter*, from the British Library, Ms 19.352, Fol 1r (with permission from the British Library Board).

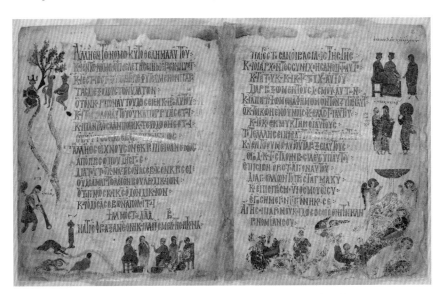

Plate 14. Psalms 1 and 2, *Theodore Psalter*, from the British Library, Ms 19.352, Fols 1v–2r (with permission from the British Library Board).

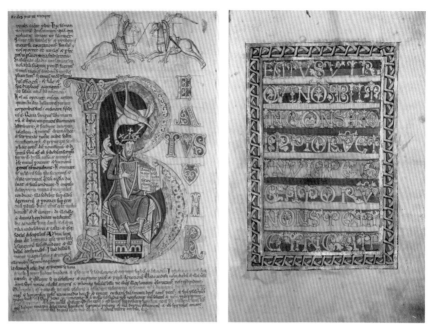

Plate 15. Introduction to the *St Alban's Psalter*, image © Hildesheim, St Godehard.

Plate 16. *Beatus* page, *St Alban's Psalter*, image © Hildesheim, St Godehard.

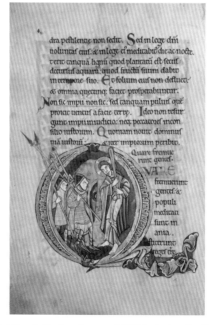

Plate 17. Psalm 2, *St Alban's Psalter*, image © Hildesheim, St Godehard.

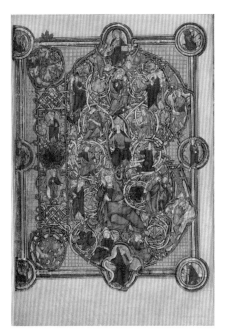

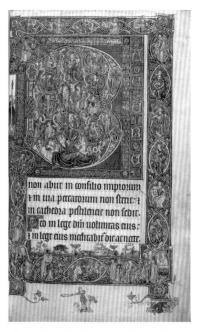

Plate 18. The *Beatus* of Psalm 1 as a Tree of Jesse, *The Windmill Psalter*, from Pierpont Morgan Library Ms M 102, © 2013, photo, Pierpont Morgan Library/Art Resource/Scala Florence.

Plate 19. The *Beatus* of Psalm 1 as a Tree of Jesse, *The Gorleston Psalter*, from the British Library, Ms Add. 49622, Fol 8r (with permission from the British Library Board).

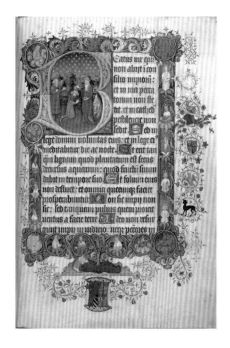

Plate 20. Psalm 1 in *The Bedford Hours*, from the British Library, Ms Add. 42131, Fol 73r (with permission from the British Library Board).

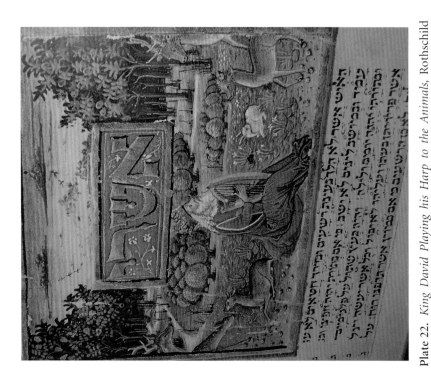

Plate 22. *King David Playing his Harp to the Animals*, Rothschild Ms 24, *c.* 1470 (with permission from Israel Museum, Jerusalem).

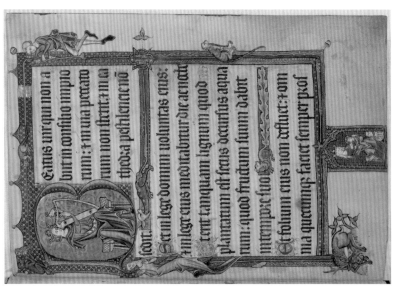

Plate 21. The *Beatus* and Virgin and Child in Psalm 1, *The Luttrell Psalter*, Ms Add. 42130, Fol 13r (with permission from the British Library Board).

Plate 23. Psalms 1 and 2, *The Parma Psalter*, from the Biblioteca Paletina, Parma, Ms Parm 1870 (*Cod. De Rossi 510*) (with permission from the facsimile of *The Parma Psalter*, at www.facsimile-editions.com).

Plate 24. Psalms 1 and 2, *The Kennicott Bible*, from the Bodleian Library, University of Oxford, Ms Kennicott 1, fol 8v (with permission from the Bodleian Library, University of Oxford).

Plate 25. Psalm 1 from Arthur Wragg, *The Psalms for Modern Life* (London: Selwyn & Blount), 1934.

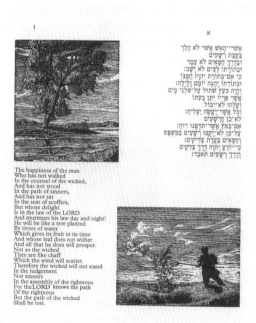

Plate 26. Psalm 1 from Roger Wagner, *The Book of Praises. A Translation of the Psalms, Book One* (Oxford: The Besalel Press), 1994 (© Roger Wagner (www.rogerwagner.co.uk), reproduced with the artist's permission).

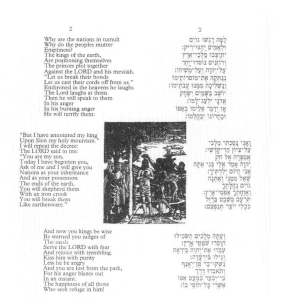

<div dir="ltr">

2

Why are the nations in tumult
Why do the peoples mutter
Emptiness?
The kings of the earth,
Are positioning themselves
The princes plot together
Against the LORD and his messiah.
"Let us break their bonds
Let us cast their cords off from us."
Enthroned in the heavens he laughs
The Lord laughs at them.
Then he will speak to them
In his anger
In his burning anger
He will terrify them:

"But I have annointed my king
Upon Sion my holy mountain.
I will repeat the decree:
The LORD said to me:
"You are my son,
Today I have begotten you,
Ask me and I will give you
Nations as your inheritance
And as your possession
The ends of the earth.
You will shepherd them
With an iron crook
You will break them
Like earthenware."

And now you kings be wise
Be warned you judges of
The earth
Serve the LORD with fear
And rejoice with trembling.
Kiss him with purity
Less he be angry
And you are lost from the path,
For his anger blazes out
In an instant.
The happiness of all those
Who seek refuge in him!

</div>

<div dir="rtl">

ב

לָמָּה רָגְשׁוּ גוֹיִם
וּלְאֻמִּים יֶהְגּוּ־רִיק:
יִתְיַצְּבוּ מַלְכֵי־אֶרֶץ
וְרוֹזְנִים נוֹסְדוּ־יָחַד
עַל־יְהוָה וְעַל־מְשִׁיחוֹ:
נְנַתְּקָה אֶת־מוֹסְרוֹתֵימוֹ
וְנַשְׁלִיכָה מִמֶּנּוּ עֲבֹתֵימוֹ:
יוֹשֵׁב בַּשָּׁמַיִם יִשְׂחָק
אֲדֹנָי יִלְעַג־לָמוֹ:
אָז יְדַבֵּר אֵלֵימוֹ בְאַפּוֹ
וּבַחֲרוֹנוֹ יְבַהֲלֵמוֹ:

וַאֲנִי נָסַכְתִּי מַלְכִּי
עַל־צִיּוֹן הַר־קָדְשִׁי:
אֲסַפְּרָה אֶל חֹק
יְהוָה אָמַר אֵלַי בְּנִי אַתָּה
אֲנִי הַיּוֹם יְלִדְתִּיךָ:
שְׁאַל מִמֶּנִּי וְאֶתְּנָה
גוֹיִם נַחֲלָתֶךָ
וַאֲחֻזָּתְךָ אַפְסֵי־אָרֶץ:
תְּרֹעֵם בְּשֵׁבֶט בַּרְזֶל
כִּכְלִי יוֹצֵר תְּנַפְּצֵם:

וְעַתָּה מְלָכִים הַשְׂכִּילוּ
הִוָּסְרוּ שֹׁפְטֵי אָרֶץ:
עִבְדוּ אֶת־יְהוָה בְּיִרְאָה
וְגִילוּ בִּרְעָדָה:
נַשְּׁקוּ־בַר פֶּן־יֶאֱנַף
וְתֹאבְדוּ דֶרֶךְ
כִּי־יִבְעַר כִּמְעַט אַפּוֹ
אַשְׁרֵי כָּל־חוֹסֵי בוֹ:

</div>

Plate 27. Psalm 2 from Roger Wagner, *The Book of Praises. A Translation of the Psalms, Book One* (Oxford: The Besalel Press), 1994 (© Roger Wagner (www.rogerwagner.co.uk), reproduced with the artist's permission).

Plates 28 and 29. Psalms 1 and 2 according to Michael Jessing (© Michael Jessing (www.m-jessing.supanet.com), reproduced with the artist's permission).

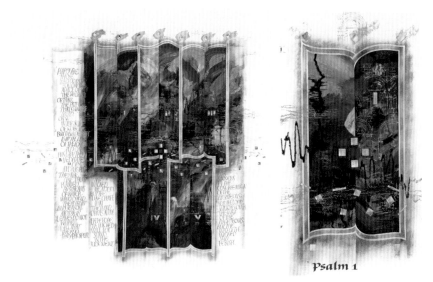

Plate 30. Psalms Frontispiece, *The Saint John's Bible*, Donald Jackson © 2004, Saint John's University, Collegeville, Minnesota, USA.

Plate 31. Psalms 1 and 2, *The Saint John's Bible*, Donald Jackson © 2004, Saint John's University, Collegeville, Minnesota, USA.

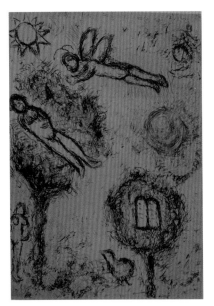
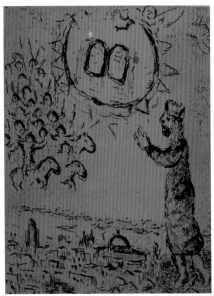

Plates 32 and 33. Psalms 1 and 2 in Marc Chagall, *Les Psaumes de David*, Gérald Cramer Editeur, Geneva, 1979, Chagall® / © ADAGP, Paris and DACS, London, 2013.

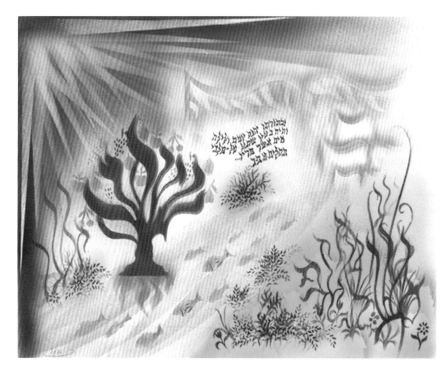

Plates 34 and 35. Psalms 1 and 2 according to Moshe Tzvi HaLevi Berger, all rights reserved (www.museumofpsalms.com, reproduced with the artist's permission).

Plate 36. Psalm 1: Morality Psalm for Yom Kippur by Irwin Davis (© Irwin Davis, reproduced with the artist's permission).

Plates 37 and 38. Psalm 1 in English and Hebrew according to Debra Band, *I Will Wake the Dawn. Illuminated Psalms* (Philadelphia, PA: The Jewish Publication Society), 2007, Courtesy Debra Band.

David (probably also representing some Byzantine ruler) is presented by Michael to receive blessings from Christ as King, seated on a throne, who stretches out his hand to bless the Israelite king.[41]

The Christological reading of these psalms is very clear. In the decorative headpiece to Psalm 1, around its three sides, are thirteen medallions. In the upper border, as well as the archangel Michael, we find the Virgin Mary, John the Baptist, and Jesus Christ. The ideal model of piety is no longer simply David, but Christ and the Church. So David who is blessed by Christ in the second psalm is David the 'blessed man', in the first psalm, whose source of blessing is from Christ Himself. The theme of a penitent David, subservient to Christ, is clear in both psalms.[42] In Psalm 1, it is through David's devotion to the Law; in Psalm 2, it is made explicit by the Greek superscription: 'Christ pardons David', which thus makes sense of the miniature, even though this has little to do with the text of the psalm itself. This in turn develops a further theme, pertinent to eleventh-century Constantinople—that of the god-fearing king: instead of the people bowing before the king, the king bows before Christ.[43]

So this is another illuminated psalter that links these two psalms together, albeit here in several distinctive ways: the theme of blessing, the mediation of Michael, and, with David as the example, the qualities of kingship (obeying and promulgating the Law, being penitent before and subservient to Christ).

The third Byzantine Psalter to be considered is the **Theodore Psalter** (see plate 14). The colophon at the end (fol 207v—208r) informs us that this was given to Abbot Michael of Studios Monastery in 1066 as a gift from Theodore, also of Studios, as an encouragement to the Abbot to stay faithful in the tradition.[44] There are 208 folios with 440 marginal illustrations, most of which are connected to the text by inscriptions in brown ink, and which, rather than repeating the text, give to it a new layer of meaning, sometimes Christological, sometimes more liturgical (again concerned with churches, altars, crosses). This is in part a didactic Psalter: it includes all 151 psalms in the Septuagint tradition (fols. 1v–189r), a 12-syllable poem about the early life of David (fols. 189v–191r), a prayer for Abbot Michael (fols. 191v–192r), ten biblical odes (fols. 192v–208r) and the final dedication colophon. This

[41] See plate 12.

[42] This is a theme found in several western psalters as well. One of the most curious is in the St Louis Psalter (Paris: Bibliothèque Nationale, MS Latin 10525), made for Louis IX around 1260 (also in the Isabella Psalter made for his sister). In both cases the historiated 'B' David is depicted as spying on Bathsheba; in the lower circle, he kneels penitently before Christ who is above him in a mandorla.

[43] This might be an implicit reference to Emperor Isaac 1, who in 1059 abdicated and retired to the Studios monastery. See Van der Horst, Noel, and Wüstefeld 1996: 92.

[44] Thus this psalter, the Barbarini Psalter (Ms Vat Bar Gr 372) also from Studios dated some ten years later, and the Ms Vat Gr 752 all have a similar provenance and date.

Psalter also displays some of the iconoclastic controversies which were evident in the Khludov Psalter. It also suggests liturgical use: the psalms are divided into kathismata and doxa, with several liturgical refrains included, and in the commentary there are many references to saints and feast days, using the Greek Fathers who were so concerned with liturgy (such as Basil the Great, John Chrysostom, and Gregory Nazianzos).

Psalm 1 is preceded by a 'Makarios' ('Blessed') page (fol 1r—see plate 13), suggesting again that the entry into the Psalter as a whole is through the words of Psalm 1.[45] It is worked over in gold, using a square frame with eight compartments and various alternating scroll patterns. The Septuagint text of Psalm 1 starts under this; to the left, albeit somewhat faded, is an image of Christ and the Blessed Virgin facing each other, with their arms creating the letter 'M' for 'Makarios'. At the bottom of the page is an image of three figures in debate: this has some associations with the Khludov Psalter, except the central one is on a throne. A demon hovers over the left figure, as again in Khludov. To the right of this is another image, of Christ handing a book to another figure who bows before him, and who is labelled 'Makarios', who might well be Abbot Michael himself. Above and to the right is Christ, with white hair, in a mandorla, with a book on his knee: he, too, has the role of the 'blessed man'.

Further illustrations to Psalm 1, which flow into others for Psalm 2, are on the next page (fol 1v) which first continues the text of Psalm 1.[46] Here the tree of life dominates the left margin. A figure reaches up to take fruit from the tree, standing between not one but two rivers running from urns: there are some links here with various myths of the Paradise Garden. Under this is the wind, personified as a figure with a cape: it blows some sort of pipe so that the three figures on the ground are blown away. In the very bottom right are three figures sitting and two standing, all in some debate. The two standing are dressed as Jews, and are gesturing as if disputing what is being said: what seems to be taking place here is that the end of Psalm 1, concerning the perishing of the ungodly, and the beginning of Psalm 2, regarding the raging of the nations, have been elided: Ps. 2.1 is on this folio, following on from Ps. 1.6.

Images for Psalm 2 continue on the following page (fol 2r). In the top right margin are two groups—one of two kings (presumably Herod and Pilate) addressed by a Jew, who points to the three figures below, who appear to be Annas, Caiaphas, and Christ. This is linked to the Christian commentaries on Ps. 2.2, where the nations who once threatened God's anointed one are now the Jews and Romans opposing Christ. At the bottom right is a depiction of

[45] See plate 13. An important resource for this Psalter is the electronic facsimile edited by Charles Barber (University of Illinois Press, in association with the British Library).
[46] See plate 14.

the Nativity. Mary is on a bed, with Joseph next to her, and two protecting angels are hovering above. The empty manger is bathed in light, and close to it are a donkey and an ox: to the left, the baby Jesus is being bathed by two midwives. Further left is another angel announcing this birth to two shepherds.[47]

Ps. 2.8 runs over onto the next folio which ends with 3.4. This way of both texts and images continuing over different folios is a typical feature of this Psalter, so the continuity of images between Psalms 1 and 2 is not altogether unusual. However, these first three folios are some of the most richly illustrated in the Psalter: the artistic effect is, by way of several Christological associations, to illustrate a clear continuity between these two psalms.

Returning to the western churches, we now turn to a twelfth-century Anglo-Norman Psalter from **St Albans** (see plates 15, 16, and 17), dated between 1136 and 1139.[48] This is a very different type of illuminated Psalter from those examined so far; it is dedicated to a woman, the Benedictine anchoress Christina of Markyate, and was commissioned by Geoffrey Gorham, Abbot of St Albans from 1136 to 1139. Whether Christina could read or not is unclear: but she would have known the Psalter by heart, so the historiated initials may well have been an *aide memoire*. It may also have been for Christina's education: in addition to the psalms it has forty full-page miniatures of the life of Christ at the beginning, as well as the Chanson of St Alexis (the namesake of the principal artist), a letter of Pope Gregory the Great (in Latin and French) on the importance of images, three pictures of Christ on the road to Emmaus, and a discourse on good and evil which appropriately is on the same page as the 'Beatus' initial of Psalm 1. The Psalter might also have served liturgical purposes: although it is not divided into any obvious liturgical divisions, it is prefaced by a Calendar (admittedly, this was a later addition in that it records Christina's death). It is followed by the Canticles, and there are several references to music, both through images of David and in a final dyptich of the martyrdom of St Alban. So, given the dedication by Abbot Geoffrey to Christina, this could be a Psalter which fulfilled several purposes.

The introduction to the Psalter as a whole is found on page 72.[49] Down the left margin and across the bottom is the conclusion to the discourse on good and evil; the two knights on horseback at the top of the page symbolize

[47] The are several similarities throughout all these images with the Bristol Psalter, the Barbarini Psalter, and the Khludov Psalter . We noted in the previous chapter that one of the few obvious liturgical uses for Psalm 2 in the Orthodox churches (Chapter 6 'From the sixteenth century to the present day': 152) was at Christmas: clearly the themes have been further developed here.

[48] See Hanney 2002; Geddes 2005. The Psalter can be viewed online through the University of Aberdeen at <http://www.abdn.ac.uk/stalbanspsalter>.

[49] See plates 15 and 16.

this fight, and offer an apposite introduction to the contents of both Psalms 1 and 2. A gilded letter 'B' fills the rest of this space, with silvery lines pointing to 'EATUS VIR' written later in the right-hand margin. Inside the letter is King David, with his harp, seated on a throne; a huge bird (apparently a dove, representing the Holy Spirit) is whispering in his ear—the words are then written in Latin on the book he holds open: 'The blessed psalmist David, whom God has chosen, has uttered forth the annunciation of the Holy Spirit'. On the following folio is an illuminated opening to part of the text of Psalm 1, omitting the 'B' and thus starting with 'eatus vir . . .'. It is set within a three-dimensional gilded border.[50] In these two images there are at least two themes which serve to introduce the Psalter: first, that David, the inspired prophet, speaks words of prayer which are then fulfilled in the life of Christ; and secondly, that the readers, meditating like David on the decorated text, appropriate for themselves the blessings once conferred on David and brought to fruition in Jesus Christ.

This is made more clear when we turn to the next folio, where Psalm 1 is finished and Psalm 2 begins.[51] The first words of the second Psalm are written in red between the end of Psalm 1 and the beginning of Psalm 2 ('quare fremerunt genti . . .'). The 'Q' then becomes the historiated initial, and the text follows, with UARE written in blue alongside it, and the rest of the text written in black ink below. The illustration, encapsulating the first two verses concerning the raging of peoples against God's anointed one, is not of David, but a cross-nimbed Christ, and the setting is not Mount Zion but the Garden of Gethsemane as Christ faces two Roman soldiers with spears and shields: he holds in his hands the 'rod of iron' (Ps. 2.9) which will depose the power of those who rage against the Messiah.

In this way the 'words of David' referred to in Psalm 1 become a 'prophecy about Christ' in Psalm 2. And the one who is marked out as 'Blessed' in Psalm 1 is not only David, or the reader, but Christ Himself, persecuted yet faithful and obedient. This then is the opening theme of the Psalter and Psalms 1 and 2 together make this point: inspired by the Christian commentary tradition at this time, the words of David, inspired by the Holy Spirit, are seen to become prophecies about Christ.[52]

Several other western Psalters only illuminate Psalm 1, and sometimes the motif of the 'Jesse Tree', linking David directly to Christ, is used explicitly in

[50] There is a strange error at the bottom of this page, in that the text ends with 'cath' and is taken up on the next page, in a different script, as 'dra', omitting the 'e'.

[51] See plate 17.

[52] There are other themes in other initials, of course: given the patron and recipient, it is not surprising that twenty include the presence of women, and almost as many others depict priests, abbots, and monks. But the theme of 'words of David' and 'prophecies of Christ' is a dominant one throughout the Psalter as a whole.

the historiated 'B' of 'Beatus'.[53] For example, a late thirteenth-century 'French Gothic' Psalter, the **Windmill Psalter** (see plate 18), possibly from Christ Church Canterbury, has both its 'B' and the 'E' illustrated, the first with a tree of Jesse and the second of the Judgement of Solomon.[54] In the bottom circle of the 'B', dressed in red, is the figure of Jesse, father of David, with branches of a tree springing from his side. David, with crown and sceptre, is above him, raising his right hand. In the upper circle is Mary, also nimbed, veiled, and crowned, supporting Christ, cross-nimbed, who holds a book with a verse from Jn 6.35 ('I am the Bread of Life') written on it, raising his right hand in blessing. Two angels flank them both. The whole image is in blue and red, and around the body of the 'B' are the six days of creation: in each scene Christ is presented as the Word (Logos) of God, sometimes with a book, often with his right hand raised in blessing, always reflecting the six stages of creation, with the last depiction being of Christ about to create Eve from Adam.

The Windmill Psalter is a liturgical psalter: hence only the initials of Psalms 1, 26 (27), 38 (39), 52 (51), 68 (69), 80 (81), 97 (98), and 109 to 147 (110 to 147) are historiated with the figure of David, and Psalm 2 has no such illustration. But the juxtaposition of David and Christ in this psalm allows for a similar Christological reading of Psalm 2. It may well have been the reference to the 'tree' in v. 3 which promoted the use of the Jesse Tree (a popular image used on full pages of psalters as well as in church architecture and stained glass) in the letter 'B' of this psalm: the fruit-bearing tree symbolizes the stem of Jesse (Isa. 11.1–2) which extended from David to Christ.

The **Gorleston Psalter** (*c.* 1304—see plate 19) is a liturgical psalter commissioned by a wealthy patron of Gorleston, Norfolk. It has richly illustrated borders with marginal grotesques on almost every page, but Psalm 1, heading up the liturgical divisions, is the most lavish of them all and also includes a 'Beatus' with a Jesse Tree.[55] The bottom of the 'B' shows Jesse sleeping, and the top part shows Christ enthroned. The three upper sides around the 'B' are filled with kings and prophets, and the bottom border has

[53] Several other richly illustrated Psalters could also have been included here. The Winchester Bible (1160–75: Cotton MS Nero C IV), for example, is a bi-lingual Psalter not only with a Jesse Tree but also with a pair of extraordinary Beatus illuminations, one of David killing a lion and a bear, and the other of Christ, judging a dying soul whose fate takes him down to hell.

[54] See plate 18. This is in Pierpont Morgan Library MS M. 102. This image and that in the letter 'E' (with a windmill above the image, hence the name of the Psalter) can be found at <http://utu.morganlibrary.org/medren/single_image2.cfm?imagename=m102.001v.jpg&page=ICA000004378>.

[55] See plate 19. This is now in the British Library (MS Add 49 622). Other psalters related to this with similar Jesse trees in the 'Beatus' include the Amesbury Psalter (dating around 1250, made for a nun in the Benedictine Convent there), now at All Souls College, Oxford, MS 6, and the recently discovered Macclesfield Psalter (*c.* 1320), now in the Fitzwilliam Museum, Cambridge (see <http://www.fitzmuseum.cam.ac.uk/gallery/macclesfield/gallery/>).

scenes from the Annunciation, Nativity, and the Presentation in the Temple (under which are the arms of England and France). At the very bottom is a typical image of David killing Goliath. A distinctive image—one used in other illuminated Psalters as well—is of some huntsmen chasing a stag at the top of the illustration; this is a symbol of the soul being attacked by the huntsmen (who are the ungodly in the psalm). This theme also anticipates the contents of Psalm 2 (again, without illumination, this being a liturgical Psalter) as well as of Psalm 1.

This motif of the Jesse Tree is also frequently used in the more personal Books of Hours, designed as private prayer books for wealthy laity. The Hours of John, Duke of Bedford has such an image before Psalm 1 (see plate 20).[56] Here the whole part of the letter 'B' is taken up with an image of Samuel anointed by David, presented to him by David's father, Jesse: the lower part of the picture has Jesse sleeping, with a vine springing from his side, and moving up the right and left borders are tendrils with medallions of the Virgin and, in the top corner, God the Father and his angels.

We conclude this survey of the reception of Psalms 1 and 2 in illuminated Psalters with the **Luttrell Psalter** (see plate 21).[57] The wealthy and pious patron, Sir Geoffrey Luttrell, Lord of the Manor of Irnham, Lincolnshire, commissioned this Psalter as a part assurance for his eternal soul, paying also for psalms and prayers to be sung daily for him after his death. It is strange, therefore, that the main interest in the book today is not so much for its spirituality (although there is a good deal of Christian iconography) as the windows it provides onto the social and political life between 1320 and 1340, with its many detailed illustrations of people, both rich and poor, at work and prayer and leisure. But this also has the hallmarks of a liturgical Psalter: it is a Gallican text, and is divided by illustrations into three divisions, in the Latin numbering at Psalms 1, 51 (*NRSV* 52) and 101 (*NRSV* 102); Calendars were added at the beginning; and Canticles, a Litany, Collects and the Office of the Dead were added at the end (suggesting this might even be the Psalter which was used for the repose of Geoffrey's soul). Three or four artists were employed for this project—which, like many ambitious psalters, was never completely finished.

Psalm 1 has a relatively small historiated 'Beatus'.[58] David and his Psaltery dominate the letter, and the borders have little else specifically theological within them. However, there are two iconographical features on this page,

[56] See plate 20. This is in the British Library as *The Bedford Hours*: Add. MS 42131, fol 7r. There is again an implicit link with Psalm 2: but, being concerned with the Hours of Prayer, Psalm 2 is not illuminated in this way. See Marks and Morgan 1981: 104–7.

[57] Again this is in the British Library (Add. MS 42130). This is to be viewed on the Turning Pages website: see <http://www.bl.uk/onlinegallery/ttp/confirmation.html?book=luttrell>. See also Backhouse 1989; and Brown 2006.

[58] See plate 21.

which indicate a specifically Christian reading of these first two psalms. The first is the small medallion of the Virgin and Child at the bottom of the page and the second, to the left, is the hunted stag. This is a psalter without any specific textual commentary: all the interpretation is through the visual images. The main purpose of the Psalter was to show how ordinary time could be attuned to a life of prayer: so the presence of the Virgin and Child, and the hunted stag, bear witness to this, but they also link this psalm to Psalm 2. The implication is that in this first psalm Jesus, Son of Mary, is the Blessed Man about whom David sings; but it leads on to the next folio, where these two images could also be seen as a comment on the incarnate and crucified Son about whom God the Father speaks in vv. 2 and 6 and 7–9. [59]

In all these examples—which are just a selection of what might have been discussed—'visual exegesis' offers significant insights into the ways in which Psalms 1 and 2 together were understood in the Christian tradition. These iconographical clues reveal just how closely these two psalms were related because of the Christian reading of both of them: this is a common feature in all the Christian illuminated psalters throughout this period.

As was noted in the introduction to this chapter, **Jewish visual exegesis** developed more gradually and more cautiously throughout these six hundred centuries. Compared with the rich Christian discourse in visual exegesis, both explicit and implicit, Jewish psalters are decorated in a very different way. Illustration is by way of motifs and symbols from the natural (and often unnatural) world, but there is little evidence of any personified illumination, and when it occurs, this is almost always kept apart from the actual texts of the psalms. The image of David playing his harp, which we noted at the beginning of the chapter,[60] is thus most unusual in that it was actually set among several psalms and prayers. There are two or three other images of this nature: one is from fifteenth-century Italy: it too prefaces a selection of psalms (as well as other religious and secular works) and is of King David, surrounded by wild animals, playing his harp and apparently singing the words of Psalm 1, as evidenced by the אשרי at the top of the picture. The words of the rest of the psalm are written in Ashkenazic script under the image.[61]

Normally, however, Jewish iconography in manuscripts of psalms is more restrained, giving us very few visual clues as to how a particular psalm has been interpreted. Two examples of decorated psalters illustrate this: only one

[59] Luttrell was devoted to the Virgin Mary, making frequent pilgrimages to Walsingham, St Mary's, Canterbury, and St Mary's, York. The Virgin appears several times in this psalter: see M. P. Brown 2006: 74–5.

[60] See Chapter 6, Figure 7.2: 162. This is from the Rothschild Miscellany, Israel Museum, Jerusalem, Rothschild Ms 24, dated around 1470.

[61] See plate 22.

is an actual independent Psalter, the other being part of a complete illustrated Hebrew Bible.

The first example is the **Parma Psalter** (see plate 23), the oldest intact illustrated Hebrew manuscript, probably from southern Italy, dated by its writing style to the late thirteenth or early fourteenth century.[62] This was compiled at a time when Jewish–Christian relations were particularly strained—the Fourth Lateran Council in 1215 had resulted in forced conversions and the burning of Jewish books: when the Angevin rulers took power in Italy in 1265, thus expanding the power of the pope, the Jewish diaspora communities in southern Italy were particularly vulnerable. This lavishly illustrated psalter—which might have been created as a wedding gift—must have represented an act of defiance in the context of persecution by the Christian Church. There are 171 illustrations, one for each psalm and twenty-one for the divisions of Psalm 119; on each page the text of the psalms usually takes up twelve written lines, leaving one line space between each psalm. Around the margins of the text, in light brown ink, suggesting a Byzantine hand, are portions of Abraham ibn Ezra's commentary on the psalms.[63] Each illustration starts with the first word of each psalm and works around it, in a small way imitating the Christian mode of illuminating the first letter (the lack of capital letters in Hebrew made such illumination more difficult). Symbolism and allegory are rarely used, and the decorations are usually of flora and fauna, domestic and wild animals, birds, and fantastic creatures such as dragons, monsters, and griffins (again partly influenced by the Christian genre of animal bestiaries). There are, most unusually, 28 depictions of animal faces and 94 of humans (only of the upper body): none of these are found near the first few psalms, as if the artists became more adventurous later in their work.

The illumination of Psalm 1 is nevertheless unusual, not only because of the size of the lettering, but because the entire psalm is bordered, its four frames containing flora and foliage. This is partly because the psalm was seen to introduce the whole Psalter and partly because of its place at the start of Book one (Psalms 42, 73, 90, and 107, marking out Books two to five, also have particularly large decorations).[64] The four foliate borders may be an oblique reference to the tree planted by the waters in v. 3, but this is far from obvious. At the top of the frame is the word אשרי, taking up the space of three lines, enclosed in a wider foliate frame. The text of Psalm 1 continues

[62] The Parma Psalter has been in the collections of Giovanni De Rossi, a Christian Hebraist, in the Biblioteca Paletina, since at least the early nineteenth century (Ms Parm1870 (*Cod. De Rossi 510*)). See Metzger 1977. Examples of illuminations can be found at <http://www.facsimile-editions.com/en/pp>.

[63] See Chapter 4 'Jewish mysticism': 88–90 for a discussion of the significance of this commentary.

[64] See plate 23.

over the page and is separated from Psalm 2 by the three-sided border surrounding that psalm, where as well as the foliage we find two animal drolleries on each side, with elongated necks. Some of this type of illumination is typical of the Luttrell Psalter, for example: but what makes it different here is that there is nothing explicitly referring to the psalms in this kind of iconography. There is no sense of any integration of image and text, and certainly no indication that Psalms 1 and 2 were viewed together as one psalm.

Another illuminated manuscript of the psalms is found in the **Kennicott Bible** (see plate 24), acquired by Benjamin Kennicott in 1771.[65] It too was compiled at a time of Jewish persecution, this time in fifteenth-century Spain. The Bible is prefaced by a grammatical treatise by David Kimḥi, on how to read Scripture. The scribe, Moses ibn Zabara, was commissioned to write this for Isaac, son of Don Solomon di Braga of Coruña in 1476. The psalms, placed in the typically tripartite order of the Hebrew Bible, follow the Prophets and are separated from them by a vivid carpet page and the double triangle symbol (later, the star of David) signifying King David. There are several pages of illuminations attached to the psalms, but these are preserved at the beginning and the end, intentionally distanced from the text.[66] Nevertheless, each psalms page is decorated, and indeed this marks the psalms out from the books of Proverbs and Job which follow them, for they have no decorations at all. The text, like the Parma Psalter, is decorated rather than illustrated: the artist, Joseph ibn Hayyim, used zoomorphic and anthropomorphic letters, and mainly decorated with flora, fauna, animals, bird, dragons, and drolleries, often more for the amusement of young Isaac than for any specific educative illustration of the text. Psalms 1 and 2 are on the same page.[67] Across the top and bottom and in the right-hand margin are various geometric patterns, in blues and pinks and red, but these have little to do with the contents of the psalm.

So from just these two examples, it is clear that Jews and Christians viewed the psalms as art forms in very different ways. Whereas in Christian illuminations Psalms 1 and 2 are often viewed as closely integrated, the visual representation in Jewish illuminations is so minimal and so generalized that it gives us no clues about whether the two psalms were seen together in any close relationship.

[65] It was transferred to the Bodleian Library, Oxford in 1872 (Ms Kennicott 1).

[66] Despite this, the psalter is richly illustrated. The vivid carpet page at the beginning and the pink and blue geometric decoration at the end—showing some influence of Islamic art forms—serve further to separate the psalms from the other books next to it.

[67] See plate 24.

THE TWENTIETH AND TWENTY-FIRST CENTURIES

The four examples of **Christian artistic reception** to be discussed below are of images published in books rather than presented on canvas. Each however is set alongside an English translation of the text, so the integration between text and image is obvious. However, they differ from illuminated manuscripts in that they all consist of one image of an entire psalm, taken from what the artist understands to be a leading metaphor in the psalm; and there is little evidence in the symbolism that this is in any dialogue with an established commentary tradition, as was the case with earlier illuminated psalters.

The first is by **Arthur Wragg** (1903–1976—see plate 25), a Christian Socialist and commercial illustrator of books. In his work between the two World Wars he was acutely aware of social injustice and the alienation of the poor from their industrial surroundings and through his images attacked those who abused their power. His works are in black and white chiaroscuro and often resemble woodcuts; but they are pen-and-ink drawings.

The image of Psalm 1 is taken from his work, *The Psalms for Modern Life*, published first during the Great Depression in 1933.[68] The text is the *King James Version*, and some forty illustrations (each taking up a full page, some double spread) illustrate most strikingly the way a relevant psalm can speak on the themes of injustice and powerlessness. The captions, using just one verse or phrase from the psalm, are at the bottom of the facing or preceding page. The caption for Psalm 1 is 'But his delight is in the law of the LORD, and in his law he meditates day and night'. The image is of an old man, watering a withering plant, surrounded by factories and tenement blocks. Everything is savagely stark and simple: the message seems to be that the only thing of beauty is the thirsty plant, and to water this is the only act of piety which the man can perform. His face betrays a look of fear and resignation; he is not looking at the plant, but beyond it, as if he is trying to summon up a vision from outside the scene around him. So this is the 'blessed man': anyone struggling to find God in the midst of oppression and suffering.

Roger Wagner (b. 1957—see plates 26 and 27) is an artist based in Oxford. His woodcuts of the psalms resemble Albrecht Dürer's illustrations for the Lubeck Bible (1494) and this is a conscious echo of the Reformation tradition. Wagner's images are also often artistic commentaries on the barrenness of the industrial landscape. His *In a Strange Land* (1988), a visual work of engravings and poems, includes images of the then desolate docklands against the backcloth of Psalm 137 ('By the waters of Babylon, we sat down and wept . . .'). But whereas Wragg's images are raw and pessimistic, Wagner's art offers glimmers of hope—trees, pastoral landscapes from

[68] See plate 25.

Oxfordshire and Suffolk, and even angels all become symbols of faith over-coming impotence and despair. Wagner takes large themes in order to show how God's glory shines through in the small and simple things of life.[69]

His *Book of Praises*, to be published in five volumes, is a moving example of how the big themes of the psalms can be understood through the artist's eye of faith. Each page has Wagner's own English translation of the psalms from the Hebrew: a woodcut is placed before the two versions—red ink for Hebrew, black for English –which illustrates the main theme of the psalm. There is no uniformity in this work: sometimes the versions intermingle, sometimes they are neatly parallel, and sometimes they simply run down the page. Many of his woodcuts are ways of reflecting on the Hebrew mindset of the psalmists through vignettes of an English pastoral landscape. There is often the threat of danger; but somehow hope shines through. Wagner describes this work as rather like the frescoes in the different cells in the monastery of San Marco, Florence—each individual cell offers a different painting for prayer and reflection and yet there are common themes which bring together the Christian story in all its diversity. *The Book of Praises* is like walking from cell to cell.[70] Others liken it to Paul Nash's work on Genesis, or William Blake's engravings of Job.

His representation of Psalm 1 has two images. In the top left of the page is a tree planted by fast-flowing waters: the wind swirls through both the sky and the water, so that the movement of the wind contrasts with the stability of the tree. Wagner explains that this interpretation was because of the way the 'tumbling assonances in the Hebrew create a sense of being borne along by whichever path we choose'.[71] The Hebrew is in the top right, the English bottom left. In the bottom right is a picture of a figure, again set against a blustery background, winnowing and watching the chaff get blown away: it is unclear whether the figure is 'the blessed man' or Christ as Harvester: it may even be an angel, as in the parable of the tares. Psalm 2 has only one image, and this is set in the centre of the page with the Hebrew and English on either side of it. This is clearly modelled on the painting by Piero della Francesca on the Baptism of Christ, thus connecting Ps. 2.7 with the words spoken by God to His Son in all three Synoptic Gospels when Jesus was baptized.[72]

[69] Perhaps his work 'Menorah', representing the crucifixion against a vast power station, is the best example of this. See Wagner 1998; also Martin 1995 at <http://www.imagejournal.org/page/journal/articles/issue-10/>.

[70] See <http://www.rogerwagner.co.uk/work/item/40/the-book-of-praises-book-one>.

[71] Taken from e-mail correspondence (August 2012). See plate 26. It is interesting to see how the 'narrative' unfolds from the top left to bottom right, as in the Utrecht Psalter.

[72] The reference to Piero della Francesca's depiction of Psalm 2 (linking it not to the Baptism but to the Passion) is in Chapter 7 'Introduction and overview': 161, n. 13. The reference to the use of Ps. 2.7 in the Baptism is in Chapter 3 'The New Testament': 41. For Wagner's image, see plate 27; we see how here the narrative starts from the centre of the scene and works outwards, a motif which was also developed in the Utrecht Psalter.

Christ stands in the now gently flowing waters and is baptized by John under a tree, resembling the tree in Psalm 1. To his left three angels look on. Thus the connection between Psalms 1 and 2 is made in several ways—the tree, the waters, and the Christ figure who plays an active part in Psalm 1 and a recipient role in Psalm 2.

Michael Jessing (b. 1953—see plates 28 and 29) is a Northumberland artist currently working on images of urban prophecies and eclectic icons, whose individual cameos of each psalm echo the ways in which spiritual realities can be found in the ordinary things of life—in family, community, and nature— by giving expression to the full range of human emotions found throughout the Psalter. Jessing's psalms speak as much of the universal human condition as to the Church alone, although most of the illustrations are also rich in Christian symbols. Some of his psalms are based on dreams, others on ancient Near Eastern mythology; some have hints of pre-Raphaelite art. His entire *Book of Psalms* was completed in 2002. Again the text is the *King James Version*, and each image—sometimes in colour, sometimes in black and white—takes up the full facing page.[73]

Jessing has made two representations of Psalm 1. The first version focused on the way the ungodly were 'blown away', connecting it with the tree motif which was in the middle of the picture. In the second version the tree is more established and rooted; a scholarly male figure is complemented by a female one, and the wind is now represented as a falcon hovering above. The seats of the scornful tumble into the earth; the stars of the night illumine what is being meditated on in the Law. 'For me', Jessing writes, 'Psalm 1 represents an approach to God's word acknowledging nature's part in the creative process "bringing forth his fruit in due season" . . . This is essentially a passive and contemplative approach to experiencing the sacred.'[74]

Jessing has also made two representations of Psalm 2. The more recent image contrasts with Psalm 1 because it represents, in a more proactive way, God's participation in human history rather than human responsibility within it. So Jessing's symbolism is focused on how God's Son is sent to hold to account the rulers and exploiters of the earth: he chose Christ driving out the money-changers as the supreme example of it. Drawing from several mural paintings he has executed in Prestonpans (near Edinburgh), Jessing shows through this image of Psalm 2 that a transformative power is at work: hence this central Christ-like figure has a rod of iron, symbolically descending from 'Mount Zion' and dashing those who exploit their power 'like a potter's vessel'. 'For me, Psalm 2 represents God's involvement in the affairs of the world . . . this is a more dynamic and messianic approach to the sacred than

[73] See Michael Jessing at <http://www.m-jessing.supanet.com>.
[74] E-mail correspondence with the artist (July 2012). See plate 28.

in Psalm 1.'[75] So in this visual representation Psalms 1 and 2 play mutually complementary roles.

The Saint John's Bible (see plates 30 and 31), officially started in 1998 and completed in 2008, is a very different project, partly because its aim is to present the first hand-written, hand-illuminated entire Bible since the advent of the printing press. It is the work of a team of artists and calligraphers all working at a scriptorium in Wales, led by the calligrapher Donald Jackson, a 'Queen's Scribe', although this book was commissioned by Saint John's Benedictine Abbey and the University of Collegeville, Minnesota. In terms of technique, albeit not in content, this has much continuity with all we have observed earlier in this chapter, because in the design of each page it seeks to combine the traditional skills of those early draughtsmen with twenty-first-century technology. The whole *manuscript* is achieved by using quills and paints hand-ground from precious minerals and stones with 24-carat gold for burnished guildings. The Bible takes up seven volumes, covering 1,150 pages.

The psalms present one of the most unusual books in this project. The illustrations are to encourage 'hearing' as well as 'seeing' the psalms, following the Rule of Benedict: 'listen . . . with the ear of your heart'.[76] Hence the singing and chanting is represented technologically, using black 'oscilloscopic voiceprints' on the vertical axis and wavy gold bars, echoing musical notation, on the horizontal axis. The actual notes are represented as gold squares, reflecting neumes used in Gregorian plainchant: these ascend and descend a four-line staff, sometimes drifting out to the borders. There are in effect six illustrations of the psalms. The first is found in the frontispiece to the entire Psalter; the others occur at the beginning of each of the five books. Interestingly for a Benedictine project, the Jewish fivefold structure is used, each psalm being assigned a different colour which is used in the headings and capital letters and for the doxologies at the end of each book. The frontispiece is of all five books set out like open scrolls: at the top of each scroll there are the lights of the Menorah, making seven in all. Psalm 1 is written down the left-hand margin and across the bottom border, in undulating gold and blue calligraphy, echoing again the rise and fall of the voice in chanting: the theological intention is to show Psalm 1, in a traditional reading, as creating a Prologue to the psalter as a whole (without Psalm 2).[77]

[75] See plate 29. These observations on Psalm 2 were also part of e-mail correspondence (July 2012).

[76] See Jackson 2006; Sink 2007: 45–6, makes the interesting point that these chant-forms represent the liturgy of St John's Abbey, which come not only from Christian but also Jewish, Native American, Taosit, Hindu Bhajan, Greek Orthodox, and Buddhist trantric traditions, thus illustrating the universal concerns in the Psalter as a whole. See also <http://www.saintjohnsbible.org/Explore.aspx?ID=4>.

[77] See plate 30.

Psalm 1 appears on the next page as well, this time as the first psalm to the first book of the Psalter.[78] It is extraordinary how one can capture the sound by sight: golden musical notations travel across the page, and the black voice-prints undulate alongside them: the reds and golds and blues add to the richness of the tone. At the top of the illustration are three Menorah lights: the middle signifies an entrance to the Temple, thus suggesting Psalm 1 is a gateway to the Psalter as a sacred place. (So Temple theology, a motif which was emphasized in Chapter 1, and which was found particularly in early Jewish and early Christian exegesis, again resurfaces here.[79]) Given that the Temple theme is more explicit in Psalm 2, with the reference to Mount Zion, and given also that Psalms 1 and 2 occur on the same page, with the golden neumes from the illustration running over visually across the text of Psalm 2, it is possible to see (and hear) a clear connection between these two untitled psalms, together forming a gateway to the Psalter as a whole. As the only obvious illuminated manuscript since the fifteenth century, this is an extraordinary piece of work. Its size (38 by 26 cm) and weight, when detached from the rest of the Bible, allows it to be used for public and private prayer.

We now turn to four selections typifying modern **Jewish artistic representation** of Psalms 1 and 2. In contrast with the Christian examples offered above, which demonstrated an explicit dialogue between the text and the image, the selections below have only one example of any such dialogue; most Jewish images are free-standing, without any implicit commentary on the text. However, like the Christian images above, they are examples of illustrations based upon a dominant metaphor from the psalm in question.

One of the best examples of these 'free-standing images' are the two sketches of these two psalms by **Marc Chagall** (1887–1985—see plates 32 and 33). Chagall worked in several modes in his illustration of the psalms, including a vast mosaic on Psalm 137 for the Knesset buildings in Jerusalem, and in the latter period of his life in stained glass (for example in St Stephen's Cathedral, Metz, the parish church of All Saints, Tudeley, and in Chichester Cathedral).[80] His interest in psalmody was in part because of how it speaks to a universal human experience, covering an enormous range of emotions, and on this count small sketches of the psalms were as much a way of communicating this as vast works in public places. The *Illustrated Bible*, commissioned by Ambroise Vollard as early as the 1930s, and eventually published by 1956, shows his attention to detail when illustrating cameos from the stories of the Bible, from the patriarch Abraham to the priestly

[78] See plate 31. The psalter version is the *NRSV*. Psalms 1 and 2 are both the work of one calligrapher, Brian Simpson. The illumination of the frontispiece and of Psalm 1 are also the work of one hand, Donald Jackson, who has been the director of the whole project.

[79] This Temple theme will be seen again in Chapter 10 'Literary-critical works': 275–6 and Chapter 11 'The theme of the Temple': 288–90.

[80] See Rosen 2013.

scribe and reformer, Ezra. A further publication of these and other coloured and black-and-white lithographs was published, as part of the Éditions de la Revue as *Dessins pour la Bible*, in 1966: here one sees his fascination with the crucifixion and the person of Jesus the Jew. In 1979, some three years after beginning the stained-glass project at Mainz, and two years after his work in Chichester, Chagall published a series of some thirty etchings of the psalms, entitling them *Psaumes de David*. Their medium was brown ink: their interpretation, more literal and moral. It has been said that they resemble the illustrations of the Utrecht Psalter in the contemporary form of Russian expressionism.[81]

Chagall produced several images of Psalm 1, and his *Psaumes de David* also has a brown aquatint etching of Psalm 2.[82] What is extraordinary about these images, for our purposes, is the close relationship between these two psalms. Psalm 1 has a title 'The Two Ways'. The 'blessed man' is lying in a tree: he is the one 'like a tree planted by the waters'. To the right in the sky is an angelic figure; this, and the depiction of the sun and moon above him, remind one of the symbolism of the Utrecht Psalter. The figure is not studying the Law: the Torah is placed on another tree, just below him: so the Torah is also the Tree of Life.[83] The large bird, a recurring motif in these etchings, seems to be wading through the life-giving waters. Although Chagall's title implies a theme of judgement, there is no real evidence of it here. The female figure under the tree might suggest Eve, so the Blessed Man could also be Adam (as understood, for example, in *Midrash Tehillim*), and the trees might therefore represent the Garden of Eden, from which Adam and Eve might soon be expelled, so the judgement theme is imminent. In this etching the Torah is central; it is the Tree of Life from which the Blessed Man—whether Adam or the observer—can now partake.

Psalm 2 has the title 'The Lord and His Anointed'. Here a figure, dressed as a Jew, but also a royal figure with a crown on his head, stands on a hill overlooking Jerusalem: this is represented by the Dome of the Rock and a church spire (or possibly a minoret). Coming towards him, out of the sky, is what seems to be an army on horseback, driven by what seems to be some demonic host. (Again, this has some echoes of the symbolism in the Utrecht Psalter.) Above the figure is the sun, and in the middle of the sun is, again, the Torah: the figure stands resolute against an impending attack, because he is protected by the light of the Law. There are hints here, therefore, of the restoration of Jerusalem.

[81] See Chatelain 1973; Rosensaft 1987.

[82] See plates 32 and 33. See also <http://www.biblical-art.com/artwork.asp?id_artwork= 22818&showmode=Full>.

[83] It is intriguing that just as the tree becomes the cross in some Christian art (see for example the Stuttgart Psalter in Chapter 7 'The ninth to the fifteenth century': 170–1), so here in Jewish art the tree becomes the Torah.

These two sketches thus take up joint themes: the Law as the source of Life (for the Blessed Man) and Light (for the Anointed Figure). If there are hints of Eden in the first etching, then what has been lost in the first psalm (the eventual expulsion from the presence of God) is about to be redeemed in the second (by the example of the figure on the hill). The image of the Torah in both psalms is striking: Chagall has made these two psalms speak of the struggles for Jewish national and religious identity.

Another pair of images of Psalms 1 and 2 is by **Moshe Tzvi HaLevi Berger** (born in Transylvania in 1925, and since 1992 living in Jerusalem) and these are found in the collection in the Kabbalistic Museum of Psalms, which Berger himself established in 1995—see plates 34 and 35.[84] The museum contains mixed media paintings of all one hundred and fifty psalms, mainly in acrylic. Berger, whose images display the influences of the mystical teachings in the *Zohar*, uses the seven colours of the spectrum to create a great sense of difference and unity between one psalm and another, as a particular colour fades but blends into the following psalm. The aesthetic concerns are complemented by an intellectual interest: in order to interpret the psalms from his own tradition Berger familiarized himself with Jewish commentators (for example, in Kimḥi and Rashi) before deciding which verse to choose as the key motif in each psalm. The composition of the image then centres on the Hebrew letters and words which refer to the verse in question.

Psalm 1, with the dominant hues of turquoise, purple, and green, is based upon verses 2 and 3 (parts of which are written in Hebrew in the sky to the right of the tree): the key motifs are thus the Torah and the Tree of Life. The tree, which dominates the picture, resembles a Menorah, and here it seems to be planted within a stream of water: fishes swim by and under it to signify the life-giving waters which nourish the tree. Surrounding the tree on three sides are plants flicked with red, reminiscent of the Burning Bush: the scene is thus also infused with the mysterious presence of God. The rushing wind which blows across the image picks up the theme of the dispersal of the wicked at the end of verse 3.[85]

Psalm 2 picks up some of the blue and purple hues of Psalm 1 but blends them with tinges of pink and ochre which frame the base of the image, giving the impression of a smouldering fire. Verse 6 ('I have set my king in Zion, my holy hill') is the key text, and although there is no figure in this image, the Hebrew calligraphy which both ascends from the base of the picture and descends in a thick cloud from the sky suggests a theophany: the letters, in

[84] Moshe Berger, also known for his huge Kabbalistic murals, began painting the psalms with a mystical interpretation in the 1980s: see <http://www.museumofpsalms.com>. I am grateful to Mr Berger for a telephone communication and further correspondence explaining some of the imagery in these two psalms.

[85] See plate 34.

purple and turquoise, are dense and jumbled, but the impression is of various oracles of assurance uttered from above which answer the cries of anguish from below. At the centre of the illustration are many thinly pointed turrets and towers, suggesting Jerusalem, and these reach up to the heavens, receiving the words which are descending upon the city.[86]

The verdant warmth of Psalm 1, with the Torah and the Tree of Life at its heart, contrasts with the sharper images of ice and fire in Psalm 2, with Zion, the city of God, at its heart. Given the mystical concerns of the artist, it is likely that the temple theme is also present in both paintings. In the first psalm, it is an image of the Temple as a garden, imbued with the presence of God, where one encounters life-giving waters and the tree of life, while in the second psalm, the image is of the Temple in the city, affording protection from the threats of danger and destruction to the nation. So, albeit in a very different way, the complementary relationship of these two psalms is again implied.

Another image, also influenced by Kabbalistic Judaism, is of Psalm 1 on its own. **Irwin Davis** (born in 1930, now a retired industrial scientist from New Jersey, but with a lifelong background in art) has represented twelve psalms for each month of the year as well as other psalms with strong metaphors and creation and Jerusalem themes. Interestingly, despite all we have seen about the minimal use of Psalm 1 in Jewish liturgy, this psalm is the one chosen for Yom Kippur in October (see plate 36). Its concern with the reading of the Law, and the judgement on the wicked, and the redemption of the righteous, make this psalm an appropriate choice for this time of year.[87] Psalm 1 is of the 'blessed man' sitting under the tree by running water. An earlier version was of a youth, sitting somewhat nonchalantly under a leafy tree, protected by the wind (typified as a giant bird) which is driving two other youths straight into the water; this later, more serene, image is of an older bearded man, gazing into the water, and to his right several 'wicked' souls are being helplessly blown away, like chaff, in the wind (again propelled by the large white bird) towards a range of barren mountains. The fertility and stillness in the rustic imagery surrounding the elderly 'blessed man' are in stark contrast to the backdrop of the flying figures. Davis labels this psalm 'A Morality Psalm', appropriate for Yom Kippur, when we are told to examine our conduct and meditate on what is good and evil in our lives. [88]

We end with a reproduction of the psalms in a manuscript form which, although less ambitious, mirrors the Saint John's Bible project. The author and illuminator is **Debra Band** (see plates 37 and 38), who calls her work

[86] See plate 35.
[87] I am grateful to Irwin Davis for his correspondence about his interpretation of this psalm. All twelve images can be found at <http://judaism.about.com/library/2_artlit/bl_artpsalm_k. htm>. Although one collection is based upon Jerusalem, Psalm 2 is not used at all in this calendrical series.
[88] See plate 36.

'Visual Midrash'.[89] Her introduction speaks of breaking through traditional and over-familiar images of the text; her concern is to open up a three-way emotional and intellectual conversation between God, the psalmist, and ourselves. Isolated illustrations—such as wall mountings—she argues, cannot bring about this connectedness. Thus her work is about the image and the text: thirty-six psalms are written on a double-page spread, the one side written (using the New Jewish Publication Society version) in English, and illustrated accordingly, the other side written in Hebrew, with a corresponding illustration. Only very rarely are human figures used: most of the illustrations have images drawn from nature and creation, with an emphasis on the significance of the imagery in the psalm within Jewish Tradition.

Psalm 1 is one of the psalms to be illustrated in this way.[90] The first whole word is enlarged and decorated, both in the English and in the Hebrew versions, following both traditions. Behind this, on both pages, is an image of a harp, and inside the music of the harp is a pomegranate tree (a symbol in rabbinic tradition of the 613 laws because of its alleged production of 613 seeds). Twelve leaves on the tree symbolize the twelve tribes of Israel. The various flowers surrounding the tree—lilies of the valley, the rose of Sharon, pink lilies, capers—symbolize fertility, survival, and life; the grapes and vines symbolize festival meals. In the distance is a cloud of chaff: this represents those who disregard the Law. Although no human form is present, the decorated pages seem to be an invitation to sing the psalms and meditate on the life-giving words of the Law.

So the last two examples, only of Psalm 1, illustrate a particularly contemporary Jewish reading of this psalm, redolent with Jewish symbols and Jewish traditions, making a contrast with the more generally religious contemporary readings in Christian representation.

CONCLUSION

We have journeyed through some ten centuries and looked at Jewish and Christian visual exegesis of these two psalms, and, for Christian illuminations, we have taken examples from the churches in both the West and the East. Three observations might be made by way of conclusion.

The first concerns how frequently Psalm 1 is depicted in art. This is mainly the consequence of its being at the head of the Psalter, so that any image sets the scene for the interpretation of the rest of the psalms. Often this is achieved by emphasizing the theme of 'blessedness' in the first word, indicating how the rest of the Psalter is about prayer and worship and obedient faith; this was

[89] See Band 2007: xiii. [90] See plates 37 and 38.

particularly clear, for example, in the St Alban's Psalter. Other early Christian psalter examples emphasized the importance of Psalm 1 by illuminating the figure of Christ as the Blessed Man found alongside (or sometimes instead of) David, to indicate that what follows are prayers and prophecies not so much about David as about Jesus Christ. This was particularly clear in the Paris Psalter, in Ms Vatgr 752, and in the Jesse Trees found in the Windmill and Gorleston Psalters.

The second observation is a corollary of this. In both periods under discussion here, Psalm 2 is rarely illustrated independently, without there being a previous image of Psalm 1; hence illustrations of Psalm 2 usually relate to what has already been depicted in Psalm 1. The two psalms are often illuminated in a connected, complementary way, with contrasting themes which together open up a visual gateway to the Psalter as a whole. The Utrecht Psalter was one example from a western psalter; the Khludov and Theodore Psalters were good examples from Byzantium. Sometimes the connection is made by the vivid images of the fate of the wicked and the blessings of the righteous; at other times, it is by way of illustrating the human nature of Christ in the first psalm and his divine nature in the second, as seen, for example, in the Eadwine Psalter: this kind of visual exegesis is an echo of the same themes we have already noted in the Christian commentary tradition.

A third observation relates more to the contemporary illustrations, and here this includes Jewish reception as well. More often than not in the examples provided here we saw how the illustrations of Psalm 1 were more socially aware (especially evident in Arthur Wragg but also in Marc Chagall), while those of Psalm 2 suggested some political interpretations (for example, Michael Jessing's figure of Christ; and, with Marc Chagall and Moshe Berger, their evocative imagery of Jerusalem).[91] Even when some of the contemporary images chosen here were also given some specific theological emphasis, this seems to have been less about defending particular doctrine (as earlier illuminated psalters were apt to do) and more about the general importance of piety and faith: this applies to illustrations used for both psalms (for example, Roger Wagner and the St John's Bible on Psalms 1 and 2; Irwin Davis and Debra Band on Psalm 1, and Moshe Berger on Psalms 1 and 2).

Visual exegesis is a creative and diverse mode of reception, sometimes working in harmony with traditional literary exegesis, but often breaking free of convention. It offers a freedom of interpretation paralleled only in musical exegesis, as the following chapter on the musical representations of these two psalms will testify.

[91] Although it is rarely found in artistic representations of these psalms, the Jerusalem Temple theme is implicit in all three examples.

8

Musical Interpretations

ASSESSING THE EVIDENCE

Several incongruities are to be found in this chapter. One is the fact that although the musical adaptation of the psalms undoubtedly has its roots in Jewish Second Temple worship, very little is known of what this actually sounded like. Another is that although Jewish psalmody lays the foundation for the musical interpretations of the psalms in Christian liturgy, there is little evidence of exactly when and how this took place. Finally, whereas we will find considerable evidence of the Christian reception of Psalms 1 and 2, particularly after the sixteenth century (for this marks the birth of metrical psalmody, as well as the public appeal of liturgical psalmody, for example in the royal court), we have no obvious testimony to corresponding examples in Jewish worship. For this we need to wait until the twentieth century, where we do find some evidence of Hebrew psalms, albeit composed for secular performance in the concert hall rather than anything to do directly with liturgy.

How might we explain such incongruities? In part the answer goes back to our chapter on liturgy, when we looked at the paucity of documentary evidence for the use of these two psalms in both early Jewish and early Christian liturgy.[1] Had we been looking for the musical reception of other psalms, our search would have been more successful. Another explanation concerning the paucity of Jewish psalmody is the 'official' prohibition on musical accompaniment and even on singing, established in the rabbinical tradition, after the fall of the Jerusalem Temple in the first century CE, as a sign of mourning its loss. Although the cantorial tradition obviously existed, it is not well documented.

So, out of necessity, this chapter will focus mostly on musical interpretations of these two psalms in Christian tradition. One interesting observation about the Christian use of Psalms 1 and 2 is that they are almost always treated as discrete entities. Even when we find an arrangement of each

[1] See Chapter 6 'Introduction and overview': 130–5.

psalm by the same composer (examples include Thomas Tallis and Henry Lawes, to be discussed later) the musical interpretations highlight their differences rather than their similarities. So whereas visual representations frequently depicted Psalms 1 and 2 in a close relationship (for example, because of their similar images of God's judgement on the wicked and his blessing on the righteous), as musical compositions they are interpreted entirely separately.

Although most of our specific examples will be from the sixteenth century onwards, it is nevertheless important to start our assessment much earlier than this—even earlier than Gregorian plainchant some nine centuries previously—and to go back to ancient practices of cantillation, most especially in Jewish music.[2] This is hardly surprising: the evidence within the Psalter as a whole, both from its contents and from its musical super-scriptions, is that originally most of the psalms were accompanied by music, and that before the fall of the Temple in 70 CE psalmody served to complement the priestly and sacrificial Temple liturgy in music and song.[3] Even after the Temple's destruction, despite the ban in rabbinic writings on singing the psalms, chanting them in some rhythmic and melodic form was local synagogue practice and compensated for the absence of a sacrificial cult, so that synagogue cantors contributed to keeping the liturgy alive as it maintained some continuity with the past.[4] It is clear that, during the Talmudic and Gaonic periods, Judaism became increasingly identified with what was *heard* rather than what could be *seen*: this 'hearing' would not only be in reading and recitation, but in chanting and responsorial singing as well.[5] On this account, the recent proposal that many of the diacritical markings (the *te'amim*) in the Masoretic text suggest musical notations is most compelling: it suggests a very early convention, which the Masoretes in the eighth century CE received, rather than invented; a convention which also affected the musical use of Christian psalmody from the start.[6]

[2] See Werner 1959: 128–66 especially, but also 17–49 and 167–205. See also Delitzsch [1894] 2005, repr. 2005: 24–30. At the same time Jewish cantillation was influenced by earlier practices used in Greek, Egyptian, and Mesopotamian cultures: see Haïk-Vantoura 1991 and the application of her theories in Mitchell 2012a: 355–77 and 2012b: 117–33.

[3] See Smith 1990: 167–86; Gillingham 2010: 91–123.

[4] Polyphonic singing, women's voices, and instrumental accompaniment were forbidden in the Babylonian Talmud (*Berakoth* 24a and *Sotah* 48a) although there were local exceptions for sabbaths and holy days. Cantillation was performed by the *hazzan*, who regulated the rhythm and the elaboration in the melodies according to local customs; any response was with male voices and in unison.

[5] See Chapter 7 'The ninth to the fifteenth century': 159–61.

[6] Cf. Mitchell 2012a: 362, who rightly argues that given the tendency of the Masoretes to preserve rather than invent, it is odd they should have invented a complete alphabet of symbols so long after the Second Temple period.

So, this chapter will fall into two disproportionate parts. In the first, we shall look at a proposed reconstruction of Jewish cantillation, applying this especially to Psalm 1, and then, using what small amount of evidence there is, assess very different and more recent Jewish compositions, focusing especially on composers such as Leonard Bernstein, whose performances are more for the concert hall than synagogue or home.

The second, more lengthy, section will trace, as far as is possible, the history of Christian musical adaptations of Psalms 1 and 2 from their Jewish origins, starting in about the fourth century CE, with the emergence of plainchant. The sixteenth century will be seen as the real watershed, because from then on we find more documented evidence of the adaptations of both these psalms (even though, of course, unlike representational art, we have no physical means of hearing how they were performed, until recordings were made in the early twentieth century).[7] The twentieth and twenty-first centuries thus provide another watershed, when it becomes possible to hear as well as see musical interpretations of both psalms, especially using internet resources. Then, in Christian as well as Jewish reception, musical interpretations of these two psalms were intended not only for church services but also for concert halls, as well as for more personal experimentation detached from any public liturgical use.

JEWISH INTERPRETATIONS

Over the last fifty years or so several Hebraists, who are also trained musicians, have published different but related theories about the decoding of the *te'amim* as musical annotations as well as signs of punctuation.[8] Some nineteen individual *sigla* regularly occur above and below the Hebrew text, sometimes combining with other signs to create twenty-six in all.[9] Those occurring beneath the text are found throughout the Hebrew Bible; the most frequent number is eight, and it is possible to see them as notes on a musical scale, taking the *silluq* (a short vertical line which is found under the final

[7] Many of these examples will have to be from the English-speaking world. But British composers cannot be viewed in isolation from those on the Continent: in the sixteenth and seventeenth centuries many travelled to the Netherlands, France, Germany, and Italy, to be influenced by musical innovations there. Coverdale's English version, the source for many later composers, is dependent upon Luther's German version, and the contents and form of metrical psalms are similarly dependent upon the French psalmody encouraged by Calvin, so we shall include German and French prototypes of the English versions of Psalms 1 and 2 as well.

[8] Scholars include Werner 1959; Haïk-Vantoura 1976, ETr. 1991; Weil 1995; and Mitchell 2012a and 2012b. See also <http://www.musicofthebible.com/teamim.htm>.

[9] See Mitchell 2012a: 357, noting also that some of the symbols are restricted to Psalms, Proverbs, and Job 3.2–42.6.

word of every verse), as the tonic.[10] Those occurring above the text might be seen as variegating the *te'amim* below the text. Some of these signs resemble the stylized chironomic hand-gestures used in early Greek musical notation: this suggests that the *te'amim* borrowed from a more universal ancient practice prevalent throughout the ancient and classical Near East. The meaning of these signs seems not to have been fully known to the Masoretes, but they faithfully preserved them, although they have been a puzzle to textual critics ever since.[11]

David Mitchell has recently undertaken the challenging project of adapting and applying these proposals to the texts of the psalms, and one of his first observations is the way that the rise and fall of the musical representation so often fits the words aesthetically.[12] One of his interpretations is of Psalm 1: this he considers to be an excellent example of what has been termed (usually with reference to poetry) as 'word-painting' in music.[13] For example, he notes how in v. 1 the accented syllable of הלך ('to walk') literally does 'walk' below and above the starting note and then returns to it.[14] Similarly the melody rises up a third on 'stand', drops down a third for 'seat' and then up again and down a fifth for the final 'sit', in each case on the accented syllable of each Hebrew word. The melody seems sculpted to fit the sense of the words.[15] Similarly in v. 2 he notes a vocal trill on הגה ('to murmur') which represents and echoes the repeated 'murmuring' or chanting of the Torah text. In v. 4 Mitchell observes how אשר תדפנו ('which [the wind] drives about') is compressed into one metrical foot, thus hastening the delivery of these words like chaff carried away by the wind. In v. 6 the whole verse revolves around the tonic triad (E–G–B) and this, along with the strong metre, gives the psalm a sense of closure, both in melody and in rhythm. Mitchell's musical representation of Psalm 1, interpreted on the basis of Vantoura's decoding of the *te'amim*, makes this point clear: it shows how word-painting can be achieved in sound as well as sense (see Figure 8.1).

Mitchell argues that the overall effect of Psalm 1 is 'cantoral and lyrical'. Although he has not to date notated Psalm 2, his informed and intuitive response to it is that it is 'bolder and stronger with a more regular martial

[10] See Mitchell (2012a: 364), who argues that given that every verse in Hebrew also ends with a *sof pasuq* (a large colon-like full stop) the *silluq* cannot serve as punctuation as well; its frequent occurrence in the middle of sentences also indicates it signifies more than a type of punctuation.
[11] See Mitchell 2012a: 364–7.
[12] See Mitchell 2012a and 2012b. We shall see later (Chapter 8 'Christian interpretations': 202–3) how this is a key feature which distinguishes Hebrew cantillation from Latin plainchant.
[13] See Mitchell 2012a: 370.
[14] Mitchell compares this with the use of the word 'astray' in Handel's 'All we like sheep': see 2012a: 370.
[15] See Mitchell 2012a: 370.

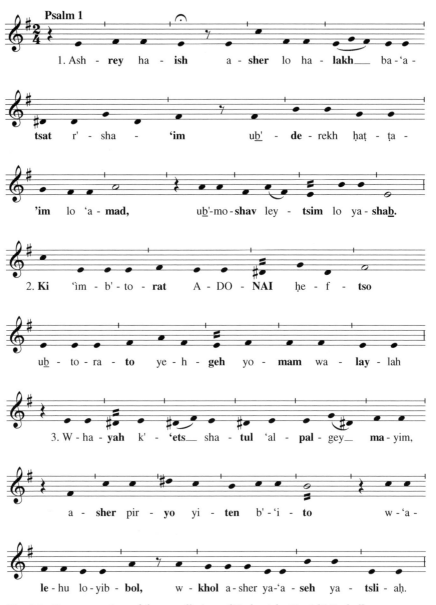

Fig. 8.1. Reconstruction of the cantillation of Psalm 1 by David Mitchell

4. Lo **khen** ha - r' - sha - **‘im** ki

‘im ka - **mots** a - **sher** ti - d - **fe** - nu **ru** - aḥ.

5. ‘Al - **ken** lo ya - **qu** - mu r' - sha - **‘im** ba - mish - **paṭ**

w - ḥaṭ - ṭa - **im** ba - ‘a - **dat** tsa - di - **qim.**

6. Ki yo - **de** - a‘ A - DO - **NAI** **de** - rekh tsa - di - **qim**

w - **de** - rekh r' - sha - **‘im** to’ - <u>**bed.**</u>

Fig. 8.1.—*continued*

metre and many strong dominants'.[16] On this account Mitchell cannot see how the two psalms have enough resemblances in terms of tone and rhythm to suggest they were actually used musically as one psalm. This actually confirms what was observed about the occurrence of these psalms in later Christian liturgy: although they could be read sequentially as one complementary work (which also resulted in a similar interpretation in art) they were used separately when sung or chanted in worship.[17]

We have already emphasized that one of the problems in trying to trace musical interpretations of Psalms 1 and 2 in Jewish tradition is the lack of documentary evidence for their use in the liturgy for which they might have been written. Yet it is quite clear that some tradition of Jewish cantillation would

[16] This is taken from e-mail correspondence (July 2012). The full version of Psalm 1 is as yet unpublished: I am most grateful for David Mitchell's permission to reproduce it here.
[17] See Chapter 6 'Conclusion': 155–6.

have continued, in all its local variety, in diaspora communities in the East and West: synagogue worship was vital for the survival of Jewish communities during periods of intense persecution from the twelfth and thirteenth centuries onwards, and psalmody in general was an important part of this.

However, by the end of the sixteenth century, in places where Jewish communities slowly began to experience a more tolerant spirit, innovative compositions of the psalms began to emerge: not surprisingly, however, these were normally designed for performance outside the synagogue rather than within it. A typical example is **Salamone Rossi** (*c.* 1570–1628), who was court musician from 1587 for Duke Vicenzo I in Mantua, and was a composer of madrigals and instrumental works for public performances. By 1623 he had also published *Ha-Shirim Asher li-Shelomo*, a collection of thirty-three psalms. These were written not only for festive synagogue occasions (using melismatic chanting by an unaccompanied chorus, to accord with the ban on musical instruments in Jewish worship since the destruction of the Second Temple) but also for use in Jewish homes (where instruments could be used based upon music from the ghetto).[18] The fact that neither Rossi nor any of his compatriots composed anything which has come to light on Psalm 1 or 2 again indicates their limited popularity, even by the time of the late Renaissance.[19]

The first clear evidence of the musical adaptation of Psalms 1 and 2, in an English-speaking medium, is some four centuries later. One example is **Lazar Weiner** (1897–1982). From singing as a child in Brodsky synagogue, Kiev, to some fifty years later composing music for the Ashkenazi rite at the Central Reform Synagogue in New York, Weiner, a Croatian émigré, both directed and composed music for synagogue liturgy. Weiner was also passionate about Yiddish folk music, not least because of its disintegration as a result of the two World Wars, and he had composed some two hundred songs by the time of his death.[20] Hence his musical compositions were both for the *bima* and the podium. Between 1920, when he was appointed as director of the Jewish People's Philharmonic Chorus in New York, and 1950, when he taught at the cantorial school of Hebrew Union College, New York, Weiner's output of both secular and liturgical music was immense (although near the end of his life he abandoned composing for the synagogue, as he considered it was becoming too ultra-fashionable in using too much 'popular' music). Perhaps

[18] See Harrán 1999.

[19] Concerning the very few Jewish responses to the music of the psalms, see Bohlman 2008; see also Chapter 6 'From the sixteenth century to the present day': 153–5.

[20] The preservation of Yiddish folk song was a phenomenon which developed first in Russia and then in America in the early twentieth century, imitating, for example, the same interest in the German *Lieder* of Schubert and Brahms, and in the works of Debussy in France, of Rachmaninov in Russia, and of Britten and of Vaughan Williams in England. Weiner had been introduced to this genre only when in America, through 'salon evenings' hosted by the violinist Naham Baruch Minkoff, who played in the Mendelssohn Symphony Orchestra, Brooklyn, where Weiner was conductor.

predictably, Weiner created several musical adaptations of the psalms throughout this time.[21] Psalm 1 was, appropriately, a composition in Yiddish: *Ashrei ho-ish asher lo holach* was written for a cantor solo, a mixed chorus, and was to be accompanied by the organ. Being not so much a prayer as a reflective poem, Psalm 1 was an ideal example of bridging the two worlds of the theatrical and liturgical, of the secular and the prayerful, yet in each case providing a marker for a distinctively Jewish ethnic identity. *Ashrei ho-ish* was actually first performed as a concert piece, in New York, in 1956.[22]

Another secular context for the performance of these psalms—in this case, a part of Psalm 2—was provided some ten years later by another American Jewish émigré, **Leonard Bernstein** (1918–1990). He was the son of middle-class Russian parents; born in Lawrence, Massachusetts, he had to persuade his father—a son of generations of rabbis and himself a student of the Talmud—to be permitted to take piano lessons and embrace a musical career. His *Chichester Psalms* was composed during a difficult period in his life, when his disillusionment with contemporary music resulted in a year's sabbatical from the New York Philharmonic. The invitation to compose a piece for the Chichester Cathedral Festival with a hint of *West Side Story* was sufficiently different and Bernstein accepted it, almost certainly using Stravinksy's *Symphony of Psalms* (composed in 1930) as a prototype. *Chichester Psalms* was performed in the Cathedral in July 1965.[23] It comprises seven principal themes in three contrasting movements: six of them derive from material written for an aborted musical, 'The Skin of our Teeth', so the Broadway influence is fundamental throughout the composition. It is at the end of the second movement that the first four verses of Psalm 2 are used to create an aggressive and discordant piece, sung only by a male chorus: this was a piece which had actually been discarded from the opening of *West Side Story*—it was originally called 'Mix'—and the words, in Hebrew, narrated the crisis of Jewish and Christian faith which was now so clearly apparent in post-war Europe and America.

The first movement of *Chichester Psalms* starts with Psalm 108.2 ('Awake, O harp and lyre! I will awake the dawn') and leads into Psalm 100 ('Make a joyful noise to the Lord!') which is set in the style of a jazz dance, with a chorus of boys and bass voices accompanied by six brass, two harps, percussion, and strings. The second movement starts more nostalgically with

[21] A selection of Weiner's psalms was produced in 2006 as 'Psalms of Joy and Sorrow': see <http://www.allmusic.com/album/psalms-of-joy-and-sorrow-mw0000561687>.

[22] I have to date found no clear evidence of a composition of Psalm 2. For Psalm 1, see <http://www.zamir.org/composers/WeinerLazar.html>. For other Jewish compositions of psalmody and choral music in the nineteenth and twentieth centuries, see <http://www.zamir.org/db/index.html>.

[23] Although it was commissioned for the 1965 Festival, the world premier took place earlier in 1965 in the Philharmonic Hall, New York, with Bernstein conducting. On Bernstein's *Chichester Psalms*, see <http://www.proarte.org/note/bernstein.html>.

the pastoral Psalm 23 ('The Lord is my Shepherd') suggesting the hope of faith, despite experience, for peace with God: it is sung as a treble solo and repeated by a female chorus (again accompanied by the harp). The harmony is then suddenly ripped apart by clashing sounds, as Ps. 2.1–4 ('Why do the nations conspire?') begins with its male chorus, *allegro feroce*, with an agitated, percussion-dominated, increasingly frenzied beat (which some have compared with the music of 'Sharks and Jets' in *West Side Story*) evoking not so much the hope of peace as the ongoing threat of war. Gradually the raging fades as the second movement once again returns to strains of Psalm 23 and the uncertain hope for peace takes over once more. The third movement opens with a more tense instrumental introduction, expressing again the anxiety created by a crisis of faith. This moves into a more harmonious and resolute piece, using the trumpet and harp and male voices, followed by a full-chorus melodic interpretation of Psalm 131 ('O Lord, my heart is not lifted up, my eyes are not raised too high') and ending with a haunting intonation, sung by an unaccompanied chorus, of Psalm 133 ('How very good and pleasant it is when kindred live together in unity!'), as a final prayer for peace, with a sustained 'Amen' once more evoking Psalm 23, while a solo trumpet soars above the chorus.

Hence *Chichester Psalms* takes up the drama of the psalms and applies it to a community of faith via the concert hall. The serious political and theological message of Psalm 2, with all its military connotations expressing the fear of war and the crisis of faith, is integral to the performance, and indeed provides the memorable high point for the entire piece.

Because the documentary evidence for the Christian musical reception of these two psalms, first for sacred and later for secular performances, began much earlier, the evidence is more prolific. We shall account for this phenomenon below.

CHRISTIAN INTERPRETATIONS

Both the Temple and synagogue influenced Christian practices of reading and singing the psalms, as the earlier chapter on liturgy demonstrated.[24] Antiphonal psalmody, for example, is an adaptation of an earlier Hebrew convention, found for instance in the refrains to several psalms (for example, Pss. 8.1, 9; 118.1, 29; and Psalm 136, which has antiphons every

[24] Synagogue liturgy has correspondences with the practice of reading and reciting in the Daily Offices; Temple worship, with its sacrificial and choral traditions, has more associations with the emergence of the Mass. Although this view has been criticized for being overly simplistic (see, for example, McKinnon 1999: 44–5), our earlier discussion of Psalms 1 and 2 in liturgy suggests it is a compelling possibility.

half-verse).[25] Antiphons comprising just one verse (or half-verse) would have been sung at the beginning and end of a psalm, leaving the body of the psalm to be sung by a trained cantor and/or choir: this became an important way of enabling the laity to learn a short piece set to a simple melody.[26] As far as Psalms 1 and 2 were concerned, phrases such as '*beatus vir qui non abiit in consilio impiorum*' from Ps. 1.1 and '*beati omnes qui confidunt in eo*' from Ps. 2.12 could well have been used in this way. Plainchant, like Hebrew cantillation, initially comprised one 'plain' unharmonized melody, sung without accompaniment, and only later was elaborated to include counterpoint. By the late fourth century this convention is evident in both western and eastern churches: one explicit witness is the fourth-century nun, Egeria, who notes on her travels to and throughout the Holy Land '. . . from (so early an) hour until it is light, hymns are sung and psalms are responded to, and likewise antiphons; and with every hymn there is a prayer'.[27]

By the fourth century, plainchant (associated initially with **Bishop Ambrose of Milan**, who we noted previously for his exegetical works on the Psalms[28]) was becoming a formative influence in the western churches: Ambrose's *schola cantorum* used not only antiphonal psalmody but also more elaborate and ornate styles of cantillation. Many of these were adaptations of anti-Arian hymnody from the Syriac and Coptic churches in the East, using hymns celebrating God as creator and king based upon psalms such as Psalms 8, 33, 104, and 95–9.[29] This phenomenon gradually took on many different forms, as churches in Milan, Toledo, Carthage, Jerusalem, Constantinople, and Rome adapted it in different ways. Gregorian plainchant, traced back to the seventh century and to Pope Gregory I, is the best-known development of this in the West: originally for use in the eight monastic offices, it later became part of cathedral liturgy as well, and in the Carolingian period was disseminated throughout France, Italy and England.[31]

[25] That Psalm 136 was sung antiphonally is clear from 2 Chron. 5.13–14. There are many other examples in the Psalter—Psalms 49, 57, and 99 have two such refrains. Psalms 42–3 and 46 have three, and Psalms 59 and 80 have four. On the evidence for antiphonal psalmody in the early Church, see McKinnon 1987: 114–15 (citing Egeria), 146 (citing Cassian), and 168 (citing Pseudo-Augustine).

[26] Other practices, each probably with antecedents in Jewish practices, include *responsorial* singing, whereby the verses of the psalm were chanted alternately between a cantor and a choir, and singing *in directum*, whereby the entire psalm would be chanted by all those present, as seen in later Benedictine practice: see Box 1996: 18–21.

[27] Taken from *Itinerarium Egeriae* sect. xxiv, pt. 2, cited in McKinnon 1999: 51. See also Wilkinson 1999. Another frequently cited reference to the various ways of singing of the psalms in North African churches is found in Augustine's *Confessions*, Book Ten: see Fassler 2001: 3–14 and McKinnon 1987: 112–17.

[28] See Chapter 3 'The Vulgate': 58–9.

[29] Greek hymnody in turn shaped and was shaped by Hebrew cantillation practices, taken from the Diaspora Jews in Syria and Egypt; so the churches in the West adapted these practices too. See Gillingham 2008a: 37–8.

[30] Adapted from Box 1996: 18.

Ex. 1

**(*The New Oxford Dictionary of Music*
(London, OUP, 1954), vol. 2, p. 67)**

Fig. 8.2. Psalm 2.1.[30] Two phrases expressed in bipartite format, in Latin.

Obviously there are many differences between early Hebrew cantillation
and later Latin plainchant, given the very different linguistic and poetic
conventions in Hebrew, Greek, and Latin psalmody. Whereas in Jewish
cantillation the melody and the rhythm were more sculpted to fit the text (as
we saw in Mitchell's interpretation of Psalm 1) in Latin, which has a different
convention of the stress of syllables, the opposite is the case: the text is
secondary and the chant is primary, so that every verse is forced into a bi-
partite form.[32] But there is a good deal of continuity, as well, as is seen
in the examples below. The bipartite form in Latin corresponds loosely
with Hebrew parallelism: the two cadential inflections, at the beginning and
end of a verse, are the hallmark of Ambrosian chant (Gregorian plainchant
often adding a third inflection in the middle of the verse) and although in
Hebrew recitation the sense is more important than the sound, the two halves
of each verse are still important. It is just that only each stressed syllable is
set against one note in the Latin, while each separate syllable is, if Mitchell's
proposal is correct, usually given one note in the Hebrew. A much simplified
example of the bipartite convention, in Latin, is illustrated in Figure 8.2.

It is also likely that Latin and Hebrew share some melodic continuity:
both Hebrew chanting and Latin plainchant basically consist of eight tones,
and in each case the mode (or, later, scale) is determined by the dominant
(usually the fifth) note with the tonic 'home-note' ending the chant.[33]
Another obvious similarity is the *tonus peregrinus*, the inflections or the
'wandering tones' at the end of the verse: in the Hebrew example of Psalm 1
this is not as evident, except perhaps at the end of v. 1, but it is a convention
which is very clear in other psalms—Psalm 114, for example, so that syna-
gogue chant and plainchant are all but identical.[34] All this requires another

[31] For an informative account of Gregorian plainchant and its relationship with other types
of antiphonal psalmody, see Dyer 1989: 535–78.

[32] It is mainly the Hebrew system of vowels which makes it less stress-timed. Latin is more
syllable-based. Thus in Hebrew the stress can encompass a number of syllables, so that the
rhythm can be speeded up or slowed down, whereas Latin prefers regular numbers of syllables
for each poetic foot.

[33] See Mitchell 2012a: 372. I am also indebted here to further e-mail correspondence with the
author (August 2012).

[34] See Mitchell 2012a: 371–6.

shared convention—the skill of a competent cantor in leading the singing and a trained (all-male) choir.

The genius of Gregorian plainchant is that it is both structured and flexible: unlike Hebrew cantillation, every single verse follows the same melody and rhythm, even though each verse, having even more syllables and stresses when translated into Latin, has to be modified to maintain some consistency and continuity throughout.[35]

A later example of a complex version of the introit antiphon from Ps. 2.7 for the night before Christmas ('The Lord said to me: You are my Son, this day I have begotten Thee . . .') is offered below.[36] This illustrates some elaboration of early notation; it is now set out in the mixolydian mode (that is, the scale from G to the G just one octave higher) as indicated by the clef for the dominant fifth (D) at the beginning of each line, so that the home-note could be anticipated from the start (the chant thus finishes on the tonic, G). The example also shows the use of the *tonus peregrinus* especially at the end of the second cadence; furthermore, it is a good illustration of the way that in the Latin the *three* phrases in the verse have to be fitted into the bipartite structure of just two cadences (see Figure 8.3).[37]

The above transcription into this written form is of course a later development. Manuscript evidence from the early medieval period is minimal: oral practices had to be committed to memory. One of the earliest written sources is *Commemoratio brevis de tonis et psalmis modulandis*, which gives detailed information about psalmodic practice and performance in ninth-century northern France. As the forms became more fixed this created more scope for even more elaborate polyphony and the use of the organ: there are records of this from Winchester and Notre Dame in the eleventh century, from St Albans in the twelfth century, and from Salisbury (in the Sarum Rite) in the thirteenth century.[38] By the fifteenth century, as printed liturgical Psalters became more the norm, Gregorian plainchant became the standard practice throughout the western churches.[39]

Just as Ambrosian and Gregorian plainchant were originally designed so that the psalms could be sung in the (Latin) vernacular, the same concern

[35] Different forms of cantillations of course existed in the western churches—for example, the Mozarabic rites and Celtic practice—but these too were influenced by Gregorian conventions and indeed by the late eleventh century were accommodated to them.

[36] See Chapter 6 'From the Second Temple up to the fifteenth century': 138–9.

[37] See <http://www.u.arizona.edu/~aversa/music/gregorian%20Chant/greg_chant.Pdf>. There are several different websites on Gregorian Plainchant, some more visual, some with recordings, some more descriptive. Two of these are <http://comp.uark.edu/~rlee/other chant.html#resources>; and <http://www.beaufort.demon.co.uk/chant.htm>.

[38] For a translation of *Commemoratio brevis* see Bailey 1979; for accounts of written records of psalmody, see Dyer 1989: 569–71; Box 1996: 21; van Deusen and Colish 1999: 105–6; and Bell 2001: 12–31.

[39] On liturgical Psalters, see Duggan 1999: 153–90.

Singing Gregorian Chant: Mode II, example

O- MI- NUS • dí- xit ad me :

Fí- li- us me- us es tu, e-

go hó- di- e gé- nu- i te.

"The Lord said to me: You are my Son, this day I have begotten Thee." The Introit antiphon for the night before Christmas.

miércoles 16 de septembre de 2009 30

Fig. 8.3. Psalm 2.7. Three phrases expressed in bipartite format, in Latin

motivated the sixteenth-century reformers, whose versions of singing the psalms in the vernacular contributed to the break with Rome.[40] The German version of **Martin Luther** and the English version of **Miles Coverdale** are obvious examples in this respect.[41] Luther's translation was published between 1527 and 1529: like Coverdale's Psalter some ten years later, it illustrates so clearly the ongoing influence of Gregorian plainchant, albeit now through the medium of German.[42] Luther's and Coverdale's versions are still more rhythmic prose than metrical rhyme: each verse is divided into two basic lines, following the same practice as in Gregorian plainchant, and

[40] It is extraordinary to read of the resistance to this; fearing the 'seductive power of music', and drawing from early writers such as Augustine, early modern writers could only justify the psalms being used in this way (despite their musical history) if the emphasis was on teaching and instruction, rather than mere enjoyment: see Hamlin (2004: 44), discussing Hooker's response to the rise of metrical psalmody.

[41] Psalms 1 and 2 are thus found in works comprising the entire Psalter. For two useful websites on musical versions of these two psalms from Luther and Coverdale, see <http://www2.cpdl.org/wiki/index.php/Psalm_1> and <http://www2.cpdl.org/wiki/index.php/Psalm_2>.

[42] Luther initially wanted to preserve the Catholic liturgy but in the vernacular, with the transference of the singing by a trained choir to the congregation; his translation was to encourage the use of the whole psalm rather than just parts of it as had been more the practice in the Roman Church. See Gillingham 2008a: 137–41.

the words have to fit each line (sometimes rather awkwardly) using two basic beats, as with the Latin.

The first three verses of Luther's version of Psalm 1 are given below. Here it can be seen that the threefold sense of the first verse creates some problems. Coverdale's version, which used Luther's translation, pauses after the second not the first part, but like Luther it still preserves the verse in two parts, not three. Similarly the fourfold sense of v. 3 creates difficulties: Coverdale here actually split the verse into two and in effect added an extra verse to the psalm, whereas Luther has two expansive lines.[43] The translation of each psalm reveals another interesting aspect: despite all that has been seen in earlier chapters about interest in hidden (Christological) meanings, neither Luther nor Coverdale 'Christianized' them: because they saw this as a translation, specific Christian references (other than the singing of the *Gloria* at the end) are notably absent—a feature which contrasts very much with later metrical versions of the psalms, as will be seen shortly.[44]

> 1 Wohl dem, der nicht wandelt im Rat der Gottlosen:
> noch tritt auf den Weg der Sünder
> noch sitzet, da die Spötter sitzen,
> 2 sondern hat Lust am Gesetz des Herren:
> und redet von seinem Gesetze Tag und Nacht!
> 3 Der ist wie ein Baum, gepflanzet an den Wasserbächen,
> der seine Frucht bringet zu seiner Zeit:
> und seiner Blätter verwelken nicht,
> und was er machet, das gerät wohl . . .[45]

It is not clear what melodies these two psalms were originally sung to in the German (although they may well have been from secular folk songs rather than sacred music) but Luther's version was the one adapted by later composers such as **Heinrich Schütz** (1585–1672).[46] Schütz's version is from 1619. Schütz was less motivated by any liturgical use, and set the two psalms for a polychoral performance of contrasting high and low voices: having trained with Giovanni Gabrieli in Venice, his was an experiment in the application of Italian (Catholic) techniques of motet concertos to German (Lutheran) sacred music.[47]

[43] Similar issues in trying to break down the Latin versification into two corresponding lines are also seen in Psalm 2, especially vv. 2, 7 and 8.

[44] The text versions of Coverdale's Psalm 2 are given in Chapter 8 'Christian interpretations': 208–9.

[45] For a further discussion of Luther's translations of the psalms, see *The Lied, Art Song and Choral Texts Archive*, at <http://www.recmusic.org/>.

[46] We shall discuss a similar adaptation of Luther's version by Felix Mendelssohn in Chapter 8 'Christian interpretations': 222–5.

[47] *Psalmen Davids sampt etlichen Moteten und Concerten* was Schütz's first collection of music on the psalms. For a website on Schütz's *Psalms of David*, see <http://www.naxos.com/catalogue/item.asp?item_code=8.553044>. Schütz's arrangement of Psalms 1 and 2 is found on *Psalmen Davids*, Cantus Cölln, Concerto Palatino, Konrad Jungänel HMC 901652.53. For a performance for Psalm 1 see <http://www.youtube.com/watch?v=vFA7o1E9Zew>.

Schütz also interprets Psalms 1 and 2 in very different ways: Psalm 1 is quieter, more repetitive and reflective, while the opening to Psalm 2 is more aggressive and forceful, changing abruptly with the dramatic moods and speakers within the psalm.

In about 1535, probably in Zurich, Coverdale was engaged with producing the first English Bible in print, and was under some pressure (not least, given the fate of Tyndale) to compose a 'rhythmic prose' English version of the entire Psalter, for which he made considerable use of Luther's 1524 German translation alongside the Vulgate. He utilized all the conventions of plainchant: his ingenuity was his felicitous command of English, with memorable turns of phrase and an astute sense of poetic balance. Like Luther (and unlike Calvin, as will be seen shortly) Coverdale's version is midway between a translation and a paraphrase, but even so it has no explicit Christian overlay other than the *Gloria*. In Ps. 2.10–12 below we can see the strategies Coverdale used to cope with some difficult translation issues while still creating a skilful binary sense and rhythm even in verses of varied lengths and rhythms:

10. Be wise now therefore, O ye Kings: be learned, ye that are Judges of the earth.

11. Serve the Lord with fear: and rejoice unto him with reverence.

12. Kiss the Son, lest he be angry, and so ye perish from the right way: if his wrath be kindled, (yea, but a little,) blessed are all that trust in him.

Coverdale's was the Psalter used by Cranmer, after the 1549 Act of Uniformity replaced the several offices of the Catholic liturgy with, mainly, morning and evening prayer. This resulted in a more consistent use of entire psalms (usually between Old and New Testament readings) within these Offices. Cranmer nevertheless adapted an English revision of the Roman Breviary and Sarum Rite, so still preserved the psalms lectionary from the Latin tradition: this meant that the only real use of Psalms 1 and 2 was at the beginning of the sequence of reading the entire Psalter within the Offices.[48]

As with Luther's version, the early musical settings of Coverdale's version are unknown. **John Merbecke's** *Booke of Common Prayer Noted* in 1550 included musical accompaniments for the 1549 Prayer Book, using material from the Sarum Breviary, but Merbecke included only one sample setting—from Psalm 6.[49] It is clear from later compositions that Anglican Chant developed into a ten-note formula, usually with three or four notes in the first half and six or seven in the second, and this is sometimes evident in later adaptations of Psalms 1 and 2. Most versions of Coverdale were designed for liturgical occasions, usually in cathedrals or royal chapels, where ironically

[48] See Chapter 6 'From the sixteenth century to the present day: 141–2.
[49] Merbecke's *Booke of Common Prayer Noted* is to be found at <http://petrucci.mus.auth.gr/imginks/usimg/9/94IMSLP93110-PMLP192133-Merbecke_-_Book_of_common_praier_noted.Pdf>.

they became increasingly elaborate so that trained choirs were required to perform the singing.[50]

Two notable composers who used Coverdale's version and interpreted it musically using the conventions of Anglican chant are from a much later period. Each uses Psalm 1: these are **William Beale** (1784–1854), whose 'Blessed is the man' evokes the regular rhythm of plainchant, and **Edward Elgar** (1857–1934) whose 'Beatus Vir', like Beale's version, was for singing at morning prayer: although Elgar was not baptized as an Anglican (his father was a converted Roman Catholic) his version is clearly for Anglican liturgy.[51] Coverdale's version of Psalm 2 has of course been adapted in several ways since this time.[52]

As well as using Coverdale's version, musical compositions of psalmody using Latin still continued. For example, vernacular psalmody was banned during Mary's reign, with a preference for Latin plainchant once again.[53] And of course this was particularly prevalent during the Counter-Reformation on the Catholic Continent: most composers of the Latin versions of Psalm 1 and 2 are from Catholic Italy or Spain. One example is the Italian **Giovanni Gabrieli's** version of Psalm 1 in 1587 for St Mark's Venice.[54]

A decisive break with the practice of plainchant did take place, however, in the form of metrical psalmody, beginning in the reformed churches on the Continent. In 1539, in Strasbourg, **John Calvin** became familiar with Martin Bucer's (German) metrical hymns and psalms: they had polyphonic melodies but were still really Lutheran chorales using plainchant and were best performed by skilled choirs. Calvin determined to use the French medium and to involve the entire congregation, so that those singing them might memorize them and sing them not only in church but also at home and

[50] See Box 1996: 26–7.

[51] *Beatus Vir* is recorded on *Psalms from St Pauls: Volume 1, Psalms 1–17*, Hyperion CDP1 1001; Beale's is recorded by Priory Records, '*O Praise the Lord of Heaven. The Psalms of David Volume 2*' by Wells Cathedral Choir PRCD 337.

[52] One example is by Heathcote Dicken Statham, 1889–1973; another is by Robert Ashfield, 1911–2006. Statham's version is recorded by Priory Records, '*Let God Arise. The Psalms of David Volume 7*', by Norwich Cathedral Choir PRCD 409. Ashfield's version is recorded on *Psalms from St Pauls: Volume 1, Psalms 1–17*, Hyperion CDP1

[53] *Christopher Tye* (c. 1505–73), for example, served in the royal chapel under both Edward and Mary and had to compose Latin church music mainly for official, courtly occasions; similarly *William Byrd* (c. 1542–1623), lay clerk in the Chapel Royal and in 1575 elected organist, lived in the unsettling political times during the reigns of Elizabeth and James I, yet remained a faithful Catholic and was able to produce music for the psalms, to suit both Anglican and Catholic liturgy, in English as well as Latin. If either produced versions of Psalms 1 and 2 this is not listed in their collected works.

[54] Tomás Luis de Victoria, Claudio Monteverdi, and Antonio Vivaldi are all known for versions of 'Beatus Vir', but in each case this is of the Latin version *of Psalm 112*, not Psalm 1. de Victoria, returning in 1585 from Rome to his native Spain, had published in that year his *capella* motet for the Tenebrae Responsories on Holy Saturday; Monteverdi's version dates from 1630 (for St Mark's, Venice); and Vivaldi (1687–1741) produced at least three versions with a double chorus.

work. Calvin initially prescribed only the human voice: there was to be no
musical accompaniment, and certainly no harmony, for metre, rhyme, and a
single line of melody were obvious ways of memorizing by repetition. To
achieve this Calvin had to use paraphrase rather than translation. So, as early
as 1539, with the help of Clément Marot, twenty-two metrical psalms had
been published for the French congregations in Strasbourg. By 1543, when
Calvin was back in Geneva, a further thirty-nine, with additional help from
Louis Bourgeois, had appeared; by 1562 the entire Psalter, incorporating
versions from Théodore de Bèze and the music of Claude Goudimel, had
been published. Calvin prescribed that these should be sung over a period of
twenty weeks, allowing for six or seven psalms a week.[55]

The two examples below are easily memorable versions, not only because
of their obviously regular metre (both psalms are set as 10–10–10–10) but
also because of their rhyme (which for Psalm 1 is in a basic aa–bb–cc format,
and for Psalm 2 is ababcdcd, very different from the translations by Luther).
Each psalm is distinct: the music of Claude de Jeune's version of Psalm 1 is
typically quiet and reflective while Louis Bourgeois' adaptation of Psalm 2
is more strident, terse, and somewhat breathless.[56]

> Qui au conseil des malins n'a es
> Qui n'est au trac des pecheurs arresté,
> Qui des moqueurs au banc place n'a prise
> Mais nuict et jour le Loy contemple et prise
> De l'Eternel et en est desireux,
> Certainement ceslui là est hereux.
>
> (Ps. 1.1–2)

> Pourqouy font bruit et s'assemblent les gens?
> Quelle folie à murmurer les meine?
> Pourqouy sont tant les peuples diligens
> A mettre sus une entreprise vaine?
> Bandez se sont les grans Roys de la terre,
> Et les Primats ont bien tant presumé
> De conspirer et vouloir faire guerre
> Tous contre Dieu, et son Roy bien-aimé.
>
> (Ps. 2.1–2)

A similarly radical break with plainchant occurred when metrical psalmody
was introduced in England. **Coverdale** himself experimented with a much

[55] Despite the fact that paraphrase could have given him more freedom to 'Christianize' these
psalms—certainly more than with Luther's translation—Psalms 1 and 2 reflect more Calvin's
historical and David-centred approach to psalmody.

[56] These two texts have been taken from the musical settings in the CD by Chant 1450, 'Du
fond de ma pensée: Vocal Music of the French Reformation' (Christophoros 77292). Again
further details of French translations of the psalms can be found at *The Lied, Art Song and
Choral Texts Archive* at <http://www.recmusic.org/>.

freer version of some fifteen psalms in his *Ghoostley Psalmes and Spiritual Songes* (1540): his was probably the first English-language version of metrical psalms set to music, ironically still using Gregorian chant and German choral melodies.[57] Psalm 2 was one of these psalms. The contrast with his earlier version is clear, as he experiments more with rhyme and rhythm. The Christian overlay in v. 1 is also more apparent (Acts 4 is written in the margin as the interpretive text). Below is a comparison of each version. The metrical psalm is in a strange 10–10–10–10–10–8–8 metre, and the rhyme is the somewhat odd ababcdb. It has little of the fluency of the prose-rhythmic version, which preserves the Hebrew parallelism and allows each half-line to be sung to a sustained pitch, with the final syllable allowing for some inflection to create what has been termed 'sung-speech'.

> Werfore do the heathen now rage thus,
> Cospyryng together so wickedly?
> Werfore are the people so malicious,
> Vayne thynges to ymagyn so folyshly?
> The kynges of the earth stoned up together,
> And wordly rulers do conspyre
> Agaynst the Lorde and his Christ truly.[58]

> 1 Why do the heathen so furiously rage together:
> and why do the people image a vain thing?
> 2 The kings of the earth stand up, and the rulers take counsel together:
> against the Lord, and against his Anointed.[59]

In 1549, while Coverdale's version was being incorporated into Cranmer's Prayer Book, a popular English version of metrical psalms was also published, dedicated to Edward VI. This was the version by **Thomas Sternhold** and **John Hopkins**, although at that time *The Whole Book of Psalms* actually only contained some thirty-seven psalms. During the reign of Mary Tudor its progress was halted but the work was expanded by those exiled in Geneva: Coverdale, Whittingham, and the Scottish churchman, William Kethe, each contributed further psalms. The entire book was published in 1562 by John Daye, first called *The Anglo-Geneva Psalter* (eventually known simply as *Sternhold and Hopkins*). This Psalter certainly bears the imprint of the churches in Geneva: like Calvin's psalms, metre is essential, allowing the same

[57] A copy of *Ghoostley Psalmes*, preserved by Queen's College Oxford, can be accessed at <http://books.google.co.uk/books/about/Remains_of_Myles_Coverdale.html?id=11gYAAAAYA AJ&redir_esc=y>, under *Remains of Myles Coverdale* (1846): 533–90. Coverdale also included versions of the Ten Commandments and several hymns based upon New Testament verses. Ironically it was banned by Henry VIII because of its Lutheran influence. See White 1997: 51. (I am grateful to Jonathan Arnold, Chaplain of Worcester College, here for his advice concerning Coverdale's and Merbecke's use of the psalms.)
[58] From *Ghoostley Psalmes*: see Pearson 1846: 568–9.
[59] From Coverdale's 1539 version, now in *The Book of Common Prayer*.

psalm to be sung to the same tune in, for example, French, German, Dutch, and English. Rhyme is less important, despite its aid for memorization (in Figure 8.4 below), Psalm 1 is set in rhyme; Psalm 2 is not). Interestingly, even though metrical psalmody, with its expansion by paraphrase, provided scope for some Christian interpretation, there is nothing explicitly Christian in either Psalm 1 or 2 in this version. Furthermore, the somewhat pedestrian style (even in the rhyming in Psalm 1) suggests that probably these two psalms were not the most in demand in worship. Neither psalm follows the most common metrical conventions of metre: Psalm 1 (like Psalm 2, in the halting 10–10–11–11–10–10 metre) is produced in a modern format below.[60]

Psalm 1

Tune: Strasbourg, 1539; Geneva, 1551

Fig. 8.4. Psalm 1 from the *Geneva Psalter* by David T. Koyzis

[60] The three standard patterns of metre emerged: Common Metre (8–6–8–6); Short Metre (6–6–8–6); and Long Metre (8–8–8–8): although basic, the result is more easily memorable than that used for Psalm 1 above. The version here is from *The Geneva Psalter* by David T. Koyzis: text and copyright © David T. Koyzis, all rights reserved. See also <http://genevanpsalter. redeemer.ca/psalm_texts.html>, which is dedicated more to the music of the Geneva Psalter than the words.

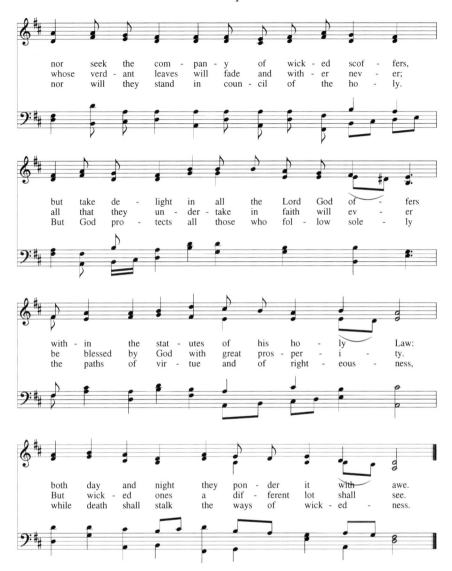

Fig. 8.4.—*continued*

By contrast, another version of Psalm 1 by **Sternhold**, which was eventually included in *The Scottish Psalter* (1635), at least has lyrics which reflect considerable poetic improvement (the rhyming ab-cb is somewhat forced). Psalm 1 again takes up seven verses rather than six, and Psalm 2 (which, unusually at this time, does have some Christian overlay) has thirteen verses rather than twelve.

Psalm 1

1. The man is blest that hath not lent
 to wicked man his ear,
Nor led his life as sinners do,
 nor sat in scorner's chair.

2. But in the law of God the Lord
 doth set his whole delight
And in the same doth exercise
 himself both day and night. . . .

Psalm 2

1. Why did the Gentiles tumults raise?
 What rage was in their brain?
 Why do the people still contrive
 a thing that is but vain?

2. The kings and rulers of the earth
 conspire and are all bent
 Against the Lord, and Christ his Son,
 whom he among us sent . . .[61]

The rhyme and the metre here both clearly demonstrate the now inevitable break with the plainchant tradition. The text, with its now predictable metre, is open to being used in a number of different melodies: one such example is that of Uriah Davenport (1755).[62]

Metrical psalmody proliferated in the seventeenth century. Examples include Henry Ainsworth's *Book of Psalms* (1612) which was the version taken by the Pilgrim Fathers to Plymouth, Massachusetts in 1620; George Wither's *Psalms of David* (1632); George Sandys' *Paraphrase upon the Psalms of David* (1636); and *The Scottish Psalter* in 1650. The versions below of all of Psalm 1 and part of Psalm 2 'for three voices and a thorough bass' are taken from George Sandys' version and are from **Henry and William Lawes'** *Choice Psalmes put into Musick* (1648—see Figures 8.5 and 8.6): Henry was a member of the 'King's Music' and the Chapel Royal; unlike his brother he survived the Civil War and subsequent Commonwealth, to be reinstated at the Chapel Royal in 1660. He produced several versions of the psalms for public occasions.[63] Psalms 1 and 2 again reveal such contrasting styles—the consistent rhythm and melody of the first psalm (and the enjoyment of the pun on his name in v. 2: '*But wholly fixeth his sincere delight / On heavenly*

[61] The version from *The Scottish Psalter* is from <http://www.cgmusic.org/workshop/smp_frame.htm>.

[62] See Uriah Davenport, *The Psalm-Singer's Pocket Companion 1755*: <http://www2.cpdl.org/wiki/index.php/Psalm_1> and <http://www2.cpdl.org/wiki/index.php/Psalm_2>.

[63] Taken from <http://conquest.imslp.info/files/imginks/usimg/e/e8/IMSLP83409-PMLP170141-Cantus_Primus.Pdf>.

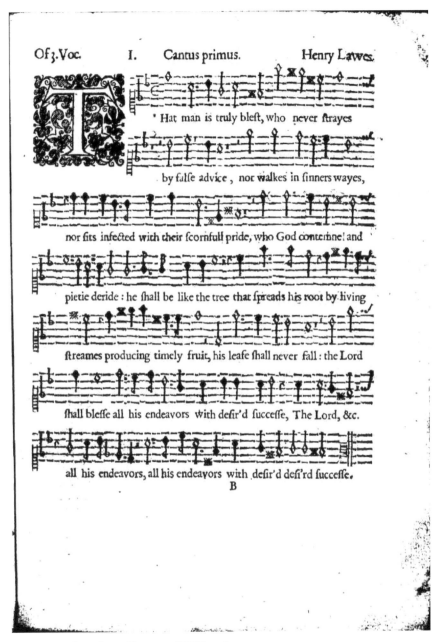

Fig. 8.5. Psalm 1 from Henry and William Lawes

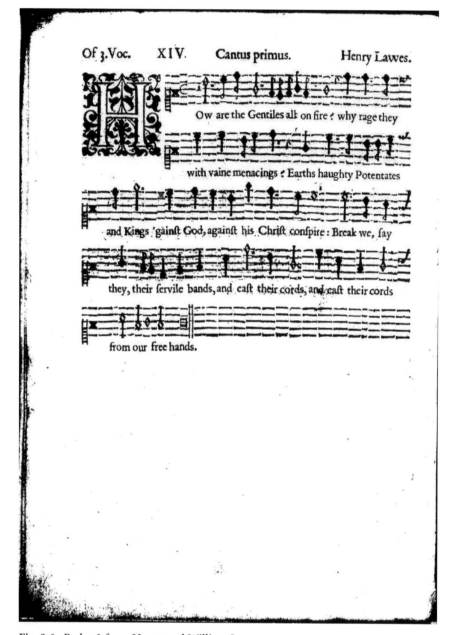

Fig. 8.6. Psalm 2 from Henry and William Lawes

Lawes . . .'), using only one syllable for every single note, and the raging of the Gentiles marked by the rise and fall in sixths (from the top F to B flat) three times in the first two lines of the second psalm.

A popular version of metrical psalmody by **Tate and Brady** (1696) eventually replaced *Sternhold and Hopkins*, in part because it was more subtle and tried to keep closer to the poetic sense and form of the Hebrew.[64] Later musical adaptations of Tate and Brady include Joseph Stevenson's version of Psalm 1 (*How blest is he who ne'er consents*) and of Psalm 2 (*Attend, O Earth, whilst I declare*) from his *Church Harmony Sacred to Devotions* (1757); Thomas Arne's version of Psalm 2 (*With restless and ungoverned rage*) to the tune of Arlington in 1784; and William Gifford's of Psalm 1, for four voices and basso continuo, from his *Twelve New Psalm Tunes* (1805).

By the eighteenth century, the distinction between a metrical psalm and a hymn based loosely upon a psalm was becoming increasingly blurred, and this in turn led to even more 'Christianizing' of these two psalms; here, the lyrics are more important than the musical medium. For example, **Isaac Watts**, who, in his *Psalms of David Imitated in the Language of the New Testament* (1719), expressed his intention as 'to make David speak the common sense and language of a Christian' made no less than three versions of each psalm, two of which in each case are explicitly Christian. Psalm 1, for example, ends twice with the theme of Christ as Judge.

> 5. How will they bear to stand
> Before that judgement-seat
> When all the saints, at Christ's right hand,
> In full assembly meet.
>
> 6. He knows, and he approves
> The way the righteous go;
> But sinners and their works shall meet
> A dreadful overthrow.

A second version (using two verses for the third verse, hence the different numbering) ends similarly:

> 6. Sinners in judgement shall not stand
> Amongst the sons of grace
> When Christ, the Judge, at his right hand
> Appoints the saints a place.
>
> 7. His eye beholds the path they tread
> His heart approves it well
> But crooked ways of sinners lead
> Down to the gates of hell.

[64] See Gillingham 2008a: 151–3.

Psalm 2 actually begins with a Prologue, not in the psalm, about 'things so long foretold by David are fulfilled when Jews and Gentiles joined to slay Jesus, thine holy child . . .'. It ends:

> Be wise, ye rulers, now,
> And worship at his throne
> With trembling joy, ye people, bow
> To God's exalted Son.
>
> If once his wrath arise,
> Ye perish on the place
> Then blessed is the soul that flies
> For refuge to his grace.

A second version of Psalm 2 starts:

> 1. Why did the nations join to slay
> The Lord's anointed Son?
> Why did they cast His laws away
> And tread His gospel down?
>
> 2. The Lord, that sits above the skies
> Derides their rage below;
> He speaks with vengeance in His eyes
> And strikes their spirits through.
>
> 3. 'I call Him My Eternal Son,
> And raise Him from the dead;
> I make My holy hill His throne,
> And wide His Kingdom spread. . . .'[65]

The two prolific hymn writers, **John Wesley** (1703–1791) and **Charles Wesley** (1707–1788) each acknowledged their debt to Watts' *Psalms of David.*[66] Charles Wesley's hymn on the 'Kingship of Christ' requires some detailed knowledge of Psalm 2 to recognize its influence, but the Christian theology used by Watts is very much evident as well as his use of metrical paraphrase. Wesley's hymnic version is still sung in Methodist churches, associated mainly with the Feasts of Ascension and Transfiguration:

[65] The versions from Watts are taken from <http://www.ccel.org/ccel/watts/psalmshymns. toc.html>. Of the three versions of Psalm 1, two have a Christian emphasis; all three versions of Psalm 2 are explicitly Christian.

[66] See Gillingham 2008a: 206–8.

1. Jesus, the conqueror, reigns,
 In glorious strength arrayed,
 His kingdom over all maintains,
 And bids the earth be glad.
 Ye sons of men, rejoice
 In Jesus' mighty love,
 Lift up your heart, lift up your voice,
 To him who rules above.

2. Extol his kingly power,
 Kiss the exalted Son
 Who died, and lives, to die no more,
 High on his Father's throne;
 Our Advocate with God,
 He undertakes our cause,
 And spreads through all the earth abroad
 The victory of his cross . . .[67]

Metrical psalmody was not only used for church worship. The sixteenth and seventeenth centuries were times of aesthetic experimentation with new poetic genres, now in English, and the psalms were seminal in this respect.[68] It is not surprising that musical experimentation followed the same trend. **Archbishop Matthew Parker's** *The Whole Psalter translated into English Metre*, published by John Daye in 1567, was one such version, intended as a devotional exercise rather than for public use. The more personal concerns of this version encouraged **Thomas Tallis** (*c.* 1514–1585) to use it as a way of experimenting more personally with four-voice harmony and psalmic forms. As one of the few court musicians attached to the Chapel Royal to survive the ecclesiastical and musical preferences of four very different monarchs, he was skilled at writing, in both English and Latin, the new chordal, syllabic style (one-note-one-syllable, again a development from plainchant) which was now required for composers of the psalms. Tallis chose eight tunes for eight psalms to match the eight tones.[69] The scale and pace of music provided an appropriate way of contrasting a wealth of emotions but in just eight musical types—meek, sad, angry, fawning, delighting, lamenting, robust, and gentle. Tallis' particular choice of psalms included 1 and 2 (see Figures 8.7 and 8.8). Psalm 1 has as its title '*The first is meek: devout to see*'; Psalm 2 (which is third, after Psalm 68 ['sad . . . in majesty']) has as its title '*The third*

[67] Taken from <http://cyberhymnal.org/htm/j/t/jtheconq.htm>.

[68] The sixteenth and seventeenth centuries also saw a good deal of experimentation in poetic imitation: see Chapter 9 'Christian translation, paraphrase, imitation, and illusion': 247–50.

[69] These 'tones' used the classical and medieval system of musical modes, which functioned in some ways like modern scales—called, for example, Dorian, Phyrigian, Lydian, and Mixolydian —and to accommodate to these was still common practice in the sixteenth century.

Nine Psalm Tunes for Archbishop Parker's Psalter

FIRST TUNE

Psalm 1

Thomas Tallis c. 1505-1585

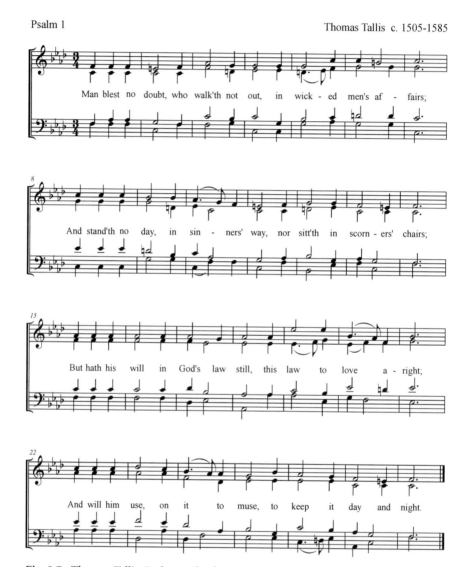

Fig. 8.7. Thomas Tallis: Psalm 1. The first tune is 'Meek . . . devout to see'

Nine Psalm Tunes for Archbishop Parker's Psalter

THIRD TUNE

Psalm 2

Thomas Tallis c. 1505-1585

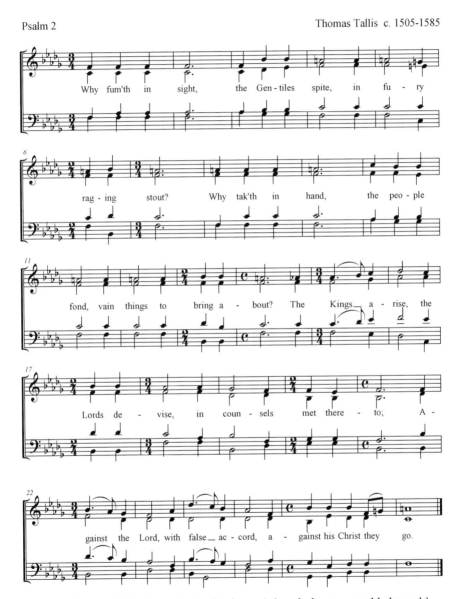

Fig. 8.8. Thomas Tallis: Psalm 2. The third tune is '. . . doth rage; roughly brayeth'

doth rage: and roughly brayeth'.[70] The Preface records that the Tenor part is for when the psalms are 'sung alone', and the other parts are for choirs to sing more privately. The contrast between the first two psalms could not be more clear: Psalm 2 undoubtedly 'rages' in forceful rising fourths, while Psalm 1 is more sustained and devoutly reflective.[71]

Tallis' arrangements of these psalms for personal and experimental purposes marks the beginning of the way in which psalmody is used not only for liturgical purposes but for public and private performance as well. Psalm 2, with its different speakers creating dramatic interludes, was in fact used more than Psalm 1 in this respect. The Dutch Calvinist **Anthoni van Noordt** (1619–1675), for example, who composed many versions of the psalms just for the organ, created an evocative version of Psalm 2 for the organ alone.[72] **Henry Purcell** (1659–1695) served both the royal court and, from time to time, the secular theatre (especially during the Commonwealth when his musical career both at the Chapel Royal and at Westminster Abbey was interrupted); he composed 'Why do the Nations?' between 1683 and 1684, just before the accession of James II. Although this was a sacred anthem for the royal court, the political overtones beyond its liturgical setting are all too clear.[73]

We noted in our earlier section on Jewish reception how by the twentieth century musical performances of Psalms 1 and 2 were beginning to take place in the concert hall as much as in the synagogue. The same phenomenon began much earlier in the Christian tradition. For example, Psalm 2 was set, a number of times, uniquely for theatrical purposes, by **George Frederick Handel** (1685–1759). His main period of composing psalms for liturgy had been during his time at the Halle, until 1703, after which he turned his attention to operatic scores, at Naples, Florence, and Venice; it was after 1711, as a composer for the Hanoverian English court, that Psalm 2, as a royal psalm, was used in a more theatrical way. It was an ideal text to use. The *Brereton Psalm 2* ('a Protestant Version of the Second Psalm') was his first use of this psalm, written in 1715 as a response to the Jacobite rebellion against George I.[74] Psalm 2 was again used at the end of the fourth Act of his oratorio *Athalia*, taken from Jean Racine's play *Athalie*, which was performed in the

[70] For a website with Tallis' music, see <http://www.youtube.com/watch2v=GwiThbJo01o7>.

[71] Both versions are taken from Ellinwood 1974: x–xi, 160–1, and 164–5. I am again indebted to Jonathan Arnold for his advice.

[72] One recording is by Peter Oowerkerk (organ), *Anthoni van Noordt Works for the Organ Volume I, Tabulature Book of Psalms and Fantasias* (1659) on Naxos 1999 DDD 8554204. See also <http://www.classicalarchives.com/work/278894.html#tvf=tracks&tv=music>.

[73] Purcell also composed a Latin motet of Psalm 3 the previous year; like Psalm 2 it speaks (albeit more personally) of being surrounded by enemies but being protected by faith in God. See Gillingham 2008a: 188–9.

[74] See Smith 1995: 216–17; Rooke 2012: 53–73, especially pp. 65–6.

Sheldonian Theatre, Oxford, in 1733, on the occasion when Handel was recommended for an honorary doctorate by the University. This time the psalm, as part of the whole oratorio, served implicitly to support the more Jacobite sentiments at Oxford: Athalia, daughter of the wicked King Ahab (2 Kings 8) is presented as a tyrant queen who usurps the throne but whose reign comes to an abrupt end when a rightful heir replaces her. The choral interlude using v. 2 fits the appropriate theme of the wicked attempting to oppose God's reign on earth through his 'anointed one': the psalm again serves a political purpose more than a theological one.[75]

Psalm 2 was also used, more fully and again politically, in Handel's *Occasional Oratorio* performed at the Theatre Royal in Covent Garden in 1746, in response to the 1745 Jacobite rebellion against George II: set in three Acts, with forty-four movements, Psalm 2 'Why do the Nations Tumult?' is the fourth movement of Act 1, set as a bass solo (with appropriate militaristic woodwind interpolations followed by trumpets and drums). It is hinted at again in the commanding Bass Aria of the twelfth movement of Act 1, 'His sceptre is the rod of righteousness' and in the soprano solo and chorus of the thirteenth and fourteenth movements of Act I, in 'Be wise, be wise at length . . .'. Its final appearance is in the last movement of Act 3, sung by the full chorus: 'Blessed are they that fear the Lord'. Much of this oratorio actually reused older material—some from *Israel in Egypt* and some from *The Messiah*. The reception was not as rapturous as the then impecunious Handel had hoped.[76]

But by far the best known of Handel's versions of this Psalm is from his *Messiah*, performed at the Music Hall in Dublin's Fishamble Street on 13 April 1741. Based completely on passages from Scripture, chosen and woven together by Charles Jennens, *Messiah* was an oratorio unlike any other. It no longer dramatized a biblical story in terms of character, dialogue, and narrative plot; rather, drawing from Handel's earlier experiences of composing Italian opera and German chorales, for example, the massed choirs and solo voices were continual participants in a much larger drama— that of the entire Christian Gospel. At this low ebb in Handel's musical career, it may well have been somewhat autobiographical as he reflected on the impact of his faith on his own life—for it seemed as if London had indeed despised and rejected him, too. Paradoxically, despite the context of the performance, Psalm 2 is used here with more theological and devotional

[75] Rooke 2012: 53–73, especially pp. 65–6. I am most grateful to Deborah Rooke for the information she has given me about Handel's use of this psalm.

[76] New College Choir, Oxford with Robert King (conductor) and the King's Consort Choristers have recorded a version of *Handel: The Occasional Oratorio* on the Hyperion label B000002220 (2000).

overtones. It is used continuously in Part Two, Movements 40–3. The first two verses ('Why do the nations so furiously rage together . . .') are a bass aria; v. 3 ('Let us break their bonds asunder . . .') is sung as a chorus; v. 4 ('He that dwelleth in heaven shall laugh them to scorn . . .') is a tenor recitative; and v. 9 ('Thou shalt break them with a rod of iron . . .') is a tenor aria, anticipating the jubilant mood of the Hallelujah Chorus (from Revelation 19) which brings Part Two to its fitting climax—that the Messiah has conquered death and has risen.[77] So the previously political appropriation of Psalm 2 is here replaced with an overt Christological reading: it is somewhat ironical that the rapturous audience response, and the subsequent reviews which hailed this as Handel's greatest oratorio, were reflections on a work which was as much personal and cathartic as designed to please others.

Another example of the use of the psalms not only in the church but in the concert hall, this time on the Continent, is **Felix Mendelssohn** (1809–1847).[78] He not only composed a vast amount of orchestral and chamber music, experimenting in part with the Classical and in part with the Romantic influences of his time, but also arranged a number of choral works—some for a more theatrical performance, like Handel, and others as oratorios and sacred works for the church. His Jewish–Christian background meant that large-scale settings of psalms were an obvious choice: choral cantatas offered him a familiar opportunity to experiment with melodies and harmonizations for both liturgical and secular performances.

His version of Psalm 2, as part of a composition of three psalms (along with Psalms 22 and 43), designed both for soloists and a double chorus, was composed between 1843 and 1846, published in 1848 and performed in 1849, shortly after his death.[79] Mendelssohn's is an ambitious arrangement of Luther's version of Psalm 2, moving between an animated eight-part anti-phonal composition to a more simple arrangement for single voices, and ending with a confident four-part Canon in the final *Gloria*. It is more restrained and dignified than Schütz's interpretation of this psalm: this is by way of his use of unstressed syllables, often disregarding the natural stresses in the German,

[77] For a website with access to Handel's compositions of psalms see <http://www.classical archives.com/handel.html>. It is impossible to list just one recording: see <http://www.classical archives.com/work/11524.html>, which lists some of the best.

[78] Most examples in this chapter have been deliberately restricted to an English language medium. However, Mendelssohn is most significant not only for his Jewish associations but also for this being such a well-known example of the use of Luther's version of these psalms: see our discussion in Chapter 8 'Christian interpretations': 203–6.

[79] This is Opus 78: <http://www.classicalarchives.com/work/93610.html>. Another notable collection is of Psalms 2, 24, 31, 91, 93, 98, and 100. Psalm 2, in eight-part polyphony and organ accompaniment, was part of this collection of psalms premiered in 1843 by Mendelssohn as an experiment in psalm melodies and harmonies: see <http://www.classicalarchives.com/work/531404.html>.

to evoke long and sustained notes. Psalm 43 uses antiphonal responses of male and female voices (with no orchestra); there is an unusually serene and unconventional arrangement of Psalm 22, which ignores the melodramatic qualities of this psalm: so the three psalms taken together offer an interesting range of experimentation in terms of mood and purpose.[80] The arrangement of the first two verses of Psalm 2 can be seen below (see Figure 8.9).

This account of Christian musical interpretations will now focus mainly on the twentieth century. Two main concerns are evident: one is that the psalms should be sung aesthetically and memorably, with technical excellence: this has much in common with what was happening to Gregorian plainchant in the *schola cantorum* during the Carolingian period. The other concern is that the psalms should be easy to understand and use: this corresponds with the Lutheran and Calvinist composers of metrical psalms in the Reformation period. The interest in the complex elaboration of styles, often using a developed form of plainchant, is now found in the equivalent of the 'cathedral offices';[81] the contemporary interest in the simple and memorable is usually found at the grass roots parish level in local congregations.[82]

In either setting, Psalms 1 and 2 usually appear coincidentally, as part of complete works on the entire Psalter. For example, publications modifying and elaborating the pointing of the psalms for chanting—again similar to the principles of plainchant—have appeared regularly since the nineteenth century, and Psalms 1 and 2 have been pointed accordingly in many of them.[83] A problem emerges, however, when we look at the plethora of editions of choral psalms set as anthems at morning or evening prayer, by more recent composers of church music such as, for example, Hubert Parry (1848–1918), Charles Stanford (1852–1924), Herbert Howells (1892–1983),

[80] For a critical performance of these three psalms, see 'Mendelssohn: Sacred Choral Works' by the choir of Trinity College Cambridge (conductor Richard Marlow) Chandos Records 2006 CHAN 10363.
[81] One might include here college chapels and churches with outstanding musical traditions. On the history of the music of parish and cathedral psalmody see Temperley 1979.
[82] This can be of any denomination where variants of metrical psalmody are more popular. See Box 1996 and Temperley 2005.
[83] One nineteenth-century example includes Pullen (1867). Similarly, the many high church compositions by the Victorian hymn-writers John Stainer (1840–1901) and Joseph Barnby (1838–96) frequently adapted psalms in this way. Perhaps the most comprehensive is *Liber Usualis*, first edited in 1896 from the Abbey of Solesmes in France, which in 1,900 pages lists every type of Gregorian chant of every psalm for every type of liturgical occasion in the Roman Catholic Church. Early twentieth-century publications include *The Psalter Newly Pointed* by the Church of England (1925). More recently RSCM published, in 1981, Anglican chants for the Psalter in the *ASB*, and since 2000 several publications have appeared to enable congregational psalm-singing to accompany *Common Worship*—for example, *The Common Worship Psalter pointed for Anglican Chant* and *Music for Common Worship I*. The latter contains an anthology of psalms and canticles with four different ways of chanting them: a simple form of plainchant, Anglican chant, 'cantor' chants, and simple chant.

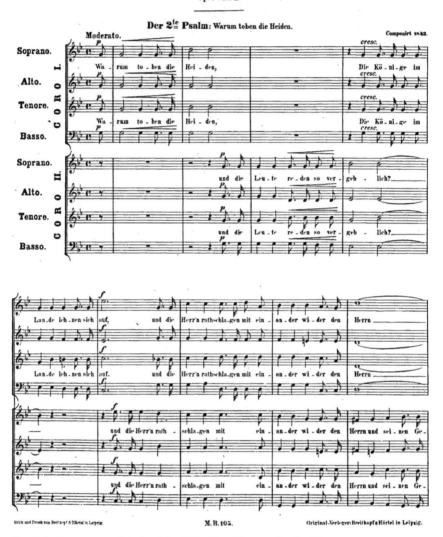

Fig. 8.9. Two verses of Psalm 2 by Felix Mendelssohn Bartholdy

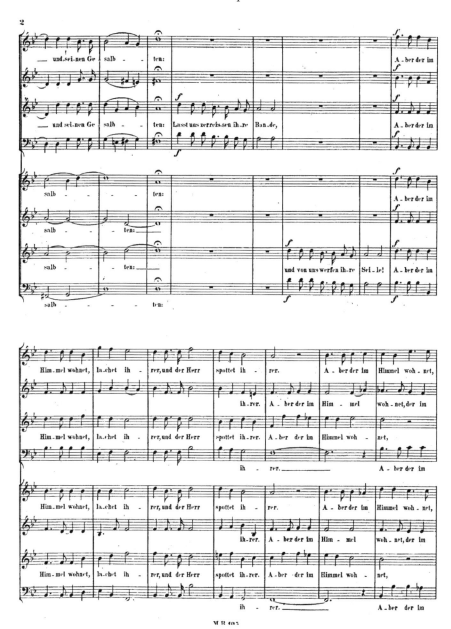

Fig. 8.9.— *continued*

William Henry Harris (1883–1973), and Jonathan Harvey (b. 1939): here the evidence of any particular interest in Psalms 1 and 2 is negligible. The only obvious examples are those mentioned earlier, by Edward Elgar, Robert Ashfield, and Heathcote Dicken Statham. [84]

Psalms 1 and 2 are however to be found in the **Gelineau Psalter**; in many ways this is a combination of the two earlier concerns (excellence through the medium of plainchant and usability through the medium of metrical psalmody), being a contemporary appropriation of plainchant, and combining responsorial and antiphonal psalm-singing in a modern vernacular translation. Above all, Gelineau's psalmody illustrates the longevity of plainchant as a way of singing the psalms.[85] Its emphasis on regular stressed syllables means that, as in plainchant, the music controls the psalm rather than the reverse. Examples of Psalms 1 and 2 are given below (see Figures 8.10 and 8.11). Psalm 1, in the Gelineau edition, has no explanation: the Preface, however, makes it clear that the translation is directly from the Hebrew and the rhythmic principle of the 'stressed syllable' (here, in English) has been followed throughout. The comment on Psalm 2 offers an additional explanation of the text: its regular beat and stresses signify it as a 'psalm of defiance' (Acts 4.19 and Rev. 19.16 are cited here)—'defiance of the spirit in the name of God'. The rhythm makes this clear: it is a very different type of psalm from Psalm 1.

Other musical (often ecumenical) editions of entire Psalters for local congregations also sometimes have adaptations of Psalms 1 and 2. One example is *Psalm Praise* (1973), which comprises some seventy-six psalms, paraphrased by a team of then contemporary Christian composers. **Michael Baughen** was responsible for both Psalms 1 and 2—see Figures 8.12a and 8.12b below: they illustrate that their affinity is more with metrical psalmody than with plainchant. An interesting addition, however, is the use of the antiphon, which, as in Gelineau psalmody, has more correspondences with plainchant.

Psalms 1 and 2 are also found in *A New Metrical Psalter*, published by the Episcopal Church in the USA in 1986, where the suggested tunes for Psalm 1 are Gardiner and Rockingham, and for Ps. 2.7–10, Uffingham. *Psalms for Today* (1990) contains one hundred and thirty-three psalms set to over two hundred psalm settings, many of which were already well-known hymn tunes, with others being set as chants or responsorial versions, and has four versions of Psalm 1 and one of Psalm 2, again using the rhyme and metre of metrical psalmody. Psalm 1 also appears prominently in the American *Selah Psalter* (2001) as 'This is the First of Songs', complementing 'This is the Song that Crowns our Singing' (which is of Psalm 150).

[84] See Chapter 8 'Christian interpretations': 207.
[85] See Chapter 6 'Conclusion': 150–1.

It is therefore clear that many musical compositions of Psalms 1 and 2 for liturgy are contemporary adaptations of traditional psalmody, and indirectly these can still be traced back to early Hebrew cantillation. By the twentieth century this genre was still being used, but now for psalms not necessarily intended as liturgical compositions. One example of a non-liturgical performance is by **Sergei Rachmaninov** (1873–1943) whose setting of parts of Psalms 1–3 is used in his *All Night Vigil*, also known (somewhat inaccurately)

Ps. 1 HAPPY INDEED IS THE MAN

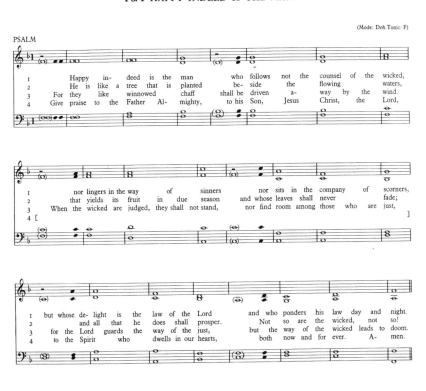

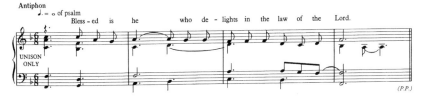

Fig. 8.10. Psalm 1, 'Happy Indeed is the Man' © Ladies of the Grail 1957[86]

[86] Taken from *Thirty Psalms and Two Canticles*, London: The Grail, 1957: 1.

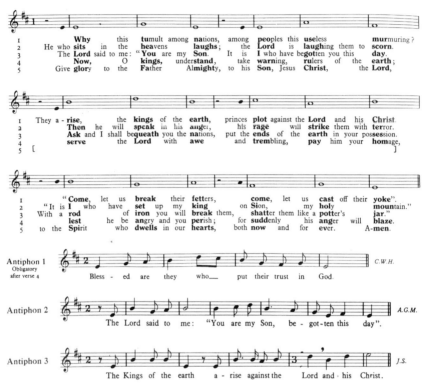

PS.**2** WHY THIS TUMULT AMONG NATIONS?

Mode : Ray. Tonic : E.
Verse : 3 + 3 + 3 + 3 + 3 + 3

Fig. 8.11. Psalm 2, 'Why this Tumult Among Nations?' © Ladies of the Grail 1958[87]

as *The Vespers*.[88] Although the Russian Orthodox liturgy and the Slavonic chant evokes a liturgical context, the lack of any liturgical rubrics suggests it was always intended to be a non-liturgical performance, akin to Beethoven's *Missa Solemnis*. Composed in just over two weeks, between January and February 1915, it was initially given as a fund-raising concert in Moscow in aid of the war against Germany. Through the use of ancient liturgical cantillation (Jewish, Slavonic, Greek) the whole performance was a way of affirming Russian nationalism, and, more theologically, of affirming the stability of tradition at a time of chaos, and peace at a time of war. There was, of course, no musical accompaniment, because of its imitation of Orthodox liturgy which prohibited it, so the impact depends totally on the contrasting

[87] Taken from *Twenty Four Psalms and A Canticle*, London: The Grail 1958: 2–3.
[88] The Vespers actually comprises only the first six movements; the following eight are for the service of Matins (including 'Glory to God in the Highest'; and Magnificat) and the last movement, completing the Easter Vigil ('To Thee Victorious Leader', based upon a traditional Greek chant), is for the office of Prime.

tones of human voices: although a four-part harmony is the most common, the harmonies increase up to eleven parts in places. As a continuously unaccompanied chorus it is arguably the most exquisitely haunting and memorable of all Rachmaninov's works.

The overall theme of movements 1 to 6, *The Vespers*, is the creation of the world, the breaking in of Eternal Light, and the coming of Christ, the creative word and the light incarnate. The first movement is the 'Great Amen', with a fourfold call to prayer set in six and eight parts. The second movement is an alto solo from Psalm 104, using a richly textured melismatic Greek chant which alternates between tenor, bass, soprano, and alto. Verses from Psalms 1, 2, and 3 create the third movement: the chant used is neither a typical Kiev format (as for movements 4 and 5), nor Greek (as in movements 2 and 15), nor the *znamenny* chant of Orthodox liturgy (as in movements 7, 8, 9, 12, 13, and 14) but is Rachmaninov's own, using an easily memorable melodic refrain. Psalms 1, 2, and 3 together play an important part in the Easter Liturgy of the Orthodox Church, as we have noted previously, and this accounts for their use here.[89] The movement is sung mainly by alto and tenor,

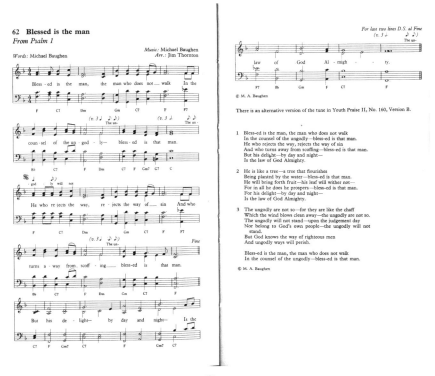

Fig. 8.12a. Psalm 1 'Blessed is the man'[90]

[89] See Chapter 6 'From the sixteenth century to the present day': 151–2.
[90] Taken from *Psalm Praise* 1973, nos. 62 and 63 © M. Baughen.

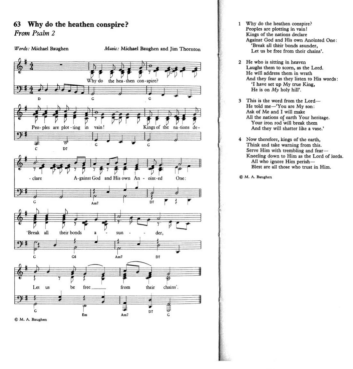

Fig. 8.12b. Psalm 2 'Why do the heathen conspire?'[91]

with the Alleluia refrain between each verse sung by a full chorus, effecting a progressive sense of expectation by repeated changes of key. Using the theme of blessing found in all these three psalms, words from the beginning of Psalm 1 ('Blessed is the Man . . .') are followed by the verse at the end of Psalm 2 ('Blessed are they that put their trust in the Lord') and then a further verse with the end of Psalm 3 ('Salvation is the Lord's: Thy blessing is upon Thy people'):

Blessed is the man that walketh not in the counsel of the ungodly. Alleluia.
For the Lord knoweth the way of the righteous: but the way of the ungodly shall perish. Alleluia.
Serve the Lord with fear, and rejoice with trembling. Alleluia.
Blessed are they that put their trust in Him. Alleluia.
Arise, O Lord; save me, O my God. Alleluia.
Salvation is the Lord's: Thy blessing is upon Thy people. Alleluia.

[91] Taken from *Psalm Praise* 1973, nos. 62 and 63 © M. Baughen.

Glory to the Father, and to the Son and to the Holy Spirit, both now and ever, and unto the ages of ages. Amen.
Alleluia, alleluia, alleluia. Glory to Thee, O God. (3x)[92]

After the Revolution, Rachmaninov escaped to America. It is somewhat ironic that such a majestic piece was to be his last composition for a public performance which was inspired by liturgical concerns.

The slightly earlier arrangement of Psalm 2 by the English composer **Ralph Vaughan Williams** (1872–1958) could not be more different. Williams experimented with many different musical genres—English folksong, chamber and ballet music, operas, symphonies, and music for brass bands—as well as arrangements of psalms for Anglican church music.[93] Originally a composition for the Three Choirs Festival at Gloucester Cathedral in 1910, Williams' *Phantasia on a Theme by Thomas Tallis*, using two string orchestras and a string quartet, was an interpretation, in three movements, of the third mode on Psalm 2 by Tallis. Tallis' arrangement of this psalm had already been used by Williams in 1906 when he was editing *The English Hymnal*, as the accompaniment to Joseph Addison's *When Rising from the Bed of Death*: the 'Phantasia' in 1910, revised again in 1913 and 1919, was more specifically on Psalm 2. The 'Phantasia' ('Fantasia') melody has been used as a theme tune for a number of films since the 1990s, including *The Passion of Christ* (2004), where the militaristic and nationalistic elements in the psalm now serve a different theological purpose.[94]

One striking motif from Psalm 1, that of the tree by the waters, has even found its way into popular culture. The lyrics of the traditional American folk song, 'We Shall Not Be Moved', probably go back to protest songs about the slave trade, although it has been adapted many times by other activists and has been popularized earlier by, for example, Johnny Cash, Elvis Presley, Joan Baez and Judith Durham. The lyrics are defiant; but the image of the tree is stable and unchanging: 'We shall not, we shall not be moved. . . . Just like a tree, that is planted by the waterside. . . .'[95] So, from the first performance of Psalm 1 by Rachmaninov to its setting as a protest song, this psalm (perhaps surprisingly when compared with Psalm 2) is capable of a political rendering.

[92] The evening hymn of light follows as the fourth movement, using Psalm 141; the fifth movement is the Song of Simeon from Luke 2; the sixth is the hymn to the Mother of God. See <http://notes.tarakanov.net/vespr.htm>. For a performance of the Vespers, see <http://www.youtube.com/watch?v=0yWZbf8BZG4>.
[93] For a selection of Williams' works on the psalms, including 47, 90, and 100, see *A Portrait of Vaughan Williams* (conductors S. Darlington and W. Boughton), Numbus 1999, ASIN B000001757.
[94] For the performance of this psalm, see <http://www.youtube.com/watch?v=9RCZFwDbFko>.
[95] See, for example, the performance by the Seekers on <http://www.youtube.com/watch?v=EYtytxc-m-4>.





This image of the tree is central to another interpretation by composer and presenter **Howard Goodall**, whose 2010 version of this psalm could not be more different. His 'Lyke a Freshly Planted Tree/iuxta rivulos aquarum' uses Philip Sidney's sixteenth century version of Psalm 1: it is the final psalm in a collection of thirteen, recorded as *Pelican in the Wilderness: Songs from the Psalms*, with the 'Enchanted Voices' female choir and the Tippett Quartet.[96] The theme of water and its refreshment for faith is found in many of the psalms in this collection: Psalm 1 actually opens with this image from the third verse:

> He shall be lyke a freshly planted tree,
> To which sweet springs of waters neighbours be;
> Whose braunches faile not timelie fruite to nourish,
> Nor with'red leafe shall make it faile to flourish:
> So all the things whereto that man doth bend
> Shall prosper still with well-succeeding end.[97]

The theme of judgement on the unrighteous so dominant at the beginning and ending of this psalm—albeit in music more tempered than in Psalm 2— has been modified not only by the use of Sidney's gentler version but also by the focus on this third verse. In Howard Goodall's own words, 'the anger is softened'; instead of defiance we hear a more wistful and poignant interpretation, especially because of the haunting female voices, on the refreshment God may give those who trust in him.[98]

CONCLUSION

Several themes emerge from this admittedly selective survey of the reception of Psalms 1 and 2 in music. The most significant observation concerns Jewish and Christian relations, which here have been consistently seen as irenic and, in terms of influence, even interdependent, with none of the hostility and criticism of each other's tradition which we have seen so frequently in exegetical works and in art. This is in part due to the 'secularization' of musical interpretations of psalmody, in both traditions, by the twentieth

[96] Classic FM 2010: CFMD13. Part of this psalm can be heard on <http://www.classicfm.com/shop/cds/listen-pelican-wilderness/>.

[97] On Sidney's version of Psalms 1 and 2 see Chapter 9 'Christian translation, paraphrase, imitation, and allusion': 245–7.

[98] Asked why he has to date avoided any arrangement of Psalm 2, Goodall explains this is partly because of its all too familiar associations with Handel's *Messiah*, but also because of the excessively racist and genocidal elements in the psalm: his interpretation of Psalm 1 here shows just how differently the contents and impact of the first two psalms are viewed. (This is adapted from an e-mail correspondence [August 2012].)

century: it was by then totally acceptable to hear Bernstein's *Chichester Psalms* in a cathedral setting, as it was to hear the indirect influence of Jewish melismatic chanting in Orthodox liturgy in Rachmaninov's *Vespers* in Moscow.[99]

Two other observations relate to two other concerns expressed in the very first chapter. The first is the way that each psalm is, in its musical adaptation, treated totally separately: the only exception cited here is Rachmaninov's *Vespers*, where, for liturgical reasons, parts of Psalms 1, 2, and 3 are used together. Usually when a composer interprets each psalm, this is to contrast them, rather than to link them: Thomas Tallis is a good example of this. Occasionally both psalms are found in some versions of metrical psalms (for example, in Sternhold and Hopkins) with the same metre and the same hymn tune, but this is rare.[100] The second observation is that here we note total silence regarding the theme of the Temple: this is mainly because most musical interpretations use the words of the psalm as they are, rather than expanding them to include other themes implicit within them, but nevertheless, the theme which even in artistic representation was occasionally apparent is completely absent here.

The extent to which these two psalms—as well, of course, as other psalms—were gradually adapted for secular performances, both in Jewish as well as Christian tradition, is a phenomenon we saw in their representation as art. This 'universalizing' of psalmody for everyone, regardless of a faith commitment, is also very much in evidence, at an even earlier stage, in the literary imitations of the psalms, both in private experimentation and in public use, as will be demonstrated in the following chapter.

[99] Admittedly, it would be most unlikely for a Jewish congregation to hear, for example, Handel's use of Psalm 2 in the *Messiah*, or Vaughan Williams' interpretation of these psalms, in the synagogue: but it is obvious that if these are used in the concert hall instead, Jewish participation is more than likely.

[100] See Hamlin 2004: 46.

9

English Literature

MUSIC AND POETRY

Representing Hebrew psalms as English poetry shares some of the difficulties of representing them as music, mainly because of the need to focus on their 'sound' as well as their 'sense'. But there is a key difference: using the words of a psalm for a musical composition has to deal not only with metre and rhyme but also with melody and harmony, and, when this is intended for a congregation to use, the result has to be both satisfying to sing and easy to remember. A poetic composition thus offers far more artistic licence: it is not constrained by as many conventions. This does not mean, however, that the task is an easy one. Transforming ancient Hebrew lyrics which were composed for a different purpose into early modern and contemporary lyrics has its own challenges.[1] Of these two psalms, Psalm 1 seems to offer fewer problems and hence more scope than Psalm 2: even in the Hebrew it already has a clearer structure, a fairly consistent use of parallelism, fewer textual issues, and its content is focused on one clear theme. Psalm 2, by contrast, has a less clear structure and several changes of speaker, less poetic parallelism, and the textual difficulties, especially in the last three verses, pose more of a challenge; in addition, because of its more violent and political overtones it is less often used. So poetic experimentation has been apt to concentrate more on the first psalm.

Because we are dealing primarily with the English medium in this chapter, our time frame will begin with the ninth century, with the first appearance of these psalms in English vernacular, and will end in the twenty-first. The evidence in Jewish tradition is inevitably more limited so this will be assessed first. We shall look at translations, paraphrases, imitations, and allusions of

[1] Hamlin, 2004: 261, makes an interesting observation: 'It is by means of translation—broadly as well as narrowly conceived—that literatures and cultures are created, and this seems borne out by the development of the English Renaissance, since so many of the seminal literary achievements of the period were translations, from biblical and classical languages as well as foreign vernacular.'

these two psalms, first, in Jewish reception, and, in a second section, in the many Christian adaptations of them.

As was seen in music, although these psalms are never interpreted as one single poem, when they are interpreted by the same person some interesting connections do appear. These will be considered in the conclusion.

JEWISH TRANSLATION, PARAPHRASE, IMITATION, AND ALLUSION

We have already noted that the first translations of the psalms from the Hebrew into a vernacular used by Jews were versions in Greek and Aramaic; another later translation was by the Egyptian-born **Saadiah Gaon** (882–942) who was the first Jewish scholar to translate the entire Hebrew Bible into Arabic, catering for Jews living under Islamic rule in Egypt and Syro-Palestine. As part of his response to the negative effects of the Karaite move-ment on local Jewish congregations, Gaon created his own version of the *Siddur* and composed hymns in both Hebrew and Arabic to be used in it: the purpose was to teach the whole Jewish congregation, who participated by singing them, so Gaon used rhyme and strophic structures for easier recitation. These hymns promoted the involvement of the laity and con-tributed to the influence of *piyyutim* (imitations of psalms in vernacular poetry) by other *paytanim* in Islamic lands as well as in eastern Europe.[2] Themes such as the study of Torah and worship of God as King suggest some affinity with Psalms 1 and 2, but any explicit adaptation of these two psalms has been impossible to find.[3]

But this vernacular appropriation was exceptional: Jews usually sang or read the psalms in Hebrew, just as Christians in the West used Latin, so the psalms were rarely translated by them into the language of the countries in which they had settled. This continued until the eighteenth century. Occasional exceptions are found in some Yiddish translations and com-mentaries on the psalms: Elijah Levita, for example, made a translation and commentary as early as 1545 for his Jewish congregation in Mantua, and his work has often been compared to his near contemporary, Martin

[2] See Gillingham 2008a: 73–4; also L. J. Weinberger 1998: 8–9, 74–7.

[3] According to Weinberger 1998: 4, there are known to be some 35,000 poems by some 2,800 poets. Yet it has been impossible to find anything which uses Psalms 1 and 2. Weinberger's own vast and comprehensive work on Jewish hymnography and poetry has no explicit reference to either psalm. The closest allusion to Psalm 2 is in hymns on *Ha-Malekh*: see Weinberger 1998: 181; also Donin 1980: 280–3. I am indebted to Rabbis Jonathan Magonet and Jonathan Wit-tenberg for their help in this research.

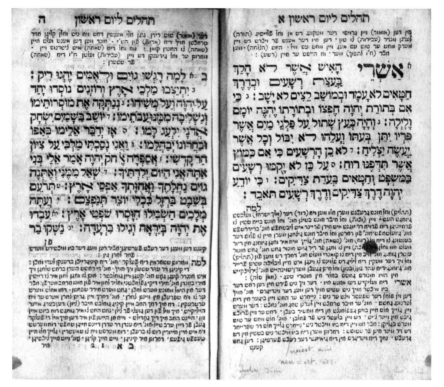

Fig. 9.1. Psalms 1 and 2 in a Yiddish Psalter, taken from *Psaumes Chants de l'Humanité*

Luther.[4] More often, however, Yiddish editions resulted in each psalm being given in Hebrew, with various prayers and commentaries above and below the psalm in the vernacular—although even here, the actual alphabet used for the vernacular was Hebrew. An example of Psalms 1 and 2 from a Yiddish Psalter is given in Figure 9.1 above.[5]

By the end of the eighteenth century and throughout the nineteenth, the gradual removal of economic, social, and religious restraints on Jewish communities resulted in the gradual emergence of the *Haskalah* throughout Europe. One consequence was a more obvious need for translations of the

[4] See Aranoff 2009: 34, n. 21: The colophon of this Hebrew/Yiddish edition reads

'And thus this work, the book of Psalms with two commentaries, the work of heaven, is now complete, done properly [lit: according to *halakha*] and in accordance with the Perfect Torah that illuminates the eyes. . . . In it he shall give God praise. . . . And this is the Torah that a person shall make and live by.' (Taken from *Tehilim*, Mantua, 1545, colophon, p. 116.)

[5] This psalter dates from 1802 (Bibliothèque du Patimoine, 11C 76) but represents earlier practices dating back to the sixteenth century: Delmaire, Haingue, Martini, Vermeylin, and Vilbes 2010: 76.

Hebrew Bible into the vernacular. In 1917 *The Jewish Society Publication Bible* was published in England, the first official edition of the psalms in English; it took advantage of both Jewish and Christian scholarship, its two key sources being the Masoretic Text and the *King James Version. The New Jewish Version,* the work of scholars from both Reform and Conservative Judaism, appeared in full in 1985. This was the text used in *The Jewish Study Bible* (2003), which involved over forty contributors and also offered essays, maps, charts, and study notes, combining the best of major Jewish medieval scholarship. Adele Berlin and Marc Brettler were together responsible for the psalms: the introduction states its equal emphasis on both scholarly and spiritual issues, and the running commentary beside the text offers different translations of Hebrew words with a theological interpretation of them from a Jewish perspective, also occasionally using rabbinical comment. Psalm 1 starts 'Happy is the man . . .'. This is a graceful and vibrant translation, making the most of the obvious Hebrew parallelism. Verse 6, for example, ends

> For the LORD cherishes the way of the righteous,
> but the way of the wicked is doomed.

For Psalm 2 the translation deals with the change of speakers in the heart of the psalm (vv. 7–8) in an elegant and scholarly way:

> Let me tell of the decree:
> The LORD said to me,
> 'You are My son,
> I have fathered you this day.
> Ask it of me,
> And I will make the nations your domain;
> Your estate, the limits of the earth'.

This version ends with references to the variant Hebrew readings in Ps. 2.11–12.[6] 'Happy are all who take refuge in Him' completes the psalm, linking it to Psalm 1, and the notes make it similarly clear that in both Jewish and Christian tradition Psalms 1 and 2 have been read as one psalm.

Orthodox Jews mainly use *The Stone Edition of the Tanach* (also called *The Artscroll Tanach*) begun by Mesorah Publications in 1976. Here the sources are the Talmud and rabbinic commentaries. *Tehillim: The Book of Psalms* (published in two volumes in 1977, revised in 1985 and 1995) is a popular edition, although it is more literal and not as stylish as a translation. It has the Hebrew text on one side of the page and the translation on the other, with a running commentary below. Both are the work of Rabbi Avrohom Chaim Feuer. Verse 1 begins:

[6] See Chapter 2 'The Apocrypha and Pseudepigrapha': 28–9, especially n. 51.

> The praises of the Man
> are that he walked not in the counsel of the wicked . . .

and v. 6 starts:

> For HASHEM recognises the way of the righteous . . .

This somewhat awkward style is continued in Psalm 2. Verse 7 may be compared with the *JSB* version as follows:

> I am obligated to proclaim: HASHEM said to me:
> 'You are My Son
> I have begotten you this day . . .'

The last verse, however, also picks up (somewhat literally) the link with the translation of Ps. 1.1:

> Praises—for those who trust in Him.

The same spirit which influenced Jewish twentieth-century translations also influenced poetic imitations of the psalms: these were initially the result of the *Haskalah*, but also, through the rise of Zionism, were responses to the violent persecution resulting in the *Shoah*; the middle of the twentieth century witnesses an outpouring of poetry which drew from the ancient traditions of the psalms.[7] Yet despite their twin emphases on the ancient beliefs in Torah and Messiah, Psalms 1 and 2 are, rather like the older *piyyutim*, hard to find. The most striking example is from **David Rosenberg**'s *Blues of the Sky* (1976), which is a reflection on the integrity of faith, using a poetic imitation of Psalm 1.[8] This most original reading of the psalm has some continuity with the intentions of earlier *piyyutim*, but it also illustrates just how far, even in Jewish tradition, creative innovation has now progressed. One of the most telling changes is the shift in metaphors: 'the paper hearts of men' are those termed 'wicked' in the original psalm, whilst the 'glib café' is the place where the 'scoffers' meet. Instead of referring explicitly to the Torah, the poet encounters now 'the world of the infinite'. The image of the tree stays the same, marking the heart of the poem as it does the heart of the psalm. The agrarian metaphors are then converted into the more urbanized symbolism used earlier in the psalm, and now the wicked blown like chaff in the wind are 'bitter men turn[ed] dry' 'blowing in the wind like yesterday's paper'. Their 'hearts of paper' burn up, later in the poem, while the poet's experience of salvation is to find he is breathing 'embracing air'.

> Happy is the one
> stepping lightly over
> paper hearts of men

[7] See Gillingham 2008a: 288–90. [8] See Rosenberg 1976: 1–2.

and out of the way
of mind-locked reality
the masks of sincerity

he steps from his place at the glib café
to find himself in the world
of the infinite . . .

. . . embracing it
in his mind
with his heart

parting his lips for it
lightly
day and night

transported like a tree
to a riverbank
sweet with fruit in time
his heart unselfish
whatever he does
ripens

while bitter men turn dry
blowing in the wind
like yesterday's paper

unable to stand
in the gathering
light

they fall
faded masks
in love's spotlight

burning hearts of paper
unhappily
locked in their own glare

but My Lord opens
his loving one
to breathe embracing air.

Perhaps it is because this is a paraphrase, not a translation, that the freedom of expression is so creative. But of all the representations of Psalm 1 we have so far seen in Jewish reception history, this is the most innovative, in that most of the traditional metaphors are given a vivid contemporary application.

CHRISTIAN TRANSLATION, PARAPHRASE, IMITATION, AND ALLUSION

From as early as the ninth century there were at least fifteen psalters with marginal and interlinear Glosses in Anglo Saxon: the best known, mainly associated in the early Middle Ages with St Augustine's Abbey at Canterbury, include the ninth century *Vespasian Psalter* (British Library: Cotton Ms Vesp A.1); the *Paris Psalter* (Bibliothèque Nationale, Paris: Ms Lat. 8846); the *Tiberius Psalter* (British Library: Cotton Ms Tiberius C); and the *Eadwine Psalter* (Trinity College Library: Ms R17.1). We have noted all these earlier because of their reception as art.[9] The most impressive is the Eadwine Psalter because it illustrates the three cultural dialects of twelfth-century England, showing how Latin was still the dominant language: the illustration used earlier shows the Gallican Psalter with the Latin interlinear, the Old Roman Psalter with the Anglo-Saxon interlinear, and the *Psalterium Hebraicum* with an Anglo-Norman gloss.[10] A version of the Old Roman Psalter with an Anglo-Saxon interlinear translation was published by F. Harsley in 1889; the extract below (Figure 9.2) is taken from this version.[11]

Nevertheless, until the fourteenth century, the predominant language of psalmody, as with the rest of Scripture, was still either the Latin text which Augustine had used, or Jerome's Latin, in one of its three versions—the *Romanum*, used in the south of England and introduced by Augustine of Canterbury; the *Gallicanum*, used in the Norman churches and brought into the north of England by Irish missionaries; and the *Hebraicum*, which was generally used only by scholars. *The Psalter of Richard Rolle* was thus the first

Fig. 9.2. Psalm 1.1–3a in the Eadwine Psalter, taken from *Eadwine's Canterbury Psalter*

[9] Chapter 7 'Introduction and overview': 159–60 (Vespasian); 158, n. 4 (Tiberius); 'The ninth to the fifteenth century': 168–9 (Paris); and 167–8 (Eadwine). In several manuscripts—for example in *The Vespasian Palter*—Psalms 1 and 2 are no longer extant.
[10] See Chapter 7 'The ninth to the fifteenth century': 167–8 and Plates 3 and 4.
[11] See Harsley 1889: 1.

full translation of the psalms into English; it was written in a somewhat stolid northern dialect, and had an extensive commentary, also in Middle English, which was essentially a translation of Lombard. Rolle's Prologue shows why he undertook this work: he describes the psalms as both a moral and mystical bridge between the physical world of words and heavenly realities where the soul could experience the love of God in Christ. Given the interest in penitent faith and the moral life at this time, his Psalter quickly became an accessible inspiration for private devotion.[12] Each verse starts with the Vulgate and is followed by the Middle English translation and explicitly Christian commentary. For example, Ps. 1.1–2 runs as follows:[13]

Here biginneþ þe Sauter book of Dauid þe prophet

{1} **Beatus uir qui non abiit in consilio impiorum et in uia peccatorum non stetit, et in cathedra pestilentie non sedit.** In þis psalme he spekeþ of Crist and his foleweris, spekynge faire to us, bihetyng blisfulhede to rightwise men, siþ he spekeþ of ueniaunce of
5 wicked men þat þei drede peyne siþ þei wolen not loue ioye. He biginneþ at þe gode man and seiþ *Blessid* is *þat man þe which ȝede not in counsel of wicked, and in þe weye of synful stode not, and in þe chayer of pestilence sate not.* He is blisful to whom alle þinges comen þat he coueiteþ, or haþ al þat he wole, and coueiteþ and wilneþ no þing þat
10 is yuel. And, as seint Austin seiþ, fyue þinges fallen to blisfulhede:

Fig. 9.3. Psalm 1.1 with commentary, taken from *Two Revisions of Rolle's English Psalter Commentary and the Related Canticles*

Rolle's Psalter also became popular in the south of England and was frequently copied (and altered) by Wycliffe's Lollard followers: for example, they provided a very different Prologue (with typically Wycliffite denunciations of ecclesiastical authorities). A stilted 'Early Version' was made between 1382 and 1384; about thirty copies have survived, some with illuminations and glosses defending the Lollard cause. This translation, sharper than that in Rolle, has been credited to the Lollard Nicholas de Herford. Ps. 1.1 here reads 'Blisful the man, that went not awei in the counseil of vnpitouse, and in the wei off sinful stod not'. The so-called 'Late Version' of 1388, attributed to another Lollard, John Purvey, has a more idiomatic slant and is closer to Rolle; Ps. 1.1 reads: 'Blessid is the man, that gede not in the council of wicked men; and stood not in the weie of synneris'.[14] It is

[12] An account of Rolle's understanding of 'Christ and His Church' hidden in the psalms is also found in his Prologue ('in this werk I seke na straunge ynglis . . . swa that thai knawes noght latyn by the ynglis may com til mony latyn wrdis'). See Hudson 2012: 6–7 (the Prologue), 8–15 (Psalm 1), and 15–26 (Psalm 2).
[13] Taken from Hudson 2012: 8. [14] See Kuczynski 1999: 191–214.

ironic, however, that Rolle's Psalter, whose purpose was to encourage all literate Christians to use it, became a means of defending the cause of a few. Psalms 1 and 2, with their emphasis on the protection of the righteous and the assaults of wicked unbelievers, served Lollardy all too well: a manuscript which contains Psalms 1–8 (BL Reg 18 B 21) has interpolations in every verse of Psalms 1 and 2. Psalm 1.1, for example, identifies the enemies of the psalmist as the 'techeris of weiward doctryn'—i.e. the Catholic Church, with whom the Lollards, according to Psalm 1, had to have no association.[15]

A very early influence on the use of psalmody in the vernacular was the emergent literary culture, whereby works composed in Middle English offered an alternative to the culture of Latin and Norman French. One such example of literary allusions to Psalm 1 (and by implication sometimes to Psalm 2, as we shall see below) is by a contemporary of Wycliffe, **William Langland** (?1332–1387), credited with the composition of *Piers Plowman* around 1377.

Langland's persona, Will the Dreamer, gives us an indication of Langland's own profession, which may well have been a 'Psalter clerk' or a reader of the psalms (in Latin) in the offices.[16] It becomes clear that, as a humble ploughman, Will can only *remember* the psalms: he does not read or write them. Psalm 1 is cited three times, and in each case we can see how its role at the start of the Psalter was seen as an entry into the teaching of the Psalms overall.[17]

For example, in Passus V Father Sloth's confession reveals that his enjoyment of hunting rabbits far surpasses any enjoyment of a priestly ministry. His confession, somewhat satirically, cites Ps. 1.1 (as well as '*Beati Omnes*', from Ps. 127.1) to show how far he has strayed from being that 'righteous man' who has not kept counsel with the wicked:

> . . . But I kan fynden in a field or in a furlang an hare
> Bettre þan in *Beatus vir* or in *Beati omnes*
> Construe clausemele and kenne it to my parrishens . . .
> (Passus V 415–19)[18]

In Passus X, the monks are warned of the importance of fidelity to their vocation, for if they do not regain their vision the reform of the church will be undertaken by those in secular power instead. The incitement for a new moral

[15] Kuczynski, 1999: 202–3, notes that of these interpolations—the 'Þat is' types of Glosses—some were merely textual, but others were references to the persecution of the Lollards. See also Everett 1922: 223.
[16] See Kuczynski 1995: 190, discussing Passus VI 45–52 which, through the words of Langland's persona, Will the Dreamer, speaks of the tools of his work being his prymer, Psalter, and seven penitential psalms for the healing of souls.
[17] This is part of what Kuczynski calls 'the poet's mental process', where psalms are simply cited without any further interpretation: see Kuczynski 1995: 193.
[18] See Kuczynski 1995: 193.

vision is by way of Ps. 1.1, this time used as a way of summarizing the teaching of the entire Psalter:

> . . . þer shal come a kyng and confesse yow Religiouses
> And bete yow, as þe bible telleþ, for brekynge of youre rule . . .
> And Barons wiþ Erles beten hem þoruȝ *Beatus vivres* techyng . . .
>
> (Passus X 322–3, 326)[19]

Finally, in Passus XV, when Anima rebukes Will for his desire to possess more knowledge and wisdom, she cites St Bernard to show how a similar desire deprived Adam and Eve of Paradise. This citation makes clear that the truly wise man is the *beatus vir* of Ps. 1.1–2, who lives according to God's laws rather than having ambition for self-improvement. The reference here seems to be just to this psalm rather than to the Psalter as a whole.

> '*Beatus est*' seiþ Seint Bernard, '*qui scripturas legit*
> *Et verba vertit in opera* fulliche to his power'.
> Coueitese to konne and to knowe science
> Adam and Eve putte out of Paradis . . .
>
> (Passus XV 60–4)[20]

So three times Psalm 1 is used as the key to a moral vision; but more than this, it is also used as the key to the moral vision that encompasses the theological worth of the entire Psalter.[21] It is interesting to see how this corresponds with the tropological interest in this psalm expressed in the commentary tradition, which we noted earlier.[22]

When we turn to the sixteenth century, which was such a seminal period for so many different modes of reception of the psalms, translating them was certainly one of the most significant of all.[23] Tyndale was the first to translate directly from the Hebrew: he actually claimed English had a much closer relationship with this ancient language than Latin had, and his (banned) version is very much a translation rather than paraphrase.[24] Coverdale, as we have already seen, could only use the Latin (and, for example, Luther's and Tyndale's versions) and on his own admission described some of this work as more paraphrase than translation.[25] Yet between 1535 and 1540 he produced no fewer than four different versions of the psalms in English (in addition to

[19] See Kuczynski 1995: 205. [20] See Kuczynski 1995: 206.

[21] Interestingly there is a complete absence of any Christological significance of this psalm in particular and indeed of the Psalter as a whole.

[22] See later Xian exegesis, for example, Peter Lombard in Chapter 5 'Medieval commentators': 105–6.

[23] Without translation, neither the liturgical nor the musical innovations which we noted in the earlier chapters would have been of any consequence.

[24] '. . . the properties of the Hebrew tongue agreeth a thousand times more with the English than the Latin. The manner of speaking is both one, so that in a thousand places thou needest not but to translate it into the English word for word when thou must seek a compass for it in Latin . . .'. Cited by Ferguson 2011: 142.

[25] His first version, from Campensis, was itself a Latin paraphrase. See Ferguson 2011: 138–9.

his version of selected metrical psalms).[26] He never pronounced one version as definitive, although the final version, for the *Great Bible*, happened by circumstance to become normative through its inclusion in *The Book of Common Prayer*. A pleasing style and a propensity for being continuously 'usable' were the two key criteria: and paraphrase thus played an essential part.[27]

By contrast, *The Geneva Bible* (published in 1559, just after the accession of Elizabeth I) contained a prose version of the psalms which was in fact translated mainly from the Hebrew, although it obviously used Greek and Latin versions as well. The *Bishops' Bible*, a compromise edition of Coverdale's *Great Bible* and *The Geneva Bible*, was published in 1568, but after the death in 1575 of its editor, Archbishop Parker, *The Geneva Bible* regained popularity, and for some eighty years dominated all other translations: this was, for example, the Bible of Shakespeare.[28] Even the *King James Version* of 1611 (which used it as a key resource in its translation) could not immediately overtake its popularity. The impetus for publishing the *King James Bible* (or the *Authorised Version*) in 1611 was as much political as theological: its preface stated it a translation 'fit for the king ... which was neither republican in sympathy, nor puritan-biased, nor catholic'.[29] The psalms were translated between 1604 and 1607 by a team of eight scholars competent in Hebrew and Greek: they were part of the group working in Cambridge who were responsible for 1 Chronicles to Ecclesiastes. Accuracy, 'middle level English', and theological uniformity (regardless of denomination) were the three agreed criteria throughout.

The following three samples contrast the first part of Psalm 1 in Coverdale's (*Great Bible*) version, *The Geneva Bible*, and the *King James Version*. Although there is not much here which illustrates the criterion of theological

[26] On Ghoostley Psalms, see Chapter 6 'From the sixteenth century to the present day': 142, n. 46. The four versions were first, from Johannes Campensis' Latin paraphrase (1534 or 1535); a version from 'Dutch and Latin' versions, in English prose, for what became eventually the Matthew Bible (1535); a revision of this for the Great Bible (1539); and a close translation of the Vulgate (1540). See Ferguson 2011: 138.

[27] See the comparison of Coverdale, *The Geneva Bible* and *The King James Version* below.

[28] Shakespeare has several allusions to Psalms 1 and 2, apparently taken from *The Geneva Bible*. For example, in his so-called *Histories*, Ps. 2.2 is alluded to in *Richard III* 4.4.151: 'Let not the heavens hear these tell-tale women I Rail on the Lord's anointed ...'. Again in *Richard III* the reference in 5.3.110 to the 'bruising irons of wrath', with its allusions to the power of the king, under God, over the nations, echoes Ps. 2.8. Similarly King Henry speaks to Prince Harry in *1 Henry IV* 3.2.10–11: 'Make me believe that thou art only marked I For the hot vengeance and the rod of heaven I To punish my misreadings ...'. In the so-called *Tragedies* Ps. 2.2. is alluded to in *Ant.* 3.6.66–68 when Caesar speaks to Octavia concerning Anthony: '(Cleopatra)-Hath nodded him to her. I He hath given his empire I Up to a whore; who are now levying / The kings o'th'earth for war ...'. The image of the tree in Ps. 1.3–4 is also alluded to, in *Richard II* 1.2.20, when the Duchess of Gloucester refers to Thomas, one of the seven sons of Edward, as 'one flourishing branch of his most royal root ... I ... hacked down, and his summer leaves all faded ...'. See Shaheen 1987a and 1987b.

[29] See Gillingham 2008a: 146–9.

uniformity, the other two (often conflicting) criteria of accuracy (if possible with regard to the Hebrew original) and an aesthetic rendering in the English equivalent require some comment. Coverdale fails in accuracy but his is the easiest to use liturgically and musically; *The Geneva Bible* succeeds in being more accurate but is the least concise and aesthetically pleasing; while the *King James Bible,* using both these versions, usually succeeds on both counts: it is closer to Coverdale's version but applies the more accurate Hebrew versification also found in *The Geneva Bible.*[30]

Coverdale	Geneva Bible	King James Bible
1. Blessed is the man that hath not walked in the counsel of the ungodly, nor stood in the way of sinners: and hath not sat in the seat of the scornful . . .	*1. Blessed is the man that doeth not walk in the counsel of the wicked, nor stand in the way of sinners, nor sit in ye seat of the scornful: . . .*	*1. Blessed is the man that walketh not in the counsel of the ungodly, nor standeth in the way of sinners, nor sitteth in the seat of the scornful. . . .*
3. And he shall be like a tree planted by the <u>water-side</u>: that will bring forth <u>his</u> fruit in <u>due</u> season.	*3. For he shall be like a tree planted by the <u>rivers of waters</u>, that will bring forth <u>her</u> fruit in <u>due</u> season: whose leaf shall not <u>fade</u>: so whatsoever he shall do, shall prosper.*	*3. And he shall be like a tree planted by the <u>rivers of water</u>, that bringeth forth <u>his</u> fruit in <u>his</u> season; his leaf also shall not <u>wither</u>; and whatsoever he doeth shall prosper.*
4. His leaf also shall not <u>wither</u>: and <u>look</u>, whatsoever he doeth, it shall prosper.		

By the sixteenth century, given that so many translations of the psalms were becoming available, there was much more scope for imitating them as well. Among the most successful is **Philip Sidney** (1554–86), who composed a version of both Psalms 1 and 2: an introduction to his work on the first forty-three psalms acknowledges them as 'one of the earliest and most ambitious attempts to grace English psalmody with the fully developed resources of the Elizabethan lyric while at the same time preserving the 'fulnes of the Sence and the *relish* of the Scripture phrase'.[31] Poetic imitation may have been a new literary genre, but it was still closely related to metrical psalmody: Sidney (who seems not to have known Hebrew) actually believed that Hebrew poetry itself was metrical, and the patterns had yet to be properly discovered.[32]

Yet this sort of exercise was also very different from metrical psalmody: generally speaking it was more immediate and unafraid of particular expressions of emotion, and because it had no requirement to be 'easily memorable'

[30] On prose translations of the psalms, see Bainton 1970; and on *The Geneva Bible,* see <http://www.genevabible.org/Geneva.html>. The words underlined highlight the key comparisons between the versions.

[31] Rathwell 1963: xv.

[32] Hamlin, Brennan, Hannay, and Kinnamon 2009: x, citing Sidney in his introduction to *Defence of Poetry.*

it could freely experiment with different lengths of stanzas and rhythms, so that it often created very compact lines which nevertheless were full of subtle and complex word play. It is undoubtedly even more a 'paraphrase' than other earlier attempts (such as Coverdale's): all that had to be faithfully represented were the tropes themselves—metaphors, images, ideas—as these were already present in the original. Working in the English language meant that the more technical poetic conventions beginning to be used in English poetry (such as alliteration, assonance, rhyme, metre, and all other rhetorical devices) could be exploited to the full.[33]

Sidney only completed versions of Psalms 1–43 before his death; Psalms 1 and 2, like every single one in this collection, have different metres, different rhyming, and different stanza forms, so the differences between them are deliberate, and no attempt is made to connect them together.[34] Both psalms are represented in full below: they reveal occasional borrowings from Coverdale or *The Geneva Psalter,* but their originality is clear. In Psalm 1 Sidney accentuates the fate of the righteous more than the wicked.[35] Psalm 2, because the subject matter was the king, uses rhyming hexameters and trimeters to create 'heroic couplets' in order to imitate a royal style, emphasizing the victory of the righteous king over the wicked nations. Verses 6 and 7 are particularly interesting in this respect.

> **Beatus vir**
>
> He blessed is who neither loosely treads
> > The straying steps as wicked counsel leads,
> Ne for bad mates in way of sinning waiteth,
> > Nor yet himself with idle scorners seateth:
> But on God's law his heart's delight doth bind
> > Which night and day he calls to marking mind.
>
> He shall be like a freshly planted tree
> > To which sweet springs of waters neighbours be,
> Whose branches fail not timely fruit to nourish,
> > Nor withered leaf shall make it fail to flourish.
> So all things whereto that man doth bend
> > Shall prosper still with well-succeeding end.
>
> Not so the wicked, but like chaff with wind
> > Scattered, shall neither stay in judgement find

[33] See Hamlin, Brennan, Hannay, and Kinnamon 2009: xxiii.

[34] The last verse of Psalm 1, only four lines long, was later modified by his sister, Mary Sidney, Countess of Pembroke, to create six lines like the other three verses of the psalm. Mary Sidney (1561–1621) actually revised the whole collection and added on Psalms 44–150. See <http://www.luminarium.org/renlit/sidbib.htm>.

[35] This was one of the reasons for Howard Goodall's choice of this version: see Chapter 8 'Christian interpretations': 232.

Nor with the just, be in their meetings placèd:
> For good men's ways by God are known and gracèd.
But who from justice sinfully do stray,
> The way they go, shall be their ruin's way.

Quare fremerunt?

What ails this heath'nish rage? What do these people mean
> To mutter murmurs vain?
Why do these earthly kings and lords such meetings make
> And counsel jointly take
Against the Lord of Lords, the Lord of everything
> And his anointed king?
'Come let us break their bonds,' say they, and fondly say
> And cast their yokes away.
But he shall them deride, who by the heav'ns is borne,
> He shall laugh them to scorn
And after, speak to them with breath of wrathful fire,
> And vex them in his ire,
And say, 'O kings, yet have I set my king upon
> My holy hill Zion.'
'And I will' (saith his king) 'the Lord's decree display
> And say that he did say:
"Thou art my son indeed, this day begot by me:
> Ask, I will give to thee
The heath'n for thy child's-right, and will thy realm extend
> Far as world's furthest end.
With iron sceptre bruise thou shalt and piecemeal break
> These men like potsherds weak."'
Therefore, O kings, be wise, O rulers, rule your mind,
> That knowledge you may find.
Serve God, serve him with fear, rejoice in him, but so
> That joy with trembling go.
With loving homage kiss that only son he hath,
> Lest you inflame his wrath,
Whereof if but a spark once kindled be, you all
> From your way perish shall.
And then, they that in him their only trust do rest,
> Oh, they be rightly blest!

Another poet who experimented with the psalms was **George Sandys** (1578–1644) whose *Paraphrase upon the Psalmes of David* was published in 1636. This version is particularly aesthetic and elegant, typically testing out a variety of metres. Later, however, Sandys published new tunes to some of these psalms, in order to show how even the variable metre could be used in worship. But his was undoubtedly primarily a literary composition: as Sidney did for Psalm 2, for Psalm 1 Sandys uses heroic couplets, thus elevating the stature of the 'blessed man'. Also evident is his use of enjambments in almost

every pair (again this is a deliberate contrast with metrical psalmody, where 'end-stopping' was far more suitable for singing). **Henry King** (1592–1669) published *Psalmes of David From the New Translation of the Bible Turned into Meter* in 1651, which was in part a deliberate reaction to the overly elegant style of Sandys: his version of Psalm 1, in 8–6–8–6 metre, seeks to demonstrate that metrical psalmody is a literary as well as liturgical work. Both versions of part of Psalm 1 are given below. It is interesting to compare King's 8–6–8–6 version of Psalm 1 with that of Sandys, who uses alternating hexameters and trimeters; although both have an aa–bb–cc rhyming scheme, it is the metre which makes King's version more forced and somewhat unnatural.

Sandys' Version:

The man is blest whose feet not tread
 By wicked counsailes led:
Nor stands in that perverted way,
 In which the Sinners stray;
Nor joynes himselfe unto the chaire
 Where Scorners seated are;
But in God's Law both dayes and nights
 To meditate delights.[36]

King's Version:

That man is truly blest, who never strayes
By false advice, nor walks in Sinners ways;
Not sits infected with their scornfull pride,
Who God contemne, and Pietie deride.
But wholly fixeth his sincere delight
On heavenly Lawes; those studies day and night . . .[37]

John Milton (1608–1674) also composed imitations of psalms in the literary tradition of Sidney and Sandys (he considered Sternhold and Hopkins' metrical psalmody to be 'bumbling and literal'), but his knowledge of Hebrew through his collaboration with Jewish scholars meant that he translated directly from the original, often italicizing words where it was difficult to find an English equivalent.[38] In 1653, as his blindness worsened, Milton composed imitations of Psalms 1–8, following Sidney and Sandys in creating many different metres and different types of stanzas for each psalm. Each psalm was dated between 8 and 14 August 1653 (Psalm 1 seems to have been written earlier as only the year is given). Unlike Psalms 80–8, which had been

[36] Taken from Hamlin 2004: 78, from King's 1651 edition.

[37] Cited in Hamlin 2004: 66–7, from Sandys' 1648 edition of *Psalmes*. Other versions of Psalms 1 and 2 include those by George Wither: see Hamlin 2004: 52–64; Richard Stanyhurst, with his classical allusions to 'Olympus' instead of Mount Zion in Psalm 2: see Hamlin 2004: 88–91; and Abraham Fraunce, with his unusual use of step parallelism in Psalm 1 ('Night and day . . . Day and night . . .'): see Hamlin 2004: 100–2.

[38] See Hamlin 2004: 74–6 and 139–44.

composed earlier and for more public viewing and use, this was essentially a private exercise.[39] Psalm 1 is, like Sandys' version, in heroic couplets, perhaps imitating the binary nature of the righteous and wicked in the psalm; Psalm 2 is set in Italian tercets. (Psalms 3, 4, and 7 have six-line stanzas, while Psalms 5 and 6 have four lines, and Psalm 7 has six, while Psalm 8 appropriately has eight.) Psalm 1 has a more theological emphasis, and its regular aa–bb rhyme and 10–10–10–10 rhythm fit the reflective nature of the contents. It is not surprising that this was later set to music.[40] Psalm 2—also in 10–10–10–10 rhythm—has a more contemporary political emphasis, with its theme of the deposition of proud kings and powers. Its *terza rima* begins in the fifth line: the first four lines follow ab–ab as an introduction to the dramatic exchanges which follow. Hamlin, like Jacobus, argues that it may well have been written at the time of the Barebones assembly.[41] The use of enjambments between almost every pair of lines in each psalm is particularly effective.[42]

> Bless'd is the man who hath not walk'd astray
> In counsel of the wicked, and in th' way
> Of sinners hath not stood, and in the seat
> Of scorners hath not sate. But in the great
> Jehovah's Law is ever his delight,
> And in his Law he studies day and night.
> He shall be as a tree which planted grows
> By watry streams, and in his season knows
> To yield his fruit, and his leaf shall not fall,
> And what he takes in hand shall prosper all. . . .

> Why do the Gentiles tumult, and the Nations
> Muse a vain thing, the Kings of th'earth upstand
> With power, and Princes in their Congregations
> Lay deep their plots together through each Land,
> Against the Lord and his Messiah dear?
> Let us break off, they say, by strength of hand

[39] L. A. Jacobus, 1987: 119–32, argues that this 'private enterprise' might also relate to a 'public cause'—Milton's (Republican) disappointment with the 'Rump Parliament' of 1653, and thus his use of words such as 'counsel' and 'assembly of the just' in Psalm 1 have a double poignancy: see Jacobus 1987: 128–9.
[40] See <http://www.cgmusic.org/workshop/milton/milton%201.htm>; also Gillingham 2008a: 177–80.
[41] See Hamlin 2008: 140–1 and Jacobus 1987: 130–1. If Jacobus is right about Psalm 1, this actually links together the concerns of these two psalms in an interesting way.
[42] Milton also alluded to Psalm 2 in Book V of *Paradise Lost*, when he emphasizes the deposition of thrones and powers as God introduces his Son to the angels: '. . . This day I have begot whom I declare | My only Son, and on this holy Hill | Him have I anointed, whom ye now behold | At my right hand: Your Head I him appoint; And by my Self have sworn to him shall bow | all knees in Heav'n, and shall to him confess him Lord . . .'. See Hamlin 2004: 141–2, who observes how Milton has also read into this allusion the New Testament use of the psalm, particularly at the time of Jesus' Baptism.

Their bonds, and cast from us, no more to wear,
 Their twisted cords: he who in Heaven doth dwell
 Shall laugh, the Lord shall scoff them, then severe
Speak to them in his wrath, and in his fell
 And fierce ire trouble them; but I saith hee
 Anointed have my King (though ye rebell). . . .[43]

A completely different example of the poetic imitation of one of these psalms
is by **Robert Burns** (1759–1796). It seems he wrote 'The First Psalm' in the
winter of 1781–1782, when he was learning the craft of flax-dressing at Irvine,
and being ill and depressed he probably turned to the psalm as a form of
comfort.[44] This version of Psalm 1 is an example of Burns' use of the simple
and traditional piety, which both feeds from the Kirk and is also critically
independent of it.

The first verse straightforwardly follows the sentiments of the first verse
of the Scottish Psalter. The second verse, however, avoids all references to
meditating on the Law, and instead classifies that piety which leads
to happiness as simply walking before one's God 'in humility and awe'—here
is a religion, one might argue, which is more appropriate and accessible for
the ordinary (less literate) Christian. Burns' third verse uses the same image
of the tree by waters, except the last line develops the idea of its 'rootedness'
rather than its never-fading leaves. The fourth verse follows this 'rooted'
imagery further: maintaining the image of the tree, Burns now applies it to
one 'whose blossom buds in guilt' (he thus avoids any reference to 'the
wicked' in this verse) who, like a tree without roots, is blown down in the
storm. Verse five in the Scottish Psalter (and in the Hebrew), concerning
the judgement on the ungodly and wicked, is omitted altogether: Burns
thus avoids the Calvinistic theology of the Kirk with its teaching on 'two ways
and two destinies'. This is borne out again in the last two lines of v. 6: instead
of the more triumphalist tone in the original, which might be interpreted
as gloating over the fate of the wicked, Burns is ambiguous about their fate:
it is left open as to whether even they might receive some partial blessing.
His imitation of this psalm thus offers a more searching and less confident
piety than its prototype. Although this is really a 'poetic imitation of a poetic
imitation', Burns' relationship with his own tradition is clearly evident:
passages underlined in Burns' version show his particular reinterpretation of
the metrical text.

[43] Taken from <http://www.dartmouth.edu/~milton/reading_room/psalms/psalm_1/index.
shtml> and <http://www.dartmouth.edu/~milton/reading_room/psalms/psalm_2/index.
shtml>.
[44] See McGinty 2003: 224–7.

1635 Scottish Psalter

That man hath perfect happiness
who walketh not astray
In counsel of ungodly men,
nor stands in sinners' way,

Nor sitteth in the sinner's chair:
But placeth his delight
Upon God's law, and meditates
on his law day and night.

He shall be like a tree that grows
near planted by a river,
Which in his season yields his fruit,
and his leaf fadeth never:

And all he doth shall prosper well,
The wicked are not so;
But like they are unto the chaff,
Which wind drives to and fro.

In judgment therefore shall not stand
such as ungodly are;
Nor in th'assembly of the just
shall wicked men appear.

For why? The way of godly men
unto the Lord is known:
Whereas the way of wicked men
Shall quite be overthrown

Burns

The man, in life wherever placed,
 Hath happiness in store,
Who walks not in the wicked's way,
 Nor learns their guilty lore!

Nor from the seat of scornful pride
 Casts forth his eyes abroad,
But with humility and awe
 Still walks before his God. . . .

That man shall flourish like the trees
 Which by the streamlets grow;
The fruitful top is spread on high
 And from the root below.

But he whose blossom buds in guilt
 shall to the ground be cast,
And, like the rootless stubble, tost
 Before the sweeping blast,

For why? that GOD the good adore
Hath giv'n them peace and rest
But hath decreed that wicked men
Shall ne'er be truly blest.

Moving on some sixty years, in order to present an example of an imitation of the psalms from yet another viewpoint, **John Keble** (1792–1866) offers an interesting illustration of a piety inspired by High Church theology and represents a more orthodox relationship with Church tradition. Keble was Professor of Poetry in Oxford between 1831 and 1836; but, as the conflicts surrounding the *Tracts of the Times* intensified, he moved to be Vicar of Horsley, and his use of poetry became increasingly pastoral as well as academic. This is very much evident in his *Psalter in English Verse* (1839) which was a poetic imitation of every psalm. Keble appreciated the auditory elements of psalmody—their rhythm, their repetitive stanzas, their earlier use as chant and their later use as song, and their ability both to 'conceal and reveal' the form and substance of the Hebrew original.[45] The importance of this version is that, unlike his more implicit use of psalmody in his great liturgical text, *The Christian Year*, his *Psalter in English Verse* interprets the psalms through a more literary lens than a liturgical one.

[45] See Keble: 1839, Preface, xxxviii–xxxix and xl–xli.

Keble composed one version of Psalm 1 and, unusually, two of Psalm 2. These two versions are particularly interesting to compare. The first uses a common 8–8–8–8 metre and an aa-bb-cc rhyme in five six-line stanzas. It is as if all the dramatic interchanges and the references to political turmoil in the psalm have been domesticated by this imposition of a consistent form and structure. The second version, however, has a more unpredictable irregular metre: the eight-line stanzas follow 11–10–11–10–7–7–11–10 (where the shorter lines mimic the speech of the enemy nations) with the rhyme abab–cc–dd. This is followed through three verses until the last two verses ('Kiss ye the Son . . .'), which each comprise four lines with the 11–10–11–10 metre and the 'abab' rhyme. As a literary artefact, the second version fits more the tensions and changing moods of the psalm. The first verses of each version of Psalm 2 may be compared below.

John Keble: First Version

Why gath'ring rag'd the realms so wild,
What dreams have heathen hearts beguil'd?
They rouse them, all the kings of earth,
The Powers in council are gone forth,
Against the Lord who rules above,
Against th'Anointed of His love.
'Now break we all their bonds in twain,
Away we cast them, cord and chain.' —
He scorns them, Who in Heav'n abides,
Their doings God on high derides.

John Keble: Second Version

Why roar the heathen hosts, so wild uprising?
Why do the realms imagine a vain thing?
Earth's monarchs rise, high chiefs the war devising,
On God, and on His own anointed King: —
 'Break we all their bonds in twain,
 Cast them from us, cord and chain'. —
He dwells in heaven Who laughs them all to scorn,
The voice of mockery from the Lord is borne. [46]

As for actual translations of Psalms 1 and 2 during this period, the eighteenth and nineteenth centuries, compared with the previous two centuries, actually produced very few new versions. It could be argued that there were so many intellectual and social changes for the Christian churches throughout these two centuries that to maintain the constancy of a familiar version of Scripture was more of a blessing than a hindrance. In the Catholic Church, for example, Richard Challoner's 1772 edition of the *Douai-Rheims Bible* (actually completed in 1609) was still the most used English edition and was revised in

[46] See Keble 1839: 3 and 5.

1911. In the Reformed and Anglican churches, the first alternative to the *King James Bible* was the *English Revised Version* (1881–1885), whose only difference, apart from the decision to omit the Apocrypha, was a few formal changes to style. The same applies to the 1901 *American Standard Version,* which was also a direct and precise revision of the *King James Bible.* By the twentieth century, however, an increasing number of new translations began to appear, not only for use in liturgy,[47] but also for preaching and teaching, for study and prayer, and for the mission and outreach of the Church.

Translations (in some cases, they might best be termed paraphrases) varied between the literal, the meaning-orientated, and the idiomatic. Within the Roman Catholic Church, seminal translations of psalms were in part the consequence of the work of the Pontifical Biblical Commission in the early 1940s and of the resultant 1943 encyclical (*Divino afflante Spiritu*) which allowed Catholic scholars to pursue historical criticism and to work from the Greek and Hebrew as well as the Latin. Raymond Tournay was responsible for the French version of the Psalms in *La Bible de Jérusalem* (1948–1954): although the idea of a study Bible, which assimilated much critical scholarship, was opposed by many conservative Catholics, a parallel British version, *The Jerusalem Bible,* was completed by 1966. This was the first widely acceptable and scholarly Catholic version of the psalms (and indeed of the whole Bible) in English since the *Douai-Rheims* version. It did not seek to promote any specifically Catholic doctrine, and became known for being ecumenical, literary, and scholarly. As far as the psalms were concerned, the most obvious changes were the use of 'you' not 'thou' when addressing God, and the use of 'Yahweh' instead of God (following the French counterpart); the translators did not tackle the emergent issue of gender-inclusive language. An expanded and heavily revised version, *The New Jerusalem Bible* (*NJB*) appeared in 1985 and is now the most widely used Catholic version, in English, outside the United States. Dom. Henry Wansbrough was the chief editor, and he had particular responsibility for the version of the psalms. Efforts were now made throughout to adopt more inclusive language. The most controversial verses from Psalms 1 and 2 are below.

Ps. 1.1–3 (NJB)

[1]How blessed is anyone who rejects the advice of the wicked and does not take a stand in the path that sinners tread, nor a seat in company with cynics,
[2]but who delights in the law of Yahweh and murmurs his law day and night.
[3]Such a one is like a tree planted near streams; it bears fruit in season and its leaves never wither, and every project succeeds.

[47] See Chapter 6 'From the sixteenth century to the present day': 145–53.

Ps. 2.10–12 (NJB)

[10]So now, you kings, come to your senses, you earthly rulers, learn your lesson!
[11]In fear be submissive to Yahweh;
[12]with trembling kiss his feet, lest he be angry and your way come to nothing, for his fury flares up in a moment. How blessed are all who take refuge in him!

The issue of inclusive language has dogged all Bible translators since the early 1960s. For example, Ps. 1.1 'Blessed is the *man* . . .' need not be exclusivist but could be read more theologically as alluding to some typology between humans and Christ; however, by translating the verse 'Blessed are those . . .', a more universal appropriation is always intended.[48] As for Psalm 2, the reference to the king being affirmed as God's son in vv. 6 and 7 is more difficult: it is hard to see it not referring to the king or Christ. Of the many versions trying to accommodate this, a notable one is *The New Testament and Psalms: An Inclusive Version* (1995) edited by Victor Gold. Verse 7 reads 'You are my child' and v. 11, 'Serve God with awe, with trembling kiss God's feet or God will be angry'. Not only does this last verse read somewhat clumsily, the concept of 'kissing God's feet' is difficult and odd. The following paraphrases of Psalms 1 and 2, by Marchiene Vroon Rienstra, are set in even more radical terms and in elegant poetic form. They are compelling—although they are hardly a gender-*inclusive* version:[49]

Ps. 1.1–4

Blessed is the woman who ignores the advice of the wicked
 Who avoids all the ways of sinners,
 Who refuses to sit with the scornful.
 She delights instead in the will of God.
 She muses on God's word day and night.

 She is like a tree planted by rivers of water. . . .
 El Shaddai establishes the ways of the just,
 But the way of the unjust shall surely perish . . .

[48] See Chapter 6 'From the sixteenth century to the present day': 147, n. 59.

[49] The extracts from Psalms 1 and 2 are taken from Rienstra 1992: 18–19 and 13–14, respectively.

Psalm 2.1–6

Why this raging of the nations and vain plotting by their people?
Their rulers defy God's will, and the leaders conspire together
Against El Shaddai and Her beloved, saying,
'Let us disregard God's commands, and break Her bonds of justice.'

She who lives in heaven laughs and derides their proud plots,
Her Word resounds against them in righteous anger,
And Her fury at their injustice frightens them.
'I have chosen my own to rule,' She says,
'I will set them in places of power.'

The decree of God is this:
We are Her children, to whom She has given birth.
She promises that the nations will belong to us,
and that the earth shall be ours to its farthest reaches . . .[50]

Turning from more recent translations and paraphrases of these psalms to experimentation in imitating them, a very different poetic response to Psalm 1 is by **Marianne Moore** (1887–1972). Her use of this psalm is a striking attempt to use the poetry of the psalm for a more strident social comment.[51] An American poet, from Missouri, spending much of her life in New York, Moore is best known for her outspoken rejection, through the poetic medium, of facile but easily acquired stereotypes, especially about race and gender. The first psalm was thus ideal subject matter, because of its affirmation of stereotypes. Moore turns them all on their head: what once reinforced tradition and convention is now reversed in her use of blunt phrases and harsh comparisons. A Jewish, male-authored psalm which represented the then conventional world view about race and gender is now reused to expose and question it.

[50] Other versions experimenting with inclusive language include *The New International Version* (*NIV*: 1978; revised 1984), undertaken over ten years by a large team of international scholars from different Protestant denominations and the *New Revised Standard Version* (*NRSV*: 1989), an update of the *Revised Standard Version* (*RSV*: 1952), which was itself a Protestant revision of the *King James Bible,* which aimed to achieve as accurate a translation as possible by reference to recently found manuscripts, while also modernizing the English; this is the version used in this book. The *English Standard Version* (*ESV*: 2001), does not use gender-inclusive language as radically, but the *ESV* is the version used both by Catholics and by many Evangelicals. Finally, the Orthodox Church, which serves the hundred or so Orthodox congregations in the United Kingdom, has one translation in English which is seen as an aid to private prayer: *The Orthodox Study Bible: New Testament and Psalms* (1993) is based on the *New King James Version* (*NKJV*), but also uses the Septuagint. However, none of these versions have any notable differences in their rendering of Psalms 1 and 2.

[51] See Moore 2003 for a complete collection of her poetry.

Blessed is the Man

who does not sit in the seat of the scoffer—
the man who does not denigrate, depreciate, denunciate;
who is not 'characteristically intemperate,'
who does not 'excuse, retreat, equivocate; and will be heard.'

(Ah, Giorgione! There are those who mongrelize
and those who heighten anything they touch; although it may well be
that if Giorgione's self-portrait were not said to be he,
it might not take my fancy. Blessed the geniuses who know

that egomania is not a duty.)
'Diversity, controversy; tolerance'—that 'citadel
of learning' we have a fort that ought to armor us well.
Blessed is the man who 'takes the risk of a decision'—asks

himself the question: 'Would it solve the problem?
Is it right as I see it? Is it in the best interests of all?'
Alas. Ulysses' companions are now political—
living self-indulgently until the moral sense is drowned,

having lost all power of comparison,
thinking license emancipates one, 'slaves who they themselves have bound.'
Brazen authors, downright soiled and downright spoiled, as if sound
and exceptional, are the old quasi-modish counterfeit,

—proofing conscience against character.
Affronted by 'private lies and public shame,' blessed is the author
who favors what the supercilious do not favor—
who will not comply. Blessed is the unaccommodating man.

Blessed the man whose faith is different
from possessiveness—of a kind not framed by 'things which do appear'—
who will not visualize defeat, too intent to cower;
whose illuminated eye has seen the shaft that gilds the sultan's tower.[52]

If Moore's twentieth-century poetry is as much about substance as about form, English adaptations of Haiku into 'psalms' are more about form than substance. Reducing individual verses of the psalms, or even entire psalms, into up to seventeen syllables in three lines of 5, 7, and 5 (and so following loosely the Haiku Japanese convention) not only requires an economy of words but also a sharp comparison of two dominant images. The following two examples are taken from a volume which offers every psalm in Haiku form, composed by a Cistercian monk from Caldey Island, Pembrokeshire.[53]

[52] Taken from Moore 2003: 294. [53] See Gwyn 1997: 3–4

I have selected the last two of the four verses of Psalm 1 and the first two of the six verses of Psalm 2: the seventeen-syllable form is identical in each case, but even so the first creates a more reflective style typical of the affirmation of piety in the rest of the psalm, and the second suggests a more abrasive and staccato style, continued throughout the haiku psalm as a whole, which here raises questions about arms control:

1.
> . . . *Wind-blown chaff of sin*
> *is no Judgement offering*
> *to win approval.*
> *God watches over*
> *all who walk in honest paths;*
> *He hates wickedness.*

2.
> *What is the meaning*
> *Of the shouting around us?*
> *Threats against Yahweh.*
> *Mocking at upstarts*
> *Yahweh strikes them with terror*
> *And makes known His King . . .*

A final contemporary example of imitating both psalms, in this case by the same poet, is **Gordon Jackson**. In the Preface to *The Lincoln Psalter* (1997) Jackson writes about the ways in which the psalms 'then and now' speak within a living tradition.[54] Jackson admits to a 'poetic irritation' with half-hearted attempts to replicate the style and form of the psalms in twentieth-century cultural terms. His version is a homage to Coverdale, using his technique of arresting idiomatic imagery which makes the psalms as contemporary as once was Coverdale's version. Jackson's representation of Ps. 1.1—'O how *well off* he will be whose nose has not been led by know-alls . . .'—is a controversial way of showing how, in Hebrew thinking, blessing was seen in terms of prosperity and how the Christian God is as concerned with the material as with the spiritual. Social critique through contemporary idiom characterizes Psalm 1, exemplified in the last four lines of this poem.[55]

> O how well off he will be
> > whose nose has not been led by know-alls,
> > whose feet have not been swept along with the crowd,
> > who has not joined in the laughter of those
> > who belittle whatever is decent.

[54] The title has nothing to do with the liturgical *Lincoln Psalter,* preserved at Lincoln Cathedral. Jackson's collection is of all the psalms transcribed by the same poet in colloquial and contemporary poetic paraphrase. These extracts are from Jackson 1997: 13–14.

[55] Jackson's use of this psalm may be compared with David Rosenberg's version of this psalm, in *Blues of the Sky,* noted earlier in Chapter 9 'Jewish translation, paraphrase, imitation, and allusion': 238–9.

His plea—sure is more on the mind of God;
 it is fixed on him in all seasons.
He is sound as a tree that grows beside running water,
 whose autumn will be full of fruit;
His leaves will never lack green;
 his labours will all pay off.
The ones that abandon God will not be so lucky;
 the wind will carry them off like chaff;
In a just society they will have no place;
 On Judgement Day they will not have a leg to stand on.
The ones that seek the Lord, the Lord is already with them;
 But those that get their own way will live to regret it.

Some of the contemporary metaphors in Psalm 2 make connections with the social concerns about justice and judgement in Psalm 1:

Why are the nations up in arms, and men drawn into insane dreams?
The world's rulers are in accord—against God, and the Lord's Anointed:
'Old God's authority is at an end—long live the Revolution!'
The Lord in heaven is laughing: to him their threats are a joke.
But one day his top will blow, and his fury flow like lava. . . .
. . . Learn wisdom smartly, O Captains, and Rulers, remember your place;
Bow to the Lord in fear, and rejoice in him with trembling;
Kiss the Son, stay his displeasure; and beware his infolded fire;
Once it erupts it will engulf
 All but the blessed he shelters.

Although they might lack the ingenuity and word-painting skills of Rosenberg's *Blues in the Sky*, these two examples contribute to our under-standing of just how far poetic imitations of these psalms, by the end of the twentieth century, in both Jewish and Christian reception, have become quite free of tradition and poetic convention—what we termed in our introduction 'far more artistic licence', particularly evident in the reading of Psalm 1. Behind all this is the concern to make these psalms 'contemporary': and this echoes the interest in the more universal and secular (non-partisan) appeal of these psalms, which we also found in both Jewish and Christian visual exe-gesis, as well as both Jewish and Christian musical interpretation.

CONCLUSION

Although this is only a selection of English-speaking poets who have been drawn to these psalms, living between the early medieval and contemporary periods, a clear picture has emerged. In an earlier period—especially in the

sixteenth and seventeenth centuries—the interest in the psalms was more aesthetic, experimenting with rhyming, rhythms, and structure. This was in part due to the way that the psalms as a whole were a central text in that literary culture. In more recent times, when the Psalter is more at the fringes of contemporary culture, the greater interest has been in making their impact more immediate and relevant by highlighting the social concerns within both of them. This has an interesting link with much earlier representations of these psalms (for example, in Rolle's translation and commentary, and in Langland's *Piers Plowman*), where the common assumption was that the psalms encapsulated what it meant to lead a 'moral life', and to refer to Psalm 1 was to open up a vision concerning this life within the entire Psalter.[56] So too, in contemporary poetic representations of these psalms—whether in translation or imitation—the interest has been in 'making them moral'—in recreating in them a gender inclusivity, or a political correctness, or a more modern sense of poetic justice. This is evident in both Jewish and Christian reception: it was clear in David Rosenberg's version of Psalm 1 and it was similarly evident in Marianne Moore's imitation of the same psalm. It is extraordinary how these two psalms, when taken together, encapsulate so many of these issues: so from a very different perspective we may note another bond that links them together.

However, when it comes to translations, paraphrases, and imitations of these two psalms, it is clear that individual writers and composers rarely deal with them as a unity, although most translations do relay accurately their shared vocabulary, especially in the first verse of the first Psalm and the last verse of the second. Those who have produced paraphrases on both of them (for example, Philip Sidney, John Milton, John Keble, and Gordon Jackson) recognize their opposing yet interrelated themes, often making deliberate contrasts both in their 'sound' (metre, rhythm, rhyme, for example) and their 'sense' (the personal appeal of the first Psalm and the more corporate interest of the second).[57] As we have noted with other types of reception of these two psalms, the poetic reception of the first psalm encourages us to emulate the poet and so become participants as we identify with the appeal for obedient faith. By contrast, the poetic reception of the second psalm, with its several voices, creates the effect of its being a drama in which we are simply observers, seeing and hearing the exchanges between God and the nations and God and the king unfolding quite independently of us. So, as we concluded about the musical use of these psalms, here, too, their reception as poetry sometimes emphasizes their interconnectedness—but mainly by highlighting their differences rather than their correspondences.

[56] See Chapter 9 'Christian translation, paraphrase, imitation, and allusion': 240–3.

[57] The best example of this is probably John Milton: see Chapter 9 'Christian translation, paraphrase, imitation, and allusion': 248–50.

Finally, it can be noted again that more recent imitations of these psalms, freeing themselves from traditional theological interpretations and also from poetic conventions, and focusing more on their shared moral and social concerns, allow for a greater *rapprochement* between Jewish and Christian readings of them. This has been a common and positive theme in the conclusion to the last three chapters, as we have reflected on their more recent reception in art, music, and now in poetry. It will be seen eventually emerging again in the last chapter, when their use in modern scholarly debates is considered; although, as we shall observe, before this emerged we shall also note the continuation of the negative interpretations of the other traditions, particularly by Christians, which was so typical of the earlier commentary tradition and contrasts so much with the conclusions noted here.

10

Modern Debates

THE CHURCH AND THE ACADEMY

During the period now under discussion—the nineteenth to twenty-first centuries—the rift between the confessional commentary tradition and that attached exclusively to the academy becomes increasingly apparent. This has created problems and possibilities both for the historical-critical works of the nineteenth and twentieth centuries (when initially most scholars still approached their work from a particular confessional standpoint) and for the literary-critical studies which have burgeoned over the last forty years or so (and where a specific confessional position is usually less explicit). Both the problems and the possibilities will become evident throughout this chapter.

However, we first need to place the earlier discipline of 'historical-criticism' in context, for it is not merely a product of the Enlightenment. An interest in the early origins of the text, especially its provenance and purpose, has been prevalent from the very earliest Jewish readings of these psalms; and although early Christian readings were apt to be less concerned with the history of the text, being more overtly theological, the Antiochene school, for example, was clearly interested in such questions.[1] Conversely, early nineteenth-century (mainly Christian) historical-critical commentators were not only interested in historical matters, and they were hardly objective in their studies. As we shall see below, they had a clear theological agenda. Many were Lutherans, and their theological concerns influenced their interpretation as much as any historical agenda. What does however distinguish them from the earlier interpreters is a certain historical scepticism—their refusal, for example, to take for granted the traditional views of Davidic authorship: one consequence of this was some theological scepticism about much earlier (especially Jewish) interpretations.

Nowhere is this scepticism more evident than in Psalms 1 and 2. Repeatedly in nineteenth- and early twentieth-century historical-critical scholarship—

[1] See for example Chapter 3 'The Church Fathers': 50–1 (concerning Eusebius of Caesarea and Diodore of Tarsus).

primarily in Germany, but also in England and America—the poet of Psalm 1 is castigated for his arrogant and exclusivist (Jewish) view of his community, not least his assumption that reading and obeying the 'Law' can make him righteous and bring about his own salvation. Similarly the drama within Psalm 2 is censured for its arrogant and exclusivist (Jewish) views about the protection of king and nation, as well as its advocacy of violence as a means of achieving national supremacy.[2] Several negative readings have been evident previously, particularly in early Christian and medieval commentators: what is different here is that the critique has a more explicitly personal, social, and political focus, with a clear anti-semitic bias.[3]

A very different emphasis can be seen when we look at examples of more recent scholars writing from a more literary perspective. Here we rarely find explicitly disparaging comments about Jewish readings of these two psalms. This is probably because literary-critical studies are apt to be quite censorious of historical criticism, and so they are equally censorious of the anti-Semitism that this approach espoused. Thus, just as we noted a better and even irenic relationship between Jews and Christians in the more recent reception of these two psalms in art, music, and poetry, we can observe the same more positive relationship in literary-critical studies as well.

The first section of this chapter will compare and contrast some of the most significant historical-critical commentaries on Psalms 1 and 2 (starting from the early nineteenth century), while the second section will assess selected commentaries with a more literary-critical bias, beginning around the 1970s. It is of course impossible to reference every commentary from England, America, and wider Europe. The selection in both sections has been made with an eye to the three concerns outlined in the Preface, namely publications which are interested in the specific relationship between Psalms 1 and 2; works which, both negatively and positively, highlight Jewish and Christian relations; and studies which are interested in the theme of the Temple within these two psalms.[4]

[2] This is really a way of using the 'hermeneutics of suspicion' which is made more explicit in later twentieth-century approaches to difficult biblical texts. Even at this earlier stage such 'suspicion' is possible because the debate is taking place in the academy rather than the Church.

[3] The Jewish commentary tradition is very different: it is still embedded within an explicit community of faith, and is engaged with the more traditional philological and textual issues, affirming continuity rather than discontinuity in their exegetical concerns. Jewish commentators include the Orthodox commentaries of Samson Raphael Hirsch (1808–1888) and Meir Leibush [Malbim] (1809–1879); and, in the twentieth century, Chaim Dom Rabinowitz, whose *Da'ath Sofrim: Tehillim* is one of twenty-one volumes on the Tanach. None of these commentaries engages aggressively with the Christian readings, preferring instead to affirm the textual and traditional insights of the great Medieval Jewish commentators. Nor do two other recent seminal commentaries by Abraham Cohen (Soncino Press, 1945; 1992) and Abraham Feuer (Mesorah Publications, 1995) reflect any of the vitriol found in the Christian commentaries mentioned below.

[4] See Chapter 1 'The aims of this reception history': 1–2.

HISTORICAL-CRITICAL COMMENTARIES

We have already noted that many prominent eighteenth-, nineteenth-, and twentieth-century German commentators were Lutherans: hence it is not surprising that much of the anti-Jewish reading of Psalm 1 has a good deal in common with Martin Luther's later comments on this psalm.[5]

Wilhelm de Wette (1780–1849) is an interesting example, because as well as being a Lutheran he also represented the newer form of Liberal Protestantism. On this account his anti-Jewish stance, in commenting on Psalm 1, is more moderate, albeit still apparent. Writing about the early Hebrew belief in a morality of rewards and punishments in the psalm, de Wette contrasts the 'externalism' in the practice of morality and piety in Judaism with the more 'inward and spiritual' concept 'among us': 'this conviction [of a more black-and-white morality] is refuted by experience so [that] we do not seek reward for virtue in external happiness'[6]. So, according to de Wette, the piety of early Judaism is inferior to Christian piety.[7]

Ernst Hengstenberg (1802–1869), albeit more suspicious of the value of the historical-critical and text-critical approaches, was a Lutheran whose views of Psalm 1 corresponded with those of de Wette. His commentary makes it clear that the Jews are simply not able to 'delight in the Law': without the grace of God through Christ, which cancels out sin, the natural man anxiously tries to satisfy the law's demands, but constantly lives under the fear of God. So, far from being like the fertile tree planted in the garden, Jews (unlike 'righteous' Christians) will be judged by God: 'Because the Jewish people did not meet the great demands of v.1 and v.2, it can no longer be a tree bearing fruit in due season; to such a tree will apply the harsh saying of Matt. 21:19: "may you never bear fruit again".'[8]

Bernard Duhm (1847–1928) following, for example, Hermann Hupfeld (1776–1866) and Julius Wellhausen (1844–1918) in their views of the antithesis between earlier Hebrew prophetic piety and later Jewish legalism, dates Psalm 1 in the first century BCE and thus sees it as representing the 'stultifying Jewish legalism' that Jesus Christ had to come to redeem. Emending the Hebrew תורת יהוה ('the law of the Lord') in verse 2 to יראת יהוה ('the fear of the Lord') Duhm argues that the attitude to the law in this

[5] See Chapter 5 'Reformation commentators': 118–20.

[6] See U. F. W. Bauer 1997; English translation available at <http://www.ejournals.library.ualberta.ca/index.Php/jhs/article/view/5999>, pp. 7–9, referring to de Wette's third edition of his *Commentar über die Psalmen* in 1829 (1st edn., 1811).

[7] What de Wette does not demonstrate, however, is that this more 'spiritual piety' is undoubtedly evident within the Hebrew Bible not least in the *Shema* of Deuteronomy 6, and in Jeremiah 17—both texts which have some affinity with this psalm.

[8] See Bauer, 1997: 10–11, citing Hengstenberg's second edition of *Commentar über die Psalmen I*, from 1849 (1st edn., 1842), p. 17.

later period of Judaism is only concerned with the 'fear of the Lord'. This is totally different from the prophetic attitude to the Torah in Jeremiah 17 from which Duhm believes this (later) psalm is derived. Such a fearful, legalistic attitude to the law is exemplified in Torah scholars who '. . . wrack their brains over whether or not one could eat an egg that had been laid on the Sabbath'. Psalm 1, according to Duhm, far from being an inspiration for Christian piety, is an example of the piety which the Christian believer must put aside.[9]

Rudolf Kittel (1853–1929) indicts the psalmist not only for his negative 'works-righteousness' teaching but also for his exclusivist animosity to those whose piety is different from his. Supposing that at the time of the psalm (which Kittel dates slightly earlier than Duhm) the 'enemies' were the pagan Greeks, he observes: 'Down through the centuries, Judaism believed itself best able to preserve its national and religious characteristics through . . . animosity toward others and separation from those who differ from themselves'.[10] Usually it is assumed that the 'wicked' in the psalm are those from within the community itself. This is, therefore, an unusual reading of the Psalm 1: it would be more appropriate for Psalm 2. Following early Christian commentators, Kittel argues that the only way the psalm can be redeemed is by reading it 'through Christ'.

Even **Hermann Gunkel** (1862–1932), whose views of the psalms as post-exilic spiritual songs have had a seminal influence upon psalms scholarship, hardly commended Psalm 1. Viewing the psalm as non-cultic and didactic, Gunkel too, like Wellhausen and Duhm, read it as an example of the degeneration of a more spiritual prophetic piety into a cold and legalistic religion. Noting the very different perspectives of Jeremiah 17 and Psalm 1, Gunkel points out that whereas the earlier prophetic text advocates 'trust in God' as the hallmark of true blessedness, '. . . here, in place of trust in God, erudition in the Law has entered in', when the 'written law determined piety . . . after . . . the decline of prophecy'.[11] This is a good illustration of the typical 'Wellhausian' anti-Jewish antithesis between (genuine) prophetic piety and (the derivative and more hypocritical) legal piety, the mark of the Pharisees.[12] Furthermore, not only the complete aversion to sinners but also the doctrine of retribution expressed here is, according to Gunkel, 'too superficial: we cannot believe that piety and external welfare always go together'. His final sentence tries to redeem the psalm: 'Yet this doctrine is founded on a fundamental conviction of all higher religion—the conviction that piety must bear fruit and that religion is not merely a subjective

[9] See Bauer 1997: 13–15, citing Duhm's 2nd edn. of *Die Psalmen*, KHC, published in 1922 (1st edn., 1899): 2–3.
[10] See Bauer 1997: 16–18, citing Kittel's 5th/6th edn. of *Die Psalmen*, KAT XIII, 1929, p. 4 (1st edn., 1914).
[11] See Bauer 1997: 19, citing Gunkel's *Ausgewählte Psalmen* (1904), p. 3, and more explicitly, *Die Psalmen*, HK (4th edn.), p. 2.
[12] See Gunkel 1903: 121.

experience—rather that the pious man receives God's blessing and guidance'.[13]

A different emphasis is found in the commentary of **Artur Weiser** (1893–1978) on the psalms, published in German in 1950, with an English translation in 1962. While still assuming that this is a didactic wisdom psalm, Weiser reads it as more attuned to the spiritual piety of 'the wise' than the legalistic religiosity of the Pharisees. He thus interprets the psalm, although late, as illustrating a more authentic Judaism, akin to the earlier piety of prophets such as Jeremiah. Its piety is however the exception, not the rule: it anticipates the piety of Christians, following the example of Jesus, who also was in conflict with the Pharisees: 'The poet of the Psalm does not get bogged down in the external aspect of Law-piety. . . . Therefore, his counsel to meditate upon the Law day and night is to be understood less in the sense of an external, acquired Law erudition, such as the strict Jew still pursues today, and more as an admonition to submit oneself unremittingly to God's will . . .'.[14] So in Weiser's view, Jewish piety, still tied to justification by works of the law, needs redeeming by the Christian response to justification by faith in God's work in Christ, from which an obedient faith follows.

Hans-Joachim Kraus (1918–2000), like Weiser, reads Psalm 1 as a didactic wisdom psalm. It is not until the end of his commentary that his similar views on Jewish piety are to be seen, where he identifies the 'righteous one' as the spiritually mature believer which 'the "Pharisee", with his external, rigorous Law observance is unable to fulfil'. More explicitly, because the demands of the Law have been fulfilled only by Jesus Christ, in whom the believer has become a 'new creation', the capacity for attaining the ideal expressed in this psalm can only, by implication, be achieved through the Christian faith.[15]

These divergent views each reflect different degrees of anti-Jewish sentiment from a German Protestant perspective. It is interesting that such comments are rarely found in Roman Catholic commentaries: Bauer proposes this is partly due to the different attitude to justification by faith compared with Lutheranism.[16] Nor are they very often found in commentaries in

[13] See Gunkel 1903: 123.

[14] See Bauer 1997: 20–2, citing Weiser's 7th edn. of *Die Psalmen* ATD, 1966, pp. 70ff (1st edn., 1935).

[15] See Bauer 1997: 20, citing Kraus' 5th edn. of *Psalmen* BK AT XV/1, 1978, p. 142 (1st edn., 1960).

[16] See Bauer 1997, §4.5 (p. 24). Nothing of this nature is found in the much-cited 1859–60 commentary by Franz Delitzsch (1894: 65–9; 2005: 81–8), who, having been converted from Judaism to Lutheranism, was more cautious about causing offence to fellow Jews he hoped to convert. However his son, Friedrich, produced a posthumous introduction to the 1894 edition which was certainly more vitriolic about the psalms: the Jewish particularism, the reliance on the Torah as a means of salvation, the reliance on dubious historical events such as the Exodus, the materialism, the thoughts of hatred towards enemies, the melancholy view of life after death all made the Psalter 'a veritable hodge-podge of erroneous, incredible, undependable figures . . . a book full of intentional and unintentional deceptions, in part self-deceptions, a very dangerous book, in the use of which the greatest care is necessary'.

English. **Charles Briggs** (1841–1913), for example, has a long discussion in his International Critical Commentary of what is meant by 'the Law of Yahweh', but nowhere does he actually cite the more critical views of Lutheran commentators.[17] The Norwegian scholar, **Sigmund Mowinckel** (1884–1965), similarly appraised the composer of Psalm 1 as a 'learned scribe' but he saw this positively, as it reflected 'the spiritual traditions and literary traditions of the Temple'.[18] Similarly **Mitchell Dahood** (1902–1962) was concerned only to show the extent to which the psalmist drew from an ancient traditional store of Canaanite mythological motifs.[19] More recently, **John Eaton** (1927–2007) also viewed the psalm in a positive light: his 2002 commentary starts with affirming 'this simple but effective poem' and ends with a citation from a Christian Easter antiphon ('I Am that I Am, and my counsel is not with the wicked, but in the Law of the Lord is my delight, Alleluia').[20] **Peter Craigie's** commentary (1983), revised after his death by Marvin Tate (2004), similarly affirms without question the piety of the psalmist, equating it with one who knows 'the fear of the Lord'.[21] The observations in **Samuel Terrien's** commentary (2003) are particularly explicit about the way the Law has an inner dynamism creating '. . . a dialogue with God. . . . The *Torah* is really gospel, for it proceeds from pure grace when it invites man and woman to fulfill (*sic*) the divine design on earth.'[22] Furthermore, when writing about earlier works, which criticize the psalm for its arrogant sense of self-righteousness, Terrien notes that this is not only a Jewish illusion, but also a Christian one.[23] Finally, in his historical and theological observations on Psalm 1 in his recent commentary, **John Goldingay** (2006) is at pains to explain that because so much of the Torah in Genesis–Deuteronomy is as preoccupied with story (Genesis 1–Exodus 20, for example) as it is with law, our understanding of Torah should be as much about grace (God's action in history) as Law (divine command); Goldingay translates 'Torah' as 'teaching' (story + command) which presupposes a much broader world view.[24]

Hence historical criticism need not always be equated with an anti-Jewish bias: there are several exceptions, and most commentaries since the Second World War—from the Continent as well as in England—affirm Jewish Torah piety. Nevertheless, of all the approaches to this psalm since the nineteenth century, the historical-critical method lends itself most to 'supersessionist' assumptions, which leads to a negative assessment of the text in its ancient setting. Ironically many of their conclusions have much in common with commentaries of some patristic and medieval commentators, despite the

[17] See Briggs 1906: 3–7.
[18] See Mowinckel 1982: 114. We may note again the emergence of the Temple theme in these more recent debates.
[19] See Dahood 1966: 1–5. [20] See Eaton 2003: 61 and 64.
[21] See Craigie and Tate 2004, 2nd edn.: 57–62. [22] See Terrien 2003: 73.
[23] See Terrien 2003: 76. [24] See Goldingay 2006: 79–81.

fact that most historical critics would find their allegorical and analogical methods of reading the text most difficult to accept.[25]

It is not surprising that a similarly negative reading of Psalm 2 is found in most of the commentators who display anti-Jewish responses to Psalm 1. Here the focus of criticism is the political and material world view of this second psalm, especially the violence which is advocated as the means of achieving the national supremacy of Israel over all nations. One particular way of circumventing this has been to 'spiritualize' the psalm and read it in the light of Christ and his coming kingdom, as in earlier exegetical tradition: nevertheless, critical questions about the violence and anger of God still remain unanswered, as we see illustrated in the commentaries below.

De Wette (1811), for example, argues that the contents of Psalm 2— especially references to the oppressive world dominion of the king—have no correlation with the reigns of any known Jewish king, and certainly not David or Solomon; but de Wette cannot give this psalm a Christian interpretation, as Jesus Christ was a suffering Messiah 'whose kingdom was not of this world'.[26] This view contrasts considerably with Hengstenberg's, who argues that the psalm can only be understand through the lens of its use in the New Testament. Hengstenberg proposes that the author was David, because this is 'stated' in Acts 4.25; but he argues that David is not speaking about his own kingdom, but, inspired by the Spirit, about another 'Divine King', whose kingdom will oust all wicked pretenders.[27]

Compared with his comments on Psalm 1, Duhm's observations on Psalm 2 (1899), despite the psalm's more violent contents, are mild. He notes that the 'world rule' in this psalm would have to be 'an ideal' and as this contradicted all known experience it could only have been fulfilled by 'christliche Rom'. Hence an 'eschatological' reading is the only one which takes any real meaning from the exaggerated claims of this psalm.[28] Psalm 2 has its own theological agenda, which runs counter to all political realities: it is a psalm imagining 'utopia', and has to be seen outside any literal and temporal context.

Kittel's focus is on the 'prophetic spirit' in this psalm (1914) and he compares this with the preaching of the pre-exilic prophets such as Isaiah and Jeremiah who were concerned with God, Israel, and the nations.

[25] See for example some aspects of Jerome's commentary discussed in Chapter 3 'The Church Fathers': 57–8 and in Gilbert of Poitier's use of Remigius of Auxerre in Chapter 5 'Medieval commentators': 104.
[26] 'Sodann passt der Psalm weder zu den jüdischen, noch zu den christlichen Vorstellung vom Messias. Nach jenen sollte er die Völker erst besiegen und unterjochen, im Psalm aber wollen schon unterjochte Völker sich gegen ihn empören und sich frei machen. . . .' See de Wette 1929: 89.
[27] See Hengstenberg 1842: 28–9. Here the similar theme of the judgement on the unrighteous in Psalm 1 is also referred to, where again the author is seen to be David. See Hengstengberg 1842: 50, where he refutes Ewald's more negative interpretation of Psalm 2.
[28] See Duhm 1922: 6–13.

Consequently, Kittel has less of a problem with the historical setting of the psalm, and equally, because of its apparent prophetic influence, he can affirm its contents in a way which was impossible for the much later 'post-prophetic' Psalm 1. But, like Hengstenberg, Kittel still finds that its ultimate meaning is in the kingdom inaugurated by Christ; this, Kittel argues, is actually in the mind of the psalmist, whose prophetic vision allowed him to look to an eschatological future.[29]

Delitzsch (1859–1960) also takes issue with de Wette: if the apostles were able to relate this psalm to Christ's kingdom (here Delitzsch uses several references from the Gospels and Acts) then so too can the contemporary Christian. A spiritual application is thus extracted from the political and military symbolism in the psalm. However, Delitzsch's reading of the psalm within the larger history of redemption leads to a somewhat unexpected anti-Jewish observation: '. . . The medieval synagogue exposition is wanting in the recognition of Christ, and consequently in the fundamental condition required for a spiritual understanding of the Psalms.'[30]

Other German commentators are more specifically critical of the tenor of the psalm in its ancient Israelite/Jewish setting. Gunkel (1904) for example, observes that 'Powerless Israel [is] arrogantly presumptive', and cites Egyptian and Babylonian kingship ideology which was more in accord with reality.[31] So here the ruling king represents an ideal which transcended the reality of a nation under threat. Weiser has similar views: 'Must we not persist in regarding it as the presumptuous utterance of an incomparable and intolerable arrogance when claims implying dominion over the whole world are here voiced for which no occasion can be found at any point in the history of Israel which would justify them?'[32] Although Weiser goes on to argue that this is only possible because this is seen through the eyes of faith in a mighty God, he nevertheless makes a partly negative point about the people who invested in this belief. Kraus is even more incisive, adapting an observation by H. Schmidt in his own concluding comments on the psalm, writing: 'How foreign to the picture of the crucified is that of the king who smashes peoples with an iron rod!'[33]

Most early twentieth-century English commentators take a more moderate stance, interpreting the psalm from an ancient Jewish world view and affirming the way it has been 'redeemed' through Christ. Briggs is typical: Psalm 2 'presents a worldwide dominion of the Son of David, such as was not a historical reality in the time of the poet or at any previous or subsequent time in history, but recognises an ideal at the goal of history. Jesus

[29] See Kittel 1922: 11–12. [30] See Delitzsch [1894], English translation 2005: 55.
[31] See Gunkel and Begrich 1988: 116.
[32] See Weiser 1959, 3rd edn., English translation 1962: 111.
[33] See Kraus 1978, English translation 1992: 134, citing H. Schmidt's commentary on this psalm.

of Nazareth is represented in the NT as the Son of David and heir of this ideal . . .'[34]

Other historical-critical scholars are interested predominantly in the ancient *cultic* use of Psalm 2, so are not particularly concerned with evaluating the psalm either positively or negatively in contemporary terms. Sigmund Mowinckel, for example, has nothing to say about the Jewishness nor about the Christianizing of this psalm: he is more interested in explaining a possible (enthronement) cultic context and he avoids any critique of the assumptions which maintain it.[35] Among British psalms, scholars **Aubrey Johnson** (1901–1985) simply expanded Mowinckel's views about the king's ritual enactment of myths in worship and reiterated the theory that the cultic prophets were the composers and performers of these psalms. Johnson's focus on the ancient setting of Psalm 2 (1955) does not explicitly criticize this teaching; for example, the 'prophetic theology' in this psalm uses the cult to represent God's defeat of darkness and death, which can only be a good thing.[36] Eaton (1976) who also wrote a good deal on the sacral role of the king, follows similar prophetic and cult-historical readings of Psalm 2. This allows him, like Johnson, to uphold the theological value of this psalm both then and now.[37]

However, whenever a twentieth-century commentator attempts to move away from more historically orientated cult-functional concerns and seeks to explain the ancient world view of Psalm 2 with a Christian comment, there is often some unease. Samuel Terrien (2003), for example, in commenting on the exaggerated 'court-style' which the psalmist has adopted in verses 8–9, notes that 'the shepherd's crook of Ps. 23:4 is here a rod of iron': in Psalm 2, the king-as-pastor becomes the king-as-executioner. He adds: 'The annihilation of tyrannical regimes was not, however, the ultimate purpose of God for the messianic era', and he thus exposes a chasm between the Jewish and Christian uses of the psalm. Recognizing that the military figure of a conquering king lies at the heart of the more historical readings of this psalm, Terrien observes: 'The image of an avenging Christ was distant from that of the Suffering Servant'.[38] Similarly the physical city of Zion, which is similarly central to this world view in Psalm 2, can no longer be read literally: 'Christianity, if not Christendom in its structural organization, understood a topographical centre to be obsolete'.[39]

Goldingay's commentary is significant because it finds a compromise between the two extremes of affirming a Christian reading and negating a

[34] Briggs 1903: 13. [35] See Mowinckel 1982: vol. 1: 62, 75; vol. 2: 132, 134.
[36] Johnson 1955; 1979.
[37] Eaton 1976. See also Willis 1990: 33–50, who also uses a historical reading, which builds upon both the prophetic–eschatological and the cult-historical interpretations: the psalm gains its legitimacy by being a 'cry of defiance' against oppressive powers (pp. 44–6).
[38] See Terrien 2003: 85. [39] See Terrien 2003: 87.

Jewish one, or vice versa. Although his 2006 commentary is by no means exclusively historical-critical, it does face head-on the clash of world views. Goldingay observes that the ancient psalmist undoubtedly thought that a relationship with God and the world was based upon force and violence, a view which contrasts with the teaching of Jesus which is ambivalent in this respect. However, although the figure of the crucified Christ is hard to find in this psalm, the more aggressive figure depicted in verses 8–9 is in fact used in Rev. 2.26–7 to speak of Jesus as the victorious conqueror.[40] Noting how Jewish writers have adapted this psalm in relation to the State of Israel, thus using it as an embodiment of Jewish identity as well as their rights as a Jewish people, Goldingay observes 'The psalm has a dangerous capacity to legitimate oppressive imperial violence'.[41] Yet he observes that the Church, too, through its history, has similarly abused this psalm, implementing its programme in an equally physical way and justifying its right to attack and oppress other peoples. He rightly sees this as a dangerous psalm: 'Psalm 2 re-creates its divine warrior mythic structure in social and ecclesial reality. It projects authoritarian, patriarchal, and exclusive structures.'[42]

Goldingay is one of the very few commentators to argue that the ending of Psalm 2 undermines some of this view, in that there all nations are asked to find a new attitude of reverence, submission, and joy: the blessing in note 12 is not only for Jews but for the nations as well. So Israel and the nations have a choice: to use violence or to submit to Yahweh, who, if they do use violence, will use violence against them in return: this may not be a satisfactory conclusion to the psalm, but at least it teaches that a violent response on either side is, however, not the end of the story.[43]

We now turn to look at the ways in which historical-critical works have written about the relationship between Psalms 1 and 2. Throughout this whole period the interest in the connection between both psalms is quite explicit, discussing whether they are interconnected by contrasting themes, or are totally separate and independent, or can be read as one single psalm. Briggs, for example, argues that Psalm 1 is one of the latest psalms to be included in the Psalter, and by referring to the New Testament, rabbinic, and Christian texts and versions, he outlines the traditional connection between Psalms 1 and 2, noting that they are two psalms with interdependent themes.[44] Mostly commentators discuss the date and purpose of the final compilation — most concur that Psalm 1 was added at the very last stage of compilation in order to create a Prologue to the Psalter, while Psalm 2, already included, was deliberately accommodated to it (perhaps this resulted in the loss of a Davidic title to this royal psalm and the addition of some of verses 10–12).[45]

[40] Goldingay 2006: 104. [41] Goldingay 2006: 105. [42] Goldingay 2006: 105.
[43] Goldingay 2006: 106. [44] Briggs 1906: 3–4, in the introduction to Psalm 1.
[45] See for example G. T. Sheppard 1980: 141–2.

A different permutation is to argue that although Psalm 2 is the earlier composition it was the later of the two psalms to be added, thus allowing the anonymous 'timeless' figure in the later Psalm 1 to be given that royal 'historical' focus so clear in Psalm 2.[46] Another view is to contend that these two (independent) psalms were both brought together at the very end of the compilation process, in order to illustrate the dual ethical and eschatological elements within the Psalter as a whole.[47]

Other commentators are not exclusively historical-critical in their views, but display literary and theological concerns as well. Nevertheless, their observations concerning the close relationship between these two psalms is made according to assumptions about whether they have a pre-exilic or post-exilic date: their explanation is thus, basically, a historical one.

For example, **Ivan Engnell** (1953) and **William Brownlee** (1971) who each defend an early (pre-exilic) date and a Jerusalem royal Temple provenance, focus on the supposed ideology and accompanying ritual enactment of 'sacral kingship', which apparently runs through each psalm. Engnell, for example, argues that the tree in Ps. 1.3 is a symbol of the king, who, in Ps. 2.6, is also identified with Mount Zion.[48] Brownlee builds upon this, proposing that both psalms were used as part of a coronation liturgy, probably after the Deuteronomic reforms of Josiah. Each psalm is a 'Messianic Treatise'—not dissimilar from the Assyrian counterparts—whereby the very last kings such as Jehoahaz and Jehoaichim (or perhaps the potential future king, Zerubbabel) might have used these two psalms, focused on both the law and king, for their own ideological purposes.[49] Such a view is fascinating; but it is also highly speculative.

Other commentators prefer a post-exilic date. **Jesper Høgenhaven** and **Phil. J. Botha**, for example, assume that a post-exilic ideology is evident in each psalm. Høgenhaven argues that an early 'apocalyptic theology' is evident in both these psalms: Psalm 1 is more concerned with the problem of divine justice and the necessary separation of the righteous and the wicked, and Psalm 2 is more eschatologically concerned, believing that God will intervene in world affairs.[50] Botha, by contrast, does not give any specific date or provenance for either psalm, but each must be presumed to be quite late, in that he sees both psalms as serving two interdependent world views about a theocratic society. Psalm 1 represents one 'in-group'—what he terms the 'religious elite'—who contrast themselves with the 'out-group' who do not conform to the teaching about the importance of separation by adherence to

[46] For example, Wallace 2009: 15–16, referring to the way in which 'the one who has not spoken' and equally 'had not been spoken to' in Psalm 1 becomes the one who 'speaks and is spoken to' in Psalm 2.

[47] For example, Delitzsch: [1894] 2005: 82. [48] See Høgenhaven 2001: 324–6.

[49] Engnell 1953: 85–96; Brownlee 1971: 321–36; see also the discussion in Høgenhaven 2001: 169–71.

[50] See Høgenhaven 2001: 175–9.

the Torah. Psalm 2 represents a different 'in-group' (what Botha calls the 'political elite') who here compare themselves with a different 'out-group'— those who do not accept the idea of a separate people bound together by their adherence to the institution of the Davidic monarchy. So each psalmist understands the resolution to these tensions is found in the ideal of a *theo-cratic society*, whereby God's world rule will eventually be made manifest through adherence to the Mosaic Torah and the acceptance of a Davidic king.[51]

Compared with the commentaries which view Psalms 1 and 2 as separate units, there is little evidence of anti-Jewish readings when these two psalms are taken together: the intrigue with the relationship between the psalms seems to dispel a negative reading of their origins. Nevertheless, not all these persuasions can be correct: historical-criticism involves a good deal of speculation, and some disparagement on the part of literary-critics about its observations and conclusions is often justified. But then, literary criticism also brings with it a number of hypotheses and persuasions; and so a similar criticism might be equally appropriate, as will be evident from the discussion below.

LITERARY-CRITICAL WORKS

To 'demarcate' the 1970s as the very beginning of a literary interest in the Psalter as a whole is too simplistic. For example, even the very earliest Greek and Latin translators could not have worked without some concern for the shape and structure of the text. The same interest is evident in the translation (and imitation) of the psalms into English during the sixteenth and seventeenth centuries.[52] Furthermore, an interest in the ways that many psalms have been deliberately set alongside others with similar linguistic motifs is already evident in the works of J. A. Alexander (1864) and F. Delitzsch (1894), to be taken up later by C. Barth on the sequences of psalms especially in Book I (1976) and J. Brennan's on Psalms 1–8 (1980).[53] Nevertheless, by the 1970s a rhetorical interest in poetic forms and linguistic ploys within individual psalms is increasingly evident, as is a new emphasis on the literary and theological relationship between one psalm and another, and with this, a

[51] See Botha 2005a: 3–7 and 7–10. Botha also writes about the literary and theological aspects of this psalm, as we shall see below.

[52] See Chapter 9 'Christian translation, paraphrase, imitation, and allusion': 245–50.

[53] Barth's theory of 'concatenation' required him to look at Psalms 1 and 2 but he considered Psalms 2 and 3 to have more parallels than Psalms 1 and 2: see Barth 1976: 38. Similarly Brennan offers some observations on the usual stylistic features shared by Psalms 1 and 2, but is more interested in the link between Psalms 2 and 149: see Brennan 1980: 25–6.

change of focus from the *text of a psalm* to the *reader of the Psalter as a whole.*[54] Despite this, very few commentaries completely exclude historical approaches to the psalms: partly this is the result of Ugaritic, Qumranic, Septuagint, and Aramaic studies on the psalms where a historical perspective is important.[55]

One of the most significant contributors who influenced much of what was later written on the literary arrangement of the Psalter as a whole (as well as the function of the smaller collections of psalms within it) was **Gerald Wilson**. His monograph on the editing of the Hebrew Psalter (1985) looked at the editorial arrangements first in Mesopotamian collections of hymns from as early as the third millennium BCE and secondly in the Qumran psalms from the second-century BCE manuscripts for a comparison with the arrangements of the Psalter. His conclusion, that the first three books (Psalms 1–41, 42–72, 73–89) have many indications of special editorial arranging, with the royal psalms (2, 72, 89) playing a major part in this, has been taken up by several scholars, including those (to be discussed shortly) who have written about the special placing of Psalms 1 and 2. This division of the Psalter, and the various proposals that there were both wisdom and royal features in its overall literary arrangement, has obvious ramifications for Psalms 1 and 2; Wilson produced several other papers on this theme.[56]

Turning first to Psalm 1, instead of the negative assessment of the ancient message of this psalm so prevalent in historical-critical enquiry, most commentators writing from a more literary perspective view its piety in a more positive light.

The title of **John Willis**' 1979 paper speaks for itself: Psalm 1 is a self-contained entity.[57] Outlining the very early references to Psalms 1 and 2 as connected together—from Qumran, rabbinic tradition, and the Church Fathers—Willis concludes that although there may have been some manuscripts which used Psalms 1 and 2 as a single psalm, most Christian commentators refer to them separately. Willis further observes that there are more linguistic connections between Psalms 2 and 3 than between

[54] Most reviews of the history of the interpretation of psalmody over the last fifty years would concur with this observation: see for example Kuntz 1994: 77–106; Zenger 1994: 37–54; Auwers 1997: 79–97; Eaton 1999: 324–9; Howard 1999: 329–68; and Gillingham 2008c: 209–16.

[55] Other more recent historical approaches are found in studies of the 'cult' as an expression of popular religion at local sanctuaries. See for example Albertz 2002: 90–100 and 101–24; Gerstenberger 1988: 30–4 and 40–50; and Zevit 2001: 664–90.

[56] See for example Wilson 1986; 1993; 2005. See also Cole (forthcoming) on the influence of Wilson on our understanding of Psalms 1 and 2. For a further more general discussion of these issues, and the contrasting emphases in the rhetorical (often synchronic) studies in American scholarship and the redactional (more diachronic) studies in German scholarship, see Gillingham 2008a: 277–80 and 2008c: 209–16. These are typified by two publications: *The Shape and Shaping of the Psalter* (ed. J. C. Mcann): 1993 and *Neue Wege der Psalmenforschung* (ed. K. Seybold and E. Zenger): 1994.

[57] The title is 'Psalm 1—An Entity'. See Willis 1979: 381–401.

Psalms 1 and 2.[58] In terms of its self-contained strophic structure (here Willis adopts a structuralist approach), he concludes 'Ps 1 and 2 are not a single psalm, but two separate self-contained entities. Accordingly, they should be studied separately, and each from its own perspective be allowed to contribute to the general understanding of OT thought'.[59]

The problem with this is that the issue is not so much that Psalms 1 and 2 were actually composed as one single psalm, but whether as independent psalms they have been deliberately placed together. **James Luther Mays** (1987) arrives at a very different conclusion by starting with Psalm 2 rather than Psalm 1.[60] Mays takes the view (which has been noted several times already) that verses 10–12 of Psalm 2 were composed as a way of combining both psalms: his specific contribution is to note that three of the linguistic similarities between the two psalms actually occur in these last three verses (דרך in 1.6 and 2.12; אבד also in 1.6 and 2.12; and אשרי in 1.1 and 2.12); he further observes that these verses are so full of textual difficulties and this might be another indication of this process of redaction.[61]

Erich Zenger and **Frank-Lothar Hossfeld** (1993) have yet another take on Psalm 1 through the prism of its relationship with Psalm 2. They note that the first psalm is about Torah, while the second psalm reflects the aspirations of the Prophets, and these scholars demonstrate that the two psalms serve not as one but two different doors into the Psalter as a whole.[62] Focusing especially on Psalm 1 as the entry into the Psalter as a 'way of teaching' (Wegweisung), Zenger and Hossfeld note the emphasis on the righteous and wicked in this psalm, which is also such a prominent theme in Psalms 1–41, and propose that this psalm not only acts as part of the general Prologue to the Psalter as a whole, but also as a more specific Prologue to Book I. They summarize this as follows: 'So klingt in Ps 1 bereits an, dass die Psalmen Wegweiser in einem vom Bösen und von Bösen bedrohten Leben sind, das seinen tiefsten Hoffnugsgrund darin hat, dass JHWH <<dabei ist>>'.[63]

Reinhard Kratz (1996) expands this argument. By virtue of Psalm 1, the Psalter is to be understood as Torah, and Psalms 19 and 119, both positioned strategically in the Psalter, add further weight to this, as do other psalms with a similar theme (Kratz offers as examples Psalms 37, 94, and 78).[64] But this Torah is not the Mosaic Torah: it is the Torah of David, illustrated for example

[58] See Willis 1979: 393. [59] See Willis 1979: 401. [60] See Mays 1987: 7–12.

[61] This reading is criticized by, for example, Jacobson (see Chapter 10 'Literary-critical works': 279–80).

[62] See Zenger and Hossfeld 1993a: 45.

[63] See Zenger and Hossfeld 1993a: 46. This paper also has one of the first explicit contemporary references to the way in which the blessed man, being compared to a tree, is intended to allude to the Temple: this is by way of linking this psalm to the teaching in Psalms 15 and 24 where the requirement to enter the Temple courts is by way of obedient faith (p. 47).

[64] See Kratz 1996, especially 1–2 and 8–12.

by the division of the Psalter into five books. Hence it is more interested in spirituality, with David as a paradigm of piety, and it has little interest in the legal obedience enshrined in the Law of Moses: hence the reference in verse 2 to 'the law of the Lord'. So Psalm 1 makes explicit what was implicit in the references in the Law and the Prophets to the Law of Yahweh.[65] So just as earlier liturgical formulae are now used in a literary way, the Psalter reflects a move from 'Temple piety' towards a more personal and private piety expressed in the prayers of the synagogue.

Jerome Creach (1996 and 1999) offers similar observations about Psalm 1, although he arrives at a somewhat different conclusion. The title of his monograph in 1996 (*Yahweh as Refuge and the Editing of the Hebrew Psaltei*) indicates his emphasis. Building upon the observations of Mays, Seybold, and Sheppard, Creach also notes the link between Psalms 1, 19, and 119 (and 1–2, 18–19, and 118–19, as wisdom and royal psalms set alongside each other). He too links the teaching in Psalm 1 with that, for example, in Psalms 15 and 24, as well as in Psalms 34 and 37. He too sees this psalm as an expression of more personal piety. However, by linking Psalm 1 more closely to Psalm 2, he finds in both psalms the theme of the Psalter as 'Refuge in God'—a theme which is made explicit in Ps. 2.12 (following Mays, a verse likely to have been added by the compilers who placed the two psalms together) and a theme implicit in Psalm 1, in that it teaches how meditation on the law (1.2) is the means of the 'righteous' finding refuge in God.[66] Creach argues that this theme is prominent in Books 1 and 2 of the Psalter so that Psalms 1 and 2 together act as a Prologue to these two books as well as to the Psalter as a whole.[67]

A second work by Creach (1999) builds upon this reading: here he argues that the motif of the tree being planted by the water (verse 3) is an allusion to streams in a temple garden; so, through the righteous man, the Torah is compared with the Temple which makes this psalm '. . . closer than any other biblical text to the rabbinic view of *tôrâ* as a replacement for the temple'.[68] So Psalm 1 is a radical psalm which advocates a new, spiritual piety taken from, but superseding, Temple worship. We will return to this idea later; arguing that Torah should *replace* the Temple when the Temple is still standing and when the Psalter is so full of references to the Temple and to Zion is not as convincing as arguing that Torah piety and Temple piety both feed the righteous man in private and public prayer.[69]

[65] 'Nach Ps 1 macht der Psalter explizit, was Pentateuch (und Propheten) als Tora Jhwhs für das Leben eines Gerechten implizieren.' See Kratz 1996: 11.

[66] See Creach 1996: 79.

[67] See Creach 1996: 83.

[68] See Creach 1999: 45. Creach arrives at this conclusion by looking at other texts using similar imagery—Psalms 52.8 and 92.12 (for trees and the temple precincts), Psalms 46.5 and 65.10 (for waters and Mount Zion)—as well as texts outside the psalms such as Ezekiel 47.1–3. See the discussion of this issue in Chapter 2 'The start of the journey: The Hebrew Bible': 15–16.

[69] See Gillingham 2005: 308–17.

Richard Clifford (2002) offers in his commentary a related, although less radical, reason for why Psalm 1 is at the head of the Psalter.[70] Linking Pss. 1.1 and 2.12 by way of their אשרי formula, Clifford notes how the same formula also occurs in 40.4 and 41.1, at the end of Book I: furthermore, the reference to the 'delight in the law' in 1.2 is found also in 40.8, so one of the key purposes of Psalm 1 is to be one of the 'bookends' for Book 1. Clifford argues that the chief theme in this psalm is the contrast between the righteous and the wicked, and that this is a prominent theme within all of Book I (more than is the case in the other four books in the Psalter). The only problem is that Psalm 1 seems to provide a gateway to the entire Psalter rather than just to Book I.

Botha's historical approach to Psalms 1 and 2 has been referred to earlier.[71] A different work (2005) questions, first, views expressed by, for example, Kratz, whereby Psalm 1 is seen as illustrating that the Psalter is Torah, transcending the Torah of Moses;[72] in this paper Botha also questions Creach's proposal that this elevated view of the Psalter serves as a *replacement* for the Temple.[73] Looking both at the text of the psalm and other possible correspondences such as Josh. 1.6–8; Jer. 17.5–13; Ps. 92.8–16; and Ezek. 47.6–12, Botha understands the reference to the 'waters' in Psalm 1 as an allusion to 'a paradise-like garden within the temple court [which] probably symbolized wholeness of life, joy, sustenance, and the experience of communion with God'.[74] Taking into account that all the related texts view the Temple in a positive light, Botha concludes that it would be odd to think of the psalmist downplaying the Temple in worship and advocating instead a type of new and more private view of the Psalter as Torah:

> According to Psalm 1, the Torah has the power to sustain because it is linked to Yahweh as its ultimate source. It therefore does not replace the temple, but plays a role parallel to that of the temple in constituting the beneficial presence (or detrimental absence) of Yahweh. . . . It leads the worshipper on a road that ultimately ends in the temple as the manifestation of the presence of Yahweh.[75]

This theme of the Temple, connecting together both psalms, is once more prominent in the recent interpretations of commentators on Psalm 1: these include Zenger and Hossfeld, Creach, and Janowski. More recent readings of Psalm 2 emphasize the Temple theme even more, on account of the more explicit reference to Zion in verse 6.

[70] See Clifford 2002: 37–8.
[71] See Chapter 10 'Historical-critical commentaries': 271–2.
[72] See Botha 2005b: 503–4.
[73] See Botha 2005b: 505.
[74] See Botha 2005b: 514, also referring to Janowski's work (2002) on the cosmological implications of 'Jerusalemer Tempeltheologie': Janowski's more recent work (2010) will be discussed below.
[75] See Botha 2005b: 518.

We now turn to literary-critical works on Psalm 2. Although **James Watts**' article (1990) is a theological discussion of Psalm 2 on its own, rather than addressing its particular literary status, it offers some important observations about the significance of this psalm within biblical theology (Old and New Testaments) as a whole. Watts notes how it contains three of the most controversial themes in the Old Testament—a belief in monotheism, royal ideology, and early eschatology. For example, 'son of God' in verse 7 reminds one of the 'sons of God' within a (mythical) heavenly council, for example in Gen 6.2, 4; Job 1.6; 2.1; Dan. 3.25; Ps. 29.1 and 89.6) and so offers hints of henotheism.[76] Watts notes how the royal ideology in this psalm is 'unrealized', and because it was never fulfilled during the lifetime of the monarchy it takes on eschatological connotations, both in Jewish tradition and in a Christian reading of this psalm—'away from the king and towards a messiah'.[77] Then follows an ironical observation about Jewish and Christian uses of the psalm: 'In their expectation of the final victory of God and his Messiah, the Old Testament and New Testament uses of Ps 2 are in full agreement.'[78]

Zenger and Hossfeld (1993a) and Zenger alone (1993b) also note the idealized view of kingship in this psalm which, because it was never accomplished in Jewish history, always has the capacity to look to the future. This at least applies to verses 1–9 of Psalm 2, which were possibly the original kernel of the psalm. This is why the psalm was chosen as an introduction to the first three books of the Psalter, affirming with Psalm 72 and the middle part of Psalm 89 a royal ideology, even though Psalm 89 ends more in despair than hope.[79] But Psalm 2 is also connected with Psalms 148–9 in its theme of the kings of the earth acknowledging God in Zion: so it can be seen as an introduction to the Psalter as a whole.[80] When Psalm 1 was finally added to this collection (when Ps. 2.10–12 might have been added to link both psalms together), Psalms 1–2 are brought even more clearly into a 'Zusammenschau' with Psalms 149–50. So together the first two psalms offer a 'Wegweisung' or an entry into the Psalter as a whole, the first more personal, and the second more communal, with the eschatology in the earliest part of Ps. 2.1–4, 6–9 echoing the eschatology in Ps. 1.5–6, and the more didactic elements in 1.1–2, 3–4 echoing the same sort of teaching in 2.10–12.[81] If the kings of the earth were to acknowledge the law of Yahweh as their mandate, they too would be echoing the way the righteous follow the law in Psalm 1.[82]

[76] See Watts 1990: 76–7. [77] Watts 1990: 84–5. [78] Watts 1990: 86.
[79] Zenger and Hossfeld 1993b: 51. [80] Zenger and Hossfeld 1993b: 51.
[81] Zenger and Hossfeld 1993b: 49–54; Zenger 1986: 508–9.
[82] 'Wenn die Könige der Völker die Tora Jahwes zu ihrem Handlungsprinzip machen, wird "ihr Weg sich nicht verlieren" [Ps. 2.11–12] wie der Weg der "Gottlosen" von Ps 1, sondern er wird gelingen wie der Weg der "Gerechten"', Zenger 1986: 509.

David Clines (1995) offers one of the most provocative discussions of how we ought to read Psalm 2. Applying his well-known 'hermeneutics of suspicion' he questions both the 'world of the text' and the scholarly tradition which has uncritically accepted it. The 'world of the psalm' is about a conflict—'between Yahweh, his anointed one and the poet on the one hand, and the nations and rulers on the other hand'.[83] Looking at the psalm through the eyes of those who have been subjected to an Israelite king and seek to 'break their chains' and 'throw off their fetters' (symbolically named the 'Moabites', at least to give them a name), Clines notes how such a possible rebellion is resisted so violently and scornfully: the Israelite king has a divine imprimatur to deal ruthlessly with such aspirations for freedom ('the sceptre of iron' and 'the potter's vessel'). Nevertheless, scholarly tradition has almost unanimously seen the psalm through the eyes of Yahweh and his anointed one, assuming it was the Israelite king's right to dominate rebellious foreign nations: Yahweh's response of scorn (verse 4), the king's right to pulverize the nations (verses 8–9), and the rule of terror sanctioned by God (verses 10–12a) are rarely directly questioned as an appropriate ideology.[84] Clines contends that Christians are as guilty of condoning the world view of the psalm as are Jews; indeed, by identifying Christ with the Israelite king, the problem is exacerbated. He notes several commentators who cannot see how this has dire implications for foreign nations: Luther is one of those most guilty here, and his affirmation of this psalm we noted earlier.[85] Clines asks: 'What is an appropriate response to assertions of national dependence and claims to national self-determination . . .?'[86] He offers a partial answer: '. . . while Israel is very happy to have been liberated itself, this psalm does not want anyone else to be liberated.' The result is the perpetuation of a political nationalism and religious exclusivism: 'The text has been chanted by millions of the faithful over two millennia, sublimely supporting, *inter alia*, papal authority, the divine right of kings, and the British empire too . . .'[87] Clines thus challenges readers who unthinkingly accept the ideology within Psalm 2, without considering the political and social consequences.

[83] Clines 1995: 245.

[84] See D. J. A. Clines 1995: 257–60. In some ways this typifies some of the anti-Jewish comments in earlier German commentaries, but here Clines is concerned with the much larger issue—the ideology of the psalm, and indeed the ideology of the whole Psalter, if this psalm, along with Psalm 1, is purportedly a gateway into the rest of the Psalms. (Here Clines cites Hossfeld and Zenger 1993a.)

[85] See D. J. A. Clines 1995: 263, citing Luther: 'If I were as our Lord God, and had committed the government to my son, as he to his Son, and these vile people were as disobedient as they now be, I would knock the world to pieces'. See Chapter 5 'Reformation commentators': 120–1 for Luther's comments on Psalm 2. See also Clines 1995: 265–6, where notes commentator after commentator calling the psalm, for example, 'a beautiful poem' 'sublime in its language' and 'words full of great poetical power'.

[86] See Clines 1995: 268.

[87] See Clines 1995: 275.

Alisdair Hunter (1999) also raises questions about the world view of Psalm 2. Having analysed its aesthetic—its structure and progressive relationship with Psalm 1—Hunter turns to the role of the 'anointed one' in the second psalm.

> The messiah indicated by Psalm 2 is clearly a powerful military figure, merciless towards his enemies, but a source of succour to his friends. Vengeful and despotic, he is as careless of his defeated victims as a potter of damaged vessels: they are fit only for scrap.... There is no suffering messiah here, no gentle victim blessing his enemies and praying for his persecutors.[88]

This may sound like earlier historical critics, except that Hunter also seeks to 'deconstruct' the psalm. In this he takes a different line from Clines. He observes how the earliest reading of the psalm is about a Jewish sect within a pagan world, but is used later by 'the secular power which is Christendom', which in turn results in the forging of an alliance with the nations whose hatred for the Jews culminated in the Holocaust.[89] Hence violence turns back on itself: the perpetrators become the victims—except that Hunter also notes how the 'Zion' in the psalm later becomes 'Zionism' and a reborn Israel, as well as the *Al Quds* of Muslim tradition as imagined in the rhetoric of Hamas, or the vision of Jerusalem in Christian apocalyptic.[90] So the violence in Psalm 2 again breeds violation and further claims to power. Like Clines, Hunter asks what can therefore be taken from this psalm: here (unlike Clines) he returns to the fact that the psalm is tempered by its proximity to Psalm 1, which prompts more of a personal mediation on its ideology: so one is led to ask: 'Am I the problem, or part of the answer?'[91]

Rolf Jacobson (2004) approaches the problematic interpretation of this psalm in yet another way. Focusing primarily on the function of the enemy's quotations against God (here Jacobson looks at every psalm with this element, not only Psalm 2), within Psalm 2 he sees how the enemy's speech in verse 3 ('Let us burst their bonds asunder | and cast their cords from us') creates an important rhetorical device within the psalm as a whole.[92] Noting that the rebellion is as much against God as against his anointed (verse 2), Jacobson observes how the so-called 'enemy quotation' is used rhetorically to raise issues about the powerlessness and infidelity of God (and so is not ultimately about Israel). Jacobson argues that the motif of power and powerlessness runs through the entire psalm. First, the enemy's quotation in verse 3 is juxtaposed with a God quotation (verse 6) which serves to address the issue of both purported powerlessness and infidelity. Furthermore, the vocabulary

[88] See Hunter 1999: 111. [89] See Hunter 1999: 114. [90] See Hunter 1999: 115–16.
[91] See Hunter 1999: 117. In some ways this corresponds with John Goldingay's reading of the psalm, as seen in Chapter 10 'Historical-critical commentaries': 269–70.
[92] See Jacobson 2004: 48–9 and 103–5.

announcing the enemy quotation in verse 2 ('The *kings of the earth* set them-
selves and the *rulers* take counsel together') is later repeated to introduce a
speech against the enemies in verse 10 ('Now therefore, O *kings*, be wise; be
warned O *rulers of the earth* . . .'), so that the direct address to the enemies in
verses 11 and 12 ('Serve the Lord with fear . . .') mirrors the earlier quotation
by the enemies in verse 3. By taking a literary and rhetorical approach to this
psalm, Jacobson advocates that its key issue here is not so much political
(opposition to Israel) as theological (opposition to God).[93]

While, as we have seen, many of the commentaries on the separate Psalms 1
and 2 consider also the relationship between them, we now turn to those
commentators, especially since the 1980s, who have explicitly examined
them as one compositional whole. Here we find that works on the literary
and theological relationship between these two psalms are prolific. Two very
different and recent summaries of studies on Psalms 1 and 2 show the extent
of this interest: both **Robert Cole**'s *Psalms 1–2. A Gateway to the Psalter*
(forthcoming) and **Friedhelm Hartenstein** and **Bernd Janowski**'s *Psalmen*
(BKAT: 2012) cite a long list of contributors. Cole notes at least ten seminal
publications over the last twenty-five years, in German, Spanish, French, and
modern Hebrew, as well as several American and English works.[94] Hartenstein
and Janowski note some seventeen contemporary authors, mainly writing in
German and English, some of whom have written two or three papers on the
subject.[95] Cole and Hartenstein/Janowski concur that scholarship has revealed
three different ways of understanding the relationship between these two
psalms.[96] The first is to see them composed and compiled without reference
to each other, but nevertheless illustrating different but complementary
themes found throughout the Psalter. The second, and even more negative,
approach is to see the entire Psalter as showing little intentional placing
of various psalms, other than a general organization into 'Five Books'. The
third stance is to view each psalm as contributing to one dominant theme
continued throughout the Psalter, whether broadly understood as about law,
wisdom, and instruction, or as about kingship, prophecy, and eschatology.
The authors below fall into one or the other of these categories.

Cole offers a comprehensive survey of the history of scholarship up to
2010.[97] Similarly his exegesis of the first three psalms with their many
linguistic and literary correspondences is probably the last word (in English)

[93] The coherent matching of verses 2–3 and 10–11 also raises questions about the later
addition of verses 10–12 to the psalm, unless we are to view the redactor as creating this overall
structural unity.

[94] See Cole (forthcoming), chapter 1.

[95] See Hartenstein and Janowski 2012: 1, n. 1; for a discussion of these works, see pp. 1–6.

[96] These options were discussed in a slightly different way in Chapter 10 'Literary-critical
works': 272–3.

[97] Cole (forthcoming), chapter 1.

on this subject for some time to come.[98] His *bête noir* is Hermann Gunkel, because of his legacy of a form-critical approach, which categorized each psalm as an independent and discrete composition for a specific purpose.[99] Cole's survey of scholarship assesses each author on the basis of whether or not they adhered to Gunkel's form-critical method: those who accept its validity, he argues, are likely to resist any integrated reading of these two psalms.[100] Cole observes how a change of emphasis came about, gradually, as a result of canonical studies in the 1970s, when the interest was more in 'books' rather than 'individual units within books'; so from this scholars were able to ask questions about the shaping of the Psalter as a whole. Cole observes how, ironically, two form-critical commentators actually paved the way for this new approach: Walter Zimmerli (on 'twinned psalms') and Claus Westermann (on the formation of the Psalter).[101] But the seminal work (as we have already noted)[102] was by Gerald Wilson, who applied Child's canonical approach more vigorously to the Psalter: this resulted in questioning (and rejecting) more radically Gunkel's form-critical hypothesis.[103] Cole's approach is to see Psalms 1 and 2 (as well as Psalm 3) each as a structural unity, illustrated by the 'inclusios' at the beginning and ending of all three psalms. Nevertheless, Cole's verse-by-verse commentary on each psalm, drawing from selections of early Christian and rabbinic tradition as well as recent scholarship, argues that it is impossible to ignore their clear interrelationship from the point of view of their inclusion in the Psalter as a whole.[104] So according to Cole, this means that the 'unnamed' man in Psalm 1 is to be read as the 'kingly figure' in Psalm 2:

> . . . his precise identity, means of attainment and eschatological military victory, nor exaltation, [were not] defined with any precision. Similarly the wicked also were identified only in a very general manner. Psalm 2 provided further detailed descriptions of these three: the blessed man, the wicked, and the righteous.[105]

Whatever one makes of Cole's view of the 'royal figure' and the 'military trappings' which are apparent not only in Psalm 2 but also in Psalms 1 and Psalm 3, it is clear that this is a formative contribution to the debate, not least

[98] See Cole (forthcoming), chapter 2 (on Psalm 1), chapter 3 (on Psalm 2), and chapter 4 (on Psalm 3). I am most grateful to Robert Cole for allowing me to read his full manuscript almost a year before publication.

[99] Cole (forthcoming) cites Gunkel in his *Introduction to Psalms* 1998: 2–3: 'No internal relationship can be discovered between neighbouring psalms . . .'

[100] '[Gunkel's] negative verdict on the usefulness of the Psalter's arrangement has had a chilling effect on subsequent study reaching to the present day' (Cole: forthcoming).

[101] See Zimmerli 1972: 105–13; Westermann 1981: 250–8.

[102] See Chapter 10 'Literary-critical works': 273.

[103] See Wilson 1985 and 1986.

[104] Cole (forthcoming) offers two useful comparative charts, which summarize his conclusions. One connects Psalms 1 and 2 and the other connects Psalms 1, 2, and 3.

[105] Cole (forthcoming). The same view is expressed in Cole 2002: 75–88.

in the recognition that Gunkel's legacy constrained any integrated way of reading Psalms 1 and 2 and also played down any appreciation of the shaping of the Psalter as a whole.[106] The fact that neither Psalm 1 nor Psalm 2 can be classified according to form, but rather, like all Gunkel's so-called wisdom psalms and royal psalms, according to content, rather highlights this *lacuna* in the form-critical methodology.

Hartenstein and Janowski offer a much briefer analysis of these two psalms, although like Cole they trace these concerns back to the Church Fathers, not least Jerome, as well as to early Jewish and rabbinic tradition including Qumran and *Midrash Tehillim*.[107] Noting, like Cole (whose 2002 paper they cite), the linguistic connections between Psalms 1, 2, and 3, they observe that the scornful in Psalm 1 echo the arrogance of the nations in Psalm 2 which in turn echoes the posture of those who oppress the suppliant in Psalm 3.[108]

Hartenstein and Janowski pose, by implication, an interesting question concerning Cole's theory of the king as the most prominent motif within Psalms 1–3. They understand Psalm 1 to be the last psalm to have been included, added to Psalm 2 which already headed up Books I to III, a psalm deliberately placed so that the twin themes of Torah and Kingship lie side by side.[109] Cole's theory makes the idea of twin themes difficult (an assumption he constantly rejects as being overly influenced by form-critical concerns). But we still have to ask: if Psalm 1 was added last, why should such a *general* psalm about 'a blessed man' be included next to Psalm 2, with its specific identification of the king as the one protected by God? How can an explicit *particular* identity be made more clear by the addition of a more *general* identity expressed in Psalm 1? If Cole is right, then logically one would expect Psalm 2 to have been added later than Psalm 1.

So these two publications on Psalms 1 and 2 serve to illustrate that the subject of the relationship of Psalms 1 and 2 is topical and relevant for our understanding of the Psalter as a whole. We now turn to some of the publications these authors cite: dating from the 1980s, our selection will be of those who have distinctive contributions to this issue.

One of the earliest contributions is by **Pierre Auffret** (1986) whose previous literary and linguistic study of Psalm 2 resulted in a paper on Psalms 1–2. Here Auffret notes not only literary and linguistic correspondences between the two psalms but also the emphasis on 'dualism' in both psalms:

[106] Cole's introduction which discusses the views of the many scholars who have written positively or negatively on this issue makes this point so clearly: those who resist this reading are still trapped in a 'Gunkelian' world view of the psalms.

[107] Hartenstein and Janowski 2012: 2–3.

[108] 'So wird dir Torheit der Frevler von Ps 1 auf das Aufbegehren der Nationen von Ps 2 ebenso durchsichtig wie der Weg des Gerechten von Ps 1 auf die Situation des Bedrängten von Ps 3 . . .' See Hartenstein and Janowski 2012: 4.

[109] 'Wahrscheinlich ist Ps 1 für das Proömium geschaffen worden . . .' (Hartenstein and Janowski 2012: 4).

the righteous and wicked; the two ways; the two choices; and the 'two gifts'.[110] Auffret sees each psalm as a self-contained entity; yet he also suggests that Psalm 1 might have been composed with Psalm 2 in mind.

In several different publications, **Patrick Miller** (for example, 1993) develops a similar way of reading these two psalms. Noting the recurrence of the 'two ways' echoed in both psalms (1.6 and 2.12) and further observing that the theme of 'the way of the wicked' dominates Psalms 3–41 while 'the way of the righteous' is in fact a prominent theme throughout the Psalter, Miller argues that the first two psalms pre-empt the two key motifs in the Psalter as a whole. Furthermore, Miller argues, taking both psalms together creates a theological agenda which might be termed 'the law of the king' (as in Deuteronomy 17.19) whereby the king maintains his righteousness and defends his kingdom against the wicked by keeping the law. The argument that these two psalms together suggest the influence of Deuteronomy 17 is not an entirely new interpretation: but what Miller brings to this is an understanding that 'the king' (the anointed one) in Psalm 2 is thus identified as 'the man' (everyman) in Psalm 1, so that 'everyman' is enjoined—that is, not just the king—to keep the law:

> Psalm 1 placed before Psalm 2, therefore, joins Deuteronomy in a kind of democratising move that stands in tension with the royal one arising out of the placing of Psalm 2 as the lead into Psalms 3ff . . .[111]

David Mitchell (1997) is concerned with the entire Psalter, but in his focus on the eschatological message of the Psalter he argues that both Psalms 1 and 2 play a vital part in conveying this theological agenda. By noting how in the history of reception they have been read together, Mitchell is able to read 'Torah' in Psalm 2 and 'Kingship' in Psalm 1. Noting that each psalm ends with an eschatological expression of the coming judgement on the wicked, Mitchell sees that the two psalms in different ways announce the eschatological triumph of God as King.[112] He observes:

> The combined effect of Psalms 1 and 2 together may be that Psalm 1 foretells the triumph of the righteous divine king who meditates on Yhwh's Torah, and Psalm 2 shows him going forth to battle with its predicted outcome.[113]

Gianni Barbiero (1999) combines both diachronic and synchronic concerns; his fundamental argument is that an eschatological purpose lay behind the inclusion of Psalms 1 and 2 together. His work is only on Book I (Psalms

[110] See Auffret 1986: 7–13.

[111] See Miller 1993: 91–2. This is of course the converse of Cole's understanding of the relationship between these two psalms.

[112] See Mitchell 1997: 87. A corresponding view of Psalms 1 and 2 revolving around the theme of eschatological judgement (which is as much an appeal to Israel as to the 'wicked' nations) is found in Renaud 2004: 225–42.

[113] See Mitchell 1997: 73.

1–41) of the Psalter: a lengthy chapter is assigned to a thorough discussion of the 'strukturelle Einheit' of Psalms 1 and 2.[114] One of Barbiero's most interesting contributions is a detailed comparison of Psalms 1–2 with Psalms 40–1, suggesting that the first two psalms also serve as a Prologue not just to the Psalter as a whole but to Book I in particular.[115] Perhaps Barbiero's most important suggestion is that because of several verbal links between Joshua 1 (at the beginning of the 'Former Prophets') and Malachi 3 (the last of the 'Book of the Twelve'), and Psalms 1 and 2, this indicates how both these psalms were already imbued with the prophetic-eschatological concerns found in the canon of the Prophets.[116] So, although Barbiero's reasons are very different from Mitchell's, he concludes the two psalms were deliberately bound together to reinforce the eschatological perspective which was prevalent at the time of compilation, echoing that expressed in the Prophets.[117] Motifs of the wind blowing away the chaff (Ps. 1.3); the use of משפט (Ps. 1.5) and the root שפט (Ps. 2.10); and the references to God's anger in Ps. 2.5 and 12 all testify to this. Hence both the 'wisdom' motifs in Psalm 1 and the 'royal' motifs in Psalm 2 are together caught up into a greater eschatological world view.

Jean-Marie Auwers (2000) lists the usual similarities between Psalms 1 and 2 (1.1/2.4; 1.2/2.1; 1.6/2.12) and also argues that verses 10–12 of Psalm 2 are a deliberate addition to bring the second psalm in line with the wisdom teaching in Psalm 1.[118] It is quite possible that the similarities between 2.2 and 2.11, concerning the relationship of the foreign kingdoms with Israel's God, may suggest that this part of the psalm was an integral whole; but one could equally argue that if there was a redactor they would have deliberately forged a link not only with Ps. 2.2. and 2.12 but also with Ps. 1.6. Ps. 2.12 ('Heureux qui s'abrite en lui!') undoubtedly fits the more general and universal understanding of 'blessedness' in Psalm 1, which is seen as 'un discours de sagesse'. Psalm 1 is the dominant psalm of the two: so Psalm 2, preserved and used after the downfall of the monarchy, has been adapted to fit with a wisdom discourse, and this is how both psalms taken together should be understood.

[114] See Barbiero 1999: 31–62.

[115] See Barbiero 1999: 51, on the links between Ps. 1.1, 2.12, 40.5, and 40.1 in the אשרי formulae. See also pp. 52 and 54, which present two tables of linguistic correspondences between Psalm 1 and Psalm 40 and Psalm 2 and Psalm 40 respectively; and pp. 57 and 60, which present tables of linguistic correspondences between Psalm 2 and Psalm 41 and Psalm 1 and Psalm 42 respectively. Barbiero also affirms the linguistic links between Psalms 2 and 149 (pp. 50–1) although a discussion of the theological shaping of the entire Psalter by these two psalms is not in his remit.

[116] See Barbiero 1999: 33–4.

[117] 'Die beiden Psalmen sind durch die eschatologische Perspektive verbunden': Barbiero 1999: 39–40.

[118] See Auwers 2000: 125–6.

Clinton McCann (1996) argues that Psalm 1 invites the reader to read the entire Psalter not as wisdom, but more generally, as 'instruction'.[119] Despite his seeing the close relationship between the first two psalms, McCann downplays the more specifically royal characteristics of Psalm 2. In a later article on 'Righteousness, Justice and Peace in the Psalms' (2001) he argues that the element of instruction in both psalms revolves around the theme of 'justice and righteousness' which is an issue in the Psalter as a whole. McCann's problem is that although this is explicit in Psalm 1, it is not as clear in Psalm 2: but, he argues, the theme is implicit in the way the psalm upholds God's sovereignty, whose justice will be made manifest through his 'anointed one'.[120]

Beat Weber has written several articles on the relationship between Psalms 1 and 2, of which the most significant are probably one in English (2006) on Psalm 1 and another in German (2010) on Psalms 1–3.[121] Weber's basic thesis is that Psalm 1 has to be read as a wisdom psalm, due to its 'directive style', and Psalm 2 has to be read through the voice of the prophets, due to the 'voice of God' at its heart, in verse 6. The difference, according to Weber, is a 'theology from below' and a 'theology from above'.[122] This presents a 'dual portal' through which one enters the psalms: Psalm 1 represents the Pentateuch and Psalm 2, the Prophets.[123] More recently Weber has written on how the first three psalms together create this portal: Psalm 3 is the first address to God in the Psalter, and it shows us more pragmatically how to 'pray with David'.[124]

Mary Daly Denton (2010) offers some quite different insights. She observes that the placing of Psalms 1 and 2 alongside each other is the result of the later 'sapientializing' of David, caused by the prolonged experience of the loss of the monarchy. This reworking of the 'sapiential' tradition about David is also evident in the Qumran Scrolls: '[This] says much about what happened to the memory of David. Now he has become a kind of sage: someone devoted to reflection on the Law. This is quite a transformation of the David we know from 1 and 2 Samuel . . .'[125] So Psalms 1 and 2 together are an important illustration of the reception of David's 'literary afterlife': '. . . fidelity to God's law [was] the basis for hope in God's fidelity to the

[119] See McCann 1996: 688.
[120] See McCann 2001: 112–18. Here McCann also refers to the association of Psalm 2 with Psalm 149 which in his view also makes this point (117–18). The problem with McCann's observations is that this theme is so general that every psalm could (implicitly) fit the proposed agenda; but given that this is what McCann probably intended, this is an interesting point.
[121] See also Chapter 1 'Comparison with Psalms 19a and 19b': 6, n. 8.
[122] See Weber 2006: 243–4 and 251–3.
[123] This follows the observations of Hossfeld and Zenger in their commentary on the separate psalms. See Chapter 10 'Literary-critical works': 274, 277.
[124] Weber 2010: 840–2.
[125] See Daly Denton 2010: 52–3.

promises to David'.[126] This has some correspondences with Miller's hypothesis: devotion to David as the keeper of the law '... would reinforce the post-exilic agenda focused on reviving the temple and fostering devotion to the Law'.[127]

William Brown's Introduction to the Psalms (2010) devotes one chapter to 'Psalms as Corpus'. Brown views Psalms 1 and 2 as 'the hermeneutical spectacles' through which the rest of the Psalter can be read. But his own reading of these psalms is that they are not about one theme, but many:

> ... righteousness and refuge, *tôrâ* and Zion, judgement and protection, justice and kingship, instruction and king, happiness and wrath. Such paired themes find their precedence in the juxtaposition of these two opening psalms.[128]

Furthermore, these two psalms cannot accommodate every single theme within the Psalter: they have been placed at the beginning as 'programmatic pieces designed to influence how one reads the Psalter selectively yet discerningly'.[129]

CONCLUSION

This selective overview of the historical and literary readings of these two psalms provokes some interesting observations. The first is that more recent literary studies have less of a dogmatic confessional bias: whereas historical-critical commentaries were rooted in a particular (denominational) theological agenda, this is less apparent in more contemporary studies of the reception of these texts. Writers are of various persuasions—some not necessarily Christian—and offer insights for the benefit of the academy as much as the Church. Hence a particularly Jewish or Christian approach may be of interest, but only at a secondary level; and the judgemental tone evident in earlier tradition is far more muted because a confessional reading matters far less.

[126] See Daly Denton 2010: 53. Denton makes the further point that the early Christians gave David in Psalm 2 yet another afterlife by interpreting the Psalm as a prophecy of the resurrection of the 'Son of David' (pp. 53–4).

[127] See Daly Denton 2010: 54.

[128] Brown 2010: 116.

[129] See Brown 2010: 116–17. Brown does contend that there is a coherence between these two psalms (for example, each agrees about the final fate of the wicked (becoming like the chaff blown in the wind (Psalm 1) or as a shattered pot (Psalm 2); and each concurs that the righteous can be secure, whether in the Torah (Psalm 1) or in the decree of the Lord (Psalm 2))). Brown also makes an interesting observation about the relationship between Psalms 1, 2, and 3: in Psalm 1 one reads of the 'righteous person'; in Psalm 2, of 'the king'; in Psalm 3, the 'righteous king' who, overwhelmed by the wicked, turns to God alone for help (p. 117).

Secondly, it is quite clear that there are many ways in which the relationship between these two psalms might be perceived. William Brown's sense of multivalent readings is a good analysis, even though some approaches are more convincing than others. The 'instructional' (and more specifically 'wisdom') approaches of writers such as Auffret, Miller, Auwers, McCann, and Daly Denton have much to commend them; equally, the 'eschatological' (and more specifically 'prophetic') readings of Mitchell and Barbiero are also compelling in that they accord with what we know about the hopes of the Jewish community at the time of the compilation of the Psalter as a whole.

Thirdly—and here this leads on to the more general conclusion about this reception-history survey of these two psalms over two and a half millennia— some commentators, whether writing from a historical-critical or a literary- critical vantage point, refer to a more hidden motif which—whether couched in historical, literary, or theological categories—may be another explanation for the juxtaposition of these two psalms. This, as has been suggested since our very first chapter, is the theme of the Temple. In this last chapter it has surfaced several times, not least in publications over the last quarter of a century: we have already noted that its key proponents are Hossfeld and Zenger, Janowski, Creach, and Botha (although Daly Denton and Cole offer some useful insights as well). The motif of the Temple was especially apparent in the very earliest period of (Jewish) reception history, so it is interesting to see how it resurfaces in this, the latest and more open-ended one.[130] This Temple motif has some rather important theological implications, not only about the interface between Jewish and Christian readings of these psalms through the centuries, but about how international scholarship reads these two psalms today. We shall examine these implications briefly as part of our concluding observations.

[130] See for example Chapter 2 'The start of the journey: The Hebrew Bible': 15–16, 'The Qumran Scrolls': 22, and 'Conclusion': 37.

11

Conclusion: The End of the Journey

In charting the reception history of Psalms 1 and 2 we have from the outset had three objectives: to gain a fuller understanding of the relationship(s) between these psalms; to increase our appreciation of the complexities of the differing Jewish and Christian responses to them; and to explore whether the theme of the Temple might in any way be a unifying theme. Now, after a journey spanning two and a half millennia, it is time to take stock.

THE THEME OF THE TEMPLE

Although the Temple has not occurred as frequently as might be expected, it is undoubtedly important because it has many implications for our two other objectives. We shall therefore start with looking at how this theme has developed throughout the book. In Jewish and Christian reception history 'Temple theology' is a rich topic, which extends far beyond the Psalter alone. Early Christian prayer and worship, for example, were profoundly influenced by the theology of the Jewish Temple: we saw something of this in the chapters on liturgy and music. Margaret Barker has written extensively (and controversially) on how Temple imagery pervaded the New Testament writings and the works of the early Church Fathers, thus influencing and shaping much of the sacramental theology and music in the formative period of the Church.[1] The Jewish Temple has not only influenced Christian theology but Islam as well.[2] The continued use of the Temple as a 'metaphor of knowledge', not only of the world but also of God, was prominent in early modern Europe.[3] It was also important for Jewish Christian relations in the early modern period, as seen in Hebrew and Christian manuscripts which

[1] See Barker 2004: 1–12; 2007: 1–18, 221–38.
[2] For example, Hamblin and Seely 2007.
[3] See Bennett and Mandelbrote 1998, which arose out of an exhibition in the Bodleian Library, Oxford, in the same year.

testify to the vitality of the Temple in the early corporate memory of each tradition.[4]

Several times we have noted how Psalm 2 suggests evidence of this Temple tradition because of its reference in verse 6 to Mount Zion: even when the monarchy had ended, in the restoration period under Persian domination, the idea of God dwelling with his people was especially linked to the Second Temple, so that the reference to 'Zion' in this royal psalm could have been an important link between the Temple of Yehud and the previous (royal) Temple. Doubtless this would have been a belief familiar to the composer of the first psalm. We have noted several times the comparisons between the Temple and Eden, with its imagery of a well-watered garden and the Tree of Life, which has obvious ramifications for a Temple-orientated understanding of Psalm 1.[5] The dominant theme of the psalm is of course 'Torah', with its wide range of meanings: this addressed the identity crisis under foreign rule of the Jewish people deprived of a king. But the literature from this period also shows clearly that 'corporate identity' for the Jews under Persian (and later Greek) rule was expressed not only in keeping the Law but by Temple worship.[6] The later literature from the intertestamental period also testifies frequently to this belief: not surprisingly it was in this period that we found the greatest number of references to the Temple as a shared motif when Psalms 1 and 2 were considered together.[7]

For Jews, the physical Temple served to mark continuity with the past and to forge a sense of identity in the present until its destruction in 70 CE. Christians replaced the physical symbolism of the Temple with a theology of the Body of Christ, both in relation to the person of Christ and to his Church; for Jews, Torah and its interpretation now became a unifying force. This might explain why there are so few references to the Temple (real or imagined) as a link between these two psalms in either Jewish or Christian interpretation from the first century onwards. Indeed, the only allusions to the Temple are by the less-than-orthodox Karaites; they compare the mystical experience they gain from entering the Psalter in Prayer with the mystical experience they might expect to have when entering the Jerusalem Temple, for worship. Indeed, they view the Psalter as the 'holy sanctuary' replacing the Temple and they also propose that one enters this 'Psalter-sanctuary' through twelve different gates (i.e. twelve different psalms).[8] Later, Kabbalistic

[4] See van Boxel and Arndt (eds.): 2009, which was the product of another exhibition in the Bodleian Library in 2009.

[5] See for example Creach 1999: 34–46 and 2008: 54–9.

[6] It is beyond the scope of this work to offer any detailed analysis, but many later prophetic texts, from Ezekiel to Malachi, as well as the Chronicler, frequently bear witness to God dwelling with his people in the Jerusalem Temple.

[7] We shall refer to examples of this in the next section.

[8] See Chapter 4 'Jewish mysticism': 90–1.

Jews compared their mystical encounters with God through the psalms with what would have been experienced within the Jerusalem Temple.[9]

Although specific Christian comparisons of the psalms with the Temple are few, this simply registers the break with Judaism after the first century CE. Despite the influence of Temple practices on singing and liturgy,[10] the prevalent view was that the Psalter *embodied* what the Temple once stood for rather than *representing* its iconic presence. There are certainly no specific references to Temple theology in the Christian exegesis of Psalms 1 and 2.

Only over the last thirty years has any extended interest in the Psalter as a Temple,[11] and Psalms 1 and 2 as an appropriate entry into it, been made explicit.[12] What is clear in these works is that Temple imagery provides a rich interpretive context for a shared Jewish and Christian appreciation of the Psalter as a whole and of Psalms 1 and 2 in particular. The Jewish loss of their sacrificial system after 70 CE, and the Christian rejection of the validity of such a system at about the same time, required both traditions to look for a symbol of God's dwelling with his people independently of the Temple. Nevertheless, the Temple offers a rich potential for further discourse between Jews who may have found their 'replacement theology' in the written Law (as in Psalm 1) and Christians, who have found the same in the Person of Christ (as in Psalm 2). Viewing the Psalter as a 'holy sanctuary' does not mean that Jews and Christians have to read Psalms 1 and 2 in exactly the same way: 'Law' and 'Messiah' will always resonate differently in each tradition. But by together viewing the Psalter to be like the Temple—what we might term a portable sanctuary of instruction, prayer, and song—Jews and Christians can find, even in Psalms 1 and 2, more to unite their faiths than divide them.

JEWISH AND CHRISTIAN CONFLICT AND CONVERGENCE

Our second aim was to use reception history to appreciate more fully different Jewish and Christian readings of these two psalms. We encountered some disquieting examples of the ways in which such differences have been expressed: unlike the other two concerns here, this has consequences not only for our understanding of Psalms 1 and 2 but also for the ways in which the entire Psalter has been read. These begin with the earliest (Jewish) Christian

[9] See Chapter 6 'From the Second Temple up to the fifteenth century': 135–7.

[10] See Chapter 8 'Assessing the evidence': 193.

[11] The Psalter has been compared to a mansion (Jerome) and to 'an anatomy for all parts of the soul' (Calvin) but not until recently as a replacement for the Temple. For recent accounts of this metaphor, see Janowski 2010: 279–306.

[12] See Brown 2010: 157–60.

witnesses within the New Testament, where references in the books of Acts and Hebrews demonstrate that Christ, not the Davidic king, is understood as the 'anointed one' in Psalm 2.[13] This is continued in the Church Fathers: the reference in the Epistle to Barnabas to the 'tree' in Psalm 1 as the cross, and the identification by Tertullian of the 'blessed man' as Christ would have made disturbing reading to the Jews.[14] Similarly Origen's prosopological reading of both Psalms, seeing Christ as holding the only key which opens the secrets of the psalms, would have been troubling to Jews;[15] so too would Jerome's view of Christ as the Wisdom of God surpassing the Jewish Law;[16] and Augustine's understanding of Christ 'the blessed man', who alone is not *under* the Law but *over* it, in Psalm 1, and who, in Psalm 2, faces the Jews as his enemies, would have been similarly provocative.[17]

Early Jewish exegesis of Psalms 1 and 2 was notably less trenchant and less explicit. The *Targum* on Psalm 1 names 'the wicked' as the Gentiles, but never specifies them as Christians.[18] Similarly *Midrash Tehillim* on Psalm 2, identifies 'Gog and Magog' who oppose the Messiah as Gentiles, but not explicitly Christians, although the affirmation of the 'Son of God' in verse 7 now as Israel is an obvious attempt to refute Christian interpretation.[19] Yet there is rarely an explicit account of alternative Christian readings. Rashi and Kimḥi both affirm in their commentaries that every pious Jew is the blessed man, and that the figure in Psalm 2 is either Israel or (the historical) David; yet there is little extensive criticism of Christian interpretations.[20] Jacob ben Reuben is the most combative commentator in his explicit refutation of the Christian interpretation of Psalm 2 concerning Jesus as God's son.[21]

Christian tradition from the early Middle Ages onwards is notably less temperate. Cassiodorus, following Augustine, sees the one nature of Christ in Psalm 1, and his two natures in Psalm 2.[22] The commentary attributed to Bede reads in Psalm 2 the hostility of the Jews to the sufferings of Christ.[23] Gilbert of Poitiers follows earlier tradition in identifying the Law in Psalm 1 as the Wisdom of Christ, and like Cassiodorus sees Christ Incarnate in the first Psalm, and Christ in his 'two natures' in the second;[24] Aquinas identifies the Blessed Man as Christ, and the kingdom in Psalm 2 as of Christ, not of

[13] Chapter 3 'The New Testament': 38–40.
[14] Chapter 3 'The Church Fathers': 44–8.
[15] Chapter 3 'The Church Fathers': 49–50.
[16] Chapter 3, 'The Church Fathers': 57–8.
[17] Chapter 3 'The Church Fathers': 59–61.
[18] Chapter 4 '*Targum Psalms*': 71–4.
[19] Chapter 4 '*Midrash Tehillim*': 79–81.
[20] Chapter 4 'Jewish commentaries': 81–4 (Rashi) and 86–8 (Kimḥi).
[21] Chapter 4 'Jewish commentaries': 85.
[22] Chapter 5 'Two early commentators': 96–100.
[23] Chapter 5 'Two early commentators': 100–2.
[24] Chapter 5 'Medieval commentators': 103–5.

David.[25] Only Herbert of Bosham and Nicholas of Lyra offer a more open (perhaps imagined) dialogue with Jewish commentators, reading 'the Law' as Scripture by referring to Rashi and reading Psalm 2 initially more historically before applying it to Christ.[26] Erasmus, by contrast, is more strident; his commentary on Psalm 1 compares the Jewish assent to keeping the Law with the outdated legalism of the Catholic Church.[27] Luther similarly ponders how it is possible to 'delight in the law' and refers to the legalism of both Jews and Catholics; he reads Psalm 2 through Acts 4 and sees it in the light of Roman and Jewish opposition to Christ.[28] Only Calvin avoids any anti-Jewish sentiments, applying both psalms to the Christian congregation, for which he was suspected of being a covert 'Judaiser'.[29]

Our discussion of the liturgical use of the psalms revealed a more irenic interpretation, for Christians had borrowed and adapted their early liturgy from Jewish practices, and as far as the psalms were concerned, each tradition often prescribed many of the same psalms in weekly prayer.[30] The only specific evidence of any 'supersessionism' is found in seventeenth-century collects explaining these psalms through a specific Christian reading.[31]

Because illuminated manuscripts were undertaken with some dependence upon the traditions in Christian exegesis, here we often find visual representations with an implicit critique of Jewish beliefs. In the Utrecht Psalter, as well as in some of the later related psalters, the Christ-figure is found above the Blessed Man in Psalm 1, and at the centre of the conflict against the wicked in Psalm 2.[32] In the Eadwine Psalter, the words 'synagogue' appear in a building to the left of the Christ figure, for these are the 'wicked' Jews who are enemies of Christ.[33] In the Paris Psalter, the Blessed Man is presented no longer as the Christian but as Jesus Christ Himself.[34] The Stuttgart Psalter depicts the tree in Psalm 1 as Christ on the cross, and the scene in Psalm 2 is reconstituted as Christ in the garden of Gethsemane.[35] Some eastern psalters produced during the period of iconoclasm are even more specific: in the Khludov Psalter we see in Psalm 1 three Jews being driven down to the pit of judgement, and in Psalm 2 they are depicted as not seeing or understanding the story of Christ's passion expressed in the psalm: the added words 'sinful nation' make their condemnation even more explicit.[36] The Theodore Psalter shows the Jews in

[25] Chapter 5 'Medieval commentators': 107–9.
[26] Chapter 5 'Medieval commentators': 109–14.
[27] Chapter 5 'Reformation commentators': 115–16.
[28] Chapter 5 'Reformation commentators': 118–21.
[29] Chapter 5 'Reformation commentators': 122–6.
[30] Chapter 6 'Introduction and overview': 131–5.
[31] Chapter 6 'From the sixteenth century to the present day': 143.
[32] Chapter 7 'The ninth to the fifteenth century': 164–6.
[33] Chapter 7 'The ninth to the fifteenth century': 167–8.
[34] Chapter 7 'The ninth to the fifteenth century': 168–9.
[35] Chapter 7 'The ninth to the fifteenth century': 170–1.
[36] Chapter 7 'The ninth to the fifteenth century': 171–2.

Psalm 1 as being blown like chaff by the wind into a pit below, and its illustration of the nativity in Psalm 2 is set in the context of Jewish figures (probably Annas and Caiaphas) opposing Christ during his trial.[37] In later western psalters the motif of the Jesse Tree is less confrontational, for example in the Windmill and Gorleston Psalters, but the concept of a 'genealogy' moved upwards through David to Christ is still controversial.[38]

By contrast, early Jewish illustrated psalters—even those such as the Parma Psalter produced during periods of intense persecution of the Jews in Italy— have no such representations, partly due to the very different (less specific and less personalized) Jewish conventions of artistic representation at the time.[39] Similarly more recent Jewish illustrations of these two psalms are more about what Judaism is than what Christianity is not: Chagall's two sketches of Psalms 1 and 2, for example, depict Jewish nationalistic motifs, with Jerusalem clearly represented in Psalm 2, but without any explicit Christian critique.[40]

We saw how the representation of Psalms 1 and 2 in music, as in liturgy, draws from Jewish traditions: a negative Christian critique of Jewish psalmody is hard to find. The 'lyrics' are usually taken from more literal translations, and the emphasis is more on continuity than conflict. Only in metrical psalmody is there any explicitly Christian overlay—for example, in Sternhold and Hopkins' specific reference to Christ's sufferings in Psalm 2, and Watts' introduction of Christ as the agent of judgement in Psalm 1.[41] The best example of all is in Handel's various renderings of Psalm 2, not least in *The Messiah*.[42] Yet Jewish musical performances of these psalms are again less explicitly hostile. Bernstein, for example, imitating the more secular conventions of Broadway musicals, universalizes the conflicts found in Psalm 2.[43] Later Christian renderings of these psalms are actually more irenic: Rachmaninoff's version of Psalm 1, Vaughan Williams' version of Psalm 2, and Goodall's of Psalm 1 all use words which accord with the 'plain-sense' meaning of the psalms and have no anti-Jewish connotations.[44]

Poetic imitations of these two psalms, some as interested in the aesthetics of the form of the psalm as its content, do not depart radically from the (Jewish) text. Sidney's version of Psalm 1 and Sandys' version of the same psalm, have no explicitly Christian overlay.[45] Milton's version of Psalm 2,

[37] Chapter 7 'The ninth to the fifteenth century': 173–5.
[38] Chapter 7 'The ninth to the fifteenth century': 176–8.
[39] Chapter 7 'The ninth to the fifteenth century': 180–1.
[40] Chapter 7 'The twentieth and twenty-first centuries': 186–8.
[41] Chapter 8 'Christian interpretations': 209–16.
[42] Chapter 8 'Christian interpretations': 220–2.
[43] Chapter 8 'Jewish interpretations': 199–200.
[44] Chapter 8 'Christian interpretations': 227–33.
[45] Chapter 9 'Christian translation, paraphrase, imitation, and allusion': 245–8.

which speaks of the 'Messiah dear', is one exception.[46] Furthermore, con-
temporary imitations, whether by Jews or Christians, are instead preoccupied
with more universal issues such as gender inclusiveness, political correctness,
and poetic justice and so are less locked in critical dialogue one with the
other.

Animosity against Jewish interpretations is apparent again in some of the
historical-critical commentaries from the nineteenth century. De Wette,
Hengstenberg, Duhm, Kittel, Gunkel, Weiser, and Kraus are all examples of
varying negative responses to the Jewish views of the Law and Messiah in
these two psalms.[47] By contrast, more recent commentators, especially those
with more literary and theological concerns, have little to say on the issue:
here the way is open for a more dynamic Jewish–Christian dialogue about
these two psalms.

Thus reception history reveals the full extent of specific Christian readings
of these psalms, often expressed with some animosity, especially in the
exegetical tradition, against Jewish interpretations. Yet reception history also
reveals a transition to a more irenic reading of Psalms 1 and 2 at about the
time of the end of the Second World War, by both Jews and Christians, when
other issues in reading the psalms (such as gender, violence, and social justice)
take precedence. So this period, aligned with what has been shown in seeing
the Psalter as a Temple, has opened the way for a more creative and honest
Jewish–Christian dialogue.

PSALMS 1 AND 2 AND THE ENTRANCE TO THE PSALTER

The third issue expressed in our introduction was to assess just how much
Psalms 1–2 have been understood as a *unity* throughout the history of their
reception. Some of this overlaps with our earlier comments about the Temple,
for in the very earliest period of Jewish interpretation it was the theme of the
Temple which frequently held these two psalms together, and indeed Psalms 1
and 2 were deemed to be like the two pillars, Jachin and Boaz, which stood at
the entrance to the Temple in 1 Kgs 7.21.[48] For example, *early Jewish exegesis*
offers a clear illustration of the interrelationship between these psalms,
especially in 4Q174 at Qumran, where the Temple is one conjoining
theme.[49] Psalms 1–2 are also seen together in the early Greek translation,
which highlights the instructional element in Psalm 2 (verses 1, 2, 10, and 12)

[46] Chapter 9 'Christian translation, paraphrase, imitation, and allusion': 248–50.
[47] Chapter 10 'Historical-critical commentaries': 263–8.
[48] I am grateful to John Sawyer for this insight.
[49] Chapter 2 'The Qumran Scrolls': 17–22.

and the more judgemental aspect in Psalm 1 (in verses 5 and 6), thus bringing the individual concerns of each psalm closer to the other.[50]

Early Christian tradition is similarly positive about the close relationship between these two psalms. An important New Testament text which we have noted several times is Acts 13.33.[51] Origen, Eusebius, and Diodore also variously discuss their close relationship;[52] and in the western churches, so too do Hilary and Jerome;[53] while Justin and Hippolytus each go so far as to see the two psalms as two parts of the same story of Christian salvation.[54]

In later rabbinic interpretation we find further evidence of reading the two psalms in close proximity. The *Babylonian Talmud* is the most explicit: *Berakoth 9b–10a* is a frequently cited text for its appraisal of Psalms 1 and 2 as 'one chapter'.[55] *Midrash Tehillim* on Psalm 1 also lists the various examples of the Blessed Man in early Jewish tradition, while for Psalm 2 the one praised is King David, whose piety confronts the enemies of the Jewish people.[56] Furthermore, Abraham ibn Ezra's commentary on these psalms is another important testament to their interrelationship, this time as religious poetry.[57]

Later Christian exegesis worked on similar principles, albeit for different reasons, and assumed the two psalms were very much interrelated. We have already observed how Cassiodorus sees Psalm 1 as the witness to the 'one monad' of Christ and Psalm 2 as the witness to the 'two monads' of Christ's human and divine natures—an intriguing example of the use of psalm numbers in formulating Christian doctrine.[58] Bede echoes more the interest in the moral value of both psalms by using only Pss. 1.1–3 and 2.10–12 in the *Abbreviated Commentary* attributed to him: the selection of verses in each psalm is more didactic in tone, thus connecting the one psalm with the other.[59] Aquinas is aware of the tradition of the two psalms being known together as the first psalm, even though he does not develop;[60] and later, Erasmus uses the same tradition in commenting on Acts 13.33 to observe that the two psalms correspond in language as well as in their (Christian) theme.[61]

However, Psalms 1–2 are never used as one unit in Jewish or Christian liturgy, although in Christian tradition they would have been prayed along-side each other in the continuous reading of the Psalter, whether beginning the first of The Three Fifties, or the first of the Twenty Kathismata, or simply

[50] Chapter 2 'The Septuagint': 25–31.
[51] Chapter 3 'The New Testament': 42–3.
[52] Chapter 3 'The Church Fathers': 49–51.
[53] Chapter 3 'The Church Fathers': 56–8.
[54] Chapter 3 'The Church Fathers': 45–6 (Justin) and 48–9 (Hippolytus).
[55] Chapter 4 'The Babylonian Talmud': 68–9.
[56] Chapter 4 '*Midrash Tehillim*': 76–81 (especially 79).
[57] Chapter 4 'Jewish commentaries': 88–90.
[58] Chapter 5 'Two early commentators': 97–9.
[59] Chapter 5 'Two early commentators': 100–3 (especially 102).
[60] Chapter 5 'Medieval commentators': 108.
[61] Chapter 5 'Reformation commentators': 126.

being the first two psalms in the monastic tradition of continuously reading the Psalter, both in eastern and western Christendom (a practice also evident in some Jewish traditions).[62] There is an implicit reference to both psalms in Jewish liturgy: the '*ashre*' saying, probably echoing Ps. 84.5, has some associations (in what follows in the *Amidah)* with both Psalms 1 and 2.[63] But the evidence of these two psalms being used as one is minimal: Psalms 1 and 2 seem to be no more closely related than are Psalms 2 and 3, or Psalms 3 and 4, and so on.

Visual exegesis—again, because of its having been influenced by the Christian exegetical tradition—offers several instances of these two psalms being represented in a relationship. For example, the Utrecht Psalter depicts the blessed man in Psalm 1 and the king in Psalm 2 in a central position in each psalm, and in both illustrations the figure is surrounded by enemies, who are then sent to the pit: the other psalters related to the Utrecht tradition follow this in varying degrees.[64] The Khludov and Theodore Psalters have a different pairing in the shared motif, that of the judgement on the Jews for their refusal to perceive the story of the Christian Gospel.[65] Another Byzantine Psalter, MsVatGr 752, is interesting in the way it pairs the two psalms as a Prologue to the Psalter, and the archangel Michael is the same protecting figure in the corresponding images.[66] Again—from a totally different tradition and culture—the St Alban's Psalter pairs these psalms by illustrating the first psalm as words from David and the second as a prophecy about Christ.[67]

Modern Jewish artistic representations also show some connections between these psalms. Marc Chagall brings the psalms together in his sketches of each psalm: this is in the repeated depiction of the Torah, which in the first psalm is depicted as the source of light, and in the second, as the source of life.[68]

In music and poetry, however, the two psalms are rarely understood as one unit. This is perhaps due to the focus on their sound more than their sense. In musical interpretations, compositions based upon Psalms 1 and 2 almost always treat them as discrete entities - the only exception being their (somewhat odd) appearance in versions of metrical psalms with the same metre allowing them to be sung to the same tune.[69] This is the same with poetic

[62] Chapter 6 'From the Second Temple up to the fifteenth century': 139.
[63] Chapter 6 'From the Second Temple up to the fifteenth century': 140.
[64] Chapter 7 'The ninth to the fifteenth century': 165–6.
[65] Chapter 7 'The ninth to the fifteenth century': 171–2 (Khludov Psalter) and 174–5 (Theodore Psalter).
[66] Chapter 7 'The ninth to the fifteenth century': 172–3.
[67] Chapter 7 'The ninth to the fifteenth century': 175–6.
[68] Chapter 7 'The twentieth and twenty-first centuries': 187–8.
[69] Chapter 8 'Christian interpretations': 210–12.

imitations of the two psalms: even when the same poet used both psalms, he or she apportioned different metres, different rhyming schemes, and different lengths and forms of stanzas for each psalm.[70] Occasionally the psalms were interpreted in a complementary way: Milton, for example, experimented with the theological appeal of Psalm 1 and the political appeal of Psalm 2, but he nevertheless represented them in a very different poetic format.[71]

Finally, in more recent exegesis, the close connection between these two psalms is now of real interest. In historical-critical studies, Brownlee and Engnell, for example, sought to show how both psalms were early compositions for a royal accession liturgy;[72] Botha, by contrast, saw each psalm as a post-exilic response to the theological and political challenges of that later theocratic society.[73] Other historical-critical commentators considered the process of the compilation of the Psalter, assuming Psalm 1 to have been a late addition and sometimes suggesting that Ps. 2.10–12 was then added to the second psalm to create a clearer correspondence between them.[74] In more recent literary-critical studies, the interrelationship of Psalms 1 and 2 has always been a prominent concern. Cole (2012) cites some ten scholars who have recently written on this theme, and Hartenstein and Janowski (2012) list seventeen.[75] Scholars such as Hossfeld and Zenger,[76] Auffret,[77] Miller,[78] Auwers,[79] McCann,[80] Weber,[81] and Daly Denton[82] have each shown in different ways that these two psalms are bound together as psalms of instruction, while Barbiero[83] and Mitchell,[84] for example, see them more related because of their eschatological message, and Mays[85] and Cole[86] emphasize two other related themes, namely the kingdom of God or some elevated royal figure. Others, such as Creach, Botha, and Janowski, cite the Temple as a uniting theme.[87] Brown, by contrast, opts for a more

[70] Chapter 9 'Christian translation, paraphrase, imitation, and allusion': 246–7 (Philip Sidney).
[71] Chapter 9 'Christian translation, paraphrase, imitation, and allusion': 248–50.
[72] Chapter 10 'Historical-critical commentaries': 271.
[73] Chapter 10 'Historical-critical commentaries': 271–2.
[74] Chapter 10 'Historical-critical commentaries': 270–1.
[75] Chapter 10 'Literary-critical works': 280–2.
[76] Chapter 10 'Literary-critical works': 277.
[77] Chapter 10 'Literary-critical works': 282–3.
[78] Chapter 10 'Literary-critical works': 283.
[79] Chapter 10 'Literary-critical works': 284.
[80] Chapter 10 'Literary-critical works': 285.
[81] Chapter 10 'Literary-critical works': 285.
[82] Chapter 10 'Literary-critical works': 285–6.
[83] Chapter 10 'Literary-critical works': 283–4.
[84] Chapter 10 'Literary-critical works': 283.
[85] Chapter 10 'Literary-critical works': 274.
[86] Chapter 10 'Literary-critical works': 281–2.
[87] Chapter 10 'Literary-critical works': 275.

multivalent reading, which presages the many themes in the Psalter as a whole.[88]

Reception history thus demonstrates how the relationship between these two psalms has been explored by both Jews and Christians over the last two millennia. It is noteworthy that more recent studies have emphasized Jewish motifs—instruction, eschatology, the ideal king, the kingdom of God, and the Temple—as a way of understanding the interrelationship of the two psalms. So although each tradition must still apply its own 'story of salvation' to make sense of their relationship, there is now much scope for further dialogue in understanding these two psalms and also the Psalter as a whole.

Reception history has recently been called 'Biblical Studies on Holiday'.[89] Behind this observation is the assumption that the discipline is a somewhat relaxed appropriation of biblical studies, partly on account of its descriptive and subjective tendencies. This study has been an attempt to dispel this view: Reception history undoubtedly has a broader geographical, historical, and hermeneutical remit than biblical studies, but precisely because it views biblical texts in different lights, it offers interpretations which can both feed into the older discipline and at the same time challenge some of its assumptions. So it is an analytical discipline; but it is also a pragmatic discipline, providing, for example, a forum for creative Jewish–Christian dialogue about biblical texts. Reception history is here to stay, and our study of Psalms 1 and 2 should demonstrate that, for many reasons, it has a constructive future.

[88] Chapter 10 'Literary-critical works': 286.
[89] See Gillingham 2013 (forthcoming). See also J. Sawyer 2013 (forthcoming).

Bibliography

Works Cited

The Alternative Service Book 1980 (Oxford: Oxford University Press, 1980).
The Common Worship Psalter pointed for Anglican Chant (Church of England Publications, 2000).
English Standard Version Greek-English New Testament: Nestlé-Aland 28th edn. (Wheaton, IL: Crossway Publications, 2012).
Liber Usualis (Abbey of Solesmes, 1896).
The Psalter Newly Pointed (Church of England Publications, 1925).
Methodist Worship Book (Peterborough: Methodist Publishing House, 1999).
Music for Common Worship (Church of England Publications, 2000).
The Psalter of David; with Titles and Collects according to the Matter of each Psalm: Twelfth edition, reproduced by the British Library from the 1702 edition.
Thirty Psalms and Two Canticles to the Psalmody of Joseph Gelineau (London: The Grail, 1957).
Twenty Four Psalms and A Canticle to the Psalmody of Joseph Gelineau (London: The Grail, 1958).

Secondary works

Abegg Jr., M., P. Flint and E. Ulrich (eds.)
 1996 *The Dead Sea Scrolls Bible* (San Francisco, CA: HarperSanFrancisco).
Aejmelaeus A. and U. Quast (eds.)
 2000 *Der Septuaginta-Psalter und seine Tochterübersetzungen: Symposium in Göttingen 1997* (Göttingen: Vandenhoeck & Ruprecht).
Albertz, R.
 2002 'Religion in pre-exilic Israel', trans. H. Harvey, in J. Barton (ed.), *The Biblical World*, vol. 2 (London and New York: Routledge): 90–100.
—— 2002 'Religion in Israel during and after the Exile', trans. H. Harvey, in J. Barton (ed.), *The Biblical World*, vol. 2 (London and New York: Routledge): 101–24.
Alexander, J. A.
 1984 *Commentary on the Psalms* (Edinburgh: A. Elliot and J. Thin), repr. (Grand Rapids, MI: Kregel, 1991).
Allegro, J. M.
 1958 'Fragments of a Qumran Scroll of Eschatological *Midrašim*', *JBL* 77: 350–4.
Anderson, G. W.
 1974 'A Note on Psalm 1', *VT* 24: 231–3.
Anderson J.
 2005 *J. Calvin, Commentary on the Book of Psalms*, Vol. 1 (translated from original Latin of 1557 and collated with French version of 1563; Grand

Rapids, MI: Christian Classics Ethereal Library) Online at <http://www.ccel.org/ccel/calvin/calcom08.i.html>.

André, G.

1982 ''Walk', 'stand', and 'sit' in Psalms 1:1–2', *VT* XXXII: 326–8.

Aranoff, D.

2009 'Elijah Levita: a Jewish Hebraist', *JH* 23: 17–40.

Atwan, R., and L. Wieder (eds.)

1993 *Chapters into Verse: Poetry in English Inspired by the Bible*, vol. 1 (New York: Oxford University Press).

Auffret, P.

1986 'Compléments sur la structure littéraire du Ps 2 et son rapport au Ps 1', *BN* 35: 7–13.

Austermann, F.

2001 'Deshalb werden nicht aufstehen Frevler im Gericht: Zur Übersetzungsweise und Interpretation im ersten Septuaginta-Psalm', in M. K. H. Peters (ed.), *X Congress of the International Organization for Septuagint and Cognate Studies* (Leiden, Netherlands) (Atlanta, GA: Society of Biblical Literature): 481–97.

—— 2003 *Von der Tora zum Nomos: Untersuchungen zur Übersetzungsweise und Interpretation im Septuaginta-Psalter* (Göttingen: Vandenhoeck & Ruprecht).

Auwers, J.-M.

1997 'Tendances actuelles des études psalmiques', *Rev Theol Louvain* 28: 79–97.

—— 2000 *La Composition Littéraire du Psautier. Un état de la question*, Cahiers de la Revue Biblique, 46 (Paris: Gabalda).

Backhouse, J. M.

1989 *The Luttrell Psalter* (London: British Museum Publications).

Bailey, R. N.

1983 'Bede's Text of Cassiodorus' Commentary on the Psalms', *JTS* 34: 189–93.

Bailey, T. (ed. and trans.)

1979 *Commemoratio brevis de tonis et psalmis modulandis* (Ottawa: University of Ottawa Press).

Bainton, R. H.

1970 'The Bible in the Reformation', in S. L. Greenslade (ed.), *The West from the Reformation to the Present Day*, The Cambridge History of the Bible, vol. 3 (Cambridge: Cambridge University Press): 1–37.

Baker, J., and E. W. Nicholson

1973 *Commentary of Rabbi David Kimḥi on Psalms CXX-CL*, University of Cambridge Oriental Publications, 22 (Cambridge: Cambridge University Press).

Band, D.

2007 *I Will Wake the Dawn. Illuminated Psalms* (Philadelphia, PA: The Jewish Publication Society).

Barber, C.

2000 *The Theodore Psalter: Electronic Facsimile* (Champaign, IL: University of Illinois Press).

Barbiero, G.

 1999 *Das erste Psalmenbuch als Einheit. Eine synchrone Analyse von Psalm 1–41*, Österreichische Biblischen Studien, 16 (Frankfurt: Peter Lang).

Bardtke, H.

 1973 'Erwägungen zu Psalm 1 und 2', in M. A. Beek, A. A. Kampman, C. Nijland, and J. Ryckmans (eds.), *Symbolae biblicae et mesopotamicae, Festschrift F. M. T. de Liagre Böhl* (Leiden: Brill): 1–18.

Barker, M.

 2004 *Temple Theology. An Introduction* (London: SPCK).

—— 2007 *Temple Themes in Christian Worship* (London: T & T Clark).

Barth, C.

 1976 'Concatenatio im ersten Buch des Psalters', in B. Benzing, O. Böcher, and G. Mayer (eds.), *Wort und Wirklichkeit* (Meisenheim am Glan: Verlag Anton Hain): 30–40.

Barthélemy, D.

 1996 'L'appropriation juive et chrétienne du Psautier', in R. D. Weis and D. M. Carr (eds.), *Gift of God in Due Season: Essays on Scripture and Community in Honor of James A. Sanders,* Journal for the Study of the Old Testament Supplement Series 225 (Sheffield: Sheffield Academic Press): 206–19.

Bauer, U. F. W.

 1997 'Anti-Jewish Interpretations of Psalm 1 in Luther and in Modern German Protestantism', translated and revised version of 'Antijüdische Deutungen des ersten Psalms bei Luther und im neueren deutschen Protestantismus', *CV* 39: 101–11 (at <http://www.arts.ualberta.ca/JHS/Articles/article8.htm>).

Baughen, M. (ed.)

 1973 *Psalm Praise* (Guildford and London: Billing & Sons Limited).

Baum, G., E. Cunitz, and E. Reuss (eds.)

 1865 *Ioannis Calvini Opera Quae Supersunt Omnia*, vol. 31 (Brunswick and Berlin: Schwetschke and Son (M Bruhn)).

Bell, N.

 2001 *Music in Medieval Manuscripts* (Toronto: University of Toronto Press and London: British Library Publications).

Bennett, J., and S. Mandelbrote

 1998 *The Garden, the Ark, the Tower, the Temple. Biblical Metaphors of Knowledge in Early Modern Europe* (Oxford: Museum of the History of Science).

Berlin, A., M. Z. Brettler, and M. Fishbane (eds.)

 2003 *The Jewish Study Bible* (New York: Oxford University Press).

Bernstein, M. J.

 1997 'Torah and its Study in the Targum of Psalms', in J. Gurock and Y. Elman (eds.), *Hazon Nahum: Studies in Honor of Dr. Norman Lamm on the Occasion of His Seventieth Birthday* (New York: Yeshiva University Press): 39–67.

Blaising, C. A., and C. S. Hardin (eds.)

 2008 *Psalms 1–50*, Ancient Christian Commentary on Scripture, Old Testament, VII (Downers Grove, IL: Intervarsity Press).

Bland, K. P.

　　2001　*The Artless Jew. Medieval and Modern Affirmations and Denials of the Visual* (Princeton, NJ: Princeton University Press).

Bohlmann, P.V.

　　2008　*Jewish Music and Modernity* (New York: Oxford University Press).

Bonnard, P. E.

　　1960　*Le psautier selon Jérémie: Influence littéraire et spirituelle de Jérémie sur trente-trois Psaumes*, Lectio Divina 26 (Paris: Cerf).

Bons, E.

　　1995　'Psaume 2. Bilan de Recherche et Essai de Réinterprétation', *Revue des Sciences Religieuses* 69/2: 147–71 .

Botha, P. J.

　　2005a　'The ideological interface between Psalm 1 and 2', *OTE* 18/1: 189–203.

—— 2005b　'Intertextuality and the Interpretation of Psalm 1', *OTE* 18/3: 503–20.

Box, G. H. (introduction) and R. G. Finch (trans.)

　　1919　*The Longer Commentary of R. David Kimḥi on the First Book of Psalms*, trans. R. G. Finch (London: SPCK).

Box, R.

　　1996　*Make Music to our God. How we Sing the Psalms* (London: SPCK).

Boxel P. van, and S. Arndt (eds.)

　　2009　*Crossing Borders. Hebrew Manuscripts as a Meeting-place of Cultures* (Oxford: Bodleian Library Publications).

Bradshaw, P. F.

　　1992　'The First Three Centuries', in C. Jones, G. Wainwright, E. Yarnold, and P. Bradshaw (eds.), *The Study of Liturgy* (London: SPCK, rev. edn.): 399–403.

Braude, W. G.

　　1959　*The Midrash on Psalms*, vols. 1 & 2, Yale Judaica Series, XIII (New Haven and London: Yale University Press).

Braulik, G. P.

　　2004　'Psalter and Messiah. Towards a Christological Understanding of the Psalms in the Old Testament and Church Fathers', in D. J. Human and J. J. Vos (eds.), *Psalms and Liturgy,* Journal for the Study of the Old Testament Supplement Series 410 (London: T & T Clark): 33–6.

Brennan, J. P.

　　1980　'Psalms 1–8: Some Hidden Harmonies', *BbThBul* 10: 25–30.

Briggs, C. A., and E. G. Briggs

　　1906　*A Critical and Exegetical Commentary on The Book of Psalms*, Vol. I (Edinburgh: T & T Clark).

Brooke, G. J.

　　1985　*Exegesis at Qumran. 4QFlorilegium in its Jewish Context,* Journal for the Study of the Old Testament Supplement Series, 29 (Sheffield: JSOT Press).

—— 1999　'Florilegium', in L. H. Schiffman and J. VanderKam (eds.), *Encyclopedia of the Dead Sea Scrolls*, Vol. 1 (New York: Oxford University Press): 297–8.

Brown, M. P.
2006 *The World of the Luttrell Psalter* (London: The British Library).

Brown, W. P.
2002 *Seeing the Psalms: A Theology of Metaphor* (London and Louisville, KY: Westminster John Knox Press).
—— 2010 *The Psalms*, Interpreting Biblical Texts (Nashville, TN: Abingdon Press).

Browne, G. M. (ed.)
2001 *Collectio Psalterii Bedae Venerabili Adscripta* (Munich and Leipzig: K. G. Saur Verlag).

Browne, G. M. (trans.)
2002 *The Abbreviated Psalter of the Venerable Bede* (Grand Rapids, MI: Eerdmans).

Brownlee, W. H.
1971 'Psalms 1–2 as a Coronation Liturgy', *Bib* 52: 321–36.

Burkhardt, H.
1988 *Die Inspiration heiliger Schriften bei Philo von Alexandrien* (Giessen-Basel: Brunnen Verlag).

Carroll, R. P.
1986 *Jeremiah: A Commentary*, Old Testament Library Commentary Series (Philadelphia: Westminster Press).

Charlesworth, J. H.
1985 'Odes of Solomon', in J. H. Charlesworth (ed.), *The Old Testament Pseudepigrapha, vol. 2: Expansions of the Old Testament and Legends, Wisdom and Philosophical Literature, Prayers, Psalms and Odes, Fragments of Lost Judeo-Hellenistic Works*, Anchor Bible Commentary Series (New Haven: Yale University Press): 725–71.

Chatelain, J.
1973 *The Biblical Message of Marc Chagall* (New York: Tudor Publishing House).

Chazan, R.
2004 'Biblical Prophecy: the Messiah human and divine', in *Fashioning Jewish Identity in Medieval Western Christendom* (Cambridge: Cambridge University Press): 233–49.

Clifford, R. J.
2002 *Psalms 1–72*, Abingdon Old Testament Commentaries (Nashville, TN: Abingdon Press).

Clines, D. J. A.
1995 'Psalm 2 and the MLF (Moabite Liberation Front)', in *Interested Parties. The Ideology of Writers and Readers of the Hebrew Bible*, Journal for the Study of the Old Testament Supplement Series 205 (Sheffield: Sheffield Academic Press, 1995): 244–75.

Cockerell, S. L.
1907 *The Gorleston Psalter* (London: Chiswick Press).

Cohen, A. (ed.)
1945 *The Book of Psalms*, Soncino Books of the Bible (London, Jerusalem, and New York: Soncino Press, rev. edn. 1992).

Cole, R.
 2002 'An Integrated Reading of Psalms 1 and 2', *JSOT* 98: 75–88.
—— forthcoming *Psalms 1–2. A Gateway to the Psalter*, Hebrew Bible Monographs, 37 (Sheffield: Sheffield Phoenix Press).

Colish, M. L.
 1992 '*Psalterium Scholasticorum*: Peter Lombard and the Emergence of Scholastic Psalms Exegesis', *Spec* 67: 531–48.

Collins, J.
 2005 'Psalm 1: Structure and Rhetoric', *Presb* 31/1: 37–48.

Cook, E. M.
 2001 *The Psalms Targum: An English Translation*, at <http://targum.info/pss/ps1.htm>.
—— 2002 'The Psalms Targum: Introduction to a New Translation, with Sample Texts', in P. V. M. Fletcher (ed.), *Targum and Scripture: Studies in Aramaic Translations and Interpretation in Memory of Ernest G. Clarke*, Studies in the Aramaic Interpretation of Scripture, 2 (Leiden and Boston: Brill): 186–201.

Corrigan, K.
 1992 *Visual Polemics in the Ninth-century Byzantine Psalters* (Cambridge: Cambridge University Press).

Cox, C. E.
 2001 'Schaper's *Eschatology* Meets Kraus's *Theology of the Psalms*', in R. J. V. Hiebert, C. E. Cox, and P. J. Gentry (eds.), *The Old Greek Psalter, Studies in Honour of Albert Pietersma*, Journal for the Study of the Old Testament Supplement Series, 332 (Sheffield: Sheffield Academic Press): 289–311.

Craigie, P., and M. E. Tait
 2004 *Book I: Psalms 1–50*, Word Biblical Commentary, 19 (Waco, TX: Word Books, 1983; 2nd edn. Nashville, TN: Thomas Nelson Publishers, 2004).

Craven, W.
 1975 'The Iconography of the David and Bathsheba Cycle at the Cathedral of Auxerre', *JSAH* 34: 226–37.

Creach, J. F. D.
 1996 *Yahweh as Refuge and the Editing of the Hebrew Psalter*, Journal for the Study of the Old Testament Supplement Series, 217 (New York and London: Continuum International Publishing Group).
—— 1999 'Like a Tree Planted by the Temple Stream: The Portrait of the Righteous in Psalm 1:3', *CBQ* 61: 34–46.
—— 2008 'The Lord's Anointed and the Suffering of the Righteous', in *The Destiny of the Righteous in the Psalms* (St Louis, MO: Chalice Press): 54–9 [Psalms 1–2].

Dahood, M.
 1966 *Psalms I 1–50. Introduction, Translation, and Notes*, Anchor Bible Commentary Series, 6 (New York: Doubleday).

Daley, B. E.
 2004 'Finding the Right Key: The Aims and Strategies of Early Christian Interpretation of the Psalms', in H. W. Attridge and M. E. Fassler (eds.), *Psalms in Community. Jewish and Christian Textual, Liturgical, and*

Artistic Traditions, Society of Biblical Literature Symposium Series, 25 (Leiden and Boston: Brill): 189–205.

Daly Denton, M. M.

 2010 *Psalm-Shaped Prayerfulness* (Dublin: Columba Press).

Danby, H. (trans.)

 1933 *The Mishnah* (Oxford: Clarendon Press).

Davenport, U.

 1755 *The Psalm-Singer's Pocket Companion* (London).

Day, J.

 2004 'How many Pre-Exilic Psalms are there?', in J. Day (ed.), *In Search of Pre-Exilic Israel: Proceedings of the Oxford Old Testament Seminar,* Journal for the Study of the Old Testament Supplement Series, 270 (London and New York: T & T Clark): 225–50.

Delitzsch, F.

 2005 *Die Psalmen* (Giessen: Brunnen Verlag; repr. of 5th edn. of 1894).

Delmaire, D., M.-A. Haingue, C. Martini, J. Vermeylin, and J. Vilbes (eds.)

 2010 *Psaumes. Chants de l'Humanité* (Villeneuve d'Ascq: Presses Universitaires du Septentrion).

Deuchler, F.

 1967 *Der Ingeborgpsalter* (Berlin: Walter de Gruyter & Co.).

Deusen, N. van, and M. L. Colish

 1999 'Ex utroque et in utroque: Promissa mundo gaudia, Electrum and the Sequence', in N. van Deusen (ed.), *The Place of the Psalms in the Intellectual Culture of the Middle Ages* (New York: State University of New York Press): 105–38.

Dimant, D.

 1986 '4QFlorilegium and the Idea of the Community as Temple', in A. Caquot, M. Hadas-Lebel, and J. Riaud (eds.), *Hellenica et Judaica: Hommage à Valentin Nikiprowetzky* (Leuven-Paris: Peeters): 165–89.

Dines, J. M.

 2004 *The Septuagint* (London and New York: T & T Clark).

Donin, H. H.

 1980 *To Pray as a Jew: A Guide to the Prayer Book and Synagogue Service.* (London: Basic Books).

Duggan, M. K.

 1999 'The Psalter on the Way to the Reformation: The Fifteenth-Century Printed Psalter in the North', in N. van Deusen (ed.), *The Place of the Psalms in the Intellectual Culture of the Middle Ages* (New York: State University of New York Press): 153–90.

Duhm, B.

 1922 *Die Psalmen* (Tübingen: Verlag von J. C. B. Mohr (Paul Siebeck)).

Durlesser, J. A.

 1984 'Poetic Style in Psalm 1 and Jeremiah 17.5–8. A Rhetorical-critical Study', *Sem* 9: 30–48.

Dyer, J.

 1989 'The Singing of Psalms in the Early-Medieval Office', *Spec* 64/3: 535–78.

Bibliography

Dysinger, L.
2005 *Psalmody and the Practice of Prayer in the Writings of Evagrius Ponticus*, Oxford Theological Monographs (Oxford and New York: Oxford University Press).

Eaton, J.
1976 *Kingship and the Psalms* (London: SCM).
—— 1999 'Book of Psalms', in J. H. Hayes (ed.), *Dictionary of Biblical Interpretation*, vol. 2 (Nashville, TN: Abingdon Press): 324–9.
—— 2003 *The Psalms. A Historical and Spiritual Commentary with an Introduction and New Translation* (London and New York: T & T Clark International).

Edmunds, S.
1983 *The Kennicott Bible and the Use of Prints in Hebrew Manuscripts* (Bologna: Universita di Bologna).

Edwards, T.
2007 *Exegesis in the Targum of Psalms. The Old, the New, and the Rewritten*, Gorgias Dissertations, 28, Biblical Studies, 1 (Piscataway, NJ: Gorgias Press).

Elbogen, I.
1993 *Jewish Liturgy, A Comprehensive History* (Philadelphia: Jewish Publication Society, trans. R. P. Scheindlin of *Der jüdische Gottesdienst in seiner geschichtlichen Entwicklung* (Leipzig: G. Fock, 1913).

Ellinwood, L. (ed.)
1974 *Thomas Tallis. English Sacred Music II*, Early English Church Music, 13 (London: Stainer and Bell Ltd, 1971, repr. 1974).

Engnell, I.
1953 'Planted by the Streams of Water: Some Remarks on the Problem of the Interpretation of the Psalms as Illustrated by a Detail in Psalm 1', *Studio Orientalia Ioanni Pedersen Septuagenario A.D. VII Id. Nov. Anno MCMLIII a Collegis Discipulis Amicis Dicata* (Hauniae, Copenhagen: E. Munksgaard): 85–96.

Everett, D.
1922 'The Middle English Prose Psalter of Richard Rolle of Hampole', *MLR* 17/3: 217–27.

Fassler, M.
2001 'Psalmody and the Medieval Cantor: Ancient Models in the Service of Modern Praxis', in M. Fassler (ed.), *Musicians for the Churches: Reflections on Formation and Vocation* (New Haven: Yale Institute of Sacred Music): 3–14.

Ferguson, J. H.
2011 'Miles Coverdale and the Claims of Paraphrase', in L. P. Austern, K. B. McBride, and D. L. Orvis (eds.), *Psalms in the Early Modern World* (Burlington, VT and Farnham, Surrey: Ashgate): 137–54.

Feuer, A. C.
1995 *Tehillim/Psalms*, Artscroll Tanach Series (Brooklyn, NY: Mesorah Publications).

Finch, R. G. (translator) and G. H. Box
1919 *The Longer Commentary of David Kimhi on the First Book of Psalms, i–x, xv–xvii, xix, xxii, xxiv* (London: SPCK).

Fischer, B.
1971 'Bedae de titulis psalmorum liber', in J. Autenrieth (ed.), *Festschrift Bernhard Bischoff* (Stuttgart: Kohlhammer): 90–110.

Flashar, M.
1912 'Exegetische Studien zum Septuagintapsalter', *ZAW* 32: 81–116, 161–89, 241–68.

Flint, P. W.
1997 *The Dead Sea Psalms Scrolls and the Book of Psalms*, Studies on the Text of the Desert of Judah, 17 (Leiden: E. J. Brill).

Foder, A.
1978 'The Use of Psalms in Jewish and Christian Arabic Magic', in E. Apor (ed.), *Jubilee Volume of the Oriental Collection 1951–1976: Papers presented on the occasion of the 25th Anniversary of the Oriental Collection of the Library of the Hungarian Academy of Sciences* (Budapest: Magyar Tudonányos Akadémia): 67–71.

Frost, D.
1981 *Making the Liturgical Psalter. The Morpeth Lectures 1980* (Bramcote, Notts: Grove Books).

Geddes, J.
2005 *The St Albans Psalter. A Book for Christina of Markyate* (London: The British Library).

Gerstenberger, E.
1988 *Psalms Part I with an Introduction to Cultic Poetry*, Forms of Old Testament Literature, 14 (Grand Rapids, MI: W. B. Eerdmans Publishing).

Gibson, M., T. A. Heslop, and R. W. Pfaff (eds.)
1992 *The Eadwine Psalter. Text, Image and Monastic Culture in Twelfth-Century Canterbury* (London: Modern Humanities Research Association).

Gillingham, S. E.
2005 'The Zion Tradition and the Editing of the Hebrew Psalter', in J. Day (ed.), *Temple and Worship. Proceedings of the Oxford Old Testament Seminar* (Sheffield: Sheffield Academic Press): 308–41.

—— 2008a *Psalms through the Centuries*, Blackwell Bible Commentaries (Oxford: Wiley-Blackwell Publishing).

—— 2008b 'Psalm 8 through the Looking Glass: Reception History of a Multi-Faceted Psalm', in J. S. Burnett, W. H. Bellinger, Jr., and W. D. Tucker, Jr. (eds.), *Diachronic and Synchronic: Reading the Psalms in Real Time: Proceedings of the Baylor Symposium on the Book of Psalms* (London: T & T Clark): 167–96.

—— 2008c 'Studies of the Psalms: Retrospect and Prospect', *ET* 119: 209–16.

—— 2010 'The Levitical Singers and the Editing of the Hebrew Psalter', in Erich Zenger (ed.), *The Composition of the Book of Psalms*, Bibliotheca Ephemeridum Theologicarum Lovaniensium, 238 (Leuven: Peeters Publishing): 91–123.

—— 2013 (forthcoming) 'David and Christ Sing the Psalms: *Vat gr.752* as Prophecy and Liturgy', in B. Crostini and G. Peers (eds.), *A Book of Psalms from Eleventh-Century Constantinople. On the Complex of Texts and Images in Vat.gr.752*, Studi e Testi Series (Rome: Vatican Library Publications).

—— 2013 (forthcoming) 'Biblical Studies on Holiday? A Personal View of Reception History', in J. Lyons (ed.), *What Is this Thing Called Reception History?* (London and New York: T & T Clark International).

Glazer, M.
 2008 *Psalms of the Jewish Liturgy. A Guide to their Beauty, Power and Meaning* (New York: Aviv Press).

Goldingay, J.
 1982 'Luther and the Bible', *SJT* 35: 33–58.
—— 2006 *Psalms Volume 1: Psalms 1–41* (Grand Rapids, MI: Baker Academic).

Goodwin, D. L.
 2006 *'Take Hold of the Robe of a Jew': Herbert of Bosham's Christian Hebraism* (Leiden and Boston, MA: Brill).

Grisbrooke, W. J.
 1992 'The Formative Period—Cathedral and Monastic Offices', in C. Jones, G. Wainwright, E. Yarnold, and P. Bradshaw (eds.), *The Study of Liturgy* (London and New York: Oxford University Press): 403–20.

Gritsch, E.
 1983 'The Cultural Context of Luther's Interpretation', *Int* 37: 266–76.

Gross-Diaz, T.
 1996 *The Psalms Commentary of Gilbert of Poitiers: From Lectio Divina to the Lecture Room* (Leiden and Boston, MA: Brill).
—— 1999 'From Lectio Divina to the Lecture Room: The Psalm Commentary of Gilbert of Poitiers', in N. Van Deusen (ed.), *The Place of the Psalms in the Intellectual Culture of the Middle Ages* (Albany, NY: State University of New York): 91–104.
—— 2000 'What's a Good Soldier to do? Scholarship and Revelation in the Postills on the Psalms', in P. D. W. Krey and L. Smith (eds.), *Nicholas of Lyra. The Senses of Scripture* (Leiden and Boston, MA: Brill): 111–18.

Gruber, M. I.
 2004 *Rashi's Commentary on Psalms* (Leiden and Boston, MA: E. J. Brill).

Gunkel, H.
 1903 'Psalm 1: An Interpretation', *BibWor* 21/2: 120–3.

Gunkel, H., and J. Begrich
 1988 *Introduction to the Psalms: The Genres of the Religious Lyric of Israel,* (Macon, GA: Mercer University Press); trans. J. D. Nogalski from *Einleitung in die Psalmen: Die Gattungen der religiösen Lyrik Israels,* Göttinger Handkommentar zum Alten Testament (Göttingen: Vandenhoeck & Ruprecht, 1933).

Gutmann, J.
 1978 *Hebrew Manuscript Painting* (London: Chatto & Windus).

Gwyn, R.
 1997 *The Psalms in Haiku Form: A Simplified Psalter* (Leominster: Gracewing Publishing).

Haïk-Vantoura, S.
 1991 *The Music of the Bible Revealed* (ed. J. Wheeler) (Berkeley, CA: Bibal Press; trans. D. Weber from *La musique de la Bible révélée*, Paris: Robert Dumas, 1976).

Hakham, A.

2003 *The Bible. Psalms with the Jerusalem Commentary, Volume One, Psalms 1–57* (Jerusalem: Mosad Harav Kook).

Hamblin, W. J., and D. R. Seely

2007 *Solomon's Temple. Myth and History* (London: Thames & Hudson Ltd).

Hamlin, H.

2004 *Psalm Culture and Early Modern English Literature* (Cambridge: Cambridge University Press).

Hamlin, H., M. G. Brennan, M. P. Hannay, and N. J. Kinnamon (eds.)

2009 *The Sidney Psalter. The Psalms of Sir Philip and Mary Sidney*, Oxford World Classics (Oxford: Oxford University Press).

Haney, K.

2002 *The St. Albans Psalter, an Anglo-Norman Song of Faith* (New York: Peter Lang Publishing).

Hannay, M. P.

2001 ' "So May I With the *Psalmist* Truly Say": Early Modern English Women's Psalm Discourse', in B. Smith and U. Appelt (eds.), *Write or Be Written: Early Modern Women Poets and Cultural Constraints* (Aldershot: Ashgate): 105–34.

Harn, R. E. Van, and B. A. Strawn (eds.)

2009 *Psalms for Preaching and Worship. A Lectionary Commentary* (Grand Rapids, MI: W. B. Eerdmans Publishing Company).

Harrán, D.

1999 *Salamone Rossi. Jewish Musician in Late Renaissance Mantua*, Oxford Monographs on Music (Oxford: Oxford University Press).

Harsley, F.

1889 *Eadwine's Canterbury Psalter. Part II Text and Notes* (London: N. Trubner & Co.).

Hartenstein, F., and B. Janowski

2012 *Psalmen*, Biblischer Kommentar Altes Testament (Neukirchen-Vluyn: Neukirchener Verlagsgesellschaft mbH).

Hauser, A. J., and D. F. Watson (eds.)

2009 *A History of Biblical Interpretation. Volume 2: The Medieval through the Reformation Periods* (Grand Rapids, MI: W. B. Eerdmans Publishing Company).

Heath, M. J.

1991 'Allegory, rhetoric and spirituality: Erasmus's early Psalm Commentaries', in A. Dalzell, C. Fantazzi, and R. J. Schoeck (eds.), *Acta Conventus Neo-Latini Torontonensis* (Binghamton, NY: Medieval & Renaissance Texts & Studies): 363–70.

Heath, M. J. (translator and annotator) and D. Baker-Smith (ed.)

1997 *Collected Works of Erasmus. Expositions of the Psalms*, Vol. 63 (Toronto: University of Toronto Press).

Hegbin, E. T. S., and F. Corrigan

1960 *St. Augustine: Expositions on the Psalms*, Ancient Christian Writers, 29 (Westminster, MA: Newman Press).

Heine, R. E.

1995 *Gregory of Nyssa's Treatise on the Inscriptions of the Psalms: Introduction, Translation and Notes* (Oxford: Clarendon Press).

Helsinger, H.

1971 'Images on the *Beatus* Page of some Medieval Psalters', *ABull* 53/2: 161–76.

Hengstenberg, E. W.

1842 *Commentar über die Psalmen* (Berlin: Verlag von Ludwig Oehmigke).

Higton, M.

2008 'The Irrepressibility of Scripture: Psalm 1 between Jews and Christians', *JSR* 7: online at <http://etext.lib.virginia.edu/journals/ssr/issues/volume7/number1/ssr07_01_e02.html>.

Hill, R. C. (translation and introduction with notes)

2000 *Theodoret of Cyrus. Commentary on the Psalms*, Fathers of the Church, vol. 101 (Washington, DC: Catholic University of America Press).

—— 2005 *Diodore of Tarsus. Commentary on Psalms 1–51* (Atlanta, GA: Society of Biblical Literature).

Hoffman, L.

2002 'Jewish Liturgy and Jewish Scholarship: Method and Cosmology', in M. Goodman (ed.), *The Oxford Handbook of Jewish Studies*, Oxford Handbooks in Religion and Theology (Oxford: Oxford University Press): 733–55.

Høgenhaven, J.

2001 'The Opening of the Psalter: A Study in Jewish Theology', *SJOT* 15:2: 169–80.

Holladay, W. L.

1993 *The Psalms through Three Thousand Years* (Minneapolis, MN: Fortress Press).

—— 2002 'Indications of Jeremiah's Psalter', *JBL* 121/2: 245–61.

Horst, K. Van der, N. Noel, and W. C. M. Wüstefeld (eds.)

1996 *The Utrecht Psalter in Medieval Art. Picturing the Psalms of David* (London: Harvey Miller).

Howard, D. M.

1999 'Recent Trends in Psalms Study', in D. W. Baker and B. T. Arnold (eds.), *The Face of Old Testament Study. A Survey of Contemporary Approaches* (Grand Rapids, MI: Baker Academic, Leicester: Apollos): 329–68.

Huber, K.

2003 *Psalm 2 in der Offenbarung des Johannes* (Göttingen: Vandenhoeck & Ruprecht).

Hudson, A. (ed.)

2012 *Two Revisions of Rolle's English Psalter Commentary and the Related Canticles Volume I*, Early English Text Society Original Series (Oxford: Oxford University Press).

Hunter, A. G.

1999 *Psalms. Old Testament Readings* (London and New York: Routledge).

Jackson, D.

2006 *Psalms. The Saint John's Bible* (Ireland: Veritas Ltd).

Jackson, G.
 1997 *The Lincoln Psalter* (Manchester: Carcanet).
Jacobson, R. A.
 2004 *The Function of Direct Discourse in the Hebrew Psalter* (London and New York: T & T Clark International).
Jacobus, L. A.
 1987 'Milton Metaphrast: Logic and Rhetoric in Psalm 1', *MiltonStud* XXII: 119–32.
Janse, S.
 2009 *'You are My Son'. The Reception History of Psalm 2 in Early Judaism and the Early Church* (Leuven, Paris, Walpole, MA: Peeters).
Janowski, B.
 2002 'Die heilige Wohnung des Höchsten. Kosmologische Implikationen der Jerusalemer Tempeltheologie', in O. Keel and E. Zenger (eds.), *Gottesstadt und Gottesgarten. Zu Geschichte und Theologie des Jerusalemer Tempels* (Freiburg, Basle, Vienna: Herder): 24–68.
—— 2010 'Ein Tempel aus Worten: Zur theologischen Architektur des Psalters', in E. Zenger (ed.), *The Composition of the Book of Psalms*, Bibliotheca Ephemeridum Theologicarum Lovaniensium, 238 (Leuven: Peeters): 279–306.
Jean-Nesmy, C.
 1973 *La Tradition médite le Psautier Chrétien, Psaumes 1 à 71* (Paris: Éditions Téquil).
Jenkins, A. K.
 2001 'Erasmus' Commentary on Psalm 2', *JHS* 3 online version 6 at <http://www.jhsonline.org/Articles/article_15.htm>.
Johnson, A. R.
 1955 *Sacral Kingship in Ancient Israel* (Cardiff: University of Wales).
—— 1979 *The Cultic Prophet and Israel's Psalmody* (Cardiff: University of Wales).
Keble, J.
 1839 *The Psalter in English Verse* (London: The Gresham Publishing Company).
Kittel, D. R.
 1922 *Die Psalmen übersetzt und erklärt* (Leipzig: A. Deichertsche Verlagsbuch-handlung).
Klepper, D. Copeland
 2007 *The Insight of Unbelievers: Nicholas of Lyra and Christian Reading of Jewish Text in the Later Middle Ages* (Philadelphia, PA: University of Pennsylvania Press).
Koch, D.-A.
 1994 'Auslegung von Psalm 1 bei Justin und im Barnabasbrief', in K. Seybold and E. Zenger (eds.), *Neue Wege der Psalmenforschung*, Herders Biblische Studien (Freiburg, Basle, Vienna: Herder): 223–42.
Kratz, R. G.
 1996 'Die Tora Davids', *ZThK* 93: 1–34.
Kraus, H.-J.
 1950–1 'Freude an Gottes Gesetz: Ein Beitrag zur Auslegung der Psalmen 1, 19B und 119', *EvT* 8: 337–51.

—— 1992 *Psalms 1–59* (Augsburg, MI: Fortress Press; trans. by H. C. Oswald of
 Psalmen 1. Teilband, Psalmen 1–59. Neukirchener Verlag: Neukirchen-
 Vluyn: 1978).
Kuczynski, M. P.
 1995 'William Langland, Radical Psalmist', in *Prophetic Song. The Psalms as
 Moral Discourse in Late Medieval England* (Philadelphia, PA: University of
 Pennsylvania Press): 189–215.
—— 1999 'The Psalms and Social Action in Late Medieval England', in N. van
 Deusen (ed.), *The Place of the Psalms in the Intellectual Culture of the Middle
 Ages* (New York: Southern University of New York Press): 191–214.
Kuntz, J. K.
 1994 'Engaging the Psalms: Gains and Trends in Recent Research', *CRBS* 2:
 77–106.
—— 1998 'Biblical Hebrew Poetry in Recent Research, Part I', *CRBS* 6: 31–64.
—— 1999 'Biblical Hebrew Poetry in Recent Research, Part II', *CRBS* 7: 35–80.
Ladouceur, D. J.
 2005 *The Latin Psalter. Introduction, Selected Text and Commentary* (London:
 Bristol Classical Press).
Lamb, J. A.
 1962 *The Psalms in Christian Worship* (London: The Faith Press).
Lane, D. J.
 2001 ' "Come Here . . . and Let us Sit and Read . . .": The Use of Psalms in Five
 Syriac Authors', in A. Rapoport-Albert and G. Greenberg (eds.), *Biblical
 Hebrew, Biblical Texts. Essays in Memory of Michael P. Weitzman*, Journal
 for the Study of the Old Testament Supplement Series, 333 (New York
 and London: Continuum International Publishing Group): 412–30.
Lanza, F. (ed.)
 2007 *Shimmush Tehillim, Tehillim, Psalms 151–155 and their Kabbalistic Use*
 (Taiwan: Providence University).
Leroquais, C. V.
 1940–1 *Les Psautiers Manuscrits Latins des Bibliothèques Publiques de France,
 Volumes 1–3* (Macon: Protat Frères).
Levenson, J.
 1985 *Sinai and Zion: An Entry into the Jewish Bible* (New York: HarperCollins
 Publishers).
Loewe, R.
 1953 'Herbert of Bosham's Commentary on Jerome's Hebrew Psalter',
 Bib 34: 44–77, 159–92, 275–98.
Ludlow, M.
 2002 'Origen and Gregory of Nyssa on the Unity and Diversity of Scripture',
 IJST 4: 45–66.
McCann, J. C. (ed.)
 1993 *The Shape and Shaping of the Psalter*, Journal for the Study of the Old
 Testament Supplement Series, 159 (Sheffield: Sheffield Academic Press).
—— 1996 *The Book of Psalms* (Nashville, TN: Abingdon Press).
—— 2001 'Righteousness, Justice, and Peace: A Contemporary Theology of the
 Psalms', *HBTh* 23: 111–31.

McGinty, J. W.
 2003 *Robert Burns and Religion* (Aldershot: Ashgate).
McKinnon, J. W. (ed.)
 1987 *Music in Early Christian Literature* (Cambridge: Cambridge University Press).
—— 1999 'The Book of Psalms, Monasticism, and the Western Liturgy', in N. van Deusen (ed.), *The Place of the Psalms in the Intellectual Culture of the Middle Ages* (New York: State University of New York Press): 43–58.
—— 2001 'Liturgical Psalmody in the Sermons of St. Augustine', in P. Jeffery (ed.), *The Study of Medieval Chant: Paths and Bridges, East and West in Honor of Kenneth Levy* (Cambridge: D. S. Brewer): 7–24
McLean, B. H.
 1992 'Psalms', in *Citations and Allusions to Jewish Scripture in Early Christian and Jewish Writings through 180 CE* (Lampeter: The Edwin Mellen Press): 67–81.
Magonet, J.
 1994 *A Rabbi Reads the Psalms* (London: SCM Press).
Maher, M.
 1994 'The Psalms in Jewish Worship', *PIBA* 17: 9–36.
Maier, J.
 2004 'Psalm 1 im Licht antiker jüdischer Zeugnisse', in *Studien zur Jüdischen Bibel und ihrer Geschichte*, Studia Judaica, 28 (Berlin: W. de Gruyter): 353–65.
—— 1983 'Zur Verwendung der Psalmen in der synagogalen Liturgie (Wochentag und Sabbat)', in H.-J. Becher and R. Kaczynski (eds.), *Liturgie und Dichtung. Ein interdisziplinäres Kompendium, 1: Historische Präsentation* (St Ottilien: Eos): 55–91.
Mann, V. B. (ed.)
 2000 *Jewish Texts on the Visual Arts* (Cambridge: Cambridge University Press).
Marböck, J.
 1986 'Zur frühen Wirkungsgeschichte von Ps.1', in E. Haag and F.-L. Hossfeld (eds.), *Freude an der Weisung des Herrn. Festgabe zum 70. Geburtstag von Heinrich Gross*, Stuttgarter Biblische Beiträge, 13 (Stuttgart: Katholisches Bibelwerk): 207–22.
Marks, R., and N. Morgan
 1981 *The Golden Age of English Manuscript Painting, 1200–1500* (New York: George Braziler Inc.).
Mays, J. L.
 1987 'The Place of the Torah-Psalms in the Psalter', *JBL* 106: 7–12.
—— 1994 *Psalms. Interpretation: A Biblical Commentary for Teaching and Preaching* (Louisville, KY: John Knox Press).
Metzger, T.
 1977 'Les Illustrations d'un Psautier Hébreu Italien de la fin du XIIIe siècle: Le MS Parm. 1870—De Rossi 501 de la Bibliothèque Palatine de Parma', *CahArch XXVI*: 145–62.
Millard, M.
 1994 *Die Komposition des Psalters: Ein formgeschichtlicher Ansatz*, Forschungen zum Alten Testament, 9 (Tübingen: JCB Mohr [Paul Siebeck]).

Miller, P.
 1950 *Four Centuries of Scottish Psalmody* (London and New York: Oxford
 University Press).
Miller, P. D.
 1993 'The Beginning of the Psalter', in J. C. McCann (ed.), *The Shape and Shaping
 of the Psalter* (Sheffield: JSOT Press/Sheffield Academic Press): 83–92.
Minnis, A. J., and A. B. Scott (eds.)
 2003 *Medieval Literary Theory and Criticism c. 1100–c. 1375. The Commentary
 Tradition* (Oxford: Clarendon Press).
Mitchell, D. C.
 1997 *The Message of the Psalter. An Eschatological Programme in the Book of
 Psalms*, Journal for the Study of the Old Testament Supplement Series,
 252 (Sheffield: Sheffield Academic Press).
—— 2012a 'Resinging the Temple Psalmody', *JSOT* 36.3: 355–78.
—— 2012b 'How can we sing the Lord's Song? Deciphering the Masoretic
 Cantillation', in S. E. Gillingham (ed.), *Jewish and Christian Approaches to
 the Psalms. Conflict and Convergence* (Oxford: Oxford University Press):
 117–33.
Moore, M.
 2003 *The Poems of Marianne Moore* (ed. G. Schulman) (London: Penguin
 Books 1967, reprinted New York: Viking Penguin 2003).
Mowinckel, S.
 1982 *The Psalms in Israel's Worship*, Volumes 1 and 2 (Oxford: Basil Blackwell;
 trans. by D. R. Ap-Thomas of *Offersang og Sangoffer*. Oslo: H. Aschehoug
 & Co., 1951).
Moyise, S., and M. Menken (eds.)
 2004 *Psalms in the New Testament* (London: Continuum).
Mozley, F. M.
 1905 *The Psalter of the Church: The Septuagint Psalms Compared with the Hebrew,
 with Various Notes* (Cambridge: Cambridge University Press): 1095.
Neale, J. M., and R. F. Littledale (eds.)
 1874 *A Commentary on the Psalms from Primitive and Medieval Writers,
 Volume 1* (London: J. Masters and Co.).
Nielsen, K.
 1989 *There is Hope for a Tree: The Tree as Metaphor in Isaiah*, Journal for the
 Study of the Old Testament Supplement Series, 65 (Sheffield: JSOT Press)
 (Originally published as *For et træ er der håb: Om træet som metafor i Jes
 1–39*. Copenhagen: G. E. C. Gads Forlag, 1985).
Noel, W.
 1995 *The Harley Psalter*, Cambridge Studies in Palaeography and Codicology,
 4 (Cambridge: Cambridge University Press, 1995).
O'Donnell, J. J.
 1995 *Cassiodorus* (Berkeley, CA: University of California Press) (available at
 <http://www.cat.sas.upenn.edu/jod/texts/cassbook/toc.html>.
O'Keefe, J. J.
 2000 ' "A Letter that Killeth": Towards a reassessment of Antiochene Exegesis
 in Diodore, Theodore, and Theodoret on the Psalms', *JECS* 8: 83–104.

Olivier, J.-M. (ed.)
 1980 *Diodori Tarsensis Commentarii in Psalmos I–L* (Turnhout: Brepols, Leuven University Press).
Olszowy-Schlanger, J.
 2003 *Les manuscrits hébreux dans l'Angleterre médiévale: étude historique et paléographique* (Paris-Louvain: Peeters).
—— 2007 'A School of Christian Hebraists in Thirteenth-Century England: A Unique Hebrew-Latin-French Dictionary and its Sources', *EJJS* 1:2: 249–77.
Oswald, H. C. (ed.)
 1974 *Luther's Works* (St Louis, MO: Concordia).
Otto, E.
 2010 'Hermeneutics of Biblical Theology, History of Religion and the Theological Substance of Two Testaments: The Reception of Psalms in Hebrews', in D. J. Human and G. J. Steyn (eds.), *Psalms and Hebrews. Studies in Reception* (London: T & T Clark International): 3–26.
Pak, G. S.
 2010 *The Judaizing Calvin. Sixteenth-Century Debates over the Messianic Psalms*, Oxford Studies in Historical Theology (New York and Oxford: Oxford University Press).
Panayatova, S.
 2005 *The Macclesfield Psalter* (Cambridge: Fitzwilliam Museum).
Parsons, M.
 2009 'Luther, the Royal Psalms and the Suffering Church', *Crucible* 2:1— available at <www.crucible.org.au>.
Patrick, M.
 1949 *Four Centuries of Scottish Psalmody* (Oxford, London, Glasgow, New York: Geoffrey Cumberlege, Oxford University Press).
Pearson, G. (ed.)
 1846 *Remains of Myles Coverdale Bishop of Exeter* (Cambridge: Cambridge University Press), available at <http://books.google.co.uk/books/about/ Remains_of_Myles_Coverdale.html?id=11gYAAAAYAAJ&redir_esc=y>.
Pederson, K. S.
 1995 *Traditional Ethiopian Exegesis of the Book of Psalms* (Wiesbaden: Harrassowitz).
Peers, G. A., and B. Crostini (eds.)
 2013 (forthcoming) *A Book of Psalms from Eleventh-Century Constantinople. On the Complex of Texts and Images in Vat.gr.752*, Studi e Testi Series (Rome: Vatican Library Publications).
Pelican, J. (ed. and trans.)
 1955 *Selected Psalms, Luther's Works Volume 12* (St Louis, MO: Concordia).
Pietersma, A.
 1997 Review of J. Schaper, *Eschatology in the Greek Psalter*, Wissenschaftliche Untersuchungen zum Neuen Testament 2. Reihe 76 (Tübingen: J. C. B. Mohr, 1995), in *BOr* LIV (1997): cols. 185–90.
—— 2000a *A New English Translation of the Septuagint and Other Greek Translations Traditionally Included under That Title* (Oxford: Oxford University Press).

—— 2000b 'The Present State of the Critical Text of the Greek Psalter', in A. Aejmelaus and U. Quast (eds.), *Der Septuaginta-Psalter und seine Tochterübersetzungen* (Göttingen: Vandenhoeck & Ruprecht): 12–32.

—— 2005 'Septuagintal Exegesis and the Superscriptions of the Greek Psalter', in P. W. Flint and P. D. Miller (eds.), *The Book of Psalms. Composition and Reception* (Leiden and Boston: Brill): 443–75.

—— 2008 <http://homes.chass.utoronto.ca/~pietersm/Psalm%202.pdf> (on Psalm 2).

Pritchard, J. B. (ed.)

1969 *Ancient Near Eastern Texts Relating to the Old Testament With Supplement* (Princeton, NJ: Princeton University Press).

Pullen, H.

1867 *The Psalter and Canticles Pointed for Chanting* (London: Macmillan & Co.); digitized by Google from the Library of Oxford University at <http://archive.org/details/psalterandcanti00unkngoog>.

Quasten, J., and W.-J. Burghardt

1960 *St Augustine on the Psalms*, Volume One, Ancient Christian Writers on the Psalms (Mahweh, NJ: Paulist Press).

Rathwell, J. C. A. (ed.)

1963 *The Psalms of Sir Philip Sidney and the Countess of Pembroke* (New York: New York University Press).

Reif, S. C.

1984 'Ibn Ezra on Psalm I 1–2', *VT* XXXIV 2: 232–6.

Reindl, J.

1979 'Psalm 1 und der "Sitz im Leben" des Psalters', in W. Ernst (ed.), *Theologisches Jahrbuch* (Leipzig: St Benno): 139–50.

Renaud, B.

2004 'Le Psautier sous le signe du jugement de Dieu: L'unité rédactionelle des Ps 1 et 2', in E. Bons, C. Coulot *et al.* (eds.), *Le jugement dans l'un et l'autre Testament, Mélanges offerts à Raymond Kuntzmann* (Paris: Editions du Cerf): 225–42.

Reventlow, H. G.

2009 *History of Biblical Interpretation, Volume I, From the Old Testament to Origen* (Atlanta, GA: SBL; trans. L. G. Perdue of *Epochen der Bibelauslegung, Band I Vom Alten Testament bis Origenes* (Munich: C H Beck oHG, 1990).

—— 2010 *History of Biblical Interpretation, Volume 3, Renaissance, Reformation, Humanism* (Atlanta, GA: SBL; trans. J. O. Duke of *Epochen der Bibelauslegung, Band III Renaissance, Reformation, Humanismus* (Munich: C H Beck oHG, 1997).

Reynolds, K. A.

2010 *Torah as Teacher. The Exemplary Torah Student in Psalm 119* (Leiden: Brill).

Riain, I. N.

2000 *Commentary of Saint Ambrose on Twelve Psalms* (Dublin: Halcyon Press).

Rienstra, M. V.

1992 *Swallow's Nest. A Feminine Reading of the Psalms* (Grand Rapids, MI: W. B. Eerdmans).

Rondeau, M.-J.

1974 'D'où vient le technique utilisée par Grégore de Nyasse dans son traité "Sur les Titres des Psaumes"', in *Mélanges d'histoire des religions offerts à Henri-Charles Puech* (Paris: Presses Universitaires de France): 263–87.

—— 1982 *Les Commentaires Patristiques du Psautier IIIe-Ve siècles. Volume 1, Orientalia Christiana Analecta, 219* (Rome: Pontificia Institutum Studiorum Orientalium).

—— 1985 *Les Commentaires Patristiques du Psautier IIIe-Ve siècles. Volume 2, Orientalia Christiana Analecta, 220* (Rome: Pontificia Institutum Studiorum Orientalium).

Rooke, D.

2012 *Handel's Israelite Oratorio Libretti: Sacred Drama and Biblical Exegesis,* (Oxford: Oxford University Press).

Rösel, C.

1999 *Die messianische Redaktion des Psalters. Studien zu Entstehung und Theologie der Sammlung Psalm 2–89,* Calwer Theologische Monographien, Reihe A; Bibelwissenschaft Band 19 (Darmstadt: Weihert-Druck).

Rösel, M.

2001 'Die Psalmenüberschriften des Septuaginta-Psalters', in E. Zenger (ed.), *Der Septuaginta-Psalter* (Freiburg: Herder): 125–48.

Rosen, A.

2013 'True Lights. Seeing the Psalms through Chagall's Church Windows', in S. E. Gillingham (ed.), *Jewish and Christian Approaches to the Psalms. Conflict and Convergence.* (Oxford: Oxford University Press): 105–18.

Rosenberg, D.

1976 *Blues of the Sky interpreted from the Original Hebrew Book of Psalms* (New York, San Francisco and London: Harper and Row).

Rosensaft, J. B.

1987 *Chagall and the Bible* (New York: Universe Publishing).

Rosenthal, E. I. J.

1960 'Anti-Christian Polemic in Medieval Bible Commentaries', *JJS* XI: 115–35.

Rummel, W.

2008 'The Textual and Hermeneutic Work of Desiderius Erasmus of Rotterdam', in M. Saebø (ed.), *Hebrew Bible Old Testament. The History of Its Interpretation. II From the Renaissance to the Enlightenment* (Göttingen: Vandenhoeck & Ruprecht): 215–30.

Runia, D.

2001 'Philo's Reading of the Psalms', *Festschrift D.M. Hay, StPhA* 13: 102–21.

Sandler, L. F.

1972 'Christian Hebraism and the Ramsay Abbey Psalter', *JWCI* 35: 123–34.

Sawyer, J. F. A.

1973 'Hebrew Terms for the Resurrection of the Dead', *VT* 23: 218–34.

—— 2013 'A Critical Review of Recent Projects and Publications', *HeBAI* 2: 298–326.

Schaper, J.
 1995 *Eschatology in the Greek Psalter*, Wissenschaftliche Untersuchungen zum
 Neuen Testament 2 Reihe, 76 (Tübingen: Mohr).
Scherman, R. N. (trans. and commentary)
 2011 סדור אמרי אפרים, The Complete Artscroll Siddur (Brooklyn, NY:
 Mesorah Publications Ltd).
Schiller-Szinessy, S.
 1883 *The First Book of Psalms with the Longer Commentary of R. David Qimchi*
 (Cambridge: Cambridge University Press).
Schwienhorst-Schönberger, L.
 2006 ' "Er wird wie Christus sein". Psalm 1 in der Auslegung des Hieronymus',
 in E. Ballhorn and G. Steins (eds.), *Der Bibelkanon in der Bibelauslegung*
 (Stuttgart: Kohlhammer): 212–31.
Seybold, K., and E. Zenger (eds.)
 1994 *Neue Wege der Psalmenforschung*, Herders Biblische Studien 1 (Freiburg,
 Basle, Vienna: Herder).
Shaheen, N.
 1987a *Biblical References in Shakespeare's Tragedies* (Newark and London:
 University of Delaware Press and Associated University Presses).
 —— 1987b *Biblical References in Shakespeare's Histories* (Newark and London:
 University of Delaware Press and Associated University Presses).
Sheppard, G. T.
 1980 'The Preface to the Psalter (Psalms 1 and 2)', in *Wisdom as a
 Hermeneutical Construct. A Study in the Sapientializing of the Old
 Testament*, Beihefte zur Zeitschrift für die alttestamentliche Wissenschaft
 151 (Berlin: de Gruyter): 136–44.
Sidney, Philip
 1877 *The Complete Poems of Sir Philip Sidney, Vol. III*, ed. A. B. Grosart
 (London: Chatto and Windus).
Sigier, A. (ed.)
 2001 *Bible Chrétienne V: Les Psaumes* (Québec: Anne Sigier).
Signer, M. A.
 1983 'King/Messiah: Rashi's Exegesis of Psalm 2', *Prooftexts* 3: 273–84.
Simon, M., and I. Epstein (eds.)
 1960 *The Babylonian Talmud: Berakoth* (London: Soncino Press).
Simon, U.
 1991 *Four Approaches to the Book of Psalms. From Saadiah Gaon to Abraham Ibn
 Ezra* (trans. L. J. Schramm of the Hebrew published in 1982; Albany,
 NY: State University of New York Press).
Sink, S.
 2007 *The Art of the Saint John's Bible. A Reader's Guide to Pentateuch,
 Psalms, Gospels and Acts* (Collegeville, MI: Liturgical Press, Saint John's
 Abbey).
Skehan, P. W.
 1948 'Borrowings from the Psalms in the Book of Wisdom', *CBQ* 10: 384–97.
Smith, J. A.
 1990 'Which Psalms were Sung in the Temple?', *MusicLett*, 71: 167–86.

Smith, R.
 1995 *Handel's Oratorios and Eighteenth Century Thought* (Cambridge: Cambridge University Press).

Soffer, A.
 1957 'The Treatment of Anthropomorphisms and Anthropathisms in the Septuagint of Psalms', *HUCA* 28: 85–107

Stec, D. M.
 2004 *The Targum of Psalms Translated, with a Critical Introduction, Apparatus, and Notes,* The Aramaic Bible, 16 (Collegeville, MN: Liturgical Press).

Sternhold, T.
 1562 *The Whole Booke of Psalmes* (London: Imprinted by John Day).

Steudel, A.
 1994 *Der Midrasch zur Eschatologie aus der Qumrangemeinde (4QMidrEschat^{ab}),* Studies on the Text of the Desert of Judah, 13 (Leiden: E. J. Brill).

Subramanian, J. S.
 2007 *The Synoptic Gospels and the Psalms as Prophecy,* Library of New Testament Studies, 351 (London: T & T Clark).

Taylor, D. G. K.
 1998–9 'The Great Psalm Commentary of Daniel of Salah', *The Harp XI–XII*: 33–42.
 —— 2009 'The Psalm Commentary of Daniel of Salah and the Formation of Sixth Century Orthodox Identity', *Church History and Religious Culture* 89/1–3: 65–92.

Temperley, N.
 1979 *The Music of the English Parish Church Volume 1* (Cambridge: Cambridge University Press).
 —— 2005 *The Music of the English Parish Church Volume 2* (Cambridge: Cambridge University Press).

Terrien, S.
 2003 *The Psalms. Strophic Structure and Theological Commentary* (Grand Rapids, MI: W. B. Eerdmans).

Thoma, C.
 1983 'Psalmenfrömmigkeit im rabbinischen Judentum', in M. Becker and R. Kaczynski (eds.), *Liturgie und Dichtung. Ein interdisziplinäres Kompendium, 1: Historisches Präsentation, I Band* (St Ottilien: Eos): 91–105.

Timmer, D. E.
 1989 'Biblical Exegesis and the Jewish–Christian Controversy in the Early Twelfth Century', *ChHist* 58: 309–21.

Toon, P.
 2003 *Common Worship Considered. A Liturgical Journey Examined* (Corbridge, Northumberland: Edgeway).

Trudinger, P. L.
 2004 *The Psalms of the Tamid Service. A Liturgical Text from the Second Temple,* Supplements to Vetus Testamentum, XCVIII (Leiden and Boston: E. J. Brill).

Vanderjagt, A.
2008 'Early Humanist Concern for the *Hebraica Veritas*', in M. Saebø (ed.), *Hebrew Bible, Old Testament. The History of Its Interpretation. II From the Renaissance to the Enlightenment* (Göttingen: Vandenhoeck & Ruprecht): 154–89.

Vermes, G.
1999 *The Complete Dead Sea Scrolls in English* (New York: Allen Lane).

Vesco, J.-L., O.P.
1986 'La Lecture du Psautier selon l'Épitre de Barnabé', *RB* 93: 5–37.

Visscher, E. de
2008 'Putting Theory into Practice? Hugh of Saint Victor's Influence on Herbert of Bosham's »Psalterium cum commento«', in Rainer Berndt (ed.), *Bibel und Exegese in der Abtei Saint Victor zu Paris. Form und Funktion eines Grundtextes im europäischen Rahmen*, Corpus Victorinum: Instrumenta (Berlin: Akademie Verlag): 429–41.
—— 2009 ' "Closer to the Hebrew": Herbert of Bosham's Interpretation of Literal Exegesis', in I. van't Spijker (ed.), *The Multiple Meanings of Scripture. The Role of Exegesis in Early-Christian and Medieval Culture*, Commentaria, 2 (Leiden and Boston: E. J. Brill): 249–72.

Visscher, E. de, and J. Olzsowy-Schlanger
2009 'Christian Hebraism in England', in Piet van Boxel (ed.), *Crossing the Boundaries: Hebrew Manuscripts as a Meeting Place of Cultures* (Oxford: Bodleian Library).

Waddell, C.
1995 'A Christological Interpretation of Psalm 1? The Psalter and Christian Prayer', *Communio* 22: 502–21.

Wagner, R.
1994 *The Book of Praises. A Translation of the Psalms, Book One* (Oxford: The Besalel Press).
—— 1998 *Songs from a Strange Land* (Oxford: The Besalel Press).

Wald, E. T. de
1942 *The Illustrations in the Manuscripts of the Septuagint. Volume III. Psalms and Odes. Part 2: Vaticanus Graecus 752* (Princeton, NJ: Princeton University Press).

Wallace, H. N.
2009 *Psalms* (Sheffield: Sheffield Phoenix Press).

Wallwork, N.
1977 'The Psalter and the Divine Office', *StLi* 12/1: 46–64.

Walsh, P. G.
1990 *Cassiodorus, Volume One: Explanation of the Psalms*, Ancient Christian Writers (Mahwah, NJ: Paulist Press).

Ward, B.
2002 *Bede and the Psalter*, Jarrow Lecture 1991. The Rector of Jarrow, Jarrow-on-Tyne (Oxford: SLG Press).

Watts, J. W.
1990 'Psalm 2 in the Context of Biblical Theology', *HBTh* 12: 73–91.

Weber, B.
 2006 'Psalm 1 and its Function as a Directive into the Psalter and towards a Biblical Theology', *OTE* 19: 237–60.
—— 2010 'Die Buchouvertüre Psalm 1–3 und ihre Bedeutung für das Verständnis des Psalters', *OTE* 23/3: 834–45.

Weil, D. M.
 1995 *The Masoretic Chant of the Bible* (Jerusalem: Rubin Mass).

Weinberger, L. J.
 1998 *Hymnography: A Literary History*, Littman Library of Jewish Civilisation (London and Portland, OR: Valentine Mitchell and Co. Ltd).

Weiser, A.
 1962 *The Psalms*, Old Testament Commentary Series (London: SCM; trans. H. Hartwell of *Die Psalmen*, Das Alte Testament Deutsch, 14. Göttingen: Vandenhoeck & Ruprecht, 1959).

Weisweiler, H.
 1937 'Die handschriftlichen Vorlagen zum Erstdruck von Pesudo-Beda *In Psalmorum Librum Exegesis*', *Bib* 18: 197–204.

Weren, W. J. C.
 1989 'Psalm 2 in Luke-Acts: an Intertextual Study', in S. Draisma (ed.), *Intertextuality in Biblical Writings: Essays in honour of Bas van Iersel* (Kampen: Kok): 189–203.

Werner, E.
 1959 *The Sacred Bridge. The Interdependence of Liturgy and Music in Synagogue and Church during the First Millennium* (London: Dennis Dobson and New York: Columbia University Press).

Westerfield Tucker, K. B.
 2001 *American Methodist Worship* (Oxford: Oxford University Press).

Westermann, C.
 1981 'The Formation of the Psalter', in *Praise and Lament in the Psalms*, trans. K. R. Crim and R. N. Soulen (Atlanta, GA: John Knox Press): 250–8.

Wette, W. M. de
 1929 *Commentar über die Psalmen* (Heidelberg: F. E. B. Mohr).

White, E.
 1988 *A Critical Edition of the Targum of Psalms: A Computer Generated Text of Books I and II* (Ph.D. thesis, unpublished; Montreal: McGill University).

White, S.
 1997 *Foundations of Christian Worship* (Atlanta, GA: John Knox Press).

Widengren, G.
 1951 *The King and the Tree of Life in Ancient Near East Religion* (Uppsala: A.-B. Lundequistska Bokhandeln).

Wiedermann, G.
 1986 'Alexander Alesius' Lectures on the Psalms at Cambridge, 1536', *JEH* 37/1: 15–41.

Wilcox, M.
 1986 'The Aramaic Targum to the Psalms', *Proceedings of the Ninth World Congress of Jewish Studies, 1985* (Jerusalem: World Congress of Jewish Studies): 143–50.

Wilkinson, J. (ed.)

　　1999　*Egeria's Travels to the Holy Land* (Warminster: Aris and Phillips).

Willems, G. F.

　　1990　'Les Psaumes dans la Liturgie Juive', *Bijdragen, Tijdschriftenvoor filosofie en theologie* 51: 397–417.

Willis, J. T.

　　1979　'Psalm 1–An Entity', *ZAW* 91:3: 381–401.

—— 1990　'A Cry of Defiance—Psalm 2', *JSOT* 47: 33–50.

Wilson, G. H.

　　1985　*The Editing of the Hebrew Psalter*, SBL Dissertation Series, 76 (Chico, CA: Scholars Press).

—— 1986　'The Use of Royal Psalms at the "Seams" of the Hebrew Psalter', *JSOT* 35: 85–94.

—— 1993　'Understanding the Purposeful Arrangement of Psalms in the Psalter; Pitfalls and Promise', in J. C. McCann (ed.), *The Shape and Shaping of the Psalter*, Journal for the Study of the Old Testament Supplement Series, 159 (Sheffield: Sheffield Academic Press): 42–51.

—— 2005　'King Messiah, and the Reign of God: Revisiting the Royal Psalms and the Shape of the Psalter', in P. W. Flint and P. D. Miller, Jr. (eds.), *The Book of Psalms. Composition and Reception* (Leiden: E. J. Brill): 391–406.

Woolfenden, G. W.

　　1993　'The Use of the Psalter by Early Monastic Communities', *SP* 26: 88–94.

Wragg, A.

　　1934　*The Psalms for Modern Life* (London: Selwyn & Blount).

Wright, R. B.

　　1985　'Psalms of Solomon', in J. H. Charlesworth (ed.), *The Old Testament Pseudepigrapha, vol. 2: Expansions of the Old Testament and Legends, Wisdom and Philosophical Literature, Prayers, Psalms and Odes, Fragments of Lost Judeo-Hellenistic Works*, Anchor Bible Series (New Haven: Yale University Press): 639–70.

Yadin, Y.

　　1959　'A Midrash on 2 Sam. vii and Ps. i-ii (4QFlorilegium)', *IEJ* 9: 95–8.

Zenger, E.

　　1986　'"Wozu tosen die Völker?" Beobachtungen zu Entstehung und Theologie des 2. Psalms', in E. Haag and F.-L. Hossfeld (eds.), *Freude an der Weisung des Herrn. Beiträge zur Theologie der Psalmen, Festschrift H. Gross* (Stuttgart: Katholisches Bibelwerk): 495–511.

—— 1994　'New Approaches to the Study of the Psalms', *PIBA* 17: 37–54.

Zenger, E. (ed.)

　　2001　*Der Septuaginta-Psalter: Sprachliche und theologische Aspekte*, Herders Biblische Studien, 32 (Freiburg im Breisgau: Herder).

Zenger, E. and F.-L. Hossfeld

　　1993a　'Psalm 1: Wegweisung für die Gemeinde der Gerechten', in E. Zenger and F.-L. Hossfeld (eds.), *Die Psalmen*, Die Neue Echter Bibel, 29 (Würzburg: Echter Verlag): 45–9.

Zenger, E. and F.-L. Hossfeld

 1993b 'Psalm 2: Wegweisung für die Völker', in E. Zenger and F.-L. Hossfeld (eds.), *Die Psalmen*, Die Neue Echter Bibel, 29 (Würzburg: Echter Verlag): 49–54.

Zevit, Z.

 2001 *The Religions of Ancient Israel. A Synthesis of Parallectic Approaches* (London and New York: Continuum Publishing).

Zimmerli, W.

 1972 'Zwillingspsalmen', in J. Schreiner (ed.), *Wort, Lied und Gottespruch, 2, Beiträge zu Psalmen und Propheten, Festschrift für Josef Ziegler.* (Würzburg: Echter Verlag): 105–13.

Index of Names

Note: Page numbers in **bold type** indicate Figures

Index of Subjects

peshat 84, 92, 93, 111, 112
 David-centred, Israel-centred 83
 distinction between *derash* and 86
Pesukei d'imra 133
Pharisaic Judaism 25 n.
Pharisees 25 n., 32, 33, 264, 265
 scribes and 115, 117 n., 118 n.
Philistines 78, 83, 113, 117, 124
Phrygian mode 217
Piers Plowman (Langland) 242–3, 259
Pilgrim Fathers 142 n., 212
plainchant 122, 206
 break with 207, 208, 212
 contemporary appropriation of 226
 development from 217, 223
 emergence of 194
 radical break with 208
 see also Gregorian plainchant; Latin
 plainchant
polyphony 193 n., 203, 207, 222 n.
Pontifical Bible Commission 150, 253
prophetic-eschatological concerns 269 n.,
 284
Protestant churches 120, 124, 142, 146, 151,
 265
 international scholars from different
 denominations 255 n.
 liberal 263
 Version of the Second Psalm 220
Proverbs 5, 57, 58, 72 n., 85, 181, 194 n.
 stark idea of retribution found in 12
 wisdom 'created' in 75
psalmody 23, 132, 145, 151, 186, 198, 220
 antiphonal 200–1, 202 n.
 auditory elements of 251
 Calvin's attention to 122
 contemporary adaptations of 227
 detailed information about practice and
 performance 203
 history of the interpretation of 273 n.
 interest in 90
 liturgy and 129, 131, 142, 146, 147, 150,
 192, 193
 Luther's love for 118
 mutual search for the *skopos* of 53 n.
 overriding interest in moral value of 51
 parish and cathedral 222 n.
 predominant traditional language of 240
 Psalm 1 seen as a great door to the whole
 building of 57
 'secularization' of musical interpretations
 of 232
 status in Christian worship 141
 threefold reading of 56 n.
 'universalizing' of 233
 vernacular 207, 242

widespread use in monastic and cathedral
 offices 137
see also Christian psalmody; English
 psalmody; French psalmody; Greek
 psalmody; Hebrew psalmody; Jewish
 psalmody; Latin psalmody; metrical
 psalmody
Psalms for Today (1990) 151, 225
Psalms of Ascent lectures (1532) 121
Psalms of Solomon 27 n., 31 n., 32–5, 36
Psalter in English Verse (Keble) 251
Psalterium cum commento (Herbert of
 Bosham) 109
Psalterium Feriale 134
Psalterium Gallicanum (Jerome) 61–2, 63 n.,
 109, 240
Psalterium Hebraicum (Jerome) 62, 100, 109,
 115, 240
psalters:
 abbreviated 100, 102
 compilers of 8, 16
 continual/continuous reading of 137, 139
 creation as five books 7
 enabling the laity to 'recite' 138
 gateway to 127
 illuminated 156, 157–63, 173, 175, 176,
 178, 179, 181, 182, 191
 late entry into 10
 Latin and Hebrew columns **110**
 liturgical 62, 135, 137, 140, 147, 151, 158,
 164, 177, 178, 192, 203, 257 n.
 medieval 59, 97, 110 n.
 organization into twelve categories 96
 praying right through 135, 142
 Preface to 123
 Prologue to 6, 42, 48, 62 n., 76, 105, 114,
 126, 139, 156
 reading/reciting the whole 132, 134, 145
 ten poetic genres of 82
 themes in 4, 103, 106
 see also under various psalters, e.g. Byzantine
 Psalters; Christian Psalters; *Eadwine;
 Ecusa; Gallican Psalter; Gelineau;
 Geneva Psalter; Gorleston; Grail; Greek
 Psalter;* Hebrew Psalter; *ICEL; Isabella
 Psalter;* Latin Psalter; *Luttrell; Ramsey;
 Scottish Psalter; Selah; St Albans
 Psalter; Stuttgart; Utrecht; Windmill*
Psaumes Chants de l'Humanité **236**
Psaumes de David (Chagall) 187
Pseudepigrapha 16 n., 31–7, 237 n.

Quincuplex Psalter (Lefèvre) 118
Qumran 26–7, 31, 37, 45, 273, 282, 294
 psalms used to legitimize the Jewish
 community at 71

Index of Psalms